Film Production Technique

Creating the Accomplished Image

Film Production Technique

Creating the Accomplished Image

SIXTH EDITION

Bruce Mamer

CENGAGE
Learning

Australia • Brazil • Mexico • Singapore • United Kingdom • United States

Film Production Technique: Creating the Accomplished Image, Sixth Edition
Bruce Mamer

Publisher: Michael Rosenberg

Assistant Editor: Erin Bosco

Editorial Assistant: Rebecca Donahue

Media Editor: Jessica Badiner

Executive Brand Manager: Ben Rivera

Senior Market Development Manager:
Kara Kindstrom

Rights Acquisitions Specialist: Amanda Groszko
and Jennifer Meyer Dare

Manufacturing Planner: Doug Bertke

Art and Design Direction, Production
Management, and Composition:
PreMediaGlobal

Cover Image: © Raymond Allbritton/Stone/
Getty Images

Library of Congress Control Number: 2013935242

ISBN-13: 978-0-8400-3091-7

ISBN-10: 0-8400-3091-6

Cengage Learning
200 First Stamford Place, 4th Floor
Stamford, CT 06902
USA

Cengage Learning is a leading provider of customized learning solutions with office locations around the globe, including Singapore, the United Kingdom, Australia, Mexico, Brazil and Japan. Locate your local office at **international.cengage.com/region**

Cengage Learning products are represented in Canada by Nelson Education, Ltd.

For your course and learning solutions, visit **www.cengage.com**

Purchase any of our products at your local college store or at our preferred online store **www.cengagebrain.com**

Instructors: Please visit **login.cengage.com** and log in to access instructor-specific resources.

Printed in the United States of America
1 2 3 4 5 6 7 17 16 15 14 13

Contents

Part III Shooting 199

Chapter 9 File Acquisition and Film Transfer 200

Chapter 15 **Executing the Lighting** **354**

Part V Editing 385

Chapter 16 **Principles, Procedures, and Equipment** **386**

Preface

The last edition of this text (2008) came at a time when change in the film and video industry had finally slowed for a brief time and, unlike the previous ten years, certain aspects had become remarkably stable. In many ways, things remain reasonably consistent. The camera situation continues to develop and the total conversion to tapeless acquisition is nearing completion, but basic camera decisions (film, 1080, 720, 3D, etc.) remain relatively unchanged. While editing systems incorporated file acquisition long ago, the ascendancy of Apple's Final Cut Pro and numerous other affordable platforms continue to make postproduction available to a wide variety of users. Rather than being faced with a bewildering array of tape formats and planning for their consistent use in the postproduction world, codecs for straightforward file import into editing systems have been an easier issue to master.

There are, of course, a number of big changes (DSLR shooting, Kodak's bankruptcy, Red-style cameras, etc.), but maybe the biggest change has come in the nature of the industry itself. Big productions with large budgets and multiple crewmembers are by no means a thing of the past, but the small user has taken on a more substantial role in the grand scheme of things. Now so much can be done by a guy (or gal) with a camera and (maybe) a sound person. A few extra people might be around for specific tasks, but a small crew can get by in more and more situations. In the old days, even local origination projects would require production management, grips and electricians, camera departments, and a smaller-than-Hollywood crew—a still significant number of people. Now, someone can put out their shingle and, while it is still tremendously competitive, start a potentially active business.

The first edition of *Film Production Technique* (1994) was an absolutely unapologetic introduction to undiluted motion picture technology, both in shooting and editing. At that time, analog video was either too cumbersome or technically inferior, both in image quality and particularly editing, to be more than a personal or agitprop medium. Camera producers tried and tried to emulate the film look, but the primacy of film as a shooting medium remained only modestly challenged. Many made video work for them in creative and productive ways, but it was always a struggle. Obviously, the slow transition to all-digital video changed all this. Every subsequent edition saw the opening of the floodgates further and further to the exciting new video technologies, particularly in the editing world. Despite this, well into the third and maybe even the fourth edition, there was still a good case for learning film editing and how to go to a final film print. Film editing still has some positives for the old guard, but it has largely disappeared from the making communities' imagination. No burgeoning independent or amateur could or should be convinced of the efficacy of film in postproduction, and almost no educational institution is going to make students shoulder the expense and complexity of a full-film workflow. With every successive edition, more and more video technology has necessarily been integrated into the text.

The point was validly made in previous editions that a producer with a film print had significant advantages over projects finished entirely on video. Festivals generally were still projecting film and having a print showed both seriousness of purpose and the financial resources of a mature maker. Even this, however, is no

longer particularly relevant. Having a film print is not anywhere near as essential, but it still can play a role in a project's exhibition life. One recent feature at a Tribecca festival boasted that it was the first film to go to a 35mm film print after being shot entirely on iPhones. While much theatrical distribution has gone digital, having a film print is still significant and understanding potential workflow options is beneficial.

So: why at this late date film? The necessary outcome of the increased viability of video is that film has migrated to the highest echelons of the industry—a process that really started 30-plus years ago but is essentially now complete. Young makers shooting for YouTube success have no logical use for film with efficiency and cost far favoring video; however, seven of the nine Oscar-nominated features in 2011 were shot on film, and it is not so long ago that 12 billion feet of film was being processed a year. Recent figures suggest processing is down to about 4 billion feet of film a year—a large drop but still a number that is by no means insignificant. Film is occasionally used by independents, however, and there are many colleges and universities that still see the benefit in giving their students a solid background in the good old photo-chemical world. For those who want "legs" in the industry, film can still be an appealing skill set. Film remains as a source for many mainstream features, some television, and commercials, all of which in many instances require its look or other specific features. Having a medium that is relatively bulletproof as an archival medium is also becoming more important. More on all this later.

While many other things could be cited, the key changes that have had a profound impact include:

Digital Single Lens Reflex Still Cameras Maybe the most significant development over the last five years is the emergence of the **Digital Single Lens Reflex** (**DSLR,** also called **HDSLR—High Definition …**)—still photography cameras with robust video capabilities—as important production tools. Digital cameras and cell phones have had modest video capabilities for a long time, but the great strides made in the quality of the video output of DSLRs and their brethren have changed the industry in many ways. Canon, Inc. led the way in this with its introduction of the EOS Mark II in September 2008, a camera that was latched onto by independents and amateurs as a dream video shooting tool. It was compact and able, with assistance, to store substantial amounts of image material which could be easily and quickly transferred into the editing system of choice. Now at the Mark III stage, amateurs, students, independents, and even many professionals are shooting projects large and small on DSLRs. While YouTube predated the Mark II, the quality and easy accessibility of the DSLR made it a primary provider of footage destined for the hopefully viral world.

Before YouTube, the problem had always been that there was no particular place that wanted or was equipped to exhibit all the new work of independent makers and dabblers suddenly given access to creating relatively polished work by new technology. Thus, the exhibition piece of the puzzle was already waiting; the rise of a venue where all this new work could find an audience. YouTube debuted in the spring of 2005 and was an immediate success. Posting to YouTube became the standard option for people who wanted to get their work seen. The problem, as always, is money. Many people who post to YouTube are not interested in money, but there are limits to how long one can produce without financial remuneration. And, indeed, YouTube has found a way for successful submissions to make a decent return. But the percentage of users making significant money is extremely low—some might say catastrophically low. Either way, the video accessorized DSLR has had a huge impact.

Kodak's Bankruptcy The problems Kodak has incurred recently is truly a sad, but probably inevitable, chapter in the grand history of the film industry. Kodak is not gone, but they are trying to reorganize in a manner that will make them a

profitable company going forward in moving and still imagery. Hopefully, unlike other bankrupt companies like Borders and Circuit City that have failed to continue as successful entities, Kodak can face its great challenges. The company's future will be dependent on its ability to re-invent itself as a company able to be relevant in a much-changed industry. Kodak, of course, is/was an integrated consumer- and professional-based industrial giant, and its motion picture division was a relatively small but historically profitable and productive component. The motion picture division was hardly responsible for the entire financial failure, but it will go just as every other division if reorganization is unsuccessful.

No company was more important to the technical, and certainly aesthetic, development of the motion picture industry through its temporally brief but storied history. Kodak worked hand in glove with the studios to expand the expressive possibilities of the film image. When we talk about Gregg Toland and *Citizen Kane* (1941), all the deep focus, complex matting, and atmospheric lighting effects were heavily reliant on the constant innovations in film stocks and processing by the engineers and visionaries at Kodak. Film noir would not have been possible without the faster film stocks and the decreased grain on the underexposure end of new and improved film stocks. Clearly, the cinematographers of the great silent era were able to create remarkable images, but post World War II shooters like the great John Alton were able to further the exploration of the expressive image in ways impossible before. As innovation followed innovation, the medium's ability to create more and more complex visual ideas allowed the American film industry to achieve ever-increasing depth. Very few other companies had a similar impact on the rise of the motion picture industry. In recent years, Fuji and other companies gave them a run for their money both in motion picture and consumer still photography, but Kodak's failure is generally regarded to be less from competition than from the inability to change with the digital revolution.

Oddly enough, critical to Kodak's future success is the fact that they hold thousands of patents on everything ranging from conventional photographic imaging to digital cameras and supporting technologies. Some have suggested that Kodak's inadequate exploitation of its digital innovations was solely to protect its conventional film business, an approach that became increasingly tenuous. Post mortems tend to be useless, but the photochemical world clearly could not sustain an industrial giant. In its motion picture division, Kodak never made its greatest profits from camera original, that is, the film that actually passed through the camera while shooting. From the very beginning in the 1890s, producers were faced with what turned out to be an easily surmountable problem: There is only one piece of film that passes through the camera in any shooting situation. How do you reduce stress on that precious commodity—the original piece of film—and how do you show the film concurrently in multiple theaters? Contact printers that created frame-for-frame copies from original film were the immediate solution with the original sandwiched with unexposed film and run past a focused light. Many hundreds of prints could be created this way, and this became a much larger component of Kodak's business than primary shooting. Thus, Kodak's greatest cash cow was in prints, both workprints for editing of camera original and, particularly, prints for exhibition in theaters. Given transfer to video from camera original and the accelerating conversion to digital projection in theaters, the demand for printed film has rapidly decreased over the last 20 years. Now it is a small, but still important, aspect of the postproduction and exhibition picture.

To the woes of Kodak, we can add a topic that easily could merit separate attention except it has been a shadowy presence for almost 15 years: the finally rapid transition to digital projection after years of anticipation and conjecture. Way back in 2001, we seemed to be standing on the edge of something that desperately wanted to happen but that just could not quite break through. It is entertaining, if not mildly comical, to go back to the trade and academic

journals of the day and read through the grandiose predictions concerning the complete transformation of the industry. Ranging from a complete elimination of the theatrical experience, to extensive interaction between audience and artwork, to a simple continuance of then-current circumstances but with digital projection, the time seemed ripe for great change with the end of film origination and exhibition being a potential by-product. But it just kept failing to materialize—until now. Now that it is finally happening, further inroads have been made into the use of film, but it still remains a hardy perennial with substantial work being shot in features, episodic television, commercials, music videos, and specialty work. We now understand many of the reasons why a complete conversion to digital video did not happen quickly. But it is upon us.

One last wrinkle that came up just before publication is that Fuji, Kodak's sole competitor in the United States and many other countries, announced that it was discontinuing its entire camera film line. This will clearly have a big impact on the film world and Kodak's role in the future. Tellingly, Fuji is continuing its archival and postproduction film stocks a trend that is discussed later in this list as well further in the text.

The End of Tape Glory Hallelujah, oh excuse me, pardon the editorial comment. OK, tape is not gone entirely but the movement to card and hard drive acquisition has eliminated a large share of tape work. No figures exist for how much production and exhibition is still done on tape, but suffice it to say that digital storage is taking over. Submissions to clients, festivals, TV stations are still predominantly made on tape, but most image acquisition is file-based. I remember people trying to edit with the old VHS format (I did some myself) and it was OK for some basic news and information projects. But for anything of any complexity, particularly when it came to audio, it was an absolute nightmare and produced a product that was mediocre at best. Even ¾-inch video, which was the professional counterpart to VHS, was only marginally better. Still it hung on well past its natural lifespan as a submission medium to ad agencies, TV stations, and grants committees. Now more sophisticated tape formats still frequently serve that purpose.

Still there was justifiably great excitement about the new technology in the 70s and 80s. Given the political currents of the time, progressive makers flocked to tape as a way of expressing ideas and ideological positions that were barely represented in the conventional media of the day. The technical and practical complexity of the classic Hollywood period was so expensive and inaccessible that only a small minority of California-based makers had access to it. Educational, local commercial, and university-based filmmakers were the genesis of producers outside the Hollywood structure who were able to make films with locally-based technical infrastructure. When tape came along, the ability of local makers, including what were charmingly called guerilla filmmakers, had a technology to produce nonmainstream work. But the new freedom was in many ways illusory. Both the crude technology and, many would say, the limited experience of the nascent makers coalesced to create work that could not compete with the polished work of the West Coast establishment. A formal, or informal, education in the aesthetics—the art—of communication was still needed.

So early digital filled many needs, but many still found the tape aspects wanting in certain ways. The endless process of capture from tape to digital files, for instance, is eliminated in file acquisition. You had to go through a log of beginning and ending time code numbers and then wait in real time while each shot was brought in. While editing on film had its own lengthy pre-edit processes (syncing up, first assembly, coding), there was something about capture that drove me, at least, crazy. Maybe it was the promise of immediacy of digital editing but, when you added in syncing up, time code tracking, and all the other organizational processes, you wound up putting in a lot of time before you could start any real editing. Things keep getting better and better.

A New Generation of High-End Video Cameras　The movement to create better and better high-end video has been a constant reality for well over 30 years. As the last edition was being completed, the Red Digital Camera Company, Inc. announced the introduction of a camera (the RED camera) that used RAW technology to acquire image, a technology that had already gained wide acceptance in still photography and image finishing in post. Adobe Photoshop pioneered RAW technology creating an endlessly manipulable image. The Red Camera was an immediate sensation and led other companies to introduce competitors. Arriflex, the great 16mm and 35mm film camera company that had long-time ties with Hollywood, had dabbled in digital cameras, but with the introduction of the Alexa in 2010 it jumped full-force into the high-end digital world. Sony, which was always a serious force with its Cine Alta line, continued innovations in its high-end line. Panavision, which, as with Arriflex, was a stalwart in the Hollywood production world, is also weighing in in the high-end world.

Much as the Red camera was breaking on the horizon last edition, the Black Magic Cinema Camera is right on the horizon and promises to be another major player in the camera world. It does all the things that other cameras do, RAW image, 2.5K resolution, uncompressed color space, many interchangeble lenses, etc., but the price point is the most revolutionary aspect of the camera. Priced at $2995 without a lens, it could open up the high-end of the industry almost as much as affordable NLEs and the myriad of other technological innovations. The Red was considered revolutionary priced at around $40,000, but the Black Magic defies reason. Initial tests have been positive and we will see if it holds up to sustained use and if producers continue to get good results. If it does, it may be a game-changer. More in cameras.

The proliferation of cameras employing what was just referred to as an uncompressed color space is another aspect moving the big-budget end of the industry. These technical specifications will be explained in later chapters, but the movement toward a full 4:4:4 color space has come to fruition with the Red, Alexa, and some Sony models. Indeed, high-end competitors have put great resources into providing the most sophisticated color space available. While the DSLRs have had a great impact, they still have some downsides, and the extensive compression of the image producing a highly compromised color space is at the forefront. Given the limited color space, the image from a DSLR is not very manipulable, a fact that can be both frustrating and extremely attractive to videographers. An image that cannot be changed much in post means that the young Turks in post-production suites can't have at a shooter's image with reckless abandon. What someone shot has a better chance of making it into the final product. Still, in the high-end world where image quality has to be sustained through endless processes, a DSLR has some limitations.

Either way, the major rental houses, who trafficked in huge 35mm film camera packages, now find themselves renting more DSLRs and Red-style cameras. Demand for the large production lights and extensive camera support equipment is slowly eroding, and the rental folks find themselves renting lots of small lights and scrambling to obtain or create all the support elements required for new smaller gear. When you see a tiny DSLR tricked out with big matte boxes and sophisticated movement gear, it looks a lot like, but isn't, overkill. The camera used to be, and in some cases still is, this huge monster with a multitude of assistants scurrying around tending to its needs. Now we frequently find ourselves showing the same deference to a master smaller than a breadbox. The whole new landscape in imaging will be covered in appropriate chapters, but suffice it to say that the high-end video options are getting better and better and smaller and smaller.

The End of Offline/Online Distinctions　The concept of offline editing and online finishing is as old as the movie industry, although those specific terms would not have been used. As suggested earlier, the fragile film original was never

subjected to the rigors of editing or exhibition. It was always the source for making prints or even more sophisticated printing elements.

In analog and early digital video, the idea was somewhat similar but many of the details differed. Of the many great curses of analog video, maybe the worst was that downstream copies of original tape grew progressively inferior image-wise. This is an issue of generations, wherein copies of copies of copies continue a process of degradation from the original image. Higher-end analog video formats (Beta SP, Super VHS) held up better but lowly ones like VHS showed significant degradation after as few as two or three steps from the original. Digital video essentially solved the copying problem with copies showing no degradation (or very little) as they went down the food chain. However, early editing systems faced other related problems. Back in the days of megabyte storage (forget gigabytes), video filled up hard drive after hard drive with high resolution information. In early manifestations, systems could not handle this high storage requirement and even short films overtaxed storage capabilities. Features had an impossibly large amounts of footage and interfacing dozens of external hard drives was unrealistic. Even more critical, instant image retrieval requirements of high-resolution digital video posed even greater problems. Each frame at high res was a multiple megabyte proposition and there were, and still are, 30 frames of video every second. Remembering how long it took to open even a low res image in Adobe Photoshop, the idea of pulling up and displaying 30 frames a second of high-res video was an impossibility. Of course, arriving with terabyte storage and faster and faster retrieval rates, all things digital are solvable over time.

To deal with storage and retrieval issues, editors over the decades of development worked with low-resolution copies (offline) and then, once all editorial decisions were made, projects were returned to an expensive online environment to finish at the highest possible quality. Sometimes they returned to film originals, other times to the tape (now digital file) elements. Online suites were state of the art environments with hourly rates only affordable by mainstream features, TV shows, and commercials. Now with storage in multiple terabytes and systems that can work with high-resolution images, the distinction between offline and online is slowly disappearing. An editor, in a small studio or even at home, can now complete a show from start to finish without returning to an expensive online studio.

While the creativity and dimension brought to bear by online studio personnel with years of experience is still a valued resource in the world of mainstream product, the generic online suite is becoming something for which many producers are finding effective workarounds. The downside of all this is that very few editors, or members of the editorial team, can possibly have complete expertise in the varied necessary technologies for finishing a project. Can an editor and his/her crew effectively mix a sound track to achieve the best quality final product? Can an editor working in a timeline have the same global perspective on color correction as someone who has devoted an entire career to the subject? Everyone involved in the making of a project has spent extensive time mastering special skills. Trying to do it all generally means someone has spread themselves far too thin—trying to execute skill sets that are beyond their reach. As the old saying goes, just because you can do it does not mean that you *can* do it. Sound is maybe the best example. I have heard many supposedly finished sound tracks that could benefit, maybe to the point of saving the movie, from some skilled hands applying a lifetime of knowledge to their construction.

Archival stability Many television and feature projects are now shot on digital video. *The Office* is a good example of a program that has a very well-thought-out aesthetic and technical approach to video origination. Unlike *Cheers* and many earlier programs, film is nowhere present in the production's workflow. Over the last few years, the stability of digital storage has come in for serious questioning. As anyone who has put an old, treasured DVD into a deck only to see it ejected, digital media can be easily corrupted over time, inadequate production, and poor

handling, thus rendering once-stable DVDs unviewable. VHS, for all its shortcomings, is still viewable, though often unacceptably degraded, after many years. When the original elements for a digital project go they are gone—period.

The greatest profitability of many shows is in syndication and/or in long-term video sales or rentals, the latter particularly true of movies. A producer's long-term approach for protecting their assets has necessarily become part of the overall plan. Archival organizations like the Association of Moving Image Archivists (AMIA) have devoted many resources to studying digital storage issues and recommending the best strategies for extending the life of visual media. At this point, one of the best is to step back a little bit in history and transfer digital origination material to a three-strip film process. The video image is "written" to three separate strips of film—the red, green, and blue records—which will serve as a transfer medium for years to come. Film itself is also notoriously unstable, with many older films being lost or irreversibly damaged due to neglect or otherwise poor handling. Film does not respond well to heat, humidity, dirt, or a host of other enemies like, for an almost ridiculous instance, aerial bombing. The original for one of the greatest films of all time, Jean Renoir's *The Rules of the Game* (1939), was destroyed during a bombing raid in World War II. A high quality print was reconstructed from other high generation prints and printing elements to save an endangered masterpiece. Maybe not quite so extreme, but similar stories abound. Even some films that strike some of us older folks as having some currency, like David Lean's *Lawrence of Arabia* (1960), have already been through extensive renovations.

Hopefully, enemy actions will not put your cherished creation at risk, but having it around to show your grandkids might be nice. If stored properly, film will last for many years, and at present, particularly calculating ever-changing digital broadcast and exhibition standards, it is the most bulletproof method of guaranteeing a long life for valuable properties. It is in the obvious best interest of producers to protect valuable assets that will be a major part of their profitability over the years. It is very difficult to channel surf and not come across endless repeats of early episodes of *30 Rock, 3rd Rock from the Sun*, or any number of other popular series. *Game of Thrones*, the immensely popular HBO series, is being shot with the Arri Alexa and while these kinds of shows are still a healthy mix of film and video approaches, guaranteeing their future life will be critical. While maybe not being part a student's learning priorities, film may be a big part of storing for the future.

The End of the Great Age of Movies This is the most slippery issue of all the ones presented herein and thus saved for last. In the festival and premiere worlds, the culture of bristling anticipation for the next feature film by Bergman or Wenders or Herzog or a host of others is at best a fading memory. The age of anticipating the next great film by an established or emerging auteur is largely gone. The audience has become so fragmented and the venues for exhibition so diverse that only a small number of viewers are going to be an excited constituency for any given film or maker. Part of it may be the new emphasis on diversity with the lack thereof in my previous list of makers being indicative of maybe or maybe not relevant cultural issues. Today, the blockbusters—the event movies—are almost all based on comic books or similar popular culture examples and, while they can be immensely entertaining, they do not have the gravity of a major work by a major maker. In fact, modern audiences can be hostile to demanding works: witness reactions to Terence Malick's *Tree of Life* (2011). The Coen brothers may be the only producers who create works that have some level of mass market anticipation, although their *A Serious Man* (2010) seemed an irritant to many modern sensibilities as well.

We still have our Cannes festivals, our Toronto's, and a host of newer venues, but they are not dominated by a number of big names that have a lot of people buzzing. A long answer may be the changes in audience already suggested. A short answer is surely that so much work of gravity and interest has gone over to

short-form TV. Series like *The Sopranos*, *Deadwood*, *Mad Men*, *The Wire*, *Boardwalk Empire*, and a very long list of others is where some of the best work is happening. Discerning adults can sit at home and enjoy intelligent and thoughtful work without having to listen to part of the unfiltered opinions of modern audience members.

The audience for classic Hollywood film may not have been monolithic, but heterogeneity certainly could guarantee producers a substantial number of viewers for entertaining works. Now, with the exception of the blockbusters, one needs to find and make a profit from niche audiences. YouTube can produce a transitory success, but who is going back to look at viral projects from 2007? Will we be going back to viral wedding dance videos like audiences go back to *The Wizard of Oz* (1939) or *It's a Wonderful Life* (1946), or will we be studying art films like Bergman's *The Seventh Seal* (1957) or Herzog's *Aguirre the Wrath of God* (1972)? To many people these look like artifacts of a world that no longer exists. Scandinavians playing chess with death? Where the audiences will go and how long YouTube, streaming video, and even the traditional theater experience will last are all unknowns in the modern landscape.

Despite all these big shifts, many elements of the process have remained reasonably consistent. Things have settled in to where there are a number of standard ways of initiating and completing a project, with determining factors of budget and desired audience leading to relatively clear choices. Certainly, there are all these new issues waiting for further discussion, but it seems to be in the details rather than in the broad-brush issues. Analog video technologies transformed the industry in the 1980s, but at that time the fundamentals of motion picture film, and particularly film editing, remained viable though in the beginnings of retreat. The evolution of digital video technologies further accelerated this incredible transformation and, in the long run, have virtually eliminated film editing—that is, the good old-fashioned practice of cutting and splicing actual pieces of film.

Clearly, the landscape for editing and finishing a visual project has changed dramatically over the last twenty-five years. As the use of the term "visual project" in the previous sentence suggests, we are even having trouble knowing what to call things. Distinctions about what constitutes something being called a "film" that were proposed in previous editions probably are no longer relevant. Is a project shot with a digital camera and edited on a computer a film? Is a project shot on film but edited and finished on video a film? Is a project shot on film, edited digitally, then returned to a film format a film? It probably does not make too much difference any longer. However, if your exhibition strategy requires a film print, and potentially successful films generally require some film prints, you are better off considering many technical and aesthetic choices in all stages of a project as it is being produced.

In this day and age, there are many roads to getting to a film print. You can create a film print without ever having committed any of your project to a single frame of film. In fact, you can make it to a film print without ever having put anything in front of the lens end of any camera, be it film or video. *The Polar Express* (2006) is considered to be the first camera-less feature film—that is, created entirely within a computer environment. More germane, film prints can be struck from virtually any digital source in a variety of very expensive processes. Writing a film image from a video image has become commonplace. The **Digital Intermediate** process (see chapter 9) has become a standard way of getting to a film print, either with or without film being used in any part of the process.

With all the digital hullabaloo, why is a film print still desirable for some producers? Digital video projection has become the norm but there are still a significant number of theaters, particularly internationally, that remain equipped with 35mm projectors. Despite all the digital advances, if you want your work to receive extensive theatrical screenings, no matter what its potentially humble beginnings, it is a good idea to have some film prints, hence the 35mm print from footage shot on

iPhones mentioned earlier. And it is not like numbers of prints are going to make any difference. The film print from your video, which may actually just be a critical element for making future prints, is the most expensive proposition. It is not like you strike a new print from your video every time. You strike a printing master and then all subsequent film prints are made from that. From that master, film prints are not cheap but the big expense is creating the source to make multiple copies. But this all applies to the high-end of the industry.

It was strongly recommended in previous editions, and I think accurately, that students of visual media should learn the film editing process and, particularly, how to make film prints. As film prints became less necessary, the recommendation became more and more based on the discipline learned rather than on some more valuable final product. The important qualification was that making a film print offered a learning experience that can easily be lost when finishing on video. It is too easy to throw things together on video pretty sloppily and call it done. One can shy away from the hard questions when finishing on video, whereas, with film, simply positioning yourself to finish was a challenging and expensive enough proposition that making everything right became a significant aspect to factor in.

Not that finishing on video is by definition simple. Nothing could be further from the truth. Done right, finishing on video is every bit as demanding as a film finish—factor in broadcast standards and you really have your hands full. The problem is that there are too many opportunities at beginning levels to not do it right. Exhaustion is always an element on projects big or small. In the editing room, when the "if I'da known then what I know now" factor makes a project look like an early plot point on the learning curve, an easy exit can be an option that is hard to resist. Unless held to an extremely high standard, beginning videos tend to be sloppy and undisciplined, whereas film just costs too much and is too hard to be undermined by carelessness. Simply stated, the effort involved in finishing a film was demanding enough that it is a tremendous learning experience. It leaves the filmmaker well positioned for less strenuous tasks.

The other argument addressed earlier was that having a film print positions you better for consideration for film festivals and distribution deals. As suggested, this is less the case today, although it still has the potential to make a difference. Having a print means the project can be exploited to its fullest potential, with screenings at venues that are not yet outfitted with digital projection. But the people who have the dubious honor of making the initial cut for festivals, pay little attention to exhibition issues in the present environment.

So, creating high quality media is the issue. As you look around at the many sources of visual media now, there is a tremendous amount of undisciplined work. That in itself is not a problem. At four or five minutes a pop on YouTube, viewers can be very forgiving, particularly if you have cute subject matter or something similarly engaging. However, even recognizing that they may not be particularly interested, the makers are not necessarily learning the skills that will serve them for a long career. The unfortunate reality is that trying to apply the skill levels YouTubers are achieving to short- or long-form media does not work. Putting many of the myriad critical issues like performance aside, when we use the term discipline we are talking about structuring and shaping our scenes, and in a more global sense the whole project, so they have economy and pace and engage the audience.

This is all well and good for budding professionals and advanced independents, but given that many readers of this text are students or otherwise novices, the central question remains, Does a typical student or novice need a film print? The answer has evolved from "it is a good idea" to "absolutely not." The brutal truth is that, beyond hitting the YouTube jackpot, only a very small percentage of initial efforts receive any, much less wide, distribution or financial remuneration. While all filmmakers suffer from the tribulations associated with how easy it looks to outsiders, it is slightly ridiculous to expect students with limited experience and no money to

pull off what the most talented professionals, with extensive budgets and the best screenwriters, actors, and technicians in the world, only do on rare occasions. So the odds that a beginner will require a film print are profoundly limited.

The issue then is how does the student or beginner begin to get a handle on the disciplined approach that is going to help move them forward. The whole film process use to be a big part of this, but the only answer I can come up with now is you have to hold yourself to the highest standard. Watch how the camera is used in films you admire. So many of the shots in YouTube videos are single takes of something interesting. In narrative work, scenes have to be broken down to guide the viewer through the appropriate places to be lavishing their attention. Don't take easy solutions when they present themselves, either while shooting or editing. Even things that appear to have an informal style or incorporate the new romance with handheld camera are not as spontaneous as appears. Again, *The Office* is a good example with a deceptively informal approach masking carefully staged scenes.

One of the major purposes of this book is to give the reader an appreciation of just what it takes to produce the images we see on-screen. It may take quite some time to achieve the level of control recommended herein. You may start out working with small lighting instruments or a cheap light meter. You may be working on your own or with insufficient help. But at all times, you want to be moving toward the basic goal presented: controlling the elements in and in front of the camera and having a clear concept of all of the possibilities in the editing room.

Changes to the Sixth Edition

The major changes included in this edition are devoted to elaboration on the recent trends presented above. The biggest single change is the creation of an entire chapter covering all the new video shooting technologies.

Expanded discussion of digital camera technologies The recent DSLR revolution has had the biggest impact on the industry. There will be discussions of adapting what is essentially a still camera to movement shooting and some of the support equipment that can aid in the process. Information on codecs and importing video files created on DSLRs will also be included. Beyond this, the new high-end cameras will also be addressed in the new chapter. The RED, the Black Magic Cinema, and the Alexa as well as some of the Sony models will also be covered and discussions of where the 4:4:4 world is going are included and the general technology explained. Another benefit to makers at all levels is that even the highest-end cameras are coming down in price, with features that verge on film-image territory. The Alexa generally rents for around $1500 a day, a figure that will give the beginner pause but is substantially below film camera costs. And though image acquisition on film is still reasonably common, this edition explores more digital camera technologies as lines blur and distinctions grow weaker.

Clarifications of production and editing workflow issues continues Again, approaches to the workflow world are in many ways becoming simpler and, rather than devoting an entire chapter to them as we did in the last edition, the information will be collapsed into other production and editing chapters. Over the last ten years, there was a lot of confusing information out pertaining to workflows and the integration of film and video. The source of all of this flawed information was not sins of commission by people of bad faith but rather the sheer technical complexity of some of the practical concerns and the fact that their implementation was so high in the production food chain that trickle down was imperfect at best. Explanations will be updated and new topics addressed.

Expanded coverage of the Digital Intermediate process is included This whole issue of creating a film print—the final photographic record of a film that is projected on a movie screen--will also be expanded upon. The Digital Intermediate (DI) process was a growing trend way back when the fourth edition was published and it is now common practice—the standard way to get from a video finish to a film print. With the DI process, the information from each video frame is literally written onto a film frame, and prints can then be generated for screening in a conventional movie theater setting. That said, before a project can be initiated, some very challenging questions must nevertheless be addressed. Although mentioned briefly in the context of video, the DI is becoming a standard part of postproduction practice, so it is now more appropriately discussed at length toward the end of the book in chapters 17 and 18.

Further clarification of the role of the film print in postproduction workflows In support of the previous topic, the key assumption of previous editions of this text that beginning filmmakers were well served by making a final film print has been abandoned. I still think there is some truth to this assertion, but creating a film print is fast becoming a rarity in the world of students and novice independents. While the DI has had many benefits, it is well beyond the budget of the average novice. This leaves the conventional route to a film print—the way it was done for the majority of film history—increasingly a specialty approach and less a part of any lab's standard practice. Doing a conventional film finish is still possible, but it requires an ample budget and the knowledge of the limited number of service providers. Students and independents might still be able to find the services at reasonable prices, but even in the Internet age it takes a lot of searching. Although this sixth edition focuses primarily on video origination, film-to-video transfer, and digital nonlinear editing, understanding the traditional film finish will be of service to many aspiring filmmakers, so we've retained in the text the fundamentals of the traditional film finish. However, I must bow to the reality that few students, if any, are spending significant time learning the traditional film-print workflow.

Continued discussions of the relationship of film and video The elements that give the film image such an exceptionally beautiful and resonant quality are also its great downfall: it is inflexible and difficult to manipulate in post. The things that give video its great advantages are also related to its shortcomings: the electronic nature of video allows it to be very flexible, and the image can be endlessly manipulated, but image quality was very limited early in its existence and it is only now that we are starting to become comfortable with the idea that they simply serve different purposes. The amount of film being shot is dropping, but the relationship will still be there for some time to come.

So students and independents, not to mention many in the industry, are faced with some tough decisions. The choice between film and video will be in play all the way from preproduction, to the obvious issues of production, to postproduction choices of what the final product will be, to questions of exhibition and audience. While openly admitting a lifelong love of film, we will try to sort out as much information as possible.

Continued exploration of the matchback process One side effect of the move toward DI finishing is that matchback—the process of matching film negative to what was done in a video edit—has taken a lesser role in the workflow to a final product. While matchback is expensive, comparisons with DI costs should be fully considered and may make some case for returning to the original film. That whole relationship of transferring film to video and then getting to some final product needs to be fully understood. Chapters on the technical characteristics of video

will fully address transferring film to video, further considerations of matchback information, and the possible pitfalls of transferring video into nonlinear editing systems.

All that said, newcomers to the field must come to terms with the fact that no matter at what level they are discussing these issues, theirs are initial efforts, requiring necessarily small steps. One of the greatest challenges of both teaching film and writing a textbook like this is that all initial filming decisions must eventually be informed by a complex knowledge of how films are made in the current environment. As with any field, it takes a long and disciplined course of study to get where you want to go. Students must take baby steps—moving sequentially—when they want to fly, a particularly grievous frustration when everyone and everything in their path seems to already be flying.

My hope is that this book will help you develop the confidence that comes with an understanding of both the craft and the art of film- and now video-making.

Introduction

This book is about creating images. People embark on their first media projects for a variety of reasons. Some want to express a vision that is unique and challenging. Others have a story to tell or something that they feel needs saying. Some want to entertain; others are busy dreaming up ways to subvert mainstream commercial product. Regardless of what brings a person to the medium, the starting place in film is the moving image.

Whatever shape the desire of a beginning filmmaker takes, this text proceeds under the assumption that his or her aims will be best served by a broad-based understanding of visual media technique. Anyone who has learned to play a musical instrument knows that before a musician is ready to play in front of an audience, a huge commitment of hours spent learning time signatures and practicing scales is required. An aspiring painter discovers the same requirement of apprenticeship: you cannot master any art form overnight. Film is no different. But perhaps because Hollywood's images look so effortless, novice filmmakers are often caught off-guard when they discover how much attention each individual shot is actually given. Now YouTube and other exhibition sources have given more attention to what we might call single-camera makers: some might call them amateurs, but the level of sophistication can be quite surprising. However, success on YouTube does not constitute meeting career goals. Suffice it to say at this point that tremendous energy and resources are devoted to every frame of film or video that is shot in professional situations. Clearly, beginning and independent filmmakers cannot emulate the scale and the approach of commercial work, but getting a clear conception of the shape of professional production prepares one for pursuing whatever future is desired.

Clearly in this age of YouTube, readily available acquisition devices, and robust editing systems on most every home computer, the whole process has been brought closer to any comer who wants to take a whack at the video world. As suggested, the task of building an actual career in the field still remains daunting. You can dink around on YouTube all you want and now some money can actually be made, but eventually you need to take it to another level. Otherwise it becomes a hobby. Of course there is nothing wrong with that, although the existence of hobby filmmakers is almost unthinkable to old-timers. The YouTube-style videomaker's presence and influence will certainly increase. That is, until YouTube is replaced by the next big thing, whatever it may be.

Assuming that one desires to go beyond idiosyncratic individual work, this book approaches the process of making films from the perspective of projects that require collaborative work with a skilled crew, whether small or of feature film proportions. While there are more and more "lone gun" filmmakers out there, the preponderance of projects require the participation of a goodly number of experienced individuals. It is critical to recognize the contributions of individual crewmembers and the general common sense with which crews are organized. The desire to be an excellent gaffer (lead lighting electrician) or grip (the crew's jack-of-all-trades) is a worthy pursuit. Moreover, for those who aspire to direct, working from the bottom up and serving in a number of capacities provide both a fuller knowledge of the

craft and a better understanding of the interpersonal dynamics on a set. To a certain extent, crew size is a function of budget, and the difference between low-budget and commercial work is frequently addressed throughout this text.

With regard to crews and technical skills, there is a tendency among people both within the industry and without to divide practitioners into "creative" and "technical" roles, in some cases deeming the technical mastery of the craft to be less important, perhaps less "artistic." In filmmaking, which could reasonably be called the most "technical" of the arts, those who truly excel, whether as directors, cinematographers, editors, or other skilled crewmembers, are both technically expert and creatively engaged. It makes no sense and is indeed counterproductive to separate these qualities in any discussion of filmmaking. People who are successful are, with few exceptions, what I like to call "technical/creative."

Another underlying assumption of the book is the importance of understanding and mastering traditional technique in terms of aesthetics. The focus in the sections on conceptual issues is on conventional (Hollywood) film style: breaking down scenes for dramatic emphasis, lighting for atmosphere, editing for pace and efficiency, and so forth. I encourage anyone interested in experimenting with film form and technique to follow that impulse but to understand the basics as well. Film schools have a tendency to denigrate the conventional in favor of technique that is inventive and nontraditional. The problem is that although different can be great, it can and with some frequency be . . . well, just bad. While this truth is endlessly played out, the real downside is that film students frequently graduate without having explored the basic storytelling skills that are the fundamental building block of many good films—even those with the most unconventional structures and content. Of course, it should not strike one as odd that these just happen to be precisely the skill sets that most potential employers are looking for when evaluating new talent.

So, have at your YouTube adventures and enjoy all this wonderful technology that is at your fingertips. As film students forty years ago, my compatriots and I could never have understood how far away we were from the technical complexity and practical mystique of the studio moviemaking process. Today, people are so much closer to easily available and usable gear that can allow them to produce at levels unimaginable even ten years ago. Just the information on crew responsibilities and organization available from websites, magazines, and books so outstrips anything that was out there in the past. But keep your eyes on the prize. Once the technical and organizational end is mastered, it is all about the aesthetics—envisioning and creating works that are engaging and which keep viewers coming back for more.

Acknowledgments

This sixth edition owes its overall quality to many people, but the most significant contributions were from those who continue to give much-appreciated direction on the new sections on nonlinear editing and digital camera technologies. Jason Wallace has been my prime invaluable source as one of the few people out there who really have their hands around the new digital world and the video/film interface. David Tufford of Cinequipt, Inc., was exceptionally helpful in providing details about how the landscape has changed in the rental world with a great day-to-day handle on the pulse of camera equipment use. Daniel Geiger was extremely helpful in talking about matchback and Digital Intermediates, adding helpful information and insights. In addition, Travis Sittard has been great in updating me about everyday practices in the editing room and keeping me in tune with how things work in the commercial postproduction world.

From Cengage Wadsworth I would like to thank my publisher, Michael Rosenberg; editorial assistant, Rebecca M. Donahue, who guided this project through development and production; and my content project manager, Jyotsna Ojha. Thanks as well to my permissions editor, Mandy Groszko.

There are also numerous people who have contributed to specific sections of the book. Craig McKay, ACE, the editor of Jonathan Demme's *Something Wild*, was most gracious in giving pertinent details about the editing of the scene reproduced in chapter 4. Thanks to Margaret Berg for allowing me to use still frames from the shooting of her script *Broken* in the examples of nonlinear editing software. Actors Jennifer Schou, Elizabeth Halliday, and Michael Romine were most gracious in allowing their images to be used in those illustrations.

Del Olson of Delden Film Labs commented on general lab work and video transfer; Greg Meyers of Lighthouse, Inc., helped with lighting equipment; and John Fillwalk, Stephen Solum, and Homer Lambrecht of Minneapolis College commented on video and sound. Fred Ginsberg of Equipment Emporium, freelance sound mixer Gerard Bonnette, and freelance sound technician Andy Mayer gave welcome input on location and studio recording issues. Michael Lindquist and Cole Koehler provided very useful comments on the current situation in camera use. Matt Ehling has been a great help in the preproduction and production area and an inspiration in just going out there and making stuff, getting it seen, and helping other people do the same.

My former colleagues at Minneapolis College have all been most helpful, including Gary Reynolds, Hafed Bouassida, and Santanu Chatterjee. Adam Olson in particular has been generous with his time and comments on cameras and the general route students are taking to final products. Also from Minneapolis College, Chauncey Dunn has been immensely helpful as a source of video information and as an ear to listen in a challenging year.

Brian Jennings, Blake Rizk, and many others too numerous to mention have been invaluable in helping me keep my finger on the pulse of day-to-day filming. Anna Rizk has been a great resource for keeping up with all of the logistics of current commercial production practices, and Tony Cammarata gave me much-appreciated insight into how students are faring in the academic world. Chris Weaver has been an immeasurable resource in detailing the shape of modern production. Benno Nelson, Brian Crewe, and Tim VandeSteeg have also been instrumental in continuing to apprise me of the lay of the land. Gregory M. Cummins, Gregory Winter, and Jay Horan have contributed to many of the insights and the stories in the text.

Most significant thanks go to Miroslav Janek and Roger Schmitz, with whom I shared many hours lugging and using cameras, lights, and sound gear—necessary experience to obtain the unique perspective required to truly understand the filmmaking process. Most of all, the late Dennis O'Rourke of Cinesound II in Minneapolis was an ongoing source of information and was one of those rare and wonderful characters—a seasoned professional who loved to work with students and share his extensive knowledge of his field. He will be greatly missed.

The reviewers for this sixth edition and were immensely helpful: Harry Cheney, Chapman College; David Pierson, University of Southern Maine; John Lucido, Western State College of Colorado; and Ralph Merkel, University of Louisville.

For assistance in the earliest stages of this project, special credit must go first and foremost to my development agent, Paul Nockleby. Paul was instrumental in making this text a reality. Readers of early versions of the first edition included Peter Bundy, Gwynneth Gibby, and Bill Caulfield. At various stages of the manuscript, Beth Berg, Tania Kamal-Eldin, and Martha Boehm were also invaluable in this regard. M. Walker Pearce and Charles Harpole were very helpful in both reading and supporting this project in its early stages. Martha Davis Beck, in particular, has been a friend and valued reader throughout the entire project.

In the years since the publication of the first edition, the ongoing surge in the quantity and the quality of work by my current and former students has been immensely gratifying. Tracking their many screenings, numerous awards, and credits on major films continually reminds me of what a great and important profession teaching is. Their frequently expressed appreciation has been very emotionally rewarding, and I would like to reiterate my many thanks to them.

Most of all, thanks go to my family—daughter Rebecka, son David, and most of all to my wife, Ellen, who talked me into doing this sixth edition under very difficult circumstances. She was so instrumental in the first five editions and her practical help and long-term support was and will be missed every day.

Part I
Blocking for the Camera

1

Creating the Shots

Film and Video

The previous edition of this text began with a recognition that, while the choices between film and a bewildering variety of video formats had been very challenging for many years, the overall scene had calmed down quite a bit. After years of rapid and complex changes, a number of standard approaches had started to be put in place. And although many new and exciting choices are available, they exist within workflows that have become relatively established.

Still, certain aspects of the wilderness of choices remain, but at least some of the fog has lifted. Things remain stabilized to the extent that it is not quite as critical that everything be clear before you start, at least for the novice filmmaker. The "great digital transformation," which was stuck in neutral ten years ago, is continuing its restarted move forward, but it is still being checked by some firm realities. The puzzling choices—film versus video, format versus format, video finish versus matchback film finish versus video-to-film transfer, digital intermediates—are still present, but the *how*'s and the *why*'s make a little more sense. Still, there is no reason that independents, students, and beginners would choose film for their initial projects. It is not even on the proverbial radar.

So people will still ask: Why film? The argument persists. As suggested earlier, film has finally completed its movement into the highest echelons of production and it uncomfortably shares that realm with high-end video. There is no particular reason that this has to be. The move away from film is primarily a financial and efficiency initiative—issues that are obviously interrelated. A. O. Scott and Manohla Dargis, critics for the *New York Times,* held a pertinent dialogue on this question recently. They suggest that film is in no way inferior to video, at least in terms of the quality of the image and the stability of production and archival practice. We do not have this medium that is so much better than what it is replacing, that the mad rush is not fueled by better and better quality. A glut of inferior digital imaging surrounds us, although Scott and Dargis rightly point out that there was plenty of the same in the film era. However, it is not like the horse and the car, nor is it akin to the typewriter versus the word processor. While there were undoubtedly those who mourned the loss of the hand-written approach, the word processor allows so much more than the trusty typewriter. (Having typed an 80-page master's thesis on an old Royal portable, I can attest to a better world for writers.)

The biggest change—and, some would say, greatest improvement—has been how a once complex and opaque technology has opened up to anyone who can afford or borrow a video camera and have access to a reasonably priced computer editing system. This has been both a burden and a blessing. To a certain extent, we have been exposed to a glut of amateur theater. Poorly staged, poorly acted, and poorly conceived projects abound; with a few glittering exceptions, the junk factor has grown exponentially. Still, as neophytes gain experience, we should see improvement.

A few notes of clarification are necessary before we proceed. Terms such as *digital filmmaking* are frequently bandied about in the popular press and, although such terms have meaning to many people, technically there is no such thing as "digital film." Film is film, digital is digital. And while these distinctions have receded from view for the audience, they remain front and center to the on-set production crew. When you are shooting film, you simply proceed differently on a set. There are pragmatic concerns and you just have to approach the day-to-day elements differently. Video shoots and film shoots proceed differently. One is not better than the other—they are simply different. The key is that when you look through the electronics of a video camera, what you see is pretty much what you get—although with an inadequate monitor I have had a few unwelcome surprises. With film, it takes a careful and measured approach to get the image you want and, notwithstanding video monitoring, you do not see your image until it is processed and transferred to another medium.

Another key term is **workflow.** There are no more devastating words to come out of a postproduction person's mouth than "you can't get there"—be it to a film print or a high-definition master or whatever—"from here." Or, the more common and equally excruciating advice, "you can't get from here to there without spending a whole lot of money." Nothing overtaxes the postproduction budget more than having to go back upstream and redo things. All of the complex shooting and finishing options are now discussed in the industry under this broad umbrella term. Understanding the proposed workflow of a project is critical from its inception. If you are reading this book as a step toward creating a project that you are hoping will have extensive distribution, be sure you understand the finishing options covered in chapter 18, as workflow is most effectively discussed in the context of postproduction options.

The bottom line is that this remains a film textbook. Film is still a significant player and, although beginners and amateurs have no need to work extensively in film, a knowledge of the film craft will hold them well in hopefully long careers. With these few simple notions in place, we can start at the beginning and, in the final analysis, an absolutely critical part—the definitions and the roles of specific shots.

The Language of the Camera

Motion picture film is made up of a series of still photographic images. **(SEE 1-1)** When projected in succession, these images provide the illusion of movement. Each individual photographic image is called a **frame**—a discrete entity that, just as in painting, has shapes, volumes, and forms arranged in a **composition.** A sequence of frames is called a **shot,** which is commonly defined as the footage created from the moment the camera is turned on until it is turned off. Despite

A motion picture shot comprises individual frames that, when projected in succession, provide the illusion of movement.

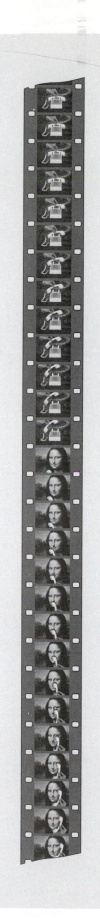

several styles of film that have specialized approaches, the shot is generally considered the basic building block of a film. The industry standard for film projection and shooting is 24 individual **frames per second (fps),** also known as the *frame rate.*

If the shot is the film's basic building block, the **setup** is the basic component of a film's production. Also referred to as *camera position, placement,* or *angle,* the setup is just what the name suggests: arranging the camera to execute a shot. If you need a simple shot of a character saying "yes," you have to set up the camera, do some basic set decoration, work out the lighting, record the sound, and so on. If you then want another character to respond "no," you have to go through the same process to execute that shot. A setup may involve something as simple as a single line of dialogue or it may cover extensive material that will be used throughout a scene.

Beyond these basic definitions, it is important to start thinking of the shot as accomplishing goals, dramatic or otherwise. A shot may show a necessary piece of information or help create an atmosphere. It may serve as a simple delivery device for a line of dialogue or produce associations that would not be elicited without its presence. A shot does not have to be discussed in a purely narrative (story) context. Like an abstract detail in a pointillist painting, it may be one piece in a grander abstract plan. It may add to the kinetic energy (movement) of a piece, as in many music videos. All shots have a purpose and must be thought out in terms of their relationship to the greater whole of the film. A shot has to do something because, whatever its content or purpose, its presence will have an impact.

When discussing shots, the idea of choice is key to the filming of any action—simple or complex, conventional or unconventional. Filmmakers repeatedly face a deceptively simple question: *Where do I put the camera to cover this action [this line of dialogue, this facial expression] in a way that is involving and dramatically effective?* Although covering the action implies a purely functional approach, there must be an internal logic to the way the camera is being used—a logic that fits the dramatic context and the formal approach of the material being shot. There must be a reason why a closer shot is used at a specific point. There must be a reason for withdrawing from the action with a wider shot at another point. A scene in which the presentation has not achieved some internal logic will appear shapeless and "undirected." The choices made will structure the viewer's perception of the scene and contribute to defining the shape and the meaning of the film. The determining factors in choosing specific shots are the context of the material and the greater structure of shots in which each single shot functions.

Overshadowing this idea of choice should be an awareness that all decisions made on a set (camera, lighting, sound, and so on) are driven by the demands of the editing room. Each shot must be approached with a sense of the whole film in mind—a process called **shooting for the edit.** A film crew comprises many skilled professionals, all of whom must at some level understand how the scene being filmed is going to cut together. To cut the audio tracks, the sound people must know what the editors need. The cameraperson must think about what compositions will cut together and whether the scenes are being appropriately covered. The lighting crew needs to understand that the quality of light must be continuous with other shots later in the scene.

With the exception of a few specialized approaches, virtually every film—whether narrative, experimental, documentary, or animated—must confront this question of the relationship of the camera to the subject and the surroundings. Some common strategies for shooting scenes—and having a strategy is crucial—are developed throughout this text, but any plan must come from the filmmaker's

understanding of the materials at hand and the dramatic needs of the subject mat-
ter. Whatever the approach to shooting, keep in mind that someone (possibly you)
will have to fit all of the pieces together. The beginning of the process must be
informed by the end.

The Shots

Though this text devotes much attention to the technical elements of filmmaking,
developing a thoughtful and intelligent approach to using the camera is the long-
term goal. These first chapters propose the development of a menu of what many
consider the resources—or the language—of cinema (see figure 2-1 for a summary).
Such a list risks simplifying many complex issues, but the following should serve as
an introduction to an array of commonly used shots employed to achieve specific
dramatic goals within individual scenes. In determining a strategy for filming any
action, whether straightforward or complex, the choices are limitless.

Proxemics

Proxemics, from *proximity,* refers to the distance between subject and camera.
Essentially, there are three basic positions: long shot, medium shot, and close-up.
There are many points in between and outside of these three, such as medium
close-ups and extreme long shots, but these alternative positions can be seen, and
will be treated, as variations of the basic three. In studio television production, shot
descriptions are clearly defined and, especially when given as part of the instruc-
tions to a camera operator, have specific meanings. In film production, the inter-
pretation of specific positions is not always so rigid.

Long Shot

A **long shot (LS)** is any shot that includes the full human body or more. **(SEE 1-2)**
A shot that includes just the person from head to toe is alternately called a **full-
body shot,** or *full shot.* A shot in which the subject is exceptionally far away from
the camera is called an **extreme long shot (ELS).**

The LS tends to be random in the informa-
tion it presents. In a general shot of people in a
space, it would be difficult for viewers to distin-
guish which character or characters are supposed
to be the main subject of the shot. Momentarily
discounting the notion that many elements—such
as lighting, costume, and composition—can direct
our attention to specific parts of the frame, we can-
not logically value one character over another in
an LS. Closer shots are then used to convey much
more specific information.

The full-body shot was much used by film-
makers in the early years of filmmaking but has
recently fallen into modest disfavor. Director
and actor Charlie Chaplin shot almost exclusively
in full-body shots. He wanted the viewer to see
both his body language and his facial expressions

1-2

A long shot includes the full human body or more.
Jean Dujardin and Berenice Bejo in *The Artist* (2011), © SonyPicture.com / The Weinstein Company.
All Rights Reserved.

1-3

A full-body shot, or full shot, includes just the person from head to toe.
Charlie Chaplin's *One A.M.* (1916)

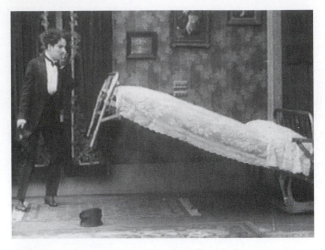

1-4

In an extreme long shot, subjects often look remote and isolated.
Brad Pitt in *The Assassination of Jesse James* by the Coward Robert Ford (2007), © WarnerVideo.com.

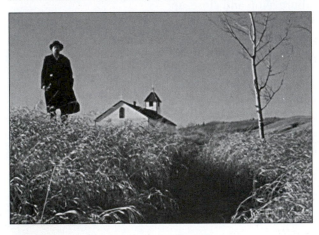

1-5

A medium shot shows a person from the waist up.
Jeff Bridges in Ethan and Joel Coen's *True Grit* (2010), © 2013 Skydance Productions, LLC. All rights reserved / Paramount.com

without the involvement of closer shots or the clutter of complex editing. Directors throughout the industry still use the shot in the same way. **(SEE 1-3)**

The LS, and even more so the ELS, can also be used to diminish the subject. Presenting a lone figure in a vast landscape will make the figure appear overwhelmed by the surroundings. Westerns are well known for using both the LS and the ELS to achieve this effect, presenting rugged individuals within vast panoramas of untamed space. Many excellent examples can be found in Andrew Dominik's *The Assassination of Jesse James by the Coward Robert Ford* (2007). **(SEE 1-4)** In this shot with Brad Pitt, the emptiness and emotional aridity of the space give visual representation to the mounting sense of mutual paranoia as the conspirators who want to kill Jesse James are both threatened and threatening.

Medium Shot

The shot of a person from the waist up gives more detail than the full-body shot but is generally neutral in its presentation of the subject. **(SEE 1-5)** The **medium shot (MS)** represents how we interact with people in life, at least in American culture. When two people speak, they generally address each other in something roughly approximating the MS, which literally puts the viewer on equal footing with the subject being filmed. We rarely get right up into other people's faces to speak. In current parlance, that would be invading their space. On the other hand, we rarely address people in LS except as part of a stiff, formal address or in the initial stages of being introduced to someone. In an MS, the subject is neither diminished nor unduly emphasized.

The key word in describing the MS is *neutral*. This is an arguable distinction because many see the full-body shot as equally neutral—if not more so—because it does not necessarily emphasize a particular element. There is merit to this argument, but the long shot's tendency toward randomness and diminishment often gives it additional dramatic baggage.

Close-Up

The **close-up (CU)** is essentially a headshot, usually from the top shirt button up. **(SEE 1-6)** Anything closer than that is an **extreme close-up (ECU)**. The **medium close-up (MCU)**, which is from midchest up, is also frequently employed.

The CU provides the greatest psychological identification with a character as well as amplifies the details of actions. It is the point in which the viewer is forced to confront the subject and create some

kind of internal psychological self. This identification in a CU can occasionally be so intense that the shot becomes claustrophobic. The CU creates a tight and confined space. It has strict boundaries both for an actor's performance and for a viewer's sense of a character's freedom of movement. The viewer can get the sense of an oppressive and menacing closeness—an in-your-face effect.

CUs are also used to amplify details. The interrelationship of these shots can be particularly successful in creating suspense. A classic example of this is in Alfred Hitchcock's *Sabotage* (1936), in which a woman (Sylvia Sidney) realizes that her husband (Oscar Homolka) was involved in the death of her younger brother. As she serves him dinner, she starts glancing at a large carving knife. The film cuts from CUs of the carving knife to the woman looking at it. The next shot is a CU of the man's perplexed response. The woman looks again at the knife. He looks at the knife and then at her. This alternation goes on for a brief period as the tension mounts. She finally takes the knife and stabs him. This type of editing is a common and effective device for creating suspense.

It is clear that the sequence of LS-MS-CU represents a natural and logical progression of moving closer to a subject. The sequence represents a general movement from information that is random and undifferentiated toward more specific information. This simple progression is one of the mainstays of the conventional approach to scene construction. (Basic principles of scene structure are discussed in chapter 2.)

Angles

Although the term *angle* is often used on the set to designate simple camera position (setup), it also has a more limited meaning in terms of camera resources, that is, the height and the orientation, or level, of the camera in relationship to the subject.

Low-Angle Shot

A **low-angle shot** is one in which the camera is below the subject, angled upward. **(SEE 1-7)** It has a tendency to make characters or environments look threatening, powerful, or intimidating. A classic example of the extended use of this type of shot is the presentation of Radio Raheem (Bill Nunn) in Spike Lee's *Do the Right Thing* (1989). **(SEE 1-8)** A scene involving a country kid's first day in the big city is another, albeit clichéd, example. The viewer is presented with low-angle shots of skyscrapers looming over the awed onlooker.

1-6

A close-up is essentially a headshot.
Lela Rochon watches her new boyfriend deal drugs in Forest Whitaker's *Waiting to Exhale* (1995), Copyright 2013 FOX

1-7

In a low-angle shot, the camera is below the subject, angled upward.

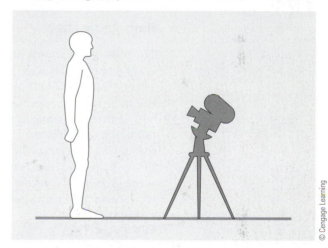

© Cengage Learning

1-8

The effect of this typical low-angle shot is to make the character seem powerful and intimidating.
Bill Nunn in *Do the Right Thing* (1989), © 40 Acres & A Mule Filmworks/Universal Pictures.

1-9

This low-angle shot features distortion between the foreground and the background, which can be intentionally disorienting.

James Stewart in *Vertigo* (1958), © 40 Acres & A Mule Filmworks/Universal Pictures.

The low-angle shot can also give a distorted perspective, showing a world out of balance. This can produce a sense of both disorientation and foreboding. A good example comes from Alfred Hitchcock's *Vertigo* (1958). In an eerie cemetery scene, James Stewart is consistently filmed from below, making the framing of background elements disorienting. The arrangement of the steeple and the trees in the background gives the shot an ominous tone. **(SEE 1-9)**

Foreground elements can also become distorted. Video artist Bill Viola used this notion to good effect in one of the movements of *Ancient of Days* (1978–1981). The section has a lengthy shot of what is apparently a huge boulder in the foreground with a group of tourists milling around in the background. As the tourists move, we slowly realize that the perspective may be fooling us as to the size of the boulder. By the end of the shot, we realize that the rock is no more than a foot or so tall.

High-Angle Shot

The **high-angle shot** is obviously the opposite of the low-angle shot, and its effects are the opposite as well. The camera is placed above the subject, pointing down. This type of shot tends to diminish a subject, making it look intimidated or threatened. This is the conventional way of making characters look insignificant.

Fritz Lang's masterpiece *M* (1931) has a classic exchange that incorporates both high- and low-angle shots. The film has a scene involving two men arguing, one of whom suspects the other of being the child murderer who is the focus of the film's story. One man is short (the accused) and the other tall (the accuser). The scene is then an interplay between high-angle and low-angle shots in which the viewer sees each man's perception of the other. **(SEE 1-10)**

Eye-Level Shot

Eye-level shots are those taken with the camera on or near the eye level of the character or subject being filmed. Eye-level shots tend to be neutral. Much like an MS, an eye-level shot puts the viewer on equal footing with the subject being filmed. It has none of the diminishing or exaggerating qualities of high- and low-angle shots.

A significant majority of shots in theatrical films, as well as a high percentage of shots in episodic television, are shot at eye level. High- and low-angle shots can be misused, occasionally implying things about a character that are not justified

1-10

A. Establishing shot

B. High-angle shot

C. Low-angle shot

Fritz Lang's *M* (1931), © Criterionco.com.

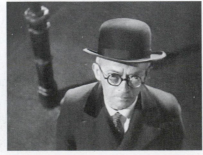

dramatically. For all of the stylistic bravura of the Radio Raheem shots in *Do the Right Thing,* some critics have wondered if the character's demeanor worked against the dramatic premise.

All of this said, most directors will tell you that they will not put the camera directly at eye level; they will position it just slightly above or below. True eye level is considered too confrontational, too direct to the audience.

Bird's-Eye View

The **bird's-eye view,** also called an *overhead shot,* is actually a variation of the high-angle shot but is so extreme that its effect merits separate discussion. This shot is from directly above and tends to have a godlike, omniscient point of view; people look antlike and insignificant.

Many classic examples of the bird's-eye shot are, of course, found in Alfred Hitchcock's *The Birds* (1963). In one of the film's early bird attacks, the townspeople are gathered in a diner near a gas station. A gas station attendant is struck by a bird, and gasoline spills out around the pumps. It is ignited, and the birds start to attack as the firefighters and townspeople try to cope with the blaze. Suddenly, the film cuts to a perspective several hundred feet above the action. As birds float serenely in the foreground, the futility and the chaos of the human response to nature's revenge looks small and pitiful.

Stephen Daldry's *Extremely Loud and Incredibly Close* (2011) has a very evocative example of the birds-eye. Thomas Horn sits on the steps as birds fly by above echoing the paper flying and the cluttered sky of 9/11, the event always in the background of the film's story. **(SEE 1-11)**

Oblique Shot (Dutch Angle)

In an **oblique shot,** also called a *Dutch angle,* the camera is tilted laterally on a tripod so it is no longer parallel with the horizon. The oblique shot takes the straight lines of the world and presents them as diagonals. This type of shot is generally used to give an overwhelming sense of the world's being unbalanced or out of kilter. One of the classic employments of the oblique angle is in Carol Reed's *The Third Man* (1949), a mystery set in post–World War II Vienna. The tilted shot is largely responsible for the film's overall sense of a world in which human values and actions are distorted. **(SEE 1-12)**

The 1960s *Batman* television series also used the oblique angle extensively. In this case, the effect is campy, the action being highly stylized to exaggerate the effect. To a certain extent, the oblique angle is problematic for just this reason: it is so transparent in its effect that it virtually announces its own cliché. Many critics have found fault with *The Third Man,* claiming that the use of the oblique angle eventually becomes predictable and finally banal.

When a technique like the oblique angle is used, we must also recognize that employing a camera that is level with the world has certain aesthetic

1-11

The bird's-eye view takes the high-angle shot to an extreme.

1-12

The oblique shot (Dutch angle) is generally used to convey a world that is off balance or out of kilter.

assumptions. With a level camera in such a high percentage of what we see in films, it begins to appear so natural that we rarely even question it. As with some of the other approaches, such as medium shots and eye-level shots, a level camera is used when subjective judgments are not desired. The level camera approximates our general perception of the world.

Point-of-View Shot

A **point-of-view shot** represents the perception or viewpoint of a specific character. It is not used as frequently as one might at first presume, primarily because camera vision and human vision are decidedly not the same. The eye has unselective focus—the constantly shifting gaze is somewhat random and chaotic in its focus of attention. If you watch a dance, your eye might randomly go from the dancer's feet to her hands, to her face, then back to her feet. The human gaze shifts with only minimal structure to the view it creates. A camera's vision is considerably more focused and selective.

Many films, however, use the point-of-view shot effectively. Horror films have come to use it quite extensively—for instance, replicating the point of view of the killer as he relentlessly stalks his prey. The selective focus actually seems to aid the effect, representing a maniacally focused perception. Robert Montgomery's *Lady in the Lake* (1946) is a classic exploration of the point-of-view shot. The entire film is played from a detective's perspective. The viewer sees what he sees. It is an interesting experiment but eventually becomes so artificial that the approach has seldom been duplicated except as snippets within a larger whole. Hitchcock's *Vertigo* has a much more common and successful approach to the point-of-view shot. The film constantly shifts from the looker (James Stewart) to what he is looking at. The film is voyeuristic, as are many Hitchcock films, in its constant positioning of the viewer and the viewed.

Movement

Clearly, camera movement is a critical aspect of the way films work, in terms of both the kinetic energy it can provide and its employment as a storytelling device. The German filmmakers of the 1920s are credited with exploring and perfecting many of the effects that can be achieved with the moving camera. They are responsible for what is generally referred to as **fluid camera technique**—an approach to shooting that smoothes out or eliminates entirely any bumpy camerawork, moving from composition to composition in an efficient and timely manner. Lars von Trier would have driven them crazy—but style moves on. Fluid camera technique was the approach adopted by classic Hollywood cinema and, although challenged by more-informal camera techniques, remains an important philosophical approach to shooting. Later chapters address some of the difficult-to-define kinetic aspects; the focus here is on the employment of movement in a storytelling mode.

Pans and Tilts

A **pan** is a shot in which the camera is simply swiveled horizontally on a tripod. A **tilt** is similar to a pan except its movement is vertical. **(SEE 1-13)** Both pans and tilts can be used to reveal new elements within the frame—elements of which the viewer may have been unaware. A typical example might be a shot of a couple walking down a street hand in hand. The camera then pans over to show a crestfallen suitor, seeing the couple together for the first time.

1-13

Pan and tilt controls enable you to swivel and tilt the camera.

With that revelation, we can create associations and, in some cases, a sense of causality. An example of the use of the pan to create an association comes from D. W. Griffith's *Birth of a Nation* (1914). There is one shot that starts with a wide view of a Civil War battle and then pans to a terrified woman huddled with small children on a wagon. To emphasize the point further, Griffith includes a pan back to the battle. The conclusion is inescapable. The misery is a by-product of the battle. Some might argue that the same effect could be accomplished with a cut between the two subjects, but with panning, the two subjects are spatially, and thus philosophically, connected.

Although the pan can be employed as described, its extensive use may be problematic because it does not really duplicate the movement of the human eye. When following a lateral movement, your eyes move by themselves or in conjunction with head and body movement. The pan is somewhat like pivoting your head without moving your eyes. We occasionally view movement in this manner—such as at a tennis match—but it is often in specific circumstances and it feels and looks unnatural.

Pans must be carefully planned in terms of both their execution and their eventual use. The word *pan* will quickly become part of your everyday vocabulary, but the movement is generally used in conjunction with subject movement or as part of larger camera movements rather than as an expressive technique. You can prove this to yourself with a few simple shooting tests. Pan from one person sitting in a chair to another, or go to a theater rehearsal and pan from subject to subject on the stage. Unless you are following movement, the pans will probably look mannered and stagy.

The general application of the tilt is similar to that of the pan—revealment and so on—except that it can also go from one angle to another, say, from eye level to low-angle. A common example would be a child running down a street and then straight into someone's knees. We then see the tilt from the knees to an intimidating low-angle shot of a disapproving adult.

Wheeled Camera Supports

The past several decades have seen a profusion of specialized devices to assist camera moves, with a trend toward electronically assisted movement. As technology evolves, distinctions between the following types of movements have blurred significantly. Many dollies have modest crane capabilities, for example, and cranes can be adapted to do other tasks. Although students rarely get their hands on the newest technologies, you should be familiar with what is available. This prepares you for professional experience and sets you to thinking about inexpensive ways of duplicating complex effects.

Dollies

A **dolly** is a wheeled vehicle with a camera-mounting device. **(SEE 1-14)** Dollies can be as simple as a go-cart–style wheeled platform on which to mount a tripod. The more sophisticated designs have seats for the camera operator and the assistant, with movement manipulated by a variety of complex controls. The earliest dollies were large, heavy vehicles that were used almost exclusively in the studio. The many new lightweight dollies make dolly work on-location so easy that their use has almost become the norm. Dollies often require specially designed **tracks** to eliminate the bumpiness of moving over uneven surfaces. **(SEE 1-15)**

Dolly shots can be quite effective because they can go from one proxemic position to another—from the random information of a long shot to the specifics of a close-up or vice versa. The camera moving in, called a *push-in,* can be used to clarify detail, identify objects of importance, and amplify emotion. Moving out, called a *pull-out,* can lose people in bigger spaces or, as with a pan, reveal elements heretofore unseen.

Martin Scorsese's *Hugo* (2011) has many wonderful examples of the uses of the dolly and other wheeled devices. In an excellent example of how to reveal information, the young boy (Asa Butterfield) is alarmed by the presence of his antagonist (Sacha Baron Cohen) as the camera dollies out to announce his presence. **(SEE 1-16)**

When the camera is mounted on a dolly, it can also move alongside an action in what is called a **tracking shot.** Although its distinction from a dolly shot may seem arbitrary, a tracking shot follows alongside, in front of, or behind a moving subject; the

1-14

Dollies can be as simple as a go-cart–style platform on wheels or as sophisticated as a computerized vehicle complete with seating.
© Courtesy of Chapman/Leonard Studio Equipment, Inc.

1-15

A dolly track eliminates unevenness and allows the dolly to be guided accurately.

© Cengage Learning

1-16

Dolly shots can be effective for going from a shot with simple information to include an unexpected new element.

Martin Scorsese's *Hugo* (2011), © Paramount.com

character's position in the frame remains roughly the same, and what changes is the background. **(SEE 1-17)** Although this may not appear to be a significant difference, it can be played for some clever effects.

Buster Keaton's *The General* (1925) has several good examples of tracking shots. **(SEE 1-18)** With the camera on a train running on parallel tracks, Keaton is on top of another train, furiously chopping wood and oblivious to his surroundings. Keaton's position within the frame remains relatively consistent, but in the background we see the entire Confederate Army pass behind him. Moments later the entire Union Army passes behind him as well, again entirely unnoticed. Thus, in one sequence, Keaton's character has unknowingly passed from behind friendly lines to behind enemy lines.

Cranes

A camera **crane** has a single elevating arm on a rolling vehicle. Cranes vary from small ones incorporated into dollies to large vehicles that can get the camera high in the air. Cranes generally have seats for the camera operator and at least one assistant. The crane can accomplish many of the same things as the dolly.

1-17

A tracking shot follows alongside, in front of, or behind a moving subject.

© Cengage Learning

1-18

The background shifts in a typical tracking shot, whereas character position remains roughly the same.

Buster Keaton's *The General* (1925)

1-19

A camera crane enables you to get above or below a subject, thus varying height in relationship to the subject.

Whereas the dolly, in its strict definition, has only horizontal possibilities, however, the crane has full freedom of horizontal and vertical movement. The ability to get above or below a subject allows one to vary height in relationship to the subject. Frequently, the camera goes up to give the viewer an omniscient view.

(SEE 1-19 AND 1-20)

1-20

A type of camera crane, the Hydrascope has full freedom of movement both horizontally and vertically.
© Courtesy of Chapman/Leonard Studio Equipment, Inc.

A good example of a crane shot is an oft-cited one from Alfred Hitchcock's *Notorious* (1946). **(SEE 1-21)** The shot starts with a dollylike movement, showing a wide shot of a party scene. Filmed from a balcony, the information is random and undifferentiated. It simply establishes the scene as a formal party. It appears to be a routine shot designed to create a simple transition between one scene and the next. Due to the conventional nature of this opening, what comes next catches the viewer

1-21

This classic crane shot goes from a general establishing shot to a very specific close-up.
Alfred Hitchcock's *Notorious* (1946), © Criterionco.com.

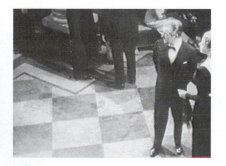

off guard. The camera cranes all the way down to a tight shot of Ingrid Bergman's hand. We see that she is tightly grasping a key—a key stolen from her husband. The shot thus goes from a random view to a very specific piece of information that is crucial to the plot. The complexity of the technical execution of such a shot is breathtaking, given that the position of the key has to be coordinated to be in just the right place in the final composition. It is similar to shooting an arrow through the hole of a moving doughnut at 50 paces.

Arms

There are many other types of movement devices, particularly modifications to the basic crane design. Lacking a seat for the operator, **arms** suspend the camera on the end of a crane-style device. **(SEE 1-22)** The camera operator uses a joysticklike remote control to execute pans and tilts while watching on a video monitor what the camera is recording.

Spike Lee's *Do the Right Thing* has a spectacular shot that was filmed with an arm or a similar device. **(SEE 1-23)** The shot starts with Mother Sister (Ruby Dee) and the Mayor (Ossie Davis) sitting on a bed. They get up and start walking toward the camera. The camera pulls all the way back and out of a window. As they look out of the window, the camera cranes around to Mookie (Spike Lee) on the street. It is an exceptional shot, tying together many of the film's elements.

1-22

Arms suspend the camera on the end of a crane-style device.
© Courtesy of Chapman/Leonard Studio Equipment, Inc.

1-23

This spectacular sequence was executed with a jib or an arm.
Spike Lee's *Do the Right Thing* (1989), © 40 Acres & A Mule Filmworks/Universal Pictures.

Handheld Camera

With the **handheld camera,** shots lack the smoothness to which so many technical resources are devoted. The handheld camera can give a you-are-there feel to the shots, a sense of the viewer's being a participant in the action. This "camera as a participant" approach can lend a sense of urgency or chaos to the action. The handheld camera can also give scenes an informal and spontaneous tone, though its use to achieve this end has a number of pitfalls.

The handheld camera has been popular in documentary and experimental films and has made inroads in **feature** films as well. The development of lightweight portable cameras and sound recorders in the late 1950s had a tremendous impact on documentary film, with filmmakers shooting handheld on-location under almost any circumstances. A significant number of experimental films have used the handheld camera as an alternative to the often-rigid formal approach of commercial cinema. In Jonas Mekas's *Reminiscences of a Journey to Lithuania* (1971), the filmmaker took a trip to his homeland, photographing short snippets of subjects that interested him. The resulting film, which Mekas narrates in a fragmented, poetic style, is a freeform collection of home movie–like shots, few of which are more than a second or two long.

Although there are occasional early examples, the handheld camera has become more frequent in commercial feature films since the 1960s. Stanley Kubrick's *Dr. Strangelove* (1964) has some beautiful examples of thoughtful use of the handheld camera. It is used most effectively in the scenes of the attack on Jack D. Ripper's compound and in those of the crippled bomber as it wings for Russia. The assault on Ripper's compound emulates the chaos of documentary combat footage. It is particularly effective when intercut with the highly formal images of the war room, where the fate of the world is being decided.

The scenes in the bomber are even more effective. Just after the plane is hit, sparks and smoke are everywhere. The handheld camera charges in and gives the appearance of capturing the action as it happens. The images, when looked at individually, take on an almost abstract quality. Many of *Dr. Strangelove*'s scenes are played for comedy, and the handheld camera scenes play as a stark and effective contrast.

In recent years, many films have employed a camera approach that might be called "heightened" handheld. In a film like Lars von Trier's *Melancholia* (2011), the approach to the handheld camera may at first appear random, but on closer look it is clearly highly determined. Any reasonably competent shooter's camerawork is more steady than what we are seeing. The cameraperson is clearly being instructed to move around on the action during the shots. The approach creates a tension that visually aids the dramatics of the scene. Whether one likes the style or not, it is clearly a consciously worked out approach to the material. Gary Ross's *The Hunger Games* (2012) is another good example of this approach, and many television shows like the American version of the *The Office* (2001) use a similar, if less exaggerated, conceptual designs.

Specialized Rigs

The many specialized rigs available today give smoothness and fluidity to shots that were previously impractical or impossible. New developments in technology undoubtedly allow filmmakers innumerable opportunities. Unfortunately, the use of these may not be feasible on smaller projects for some time to come.

Steadicam The **Steadicam** was designed in recognition of the freedom-of-movement benefits offered by the handheld camera while also recognizing the desire to eliminate its attendant shakiness. A device that mounts on the camera operator's chest, the Steadicam incorporates balanced weight and reciprocating movement to give fluidity to what are essentially handheld shots. It is an expensive piece of equipment that requires a trained operator in top physical condition, and its use has become widespread, particularly in the shooting of commercials.

One of the first uses of the Steadicam in a theatrical feature was in John Schlesinger's *Marathon Man* (1976). In one scene, Dustin Hoffman is chased on foot through New York's Central Park. He runs up and down stairs and across cobblestone streets, and the camera is with him every step of the way. These shots would have been almost inconceivable without the Steadicam, requiring either a handheld camera or extensive track. In the first case, the shot would have reflected each of the camera operator's footsteps. In the second case, conventional track would often be in the shots and could not easily accommodate things like the shape of a staircase.

The Steadicam proved so popular that the company introduced the **Steadicam Junior,** a smaller and less technically complex version that has since been discontinued. It could not compete with the numerous rigs created by the many industrious tinkerers who create wonderful things for the independent film world. They are usually a Rube Goldberg approach to balanced weight and can produce results close to those of a Steadicam but with smaller cameras. If you know any of these tinkers, start establishing a friendship now.

Car rigs Scenes often call for shots from moving vehicles. Often these are just standard close-ups or medium shots of the vehicle's occupants. They would be routine, except that engine vibration and road bumps are major complications.

Specialized mounts are used to attach the camera securely to the vehicle and, with a design almost like a shock absorber, minimize pavement bumpiness. Recent trends have been to put the car on a low-riding trailer and have a vehicle, usually carrying the camera crew, just pull it.

Shooting out of the window of a moving vehicle can be used to establish a sense of place or create an impression of great expanse. Terrence Malick's *Badlands* (1973) has many exceptional moving-vehicle shots of the arid northern plains as representations of the emptiness of the film's rootless and unconnected characters. Toward the end of the film, distant mountains serve as both an actual and a metaphorical destination that is continuously moved toward but never reached.

Aerial **Aerial shots** (from planes and helicopters) have their own particular aesthetic and also need specialized mounts to reduce vibration. Aerial shots can be used as variations of crane shots, but the movement and the elevation set them apart. Ken Burns's television series *The Civil War* (1990) employed long aerial shots with the camera literally floating down some of the backcountry rivers of the battle areas. These shots served as transitional devices, background for narrative, and a means of giving the viewer a strong sense of place. One lengthy shot traveling down a beautiful, hazy river at sunset is juxtaposed against a speech by Frederick Douglass about the openness and the promise of America versus the reality of slave life.

Focus Effects

Occasionally, beginners expect that, as a rule, everything should be in focus. Although this is indeed the approach of many films, focus can be used to create special effects—from those so subtle that they are rarely noticed by the viewer to others so big that they demand interpretation on a thematic level. As should be expected, there are a number of approaches to using focus as an aesthetic expression.

Deep Focus

The approach that keeps all elements in the frame sharp is called **deep focus.** It has been written about extensively and has many champions in the critical and theoretical world. Theorists interested in deep focus are usually champions of a realist approach to cinema. Orson Welles, Jean Renoir, and Alain Resnais, among others, have been generally recognized as creators of some of the great experiments in deep focus. Renoir's *The Rules of the Game* (1939) is often cited as an early example of the use of many different planes of focus to facilitate complex, multilevel action. Working with the technical elements that maximize focus is critical to achieving this goal. Gregg Toland's cinematography on Welles's *Citizen Kane* (1941) is considered the great early exploration of the effects possible with great deep focus shots.

Shallow Focus

Shallow focus is an approach in which several planes of focus are incorporated within a single image. This can create a purposefully less realistic image—one that manipulates viewer attention and suggests different planes of action both literally and figuratively. Shallow focus is less of a theoretical construct than deep focus is,

and it does not have as strong a critical following, probably because realist critics are so firmly committed to deep focus.

The play between soft and sharp focus can be used to achieve a number of effects:

- Suggesting other planes of action without allowing them to dominate viewer attention

- Isolating a subject in a space

- Suggesting that a subject lacks clarity

- Shifting focus for dramatic emphasis or to draw viewer attention to a specific part of the frame

- Acting as a transition from one scene to the next

Planes of focus can direct viewer attention to specific parts of the frame. Just as you can choose different shots—LS, MS, CU—you can choose different areas of the frame to be in focus. In Tate Taylor's *The Help* (2011), the foreground character (Emma Stone) is left out of focus in order to direct viewer attention to her mother's (Allison Janney) response to what is being said. Rather than awkwardly cut to emphasize the dynamics of the scene, a simple selection of focus accomplishes the same goal. **(SEE 1-24)**

In addition, it is also very typical to leave a background out of focus in order to highlight a character and, in some cases, isolate them from their surroundings. A major thematic thread in Robert Redford's *The Conspirator* (2010) has the main character (james McAvoy) increasingly estranged from his social circumstances. **(SEE 1-25)** The completely out of focus background makes him both the unmistakable object of our attention as well as reinforces his increasing separation from those around him.

Bernardo Bertolucci's *The Last Emperor* (1987) also has many examples of a shallow-focus approach. The young emperor (John Lone) is frequently portrayed as being alone and isolated. To emphasize this, both foreground and background elements are often purposefully out of focus. **(SEE 1-26)**

1-24	**1-25**
Focus isolates the foreground subject, forcing the viewer to concentrate on the subject in the background.	Leaving background detail out of focus prevents the viewer from being distracted by it.

1-26

In a shallow-focus approach, several planes of focus are incorporated within a single image.
Bernardo Bertolucci's *The Last Emperor* (1987), © Criterionco.com.

Shifting Focus

The discussion of focus so far has left out an obvious complicating factor: movement. Not only do subjects move, but camera movement is often incorporated into shots as well. As either the subject, the camera, or both move, focus is necessarily going to have to change. You therefore have to **rack focus,** or physically shift the focus ring as the shot is being executed. Racks are usually done by the **first assistant cameraperson** (**1st AC**)—the crewmember responsible for the cleanliness and the proper operation of the camera. British films actually have a separate credit for "focus puller," a recognition that suggests how frequently this crewmember's talents are employed. Planning and executing a rack focus usually require setting up marks on the floor and tape on the focus ring. Practical aspects of a rack focus are covered in chapter 8.

The rack focus effect is employed frequently, although it is most often used to keep a moving subject in focus. As such, it goes largely unnoticed. Occasionally, it is used as a transitional device to get from one scene to the next: a shot will be slowly racked out of focus; then the first shot of the new scene often will start out of focus and be racked into focus. Another technique is to start with some foreground element in focus and then rack to a background element.

Focus can also be used effectively to delineate different elements of a shot—to change the emphasis, and hence the viewer's attention, from one area of the frame to another.

A shot from Mike Nichols's *The Graduate* (1967) illustrates this effect well. **(SEE 1-27)** It occurs in a scene in which Elaine (Katherine Ross) learns that Benjamin (Dustin Hoffman) has been having an affair with her mother (Anne Bancroft). The revelation is handled visually: Benjamin looks at Mrs. Robinson, who is standing behind Elaine. Mrs. Robinson is out of focus. As Elaine turns, there is a rack focus to Mrs. Robinson that makes Elaine's sudden comprehension of the situation inescapable. As Elaine turns back to Ben, she remains out of focus for several seconds, serving to amplify her emotional confusion. Then she is racked back into focus. Focus racks are often timed to specific movements so that they are less noticeable.

Racking focus between characters in conversation to achieve an effect similar to editing is occasionally tried. One character says her line, then focus racks to another character, who says his line, and then it racks back again. This was a popular approach in a number of films in the 1960s and 1970s. It is occasionally employed today, though, if overused, the effect can appear mannered and artificial.

1-27

A rack focus can be used metaphorically, such as to symbolize a character's confusion and then sudden comprehension.

Mike Nichols's *The Graduate* (1967), © mgm.com.

Lens Perspective and Characteristics

Lens perspective refers to the way lenses represent space. Different kinds of lenses have different effects on the way we perceive depth and dimensionality within an image. This aspect of lenses has a great impact on the process of choosing a lens. Directors and cinematographers generally do not choose lenses for how close they bring the viewer to the subject; that can be controlled by simple camera placement. Lenses are usually chosen for how they represent space.

Wide-Angle

The defining characteristic of the **wide-angle lens,** also called a *short lens,* is that it elongates space; that is, objects appear more distant from each other than they actually are. A number of objectives can be accomplished with this. Like the LS, which can diminish a character, the short lens can be a critical element in this effect. It can take a big space and make it even bigger. Using a short lens on a lone figure within a vast landscape can increase the effect of isolation and diminishment.

Orson Welles's *Citizen Kane* (1941) was one of the first films to extensively explore the use of the short lens for effect. In *Citizen Kane*'s low-angle shots, the short lens adds to the sense of a cavernous and oppressive space. In a similar use, one impressive shot from Martin Scorsese's *Hugo* shows the inspector (Sacha Baron Cohen) lost in the vast space of the train station. **(SEE 1-28)**

Wide-angle lenses also bend lines in the composition outward. Orson Welles used an extreme-wide-angle lens for several car shots in *Touch of Evil* (1958), giving the conversation between the two men an unsettling subtext. **(SEE 1-29)** Extreme-wide-angle lenses bend corners and give almost funhouse-mirror distortion to the objects or people being filmed. They are rarely used for portraiture because they balloon people's faces and make them look heavy or freakish. The closer the lens is to the subject, the more pronounced the effect. The most noticeable distorting lens is called a **fish-eye lens,** which sees almost a full 180 degrees in front of the camera. Its effects are so extreme that it is not used frequently.

The most inappropriate use of a wide-angle lens that I can remember came from a film about a family farm being foreclosed. There was a shot of a character looking on sadly as all of the household goods were being sold. The cinematographer shot the character with a wide-angle lens, which made her look grotesque and freakish. I have never been able to discern why the cinematographer made that

1-28

The wide angle of this shot maximizes the sense of tiny figures dwarfed by their surroundings.
Martin Scorcese's *Hugo* (2011), © Paramount.com

1-29

This extreme-wide-angle shot gives the interaction between the characters an unsettling subtext.
Orson Welles's *Touch of Evil* (1958), © universalstudios.com/home

choice. Possibly he thought it would make the woman look miserable and down-trodden. It was clearly a carefully considered decision on his part because he had to get right up into her face to get the shot—something that made her, a nonprofessional, quite uncomfortable. Wide-angle lenses are used extensively, but care must be taken with some of their more extreme characteristics.

Normal

A **normal lens** basically gives a normal representation of space and perspective. Subjects look roughly the same size as they do from the camera, and the distances among subjects look unaltered. One must remember, however, that the film image is two-dimensional. Just because a normal lens is used does not mean that the image will accurately represent three-dimensional space. You have to think of many more issues, such as composition, focus, and lighting, if you want to create an image that appears to have some depth. As a developing pattern might suggest, the normal lens is probably the most commonly employed.

Telephoto

The **telephoto lens** does the opposite of the wide-angle lens. Rather than elongate perspective, the telephoto lens, or *long lens,* squashes it, making things look closer together. This is a very common effect, and many examples come to mind. In films that are set in big cities, directors and cinematographers like to use telephoto lenses to shoot crowd shots on streets. It makes people look crowded together and cramped and exaggerates the effect of people packed together like rats.

The long lens can also make movement toward the camera look distorted, giving a subject an almost dreamlike inability to reach its destination. Another shot from Mike Nichols's *The Graduate* provides an excellent example of this effect. Near the end, Benjamin (Dustin Hoffman) is running toward a church where Elaine is getting married. To amplify his desperation, one of the key shots is clearly executed with a long lens. Hoffman is running as fast as he can, but he does not appear to cover any appreciable space. **(SEE 1-30)**

1-30

This telephoto shot gives a dreamlike aspect to the character's desperate, yet seemingly futile, pursuit.
Mike Nichols's *The Graduate* (1967), © mgm.com.

As the shot starts, you can see how compressed the space appears. You can tell that the car and the telephone pole are at different distances from the camera, but you would be hard-pressed to tell how far apart they actually are. It is also difficult to tell if Hoffman has passed the car or is still behind it. The second frame represents a point 4 seconds into the shot, 4 seconds being a much more substantial amount of screen time than it might seem. Again, it is impossible to judge how much distance he has covered. The third frame shown is 8 seconds into the shot. The effect is not quite like he is running in place, but it does seem as though he is spending a great deal of time and exerting a tremendous amount of energy to cover what appears to be a very short distance. The entire action of this segment of the shot takes 18 seconds.

The effect can even jam things together to the extent that it almost makes the image appear abstract. Landscapes can take on an exaggerated and heightened form. Telephoto lenses also flatten surfaces in a way that can be considered the opposite of the ballooning effect of wide-angle lenses. The human face can appear narrow and compacted, with the nose flattened and the eyes closer together. This effect is not as unflattering as the wide-angle one.

Zoom

The term *zoom* as it is meant here has existed long enough that most people understand what it means. The **zoom lens** includes all of the focal lengths discussed previously. Although it may strike some people as odd that the zoom lens was omitted from the section on camera movement, it was left out because it is not a *movement* per se. The zoom effect is created by movable elements in the lens that either bring the subject closer to or push it farther away from a stationary camera. This allows shots, like some camera movements, to go from very random information to very specific information and vice versa. Obviously you can move the camera during a zoom, but each element is accomplishing something different.

The zoom has side effects, however, that are clearly specific to it and that distinguish it from traditional camera movement. It includes a transition from the spatial characteristics of one focal length to those of another. If we zoom in on a subject, we go from the elongation of the wide-angle lens to the squashed perspective of the telephoto. The dolly shot looks decidedly different because it is usually done with a fixed lens, so the perspective characteristics remain the same throughout the movement. The dolly gives the feeling of moving independently through a space, whereas the zoom gives the feeling of being mechanically moved through space. In effect, the dolly brings the viewer to the subject, and the zoom brings the subject to the viewer.

Despite this difference, many directors still tend to use the zoom like the dolly. It takes much less setup time and equipment, thus accomplishing roughly the same effect at a much cheaper price. In the faster working climate of television, it is particularly popular. As such it has gotten a reputation as the poor man's dolly or the

hack director's dolly. It is rarely used thoughtfully as a means of representing different spatial approaches.

The previously mentioned shot from *The Graduate* of Dustin Hoffman running toward the church is one of the few good examples of how the spatial characteristics of both extremes of the zoom lens can be used to good effect. **(SEE 1-31)** Hoffman's run toward the camera is only one segment of a longer shot. When Hoffman reaches the camera, the camera pans and zooms out at the same time. **(SEE 1-32)** The result is the transition from a lens that squashes space to a lens that elongates space. Suddenly, Hoffman is a tiny figure dwarfed by a huge church.

The zoom lens can also be used for what has become known as a *vertigo shot,* popularized in the Alfred Hitchcock film of the same name. In a vertigo shot, the lens is zoomed in as the camera is dollied out or vice versa. If this is done carefully, the framing of the composition remains exactly the same while only the perspective characteristics change. The perspective of the shot is thus smashed or elongated like an accordion, which can give a very distorted or subjective sense of screen space. In *Vertigo,* it is used to re-create the point of view of a man terrified of heights. In Martin Scorsese's *GoodFellas* (1990), the technique is employed to represent the subjective perspective of the Ray Liotta character in his most drug-addicted and paranoid state.

1-31

The perspective shifts in the zoom shots.
Mike Nichols's *The Graduate* (1967), © mgm.com.

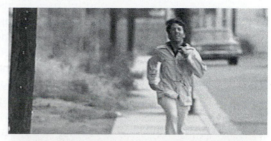
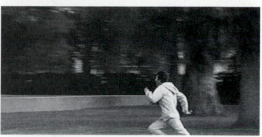

1-32

The simultaneous pan and zoom changes the perspective from a squashed space to an elongated space.

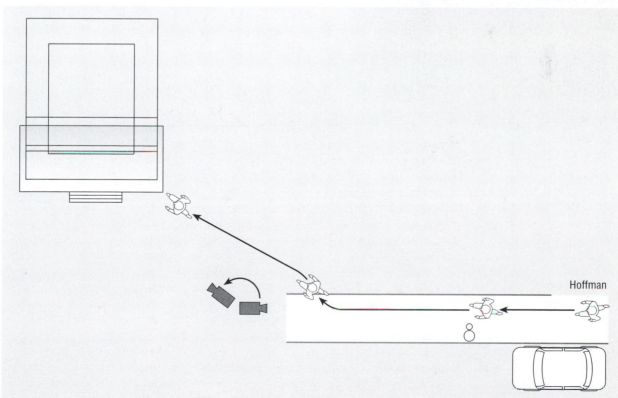

Hoffman

© Cengage Learning

Choice of lens is a key part of all shooting decisions. The employment of a specific lens brings with it both the lens's representation of space and its inherent characteristics. Occasionally, someone comes up with the mistaken notion that telephoto lenses are used for close-ups and wide-angle lenses for long shots. You can use a telephoto lens for a full-body shot, but the field of view will be narrow and you will have to be some distance from the subject. Wide-angle lenses are often used for close-ups, though one must be aware of their distorting qualities. It all depends on what you are trying to achieve visually. If a director wants a scene to have a sense of open space, he or she will opt for a wide-angle lens. Scenes that seek a very constrained sense of space require the opposite. You must understand the properties of different lens types because lens choice has a big impact on the image and thus occasions many preshooting discussions.

2

Constructing the Scene

One of the necessary steps in planning the filming of a scene is to develop a strategy for shooting. Although this involves developing a specific approach in the form of a storyboard or a shot list, some basic principles of scene construction must be considered before trying to sketch anything out.

In theater production, *blocking* refers to planning where the actors will be and how action occurs in relationship to the set, lighting, and stage space. In film, this is complicated by the presence of the camera. **Blocking for the camera** refers to staging action for the camera. As much as or more than any other element, blocking for the camera must be done with a clear concept of how the scene is going to be edited. It might be useful to think of a film as a jigsaw puzzle, each piece of which must be cut individually and must have a specific place in the finished pattern. But unlike a puzzle, a film has no single, correct way to be put together. The design of each film bears the mark of the filmmaker's personal style, with the result being a unique work.

The choices you make in terms of setups are entirely up to you, but seeing all choices as equal is a mistake. Shooting a scene should be done with the knowledge not only of a wide set of rules intrinsic to film but also of accepted, often anecdotal folk wisdom that has evolved over the years and of many aesthetic principles developed by filmmakers and artists in other media. There may not be one single right way to shoot a scene, but there are myriad wrong ways. There are approaches that many talented people have determined work; there are others that simply do not. If the goal is to create a scene that is clear and coherent to the viewer, understanding basic scene construction is crucial.

The Shape of Production

The hierarchy on a film shoot can often get confusing for the outsider, with executive producers, associate producers, line producers, and many others involved. In the past 60 or so years, writing on film has become very "director-centric," with much of the success or failure of a film being ascribed to the director's efforts. But the role of the **producer** is usually that of the central figure in how a film takes shape. The producer puts together the "package" of all of the main players and elements in a film's genesis. It is the producer who chooses the director, although often in conjunction with other parties. The producer is generally also the key figure in the initial shaping and the general direction of the script. Key actors are frequently part of the deal as well.

A film is organized into three critical phases: preproduction, production, and postproduction. **Preproduction** constitutes the planning and preparation: the process

of identifying and securing all of the elements—aesthetic, human, and material—that will be needed for the film. This includes fine-tuning the script, casting, scouting locations, designing sets, finding props, organizing the shooting into a series of manageable tasks, and whatever else it takes to get into a position to shoot. **Production** includes the actual shooting. Producers often play a critical role here, but the director is usually the key decision-making force at this stage of a film. **Postproduction**, the editing and the detailed finishing processes, is covered in part V.

The Director

Directors are usually involved from near the beginning of a project all the way to, in some cases, the creation of the final print. Beyond the activities of the producer, it is the director's choices that drive the rest of the crew's actions. On fictional films, the director is responsible for determining the **look**—the visual character—of the film, rehearsing and organizing the actors' performances, selecting the setups and all attendant details, and marshaling all of the forces toward the completion of the material. Although other key crewmembers have varying levels of input, it is the director's responsibility to define the script in terms of both a theatrical, dramatic interpretation and the story's visual presentation.

The Menu

Before discussing scene construction itself, a summary of the visual resources presented so far is in order. **(SEE 2-1)** Lists such as this risk constant editorializing. On close scrutiny, some of the categories begin to break down, and there are always exceptions to any suggested effect. Knowledge of these basics, however, can serve as a starting point for both those who want to learn conventional film techniques and those who want to go beyond them. That said, the implementation of certain techniques, such as close-ups, is often consistent from the most adventurous independent production to the most conventional of product, even though the content of the shots may be radically different.

Certain patterns start to suggest themselves with these shots. If you want an essentially neutral portrayal, for example, you might choose specific approaches, such as a medium shot, at eye level, with a level camera and a normal lens. Most of the shots of Radio Raheem in Spike Lee's *Do the Right Thing* are from a low angle, but several have even more extreme characteristics. One shot of the character is from a low angle, photographed with a wide-angle lens, with the camera at an oblique angle. **(SEE 2-2)** The wide angle exaggerates the character's features, and the oblique angle gives the sense of a world out of balance. Whether or not one agrees with the

2-1

The menu of the camera resources presented so far

© Cengage Learning

Proxemics	Camera Movement	Lens Perspective and Characteristics
Long shot	Pan	
Medium shot	Tilt	Wide-angle
Close-up	Dolly	Normal
Camera Angles	Tracking	Telephoto
Low	Crane/arm	Zoom
High	Handheld	
Eye-level	Steadicam	**Focus**
Bird's-eye view	Aerial	Shifting focus
Oblique/level		Deep focus
Point-of-view		Shallow focus

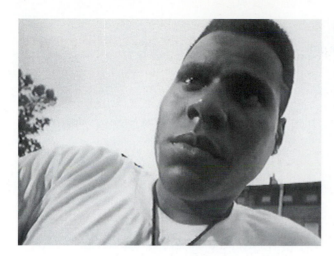

2-2

An oblique, low-angle shot with a wide-angle lens exaggerates the character's features and conveys a world out of balance.
Bill Nunn in *Do the Right Thing* (1989), © 40 Acres & A Mule Filmworks/Universal Pictures.

intimidating nature of the combination of these effects, one can appreciate how a shot like this figures into the grand plan of the film. One of the major elements of *Do the Right Thing* is the increasing tension caused by the hot and stifling day on which the action occurs. This shot of Radio Raheem, as well as many other elements of the film, creates an atmosphere where everything is distorted and on the edge.

Although lists like figure 2-1 can give valuable ideas, these effects should not be treated as a mix-and-match recipe. It is not a matter of getting diminishment by mixing two-thirds long shot with one-third high angle. That approach would most likely be stereotypical and clichéd. Rather, the camera should be approached as a meaning-producing instrument. A list like this should never be seen as an end. The myriad subtleties continue to be explored more than a century after the first frame of film saw a glimpse of light.

Basic Scene Structure

It is clear from the discussion of shots and other resources that where the camera is placed in relation to the scene plays a central role in guiding how the viewer interprets character and action. A long shot of a character responding to something, for example, does not draw us in as persuasively as the same response in a closer shot. The sequence of long shot–medium shot–close-up (LS-MS-CU) represents a process of moving closer to the action, of moving from a random view to much more specific information.

Dramatic Emphasis

The concept of dramatic emphasis lies at the heart of narrative filmmaking and can be a critical component of experimental and documentary film as well. Simply stated, **dramatic emphasis** refers to the use of the camera by the director to show us the action in the order and with the amplification that he or she wants. The director breaks down the scene into an interrelationship of dramatic perspectives (shots) that focus viewer attention on specific information, characters, dialogue, action, and so on.

Alfred Hitchcock's *Notorious* has many remarkable sequences, but one of its more subtle scenes provides a clear example of this concept. **(SEE 2-3)** The scene takes place about one-quarter of the way into the film and involves Alicia (Ingrid Bergman) trying to have a discussion with an unresponsive suitor, Dev (Cary Grant). Struggling with a shady past, Alicia is trying to start over—making the insult that Dev delivers in the middle of this scene all the more humiliating. The

2-3

Dramatic emphasis—when the camera shows the action in the order and with the emphasis that the director wants—lies at the heart of narrative filmmaking.

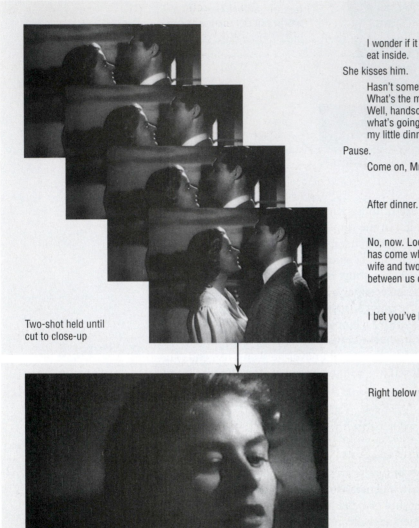

Two-shot held until cut to close-up

Ingrid Bergman and Cary Grant in *Notorious* (1946). © Criterionco.com.

ALICIA

I wonder if it is too cold out here. Maybe we should eat inside.

She kisses him.

Hasn't something like this happened before? What's the matter? Don't look so tense. Troubles? Well, handsome, I think you'd better tell mama what's going on. All this secrecy is going to ruin my little dinner.

Pause.

Come on, Mr. D, what is darkening your brow?

DEV

After dinner.

ALICIA

No, now. Look, I'll make it easy for you. The time has come when you must tell me that you have a wife and two adorable children and this madness between us can't go on any longer.

DEV

I bet you've heard that line often enough.

ALICIA

Right below the belt every time. That isn't fair, Dev.

entire beginning of the scene is played in a **two-shot,** so named because it shows two people from roughly the waist up. The timing of the cut to the close-up is key to the scene's effect. The exact positioning of the cut is indicated by the horizontal line, right at the end of Dev's line of dialogue, and the camera subtly emphasizes the emotional deflation visible in Alicia's face.

The two-shot is played out for an unusually long period of time—almost 45 seconds. Some argument could be made that the director could have broken down the scene into other shots to emphasize Grant's taciturn response or Bergman's attempt to draw him out; and yet the choice of playing this part of the scene in a two-shot has an unquestionable logic. There is nothing occurring that

cries out for emphasis. It is just a simple exchange of dialogue, and a cut is not necessary until the intensity of the interchange increases. When the cut finally does come, its logic is inescapable. If anything, cutting the lengthy two-shot would dilute the impact of the cut when it finally does come.

You need not look far to see examples of scenes that use shot selection for dramatic emphasis. The technique is pervasive. In the hands of a competent craftsperson, the approach is so natural to the logic of the scene that we barely notice it. Indeed, most commercial films are purposely designed so that the editing—how the scenes are constructed—is virtually invisible.

Master Scene Technique

As suggested, the sequence of LS-MS-CU represents a common movement from random, general information to very specific information. Scenes often begin with a relatively random long shot; then the focus tightens and becomes more specific. In most cases, a wide view of all or parts of the scene are shot first, and then the shooting is broken down into medium shots and close-ups. Though this process of breaking down scenes into their constituent elements has a variety of permutations and goes under several different names, it is generally referred to as **master scene technique**. "Elements" are simply those things—people, objects, and places—that are key aspects of the scene being shot. If a scene has two characters talking, there are two core elements. If they are arguing over the restaurant check in front of them, the check might become a third element. The elements are then presented in the groupings and the order that the director desires to create dramatic and engaging scenes. Though others were experimenting at the same time, the early filmmaker D. W. Griffith is generally credited with pioneering this concept.

Master scene technique is an approach in which the director stages the scene essentially as it would be staged in a theater. All or part of the scene is shot in a **master shot**—a shot in which all, or most, of the elements are presented together. This shot is also called, more descriptively, an *establishing shot* because it establishes the space in which the scene is occurring, where the characters are in relationship to one another, any important objects that may be present, and so on. The director then stages the scene many more times, but shooting it in a variety of MSs and CUs. Medium shots convey more-specific information, though not with the emphasis or intensity that can be achieved with the close-up. Directors will tell you often they generally save close-ups for the most intense part of an individual scene—the climax. The material is then given to an editor, who cuts it into an effective sequence.

This method can have an almost assembly-line approach; and in the heyday of the Hollywood studio system—the 1920s through the 1950s—films were ground out in a highly efficient factory. Indeed, one production unit at Warner Bros. even referred to itself as the "Sausage Factory." Directors who had some clout, or who worked on such low-budget films that no one paid much attention to them, were able to make films with some individual character, but the assembly-line approach influenced virtually all films of the day. In certain cases, particularly episodic television, it still does.

This method has been recognized under a variety of different names, such as *invisible editing, continuity style, classic Hollywood style,* and *master shot discipline,* among others. By whatever name, the approach was standard operating procedure in American filmmaking. There is, after all, a certain logic to this progression of moving closer to a subject. As with so many other techniques in the Hollywood approach, this is a natural replication of human perceptual experience. When we are curious about something, we move closer to it. Different and more-adventurous styles have been experimented with, particularly in the 1960s and 1970s, but the traditional approach still has profound influence.

2-4

Shot/reverse shot involves
shooting all of person A's
dialogue from setup #1, then
moving the camera to setup #2
and shooting all of person B's
dialogue.

Shot/Reverse Shot

In its simplest and most common manifestation, called shot/reverse shot, master scene technique provides an easy way to handle a conversation between two or more characters. Once pointed out, the approach is familiar to everyone, particularly those who watch television interview programs such as *60 Minutes*. It is the bread and butter of thousands of movies and countless television shows.

Quite simply, **shot/reverse shot** involves shooting all of person A's dialogue from setup #1, then picking up the camera and moving it to setup #2—called the *reverse shot*—and shooting all of person B's dialogue. **(SEE 2-4)** The results are then intercut as a simple back-and-forth exchange. We have a shot of person A saying a line of dialogue, then a shot of person B responding. To keep things visually interesting, other types of shots are worked in, such as two-shots or **over-the-shoulder (OTS)** shots (done over a character's shoulder).

The usefulness of this basic approach in shooting interviews is obvious. Several hours of an interview with person A are shot. When the interview is over, the subject is excused and the camera is moved to the reverse shot (setup #2). Several minutes of the interviewer (person B) nodding in assent (or maybe staring blankly in disbelief) are then shot. The inevitable dull interludes in the actual conversation can simply be edited out and the resulting jump in the footage covered with a shot of the interviewer responding to what is being said. This method of shooting allows the footage to be manipulated into the desired order and length—which can also extend to manipulating the context and the content of what is said. Indeed, *60 Minutes* was sued many years ago when an interviewee objected to the way he felt his words were being manipulated. Although many films, from Orson Welles's *Citizen Kane* to the work of Robert Altman, try to find more-adventurous approaches, shot/reverse shot remains a common method of delivering dialogue.

Although these techniques—master scene technique, shot selection for dramatic emphasis, and shot/reverse shot—are relatively straightforward to describe, practical experience is required to truly understand and control them. Moreover, it is important to recognize the function they serve. These techniques are essentially tools that enable you to communicate narrative information clearly and effectively. On occasion, a more adventurous shot selection may overcomplicate material that demands a straightforward presentation. These techniques also serve a purpose common to most narrative art forms: they start with a general view of the subject, then move to a closer, more specific perspective.

Continuity

Style in American film has largely been subservient to the goal of presenting seamless and involving stories that, at least in their parts, are portrayed as unfolding in real time. Scenes are put together in such a way that their construction—the shot selection, the editing—goes largely unnoticed by the viewer. In film theory, this has most aptly been referred to as **invisible editing**.

A substantial part of this approach is based on **continuity shooting**—the creation of shots that when cut together represent continuous action. The style employs both story structures and formal elements that do not deviate substantially from realistic portrayals of events. Although this style has indeed been pervasive, other traditions have evolved that either present alternatives or, in many cases, are conscious assaults on the ideological assumptions of this dominant approach. The remainder of this chapter explores some of the underlying principles of continuity shooting.

The general application of the concept of continuity in film is familiar to most viewers. It is most noticeable in scenes where it is lacking—sequences where the action does not match from shot to shot. For example, in one shot, a character has on a tie; in the next shot, the tie is missing and the character's shirt is casually unbuttoned. In one shot, a character reaches for a drink with her right hand; in the next, she picks up the drink with her left hand. In a master shot, there is a full glass of beer on a table; in the medium shot, it is empty. The mistake reaches comical proportions when the master shows the glass full again. Some of the mistakes are so obvious that it seems unthinkable that someone could have missed the problem, but during the lengthy delays between setups and the pressure of never-ending competing demands, elements are easily shifted, lost track of, and mislaid.

Although these examples are common things that most observant viewers have noticed at some time or another, shooting in continuity has a broader definition with wide-ranging implications for the way elements must be monitored while shooting a scene: when you are shooting in continuity, you are creating a real-time relationship between the shots. As should be clear by now, films are not shot in order, much less in real time. A scene that takes several minutes of screen time could easily have taken a day or more to shoot. Shooting in continuity means you are creating pieces of film that will later be cut together in such a way as to suggest that what the viewer is seeing is occurring in real time.

Continuity editing is dependent on the **match cut,** a common type of cut in which the action matches from one camera angle to the next. If a person is going out of a door, he or she starts to open the door in the first shot, and the next shot picks up the action at the same point in time, from the opposite side of the door. In a cut from a long shot of someone sitting down in a chair to a closer shot, the action in the two pieces should match.

The opposite of a match cut is a jump cut, something that was virtually heretical in the golden age of the Hollywood studio system. The **jump cut** is a cut between shots in which there is a jump in time—an ellipsis—between the shots. In his landmark film *Breathless* (1959), French director Jean-Luc Godard incorporated the jump cut into a structure that both made narrative sense and subverted dominant stylistic approaches. In this formally radical approach, when Godard wanted to get a character from one side of town to another, he simply cut him from one place to the other. When he wanted to get from one part of a conversation to another, he simply cut out all of the intervening material. The result is that characters jump from one place to another, creating a jumbled, chaotic sense of reality. These are cuts that draw attention to themselves and, by extension, to the process of making a film. Godard's film openly flouted the conventional approach, giving a highly subjective representation of space and action. American films in general still attempt to create a relatively seamless sense of real time and real space, but Godard's influence has had a profound impact on everything from the most typical Hollywood features to commercials and music videos.

Continuity Shooting

Shooting out of sequence requires careful attention to detail to ensure that all elements of a scene remain consistent from shot to shot. Something shot early in the morning may have to be matched with something you are going to shoot late in the afternoon. Even if you are doing shots relatively close together, you can run

into problems. A student film from several years ago contained an example of this. The film had a simple sequence of a woman entering a house. The student put the camera outside to shoot the first part of the movement. When that shot was completed, she moved the camera indoors to do the match shot of the completion of the entrance. The actor sat down to wait and, as it was a bright, sunny day, put on her sunglasses. When the next shot was done, she had forgotten to take off the sunglasses. One can appreciate the sinking feeling the student had on getting the film back and seeing the mistake which, as glaring as it was, would be noticed by most viewers.

In the golden age of the Hollywood studio system, continuity was monitored by the "script girl"—now of course an outdated credit. The elements within the frame, the position of the performers, and the general action were tracked with rough sketches and detailed notes. Today the continuity person is called a **script supervisor,** and technical advances have transformed that role.

Polaroid instant cameras were one of the first things to have a big impact. The script supervisor could produce an instant representation of how all of the elements within a frame were arranged. Sketches and notes were, and still are, essential, but the job was substantially simplified.

In the 1980s, Polaroids were partially replaced by a virtually foolproof method of monitoring continuity. The **video assist** is a tiny video pickup device mounted in the viewing system of the film camera; it gives a video representation of the shot, albeit not always a high-quality one. A video feed of the camera image has many purposes on a set, with continuity being but one part. With it the script supervisor could go back to check where specific movements occurred in relationship to dialogue and action or to find the precise positioning of objects within a frame. One drawback to this approach was that it could be quite time-consuming, particularly if the script supervisor and the video assist person had to roll through a substantial amount of tape to find what they needed. If other people felt the need to get involved, the whole set could come to a standstill, with everyone standing around drinking coffee and watching the monitor.

When shooting on video, using record decks and source tapes to monitor continuity would be untenable, so the camera signal could be fed to another deck for general monitoring. Another drawback is if crewmembers such as the director or the producer are using the video feed for other reasons; it can cause quite an inconvenience to shuttle through tapes in their presence. And these are generally people you do not want to be inconvenienced.

Digital still cameras have become the device of choice for monitoring almost all pertinent details. With a laptop computer handy to organize and store images, the script supervisor can reference almost anything at any time. A computer paired with a small photo printer is standard issue for many departments. Polaroids are still used occasionally on remote locations, mostly in the costume, makeup, and hair departments. Video assist is always there if needed, but keeping all questions within the script supervisor's domain is the most efficient use of resources.

Types of Continuity

The script supervisor is actually involved in only a few types of continuity. Some elements, such as lighting, are so specialized that they are left to their respective departments. The following categories of continuity are general areas, rather than rigid classifications, that have been defined and elaborated on over the years.

Action The position of performers and other moving elements within the frame must be carefully monitored. This refers to matching action between closer and longer shots as opposed to being concerned with what characters are wearing or how props are arranged in a scene.

If an actor says his line before sitting down in the master shot but after sitting down in the medium shot, the two shots will be uncuttable. If he is scratching his chin in the MS but has his hands at his sides in the master, the pieces again will be uncuttable. This is always a difficult issue because, although you have to communicate to the actors the need for continuity so that their actions match between setups, you do not want to inhibit them. Experienced professionals are generally very knowledgeable about the requirements of the medium, understanding what it takes to placate the continuity gods. For nonprofessionals, it can be quite disconcerting.

Props, costumes, hair, and makeup A short scene can easily take a day or more to shoot. Invariably, elements are moved around as lighting is adjusted, and objects are moved to balance compositions. Costumes, hair, and makeup also require constant attention. Responsibility for the consistency of these elements is shared by the script supervisor and the crewmembers in the respective departments.

Seemingly simple things such as candlelight can drive the script supervisor to distraction. Over the course of a shoot, candles will have to be carefully controlled so that they remain consistent. If the candles are allowed to burn down, they may not match from the beginning of the scene to the end. A script supervisor would probably ask the prop person to bring a substantial number of extra candles. The prop person may burn some candles to certain lengths the night before so as to substitute specific lengths. Assuming the standard delays between takes and setups, the candles might have to be blown out between shots. Because many smaller projects do not have a continuity person, or they have one who has additional, seemingly simple responsibilities, things like this can get overlooked.

Historical Especially important in period pieces, historical continuity refers to checking that all elements are historically accurate for the context of the film. People reading printed books in a version of Chaucer's *Canterbury Tales* would be anachronistic; similarly, satellite dishes in a film set in the Civil War period would be out of place. Many films play fast and loose with historical continuity. You will often hear of films including a song or some other element that was created after their action occurs.

Achieving historical continuity is often a matter of research, the responsibility for which can fall on a number of different shoulders. For a song, it may fall to the screenwriter or, if the song's inclusion is an editorial decision, the film's postproduction team. For elements in the frame, the research may be the purview of the **art department,** an umbrella term for everyone involved in the design elements of the image. Extensive research abilities may be part of the job description for many crew positions, particularly for period pieces.

As with everything, purposefully breaking the conventions can yield interesting results. Alex Cox's *Walker* (1988) is set in 1850 Nicaragua, with the title character installing himself as the imperialist president of the war-torn country. To emphasize parallels to modern events, the film includes such historical impossibilities as William Walker and his men being saved by army helicopters in images that are eerily reminiscent of the 1975 fall of Saigon. There are many other improbable elements, including a computer-outfitted command center and Walker's pride in making the cover of *Time* magazine. The purpose is clearly to create parallels with modern events and to break with realistic modes of historical interpretation. Baz Luhrmann's *Moulin Rouge* (2001) is another good example of a film that purposefully mixes historical periods for stylized effect.

As you watch films more carefully, you will notice unintentional historical continuity errors with some frequency. One of director Anthony Mann's great westerns, *The Far Country* (1955), has jet contrails in the sky above scenes supposedly occurring in the 1880s. The more actual film production experience you get, the more you realize that things like this are usually not mistakes but rather the unavoidable compromises one must make when under time and budgetary

constraints. Perhaps they were losing the light, and the director was forced to shoot despite the conditions. The more you know, the more you may be amazed that films get made at all! The production of a film is such a complex tangle of marshaling elements to occur at just the right time that you are often forced to proceed even when you do not have everything you want in place. Of course, in the digital age, those jet contrails could easily be taken out in postproduction. While this would probably be a reasonable budget item for a commercial feature, it would be an expensive and complicated option for an independent shooting on film.

Lighting Matching will be a problem if shots that are to be cut together look different in terms of the color and the quality of the light. This issue is often referred to as **photographic consistency.** It will drive many of the technical considerations you need to be concerned with while shooting. The script supervisor is generally not involved in lighting-continuity issues other than occasionally taking notes for the lighting crew.

Continuity is one concern that distinguishes motion picture photography from still photography. Still photography is usually not sequential in its presentation. Even if a still photographer is attempting to create some kind of photomontage, the images are nevertheless presented as discrete entities, and only extreme differences in lighting would be noticed. In film, however, if you want the illusion of shots occurring in real time, the quality and the intensity of the light must match from shot to shot.

Still photographers who visit film sets are often amazed at the complexity of the lighting approach. They invariably suggest that a simpler approach might work, until they are made aware of the kind of matching that is being attempted. Even then some of them cannot grasp the difference. Still photographers have extensive control in the printing process, including dodging or burning specific areas of the image and manipulating exposure and processing times. If they create a decent negative when they are shooting, they can often still produce the kind of image they want in printing. Although there is some room for image manipulation in film, these discriminations can generally be applied only to the whole shot and the entire frame. It is imperative that you work out all matching issues when you are shooting. Again, the digital realm provides some leeway here, but expense and complications remain issues.

The following story gives a sense of the kind of hoops one must jump through in this regard. I once worked on an exterior shoot in a Midwestern state on one of those days that people who forecast the weather like to call "partly sunny"—an ambiguous term that leaves in question whether there will be more clouds or more sun. This was definitely a "more clouds" day: weather that reminds one why filmmakers prefer the largely cloudless skies of Southern California. It was a relatively simple scene that the **production manager (PM)**—the person responsible for all scheduling—had budgeted the morning for shooting, with the intent of shooting another scene in the afternoon. The problem in such a situation is that the quality and the intensity of the light between the sunny and the cloudy periods do not match. The scene would have proved uncuttable—that is, would have appeared awkward or poorly staged to the viewer—had we attempted to shoot under both conditions. The three- or four-hour shoot became a daylong ordeal in which a succession of hapless souls tried to estimate, with limited success, how much sunshine we were going to be blessed with at any given time. The production manager was tearing her hair out because the afternoon shoot, which was logistically complicated, had to be canceled and rescheduled while a large number of costly elements (actors, extras, props, and the like) waited idly by.

If it had been a bigger shoot, we probably would have had the resources to overcome our difficulties. There are lights that, as their manufacturers love to boast, "outshine the sun at 20 paces." But our options were limited, and we spent substantial time just waiting. Natural light has a nasty habit of changing quite frequently. Artificial light requires a level of control that can be imposed only with experience and budget.

Sound This refers to creating a sound track that is consistent, with no big shifts in either the volume or the quality of the recorded sounds. Although the location recordings must be as consistent and high quality as possible, sound continuity is largely an editorial issue. Many imperfections can be covered or fixed, either during the editing process or when mixing the final sound track in the studio.

Sound can also have implications for historical continuity. When doing period pieces, modern sounds can present problems. The sound mixer on a film that was set in the 1840s, for example, which was shot about 40 yards from a major highway and a half mile from a private airport, had to work out many details to get usable sound.

Performance With action being shot from so many setups, performance must be standardized so that it matches between camera angles. This is generally not a problem on larger productions, where most actors, as well as the director, are experienced professionals. But on films where you may be working with nonprofessionals, it can be a big issue both in terms of what a performer can produce and in how an inexperienced director evaluates that performance. Before shooting, details of a performance—the level and the tone—should be completely worked out between the **talent** (actors) and the director. A director who asks for anything different between takes can cause enormous editing problems. Although this is not necessarily the domain of the script supervisor, a good one will recognize glaring errors.

I had one job working with an inexperienced director who was directing a very emotional performance from an untrained actor—a bad mix if ever there was one. He was not getting from her what he wanted, but he started shooting anyway. We did several takes of the master shot of one of the actor's long speeches, then moved in for medium shots and close-ups. Between setups, the director decided that her performance was too unrestrained in the master, so he asked the actor for less. The next time he got too little, so he asked for more. He got too much. He was trying to shape the performance as we were shooting, and the resulting footage proved uncuttable. The editor was eventually forced to play the whole thing in master, an option that suited neither the scene nor the shape of the film. If this kind of mistake were made on a larger project, the eventual outcome would probably be a reshoot (and people would be fired). On smaller budgets, this option does not always exist.

Spatial Spatial continuity, or creating an understandable sense of space, is the focus of the following section.

The Line

A director friend likes to call the line "the central organizing principle" of narrative cinema. The **line,** also called the **180-degree rule** or the *axis of action*, refers to a principle used to create an understandable sense of the space in which the action is occurring. The line is relatively easy to understand on a superficial level, but its application is something that takes on-set experience to truly comprehend. Simply stated, the rule says that *if shooting is begun on one side of an action, it must stay on that side.* If the camera jumps to the other side of the action—that is, crosses the line—the sense of an understandable and continuous space can be disrupted.

Before doing storyboards or blocking the action for the camera, this line is figuratively drawn in the shooting space. The application of this rule has become less rigid in recent years, but if the goal is to create a logical and continuous sense of space, shooting with an understanding of the line is a must. As with anything painted with such a broad stroke, there are exceptions, but they are fewer than might be expected. Even if a distorted sense of space is desired, a knowledge of the line's effect is still necessary.

The location of the line is generally based on one of two factors: sightlines or direction of action.

Sightlines

With **sightlines,** the line is created by drawing a straight line that represents a character's direction of vision. The line is based on the sightlines of the character who is on-camera, and it can change as his or her direction of view changes. Often the line is drawn between two people in conversation, though it applies to an individual character watching an action as well as to multiple-character situations.

If you start on one side of the sightlines between two characters, you must stay on that side. If you use a setup from the other side of the line, the characters will not appear to be looking at each other and may seem to have switched places.

If you start shooting from setup #1, the rest of the setups should be on that side of the sightlines. **(SEE 2-5)** If you cut to anything on the setup #2 side, you will have problems with matching sightlines, and the characters will appear to be looking at some unseen third space. It does not make any difference on which side of the sightlines you start. That should be an aesthetic determination based on what you want to see in the background, which profile of the performers you want to film, and anticipated character movement. But once you have started on one side, you must stay on that side.

This can be difficult to conceptualize, so taking the most extreme example should make it easier to understand. In this example, setup #1 is at a right angle to person A, and setup #2 is at a right angle to person B on the opposite side of the line. **(SEE 2-6)**

The key to understanding this is to consider the direction that the character will be looking in the resulting film. If we can transpose the shot from setup #1 to see how it would look on-screen, the character would be looking screen-right. **(SEE 2-7)** If the same thing is done with setup #2, which way would the character be looking? This may be more difficult to visualize, but if we pull the camera around while moving the character with it, the direction can be determined. **(SEE 2-8)** Again, the character would be looking screen-right.

The problem is obvious when we attempt to cut the two pieces together. **(SEE 2-9)** It appears as though person A is talking to the back of person B's head. If the angles chosen are less extreme than in this example, the problem remains. This may be more difficult to visualize, but characters will appear to be looking at some abstracted third space. Though audiences will not point to the screen and say, "Look, they crossed the line," on an unconscious level it will be difficult to discern a logical space, that is, to understand where the characters are in relationship to each

2-5

The "line" refers to a principle used to create an understandable space in which the action occurs.

© Cengage Learning

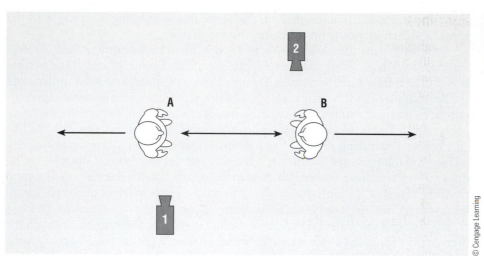

2-6

Mismatched camera positions help illustrate the concept of the line.

© Cengage Learning

2-7

The subject from setup #1 is looking screen-right.

© Cengage Learning

2-8

The subject from setup #2 is also looking screen-right.

© Cengage Learning

2-9

The characters do not appear to be looking at each other.

© Cengage Learning

other and the space. This confusion, this sense that something is wrong with the scene, will disrupt viewer involvement with the drama.

Clearly, many filmmakers *want* to disrupt this seamless, unimpeded involvement, or they wish intentionally to create a confused sense of space and action. If you deliberately want to create a disrupted sense of space, you must understand the application of the line just as clearly as when you want a conventional representation. In many situations, a confused sense of space does not serve the narrative context even if what you are doing is unconventional. The director who calls the line "the central organizing principle" of narrative cinema is no dull conventionalist—he has won international awards for some odd and unconventional stories—but he does not want confusion over spatial relationships to distract the viewer's attention from the action of his films. Planning out the entire scene in terms of setup, character positions, and the line is a necessary component of scene construction.

Character movement complicates the line in regard to sightlines, although the line simply changes as a characters' sightlines change. Sightlines also become more complicated when there are more than two characters. Usually, when filming a conversation involving multiple characters, one should try simply to stay to one side of the action or the other.

Action

In terms of action, the concept of the line is even more clear-cut. If you film a car driving down the street from its right side, it will be moving from left to right in the resulting shot. If you then cross the street and film the same car continuing in the same direction, it will be moving from right to left in the resulting shot. When you try to cut the two pieces together, the car will appear to have changed direction. **(SEE 2-10)**

D. W. Griffith certainly understood this idea by the time he made *Birth of a Nation*. The Civil War battle scenes would have been virtually incomprehensible without following this rule. In one sequence, the Confederate troops charge the Union lines. Because all setups are to the right of the charge, the Confederate troops are always moving from left to right. **(SEE 2-11)**

2-10

Crossing the line in an action shot causes the car to appear to have changed direction.

2-11

Setup showing action moving left to right

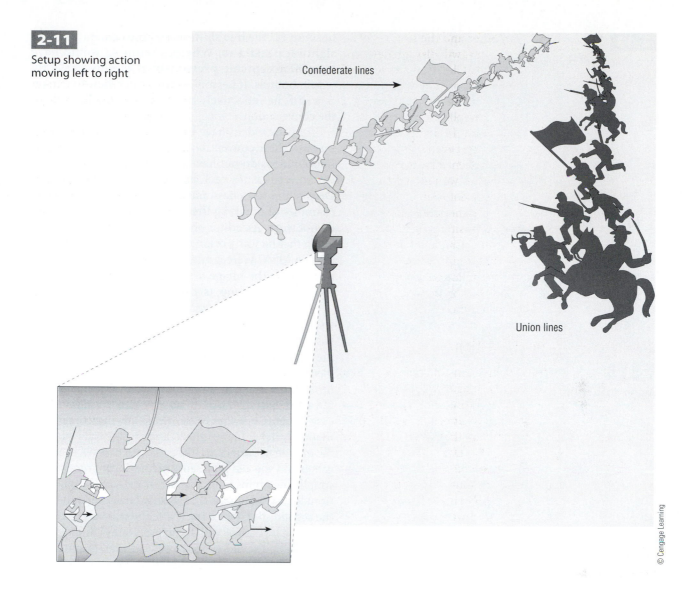

Confederate lines

Union lines

© Cengage Learning

What would have happened if Griffith had tried to mix in some setups from the left side of the Confederate charge? The Confederate troops would have moved from right to left. **(SEE 2-12)** They would look like they were retreating when intercut with shots from the other side. When shooting any action that depends on a continuous sense of direction, from battle scenes to football games, the line must be a chief consideration.

Conceptual Errors

Other than disregarding the line altogether, the biggest mistake beginning filmmakers make is thinking that the line is from the camera to a character, when it is actually between one character and another. As a character's sightlines change, the line changes. If person A shifts her gaze from person B to person C

2-12

Crossing the line reverses the direction of the action.

Confederate lines

© Cengage Learning

2-13

As a character's sightlines change, the line changes.

2-14

Music video setup

in setup #1, the line shifts across the camera with her sightlines. **(SEE 2-13)** Whereas setup #2 would have been unacceptable previously, it is now perfectly within bounds. If person A returns her view to person B, a shift has effectively been made to the left side of the conversation.

Music videos have had a tremendous impact on many of these conventions of film construction. Many music videos do not have a clearly thought-out strategy toward issues such as the line, nor should they. Despite this looseness, music videos still provide some examples of breaking the 180-degree rule that clearly do not work. An editor once showed me a Patti LaBelle video that he was working on that eventually got some play on MTV. Were it not for video's inherent ability to manipulate the image, it would have included a very disruptive **line jump**. **(SEE 2-14)**

The video had a sequence of shots of a gravedigger wielding a pickax. The director had made one of the most basic conceptual errors possible. He shot the full shot of the gravedigger from one side of the action (setup #1); then, inexplicably, he shot a close-up of the pickax gliding through the frame in slow motion from the other side of the action (setup #2). With an action of this nature, it is easy to figure out where the line is. The direction of the motion matches the sightlines, and the line is the plane of the motion of the pickax. Imagine these two pieces cut together and you can get a sense of how incongruous some simple line jumps look. The arc motion of the pickax is from left to right in the first shot and from right to left in the second shot. **(SEE 2-15)** The scene was salvaged only because it is possible, with the appropriate high-end video gear, to flip the video image side to side, in much the same way as can be done with many computer graphics software programs. Unaltered, though, these two pieces do not fit together except as a disjointed representation of a simple movement—not entirely inappropriate in some circumstances but not viable in this particular piece.

2-15

A line jump results in the pickax's swinging from the other side of the action.

After several sessions of having the line concept drilled into him, one student was gloating about finding a line jump in Nicholas Ray's *Rebel Without a Cause* (1955). Occasional line jumps are found in classical-era Hollywood films. Sometimes they appear to be mistakes that could not be fixed; other times they simply represent the director's avoiding complicated steps to reposition the camera, assuming that the audience will be able to follow the action. Indeed, when the space is straightforward or innately understood (a baseball field is a good example), certain leaps of faith can be taken with the camera. Some line jumps are simply not a big problem. It may be just as well to brazen your way across, being more efficient than going through some fancy, schematic footwork to cross over. Other line jumps, however, cause noticeable breaks in continuity.

Sometimes line jumps can be part of a greater plan; other times they are just irreversible mistakes in conception with which one must live. Some films owe their informal effect to a complete or partial disregard for the line. A line jump is essentially a jump cut, and just as Godard employed jumps in time in *Breathless,* disruptions of conventional space can create specific effects, most notably confusion or chaos. At the other extreme is a film like Milos Forman's *Amadeus,* which is so dependent on emphasizing Salieri's responses to Mozart's actions—on Salieri watching Mozart—that the line is scrupulously observed. Whatever the approach, the line must be clearly understood to achieve desired spatial effects.

Screen Direction

The concept of screen direction comes into play when a character leaves a shot and then has to reenter in another shot. This is essentially a function of the line, although the difference is that screen direction ties together separate spaces by direction of movement. Simply stated, the way to achieve consistent screen direction is by having characters enter the frame from the opposite side they exited. If they exit frame-left, they must enter the next shot frame-right. If this simple rule is not observed, it will look as though the characters have turned around and gone in the opposite direction. Of course, such screen direction can also be applied to deliberately create a discontinuous or confused sense of space.

When the spaces in which consecutive scenes are taking place are not closely related, failure to think out screen direction can create at most some modest disorientation. If a character's next scene is across town, the direction he exits and enters the frame may not make much difference. When spaces for scenes are closely related, however, failure to think out screen direction can be disastrous.

A good example of the latter would be a sequence of shots of someone getting up and going from one room to another. **(SEE 2-16)** If you start the movement from

Kitchen

2-16

Screen direction comes into play when a character exits a shot and then reenters in a subsequent shot.

© Cengage Learning

setup #1, the character will exit the frame screen-right. If you make the mistake of shooting the next part of the movement from setup #2, the character will enter from the right and move to the left. It will appear as though she changed directions rather than walked in a straight line. It may even appear that she walked around behind the camera.

Somewhat related to screen direction are the generally accepted expectations that certain types of movement go in specific directions. This is particularly true of points on the map. When characters travel east, we expect them to move from left to right; if they are traveling west, right to left. When Woody Allen flies to California in his 1977 film *Annie Hall,* viewers would probably not accept the plane moving from left to right. Westerns also incorporate substantial right-to-left movement, indicating a westward direction.

A number of film critics and theorists have suggested that the line is a byproduct of the theatrical heritage of film, that cutting to the far side of action would be tantamount to making the audience jump to the opposite side of the stage or suddenly view the play from backstage. Early filmmakers, realizing that the audience's closest frame of reference was watching stage productions, were loathe to disrupt conventional audience positioning relative to the action.

There is a certain amount of truth to this, but the 180-degree rule mainly serves to create matching sightlines and continuous direction of action. If the line is not observed, people will appear as though they are not looking at each other, and action will appear discontinuous. Again, few audience members will recognize this on a conscious level. As some of the rigid rules of narrative filmmaking break down, the line may become less important—or maybe filmmakers are just paying less attention to it. Nevertheless, it is crucial that application of the line be understood no matter what one is attempting to accomplish.

3
Crew Organization

Although creating a plan for shooting—thinking out the shots and the dramatic context of the scenes—is the primary goal during preproduction, the search for and the hiring of a crew are also of primary importance. A number of craft positions may not need to be filled until closer to the actual shooting, but many of the critical creative people should be hired in the film's earliest stages. Many crewmembers indeed will have invaluable creative input in planning out the conceptual approach to shooting. In addition, locations must be found and secured; audition calls must be placed; insurance and bonding issues must be settled; the needs of cast and crew—like food, transportation, and comfort—must be addressed; and myriad other things have to happen before the shooting can proceed.

Although independent filmmakers and students may not use all of the positions described here, it is important to be familiar with the various roles and their attendant responsibilities. As with so much else, even if no specific person is on board for a certain job, the job nevertheless has to be done. (The director picking up donuts for the cast and crew is purely the province of the student and independent film.) Each job is simply one more thing for which you, the filmmaker, must do or, hopefully, find a responsible individual. The organization and the sophistication with which a project is approached have a direct bearing on the final product.

The Sequence of Events

Although all three phases of the creation of films—preproduction, production, and postproduction—have legitimate claims to being the most critical, a film that is not properly prepped is a disaster waiting to happen. Even films that appear very improvisational require extensive preparation and input from key creative personnel.

Film crews are broken down into departments, with the camera department, design, and other departments addressing all of the various requirements that a given film might have. A film that is effects-heavy may have a large special-effects department. An intimate drama would have other requirements.

Script The first step is coming up with an acceptable script. Scripts can come from many sources, ranging from original scripts, to adaptations of acquired short stories or novels, to simple story ideas that a producer wants a screenwriter to develop. However advanced the script is, the producer generally engages writers to rewrite, adapt, or develop the project.

Director and key people The producer's next hire is generally the director, although *talent,* stars usually, may also be brought on board at earlier stages. The

director, who is most often the key decision-making force in almost all stages of a film, then starts developing the script in terms of casting, general visual style, and dramatic approach.

Once funding, script, and director are in place, the sequence of events is fairly straightforward. Putting a film together in preproduction has become something of a science. Early in the process, the producer hires the **production manager (PM),** who is responsible for the general organization of the crew as well as the practical planning, day-to-day budgeting, and scheduling of the film. A good PM can break down a script and estimate costs to within a few percentage points.

The next step is usually to hire the other key personnel: the **director of photography (DP)** (also called the *cinematographer*), a production designer, and anyone else whose input may be needed during the initial stages. Crewmembers who are specific to actual shooting—sound engineers and people for props, costumes, makeup, and so on—can be hired closer to actual production, although almost everyone needs some prep time to anticipate the needs of a given project.

In conjunction with the director and the cinematographer, the **production designer (PD)** begins preliminary work to determine the overall design approach of the film. Many major design decisions have to be made prior to shooting. One of the first has to do with the amount of studio shooting versus location shooting. Certain scripts demand studio time, whereas others clearly require location work. Most films fall somewhere in the middle, where locations and studios must be weighed in terms of costs and a variety of other factors. A common approach is to shoot the exteriors on-location and all interiors on matching sets created on soundstages. Independents and students, unable to afford the costs of renting expensive studio space and building sets, frequently do all work on-location. Although location shooting does have cost advantages, it also requires extensive preparation and, often, visual compromise, which all can be as complicated as a sophisticated interior design or as minimal as bringing in a few props, painting some walls, and moving around some furniture.

Once these central people are in position, the following tasks have to be undertaken, and personnel to assist in these stages must be hired.

Casting Careful and thoughtful casting is critical to the aesthetic success of any narrative film. There are certainly films that do not rely heavily on the performers, like some action and horror movies, but most rely on the creation of credible characters in believable situations. Casting can be quite informal for independent and student projects, but it is a major undertaking for commercial films. Like so much else, casting has become specialized, with agencies playing a key role in auditioning. Casting crews often separate into groups for casting main roles, peripheral roles, and even extras.

Union rules are a critical consideration in casting. Many actors are members of the Screen Actors Guild (SAG) or the American Federation of Television and Radio Artists (AFTRA), which have stringent rules about participation in films that do not pay the talent or that defer payments until later. You need to become familiar with these rules. Many independents choose to work with nonunion performers, although this option obviously excludes many talented people.

Auditions are a must. For independents and students, this generally means putting a notice for an *audition call* in the classified ads of a local newspaper. Major urban newspapers have a specific section for these—often referred to as "cattle calls"—and actors consult them frequently. It is also worthwhile to post notices at local theater companies and at university drama departments. The notice can be general, although you may want to list the number of roles, the gender and the age, and such issues as controversial subject matter. When holding auditions, be upfront with actors about what their time investment will be during shooting, the subject matter, and the payment they can expect. If an actor sees anything as objectionable, it is better to find out at this stage and not waste either your or the actor's time. One

recent video that caused violent international strife had the actors overdubbed to create controversy. While the actors were blameless and went public about how they had been duped, harm to reputations may be irreparable. Some may see the ethics of the situation as being relative, but actively harming another person's career is self-serving at best and immoral at worst.

Actors are usually asked to do a *cold read* of a short section of the part for which they are being considered. A good approach is to explore the actor's ability by asking for different interpretations of the chosen selection. Find out how responsive the actor is and how sensitive to trying out different approaches to a character. In auditions for stage plays, actors are generally asked to perform a monologue from a play of their choice. Beginning directors may find these useful to evaluate how animated performers are and to get an example of their overall ability, although monologues are generally not required in film auditions. In this initial phase, 10 to 15 minutes should be allotted for each audition.

The director of the session must bring thoughtful, interpretive skills to each audition and must be able to look at a script and perceive the character, motivation, and nuances of every role. This is as true for a main character who is in every scene as it is for a bit part in a single shot. It takes an experienced eye to be able to evaluate individual talent for specific roles.

In an independent/student setting, the biggest mistake that directors make is evaluating performance in terms of an actor's interpretation of a part. This is usually because the director has not defined the character clearly in his or her mind before the casting session starts. The director's interpretive engagement with the script, whether approached alone or in consort with other key personnel, should result in the formulation of at a minimum a brief analysis of every character. Again, asking actors for different interpretations of the part will yield a clue to their general abilities. This establishes an actor's general ability more than their ability to find the "right" interpretation. That is your job.

Sometimes an actor will show up at an audition and appear to have all of the physical characteristics to be perfect for a specific role—perfect as you have visualized that particular character. Though this works occasionally, don't let superficial appearances determine character. Type is certainly important, but if the performer cannot be successful in the role, the approach is defeating.

The first auditions should produce a number of potential candidates for each role. **Callbacks** are generally needed to make final decisions, and spending more time and working with a larger section of the script should help identify the performers you want for the roles. Particularly for novice directors, try to find some measure of the talent's commitment to the project as casting decisions are narrowed down. If you sense hesitation or a condescending attitude from an actor, those feelings may become magnified when shooting commences. Inexperienced performers often do not understand exactly what they are getting themselves into; and if their maturity level is low, it can cause such problems as tardiness, a lack of concentration, and so on. Although someone's attitude cannot be dictated, commitment is simply a requirement of performance. Once filming has begun, disaffected talent are usually impossible to replace without starting over from scratch. Rather than struggle with a talented but balky actor, hiring a potentially less talented performer may make sense if that person is reliable and committed to the project.

Rehearsals Arranging as much time as possible for rehearsals is a good idea, but in reality they are rarely afforded as much time as the talent and the director would desire. It is not uncommon for a project to have no rehearsal time at all, particularly for actors with smaller roles. This is particularly true when actors work for free, as is often the case in independent projects. A stage play is often rehearsed for months before it is seen by the public. In film, however, actors must give a usable performance from the first day of shooting. Any rehearsal time is a bonus; but if none is

possible, be ready to start producing at a high level right from the start. When preshooting rehearsals are not feasible, set aside time on the set to walk through the entire scene before commencing to shoot. This gives the actors a sense of the shape of the scene prior to breaking it down into the individual pieces.

Location scouting Location scouts, all of whom have explicit descriptions of the features of desired environments, are responsible for finding a number of options for suitable settings for every scene. Familiarity with the script is generally required, although some location scouts are armed with only a list of needed locations and their desirable features. Once suitable possibilities are found, the director, the DP, and, in some instances, the PD will visit the locations and evaluate their visual and technical appeal. With the input of the DP and the designer, not to mention the financial people, the producer and the director make the final decisions.

Permission to use locations must then be secured. Public spaces require contacting the appropriate authorities; use of private property must also be authorized. Most states have film boards, and many large cities have a liaison to facilitate the needs of film- and video-makers in this regard. Cities where filming is common may require permits, location fees, and other guarantees. Insurance is required for many different eventualities. Security precautions may be stipulated as well. In smaller markets, local people are generally more enthusiastic about movies, often letting students and independents use locations for free. This can be a great opportunity unless something happens, such as damage to property or an accident resulting in injury, which makes liability an issue. Industry practice is to have all bases covered when shooting on-location—"owning" the location is the term used. The care for property and the placation of the people (and their neighbors) providing it are critical tasks, with a crew of **location managers** being key players in the logistics of location shooting.

Many young filmmakers are tempted to grab locations without prior permission, thinking they can be in and out before anyone knows they are there. This is a bad idea. The entire shoot is then spent looking over your shoulder to see if anyone is coming to throw you out. This atmosphere invariably colors how the scene is executed. If shooting is indeed completely disrupted, the consequences are not only failing to get the scene and needing to reshoot but also potentially alienating the local officials and individuals you may need to help you get your film done. Many communities have permanently removed the welcome mat for film crews, having had bitter experience with how productions can tax local resources and tempers.

Be honest with people about how long you expect shooting to take. Substantial sums are spent on commercial film projects to make the use of locations as simple and hassle-free as possible. Filmmakers with adequate budgets can simply clear everyone out and shoot in peace. For independents, shooting around the comings and goings of the rest of the world can be trying at best. Independents frequently find themselves relying on the kindness of strangers to let them use locations, particularly when public spaces or businesses such as restaurants or bars are needed. When a shoot that is sold as taking a couple of hours becomes an all-day ordeal, goodwill dissipates quickly.

Independents are often compelled to conform their needs to the vagaries of a convenient location, whereas commercial features can manipulate existing spaces to conform to their needs. A colleague tells the story of how he had a location scout scouring a city for a professor's office, with nothing left in the budget for location fees. After days of searching, the scout turned up at my friend's office with the news that he had found the best possible spot. They were standing in it. It was the best possible spot because the price was right—free. My friend was stuck with a location forced upon him rather than one that may have better suited his purposes.

Such are the decisions made in the independent world. For *The Long Goodbye* (1973), Robert Altman shot several scenes at his own beach house. Having a film

crew in your home is akin to having scouts set up camp in your living room for a week. Heavy dollies and lighting instruments, furniture rearranging, and the constant parade of crewmembers can take their toll on any space.

Building a set on a soundstage has many advantages; the biggest factor against it for independents is the cost of space rental and of the materials and the labor involved in construction. Despite the cost, studio work should be carefully considered. Extended work in a single location can become stressful, with the disruption to neighbors and local businesses becoming an increasing source of irritation.

The Production Crew

Most film crews are put together from scratch, with skill positions being filled from a pool of experienced freelancers. In the studio days, all crewmembers were in-house employees. The costume department may have been working on a half dozen films at a time. The music department had an in-house orchestra that worked hand in glove with composers, songwriters, and film editors. The grips were assigned to specific soundstages and worked on dozens of films per year.

Putting together a film crew today is somewhat akin to assembling an entire orchestra from scratch to perform an original composition one time. Many people have to be brought on board and their efforts coordinated toward achieving a common goal. Freelancers are known by their reputations and are sought out and hired for each new film. People who are fast, understand the needs of a set, and bring creative decision-making to their craft are always in demand. In many instances, being fast may be the most valued asset.

Many newcomers to the process are seduced by stories of people who have started at the top, but most people start in entry-level positions: production assistant, cable puller, or the new guy or gal on the grip crew. Some stay there; others slowly work their way up to positions in which they are most able to demonstrate their skills. Most successful professionals tell of how humbly they started and what they had to go through to get where they are. Movement within a department is clearly possible, but moving to different skill positions can be a challenge in Hollywood and related environments. Once pigeon-holed, it can be tough to break out. It is simply one of the great challenges of the field.

Established craftspeople frequently turn down work, whereas the newcomer struggles to get name recognition and to nail down a few paying jobs. It is the old Catch-22: you need proof of your ability to do good work, but no one will give you the opportunity to prove yourself without a list of credits. Newcomers often have to work for free to get recognition, although one should be wary of abuses. Film companies love to get this free labor, but newcomers should put strict limits on how many freebies they are willing to do. The more you work for free, the more people tend to take advantage. After two or three projects, if you have not proven your worth so that someone is willing to pay you, you may want to look for another company.

Crewmembers generally have no more job security than the project of the moment and the network of employers who know and trust their work. Freelancers have to handle deductions for things like taxes, Social Security, health insurance, and retirement on their own. All of the ramifications of being self-employed need consideration.

Team Spirit

Although sports metaphors can be irritating, team spirit is essential to making films. In the early 1960s, the *auteur theory* became popular in the United States. Derived from the writings of François Truffaut, Jean-Luc Godard, and other contributors to the influential French journal *Cahiers du Cinéma*, the major tenet was that the director is the "author" of the film, that is, the key motivating force in the creative

life of the work. Though the theory gave much-deserved attention to such directors as Alfred Hitchcock, Howard Hawks, and John Ford, it has led to a significant misunderstanding about the role of the support crewmembers. It would seem unnecessary to repeat the cliché that filmmaking is a collaborative art, except that few people outside of the industry truly understand what that means: every crewmember is faced with decisions large and small that contribute many elements to a film. If each person does not bring some measure of creativity to these decisions, the project as a whole will suffer.

Particularly in independent settings, the key to putting together a crew is to assemble a group that is basically compatible and, more important, committed to finishing the project. Little is more destructive than having people around who clearly want to be elsewhere, for whatever reason—be it immaturity, ignorance of their role, or other excuses for being unproductive. Film crews tend to be an amalgamation of iconoclasts and eccentrics, individualism and ego seemingly a necessary attribute to successfully staying in the field. Despite this, responsible crewmembers understand the need to move forward as a unified whole. They also do not make the mistake of overestimating or underestimating their contribution. Chronic complainers can poison the atmosphere on a set and make everyone wish they were somewhere else. If someone on the set does not want to be there, do yourself a favor and grant his or her wish.

A crew that is committed and harmonious is, of course, the ideal, although anyone remotely involved in the business has endless war stories about the stresses and the personal frictions that can occur. The creative process involves the clash of temperaments and visions that strong personalities bring to any venture. In addition, the amounts of money involved have become so astronomical that the whole enterprise can be suffused with the tensions produced by needing to get it right under intense pressure. I have been on sets where the bickering was constant. Despite this, the goal of producing the necessary material was never lost. Those who are unproductive or who hinder productivity need to be shown the door.

The crew is there to maximize efficiency. An inefficient set results in inadequate footage, leaving the editorial staff without enough material with which to work. In the final analysis, the crewmembers exist to relieve the director of some of the decision-making pressure. Crews that force the director to focus on minutiae are not doing their jobs. The director must be able to focus on the important issues: performance and the camera. This is a major concern for independents, with the overwhelming technical and logistical considerations, if unattended to, detracting from what is occurring in front of the camera.

The Crew's Responsibilities

What follows are brief descriptions of some of the key positions on a film crew. Feature films have many more credits not covered here, including guarantee companies, bonding agents, and assistants to the stars. Although these people are important players in making a commercial feature film, many independent shoots consist of just camera and sound, some talent, and a location. The job descriptions outlined here represent the skill positions needed during actual shooting. Although the duties of a number of positions may fall to a single individual on a small crew, all of these jobs must nevertheless be done. The effectiveness with which they are carried out has an impact on the overall quality of the work. For lack of an adequate crew, beginners may find themselves in the role of grip/boom operator/part-time script supervisor or some similarly outrageous combination. This much multitasking is discouraged, certainly, but it represents the reality of working with limited resources.

Although credits for contemporary films have grown to exaggerated lengths, they still do not encompass all of the people who work on a project. Crew sizes vary

but generally depend on how logistically ambitious the scene being shot is. A scene between two people in an easily manageable location takes a relatively small crew by feature film standards. Bigger scenes require hiring additional crewmembers, called *day players.* Carpenters, crowd control specialists, security guards, and a host of others may be needed for a few specific shots. Day players with specialized skills, such as Steadicam operators or animal handlers, get into the credits because they must market their specialty to other productions. Individual films have unique credits—for example, a horse wrangler in a western or a prosthetics person in a horror film. One film listed a pigeon wrangler, which might appear absurd except that whenever an element that is difficult to control has to perform on cue, professional services are a must.

As with performers, union rules often dictate the boundaries of a particular crewmember's responsibilities, with other crafts being barred from doing specific jobs. These rules occasionally seem ridiculous, but the delineation of responsibilities clarifies who does what; and when division of responsibility is not clear, important things can slip through the cracks. Time spent haggling over who is responsible for what on a set is better devoted to productive pursuits.

Most independent shoots are nonunion, and the boundaries often blur into a "let's pitch in and get it done" approach. The sound crew helping to strike the lights is unheard of on a union shoot but it is not uncommon with a small crew. As suggested, the parameters of some positions can be fluid even within union rules. The moment someone says "a director does this," someone else interjects his or her own experience with a slightly different crew structure. General responsibilities of crew positions are outlined in the following discussion, and significant deviations are considered where appropriate.

As suggested, crews are broken down into departments—the art department, the grip department, and so on. Three key positions—the sound mixer, the boom operator, and the script supervisor—and their crafts and responsibilities are explained in the appropriate chapters. Some of these roles have already been described, though a brief summary is in order. Editing personnel are discussed in part V.

The Producer's Team

The job of the **producer** is to shepherd a film from beginning to end, although that role can vary with the size and the complexity of the project. *Supervisor* is probably the best description, although the job can range from being a figurehead to being the pivotal go-to person in a film's entire life. Usually present from before the project starts to long after it ends, the producer ushers the film from its initiation all the way through to its editing, exhibition, and residual economic afterlife.

On the traditional Hollywood path, the producer is the major organizing and capitalizing force in preproduction. On commercials, however, the producer may also be the ad agency executive who developed the ad concept, and he or she may be a powerful presence on the set. The director in this situation may be a hireling whose sole job is to execute a highly developed storyboard. Although a film produced by George Lucas or Steven Spielberg may have as much of their individual imprint as that of the person who directed it, most producers are generally not involved in the day-to-day logistics of shooting except in a monitoring capacity.

Production Manager

As stated earlier, the *production manager* is responsible for initial budgeting and logistical planning and, once shooting starts, for managing the pragmatic aspects of a film's production. The PM also controls the production company's purse strings, approving most major cash expenditures. The PM works mostly out of the **production office,** the hub of communications for the entire shoot. Much of the work is

done in conjunction with the **assistant director (AD),** both being responsible for scheduling the daily operations of the crew. Although ADs are technically part of the producer's team, they work so closely with the director that their responsibilities are covered in that section.

Production management has been boiled down to a science of how most effectively to manage all of the disparate elements it takes to create a film. Any film can be broken down into manageable tasks. The PM analyzes the script and subdivides the individual scenes into elements needed for their execution. These elements include main players, locations, props, extras, vehicles, stunts, and anything else the script requires. The producer, the director, and, in particular, the AD help the PM devise the most efficient schedule for shooting the film. From this, they create a master plan in the form of a chart called the **production board** (see figure 4-8 on page 67 for a description). On union shoots, the PM must consider overtime, night shooting, remote locations, and other factors to minimize costly crew holdovers. The PM's goal is to maximize production resources while maintaining cost efficiency.

When scheduling shoots, particularly with exteriors, the weather and acts of God can make the PM's job demanding. Most PMs could probably write a dissertation on the accuracy of the weather-forecasting industry. When a shoot depends on such factors as weather, the production manager must consider which other scenes can be shot instead if the weather does not cooperate. The job is a constant juggling act, marshaling talent and resources to be at the right place at the right time.

A film I was involved with that was highly reliant on exteriors coincided with the rainiest month in the history of the film's location. This left intended locations flooded and made photographic matching of one day's shoot to the next difficult. Every rainy morning found the production manager scrambling to put together an interior shoot on obviously short notice. On overcast mornings, she had to consult the DP to see whether the light matched previously filmed scenes before she formulated a plan. She eventually ran out of alternative interiors to shoot, and it was still raining. Rather than keep the full crew standing by, we wrapped and then returned with a smaller crew once the weather cleared.

Craft Services

The notion that a film crew runs on its stomach is well worth remembering. Some directors can work a whole day without eating, running on nervous energy alone. Crewmembers' stomachs are not so forgiving. The student who gets all of the pieces of the puzzle into position but forgets to feed the crew is courting dissension and possible mutiny. Small amenities like coffee can make the difference between a productive crew and a snarly one.

The time and the expense involved in rounding up the required foodstuffs must be anticipated. Although this would never happen on a commercial shoot, time is not being spent wisely when the director has to stop somewhere before the shoot to get coffee and rolls for the rest of the crew. Someone who enjoys feeding other people may be interested in the job. Have this person poll the crew for any special dietary needs or preferences, such as vegetarianism. Get a sense of preferred beverages and provide as wide a range as possible. The crew is important, but the talent's needs should be particularly considered. A thirsty performer is one who is not focusing on the appropriate concerns.

The Director's Team

The people discussed here report to the director personally. Their major role is to take some of the pressure of the routine pragmatic decisions off of the director's shoulders. Although the director is one of the key forces in almost every phase

of a film's production, the extent of his or her involvement in postproduction depends on contractual obligations. In the golden age of the studios, after shooting concluded, many directors did not see the film again until it was on-screen. Contemporary directors generally have more power, though it is still a matter of the director's reputation. A director such as Woody Allen or Spike Lee is a strong presence in the editorial process; there are obviously others who cannot exert similar influence. Directors rarely do any actual cutting because it is so time-consuming and painstaking, but they will generally look at rough cuts of the film periodically and make suggestions.

First-time crewmembers are sometimes surprised at how unapproachable directors often are—some are brusque to the point of being rude. It was only when I started to direct that I understood this; the director has so many details to consider that it is not so much rudeness as simply the blinders of intense concentration.

There is a story of a famous director who was re-creating a World War II conflict over a river bridge. Because it was the only bridge for miles, he was able to use it for only one morning. In the frantic preparations on the day of the shoot, a battery of assistants buffeted him with questions to which he answered a perfunctory "yes," assuming that most details were inconsequential in the grand scheme of things. But when he was asked if all of the extras in the German uniforms were supposed to be on the near side of the bridge or the far side, he decided he had better stop and think for a moment.

Assistant Director, with Caveat

The caveat here is, as suggested, that on commercial productions the assistant director is actually part of the producer's team. While the collaboration is hopefully friendly, the AD's role is to keep the production on schedule and make sure everyone, including the director, is using time efficiently. The AD, however, is the director's right hand and is both the conduit and the buffer between the overwhelming technical preoccupations of the crew and the director's need to focus on performance, action, and camera. In many independents, the distinctions blur.

In the big picture, the AD is responsible for communicating with all of the departments, making sure the production is progressing. On independent and student shoots, he or she tends to be the director's point person. As suggested, the AD also works hand in hand with the production manager in scheduling all of the needed elements for each scene. A good AD often has a reputation for toughness, being the one who comes down on crewmembers who are not producing at the level or speed expected of them. "What are we waiting on here?" is a question often heard on the set, and it most frequently comes from the AD.

The critical question that the AD is always asking is "What is standing between us and the camera rolling?" Is it a camera thing? Are there some costume issues? Is it the lighting? Everything must be in position before the shot can be executed. A large part of filmmaking is problem solving, including the need to resolve pragmatic, technical, and aesthetic questions. The AD is in the thick of the battle.

The AD is responsible for letting the crew know what the next shot is and what is expected of them or else things can deteriorate quickly. The AD must also make the crew aware of upcoming shots. Much of the ability to anticipate needs is left to the initiative of the individual crewmembers and departments, but they must be told the essential blocking of the scene and the camera angles. The farther ahead that the departments can plan, the more prepared they can be for all eventualities.

However important the AD's communication with the crew is, it depends on the director's ability to communicate with the AD. A disorganized director leaves the AD impotent in terms of arranging for what is going to be shot next. The goal is always forward movement. When people are donating their time, which is often the

case on student and independent productions, it is crucial that their time be spent thoughtfully and productively. When the crew is paid, mounting costs are the issue.

Talent

It is probably not appropriate to lump the performers in with the rest of the crew. The role of the talent is not so much central to the technical aspects of creating the image as it is being the subject or focus of the image. They clearly exist for a much different purpose than everyone else. Despite this, how the actors interact with the rest of the crew is critical, mostly in the way the atmosphere on the set is conducive to the actor's best work.

Working with talent is one of the most challenging areas for the inexperienced director. The director's role is to guide the actors cooperatively in the evolution of an organic performance. In the best situation, this is a team effort in which the actor works out a suitable approach within the director's interpretation of the story. The most important thing a director can do is allow performers to find the characters on their own. This does not mean the director has no input or gives the actor complete freedom. If the director can create the conditions where trust is a given, talented actors will be able to find their characters. If young directors err, it is typically on the side of under-direction, leaving performers without firm footing in creating a consistent approach. Actors bring a tremendous amount to their roles, but it is the director's responsibility to help them shape a coherent performance.

The question is how to translate the words in the script into recognizable human behavior. What language does the director use to describe emotion? How is a response in the script qualified? If a character is told that the bank is going to foreclose on his home, what are the possible responses? Desperation? Passive acceptance? Rage? How many different ways can rage be expressed, and which is most appropriate for this character? Is it quiet steaming, uncontrolled yelling, or throwing things? Clearly, the choices are many, and each defines the character in a distinct way. Think of Orson Welles's *Citizen Kane* and the way the title character destroys his wife's room.

In the final analysis, the actor must be responsive to the director's interpretation of the role, although there is a rich history of conflict on this issue. Both theater and film abound with stories of actors who have their characters clearly thought out before the director is even on board or who have clashed with directors about interpretations. This sort of friction usually represents the actions of a professionally secure actor and can in many instances yield productive results. Despite attendant tensions, this does not diminish the need for directors to state their ideas forcefully.

The inability to pay actors often forces young, inexperienced directors into a marriage of convenience with young, inexperienced talent. Even though some young actors are as talented as established ones, they are still in the process of developing their craft, and as such their life experiences are often neither broad enough nor rich enough to offer thoughtful and compelling performances. One can tell when a performer is emulating the common stereotypes he or she thinks typify a specific group. Portrayal requires empathy, and empathy requires insight. When empathy is not present, acting takes on the character of impersonation. A performer must be capable of crawling inside the character's skin and creating visual signs of an inner life. Although the responsibility for an inorganic performance is usually laid at the actor's feet, it lies equally, if not more so, with the director.

Two key issues need to be addressed when working with either stage-trained or untrained performers. The first is the often remarked-upon difference between stage and film acting. On the stage, the performer has to act for audience members in the back row. If this is done in film, the performance will be too intense and overblown for the intimacy of the camera. Almost invariably, performers from stage

backgrounds are asked to give less; broad facial expressions and gestures must be made subtle so the performer does not "knock the camera over." Second, the pace of performances often looks much slower on-screen than when shooting; screen time is remarkable in how it makes normally timed events feel drawn out. To avoid slow sections on-screen, performances frequently need be delivered a little faster than what at first appears normal. You will often hear seasoned performers asked to "slow down," but one comes to find they are referring to the pauses between the lines. Slow delivery can draw scenes out to unbearable lengths. Chew on the pauses, not the words.

If possible, it is better to use professional talent for even the most peripheral roles. Inexperienced production crews often try to get friends, family members, or significant others to do small roles. This is generally a mistake. People unfamiliar with the process often don't understand the timing necessary to create shots that are appropriately paced. Talent who can take direction and perform peripheral actions in the same way every time minimize delays and allow the director to focus on foreground action.

During shooting, the number of people who are communicating with the talent should be limited. Sound problems should be funneled through the AD. Discussions of continuity problems should probably follow the same route. Although it has been suggested that the crew is there to take pressure off of the director, eventually you will realize that everything is there for the performers so they can do their job with as few distractions as possible. To a certain extent, the crew's major responsibility is to keep the chaos of the film set under control so that the actors can perform unhindered.

Production Assistants

Production assistants (PAs) do the general running around on the set and behind the scenes. They are responsible to the assistant director and as such are actually part of the producer's team. They do all of the inevitable last-minute tasks that arise. They can be made available to other departments, but only at the direction of the AD.

Although PAs are not pivotal players, the assistance they provide is indispensable. The position warrants discussion because it has traditionally been where many beginners get their start on crews. This is an excellent entry-level position in which you can gain a vantage point, albeit an active one, on the inner workings of a film crew. Be aware that in recent years beginners have been forced to compete with a growing pool of professional PAs. The position has evolved to the extent that an experienced and knowledgeable PA can be a valuable asset on a set.

The Camera Crew

In most commercial productions, the DP does not actually look through the camera as the shot is being executed; all actual shooting is done by a **camera operator**. The DP calls the composition and relies on the operator to execute the correct framing. This distinction between job descriptions is the product of union rules. International cinematographers who must conform to these working relationships often find them stifling. Nonetheless, the operator/DP relationship has become one that works relatively well.

The camera itself requires several highly skilled technicians. This crew is led by the **first assistant cameraperson (1st AC),** whose responsibility is the organization, handling, loading, transport, setup, maintenance, and cleaning of everything having to do with the film, the camera, and its lenses. This includes all tripods and other camera support equipment. Sometimes the grips will help, and additional

personnel will be brought in for complex setups involving cranes, aerial mounts, and the like.

Most projects employ a **second assistant cameraperson (2nd AC),** also referred to as the *clapper/loader.* The 2nd AC is responsible for marking the scene and loading magazines as well as filling out camera reports, preparing the film for the processing lab, and assisting the 1st AC. For a detailed explanation of the responsibilities of the camera assistants, see chapter 7\164.

On a set, the ACs constantly attend to the needs of the camera, going to seemingly fastidious extremes to make sure it is clean and operating properly. If you are working by yourself, it's up to you to take care of these concerns. Whether on your own or with a full crew, the camera is no small responsibility; if it does not perform as it should, you will not be successful. A commonly heard expression—ignoring the double negative—goes something like "If you ain't got the camera, you ain't got nothin.'"

The Director/DP Relationship

Many directors have a very clear concept of the photographic aspect of a film, in which case the DP is there to implement that vision. Other directors may hand over the entire visual approach of the film to the DP. In the first case, the DP still brings rich talent and experience to the visuals. Alfred Hitchcock had an extremely clear visual sense, yet you can see stylistic differences among his many cinematographers, particularly when looking at films shot by his longtime collaborator Robert Burks. The directors who turn responsibility for composition and lighting over to the DP (which is more often the case with contemporary than classic Hollywood directors) tend to see their role more as working with actors and story.

Few directors shoot their own films, a fact that surprises many newcomers until they understand the complex demands of both positions, each discipline requiring competing sensibilities. Despite their far-ranging responsibilities, directors must focus on the performance when the camera is rolling. Rather than watch the performance, DPs tend to treat the entire field of camera vision as an abstract space, focusing on the movement of form and shape. The DP who focuses on the talent may miss other elements in the frame, such as background movement, lighting problems, mic boom shadows, and so on. Though not mutually exclusive, each approach requires treating the frame in different ways. Shooting and directing at the same time is more common in commercials, where more attention is paid to each image and less to issues of performance, continuity, and marshaling the many resources that it takes to make a feature.

Grip/Electric

Outside of the ACs, the other major camera support crews fall into two distinct departments: grip and electric. These departments, often lumped together as *grip/electric,* work closely together on lighting, although the grip crew is also responsible for much of the rigging involving the camera, from dollies and tracks, to camera mounts on cars, to flags for lens flares. The **gaffer** is the head of the electric crew, and the **key grip** is the head of the grip crew, although the grips' work with the instruments is generally at the direction of the gaffer.

The gaffer is responsible for locating the sources of electricity and directing the setup of the instruments. The name comes from the hooks, resembling those used by fishermen, that old-time electric company workers used to climb poles. The **best boy** is the gaffer's right hand. A number of **electricians** fill out the crew.

The **grips** are the jacks-of-all-trades on a set. The name comes from the suitcases full of tools that the predecessors of today's generation of grips used to bring to the set every day. The skills needed by the grips range from basic carpentry and

metalworking to knot tying to just about everything under the sun. The grips are the great practical problem solvers on the set.

A gaffer I know likes to joke that the electricians are the forces of light and the grips are the forces of darkness. The electricians erect the instruments and "fire them up." The grips then cover the light, shaping and manipulating it to create the details and the shadows necessary for a complex image. The grips take care of everything in front of the instruments, and the gaffer and the electric crew take care of everything at and behind the instruments. If it is electric and produces light, the electricians do the work. If it needs rigging or is not electric and needs to be set on a stand—silks, flags, and so on—it's the grips' job.

Although the two crews work together on lighting, they have carefully delineated responsibilities. More than other positions, these distinctions tend to break down on small independent shoots. The people who are called grips on indies do just about everything conceivable. Having a few people around who can troubleshoot and rig setups will greatly expedite filming.

Art Department

The *art department* is technically aligned with the camera. The previously mentioned PD is responsible to the director but often works most closely with the DP. The PD is the nominal head of the art department, which is an umbrella for a wide range of skilled people. The key personnel responsible to the PD are those involved in the building and the decoration of the set or location.

The **art director** is an expert in materials and building and is responsible for executing the PD's plans. Carpenters, painters, and other specialists assist in the actual creation of the set. The **set decorator** plans the small items on the set, the details that make the space look realistic. The **set dresser** executes the set decorator's conceptions. Loosely associated with this group are the **costume designer,** the **props master,** the **hairstylists,** the **makeup** people, and everyone involved in the non-photographic content of the frame. On commercial features, each skill position has a battery of assistants.

Away from the comforts of the soundstage, most locations need extensive prepping. The art department generally works several days ahead of the shoot, dealing with painting, general layout of the space, and all things that need to happen before shooting can commence. Assistants are present during shooting to respond to the inevitable last-minute needs of the talent and the set. They are responsible for the myriad activities necessary to produce the kind of look that is desired.

Films vary dramatically in terms of how much the art department contributes to the process. A film with a contemporary setting that is shot largely in exteriors or on-location may require modest prepping, ranging from painting to hiding, cheating, or changing the elements that are present. On films that are design-heavy, particularly period pieces and futuristic or fantasy projects, the PD is on board early in preproduction and can have a substantial impact, participating in discussions with the director and the DP to determine a general approach to the look of the film.

All of the people who are part of the camera team are informally referred to as "picture people." There are many people on a set devoted to the picture, and their efforts and skills facilitate much of the character and the complexity of the image. They contribute to what is called the film's **production values**—a general term referring to the overall quality of the image. Films in which the sets are cheap and poorly lighted are said to have poor production values, the opposite being the film in which the image is appointed appropriately to the dramatic context of the material.

4

Previsualization

Armed with some basic principles, the next step is to formulate a strategy for shooting each individual scene. This strategy is largely the director's responsibility, although other craft positions will become involved. It can take a variety of forms: shooting scripts, shot lists, storyboards, and so on. Whatever form the strategy takes, the key is to be prepared. Although this will be amplified throughout this chapter, nothing sows the seeds of failure more effectively than not being mentally and organizationally ready to shoot a scene.

Preparation

A prepared director has planned the visual and dramatic approach to the day's work, including thinking out the blocking of the scene, the setups, the personality and the motivation of all of the characters, and the importance of the action within the larger context of the script. There are a number of ways to prepare a scene. You can plan each shot meticulously, including the exact framing and incorporation of all movement, or you can determine the rough parameters of the shots, intending to work out the finer points on the set. You can also come in armed with only a clear mental picture of the scene so long as that picture has been communicated to the key creative people. This latter approach is the mark of an experienced director; beginners should not attempt this. Whatever the method of preparation, a director should walk "on the floor" knowing the movements of all of the characters, where they should be when they deliver their lines, and how the camera is going to cover the script.

Maximum efficiency on the set is an important goal. In all but the most specialized circumstances, there is material from a script that must be accomplished—that is, a certain number of setups to be shot—and action to be covered. No matter how high the budget, you are always working with limited resources and time. On a practical level, a lack of organization causes lengthy delays, poorly communicated needs for props and technical setups, and frequent duplication of effort. The result is anxiety and tension on the set, inhibiting productivity in a way that usually shows in the final product. On a conceptual level, disorganization can indicate fundamental flaws in the way a director is shaping the visual approach to the material. An unprepared director tends to create scenes that are shapeless and paceless, with the internal logic—the logic of dramatic emphasis—clearly missing.

A certain case can be made for a spontaneous approach to filming, although that case tends to be both overstated and romanticized. In most instances, it is a

surefire way to create an uncuttable mess. Even films that appear informal are usually more planned than people realize. The simple fact is that a lack of preparation can be disastrous, particularly for inexperienced and independent directors. Independents often depend on the donation of time and materials from many people. Film schools abound with stories of talent or crew who left a project because they felt that their time was being wasted. Few things are more destructive to the morale on a set than crewmembers being forced to cool their collective heels while decisions that should have been made in advance are being pondered. These are particularly sticky issues for inexperienced directors because they are still learning the organizational skills needed to avoid such problems in the first place.

Methods of Previsualization

Being able to visualize a film in advance, to dream it out, is a difficult skill to develop. Although it may be easy to come up with great ideas for individual shots, planning an entire scene is a formidable challenge. Indeed, novice directors have a tendency to come to scenes with a few flashy shots thought out, lacking the connecting material to stitch the whole scene together. Line problems, lighting continuity, pacing issues, and a host of associated problems become apparent. Previsualization requires experience and knowledge of all of the things that do and do not work in specific situations. A number of important tools aid in previsualizing scenes, including overheads, storyboards, shot lists, and, to a lesser extent, shooting scripts. These tools also play an essential role in giving the appropriate crewmembers the information they need to do their jobs effectively.

These tools are invaluable in forming a strategy for covering the action. Presented with an action, what choices do you make to film it? If a character crosses a room, do you dolly or pan? Would planning a cut to a wider shot be a better strategy? If a character looks off-screen, an expectation is created of seeing what the character sees. Do you plan a cut to what is seen? Do you pan to it? An action can be uncomplicated—simply getting the character from one place to another—or it can be invested with all manner of figurative overtones, whether symbolic, metaphoric, or allegoric.

As the rationales for the following previsualization tools are being discussed, keep in mind that many scenes are shot with a single camera. This is done for a variety of reasons, most notably to avoid complications in lighting design and the expenses of extra cameras and crew. With the cost of producing a film so exorbitant, however, the preference for single-camera shooting has been changing. When it costs what it does to get a full crew on-location and to create the required look for a film, needing to go back for reshoots or missed shots may simply not be possible. Pressure to produce something cuttable increases, and a second or even third camera may ensure that enough material is generated. Despite this trend, the discussions here will stay with the still-prevalent single-camera model.

Overheads

Overheads—views of a scene from directly above—are the best starting place, being a good prelude to storyboarding. Draw an overhead of the location or set and start thinking about the movements of the characters as they go through actions or deliver dialogue, blocking the scene as though it were on a theatrical stage. In a best-of-all-possible-worlds situation, this blocking is developed with the actors in rehearsal. Once you have determined where the characters are going to be during the scene, you can devise a few setups. You can then start deciding what material from the script you want to be covering from each individual setup. Drawing a vertical line on a copy of the script to denote the material covered is a good method for cross-referencing setups against the dialogue and the action. For some directors

this is all that is needed for an organized approach to a scene, although moving on to storyboarding is highly recommended.

Once some basic setups are worked out, other things start to fall into place. You can work in some complicated shots, some atmosphere shots, and a variety of other effective options. You might eventually wind up discarding the original setups altogether, but at least there is a starting point from which to develop engaging ideas.

Overheads will also help you with the line. When looking at a scene from above, the line can be drawn, based on sightlines or direction of action, and a determination can be made about where to start shooting. Having this determined in advance can prevent getting worked into a corner.

One beginning filmmaker was shooting a scene in which he made a central mistake that could easily have been avoided with some forethought. The scene involved a conversation between a person in a kitchen and another seated on a couch across the room. **(SEE 4-1)** Without carefully considering the ramifications, the filmmaker began shooting the person on the couch from an apparently logical place—setup #1. When he began to shoot the second character, he had a problem. Setup #2 would have been the logical place for shooting the second character, but this would create a sightline mismatch. To preserve the line, he wound up shooting this part from setup #3. This left the actor's back to the camera as he turned to talk to the character on the couch, a solution that neither pleased the actor nor made much sense in the final product. To incorporate setup #2 and preserve the continuity of sightlines, the appropriate place to shoot the first character would have been from roughly setup #4. The best solution may have been to rearrange the space.

When a specific setup is logical or desired for a scene, such as setup #2 in the previous example, it can be drawn on the overhead; then the other setups can be determined in relation to it. A basic, conventional approach to shooting a scene should be easy to work out.

4-1

Overheads of scenes are helpful for blocking and determining camera setups and can be useful in identifying potential conceptual problems.

Storyboards

A **storyboard,** or simply *board,* has each shot drawn on one side of the page, with the script material it covers—dialogue, action, objects, and so on—on the other side. In a certain sense, it is the comic-book version of the film. A standard storyboard form will have room for three storyboard frames vertically down one side of the page, with room for the dialogue and the action on the other. Some commercial forms are quite elaborate, with space for camera directions, continuity notes, overheads, and whatever else is necessary. Computer software is available that can generate the forms, and many programs have clip art based on common framings. Creating a simple storyboard form by hand or on a computer is not complicated; all that is needed are three rectangles arranged down the side of a page.

A good starting place is to determine a limited number of camera setups on the overhead and apportion the action and the dialogue to those setups on the storyboard. Though this sounds similar to drawing vertical lines through the script, the storyboard gives the framing of the shots and the movement of the camera and the talent.

If six setups are envisioned, for example, you can start assigning lines and action to those specific cameras. If a line of dialogue is to be done in a medium shot (MS) from a particular camera angle, the storyboard would include a drawing of the character in an MS, including rough positioning against the background, with the dialogue to the side. If the shot includes camera movement, the storyboard would have representations of key framings, with arrows indicating direction of movement.

The storyboard draws out every shot, not just general positions or a few representative shots. It can represent an action as simple as the delivery of a line of dialogue or as complicated as the opening eight-minute shot from Robert Altman's *The Player* (1992), a shot that, if indeed it were storyboarded, could have had many drawn frames representing many of the specific points in the movement.

Storyboards can be formal, consisting of elaborate drawings indicating precise framing and movements. These are created according to the director's instructions and are usually the handiwork of a *storyboard artist* hired specifically for the purpose. Storyboards can also be exceedingly simple, with stick figures and crude line drawings to show rough positioning. Whatever the form, the purpose of the storyboard is the same: to previsualize and communicate the shooting strategy to the appropriate individuals.

Certain films demand scrupulous storyboarding, particularly those that employ extensive special effects. Robert Zemeckis's *Who Framed Roger Rabbit* (1988), with its carefully executed animation combined with live action, was storyboarded down to precise camera framing, character position, and even lens length. Some directors (Alfred Hitchcock is a famous example) have the entire film completely storyboarded before shooting a frame of film. Hitchcock used the storyboard like a blueprint for a building, seeing the actual shooting as a messy afterthought to the truly creative previsualization part of the process.

Shooting Scripts and Shot Lists

Initial scripts are relatively bare-bones affairs. Camera directions and the specifics of character movement are largely left to the discretion of the director. Once everything is determined in terms of camera and movement, the director puts together a detailed version of the script, called the **shooting script,** which is essentially an annotated version of the script, numbering the scenes for preparation and logging during shooting. This is not so much a previsualization tool as it is the result of previsualization, a formal version of the director's initial intentions.

The **shot list** is a less formal alternative to the storyboard. It lists brief written descriptions of the intended shots. Experienced directors frequently use the shot list because it is the minimum that will serve their purposes when, given their abilities to shape a scene, making a storyboard is unnecessary. For people who can visualize from it, a shot list can be as instructive as a storyboard.

A Typical Scene

If we take a simple script involving two characters as an example, these processes become clearer. **(SEE 4-2)** The numbers on the side of the heading denote the scene number from the shooting script.

The first step is to draw an overhead of the chosen location with rough positioning of talent. **(SEE 4-3)** A typical approach is to plan a master shot for the first several lines—setup #1. Medium shots of both characters are also conventional options for the ensuing dialogue, shooting John from setup #2 and Andrea from setup #3.

When the scene is storyboarded, the dialogue can be apportioned to the setups that have been devised. A potential storyboard, in this case, is a simple approach to shooting a few lines of dialogue. **(SEE 4-4)** The circled numbers in the upper right refer to the setup, although most storyboards do not cross-reference setups like this. The numbers on the left are scene numbers used to identify the location in the script. How they are generated is explained in chapter 7.

Although this is a simple example, with the shot being used as a vehicle for the dialogue, the same process that breaks this scene down in such a straightforward manner could be applied to more elaborate ends as well. If the goal were in a more expressive realm, the shots would differ but the same basic reasoning applies.

This method, of course, represents the basic style of scene breakdown that D. W. Griffith pioneered: the interrelationship of shots for dramatic emphasis. Although this approach can be highly effective, it can leave out subtle shadings and the active participation of the camera. It is a functional approach that values covering a scene, though some would argue that it has the potential to be dull. Many of the shots outlined in this approach can be a useful jumping-off point, even when a director intends some adventurous shooting. Although this

4-2

Sample script of a typical scene

4-3

Overhead of a typical scene

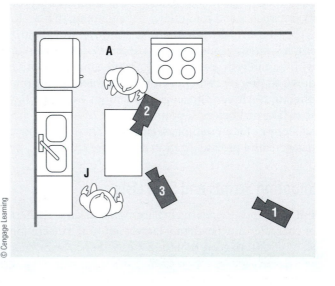

© Cengage Learning

4-4

Storyboard of a typical scene

approach may sound easy, it is difficult to make even the simplest of scenes work. Even the most conventional television product requires facility and experience to pull off.

Coverage

Shooting the action and the dialogue of a scene from more than one setup—called coverage—should always be built into the shooting plan. The initial storyboard examples may appear to suggest that lines in the script are shot from only one angle. This is not the case. Directors must direct the setups so that their vision shapes the material, but they generally shoot individual dialogue and action from at least a few different angles as well as cover longer portions of the script from the setups. This provides options in the editing room if there are any conceptual errors in the way the scene was shot.

In the most excessive variation of this approach, the director (and only a very insecure director would do this) shoots the material from almost every conceivable angle. The footage is then handed over to the editor with a simple "good luck" as the only guide. Editors hate this. It forces them into the position of redirecting the film. The idea of coverage should not deny the logic of using specific camera setups.

One first-time director, overcompensating for the coverage mistakes he had seen in his experience as an assistant editor, felt the necessity to shoot his scenes from just about every possible angle. Every time the principal shooting appeared to be over, he would think of one more angle that he absolutely had to have to edit the piece. The crew was looking for a noose and a sturdy tree. The director should shape the scene while still providing options.

You may have heard of the opposite extreme in which directors shoot specific parts of the script from one and only one angle, imposing ultimate control by not providing any options for the editors. Both Alfred Hitchcock and John Ford were

famous for maintaining this kind of tight control. Before you fall into what many call "the Hitchcock syndrome," however, be aware that both Hitchcock and Ford achieved this control of the expressive powers of cinema only after directing many films. Ford made dozens of shorts and routine action films, many now lost, before making any of the films that contributed so much to his reputation. In Hitchcock's case, with a few notable exceptions, his first 15 or so films are largely unremarkable.

Independents and students often attempt to conserve film to stay within minuscule budgets, forgoing some angles to maintain an arbitrary amount of footage allotted for a scene. This can sometimes lead to false savings. Missing key shots can diminish a scene's total effect. Although shooting must be economical, do not skimp on the necessary elements.

A Caveat

Preparing a script can be very methodical, but an increasing number of films appear overplanned and devoid of life—bland executions of meticulously thought-out storyboards. The shots in such films are machine engineered and factory assembled to the extent that they lose any semblance of being part of an organic whole.

Rather famously, one episodic television program was so meticulously planned that it required only about one month's work from its star player. The star was in the studio for a week or two to shoot all of the close-ups and medium shots for the entire season. The rest of the cast was called in, and all of the star's two-shots and masters were filmed. The star was then released, and the next several months were spent shooting the material for the rest of the cast. Thus, a shot of the star giving sage advice to a character may have had its reverse done weeks or even months later. Although the skills of the makers largely hid the approach, the result felt overcalculated.

Cautioning against overplanned films is important, but there is some danger of encouraging the opposite—completely spontaneous shooting, an approach that rarely yields fruitful results. There is a tendency among some beginners to regard previsualization as being overdetermined, somehow destroying the spontaneity of artistic creation. This perception can be a strong one. Marlene Dietrich was once reminiscing for a university audience about Orson Welles and his exceptional creative ability and vital imagination. Undoubtedly swept up in the moment, one questioner asked if Welles, being the instinctual genius that he was, ever stooped to working from storyboards and shooting scripts. After a stunned pause, Dietrich's response was a somewhat contemptuous "of course," which spoke volumes about the naïveté of the question. The notion that ideas just jump out of the brain straight onto the screen has occasioned more bad beginning films than any other single misconception. Clearly, some middle ground is required.

The storyboard is certainly a key previsualization tool, but it is not set in stone and should not intimidate thoughtful improvisation on the set. By the same token, any deviation from a well-thought-out game plan should be carefully considered in terms of how it will be integrated into everything else. After a long day, crews can get slaphappy and make decisions that at the time appear brilliant but later look ridiculous. Do not let yourself be put in a position in which wholesale changes occur because the shape of a scene as a whole can get lost. All changes must be weighed and carefully incorporated into the shooting plan.

Production Design and Costume

Although production design and costume are not by definition storyboard issues, their planning is often done at the same time or is included in the storyboarding process itself. The production designer—the person responsible for designing the

film's settings—will often use the storyboards as a guide to create sketches of the settings. These elements often come under the general heading of *decor,* which also includes props, makeup, and any other element that is part of the physical content of the frame.

German filmmakers of the 1920s are generally credited with the first significant explorations in the use of decor to create effect. In films such as F. W. Murnau's *Nosferatu* (1922) and Fritz Lang's *Metropolis* (1926), the directors investigated how external settings suggested or reflected internal states of mind. Both theater and painting have precedents for this kind of approach, and film's incorporation of many common devices from these traditions was inevitable.

Design for realistic films has a great deal to do with visual stereotypes—the way the viewer expects certain things to look. If a script calls for the establishment of an upscale home, certain elements can be used to create that effect. If the goal is to establish an isolated, dilapidated mountain cabin, other components can be incorporated to suggest that. The settings for a fantasy film may be more the creation of an imaginative designer, but even they are done within the context of what viewers expect, though some play against visual stereotypes, such as the seedy, rundown futures of Ridley Scott's *Alien* (1979) and Terry Gilliam's *Brazil* (1985).

Production design can range from the relatively simple to the costly and complex. Martin Scorsese's Hugo is a classic example of a wonderfully design-heavy film. The cluttered decor with the officious clerk looming over the children aids in the great fantasy elements of the film **(SEE 4-5)**. The designer Ken Adams's work on the early James Bond films both influenced and was influenced by modern design. Looking back at these films, one realizes that the novelty of their look was a substantial part of their appeal.

Visual environment helps define character. A messy, cluttered environment tends to establish similar traits in the character. The opposite is a very stark, empty environment as featured in films like Mary Harron's *American Psycho* (2000) and Woody Allen's *Interiors* (1978), both films about cold, emotionally empty people. **(SEE 4-6)** Clearly, many other elements contribute to the tone and the atmosphere of a scene. Color plays an important role, with scenes being conceived in a variety of emotional tones, from warm tones and cool tones to earth tones, and so on.

Another factor used to define character is costume. Emil Jannings's doorman in F. W. Murnau's *The Last Laugh* (1924) is an oft-cited example. When the doorman has his uniform, he is a proud and overbearing character; when he loses the

4-5

Strong production design elements play a major role in establishing the film's fantasy milieu.
Martin Scorsese's *Hugo* (2011), © Paramount.com

4-6

Visual environment can define character and context.
Mary Harron's *American Psycho* (2000), © Lionsgate Entertainment Inc. All rights reserved.

uniform, he becomes small and pitiful. A major contrast in Julie Dash's *Daughters of the Dust* (1991) is between the stiff and repressed country women and the independent city women. The country women are costumed in reserved darks and lights, with straight and harsh lines. The city women are dressed in cream colors, with decorative frills and fashionable hats.

Makeup is in a somewhat different category because its use is often purely functional, although many films employ makeup as either a major design element or for purposes of character definition. In either case the employment of makeup is never simple. Beginners do not usually have experience with makeup, a fact that leads to a variety of pitfalls when they attempt basic effects. Many makeup people come to film with a theatrical background, and it is important to realize that the kind of makeup performers need for an audience 20 to 100 feet away is vastly different from the kind needed for a camera that may view the talent in an extreme close-up. Good makeup people understand how the materials they use will photograph and how the proximity of the camera will represent their work.

These are just a few possibilities of what design can produce. A film can obviously go in many different directions in terms of decor. The key is that it has to go somewhere. If low-budget films have a common failing, it is that they frequently lack a consistent approach to visual style. Often this is both a decor and a camera matter and is also largely an economic reality. The personnel and the material for set design and decoration are frequently beyond the available resources. Low-budget films often get stuck in the locations that are available to them, shooting without the resources or the time to change things. Commercial features, as well as many other productions, spend great quantities of money to "own" their locations so that they can change whatever they want to achieve the desired effect.

Organization on the Set

Once preproduction is concluded, a film moves into **principal shooting**, the concentrated shooting schedule of the scenes. When preparing a film, it seems as if there are always things left undone prior to shooting. This is just the nature of the beast. Shooting can be seen as a series of tasks, replete with obstacles and rewards—all requiring a measured and thoughtful approach. It is almost impossible to anticipate all eventualities, but with experience comes the ability to visualize most potential problems and to take preemptive steps. It is essential to position yourself well. I always tell aspiring filmmakers that they can put themselves in a position where success is possible. Conversely, people can put themselves in a position where failure is not only possible but virtually guaranteed. Preproduction is where it all happens.

The preparation for shooting has become somewhat of a science. The following tools are useful in creating an order for shooting and determining the other practical aspects of daily activity on the set.

The Production Board

A key factor in creating an efficient approach to shooting is the **production board,** a representation of the scenes and all of the elements that the script requires—characters, props, vehicles, and the like. **(SEE 4-7)** All of the elements are listed down the vertical axis. The individual scenes themselves are listed or

arranged on strips across the horizontal axis, with needed elements being checked in the column underneath the scene. The scenes are put in the order in which the production manager foresees shooting them. Scenes—and indeed entire films— are not shot in chronological order; they are shot in the order that allows the crew to be most efficient. Script pages are broken down into eighths for logging and shooting.

Most production managers today use computer software designed specifically for the purpose, but in the old days the production board was a huge chart kept by the production manager (PM) in the production office. Each scene was on a long strip that was removed when the scene was completed. Whether on a wall or a computer, the production board dominates the film crew's efforts, being an overall flowchart detailing all of the elements, both human and material, needed to make a specific film. It is an ever-present entity, the visual record of how the shooting is proceeding.

As suggested in chapter 3, the major purpose of the board is to assist the PM and the assistant director in organizing the most efficient approach to shooting an entire film and in knowing at a glance what resources are needed for each scene.

4-7

The production board comprises long, removable strips representing individual scenes across the horizontal axis. All of the elements that the script requires are listed down the vertical axis.

Scene	8	49	37	9	34	78
Day/Night	N	N	D	N	N	D
Interior/Exterior	I	I	i	I	I	I
Location/Studio	L	L	L	L	L	L
Number of Pages	1⅞	⅜	6/8	1⅝	1⅛	⅞
Title: THE WOK	KITCHEN	KITCHEN	KITCHEN	THEATER	THEATER	THEATER
ANDREA MARTIN	X	X		X	X	
JOHN MARTIN	X		X	X	X	X
THEATER MANAGER				X	X	
PROJECTIONIST				X		X
CLEANING SUPPLIES	X		X			
WOK	X	X	X			
MONEY BELT W/BILLS				X		

All of the scenes to be shot at a specific location are grouped together, regardless of whether they occur close to each other in the narrative.

For example, both the beginning and the concluding scenes from Jonathan Demme's *Something Wild* take place in and just outside of the same New York City restaurant. In both scenes, the shots are similar, with only the lighting and the actors' wardrobes changing. One can presume that both scenes were shot in the same time frame. When the material from the first scene was completed, the same setups—with lighting and wardrobe changes—from the final scene were then done. Everything is organized to be both cost-efficient and logistically practical.

The production board starts as an apparently unwieldy mass of information. After each scene is completed, the corresponding strip is removed. As the film is shot, the board becomes smaller and smaller. The removal of the last strip usually occasions huge sighs of relief, wild partying, and submissions to exhaustion.

Storyboards and Organization

Storyboards are not only important conceptual tools but also valuable organizational tools. As a production board is used to organize an entire script, the storyboard (shot lists and other approaches work for this too) can be used to organize the crew's daily activities. Thus, sections of the script that are to be shot from a specific setup can be grouped together and shot at the same time. The scene can then be organized so that setups are shot in a sequence that makes sense for all departments, particularly the lighting crew. Relighting an area that has already been struck—that is, the equipment taken down and repositioned for the next setups—can cause lighting continuity problems no matter how carefully the plan is reconstructed. The cost of talent and extras is also an issue. The setups can be sequenced so that time with talent is efficiently used and there is as little duplication of effort as possible.

The storyboard can thus be interrelated with the idea of the shot list to produce a snapshot of a day's work. In addition, when the frame and its contents are essentially a matter of public record, individual departments can anticipate almost any need. This is true of both preproduction and daily shooting. Many productions post storyboard sheets in a prominent place, either in the production office or on the set, where the crew can consult them whenever needed. The camera department will know if specific camera mounts are needed. The lighting crew can be prepared to match color temperatures and respond to potential differences in the volumes of light if windows are in a shot of daytime interiors. Design and costume people can have everything prepared in advance. The props people can evaluate what is expected of them in terms of providing elements for each scene, and so on through the departments. The storyboard may not completely eliminate the need for consultation with responsible parties, but it does assist in individual initiative. The Coen brothers are a good example of a production team that posts the day's storyboards, and they are well regarded for their immaculately organized shoots. Their films reflect their careful and thoughtful approach.

Because the storyboard lays out how shots are supposed to be edited together sequentially, it is also of assistance to the script supervisor, who can be aware of which elements in the frame require attention. Novice directors are most frequently the culprits here, but little is more frustrating for a script supervisor than being unable to understand a director's ideas about how a scene is supposed to cut together.

The Lined Script

The **lined script** is a visual record of how a scene is being shot; it is the script supervisor's responsibility. Using a method similar to one for working out coverage in the script, the script supervisor will draw a vertical line through the dialogue and action that is being covered from a specific setup. **(SEE 4-8)** If you were covering the

4-8

The lined script, denoting setups, shot types, scene numbers, and often camera roll and footage numbers, is a visual summary of how a scene is being shot.

Interior. Kitchen. Night.

8A/Master

JOHN

I don't want to spend the evening at home. What do you want to do?

8B/MS
John

ANDREA

I should probably stay home. I've got a lot of work to do. What are you thinking about doing?

8C/MS
Andrea 8D/CU
Andrea

JOHN

(exasperated)

Anything. I just want to get out of here. Do you want to go to the movies?

ANDREA

I don't know. What times are the shows?

© Cengage Learning

first four lines of the script in the master, you would draw a line through those four lines of dialogue. If you were shooting everything except the first line in a medium shot from setup #2, a line would be drawn accordingly. If the last two lines were covered from setup #3, the appropriate line would be drawn. If you shot the fourth line in close-up, it would be marked as well. Different-colored pencils are used to denote the different types of shots—CU, MS, LS. Scene numbers are also listed on the lined script, with camera roll and footage numbers often recorded as well. There are many other potential markings on this version of the script, but the general idea is to show what material has been covered from what angle.

The lined script is indispensable for keeping track of how much coverage is being done. The director and the script supervisor can refer to it at any point to determine if the appropriate footage is being generated. As important as the lined script is on the set, it is also essential for the editorial staff. They use it to determine quickly if specific angles have been shot. For instance, if a close-up of a specific character would work well at a certain point in a scene, the lined script is first consulted to see if a close-up (CU) was shot. If the close-up was shot, the scene number will appear on the lined script. The editor will then consult the camera reports to find exactly where the shot is on the many rolls of film or to determine its location on the computer.

Production Forms

Sophisticated recordkeeping is necessary both in the production office and on the set. Over the years, the commercial film industry—and episodic television in particular—has developed production forms and notation sheets that help in the preparation and the shooting of scenes. The phrase "verbal orders don't go" applies here. With the myriad elements that must be in the right place at the right time, all instructions must be in writing. As with storyboard sheets, the forms suggested herein are available commercially; there are software programs that can generate them as well, and many can be found online. Although individual forms from different sources may vary somewhat in detail, they request the same basic information. Almost every department is expected to do some written recordkeeping, and only a few key forms are described here.

Budget forms Budgeting is essential to the creation of a workable shooting plan. A multitude of detailed forms list areas of potential cost. Many of these are nonissues for independents and students, though some costs are unavoidable, including those for raw stock, processing, printing or transferring, sound, finishing, and so on. Becoming familiar with the expenses that are easy to identify as well as those that are hidden will help avoid much painful recalculation down the road.

Script breakdown forms Prepared by the AD or the PM, script breakdown forms precede the production board and represent all of an individual scene's needs on a single sheet. The form is generally a grid, with each square requesting information about specific needs, such as cast, extras, props, wardrobe, special effects, animals, and so on. A modified version is often used in actual production.

Call sheets The responsibility of the AD, **call sheets** are just what the name implies: They inform the talent of when they must be on the set and how much time is given to makeup, hair, and the like. They also detail for crewmembers when they are supposed to be where, and what will be needed from them.

Continuity logs Continuity logs are kept by the script supervisor for records about specific elements in the frame. Some forms have an area for a rough sketch of the scene, but most require written information.

Script note forms Also filled out by the script supervisor during shooting, script note forms list all of the technical details of the shots, including f-stops, filtering, lens length, duration of the shot, and so on.

Although the specific materials for organizing a shoot will be unfamiliar to the beginner, you should make every effort to establish and maintain organized work habits. The tools discussed in this section should provide guidance. It is difficult to realistically communicate the kinds of pressures you will find on the set. Suffice it to say that shooting a scene with a full crew is an intense experience. It may seem as though chaos is but a short step away; but if you can keep it at arm's length, your time and efforts will be spent more productively.

Things will undoubtedly change on the set, no matter how carefully a shoot is planned. Unanticipated problems will require changes in some shots and will render others impossible. This is particularly true for beginners, who lack the experience to visualize every eventuality. Crewmembers who can look at any shooting situation, anticipate problems, and deal with them in advance are greatly valued resources. Part of learning is understanding how to anticipate problems.

Another Typical Scene

What kind of synthesis can be made from all of this information on shots, scene construction, and crews? It can be useful for beginners to take the backdoor approach to visualizing, organizing, and executing a scene: start with a scene in a finished film and work back to a storyboard. This gives a sense of what choices have been made in camera positions. It can also clarify issues of the 180-degree rule and allow speculation on some practical organizational principles.

Breaking down a scene in this fashion produces a clear idea of what is occurring visually in relationship to the dialogue and the action in the script. As always, the key words are *choice* and *strategy*. Creating overheads and storyboards facilitates planning the blocking of the scene, determining suitable setups, and apportioning the dialogue and the actions accordingly. Reviewing the idea of elements is helpful. A scene consists of elements that the director must decide how to photograph, thus determining what should be emphasized at what point.

One straightforward and exceptionally effective scene from Jonathan Demme's *Something Wild* is a good example of this. Set in a diner, the scene involves the film's three main characters, Charlie (Jeff Daniels), Lulu (Melanie Griffith), and Ray (Ray Liotta). Charlie is attempting to get Lulu away from Ray, an ex-con on a crime spree. Charlie uses the presence of several police officers sitting nearby to intimidate Ray. The film is from a script by E. Max Frye.

As you read the transcription of the dialogue, think about breaking down the scene into elements. **(SEE 4-9)** Who are the key characters, and what objects and actions are important to the scene? What are the potential setups?

What would be considered the elements of this scene? There are clearly five: Lulu, Charlie, Ray, the waitress (Darlene), and the police officers. The scene is thus an interrelationship of these five elements. What are some potential setups? The

4-9

Dialogue from the diner scene in *Something Wild*

90. INTERIOR. DINER. NIGHT. 90.

RAY
Uh, let me have the
"Rustler's Rhapsody."

DARLENE
"Rustler's Rhapsody."
Charlie enters from behind Ray.

CHARLIE
Just coffee for me . . . Darlene.
You don't mind, do you, Ray?

LULU
Charlie, you gotta be outta your mind.
You don't know what you're doing.

RAY
Charlie, you are one dumb son of a bitch.
I'm almost starting to like you, Charlie.

DARLENE
(entering with coffee)
Here ya go.

CHARLIE
Thanks, Darlene.
(to Ray)
I want Lulu.

RAY
Is that your name this week? Lulu?

LULU
Yes.

RAY
You know, Charlie, she's not going
to be too happy driving around in
a station wagon the rest of her life.
You better think about that. You better
ask yourself if you really want her.

(Continued on following page)

4-9

Dialogue from the diner scene in *Something Wild. (Continued)*

CHARLIE
I really want her.

RAY
Ahhhh.

LULU
Great.

RAY
Charlie, you gotta fight for
a woman like this.

CHARLIE
I don't have to fight you, Ray. I'm
gonna take Lulu and we're gonna
waltz right outta here and there's not
a damn thing you can do to stop me.

RAY
Ooh. Rrrrrr. Ha, ha. Oh, Charlie, you
are somethin'. You are somethin'.

CHARLIE
Take a look over there. Go ahead.
Evening, officer.

OFFICER
How's it goin'?

CHARLIE
Ray, you're a convicted felon. You're in
the possession of one, if not several,
concealed weapons. You robbed a
grocery store. You assaulted that
poor kid with a gun. You left the state
of Pennsylvania, which is gonna
come as a surprise to your parole
officer. And I'd be willing to wager
that that Cadillac of yours sitting out
in the parking lot, I bet it's hot.

LULU
Charlie!

CHARLIE
Now it's you with something to lose.

RAY
Fuck you.

LULU
He's got you, Ray.

RAY
Fuck you too, Lulu.

The police officer is joined by two others.

CHARLIE
Evening, officers.

OFFICER
How ya doin'?

CHARLIE
Oh, good, pretty good. Thank you.
(to Ray)
Hand over the car keys. Come
on, hand over the car keys.

LULU
Let's go.

RAY
You're going to regret this.

CHARLIE
Well, life's full of regrets.

RAY
No. You are really going to regret this.

CHARLIE
Now your wallet.

LULU
Charlie, come on.

RAY
You think you're pretty smart,
don't you, Charlie.

CHARLIE
Pretty smart. Well look, Ray, just
to show you there are no hard
feelings, this one's on me.
Charlie waves the check at Ray.
Charlie and Lulu exit.

CHARLIE
(to police)
Good night.

OFFICERS
Good night.

DARLENE
(giving Ray the check)
The gentleman said you'd
take care of this.

RAY
That son of a bitch.

entire action is presented from eight setups, at least until everything significantly changes when Charlie and Lulu exit. The first setup is the master shot, the starting point of all conventional scene breakdown. There are two over-the-shoulder (OTS) shots, one of Ray over Lulu's shoulder and one of Lulu and Charlie over Ray's shoulder. There are three close-ups of the key people: Lulu, Ray, and Charlie. There is one setup for Darlene and one setup for the police officers. The two setups covering the exit are described later.

Note the overhead. **(SEE 4-10)** The positioning of the cameras for the close-ups (setups #3, #5, and #6) is slightly misleading because the squashing of perspective and the out-of-focus background make it obvious that they were done using a longer lens, a telephoto, from roughly the positions of the OTS shots (setups #2 and #4). Even if they were done from precisely the same place as the OTS shots, the change of lens length marks them as different setups.

The scene is broken down in the following figure. **(SEE 4-11)** The ellipses (. . .) denote when a character's dialogue continues into the following shot. Pay attention to the way the shots break down in relation to the dialogue. How often are the

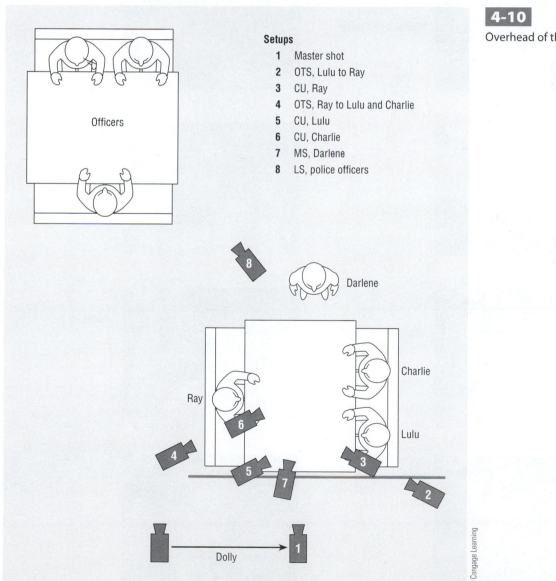

4-10

Overhead of the diner scene

Setups

1 Master shot
2 OTS, Lulu to Ray
3 CU, Ray
4 OTS, Ray to Lulu and Charlie
5 CU, Lulu
6 CU, Charlie
7 MS, Darlene
8 LS, police officers

Officers

Darlene

Charlie

Ray

Lulu

Dolly

4-11

Breakdown of the diner scene
Jonathan Demme's *Something Wild* (1986) © Photo courtesy of Bruce Mamer.

Dolly over

RAY

Uh, let me have the "Rustler's Rhapsody."

DARLENE

"Rustler's Rhapsody."

CHARLIE

Just coffee for me, Darlene.

You don't mind, do you, Ray?

LULU

Charlie, you gotta be outta your mind. You don't know what you're doing.

RAY

Charlie, …

… you are one dumb son of a bitch.

… I'm almost starting to like …

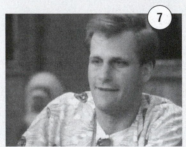

…you, Charlie.

DARLENE

Here ya go.

CHARLIE

Thanks, Darlene. I want Lulu.

RAY

Is that your name this week? Lulu?

LULU

Yes.

4-11

Breakdown of the diner scene *(continued)*

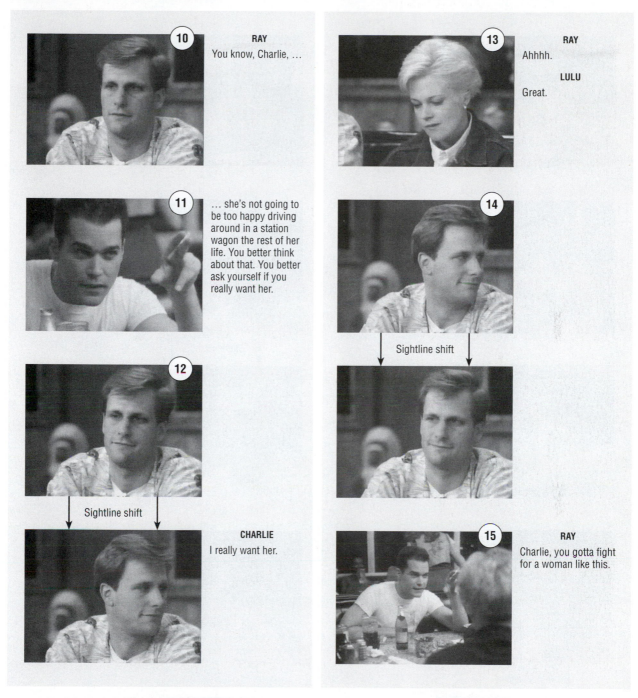

10

RAY
You know, Charlie, …

11

… she's not going to be too happy driving around in a station wagon the rest of her life. You better think about that. You better ask yourself if you really want her.

12

Sightline shift

CHARLIE
I really want her.

13

RAY
Ahhhh.

LULU
Great.

14

Sightline shift

15

RAY
Charlie, you gotta fight for a woman like this.

reaction shots done without any dialogue? Is the 180-degree rule observed? How are the setups used to play the climax of the scene? Are the setups used in a logical way that reflects the shape of the scene?

As suggested, the master is used sparingly—three times to be exact (shots 1, 32, and 43). The first (1) does exactly what a classic master is supposed to do: present all of the elements together. The police officer is shown seated as Charlie enters behind him. Then the camera dollies over to show Darlene taking dessert orders from Ray and Lulu.

4-11

Breakdown of the diner scene *(continued)*

16

CHARLIE
I don't have to fight you, Ray. I'm gonna take Lulu and we're gonna waltz right outta here and there's not a damn thing you can do to stop me.

17

RAY
Ooh. Rrrrr. Ha ha. Oh, Charlie, you are somethin'. You are somethin'.

18

CHARLIE
Take a look over there …

19

… Go ahead …

Sightline shift

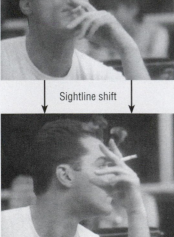

20

… Evening, officer.

OFFICER
How's it goin'?

21

Sightline shift

22

CHARLIE
Ray, you're a convicted felon. You're in the possession of one, if not several, concealed weapons. You robbed a grocery store. You assaulted that poor kid with a gun …

23

… You left the state of Pennsylvania, which is gonna come as a surprise to your parole officer …

4-11

Breakdown of the diner scene *(continued)*

(24) … and I'd be willing to wager that that Cadillac of yours sitting out in the parking lot, I bet it's hot.	(28) **RAY** Fuck you.
(25) **LULU** Charlie!	(29) **LULU** He's got you, Ray.
(26)	(30) **RAY** Fuck you too, Lulu.
(27) **CHARLIE** Now it's you with something to lose.	(31)

After the initial master, the scene quickly moves in for the medium shots and the close-ups. The first cuts are between the two OTS shots (setups #2 and #4). Close-ups are then used to present the basic elements at issue. Because the most intense part of the scene is yet to come, the cutting retreats back to mediums. Parameters of performance, such as the body language, are always key issues. One shot where Ray shakes his arms and hands to mock Charlie (17) clearly requires the medium shot. Although the logic of the scene may require an MS here anyway, it is clear that the MS is used to facilitate Liotta's striking performance.

4-11
Breakdown of the diner scene *(continued)*

32

CHARLIE
Evening, officers.

OFFICER
How ya doin'?

CHARLIE
Oh, good, pretty good.
Thank you …

33

… Hand over the
car keys …

34

… Come on, hand over
the car keys.

Sightline shift

35

36

Sightline shift

37

The most intense part of this scene, the climax, is when Ray swears at Charlie and Lulu. As expected, it is played entirely in close-ups (21–31). Immediately after this the scene cuts to the master shot (32) in which Charlie makes casual verbal contact with the police officers. Used in the middle of a scene like this, the master shot can act as a release valve for tensions that have built up. Both the intensity of a scene and the closeness to the subjects can be such that we literally need to back off. Although the comic content of this shot is also a factor, the placement of the master makes one almost feel oneself breathe a sigh of relief.

4-11

Breakdown of the diner scene *(continued)*

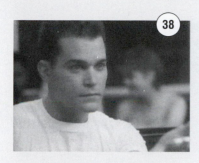

LULU
Let's go.

RAY
You think you're pretty smart, don't you, Charlie.

CHARLIE
Pretty smart …

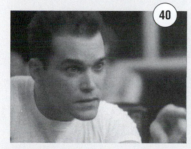

RAY
You're going to regret this.

CHARLIE
Well, life's full of regrets.

RAY
No. You are really going to regret this.

… Well look, Ray, just to show you there are no hard feelings, this one's on me.

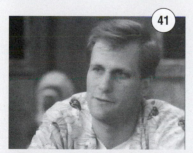

CHARLIE
Now your wallet.

LULU
Charlie, come on.

CHARLIE
Good night.

OFFICERS
Good night.

4-11

Breakdown of the diner scene *(continued)*

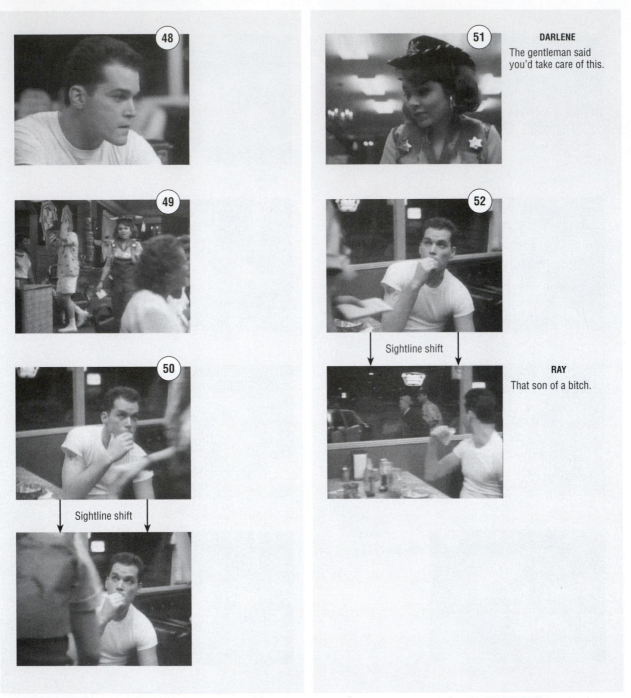

48

49

50

Sightline shift

51 **DARLENE**
The gentleman said
you'd take care of this.

52

Sightline shift

RAY
That son of a bitch.

Despite this brief respite, the scene maintains its intensity. It returns to a sequence of close-ups for the exchange of the keys and the wallet (33–42). As is so often the case, the master is also used to "bookend" the scene, although its final use (43) is somewhat before the end of the scene. Everything changes once Lulu and Charlie get up to leave (46). This requires two more camera positions. **(SEE 4-12)** Setup #9 is used just once (49) and is essentially a variation on the master shot. Setup #10 is used twice and has some significance in terms of the 180-degree rule.

4-12
Shooting the characters' exit
requires two more setups.

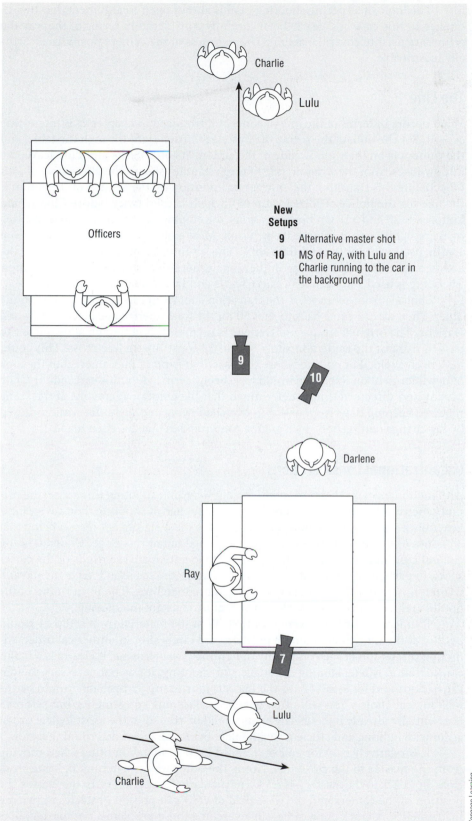

**New
Setups**

9 Alternative master shot

10 MS of Ray, with Lulu and
 Charlie running to the car in
 the background

The logic of a specific shooting plan is always open to argument, but the sequence in this case has clearly been carefully considered in terms of the way the setups are used to cover the action. The rightness of the camera positions is virtually inescapable.

The Line

What occurs in terms of the line (a concept introduced in chapter 2) is interesting as well. For the bulk of the scene, the line clearly runs right through the table, and the camera is on the window side of the action. When Charlie and Lulu leave, the line switches from the window side to the restaurant side in the alternative master (49). Before this transition the only camera position on the far side of the action is the one for the police officers (setup #8), which is used twice before Charlie and Lulu's exit (20 and 35). On both occasions, the employment of this setup is justified by Ray's sightline shift prior to its inclusion. Most editors would argue that the shot can be used without the sightline shift. The setup maintains the direction of the action and is lined up pointing in the same general direction as the other setups. The setup is used a third time (47) as Charlie and Lulu leave.

Shot 49, from setup #9, is the transition shot from one side of the line to the other. Then we can come back to shot 50 for the final interchange between Ray and Darlene. The original setup #7 of Darlene is used for this, although allowing her to pass in front of the camera in shots 50 and 52 constitutes a line cross. This could have been avoided by cutting before she passed in front of the camera, but the look of bewilderment on Ray's face would have been sacrificed. In this case, editor Craig McKay and director Demme determined that the emotional content of the scene required keeping Ray's response, thus overshadowing any slight dislocation caused by the change of direction. Such are the compromises that are often made.

Organizational Considerations

Although many considerations undoubtedly went into shooting this scene, the primary focus in the discussion here is on the sequence of shooting. For novices it is generally a good idea to shoot masters first, the most significant reason being that all issues of movement and continuity are ironed out at this stage. Understanding general continuity will allow all departments to anticipate the needs of the closer shots. In particular, the script supervisor can watch the scene and make mental and written notes about the details that will require matching. The positioning of the bottles and the plates on the table would require constant monitoring.

If indeed the masters were shot first, all of the material from setup #1 would be shot at the same time. Camera positions are rarely shot in numerical order. Although discussion of the complexity of lighting is yet to come, it clearly is a major consideration when planning a sequence for shooting. It was not necessary to light the background for setup #2 for the master; thus, setup #3 probably would be the next logical choice. You will often have to make some adjustments, but setup #3 is essentially already lighted. The shots would be filmed in the most logical order, again with lighting and efficiency with talent being the major determining factors.

It is relatively easy for an experienced crew to match lighting when moving from the master to the close-ups. Going the other way—matching lighting from close-ups back to the master—is tricky, particularly for beginners. In the master, the position of the camera and the wide field of view can present obstacles to placing instruments. A crack crew can easily overcome these problems, but master shots commonly require compromises in the lighting. It is essential to know what compromises must be made before lighting the closer material. Re-creating the lighting

from a close-up with an instrument repositioned to shoot the master can consume important time on the set as well as produce uneven results.

There are numerous other considerations. In the scene just analyzed, the tables undoubtedly had to be moved away from the wall to create space for the camera. Indeed, many things changed in the final setups (#9 and particularly #10), and time devoted to relighting is a key consideration. The inside of the restaurant needed to be lighted for the initial eight setups. When the whole thing turned in the other direction, the exterior of the restaurant became an issue, in terms of both the lighting and the control of elements in the parking lot. The last setup required an entire relight—a demanding, albeit common, occurrence. Shooting scripts or storyboards can be analyzed for significant shooting complications and the appropriate responses planned. Allowances for time, materials, and extra personnel can thus be made.

Another consideration is the scheduling of talent. The master shot usually requires the most bodies. Keeping and feeding extras is expensive, and the production office wants them cut loose as quickly as possible. The peripheral characters—the waitress and the police officers—also can be used in an efficient manner. For this reason, all of the shots requiring the most people are often shot at the beginning. Being able to dismiss the extras and the bit players in a timely manner reinforces the importance of organizing the sequence of shooting. A four-minute scene like this could easily have taken a day or two to shoot, and keeping all of the extra bodies around for the whole time would waste precious resources. The AD needs to know the direction of all of the shots in the scene, allowing him or her to identify which elements—characters, extras, and so on—are necessary and for how long. There is nothing like coming to a setup late in a shooting day and realizing that the appropriate elements are no longer available.

This scene represents the classic approach to scene breakdown at its best. Camera setups are devised, and the dialogue to be covered from each setup is determined. The scene is thus composed of an interrelationship of the different shots to emphasize the action and the responses—the dramatic emphasis. Though other approaches can be considered, the clarity achieved here is undeniable. This straightforward example may lead some to believe that the conventional approach is somehow easy. Nothing could be farther from the truth. The difficulties of creating a seamless scene can be understood only by trying to create one yourself. It takes the skill of many different people to make any scene work.

Part II
The Camera

5

The Camera Body

The Future of Film

The preponderance of motion picture film shot commercially these days is transferred to video and then posted in a digital environment. From there either it goes to a video finish with the option of a Digital Intermediate (DI) for creating film prints or data are generated during the edit for a return to the film negative. Returning to the negative is called *film matchback* (see chapter 9 for an extended discussion) and can be used to generate film prints or high-end transfers for a high-end video finish, although the latter is becoming less common. This section continues the focus on film cameras and shooting that was present in previous editions. This remains, after all, a film textbook, and many of the principles herein apply to videography, the basics of which are covered in chapter 8. Nonetheless, the great debate persists: film versus video, the chemical versus the electronic.

The buzz in the late 1990s was that the future was digital—that film was indeed finally dead. The days of independent filmmakers' struggling against overwhelming odds to raise the huge amounts of capital needed to shoot a project on film were over. Inexpensive digital cameras and desktop digital editing would spark an outpouring of digital features that would revolutionize not only the content and the delivery of the product but also the makeup of those who create the product. We would soon be inundated with smart, exciting out-of-the-Hollywood-mainstream digital features that were either beamed to digital theaters or available for download on the Internet. The nonmainstream part of this equation was, and still is, at least part silliness, and the exhibition aspect is finally coming to fruition. In fact, billions of feet of film continue to be shot every year, and film is still a player, albeit diminished, in theatrical presentation, although the revolution took a long time to materialize and has done so only in parts.

Why does the digital revolution in shooting at least remain at bay? If you think or try to remember the other analog technologies that appeared indispensable in 1980, why has film—almost alone—been able to hang on? The humble electric typewriter and the turntable make occasional appearances. Typeset printing, lithography, dial phones, cassette tapes, and many others have gone the way of the passenger pigeon. The economic downturn that started in July 2000 was probably the biggest culprit in the exhibition world. Theaters were particularly hard hit, with a number of major exhibitors filing for bankruptcy. An industry that is under significant financial pressure would be hard-pressed to make the massive investment required to retool its primary vehicle of delivery. With economic pressure and industry assistance, most theaters have been able to make the transition.

Smaller theaters and many international ones have been slower to follow along. One community theater in Minnesota did a donation-based fund drive to convert. Imagine having bake sales to go digital.

Despite ever-increasing pressure, film remains. I am perhaps overly fond of telling students that it was just over 35 years ago that I first heard someone predict with great certainty that film would be dead in five years. It was right at the beginning of what could be called the "second great video revolution": the widespread introduction of portable video gear and the ensuing transformation of the television news-gathering process from shooting on film to shooting on video. I was a film student chatting with television students and, with little hard information to support my argument, fell back on an impassioned defense of the beauty, subtlety, and power of the film image as an expressive tool. To a limited extent, it was a question of art versus information. Now the artistry of video has caught up, but it is still not, at least aesthetically, fundamentally better.

From the start of this second transformation, video was clearly going to knock film out of the box in everything from news to social service promos to political agitprop. This is not to say that video was not making—and is not continuing to make—great strides as an art form. But video was clearly going to have a complete lock on the information aspect of visual media. Why go to the expense of film for a product that would be solely disseminated on video? The question thus has remained the same since then: will the expressive quality of the film image allow it to coexist with video?

Over a quarter of a century later and in a new millennium, I find myself supplying the same answer. It seems that at roughly five-year intervals, I have been forced by some circumstance to reestablish my passion for the future of film. My favorite occasion was in the mid-1980s, when a colleague with a dubious agenda made the assertion to students that you couldn't even track down 16mm film stock any longer.

The over-the-top predictions about the demise of film were fueled by a lot of misinformation and inflated wishful thinking. A November 2000 article in the *New York Times* about George Lucas and his newest *Star Wars* epic was a good example of how the waters were being muddied. The article went overboard both in asserting the supremacy of new digital projection technology over film and in predicting the imminent demise of shooting and distributing on film. New digital video systems are getting results close to film, but they are dauntingly expensive. The price will come down, but the question of how much and when remains.

Several months later the *Times* printed a response from cinematographer John Bailey, who said that indeed digital cinema was going to make further inroads but that film would remain the medium of choice for projects that require the qualities of the film image. The choice between film and video would be project- and exhibition-specific. In reality, and as Bailey asserted, this has been clear from the outset. Either way, the argument refuses to die.

Another part of the problem is connecting with an audience. You can put a great movie on your Web site, but without expensive advertising only the most adventurous Web surfers are going to track it down. And then how do you recoup your costs? Advertising is one answer, but making the connections is tough for someone with no track record. Plus, people will go to great lengths to get their Internet content free of charge.

Connecting and profiting are difficult enough, but the fundamental flaw in the whole argument is that inexperienced makers with small cameras, inadequate support equipment, limited budgets, untested actors, and questionable directing abilities cannot really be expected to consistently create product that ranks with the great or even the average works of American and international cinema. This is a bitter truth. What the digital world sparked were hundreds of marginally watchable digital features with barely audible sound, awkward execution, poor pacing, and myriad other

technical and aesthetic problems. Certainly, there are wonderful exceptions, but the countless videos that are lying on dusty shelves while their owners wax philosophical about how much they learned from the experience vastly outnumber them.

Simply stated, much of the new digital work is undisciplined and devoid of the elements that frequently make commercial features (and my umbrella here is very big) successful entertainment experiences. We have this great democratizing technology, but technology does not make movies. People make movies, and the polished, engaging, consumer-friendly work is at least positioned within that West Coast firmament of distribution and exhibition.

Many will complain about conditioning and monopolistic practices, but typical commercial feature films remain seamless, involving experiences. Whether some people like it or not, this experience is still highly valued by the majority of the movie-going public. Keep in mind here that I am not talking about content, which many people from both ends of the political and artistic spectrum might in some instances find objectionable; I am talking about pure visual storytelling ability. And the fact that Hollywood produces such a small percentage of good films is not a function of lack of talent, lack of vision, or obeisance to perceived commercial requirements (although the latter two factors may in some limited sense have an impact). The reality is that making something good is incredibly difficult.

A great film or even a good one represents the confluence of so many disparate factors that it is simply going to happen with relative infrequency. And this is the way it is with every art form. All of the smart guys hanging around in bars berating the movie "hacks" need to get a life. Creating an aesthetically successful film starts to look more like chance than anything else. But remember the old saying: chance favors the well-prepared mind.

Despite claims to the contrary, the bottom line on the future of film may hearken back to my initial argument: that video has simply not achieved the qualities, the durability, and the versatility of the filmed image. Or if it has gotten close, it remains so expensive that one might as well shoot film anyway. When I embarked on the first edition of this book in 1992, a number of colleagues in the field wondered aloud why I would put so much effort toward a medium that had such a limited future. Well, the future continues unabated.

Granted, many of the democratic changes predicted above will eventually come to pass. When the talented individuals who rushed to make digital features get some experience and start making more-polished and engaging work, we will see some of the much-anticipated democratization. It would be nice to see more work coming from other arenas, but that is not going to happen until people learn the hard lessons of commercial features; that is, you need to create films that have good storytelling qualities, engaging performances, efficient pacing, and logical scene structure—in other words, films that have the elements that can involve and excite an audience.

Finally, there are two relatively mundane issues that seal the deal, if they are not the real reason behind it all. Film remains the archival medium of choice, and it is essentially format-change-proof. Long-term digital storage remains a question mark, and film has a great shelf life if stored properly. As for format, the highest resolution of video—used in 1080p or 1080i systems—is currently 1,080 vertical lines by 1,920 horizontal lines (the *p* stands for progressive scanning, and *i* stands for interlaced). It is great and looks wonderful, but there will inevitably be further developments, particularly in progressive scanning, in the never-ending quest to improve resolution. Will 2160p be next? Well, it is already here at least in shooting and editing. Then 4320p? What will happen to all the older shows done in 1080 with the advent of 2160p exhibition? The 1080 image bumped up to 2160p will have half as much information, resulting in a lower-quality image, and so on. Will interlaced continue to be supported? Whatever new format comes down the road, you will always be able to transfer film to it and extend any program's economic future.

Last but not least, film remains the only consistent element on the international scene. Different countries have different video systems, and the most cutting-edge

technologies may take awhile to get to developing nations. You can probably project a film in a community theater in the farthest reaches of the globe and, barring that, you can transfer film to even the most esoteric medium. In a greater backyard than just Hollywood, the engine fuels itself on people around the world seeing the product, and film is still well placed to serve that end.

Movement and Perception

In the late 1880s and early 1890s, Thomas Edison and W. L. K. Dickson produced what now constitutes the basic mechanism of the motion picture camera. The phenomenon that allows us to perceive a series of still images as a continuous representation of motion is based on the idea that the human eye will hold an image for a split second. For an example, look at a light bulb for a few seconds and then look away; the eye will hold the imprint of that bulb for a short period. When presented with a succession of images, each one making a momentary imprint, the eye blurs them into movement. The key to this process is that a person's view must be disrupted between the successive drawings or photographs. If not, all one will see is a complete blur.

Prior to the advent of motion pictures, inventors and tinkerers had perfected many contraptions that allowed people to perceive motion created from individual drawings of sequences of movement. Invented in the 1830s, the zoetrope is probably the most famous of these. **(SEE 5-1)** It was a simple drum on a turntable. The drum had vertical slits, spaced equally all around the drum. Individual drawings, each representing a sequential point in a simple movement, were placed around the edges of the inside of the drum. When the drum was rotated, viewers would look through the slots at the pictures on the far side of the drum. They would see one picture; then their view would be disrupted by the exterior of the drum. The next slot would allow them to see the next picture, and so on. When the drum was rotated at the correct rate, viewers would see the pictures as a continuous movement.

These experiments quite naturally began to incorporate the relatively new technology of still photography. The most famous early experiments were by Eadweard Muybridge. The story goes that Leland Stanford, then governor of California, bet a friend that there were times in a horse's gallop when none of the animal's four feet was touching the ground. Stanford hired Muybridge to test this hypothesis. In 1878 Muybridge set up an ingenious testing ground in which

5-1

The zoetrope, circa 1830, is an early example of simulating motion by viewing a series of individual drawings.

© Cengage Learning

he used still cameras with strings attached to their shutter releases. At brief intervals along a racetrack, he rigged a sequence of several dozen such cameras. As the horse ran by, the camera would take a picture of a discrete point of the horse's progress. When finished, Muybridge had a series of pictures, representing sequential points in the motion of a running horse. It was a simple matter to adapt these pictures to a zoetrope, and the result was a smooth representation of the horse's gallop—and Stanford's winning the bet. This is precisely what film is—a series of still photographs that, when presented in sequence, re-create movement. The only thing needed at that point was a more efficient way of capturing the image and a more sophisticated presentation device.

The technology to produce still photographs had existed since 1839, when Louis-Jacques-Mandé Daguerre introduced a device that could capture and transform light into a permanent image. The big step for motion pictures was to design both the equipment that could photograph a sequence of images and a medium on which those images could be recorded. Edison and Dickson were poised to provide a solution to the first requirement, and when George Eastman provided them with strip celluloid film, their problems were solved. Despite many design variations, what they invented more than a hundred years ago remains the basic film mechanism. It is a relatively simple device, not unlike a sewing machine, and filmmakers need a sophisticated understanding of how it works to get the desired images on film.

In the age of home video, many beginners have the expectation that the camera is just magically going to work. In film you find that it takes a measured and thoughtful approach to make the process work. And understanding the camera is the first step.

The Basic Mechanism

The fundamental mechanism that transports and exposes the film is made up of a small number of essential elements that are present in some form in virtually every camera. Their relatively simple interrelationship, what is called the camera's **action**, is the "how" of recording the images.

An illustration of a representative view of the interior of a camera is shown on the facing page. **(SEE 5-2)** Each of the elements plays a specific role. All cameras have a **film chamber**—the space in the camera where the unexposed film is stored. Many cameras employ a separate **magazine**, or *mag*, as the film chamber. The design pictured here will have a *cover plate*, or *lid*, that closes over the film chamber.

The feed spool and the take-up spool do what one would expect. The **feed spool** holds the unexposed film that you have bought from the manufacturer, referred to as **raw stock**. The **take-up spool** winds the film after it has been exposed. Both spools are mounted on spindles, the take-up being driven by the camera's motor. The feed spool turns as the film feeds off of it.

The **sprocketed rollers** feed the film into and out of the area where each image is exposed. Each roller has sprocket teeth that correspond to the **pitch**—the distance between the **sprocket holes**, or *perforations*, of the film; these rollers drive the film forward continuously. The two rollers are geared together so that they run at precisely the same speed: as the top roller is feeding the film in, the bottom roller is feeding it out. This is key because the rollers keep a consistent amount of film in the gate area. When the roller is viewed from the front, the sprocket teeth are on the edge of the roller toward the body of the camera, away from the side you would be looking at.

Although this two-roller configuration is quite common, some camera designs employ a single sprocketed roller that does double-duty—one side of the roller feeds the film in as the other feeds it out. **(SEE 5-3)** The CP-16 (*CP* stands for *Cinema Products*) is a good example of 16mm cameras with this approach.

Keepers do exactly what their name suggests: keep the film tight against the sprocketed rollers. Their sole function is to ensure that the film does not slip away from the rollers, which would throw off the whole system. They usually can and need

5-2

All of the parts shown here are important, but the real action occurs with the pull-down claw and the shutter.

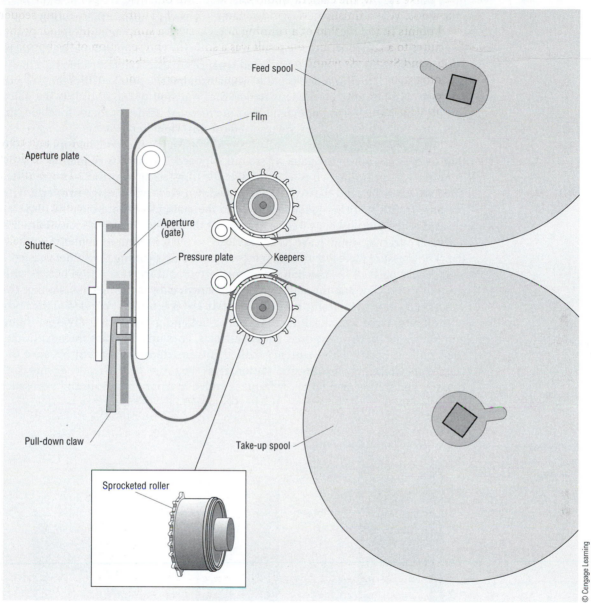

Feed spool

Film

Aperture plate

Aperture (gate)

Shutter

Pressure plate

Keepers

Pull-down claw

Take-up spool

Sprocketed roller

© Cengage Learning

5-3

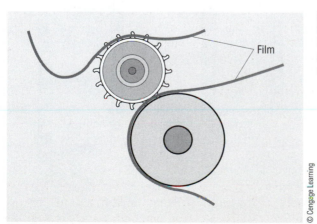

In a single-roller design, one side of the sprocketed roller feeds the film in as the other side feeds it out.

Film

© Cengage Learning

to be pivoted out of the way for loading and cleaning the camera. A spring-loaded pin (one that has a spring that pulls it back into position after it has been disengaged) locks them back in place. Forgetting to close the keepers can lead to camera jams and ruined film, although many cameras have safety features guarding against this mistake.

The **aperture**, usually referred to as the *gate*, is where each individual frame is exposed. Although the gate is a rather unassuming rectangular hole, it is a finely machined opening, and its care and maintenance are essential to producing a high-quality image. The **film plane** is not a mechanism but the point—the plane—where the light that has entered the lens strikes the emulsion of the film. It is the place toward which all efforts, hopes, and fears are directed. Issues of focus, focal length, exposure, and a host of others are resolved (or not) right here.

The **aperture plate**, also called the *film guide*, is the polished metal plate that guides the film to the gate, where it is exposed. The **pressure plate** is usually mounted on spring-loaded pins and holds the film flat against the aperture plate. The film must be held flat so that the pull-down claw will engage properly. The pressure from the spring-loaded pins is also the main force that holds the film stable as it is being exposed, as well as flat against the gate for uniform focus. Film has a natural curl that would leave its edges closer to the lens than its center if not held flat. The pressure plate is generally removable to make cleaning the camera easier.

These parts of the mechanism are important, but the real action occurs with the pull-down claw and the shutter. The **pull-down claw** is the mechanism that advances each individual frame for exposure. **(SEE 5-4)** It is usually recessed in the body of the camera and, when rolling film, comes out and grabs each individual frame and pulls it down to be exposed. It then retracts, goes up and grabs the next frame, then pulls it down. This sequence, called **intermittent movement** because the frames are alternately moving and stationary as they rush past the gate, occurs continually, and in this manner every frame is pulled in front of the gate and exposed.

5-4

The pull-down claw advances each frame of film for exposure.

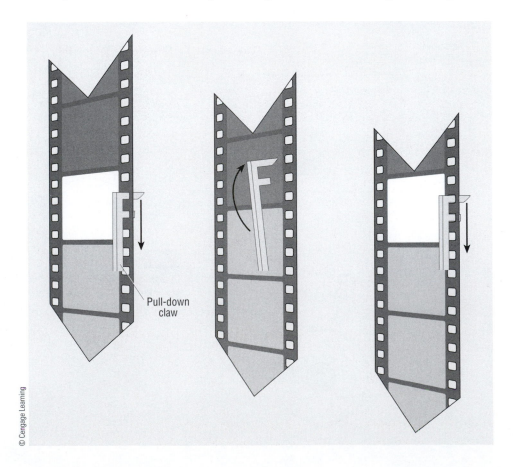

Pull-down claw

© Cengage Learning

The shutter is the other key element. As stated, both the production and the projection of the film image are based on disrupted vision. If there were nothing to block the light from the film as the pull-down claw advanced each frame, the image would blur because the film would be exposed while it was moving. The **shutter** is the necessary response to the action of the pull-down claw: it continuously rotates in front of the film, blocking the light while the film is moving and allowing the light to reach the film for the brief moment that it is stationary in front of the gate. Many cameras employ a half-disk–shaped shutter called a **half-moon shutter**. (SEE 5-5) In most designs the half-disk is actually slightly smaller than the 180 degrees of a half-circle. Other shutter designs are discussed later in this chapter in the context of viewing systems.

This is how each frame is brought to the gate for exposure. The pull-down claw brings a frame to the gate, and the shutter blocks the light as the frame is being moved into place. As the claw is going up to get the next frame, the current frame is exposed while it is stationary in front of the gate. All of the other elements in the basic mechanism support this simple action.

The **Latham's loops** are an idiosyncrasy of the film stock. Named after their discoverer, they are not really part of the basic mechanism of the motion picture camera but are so essential to the way the image is formed that they warrant equal consideration. It is apparent that the basic mechanism employs two different types of motion. There is both the continuous motion of the sprocketed rollers and the intermittent movement of the pull-down claw. There clearly has to be someplace for these two movements to be reconciled. That place is in the loops. When loading film, you form a small loop with the film both above and below the gate. These flexible loops are where the give-and-take of the two movements occurs. If you run a "dummy load" with the lid open, you will see the film "chattering" (vibrating slightly) on the top and the bottom.

With most cameras these loops are set at the start, and unless a malfunction occurs or the camera gets rough treatment, there should be little concern about "losing the loop." High-end professional cameras have ways of checking the loops between shots, and you will see them being checked with relative frequency. These loops are crucial to achieving a usable image. Most everyone has seen a projector lose the film loop, whether during a classroom film presentation or at a commercial theater. When this happens the image starts to blur vertically. Most projectors have a loop restorer, a lever that pushes the film back into the correct position; if not, someone has to stop the projector and reset the loops.

When the loop is lost, the film becomes taut between one of the rollers and the pressure plate. (SEE 5-6) As the illustration suggests, the camera usually loses

5-5

Many cameras employ a half-moon shutter, which is actually slightly less than 180 degrees of a circle.

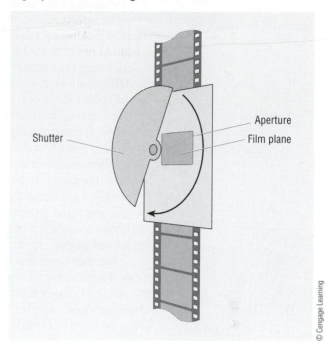

Shutter

Aperture

Film plane

© Cengage Learning

5-6

"Losing the loop" means that the film becomes taut between one of the rollers and the pressure plate.

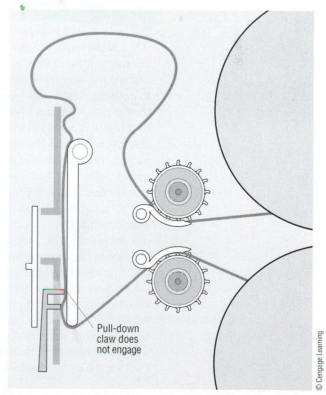

Pull-down claw does not engage

© Cengage Learning

the loop on the bottom, with the excess film collecting at the top. When this happens the pull-down claw is no longer engaging with the sprocket holes—it is striking the film between sprockets. Rather than being driven by the intermittent movement of the claw, the film is being driven by the continuous movement of the sprocketed rollers. It is thus moving while it is being exposed. This is what creates the blurring effect, which is most noticeable in the bright areas of the image. If a shot has fluorescent lights in it, for example, it will look like someone hung out the bed sheets.

Losing the loop in the projector can be easily corrected, but its loss while shooting is disastrous. The image is exposed while the film is moving, and the resulting blur is not correctable. Reshooting or abandoning the material is the only option. Experimental filmmakers have occasionally used footage with a lost loop to good effect, most notably in Bruce Baillie's *Castro Street* (1966). In most situations, however, it is undesirable.

Cameras do not lose the loop often, but when they do, the camera will usually sound different. Although it happens infrequently, you should nevertheless be constantly checking and guarding against losing the loop. The biggest culprit of lost loops is improper loading—one of the many reasons why learning proper loading technique is critical. Not closing the keepers is also a common loading mistake that causes lost loops.

Another cause can be the film's **plastic memory**. If the camera sits loaded and unused for an extended period (as little as half an hour), the film will conform to the shape in which it was left. When the camera is started again, that semi-rigid shape can cause the film to run through the mechanism poorly and lose the loop. A jar to the camera (which should always be avoided for obvious reasons) or flaws in the raw stock (which are almost nonexistent) can also create the problem. Another cause is camera malfunction, such as in the pull-down claw or the sprocketed-roller mechanisms. Such a malfunction would result from a serious mechanical breakdown and would occasion replacement of parts and thus major repair costs.

Two other design options are part of the basic mechanism on many cameras. A registration pin and an inching knob are not absolutely necessary but are generally desirable. The purpose of a **registration pin** is to hold the film absolutely steady as it is being exposed. It is usually below the film gate and, like the pull-down claw, extends out and engages a sprocket hole.

In the explanation of the basic mechanism, it is apparent that nothing is holding the film in place when it is being exposed except the force of the pressure plate and the friction of the movement. The pull-down claw has retracted and is going up to grab the next frame. All cameras hold the image reasonably stable, but the registration pin guarantees perfect **registration**—that the frame will be absolutely stable in the gate. The pin extends from the body of the camera and engages the sprocket hole as each individual frame is being exposed. It retracts as the next frame is being pulled down. Perfect registration is essential in many applications, including animation, shooting for transfer to video, and when the film is going to be blown up to a larger frame size or projected a long distance.

An **inching knob** is used to manually move the basic mechanism backward and forward. It is usually found on the exterior of the camera, though occasionally it is inside the film chamber (a design that can be annoying). The knob is helpful in loading because the mechanism can be advanced to ensure that the film is properly threaded (the pull-down claw and the sprocket teeth properly engaged and the loops correct). In cameras where the shutter can stop in a position that blocks the viewing system, the inching knob is particularly helpful in moving the shutter to enable you to see through the camera. In addition, it can be used to swing the shutter away from the gate to check for dirt and emulsion slivers and to roll film with the plastic memory effect out of the sprocketed rollers, thus avoiding problems with the loops. Inching knobs are essential parts of projectors as well.

Although both the registration pin and the inching knob are desirable, many fine cameras have neither of these features. The Bolex, for example, can produce an exceptional image but has neither a registration pin nor an inching knob.

Most basic technical mistakes with the camera occur because of a lack of knowledge about the camera's inner workings. In the age of video, when many people just pop in a cartridge and expect things to work, producing a film image takes careful attention to detail. It inevitably strikes the aspiring filmmaker that the aspects of film that ought to be simple (such as getting a usable image) are difficult and those that ought to be hard (such as being an artist) are nearly impossible.

As the mechanical age yields to the electronic age, there is nevertheless something irresistibly beautiful about the action of a well-designed camera. An understanding of the basic mechanism will serve both your ability to create images trouble-free and your awareness of film's possibilities. This appreciation not only enables you to know if a camera is malfunctioning but also allows you to understand any camera with which you might have to work. Comprehending what is going on inside a camera is also critical to understanding what can and cannot be accomplished visually. The deceptively straightforward task of making sure the camera operates correctly will always require your careful attention.

Frames per Second

Frames per second (fps), or the more general *frame rate,* refers to the number of individual frames being photographed each second. The professional frame rate is 24 fps; that is, 24 individual photographs are recorded per second. Many cameras come with several frame rates, with rates lower and higher than 24 used for fast- and slow-motion effects. **(SEE 5-7)** The standard rate for projection equipment is 24 fps as well.

Prior to the introduction of sound in the 1920s, films were shot at 16 fps—the minimum number of frames that could reproduce normal motion without the flicker created by a slow-moving shutter. The change to 24 fps occurred with the advent of sound. Sixteen fps, or more frequently 18 fps, has remained the amateur standard, although not much amateur film is still being shot.

Motors

Motion picture camera motors can be divided into two useful categories: synchronous (sync) and wild. A **synchronous (sync) motor**, also called a *crystal motor* and a *DC servo-controlled motor*, is a speed-controlled motor that produces a virtually perfect 24 fps. This allows sync-sound filming—shooting in which the actual location sound is recorded in sync with the image. Sound for film is recorded separately on conventional or digital audio equipment, and precision speeds are necessary for the two to run in sync. (See chapter 10 for a further discussion of the synchronization of sound and picture.)

A **wild motor**, on the other hand, will deviate slightly from the set frame rate. If set to run at 24 fps, the speed of a **wild camera** could vary a percentage point or two from a true 24 fps. Although this deviation would never be visible to the eye, the lack of precision makes later synchronization with sound virtually impossible. Wild cameras are used in situations where sound is not needed or, more commonly, when sound effects will be edited in later. They are used much more frequently than one might at first suspect.

Beyond this key distinction, two types of motors are in general use: electric and spring-wound. Electric motors are the standard, but spring-wound types still see use in the 16mm format. Cameras with spring-wound motors are by definition wild cameras. Sync-sound filming requires an electric motor, although not all

5-7

Film formats are distinctions based on the size of the film stock and the size of the image.
© Photo courtesy of Bruce Mamer.

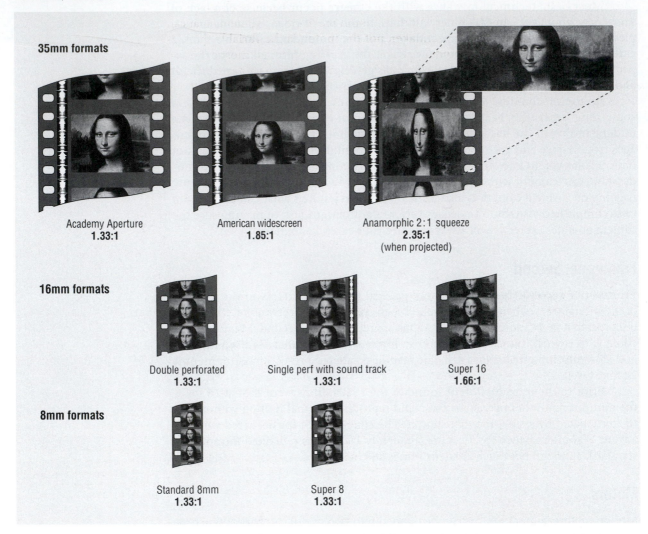

battery-operated cameras have crystal motors. Electric motors generally run on rechargeable nickel-cadmium batteries, referred to as **nicads**. Individual cameras have different voltage requirements, usually somewhere between 8 and 20 volts.

Spring-wound motors are driven by a spring similar to that found in a mechanical clock. A hand crank on the side of the camera is used to manually wind the spring tight. The camera is driven by the spring's releasing its pent-up energy. Winds generally last about 30 seconds when filming normal motion. The camera has a "governed" motor that allows it to run at a constant speed—it does not slow down as the spring gets to the end of its wind.

The major advantages of spring-wound motors are their low cost and their ability to be used in situations in which electricity, either for camera operation or battery recharging, is either unavailable or impractical. Prior to the days of portable battery-operated cameras, spring-wound cameras were used to shoot most location documentaries, particularly combat footage and exploration footage. Unless preventive measures are taken, batteries perform poorly in the cold, making the spring designs particularly helpful in frigid climates. The drawbacks to the spring-wound motor are limitations on shot length, the need for constant rewinding, and the inability to run at a perfectly controlled speed.

The humble spring-wound motor will appear to the young techie as a curiosity at best. Even ten years ago, I had a particularly wired-in student who loudly wondered if they were some kind of windup toy. Not undeserved, but keep your mind open. Out in the bush, as it were, many things are possible. Spring-wound cameras may appear old-fashioned, but they are still precision instruments that can produce stunning images. The filmmaker, not the motor, is the variable that determines whether the camera produces beautiful images. Although most everyone thinks in terms of dialogue scenes, the relatively high number of shots that do not require sync—having sound effects added later—is surprising. All this said, battery-operated cameras are the standard for professional use.

Once you step into sync shooting, you enter a world where costs limit access and where personnel demands call for a larger crew (sound mixer, boom operator, and others). A bare-bones 16mm sync **camera package** (camera, lenses, magazines, batteries, battery chargers, tripod, and any other camera needs specific to the shoot) rents for roughly $600 to $800 a day. Access to this high-end equipment can be limited, particularly in university film programs. For this reason and many others, initial projects are usually shot with wild cameras—even the occasional spring-wound types.

Formats

The term **format** refers to the size of the film stock and the size of the image. Two standard formats are in general use: 35mm and 16mm. A third format, **Super 8**, was introduced as an amateur standard in the early 1960s but, although after almost disappearing from the public imagination, has recently reappeared with some intriguing professional applications. It replaced Regular 8, a format in which you might find interesting archival material. Super 8 was a very robust format 30 years ago with a reasonable sophisticated support structure to produce at a relatively high level, but the introduction of home video pretty much relegated it to the back shelf. There have been occasional comebacks as a transfer-to-video source and it recently made some breakthroughs, with Kodak, in particular, being aggressive in making more film stocks available. Super 8 has made numerous unsuccessful feints at finding greater acceptance, so research it with care before committing. It does have the potential to be a great low-cost source.

Super 16 is an adaptation of the 16mm format. It has achieved wide use and will be covered after standard 16mm. A number of other formats, such as 65mm, IMAX, and so on, have highly specialized applications and are prohibitively expensive for students and independents. Despite this, the feature world remains interested: a recent film, Paul Anderson's *The Master* (2012), was shot primarily in 65mm, a somewhat throwback approach that occasioned much discussion. Anderson went into the deep end of the pool with a full film finish wanting to have final prints that did not reflect anything that went through a digital post process. A DI was struck to create general release prints, but film prints were screened wherever possible. There seems to be more of these throwback approaches, with a film like *The Artist* (2011) shot in the 4:3 aspect ratio to emulate early film practice.

The bigger of the two standard formats is 35mm. It demands a substantial budget in terms of both the stock itself and the equipment used to shoot it. A 16mm frame is roughly one-quarter the size of a 35mm frame. The frame's width-to-height relationship is called the **aspect ratio**. The 35mm film stocks have perforations on both sides of the film, referred to as **double perf**, or *two row*. The 16mm stocks are available in double perf as well as **single perf**, or *one row*, where sprocket holes are on only one side.

Beyond cost, the biggest difference among the formats is in image quality. The larger the frame, the more information contained and the more defined the image.

More definition aids in projectability and, of more importance recently, a higher-quality transfer to video. In a commercial theater, the projected image is as much as 300,000 times larger than the 35mm frame from which it originated. Because a 16mm image contains less information, it will not stand that kind of expansion without significant image deterioration. Anything smaller (like Super 8) would be a dim blur.

35mm

If you see a conventional movie projected at a commercial theater, odds are that it was shot on **35mm** film. Music videos and commercials are also frequently shot on 35mm, then transferred to video for editing and finishing. Cameras for 35mm are large and expensive to rent and require substantial technical support, in terms of both crew and equipment. The use of 35mm is difficult, though not impossible, for low-budget independents and virtually impossible for students.

The 35mm stocks have four individual sprocket holes per frame. The high number allows for gentler handling of the film in cameras and projectors, sparing a single perforation from supporting the entire bulk and weight of the larger frame size. It is difficult to think in terms of the weight of an individual frame, but the film is so flexible and is being moved at such a high speed that it needs as much stability as possible.

The aspect ratio for 35mm film is expressed as 1.33:1, meaning that the frame is four fields wide by three fields high. This is referred to as the *Academy Aperture*. The name derives from the standardized frame size and sound track configuration accepted by the Academy of Motion Picture Arts and Sciences shortly after the introduction of sound in 1927. The area to the left of the frame is for the sound track in final prints. This area also remains unused by the gate in the camera, though there are some applications in which the full frame is used.

In practice the Academy Aperture is frequently shot but rarely projected. It is usually masked in the projector to create widescreen. The masked image in **widescreen** has an aspect ratio of 1.85:1—almost two fields wide by one field high. This is the way most feature films are presented in commercial theaters. An even greater widescreen is the 2.35:1

Widescreen is close to the **high-definition television** (**HDTV**, *hi-def,* or just *HD*) frame, which has an aspect ratio of 16 × 9. This has led to a significant recent trend in 35mm shooting—the use of *3-perf,* which is also called *Super 35.* In this approach a specially modified camera dedicates only three perforations to each frame. The area devoted to sound on a conventional Academy Aperture is devoted to picture, and the total effect is a great savings in film stock and an aspect ratio that allows an almost full-image transfer to HD video. The 3-perf approach is having a big impact in television production. In addition to 3-perf, there is a small but growing movement toward shooting 2-perf, with each image occupying only the area of two perforations; 2-perf gives an aspect ratio of roughly 2.37:1, a popular shooting and exhibition configuration.

In the past, ratios larger than 1.85:1 were generally achieved with an *anamorphic* process. The film frame itself is the standard 35mm size (the image area is actually slightly larger than the Academy Aperture), but the anamorphic process uses a camera lens that squeezes the image, so it appears to be stretched vertically. It is then "unsqueezed" in projection. The best-known anamorphic process, CinemaScope, has a projection aspect ratio of 2.35:1. When shown on television, title sequences are often left squeezed so that the sides of the credits are not cut off, thus allowing the viewer to see this strange squeezed image. While some anamorphic is still shot, there are both film and video cameras that can emulate the anamorphic aspect ratio without the image-squeezing.

16mm

The **16mm** format is used in many independent film projects and in most inter-mediate and advanced film production classes. This is the format that can support, in terms of equipment and technical resources, a level of production that students both need to learn and can afford. The term *afford* is used advisably because using this format is still quite expensive.

The 16mm format was introduced in the 1920s and quickly became the ama-teur stock of choice. It took on greater significance with the rise of instructional filmmaking in the 1930s and 1940s and came to wide acceptance during World War II, when the majority of combat footage was shot with 16mm cameras. It has developed into a full-blown professional format in the years since, particularly in the Super 16 adaptation, though video has made a dent in its popularity.

The 16mm film stock has one sprocket hole per frame. The sprocket hole is right at the **frame line**, the hairline dividing one frame from another. The aspect ratio of 16mm is 1.33:1, four fields wide by three fields high.

Super 16

Super 16 is an adaptation of the 16mm format. It was introduced around 35 years ago to provide a better source for blowing 16mm up to 35mm for theatrical re-lease. While this remains an infrequent use, the Super 16 format has evolved into one of the primary shooting sources for transfer to HD. This approach has had a particularly big impact in episodic television, where a number of shows are using it. Many commercials and music videos are going this route as well. It is also get-ting more use in the feature world, with film shot on Super 16 being a good source for DIs.

For many years, it was a relatively common practice for independent projects to be shot in standard 16mm with the intention that there would be a blowup to 35mm for theatrical presentation. The drawback to this approach was that the dimensions of a 35mm widescreen frame are proportionally wider and shorter (1.85:1) than the 16mm frame (1.33:1, or 4 × 3). To transfer to 35mm, the top and the bottom of the 16mm composition were cropped off to conform to the part of the 35mm frame being used. This cropping dramatically reduced the already small amount of information available to create the 35mm image. Super 16 uses standard, single-perf 16mm stock and a modified 16mm camera. The area of the film that would be taken up by the second row of sprocket holes is used for ad-ditional image, producing a composition with roughly the same dimensions as widescreen 35mm. This substantially increases the amount information available for blowup.

Most newer production cameras are now designed specifically for Super 16. Older cameras would require extensive retooling, an approach that is generally not cost-effective unless you foresee doing a substantial amount of work in Super 16. To shoot Super 16, a camera would require a wider-than-normal gate as well as a mod-ified lens mount and viewing system. Given the expense of these modifications, an adaptation may be questionable.

Beginning filmmakers should keep in mind that the only reasons to shoot Super 16 are the two that have been suggested here. The first is when a blowup to 35mm is planned. Shooting Super 16 to finish in conventional 16mm would be counterproductive. In conventional 16mm the area of the second row of sprocket holes is eventually devoted to the sound track, meaning the elimination of an entire portion of the Super 16 frame. The DP's beautifully balanced compositions might suddenly look askew. The second reason for using Super 16 is as a source of visuals for HD. Shooting for HD has become the genesis of the majority of work produced on 16mm film.

Camera Loads

Raw stocks in 16mm can be purchased loaded in two different ways: on daylight spools and on cores. In 35mm, film is available only on core loads. Daylight spools and core loads each have advantages, although daylight spools are used more frequently on small projects, and core loads are the industry standard. Core loads are more complicated to use because they must be loaded in absolute darkness, usually in a **photographic darkroom bag**, often referred to as a *changing bag*.

Daylight Spools

Daylight spools are so named because they allow the camera to be loaded in the light. They have two black metal flanges on a core with a hollow center. **(SEE 5-8)** The side flanges protect the film from accidental exposure.

The flanges of a daylight spool are slightly farther apart than the actual width of the film to prevent the film from binding as it feeds off. So that light does not seep down into the center of the roll, the film is fed onto the spool with a reciprocal action. **(SEE 5-9)** One layer of film is fed against one flange of the daylight spool, then the film is shifted slightly to one side, and the next layer is fed against

5-8

Daylight spools allow a camera to be loaded in lighted conditions.

5-9

Reciprocally fed film on a daylight spool.

the other flange; the next layer is fed against the first flange, and so on. The outer layers of film prevent light from getting to the center of the roll during the loading process.

The 100-foot daylight spool, which runs for 2 minutes 40 seconds in normal filming for 16mm, is the most common for beginning projects. Daylight spools are generally used in smaller 16mm cameras, ones with the film chamber designed specifically for them. Daylight spools are also handy when working in remote locations or when just one or two shots are needed. Also available are 400-foot daylight spools, which run just under 11 minutes in 16mm, but their use has diminished in the years since video replaced film for shooting TV news. Television news photographers used to have to change film rolls on the fly, and daylight spools were convenient. Their major drawback is that they are noisy in a magazine. Several cameras have felt-lined interiors to deaden the sound, an approach that would appear to deserve wider acceptance except for the difficulty of keeping the cloth clean.

5-10

Camera loads use 2-inch cores, which have no flanges, necessitating the use of a photographic darkroom bag.
© Photo courtesy of Bruce Mamer.

Core Loads

Core-loaded raw stock is the norm in professional film applications. A **core** is a circular plastic piece on which the film is wound. Unlike the daylight spool, it has no flanges to protect the film, meaning that all **core loads** must be loaded in light-proof environment. In 16mm the most common size is the 400-foot load; 1,200-foot loads are available but are practical only in highly controlled situations due to the bulk and the extra weight of the attendant equipment. The 1,200-foot loads were once popular for formal interviewing situations, but so much of that type of application is now done on video that their use has diminished. Stock for 35mm is available in 400- and 1,000-foot loads, with the larger loads having more acceptance than in 16mm.

The cores themselves come in a variety of sizes and are also used extensively in the film editing process. **(SEE 5-10)** Camera loads use 2-inch cores, whereas most editing applications use 3-inch cores or larger. The 3-inch cores limit the stress on the inner layers of film, which is particularly important for sound stock. Labs generally wind processed film on 4-inch cores to eliminate as much stress as possible on the fragile emulsion.

Viewing Systems

The *viewing system* allows the cameraperson to view the image being filmed. Different makes of cameras employ different strategies to facilitate this, but two basic types are available: the rangefinder system and the reflex viewing system. With the rangefinder, the operator looks through a facsimile lens that is mounted on the side or the top of the camera. In the reflex system, you are actually looking through the camera's lens while filming. Cameras with some kind of reflex viewing system are the industry standard.

Rangefinders

Rangefinder viewing systems are found only on older cameras, but there are enough of them still around to warrant a brief discussion. The biggest drawback to the rangefinder system is that the framing the operator sees is not exactly what is being filmed. This can result in minor framing errors when the subject is some distance from the camera as well as major ones when the subject is close to the camera. This phenomenon is called **parallax**. A subject a long distance from the camera has enough room on either side that minor parallax differences are relatively unnoticeable. When the subject is closer to the camera, however, these difficulties are increased.

Most rangefinder cameras have some method of **parallax adjustment**, the control for which is found around the eyepiece. It manipulates a hinge with which the back of the viewing system can be swiveled either toward or away from the body of the camera to make the center of the viewer image the same as the center of the film image. The control knob is calibrated with the same numbers as on a focus ring. If filming a subject 8 feet away, a parallax adjustment set to 8 feet will give the same center point for both images. This strategy is clearly useful for simple images, but it breaks down with complex images incorporating camera/subject movement and multiple focus points.

Reflex Viewing

Reflex viewing systems employ several different strategies for diverting light to the camera operator's eye. All reflex viewing, also called *through-the-lens (TTL) viewing*, systems must be engineered with the camera shutter in mind. Either there is something in front or back of the shutter that diverts the light, or the shutter itself is part of the viewing system.

The Bolex employs a split-prism viewing system wherein a prism in front of the gate and the shutter diverts a percentage of the light up through the viewing system. The rest of the light continues unhindered to the film plane. Split prisms are an excellent viewing strategy with one minor drawback: the light diverted to the viewfinder reduces the amount of light that is exposing the film. Though the amount of light diverted is not large, it is enough that it must be compensated for in exposure. In low-light situations where you need all the light you can get, the lost light can be a significant complication. It also means that the light available to the viewfinder is sometimes insufficient. Viewfinders can be dim, occasionally making the framing difficult.

A second type of viewing system has achieved wider acceptance. It was introduced by Arriflex in the 1930s, and to this day the simplicity and the logic of the design remain a thing of beauty. The design employs a **mirrored butterfly shutter**—the shutter is shaped like a butterfly—with **front-surfaced mirrors** for "wings." As opposed to the vertical design of conventional shutters, this shutter is set at a 45-degree angle to the film plane. As it rotates, the shutter alternately allows light to reach the film plane or, via the mirrors, blocks light to the film and sends it to the viewing system, so there is no reduction of light in this system. **(SEE 5-11)** The shutter allows about 100 percent of the light to reach the film plane in exposure; then the same is diverted to the viewing system.

A word of caution: front-surfaced mirrors should be cleaned professionally. If you attempt to clean the mirror with a cloth or tissue, you may wipe off the mirror silver itself! Household mirrors are rear-surfaced mirrors: you look through glass to see your image. Minor distortion is not a problem in a household mirror, but in critical optics any distortion is unacceptable. With the mirror on the surface of the shutter, care must be taken that the surface is not damaged.

Viewing system with a rotating mirrored butterfly shutter, which alternately sends light to the film plane, and via its mirrors, sends light to the viewing system.

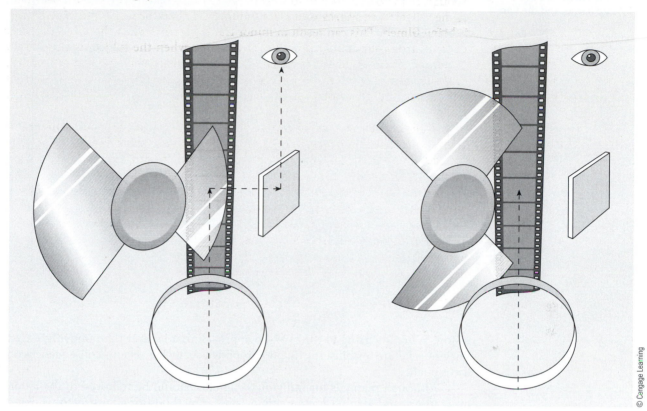

© Cengage Learning

Viewing Screens

As you look through the viewing system, you will see the viewing screen. **(SEE 5-12)** This screen is generally referred to as the **ground glass** and is mounted just above where the light is diverted by the shutter into the viewing system—adjacent to the butterfly shutter in that common design. The ground glass, also referred to as a **target**, has a series of markings that usually consist of crosshairs, the TV-safe frame, and the film frame itself. Most modern cameras have interchangeable ground glasses, offering academy aperture, Super 16, and other common framings. The **crosshairs** are right in the center and can be quite helpful in planning and executing movements. The **TV-safe frame** shows the boundaries that ensure appropriate framing when film is transferred to standard video, some of the edge areas of the film frame being lost in the transfer. Most professional cameras have some extra viewing room around the film frame so that you can see elements that are approaching the frame.

Diopters

All reflex viewing systems must be set to the operator's eye. This is achieved by setting the **diopter**—an adjustable glass element in the eyepiece. Every human eye is slightly different, and the diopter allows you to adjust the viewing system for the peculiarities of your eye to ensure as sharp an image as possible while shooting. Even two people with 20/20 vision need to set the diopter to the slight differences in their

5-12

The viewing screen usually displays crosshairs, the TV-safe frame, and the film frame.

© Cengage Learning

vision. When focusing to the eye—an approach that is rarer than one might first imagine—failure to adjust the diopter properly usually has serious consequences on focus quality.

Although manuals for individual cameras should be followed to the letter, most 16mm and 35mm cameras employ similar methods for adjusting the diopter. The control for the diopter is found on or near the eyepiece, and all diopters are set with the lens removed from the camera. The lens is a confusing factor because you are not setting the lens to your eye; you are setting the viewing system to your eye. The lens is set to the film. The diopter will have a setscrew or a locking ring for making adjustments. Most camera manufacturers recommend that you rotate the diopter until all of the framing aids are crisp and sharp. This includes crosshairs and any boundaries for the frame. Once they are perfectly focused, lock the setscrew or ring.

Once the diopter is set, you do not need to touch it again. The viewing system is set to your eye, and the process is complete. The focus ring on the lens will be used to focus each individual shot. Occasionally, people get confused about this and fiddle with the diopter during filming. This can be a recipe for disaster. Remember, you are setting the viewing system to your eye, not using it to focus on any one object.

The only caution on all of this is that the human eye can change during the course of a long day of shooting. Your eye can get fatigued, and as it tires, it actually changes shape. It is a good idea to check the diopter when you start to sense the strain of a long day.

Cameras

In terms of what is available, the range of camera types has consolidated considerably since the advent of video. Only a small number of companies have been able to weather the reduced demand. Although many amateur and off-brand cameras are no longer widely used due to age and peculiarity of design, a number of

16mm cameras have either held on or flourished: Arriflex, Aaton, Eclair, Bolex, Scoopic, and to a lesser extent, the Bell & Howell series. Many of these are no longer produced, but their durability and quality have kept them around and working, particularly in education programs. Production cameras in 35mm generally come from two companies: Arriflex and Panavision. This discussion focuses on 16mm cameras and the available choices. There was one Russian camera—the Krasnagorsk—that achieved some popularity around the turn of the century, but it has largely disappeared from view.

The first four cameras discussed are *wild*—that is, nonsync—cameras. All four have film chambers designed for daylight spools, although some models can be adapted for magazine use. **(SEE 5-13)** The Bolex and the Bell & Howell are springwound cameras. The Bolex is a finely engineered piece of equipment that has been the camera of choice for independent and nonsync professional work for many years. It is still being manufactured in Switzerland and a wide variety of accessories are available, including electric motors that can be mounted on the side. Bolex produced a number of advanced models, including sync cameras, but they have not weathered the digital storm.

The Bell & Howell was lovingly referred to as the "nail pounder," so named because it is so rugged that people said it could be used to drive in tent stakes (do not try it). It was designed to withstand situations in which tender treatment was difficult, such as when thrown off landing barges during World War II. The Bell & Howell is no longer produced, although many of them are still available and providing excellent results. Although verging on being a museum piece, the camera is,

Bolex Rex 5

Bell & Howell 70-DL

Arriflex S

Scoopic MS

5-13

Nonsync cameras generally use daylight spools, although some can be adapted for mag use.

© Photo courtesy of Bruce Mamer.

when found used, a good one for beginners. Both the Bolex and the Bell & Howell can be readily found on eBay for reasonable prices and are wonderful for testing and other initial efforts.

The Arriflex S (Arri S) and the Canon Scoopic are battery operated. Some models of the Scoopic and all Arri S cameras can accept magazines. The Arri S, there is also an Arri M that is similar, is the only one of these cameras that has a registration pin. This camera was the workhorse of the nonsync 16mm world and, although it is no longer manufactured, it produces high quality results, and is durable enough that it still shows up frequently in film programs and on eBay. Lenses are interchangeable, offering access to high quality optics. The Scoopic is specifically designed for easy handheld work and was used extensively in sports filming. Some models of Scoopics have motors that allow the camera to do sync sound, though they are generally too noisy and inflexible for critical applications. The camera has a fixed zoom lens that makes it a little less desirable. However, the Arriflex company remains a big player in the digital and film camera world. Again, eBay is a great source.

All five cameras in the next group are designed for sync-sound filming. **(SEE 5-14)** They are magazine-loading cameras with no room in the camera body for daylight spools, although they can be loaded in the magazines. The Eclair NPR, the Arriflex BL, and the CP-16 are no longer produced but are still commonly found

5-14

Sync cameras are magazine loading and are used for sync-sound filming.
© Photo courtesy of Bruce Mamer.

Eclair NPR

Arriflex BL

Arriflex 16SR 3
Photo courtesy of Arriflex Corporation

CP-16

Aaton ProdProfile 400
Photo courtesy of AbelCine-Tech, Inc.

in educational and media arts center situations. The Arriflex and Aaton companies produce state-of-the-art major production cameras and, as much as 16mm is used, currently get extensive use. Both companies also produce 35mm cameras and have high-end versions. Panavision is another player but it no longer offers a 16mm camera. Interestingly, Panavision does not produce cameras itself, but modifies existing cameras: they "Panavise" them, as the company likes to say. Panavision has been a major supplier to the high-end industry and presently have 35mm, 65mm, and digital cameras that are widely used.

The Eclair revolutionized the film industry in the late 1950s and 1960s. The camera's relatively light weight made it both portable and flexible enough to use in almost any situation, allowing it to go places a sync film camera had never gone before. For film history buffs, it was the camera that enabled the great cinéma vérité movement of that period. The NPR (and the BL as well) became the production cameras of the 1960s and 1970s. Both have registration pins and inching knobs.

Although the Eclair was a revolutionary handheld camera, it is a shoulder wrecker when compared with the modern Aaton and Arri models. Eclair also had a more portable camera, the ACL, but it is a camera that has a reputation for being finicky. The Arri BL has an extensive and bulky housing to make it noiseless. It was great on a tripod for lengthy interviews, and 1200-ft. magazines were available. It can be handheld for short periods, but impossible for extensive documentary work. The CP-16, the most portable and lightweight of the older cameras, was designed for television news filming, and it was equipped with a zoom lens of often dubious quality. Though it does not have a registration pin, it can provide excellent results if used intelligently.

The Arriflex SR was the camera designed to replace the BL, whose inflexible nature could not keep up with modern production practice. The SR was a beautiful example of engineering and design and was, along with the Aaton, the workhorse of 16mm production from its introduction in 1982 to its replacement by Arri's most recent addition, the Arriflex 416. **(SEE 5-15)** The 416 is designed for the Super 16 format and receives wide use in the industry. Many SRs are still in use, with the original, although it wasn't numbered, often referred to as the SR I. Arri improved on the original with the SR II and eventually the SR III, each having more features and a more sophisticated interface with video. The Arriflex company dates back to the 1930s, and its cameras have been widely used in both 16mm and 35mm and now digital.

The Aaton is less common in the United States but is considered by many to be the equal of the Arri. Their major 16mm production camera was the XTRProd, which has been replaced recently by the Xtera, a camera designed exclusively for Super 16 although usable in standard 16 mode. **(SEE 5-16)** Aaton also produced the A-Minima, a camera that attempts to emulate the best features of portable video cameras. It shoots 200-foot camera loads and is lightweight, designed to comfortably fit the hand. Kodak offers the 200-foot loads. The A-Minima is a marvel of lightweight film design.

The newest models of the Aaton and Arri cameras, including later versions of the SR, are capable of recording *time code*, the rolling-clock reference used in video (see chapter 9). They are all pin registered and either are factory-set or are adaptable to the Super 16 format. These last cameras are not affordable to the average user and are most frequently rental house items. The rental house will become a common stop the higher you get in the business, with cameras like the 416 renting in the neighborhood of $500 a day. And this is 16mm; hold onto your hat for 35mm.

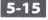

5-15

The Arriflex 416 Plus.
© ARRI Film & TV Services GmbH.

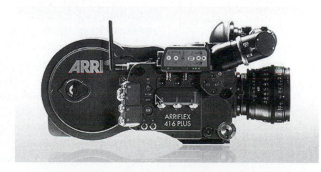

5-16

The Aaton Xtera and the A-Minima.
© Photo courtesy of AbelCineTec, Inc.

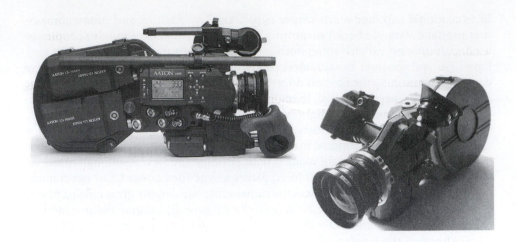

Get used to all of it and get used to creating a positive experience in the often high-dollar rental world. In other words, learn how to budget so you can pay your bills.

Basic Threading Procedures

Although the basic theory is consistent, threading procedures vary slightly from one camera to the next. Some models are relatively easy to thread, whereas others require a modicum of understanding and skill. A number of wild cameras have an **automatic-threading mechanism**, designed to feed the film unassisted. Most cameras, however, must be manually threaded. Wild cameras that employ daylight spools are covered here; tips for the more complicated magazines are discussed in chapter 8.

Very early in his career, a friend of mine was hired to shoot a high school football game, using a camera with which he was unfamiliar. He set the lens mount in the wrong position and shot the first half with the lens turret in front of the gate leaving the film unexposed. He figured it out for the second half, but when he later was complaining to a lab tech about his misfortune, the grizzled old guy's sole response was "Ya gotta know yer camera . . . Ya gotta know yer camera." Well folks: ya gotta know yer camera.

Finding a manual and following the instructions is the first step. Cameras often have either a printed diagram somewhere on the camera body or lines in the film chamber that indicate the threading path. These guides are indispensable, but the best way to learn about a camera is to be walked through it by someone with extensive experience. An hour or two with a person who really understands a specific camera can be an eye-opening experience on many counts. The following overview provides some basic tips.

All cameras are designed with as little excess space as possible in their film chambers. Space means bulk, and bulk means weight. There is precious little finger room, so keep the film chamber as free as possible, particularly by removing the take-up daylight spool.

On automatic-threading cameras, a small cutter in the film chamber is used to create an edge on the film. The film is fed into the top sprocketed roller as the camera is being run, the film thus feeding all the way through the mechanism. Automatic-threading cameras employ **loop setters**—small guards above and below the gate that create loops of the appropriate size and shape. The loop setters are closed for threading the film and open for shooting. Most cameras with this design have a release that automatically opens the loop setters when the cover plate

is in place. Some older models have loop setters that must be opened manually, a step that if forgotten will result in ruined film. The Bolex and the Scoopic are examples of cameras with automatic-threading mechanisms.

All other cameras must be threaded manually. This simply means opening the keepers and inserting the film, creating the loops, and threading the film in front of the pressure plate. Two major considerations are making sure that the loops are the correct size and that the sprocket holes of the film are engaged in the teeth of the rollers.

Making the loops just the right size is a requirement that may leave some people scratching their heads, but it should be clear on each individual camera. **(SEE 5-17)** The loops must not be so big that the top of the curve of film strikes the interior of the film chamber. Any contact brings with it the possibility of scratches on the film. Oversized loops may also cause poor registration because the film is bouncing off of the camera body as it is being exposed. The loops must not be so small, however, that they prevent the give-and-take between the continuous and intermittent movements.

Additionally, check to make sure that the sprocket holes are engaged in the teeth. This usually requires checking visually or gently pulling the film back and forth over the roller to ensure that it is engaged. Make sure the keepers are closed before proceeding.

Before putting on the cover plate, run the camera for two or three seconds to make sure all systems are working. Check the loops to ensure that both of them are the correct size and are holding their shape. Make sure the bottom daylight spool is taking up correctly. The take-up spool is usually the previous user's empty feed spool. Make sure it has not been pinched or otherwise damaged. If it has been pinched, the film will collect around the edges of the spool. Even if the film then seems to be falling onto the reel after passing the pinched section, you will have problems later—the film will be loose on the take-up reel, and the full 100 feet will not fit onto it; the camera will jam toward the end of the roll. When you take off the cover plate, it will be like opening a jack-in-the-box—the "accordioned" film popping out of the camera because it had no place to go.

Beyond being correctly threaded, the other major consideration in loading a camera is that as little film as possible be exposed to light. As in 35mm still photography, manufacturers make the rolls a little longer than their stated length to allow for some spoilage during loading. Footage that is exposed to light in the loading process is referred to as **light-struck**, and efforts are made to minimize the amount of film subjected to this effect. Daylight spools can be loaded in bright daylight, though this should be done only if absolutely necessary because you lose more film at the beginning.

Once you close the camera, use camera tape to cover all places where the camera body meets the cover plate. **Camera tape**, a 1-inch-wide opaque tape with an adhesive that does not leave a gummy residue, protects against **light leaks**—unwanted light striking the film, caused by any irregularities in the camera's tight-fitting junctions. Camera tape can be found at any film-supply company or rental house.

5-17

Interior of a Bell & Howell with correctly set loops.
© Photo courtesy of Bruce Mamer.

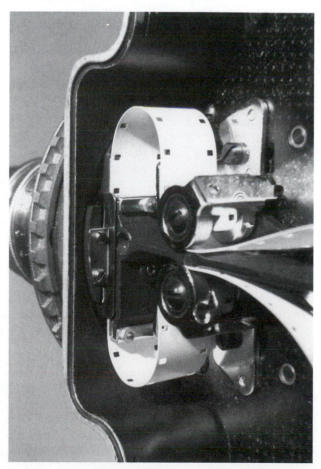

Light leaks can be a problem with any camera but particularly with older models, where constant use has weakened latches or metal seams. Light leaks can be responsible for minor occasional flaws or completely destroyed film—clearly a problem to be avoided regardless of severity. Leaks are not common, but compulsory taping follows the old maxim: an ounce of prevention is worth a pound of cure. It is far better to expend a few cents' worth of tape rather than risk having an undetected problem ruin the film.

Gaffer's tape is the same material as camera tape, only it is 2 inches wide. These tapes look similar to common silver duct tape, but no substitutes should be used. Any other tape, particularly duct tape, will leave a gummy residue or tear off the camera's exterior covering. The residue is particularly destructive because it attracts dirt that can eventually work its way into the camera. Gaffer's tape is a handy problem solver used by almost every member of a film crew.

Once the camera is closed and taped, it should be run for several seconds to get past the film that was light-struck in the loading process. This can be done with the assistance of the **footage counter**, also called the *gas gauge*, an indicator that keeps track of how much film has been shot. Some cameras have rolling numbers similar to the odometer on a car; others have a simple tension bar that rests on the film inside the film chamber, driving a gauge on the body of the magazine or camera. On cameras using daylight spools, the counter will often have some room beneath the zero point (negative footage numbers) so that the film can be run past the light-struck footage. This is called "running the camera to zero."

The following summary of the basic threading procedure may prove helpful.

1. Make sure the camera is wound or the battery attached.

2. If the camera has automatic threading, close the loop setters before threading the film.

3. On automatic-threading cameras, a small film cutter can usually be found just below the bottom loop setter in the film chamber. Use it to trim the front edge of the film. Insert the film in the top sprocketed roller with the trigger depressed—the camera running. When it feeds through to the bottom, stop the camera.

4. On manual-threading cameras, open the keepers and the pressure plate and insert the film. Make sure the sprocket holes of the film are engaged with the teeth of the sprocketed rollers. Once the film is properly inserted, close the keepers and the pressure plate.

5. Set up the bottom daylight spool for take-up.

6. Make sure that the loops are set as they should be—not too big and not too small. This will require opening the loop setter on automatic-threading cameras.

7. Check that the take-up reel is taking up correctly. If a daylight spool is pinched, the camera will jam later.

8. Close and tape the camera. Run the camera to the zero point so that you get past the light-struck film.

When you are **downloading**—unloading the film—greater care must be taken to avoid light-struck film. The reciprocal-feeding process described does not occur during take-up in the camera, and light can find its way deep into the spool, ruining many shots. Find a dark place or cover the camera with a heavy cloth. Do whatever you can to minimize contact with light. The last several shots on the roll will usually be ruined in downloading; if these shots are important to you, they can be saved by downloading in absolute darkness. You need to only take the reel out

and get it into its packaging; this is not difficult to accomplish because there is no unthreading involved. Finding a dark place may be the only obstacle. A friend tells the story of one shoot where he wanted to save every possible frame of the last shot on a roll. The only dark place he could find was the trunk of his car. His crew locked him in, and he emerged in a few moments with the carefully preserved roll. He was quite pleased with his inventiveness until the police arrived with guns drawn, demanding that the assembled crew "let the guy out of the trunk." Seeing only the first part of the action, an onlooker had assumed that some Jimmy Cagney–style mayhem was about to occur.

Develop good camera habits from the start. Beginners often get rushed and forget important procedures, then cross their fingers and just hope that the film turns out. Work toward eliminating luck as part of the equation. Shooting requires a measured and logical approach that takes all potential problems into consideration. Misthreading a camera is the most basic and destructive mistake that can be made. Ya gotta know yer camera.

Magazines

In the magazine (mag) design, the film chamber is separate from the camera. The magazine is loaded with film, then mounted on the camera. Core loads are used almost exclusively in magazines, although most mags can be adapted to use daylight spools.

Again, core loads require the use of a photographic darkroom bag. There are two styles of magazines in general use: front-to-back and coaxial.

Single and Dual Compartments

The front-to-back style of magazine is probably the most familiar, with some mags having a single compartment for feed and take-up and others having an individual compartment for each roll. Some versions of these, particularly older designs, resemble and are thus called "Mickey Mouse ears." The front-to-back approach has a front spindle that holds the feed roll and a rear spindle that holds the take-up. The film is fed out of the feed side and into the take-up side by means of a **light trap**, which guarantees that light will not penetrate the chamber. The front-to-back mag design has become less common in 16mm, although it is still used in a number of 35mm cameras.

In the front-to-back design, a loop of film is held out of the magazine to be threaded through the sprocketed rollers and the gate area. The inside of the camera itself has the basic mechanism without room for daylight spools. The sprocketed rollers of the camera drag the film through rollers in the magazine's light trap. The drawback to this method is that it can take some time to thread the camera. The CP-16 employs this design. **(SEE 5-18)**

A modification of the front-to-back design employs sprocketed rollers in the light trap instead of simple rollers. The sprocketed rollers transport the film out of and back into the magazine. The mag takes more time to change in the changing bag because the film must be threaded through both rollers, but the film has to be inserted only in front of the pressure plate in actual threading. The mag requires

5-18

The front-to-back magazine design employs a front chamber that holds the feed roll and a rear chamber that holds a take-up. CP-16 magazine / © Photo courtesy of Bruce Mamer.

This modification of the front-to-back design employs sprocketed rollers in the light trap.
Arri BL magazine / © Photo courtesy of Bruce Mamer.

more attention because the correct number of frames must be between the rollers to make the loops the right size. The Arriflex BL is the best-known 16mm camera employing this configuration. **(SEE 5-19)** There are two basic styles of magazine lids in the front-to-back design. One design hinges a front chamber and a rear chamber separately. In this style all that has to be done in the darkroom bag is get the film into the front chamber and fed through the light trap; lock the front compartment and you're done. The back can be set when you get out of the bag or when you are threading the camera.

The second style employs a single chamber. Most of these are called *displacement mags*, with a space-saving design in which, rather than devoting space for both rolls, the take-up displaces the feed roll during shooting. Having one compartment of course means that both feed and take-up must be threaded in the changing bag. If the film is not properly attached to the take-up core, the camera will jam quickly because there will soon be no place for the film to go. Tape is never used to attach the film because it attracts dirt and causes problems in the processing machines. You should put about an eighth-inch fold in the film that is slid into the core's slot. Threading this style of magazine can be somewhat intimidating at first, but it is easily mastered. The Arri BL magazine is a typical example of this design.

Coaxial

Most of the newer generation of cameras, particularly in 16mm, use the **coaxial** design with adjacent take-up and feed compartments. All of the elements that transport the film to the gate (sprocketed rollers, keepers, pressure plate, and room for loops) are in the magazine itself. The actual cameras themselves look quite odd because they comprise only a lens mount, a pull-down claw, a gate, and a viewing system attached to a motor. The main bulk of the camera comes when the magazine (and the lens) is attached. The Arriflex and Aaton cameras as well as the older Eclair NPR and ACL are examples of 16mm cameras that use this design.

With the coaxial design, the film must be loaded and threaded through the magazine's first set of sprocketed rollers in the changing bag, but the rest can be done in the light of day. When you emerge from the bag, the film will be threaded out the front of the magazine on top of the pressure plate. It is then fed in at the bottom of the pressure plate to the bottom sprocketed roller. You will have to leave out enough film to form the loops; every camera has a specific number of frames that must be left out. These frames are then pushed back into the magazine both above and below the pressure plate. The only nerve-racking aspect of this magazine is that the loops on some designs are hidden behind a facing plate, where you cannot see or test them.

The beauty of the coaxial design is that, once loaded, it is easy to change magazines. When a roll runs out, you pop off the magazine and pop on the next one. The change should take a second or two, whereas conventional magazines can take several minutes. Camera assistants are responsible for making sure that there is always a fresh magazine at the ready.

Magazines and magazine loading with core loads are the standard industry approach. Daylight spools are handy for quick-and-dirty shooting or when you have just a few shots to get, but their drawbacks—noise, weight, and short length—generally exclude them from most professional applications. To facilitate

fast changeovers, camera packages should include two or more magazines, which should be numbered or otherwise identified in case problems show up when the film is processed.

5-20

Frame rate determines the number of frames photographed per second.

Camera Options

Two important options that allow filmmakers to manipulate time relationships are available on many cameras: variable frame rates and single framing.

Variable Frame Rates

As mentioned earlier, many cameras come with the capability to vary the frame rate. **(SEE 5-20)** Continuous running at frame rates other than 24 fps yields either slow-motion or fast-motion effects. Some cameras, like the Bolex, have a dial or switch that gives a number of relatively common options. Other cameras, particularly certain Arriflex models, have a rheostat that lets you dial to the rate you want.

The following statement may at first appear contradictory: faster frame rates (36, 48, 64, etc.) produce slow-motion shots, and slower frame rates (9, 12, 16, etc.) produce fast-motion shots. The key to understanding this is remembering that all projectors run at 24 fps. If you record 48 frames in 1 second and project that same piece at 24 fps, what took 1 second to shoot is going to take 2 seconds to project. Time is expanded, so 48 fps makes the action twice as long. Conversely, if you shoot at 12 fps, the material that is filmed in 2 seconds is presented in 1 second. In this case, the time is collapsed. **(SEE 5-21)**

5-21

Shooting time versus projection time.

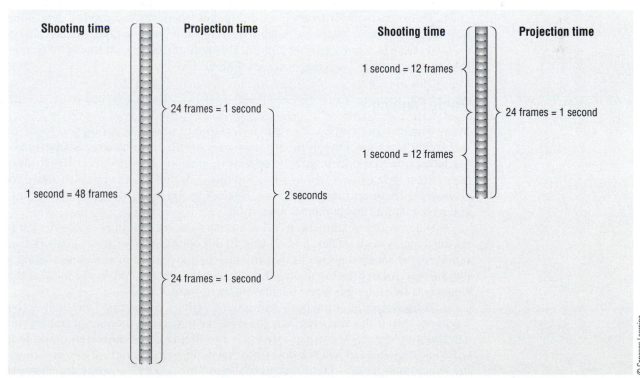

There are two considerations you should be aware of when creating motion effects. The first is that you should never run a camera empty at speeds greater than 24 fps. The claw is designed to go out and engage a sprocket hole, and it overreaches if there is no film in the camera. At high speeds the life of the mechanism can be significantly reduced. The second issue is that the basic mechanism—and thus the shutter—is running at a different speed when creating motion effects, and the amount of light the film is receiving differs from that at the 24 fps standard. Cameras with built-in exposure meters automatically compensate for this, but in most situations you need to know how to make the adjustments. Specific calculations are covered in chapter 14, but this should be kept in mind.

To create really dramatic slow-motion effects, a specialized camera is often necessary. General-use cameras that have variable frame rates usually go up to only 48 fps or at most 64. At 48 fps action is expanded to twice its natural length. For actions that take some time to unfold, such as human movements, 48 to 64 fps can create nicely stylized effects. For actions that take a brief time, this slowdown may be almost imperceptible. Students often ask how to achieve that lovely slow-motion ripple effect when a drop falls into water. It is useful to ask yourself how long this event takes in real time. A drop falling in water takes some fraction of a second. If you then double that time, it is still quite brief: the attempted slow-motion effect is barely noticeable.

The kind of effect that will make a speeding bullet visible takes a substantial number of frames per second. Both Photo-Sonics and Arriflex make cameras capable of running up to 150 fps. Specialized cameras can shoot up to 10,000 fps. Some basic math indicates that what took 1 second to shoot at this rate takes almost 7 minutes of projection time. High-speed cameras are used extensively in motion analysis, and this is one of the few areas in which video has not made inroads. NASA uses high-speed cameras to shoot a tremendous amount of footage of every takeoff. Construction and manufacturing companies also use them to analyze how products and structures resist stress. High-speed cameras can create a variety of dramatic effects, though their use necessitates many technical considerations that are not immediately evident.

Filmmakers quickly become conversant with all of the multiples and divisors of 24. This is particularly true when editing. But whenever you need to determine how long a shot must be or how much screen time it is going to take, you can always calculate frames. Time becomes a physical length of film: a shot that is 72 frames long is going to take 3 seconds of screen time, and so on.

Single Framing

Many cameras also come with a single-framing function, enabling you to shoot one frame at a time. One of the primary uses of this is, of course, **animation**—the technique that puts inanimate objects in motion. The most familiar form is the cartoon style of Walt Disney films and others of that ilk, an approach called *cel animation*. There are many other types, including clay animation, pixilation, cameraless animation, and computer animation.

The majority of animations, cel and otherwise, attempt to re-create the natural movements of characters and objects. In this approach one creates artwork that represents sequential points in movement. The movement of someone waving a hand would mean creating many points within that motion, from the hand at the character's side to points along the movement upward.

Animation is an immensely painstaking activity. Some basic math gives you a sense of this. If fluid movement is the goal, the maximum number of frames you can shoot of any single piece of artwork is two. If you shoot more, the movement will look staggered—it will not flow from one drawing to the next. If you are shooting two frames per drawing, 1 second of screen time takes 12 separate drawings. At

12 drawings for 1 second, a minute's worth of animation requires 720 drawings. A 90-minute film would need 64,800 drawings. The classic animations of the major studios were done shooting one frame of film for each drawing. Just multiply all the previous figures by 2 if this approach is chosen. If all of this does not give you pause, you might have a future as an animator.

Camera Features

A number of other options are common on many cameras. The basic features include the following.

Frame counter **Frame counters** can be found on many wild cameras but only infrequently on sync cameras. Usually located close to the footage counter, the frame counter counts individual frames and is particularly helpful in such applications as animation. Usually, one dial counts individual frames, and another keeps track of the frames in increments of 50 or 100. At normal running speeds, the frames fly by so fast that counting is useful only in such specialized situations as backwinding.

Backwinding With **backwinding**, the basic mechanism of the camera can be driven backward with a hand crank. One can do a shot, back up, and make another pass over the same piece of film. This is useful for doing superimpositions, matte shots, and a variety of other effects. Multiple passes are possible, though modern multiple-exposure shots are usually done on separate pieces of film and later printed together on a single piece. Be aware that when backwinding you wind the film through the entire mechanism, including the shutter. The lens must be blocked or the film will be exposed while being backwound. At present the only commercially available 16mm camera with a backwinding feature is the Bolex.

Battery tester Most cameras with electric motors have rudimentary battery-testing functions. Usually, a small scale with a pointer indicates whether there is adequate power. These scales are functional, but a handheld battery tester is much more useful. There are testers on the market that have multiple functions, many of which are useful for a variety of applications. Generally, one tests the voltage of the battery to see if it is at the level necessary for the camera to perform properly. (For further discussion see "Batteries" later in this chapter.)

Lens turret An option on a small number of cameras, a **lens turret** is a movable plate in front of the film gate with which you can rotate different lenses in front of the film, allowing you to switch lenses quickly between shots. Both the Bolex and the Arri S have turret systems.

Filter slots and holders Many cameras have small **filter slots**, either in the film chamber or on the exterior of the camera. The desired filter is mounted in a holder (a slide), which is then slid into a slot that positions it between the rear element of the lens and the film gate. Many cinematographers prefer filters that mount on the front of the lens because rear filters affect the rear-element–to–film plane relationship. Dirt or markings on rear filters are disastrous and are more difficult to control because they are unseen. Filter slots can also be used to insert opaque slides with patterns cut in them, such as a binocular-shaped cutout.

There are two cautions about the use of filter slots. First, if the filter slot is on the exterior of the camera, be sure that a dummy slide is in the slot if you are not using a filter. An empty slot allows a direct route to the film gate, and light will fog the film. Both the Bolex and the Scoopic have this design. Second, make sure that the previous user did not leave a filter in the camera. An unwanted filter will add

undesired color and will change exposure. Thus the filter slot should be checked, although the presence of a filter should be apparent when you clean the camera.

Variable shutters A small number of cameras come with a **variable shutter**—a means of changing the shutter's size. Variable-shutter controls most often make the shutter bigger, with smaller shutters not allowing time for the pull-down claw to advance each frame of film. The 180-degree shutter configuration is the size that gives optimal recording of natural movement. Shutters that are larger record such a small percentage of the action that movements do not blur seamlessly from frame to frame. This causes a strobelike effect that can be interesting but is generally undesirable. Variable shutters can be used to create fades, though they usually show the imperfections of moving the control by hand. Closing the variable shutter entirely is a good way of blocking light when backwinding the camera.

Tripod threading holes On the bottom of the camera body are one or more **tripod threading holes** that are used to attach the camera to the tripod head. (For distinctions involving their use, see "Tripods" later in this chapter.)

Cleaning and Care

Whoever coined the saying *Cleanliness is next to godliness* must have been a filmmaker. It is imperative that the camera be meticulously clean. If it is not, the resulting footage may be jeopardized. Bright hopes are often dashed, and pocketbooks emptied, when film comes back from the lab scratched or otherwise ruined. It is clear that a few front-end preparations can deter a substantial percentage of disappointments. When film is ruined, the only remedy is reshooting, although the digital age provides a few other solutions. The cleanliness and the care of the camera are among the numerous responsibilities of the *first assistant cameraperson*.

Cleaning Kit

The 1st AC always carries a cleaning kit. Experienced ACs often have quite sophisticated kits, but for people shooting their first films it is easy to put together a simple one. The following items are inexpensive and available at either a camera shop or a discount store.

Swabs Many ACs use cotton swabs, although they have some obvious drawbacks, the main one being that fibers on the tip can come off and work their way into the camera. Swabs with sponge tips are now in general use. They are substantially more expensive, however, and you may have to order them from a film-supply catalog.

Alcohol Denatured alcohol is preferable, although isopropyl will do in a pinch. Isopropyl alcohol has a lubricant that many ACs will warn you against, although I have never had a problem with it.

Orange stick You can buy an orange stick for about a dollar at a camera store or pay 79 cents for a half dozen at a discount store. So named because they are made of the wood of an orange tree, they are used by manicurists to push back cuticles. For our purposes they are used to clean the gate; nothing else, unless designed by a camera's manufacturer, should be substituted.

Blower brush or camel-hair brush Inexpensive blower brushes are available at camera stores and are simple rubber squeeze bulbs with a gentle-bristle brush attached. Many ACs prefer a camel-hair brush, a better but more expensive option.

Providing a very gentle bristle, most come in lipstick-style tubes in which the brush can be extended or withdrawn, an important feature because it is essential that you never allow the bristles to get dirty. Touching them leaves skin oils that attract dust. Eventually, you will be brushing dirt into the camera. Brushes that get dirty are usually thrown away. If you have a simple blower brush, use the same care.

Lens-cleaning tissue and lens-cleaning fluid Both lens-cleaning tissue and lens-cleaning fluid are available at any camera store and are necessary parts of a cleaning kit. They are produced by a number of different companies but are very specific items, and no substitutes—such as facial tissue or a shirtsleeve—should be used. (Lens care is covered in chapter 6.)

Canned air An optional item, canned air is used to blow dust out of the camera body and magazines. Canned air used to contain chlorofluorocarbons, which are one of the major contaminants of the earth's ozone layer, but many of the newer canned-air products do not. You may want to check the contents of specific canned-air products to determine if they are environmentally friendly. This is the most expensive element in the cleaning kit.

Cleaning Methods

Cleaning techniques are specific to individual ACs, and there are probably those who would disagree with some of the following recommendations. But I have used these procedures enough, and have seen other ACs use them, to feel comfortable with their applications. You are free to work out your own methods, although some important "don'ts" are discussed as part of the process.

All pieces of the camera must be cleaned—from the lens to the body to the magazine. It would be silly to spend a half hour making sure the body of the camera is immaculate but then not clean the magazine. The film stock will just carry all the dirt from the magazine right into the body when you start filming.

The first step is to use the brush to dust out the camera completely; canned air can also be used. You may be able to see many dust particles. Clean out what is visible and make every effort to get out anything else that may be in there. This applies to the magazines as well. Also clean the film chamber's cover plate or door, but do not open or remove the pressure plate.

The next step is to use the alcohol and swabs. Moisten a swab and use it to clean all of the metal and plastic pieces with which the film is liable to come in contact. This does not include the pressure plate and the gate. Clean the rollers and the keepers and anything else that the camera's specific design includes. Do not reinsert a dirty swab into the alcohol as it will contaminate what remains in the bottle.

You will always encounter the two roller designs illustrated. **(SEE 5-22)** The sprocketed rollers are specifically designed to drive the film forward; all other rollers guide the film either from the feed or to the take-up. Cameras are designed so that the film's emulsion touches as few surfaces as possible. Any contact carries with it the possibility of scratching or abrading the film. All rollers, both sprocketed and ordinary, have a recessed center so that the film touches them only at its edges, in the area of the sprocket holes. Whenever you see either of these designs, the emulsion almost invariably goes toward

5-22

Both types of film transport rollers have a recessed center so that the film touches them only at its edges.

Sprocketed roller

Ordinary roller

© Cengage Learning

the roller's center. Much of the rationale for camera and magazine design is made with protecting the film in mind.

As you are cleaning the camera, parts of the roller may be toward the keepers and thus inaccessible. In this case use the camera's inching knob to move the entire mechanism so that you can access these areas. If the camera does not have an inching knob, it may have a single-framing capability that will allow you to move the mechanism in the increments necessary to get the whole assembly clean. In many cases not much more than the rollers and the keepers need cleaning in this step.

To clean the pressure plate and the gate area, the first step is to remove the pressure plate. With a clean, dry finger, just wipe the pressure plate. Then wipe the film guide. If the pull-down claw is extended, be careful not to jostle it unduly as that can cause damage. Many ACs use a small chamois to wipe this area, but I have found wiping it with a finger to be perfectly adequate. Although skin oils attract dirt, this should be a relatively dirt-free environment. Again, cameras are designed so that the film comes into contact with as few surfaces as possible, and this is the only place where contact is unavoidable, so cleanliness here is critical.

The cleanliness of the gate is the chief goal of this entire process. The goal is to make sure that no dust, hair, or any other offending presence is in the gate. The call of "hair in the gate" (actually slivers of emulsion scraped off by the pull-down claw) is the bane of a film crew's existence. Everyone knows how distracting it can be when something gets in the projector gate at a theater. If you get one hair, it will soon be joined by brother and sister hairs. If this happens while shooting, the offending object is recorded for posterity. In addition, foreign matter anywhere in the camera, but particularly in the gate, can cause scratches.

■ **RULE** Regarding cleaning the gate itself, do not clean it if you cannot see any dirt.

Excessive cleaning will start to wear down the finely engineered edges of this critical area. Any dirt or hair that can cause a problem should be visible to the naked eye, although all ACs carry some type of magnification device for careful inspection. If dirt or hair is in the gate, clean it immediately, using the orange stick to gently flick it off. Do not use anything else, such as a toothpick or, worse, a paper clip. Anything hard can cause immediate damage to the aperture.

After this, give the camera another quick brushing to get rid of any dirt that may have been dislodged in previous steps. It is impossible to get anything absolutely, certifiably clean, but the idea is to get the interior of the camera as clean as is humanly possible. This process should take 20 to 30 minutes at the beginning of the day, and the camera should be checked frequently during shooting. Magazines are cleaned thoroughly every time they are reloaded. The film chamber is also cleaned as the camera is being reloaded.

The cleanliness of the gate is the most important consideration. All production cameras have a means of checking the gate between takes. Usually, the lens is removed and the inching knob is used to rotate the shutter out of the way. The AC, often with the aid of a flashlight and a magnifying device, can then see if anything is in the gate. Many ACs check the gate with the lens still on the camera—using the lens as a magnifying glass—but this takes some experience to know what to look for.

Checking the gate is usually done immediately after the shooting from an individual setup has been concluded. No lights are struck and no actors are excused until the 1st AC gives the go-ahead. If a substantial amount of material is being done from a single setup, the gate will be checked after each individual segment. If hair or dirt is found in the gate, all of the preceding material will have to be reshot.

Canned air, blower brushes, and alcohol should not be used on anything to do with the gate or pressure plate. The air and blower brushes will just knock dirt into the shutter mechanism. Alcohol should not be used because the interior of the gate

is covered with an antireflection coating that will eventually break down; pressure plates are generally covered with this material as well.

In many beginning courses, it is just you and your camera. Crew work and specific job responsibilities are yet to come. In this case remember that the cleanliness of the camera is your responsibility. Do not expect rental house or equipment room personnel to do your job for you, even though they should be giving you a clean and well-maintained camera. No matter whose hands you take the camera from, you should look it over and clean it before you shoot. The gate should be checked constantly, and the entire camera should be recleaned between rolls of film. Nothing strikes terror in the heart more than looking at your lab report and seeing these words: *hair in gate* or *scratches*. The aforementioned notion of an ounce of prevention's being worth a pound of cure definitely applies here.

Check the loops to ensure that they are the correct size and shape. Use camera tape to ward off potential light leaks. Clean the camera and check the gate. Start developing good habits. With most camera problems, the only option is to reshoot—always a costly and dispiriting proposition.

Batteries

If you were to speak to every person who had ever shot with a motion picture or video camera, you would probably hear at least one battery-related horror story from each of them. Battery care and maintenance are essential to the proper operation of the camera. There is no feeling quite like having to scrap an expensive and preparation-heavy shoot right in the middle because of battery problems. **(SEE 5-23)**

Most batteries designed for film (or video) are the slow-charging type. They are usually plugged in during the evening and are ready for use the next morning, although they need a long night's charge (12 or more hours). Quick-charging batteries are made for some cameras, but the slow-charging models are generally more reliable and less expensive. The lengthy charging time does take preplanning so you do not get caught without power. The 1st AC, who is in charge of the batteries, will have at least one if not more backups. The number of magazines a battery will drive varies from camera to camera, but a fully charged battery should run at least four or five 400-foot magazines.

5-23

Battery care and maintenance are essential to the proper operation of the camera.
Cine 60 battery / © Photo courtesy of Bruce Mamer.

The key to long battery life is frequent, complete discharging. If a battery is not totally discharged over a period of time, it can develop **memory**: it will "memorize" the small amount of charge it needs to be topped off. When the battery is completely discharged after it has developed memory, it will recharge only the amount it has memorized, thus not giving its full potential. This problem is correctable, but the whole process significantly cuts down on the life of the battery. The way to avoid this problem is to make sure that the battery is fully discharged relatively frequently—once every week or so when in constant use.

Beyond the battery itself, most cameras employ a cable to hook the camera to the battery. This also requires care and attention. A general rule is to unplug the battery whenever the camera is not in use, even on relatively short delays between takes. The battery will discharge even if the camera is not running. Although this is standard procedure, it can cause quite a bit of wear and tear on the cable. When picking up the camera package, first make sure the cables are present—you will not shoot if you get out on-location and they are not there; second, make sure the cables are working. As many student shoots close down over bad cables as over insufficient battery power.

Tripods

Creating steady shots, both moving and static, has been a goal since the experiments of the pioneer filmmakers. A handheld camera, though having a viable aesthetic of its own, does not offer adequate shot stability, thus necessitating the use of tripods or other related gear. This gear is referred to under the general category of **camera mounts**, or *camera support systems*, both umbrella terms that include tripods, dollies, cranes, the Steadicam, and many other specialized mounts.

A **tripod** is a three-legged camera support that is familiar to most readers. What is referred to as a tripod is actually two separate pieces: the *legs*—the actual tripod—and the head. The *head* is the mechanism on which you mount the camera and that has pan and tilt controls. The head-to-legs mount is usually a bowl design in which sits the rounded bottom of the head. A bolt and a knob (usually a wing nut or similar design) extend from the bottom of the head for locking it in place. This knob-and-bolt arrangement plays a key role in leveling the tripod.

Tripods are a fundamental part of the camera package for most smaller projects, even though their use on larger projects is not quite as common as it used to be. This is simply because the more versatile support systems, such as the new generation of relatively lightweight crab dollies, have become the standard. Rather than take down and reset the tripod, you can simply roll the camera to the next setup with a dolly. On films with a generous budget and a large camera/grip crew, the high rental cost, weight, and size of a dolly are easy obstacles to overcome. For smaller, inexperienced crews, the tripod is still the camera mount of choice.

Legs

There are two common types of legs available: wooden legs and the newer metal legs. Wooden legs were the industry standard for many years, and though they still have many followers their use has become less prevalent. Metal legs have become popular because of their versatility and lightweight, sturdy design.

Wooden legs are designed so that one set of legs moves inside the other. A twist lock allows the user to set them at the desired height, as it does on some of the metal leg designs. This lock must be used to tighten the legs together. If the lock pushes the legs away from one another, damage can eventually result.

Wooden legs come in two different forms: standard legs and baby legs. **(SEE 5-24) Standard legs** are about 4 feet tall and extend from that height to around 7 feet. As their name implies, standard legs are used for shots that are done at a standard height (eye level or thereabouts). **Baby legs** are used for low-angle shots. They are about 2 feet tall and can be extended to the lower end of the standard legs' range. To get lower than this, one needs to put the head on a **high hat**, which is basically a head mount with three feet. It stands about 6 inches tall and is also useful for mounting on tabletops and other surfaces. The head of the tripod is removable and is switched among these three types of legs, depending on the shot.

Wooden tripods do not have stops on the legs like many amateur and newer professional tripods, so the tripod will collapse spread-eagle on the floor if something does not hold the legs in place. For stability the legs require a **spreader**, also called a *spider* and *tri-downs*. The spreader is put on the floor and has three arms that extend to hold the tripod legs in position. The tripod legs have *spurs* (small pins at the base of the legs) that are put in the cups that hold the tripod legs. A large spring-loaded pin holds the legs in place. The spreader is an absolute necessity on smooth surfaces. If you are working on a rough surface, such as the ground or a carpet, the spurs dig in to hold the tripod steady. Most camera crews will use a spreader anyway because it eliminates the possibility of someone's carelessly knocking out the legs.

Metal legs are more popular because they generally incorporate all three heights in their design. With wooden legs you have to bring three different leg systems (standard, baby, and high hat) and switch the head among them as the shot demands. This is not as big a hassle as some people make it seem, but it does complicate the task. Because the metal leg extensions slide into each other, much greater height range can be achieved in a single leg. Metal legs stand about the height of baby legs but can be extended to the highest range of standard legs. They usually have stops that allow the legs to be locked in the normal upright position, eliminating the need for a spreader. Many makes of tripods have stops that allow the legs to be spread out so they get the camera down to almost high-hat level.

5-24

Standard legs are used for eye-level shots; baby legs are used for low shots.
© Photo courtesy of Bruce Mamer.

Heads

There are three basic types of heads: mechanical and friction heads, fluid heads, and gear heads. Fluid heads are generally preferred for initial efforts, although mechanical and friction heads also see use. Gear heads are the industry standard for 35mm shooting. Newer fluid-effect heads are also making inroads in the amateur market. (See "Fluid heads" below.)

The **head** is involved solely in pans and tilts. All heads have knobs for locking the pan and the tilt, and many also have independent controls that regulate the amount of resistance in the movement. **Resistance** is the force against movement—a tightness that makes it more difficult to move the tripod head. At first this seems to be a contradiction. Why would anyone want something to be harder than it needs to be? Without this resistance, however, the operator tends to overpush or underpush. If one is overpushing, the tendency is to respond by slowing down, and the

move becomes uneven; underpushing produces the opposite result. When there is resistance to the movement, one can push more uniformly. The fineness of the pan and tilt fluid control plays a big part in the quality of the moves you are attempting to make.

Mechanical and friction heads Many people do not distinguish between mechanical heads and friction heads, but there are slight design differences that warrant discussion.

Mechanical heads are both the most rudimentary and the most common type of tripod head. They are designed for still photography; people use them in film solely because of their availability. They are functional but are inadequate for finely defined movements. The movements of panning and tilting are simply metal on metal. The pan and the tilt are either locked or unlocked; there is no means to cushion the move or create any resistance because the head is designed simply to get the camera from one position to another for still photographs.

Friction heads are close cousins to mechanical heads. They also have metal-on-metal interiors, although there is an effort to cushion movement, usually in the form of an internal swelling ring. Thus the pan and tilt controls will give some gradations of resistance between completely loosened and locked. Friction heads are a small step up from straight mechanical heads, although you still have to fight for the smoothness of movement easily achieved with professional heads. Friction heads are an older design expressly produced to be an inexpensive alternative to fluid and gear heads, a role largely taken over by the newer fluid-effect heads.

Fluid heads The fluid head will probably be the tripod of preference for the work you will be doing. **Fluid heads** actually employ a hydraulic fluid that is forced from chamber to chamber in the head. This is where you find the independent controls, labeled *pan fluid* and *tilt fluid*, that allow the user to regulate the firmness of resistance to movement.

Many newer tripods are billed as having fluid-effect heads, and some of them are surprisingly good. The design of **fluid-effect heads** is similar to that of friction heads, but their moving parts are further cushioned with an enclosed viscous fluid that assists the metal-against-metal movement, facilitating smooth pans and tilts. They were designed to be a low-cost option that would produce results close to those from the more expensive true fluid heads. They seem quite useful for smaller cameras, though larger cameras still require a true fluid head or gear head.

Gear heads **Gear heads** are the standard in 35mm shooting. The pan and tilt movements of gear heads are controlled by hand cranks attached to gears. The operator turns the pan crank and the tilt crank to the desired positions. Resistance is not an issue because the head is responding to the movement of gears.

Gear heads yield exceptionally smooth movements, but one must learn how to hand-crank both the tilt and the pan gears simultaneously. This can be tricky, though it is easily mastered with practice. Moves can also be preplanned: an assistant can put erasable marks on the head so that it can be cranked to a specific position. Gear heads are heavy and bulky as well as expensive to rent, and they are largely intended for smooth moves with big cameras. They can certainly be used with smaller cameras, but fluid heads can often yield moves of equal quality when used with smaller cameras.

Good movements can be made with inexpensive or poorly designed heads, but they certainly make the task much harder. On small projects you often have to use whatever tripod you can get your hands on. Such is the reality of the way you may have to work, but it is difficult to get the performance you want from tools that are inadequate or not designed for the purpose. You should get in the habit of doing everything possible to obtain the best tools for the job, regardless of the

dent it puts in your budget. Using equipment that makes the task harder can lead to hidden costs (lost time with location, talent, or lighting and, worst of all, inadequate results) that can be greater than anything expended on the front end.

Attaching the Camera

There are two common types of threading on the screws used to attach a camera to a tripod head. The first is found on small and amateur cameras, and the second is the professional standard. The first screw type is a 1/4-20 (quarter-twenty). Consumer video and small 16mm cameras have this type. The 1/4 refers to the diameter of the screw; the 20 refers to the pitch of the screw threading. This is a common screw size available in any hardware store. With a few carpentry skills, you can use this knowledge to build many nifty camera supports. Be cautioned, however, that the screw used should not be deeper than the hole in the camera. The camera body often has circuitry above the hole. A screw that is too long can cause extensive—and expensive—damage.

The second type of common camera screw is a 3/8-16. Again, these numbers refer to the diameter of the screw and the thread pitch. This is the attaching screw for most larger 16mm and all 35mm cameras and is used simply because the professional cameras are heavier. The 1/4-20 screw is not strong enough to support the weight of the larger cameras.

Many smaller cameras have both sizes of screw holes, allowing them to be used on any tripod. Larger cameras often have a choice of two 3/8-16 holes, one toward the front of the camera, the other toward the back. This is to compensate for the weight of the lens you are using. If you are using a heavy lens, to keep the weight of the camera evenly distributed on the tripod you would use the front hole. The back hole is used with a lightweight lens.

Tripods and heads are rated for the maximum-weight camera that they can support. Never put a camera on a tripod and head not rated for its weight. If you do, with some effort you may still be able to create decent movements, but the arrangement will be an accident waiting to happen. The camera will be top-heavy and will fall over with the least encouragement.

Occasionally, there is cause to adapt between the smaller threading and the larger hole. Bushings are available that will adapt a 3/8-inch camera-mounting hole to 1/4-20 tripod threading. On smaller cameras that have only the 3/8-inch threading, such as older Bolexes, these can be quite useful. For safety reasons cameras bigger than the Bolex should not be adapted to the 1/4-20 threading.

Older heads come with the attaching screw permanently mounted in the plate on which the camera rests. Newer head designs employ a **quick-release plate** that is detachable and screwed independently into the bottom of the camera. Plate and camera are then simply secured to the head. In all types of shooting, the quick release is quite handy for getting the camera off of the tripod quickly as new shots present themselves.

Caution: When attaching a camera to a head, whether with a quick-release plate or the traditional design, make certain the camera is properly attached before leaving it. Both the threads and the plates can appear to be attached without actually making a connection. If you step away, you may find the camera on the floor when you come back. Always test the connection by lifting the camera slightly; if the screw is properly threaded, the tripod will come with it.

Leveling the Head

Almost all tripod heads sold specifically for film or video work come with some means of leveling to ensure that the head is straight with the world. Most employ a *spirit level*—a small leveling bubble centered inside a circle—similar to that found

on a carpenter's level. Some tripods have a knob and a bolt on the underside of the head that are part of one leveling design called **ball joint leveling**, where turning the knob slightly clockwise loosens the head in the bowl. You can then position the head so that the leveling bubble is in the center of the circle. This is done with the camera on the head because the weight of the camera may change the level slightly. This method is popular on 16mm tripods, whereas tripods for 35mm employ a variety of means. With some tripods, you have to adjust the legs to achieve level, an approach that is annoying until you get used to it.

Leveling the head should become automatic. It is the first thing the AC does when moving to a new setup, even if there is a possibility that the camera position may still change. No effective evaluation of shot and composition can be done without a level tripod head. Shots can be set up that appear straight with the world, and a simple movement turns the world askew. When attaching the camera to the quick-release plate, be sure that the camera is straight on the plate. If it is cockeyed, it will affect the alignment of the camera with the horizon. Even if the head is level, the shots will not look level, particularly when panning and, to a lesser extent, tilting.

Camera Safety Checklist

☑ There is one essential rule of tripod safety: never walk away from the camera without being 100 percent sure that the tilt is locked. If the tilt is not locked, the weight of the lens can cause the camera to tilt forward. As it moves, it will gain momentum, and the lens can smash into a tripod leg. If the tripod itself is not secure, the whole system can fall over or the threading screw can shear off. In both cases the camera smashes to the floor. ACs never leave the camera for any reason. It is under their protection. If they absolutely must leave, they will get the 2nd AC to mind the camera until their return.

☑ The balance mechanisms on tripods are wonderful, but they can give camera personnel a false sense of security. With ball joint leveling, the head can be made level while the legs are uneven, leaving the whole system in a precarious position. Often the legs will have a leveling bubble as well; and although it is not necessary that it show absolute level, the closer to level it is, the better.

☑ Set up the tripod so that one of the legs points in the same direction as the lens. As mentioned, the greatest weight of a camera is usually toward the lens. If a camera falls over, it tends to fall lens first. With one tripod leg pointed forward, the majority of the camera weight is supported.

☑ If a particular setup is the least bit insecure, use **sandbags** or other weights on the legs. The use of sandbags to secure light stands is common, and several should be brought along for the tripod as well. Sandbags can also be used for **lockdowns**—situations in which the framing must be absolutely consistent from shot to shot, such as with superimpositions and matte shots.

☑ The camera must be secure at all times. One thing you can count on is that if you set up the camera so that some fool can knock it over, some fool will knock it over. This is a truth that extends to anything you rig on a film set. There can be dozens of people wandering around a set, and the odds are that at least one of them has no common sense around equipment.

A top-of-the-line 16mm production camera with a good lens can easily cost $200,000 and up. An improperly set tripod can be responsible for damage that either makes a rental company very unhappy or destroys your own investment. However

much many of us enjoy building odd camera mounts—and encourage students to experiment with them as well—the camera should never be put in jeopardy. It makes no sense to risk damage to the one tool that is indispensable in making films. Cameras can be repaired, but they often cannot be brought back to their original condition. After being dropped lens-first from a tripod by a careless crewmember, one camera was never again as quiet.

☑ Get set up and comfortable. Be sure that the tripod legs will not be in the way of any of your movements while executing a shot. Pans often require moving around the tripod, and anything blocking your way can affect the shot. Having to strain or stand on tiptoe to look through the eyepiece will also affect your ability to execute the shot smoothly. Find something stable to stand on, or reposition the tripod so that you feel completely comfortable. Do not change the shot unnecessarily for your comfort—just find a way to make yourself comfortable.

6
The Lens

The camera *lens* is the vehicle that transfers light to the film. It can be as simple as a single piece of glass (or plastic), called an *element*, or as complicated as multiple elements that can be moved in relation to one another.

The lens always includes three basic features that will be part of the decision-making process whenever you are shooting. On most lenses two of these features are in the form of movable rings that have to be set for every shot: the focus ring and the f-stop ring. The third refers to the length—wide-angle, normal, or telephoto—of the lens, what is referred to as focal length. In a zoom lens, focal length is also a variable and will have a ring devoted to it as well.

The camera itself is based on the **camera obscura** phenomenon, observed when rays of light pass through a pinhole on a surface. The crossing rays create an upside-down and reversed representation of the world on the other side. A lens transmits the light in the same way, only more efficiently because the pinhole does not allow light through in sufficient quantity to create a workable exposure. When the film is later shown on a screen, the projector reverses the process. **(SEE 6-1)**

Focus

Light rays emanate from a point on a subject. They strike the surface of the lens and, as they travel through the lens and exit the rear element, are bent toward the film plane. After they pass out of the rear element, they converge and are represented as a point on the film plane. The illustration below shows a single-element lens, though virtually all lenses used for film or video are composed of multiple elements. **(SEE 6-2)** If this light comes from a subject at the distance for which you have set focus (point B), the light comes to a point right at the film plane. If the subject is at a different distance (point A or C), the light comes to a point either in front of or behind the film plane.

Every shot you execute must be focused, and many shots (more than one would anticipate) may require shifts of focus to accommodate all of a scene's action. Many video cameras, particularly DSLRs, have automatic focus functions, but this text will proceed on the idea that executing all functions in manual is the eventual goal. In a given composition, you have to choose a subject that you want to be in focus. You can focus on only one distance at a time. Everything in front of and behind that point is going to be out of focus to some degree. How much out of focus is dependent on depth of field, an issue that complicates any discussion of focus and is explained fully later in this chapter.

© Cengage Learning

6-1

The camera obscura phenomenon projects an inverted image of the light entering through a tiny aperture.

In a simple lens, the **focus ring** controls the position of the front element of the lens in relation to the film plane. The front element is moved forward or backward as you turn the ring. As the front element moves, the points where the light rays converge change. **(SEE 6-3)** The focus ring gives a series of distances, from the closest focus point that the lens is able to achieve to infinity. **(SEE 6-4)** The universal symbol for infinity is ∞. A hatch mark against the focus ring is used to set the desired distance. If the subject is 8 feet away, you set the ring to 8 feet. **(SEE 6-5)** Focus rings are often marked in both feet and meters. Be sure you know which one you are using. Reading the meter indicator when you're thinking in feet will obviously ruin many shots.

There are two methods of focusing. The first method works effectively only with cameras equipped with a *reflex viewing* system and a zoom lens. In this method the lens is focused to the eye as you look through it. To focus to your eye, you must have the *diopter* set properly. The first step is to zoom in all the way to the subject, gradations of focus being much more distinct with a telephoto lens. With most

6-2

Single-element lens.

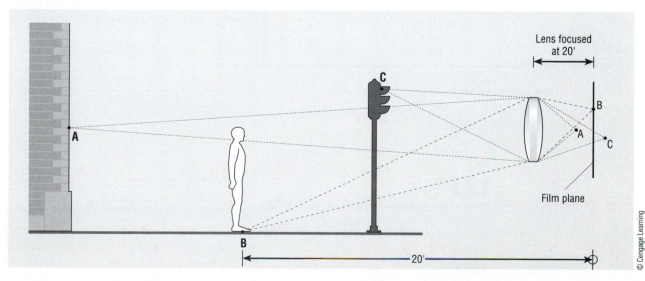

© Cengage Learning

6-3

The streetlight resolves at the film plane when focused at 12 feet.

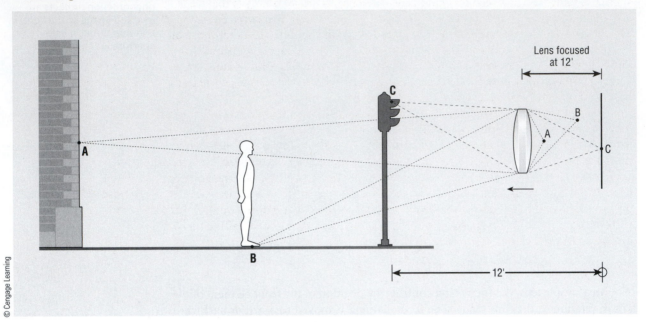

6-4

Subjects resolve at different points when the focus ring is shifted.

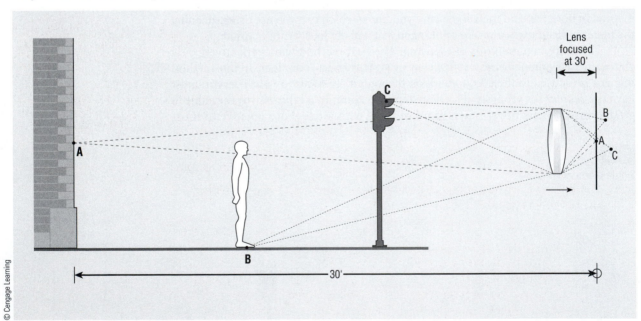

6-5

The focus ring controls the position of the front element of the lens in relation to the film plane.

cameras, you then rotate the focus ring until the subject is as sharp as possible. If you try to focus with a short lens or even a normal lens, you can rotate the focus ring a substantial distance without seeing a significant difference in the sharpness of the image.

The second method for setting focus is by using a tape measure. This might appear time-consuming and disruptive, but it is by far the preferred method. You simply measure from the camera to the subject and set the ring accordingly. It is virtually foolproof. You measure to the universal symbol for the film plane—not, as some might expect, to the front of the lens. This symbol can be found on the body of virtually every camera. **(SEE 6-6)**

Although some viewing systems can be difficult to use, the biggest culprit in focus problems is inattention to detail by the user. Not setting the diopter properly causes a substantial percentage of the problems, but the primary reason is simply inexactness of approach. When working by yourself or with a small, inexperienced crew, it is easy to overlook many details. So many things demand attention, and there is constant pressure to keep the whole process moving forward. It will quickly become apparent that focus is one detail that can be overlooked only at the cost of your entire film. When even one piece of the puzzle is bad, it can be difficult to fit the whole thing together.

6-6

The universal symbol of the film plane is found on the body of virtually every camera.

© Cengage Learning

f-stop

The *f*-stop ring controls a small diaphragm in the lens, which regulates the amount of light reaching the film plane. **(SEE 6-7)** Its setting is determined by using a light meter or a through-the-lens metering system. Discussion of the role of the *f*-stop in exposure dominates part IV of this book, and you will eventually come to see the *f*-stop as the starting point for any understanding of the creation of the motion picture image. How it interrelates—or, more accurately, how you make it interrelate—with what is in front of the camera in terms of light is one of the dominant controls of the dramatic and expressive power of a film image.

Everyone has seen over- or underexposed film, and in its most simplistic sense the **f-stop** is used to obtain a usable exposure. If the *f*-stop is improperly set, the film will be over- or underexposed. The *f*-stop ring has a series of numbers. **(SEE 6-8)** Many lenses do not have numbers either as high or as low as are shown here, but these are the general parameters. Theoretically, the *f*-stops could go on to infinity.

The numbers can be somewhat confusing because the smallest number represents the widest opening and the highest number represents the smallest opening.

■ **RULE** The lower the number (e.g., *f*/1), the larger the opening; the higher the number (e.g., *f*/22), the smaller the opening.

Thus, the lower *f*-stops let in more light, and the higher *f*-stops let in less light. Most lenses do not have anything numerically larger than *f*/22. Some lenses have *f*-stops less than *f*/1—Stanley Kubrick used one to shoot in candlelight in *Barry Lyndon* (1975)—but they are so rare that *f*/1 serves as a sensible starting point.

Circles are used to represent approximate size relationships among the stops. **(SEE 6-9)** The actual size of any stop will depend on the focal length of the lens.

6-7

The aperture in the lens regulates the amount of light reaching the film plane.

© Cengage Learning

1	1.4	2	2.8	4	5.6	8	11	16	22	32	45	64

© Cengage Learning

6-8

The *f*-stop ring is used to set the *f*-stop for the desired exposure.

6-9

Relative sizes of *f*-stops correspond to the size of the aperture.

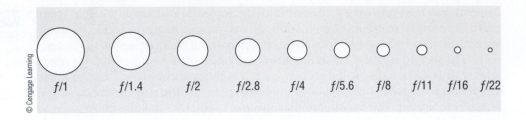

f/1 f/1.4 f/2 f/2.8 f/4 f/5.6 f/8 f/11 f/16 f/22

This more-light/less-light approach is invariably the way *f*-stops are presented, but it is somewhat of a backdoor tack. The goal in choosing an *f*-stop is often, though certainly not always, a clear and true-to-life picture, or what is referred to as **normal exposure**. It takes a certain and reasonably consistent amount of light to produce a normal exposure on any given film stock, and the *f*-stop is used to transmit this light. In bright light the stop must be small so that too much light does not reach the film. In low light the stop must be large.

Shutter Speed

As seen in the discussion of cameras, the shutter is not technically part of the lens—it rests directly *behind* the lens. However, once *f*-stops and exposure are introduced, initial discussions need to be started. In addition, once you get to DSLRs (see chapter 8), some background is required in order to understand issues of automatic exposure. **Shutter speed** refers to how long each individual frame of film is exposed to light. It is referred to in terms of fractions of seconds, say, 1/30, 1/500, and so on. Those with experience in still photography know that shutter speed, along with the *f*-stop, is a major control of how an image is exposed. In film, shutter speed is not so critical a variable because, unless you are going for some specialized motion effect, shutter speed is a constant, dependent on the number of frames per second (fps) at which you are running.

Shutter speed in motion picture film is calculated by a straightforward formula:

$$\frac{1}{2 \times \text{fps}}$$

This is simple common sense. If the camera is running at 24 fps, how much attention is each individual frame of film receiving? Each frame has 1/24 of a second devoted to it, but it is actually being exposed only half that time—the other half of the time the light is being blocked by the rotation of the half-moon shutter—so the frame is being exposed for half of 1/24 of a second. **(SEE 6-10)** The actual shutter speed then would be 1/48 second, usually rounded off to 1/50. Whatever frame rate you have chosen for the camera, the frame is getting light half of the time of its possible exposure. Shutter speed becomes an issue only when you change running speeds (that is, frames per second) for slow- or fast-motion effects. If you change speeds, you have to make the necessary adjustments. (See the discussion of slow motion and fast motion in chapter 15.)

The variable that is not addressed in this simple formula is the size of the shutter. Most shutters are the half-moon configuration or close to it (most are actually a little smaller). But if for some reason you need to use a different-sized shutter, which would rarely happen, you have to know the following complete formula:

$$\frac{\text{degrees of shutter}}{360 \text{ (total degrees in a circle)}} \times \text{fps}$$

If the camera shutter has the half-moon configuration, which is 180 degrees of the circle, the first part of the formula will simply reduce to one-half (when 180 is divided by 360). With a normal shutter, the formula is always going to be simple: 1/2 times the frame rate. Again, the only time you need to do a more complex calculation is when you are dealing with a shutter that is not the standard half-moon configuration.

On still-photography cameras, the shutter speed is an important variable. The absence of a variable shutter speed on a film camera can be a real shock for people with a photography background. I often use Kodak Tri-X black-and-white film for outdoor still photography. Because it has such a high **exposure index (EI),** I can shoot at a high shutter speed and a high *f*-stop; that would stop fast-moving action and give tremendous depth of field. In motion picture photography, you just cannot do that. Without substantial filtering, a stock with an EI like that of Tri-X (400 in still photography) would be unusable on a bright, sunny day. Without the ability to get less light by changing the shutter speed, you would need to film at an *f*-stop higher than anything on the lens. It makes for a whole new set of considerations.

Exposure Index

The relationship between a specific amount of light and an *f*-stop is dependent on the exposure index. This concept is also discussed in the context of film stocks, but its impact on the *f*-stop warrants initial coverage here. The EI rates how sensitive a film stock is to light, what is referred to as *film speed.* Different sources may refer to this as *ASA* (for American Standards Association) or *ISO* (for International Standards Organization), but they are just different names for the same thing. Video, somewhat inexplicably, has settled on ISO, but film has stayed with EI. Under whatever name, the EI is represented by a number that is found on the film's packaging. This number will be set on the light meter and is the sole variable in the conversion of an amount of light in front of the camera to the corresponding *f*-stop. How the film stock responds to different volumes of light depends solely on how the manufacturer (Kodak being the primary one) has designed and produced the stock.

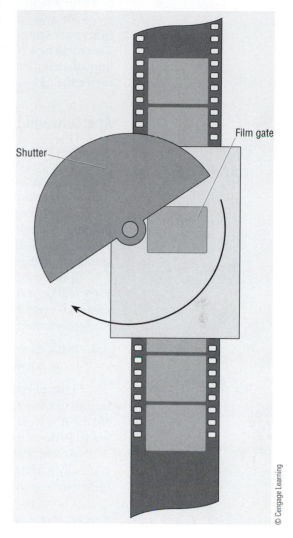

The shutter allows light to reach the film plane during half of its rotation.

Film gate

Shutter

© Cengage Learning

> ■ **RULE** The lower the EI number, the less sensitive the film is to light; the higher the EI, the more sensitive the film is to light.

A film stock with a low EI, such as Kodak Plus-X black-and-white reversal film (EI 40), is less sensitive to light; thus you need a greater amount of light to expose it. Plus-X would therefore be easier to use in a high-light situation, such as outdoors in sunlight. A film stock with a higher EI, such as Kodak Color Negative 7230 (EI 500), is more sensitive to light; less light is required to expose it, thus making it easier to use in low-light situations, such as indoors.

At least in the early stages, you will probably want to determine your film stock by the lighting conditions in which you are shooting. Most beginners will make this simple distinction: when shooting outdoors use a stock with a lower EI; when shooting indoors use a stock with a higher EI. This is not a bad way to start out, but be aware that most film professionals do not choose their film stocks on

this basis. If someone is shooting indoors but wants the look of Plus-X, he or she will just light the set so that Plus-X can be used. This idea of the look of a film stock is quite complicated, but it mostly has to do with issues of grain, color separation, and response to under- and overexposure.

For now you should probably use the manufacturer's recommendation on the film's packaging, which will say that the stock has an EI of 50 or 320 or whatever. There will be a place to set the number on the light meter, and this should be done immediately. Once you have decided on a film stock and have set its EI on the light meter, the EI becomes a constant.

Aperture and Light

The term **lens speed** refers to the **maximum aperture**—the widest the lens diaphragm will go. A lens with a maximum aperture of $f/3.5$ is considered a slow lens; a lens with a maximum aperture of $f/1.8$ is a fast lens. Due to the length of the lens and the construction of the lens barrel, telephoto lenses are almost always slower than wide-angle lenses. It makes sense that a short, squat lens would have a wider maximum aperture than would a long, narrow one. If you want to use a telephoto lens in a low-light situation, you can almost surely anticipate some problems due to its slow speed; but with proper preparation, any situation of this nature can be handled.

It is recommended here that you bite the bullet and memorize the f-stops. They will be your constant companions if you have anything to do with **technical camera**—everything concerning the camera except calling different shots. If an aid to memorization is helpful, the following rule is a useful mnemonic.

> ■ **RULE** Every stop is a numerical double of the second previous stop; that is, 2.8 is twice 1.4, 8 is half of 16, and so on. **(SEE 6-11)**

They cheat and round it off between 5.6 and 11. A second way is even more fun: all of these numbers, starting with 1, are multiples of the square root of 2 (1.4). Maybe if you are an idiot savant, this will be an acceptable method, but the point is made. Perhaps rote memorization is your preferred modus operandi.

As with the focus ring, there is a hatch mark by which to set the f-stop. There is usually a **detent**, or a click stop, at each number. You can and frequently will use in-between settings, called *half stops*, *quarter stops*, and so on.

The numbers shown here are the true f-stops, referred to as *full stops*, and they represent specific points in the transmission of light. They are derived from a mathematical formula that divides the focal length of the lens by the diameter of the diaphragm opening. Expressed as a formula, that is:

$$\frac{\text{focal length}}{\text{diameter}}$$

In terms of what you need to know to light a scene, this is not particularly earth-shattering information. It is important, however, to understand that f-stops have a mathematical derivation. In fact, everything becomes very mathematical once you start to light. You will occasionally see different numbers, but those are mid-positions and are specific to the lens you are using. In menus that control the lenses on DSLRs

6-11

Every stop is a numerical double of the second previous stop.

© Cengage Learning

| 1 | 1.4 | 2 | 2.8 | 4 | 5.6 | 8 | 11 | 16 | 22 | 32 |

and other video cameras, you will find that many different inter-stop numbers are listed, but you will find it useful to keep the critical numbers in mind.

This is a simplification, but in general the higher-numbered f-stops are used in bright-light situations, such as outdoors, and the lower-numbered f-stops in low-light situations, such as interiors. In essence you must determine the correct f-stop to get the exposure you want. It is worthwhile to think of the process of learning exposure technique as determining how to avoid major mistakes. At some basic level, mistakes result in under- or overexposure.

The term *mistake* is used carefully because you might ask if there are not times when we actually want over- or underexposure. If you have a shot of a person walking down a dark alley at night, the image would certainly incorporate many elements of underexposure. Virtually all film images have a wide range of volumes of light; an image without a range results in a shot that is flat and uninteresting. Eventually, you will come to see the task as controlling all of the levels of exposure in what will often be a very complex image.

Thus the key to exposure lies in understanding the f-stop and how it relates, in terms of light, to what exists in front of the camera and what is happening at the film plane. Once lighting is added, what exists in front of the camera will eventually be something over which you have complete control. Once you fully understand f-stops, their use will appear somewhat easier; that said, however, the use of the f-stop will never be simple.

Focus and exposure are the two major areas in which beginning filmmakers consistently make technical mistakes. The key is to remember that both must be considered and addressed for every shot. Failure to do so in the first case will result in blurred and unusable images. In the second case, over- and underexposure are the most immediate results of mistakes, but an image that does not express what you want is the real downside.

Focal Length

The third feature of the lens is focal length, an issue that was approached from an aesthetic perspective in chapter 1. **Focal length** is usually expressed in millimeters (mm) and is the measurement from the optical center of a lens, which is usually in the front element, to the film plane. (SEE 6-12) A lens is referred to as a 25mm lens or a 75mm lens, for example, although focal length numbers should not be confused with the metric measurements of the common formats. The focal length of a lens can generally be found on the barrel next to the front element. It is expressed as $f = n$, so $f = 25$ is a 25mm lens. Older American lenses often have focal lengths expressed in inches. Every inch is equal to 25mm, so a 2-inch lens is a 50mm lens, a 3-inch lens is a 75mm lens, and so on.

There are two major categories of lenses: prime and zoom. A **prime lens** is any fixed-focal-length lens; that is, it gives a fixed angle of view. Essentially, a prime lens is any nonzoom lens. A **zoom lens** has many different focal lengths and is referred to in terms of its range. For example, a lens having a range from 12mm to 120mm is referred to as a 12–120 lens. A sequence of numbers on the zoom ring indicates at which focal length the lens is set. (SEE 6-13)

6-12

Focal length is the distance from the optical center of a lens to the film plane.

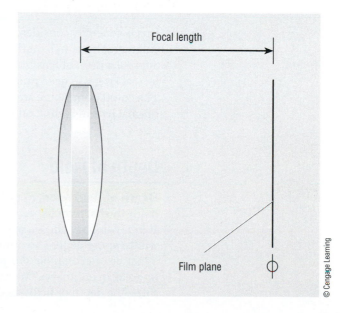

Focal length

Film plane

© Cengage Learning

6-13

The zoom ring on a lens has a sequence of numbers that indicate focal length.

Zoom ring on an Angénieux 12–120 lens / © Photo courtesy of Bruce Mamer.

6-14

Focal lengths in different formats.

	Wide-angle (short)	Normal	Telephoto (long)
Super 8	<12	12	>12
16mm	<16	16–25	>25
35mm	<50	50	>50

Lenses can be grouped into three categories: wide-angle (short lens), normal, and telephoto (long lens). A **wide-angle lens** makes the object we are filming appear to be farther from us than it really is. A **normal lens** does just what the name suggests: gives a normal view of the scene. A **telephoto lens**, like binoculars, makes objects appear closer than they actually are. The zoom lens allows us to go uninterrupted from a wide shot to a closer shot and vice versa.

The lens size required to achieve a specific distance effect varies with the size of the format being used. A smaller format requires a shorter lens to fill the smaller area of the frame. Many readers who have done 35mm still photography, one of the most common formats in still photography, know that a 50mm lens is generally considered a normal lens. This is true in 35mm motion picture cinematography as well. In the 16mm format, a normal lens is roughly a 25mm lens. In Super 8 a normal lens is roughly 12mm. The pattern here is clear: as you halve the format size, you need roughly half the lens length to create the same effect. **(SEE 6-14)** The cutoff points here are rather arbitrary. Many people consider the 50mm lens the normal lens in 35mm; others consider normal to be somewhat less than 50mm.

Depth of Field

Depth of field refers to the distances down the field of the camera's view that remain in sharp focus. As stated earlier, focus must be set one distance at a time. When you have chosen a focus point, everything in front of and behind that point will to some degree be out of focus. The quality of focus at different distances is a matter of *acceptable sharpness*—the crispness or clarity of the detail of subjects or areas in an image. The range of distances before subjects become unacceptably soft—the depth of field—is dependent on several technical variables.

The overriding variable affecting depth of field is format size. The lenses used with larger formats have shallower depth-of-field characteristics than their counterparts in smaller formats. That is, if you use a lens that produces a normal perspective in the 35mm format (a 50mm lens) and a lens that produces a normal perspective with a 16mm camera (25mm), the latter lens will produce more depth of field. Clearly, you would never choose a format based on depth-of-field concerns; usually, format is selected for such reasons as presentation or economics.

In video, the idea of format is a greater variable. Just as with format size, video depth-of-field is dependent on chip size—the chip being the light-collecting agent in video. Many of the smallest video cameras have a very small chip. Many mid-range and even high-end cameras have a 2/3-inch chip, approximately the size of a 16mm frame. The DSLRs and many high-end cameras have a full 35mm size frame and thus have shallower depth-of-field characteristics. As with film formats, you are stuck with the depth of field of your camera choice, but the choice between a camera and a film-format size is a different kind of choice. They are both probably economic choices but the technical character of the image produced on different video cameras has a greater impact.

Beyond the choice of format size, the three variables of depth of field that are used while shooting are the same three found on lenses: f-stop, focal length, and focus point. There are two ways of determining the depth of field in a given situation: markings on the lens and printed depth-of-field tables. There are complex technical reasons for depth-of-field effects, but some general rules are presented here.

f-stop Higher f-stops yield greater depth-of-field characteristics—more will be in focus. Lower f-stops yield shallower depth-of-field characteristics—less will be in focus. If you are shooting at f/16, you will have greater depth of field than if you shoot at f/2.8. Do not take this to mean that you can arbitrarily set the f-stop to achieve greater or lesser depth of field. The f-stop is dependent on the lighting conditions under which you are shooting. If you were to get a reading of f/5.6 and decide to set the f-stop ring to f/22 to get more depth of field, the image would be completely underexposed. This may appear to make the f-stop an inflexible variable on depth of field, though part IV suggests how there can be room for changes.

Focal length Wide-angle (short) lenses yield greater depth of field. Telephoto (long) lenses yield shallower depth of field. This is why, as noted earlier, gradations of focus are more distinct with a long lens. If you are shooting with a 20mm lens, you will achieve greater depth-of-field characteristics than if you shoot with a 75mm lens. Again, filmmakers tend to choose lenses for the way they render space. If you are attempting to achieve specific focus effects, the depth-of-field characteristics of the lens clearly become part of the equation. You would not choose a 10mm lens if it defeated the way you envision the space; but filmmakers desiring a deep-focus effect generally shoot with a wide-angle lens. The film noir style of the 1940s and early 1950s incorporated as much depth of focus as possible within the image, and short lenses were clearly a central factor in the production of these films. A film such as Orson Welles's *Citizen Kane* employs the depth of field inherent in a wide-angle lens in conjunction with the lens's elongation effect to create its extraordinarily wide fields of focus.

Focus Far focus settings yield greater depth of field. Close focus settings yield shallower depth of field. There is greater depth of field if focused at 20 feet than if focused at 10 feet. Thus focus becomes more critical the closer the subject is to the camera. Focus is generally less of a variable than f-stop and focal length. If something needs to be in focus, you will frequently set focus to it. Focus is often manipulated, however, to create effect.

The depth of field—that is, how much of the image is in focus—is thus dependent on these three variables. Clearly, there are ways to minimize or maximize focus for effect. Factors that maximize focus are short lenses, high f-stops, and far focus points. Factors that minimize depth of field are long lenses, low f-stops, and close focus points.

Over the years, depth of field has become a critical topic in the ongoing discussions of film versus video. As suggested elsewhere, novices often come to initial projects with the ill-formed but understandable notion that everything should be in focus throughout the image. However, one comes to see that gradations of focus are critical to the warmth, depth, and power of the image. Film, due to the generally larger format size, always had shallower depth of field characteristics and thus remained preferable for the many DPs who valued the expressive power of focus in the image. Many newer digital cameras now incorporate chip sizes comparable to 35mm so video again continues the quest for parity. The debate will continue. Either way, it has always been a matter of how you manage the technical issues to create the effects you want. With film, at least in terms of focus, it may have been a little easier.

Determining Depth of Field

There are two methods of determining depth of field for a given shot. The first is an option found on many prime lenses, which have hatch marks that give the parameters of depth of field. **(SEE 6-15)** On either side of the focus hatch mark is a sequence of f-stop numbers. In this example, if you were shooting at an $f/4$ and focused at 8 feet, you could tell that everything from roughly 6 to 12 feet would be in focus; *roughly* is the key word here because this method gives only general parameters. Many lenses use these markings, although there are different methods of indicating the boundaries. Bolex lenses, which usually have the name *Kern* or *Switar* on them, have a clever strategy that employs gold dots that appear as you close the aperture. Zoom lenses do not have these markings because the focal length varies as you zoom and thus no single chart would be correct.

The second method is far more common, mostly because of the inexact nature of the first method. **Depth-of-field tables** have a chart of the near and far parameters of focus for the common focal lengths. These tables generally list the depth of field down to inches. The *American Cinematographer Manual*, which is published by the **American Society of Cinematographers (ASC)**, is generally used as a source for these tables, though they can be found elsewhere. The pocket-sized ASC manual is used continuously on the set.

In video, it could be said there is a third method: simply eyeballing it. As with exposure and a variety of other things, the digital viewfinder or a field monitor will pretty accurately represent focus effects. As with everything, however, exercise caution here, as an inadequate monitor may not fully reflect all the details of the image. A subject that may appear sharp on a less-than-perfect monitor may look entirely different on a high-end video projector. Using a chart can never hurt.

Because lens length is a constant at any given point during a shot, there are tables devoted to specific lens lengths. You need a table for the format being used. The ASC manual has tables for 35mm and 16mm but not for Super 8; you might have to do some searching for a Super 8 table. If you are shooting 16mm and using a 35mm table, your results will be skewed. In 16mm the ASC manual has individual tables for 8, 9.5, 12, 16, 25, 35, 50, 85, 100, and 135mm lenses.

6-15

The markings on the lens barrel give the depth-of-field parameters.

6-16

Sample depth-of-field table

Lens focus	*f*/1	*f*/1.4	*f*/2	*f*/2.8	*f*/4	*f*/5.6	*f*/8	*f*/11	*f*/16	
50'	36' 80'			25' Infinity					7' Infinity	Near Far
25'	21' 1" 30' 8"									
15'						9' 3" 40'				
10'				7' 9" 14' 3"		7' 1" 17' 2"			4' 7" Infinity	
8'				6' 6" 10' 6"		6' 12'				
6'										
5'										
4'										
3'	2' 11" 3' 3/4"									
2'	1' 11 3/4" 2' 1/2"			1' 11" 2' 1"					1' 7 1/2" 2' 7 1/2"	

If you are shooting 16mm film with a 25mm lens, first you would look up the 25mm table. The tables have axes for both the focus and the *f*-stop. These tables are set up somewhat like mileage tables in an atlas, where you can look down a column and across a row to see how far it is from Minneapolis to Indianapolis. The sample table here includes only a few numbers but is representative of depth-of-field tables in general. **(SEE 6-16)**

If you are using a zoom lens, you can read the focal length off of the zoom ring. If the ring setting falls between numbers, you should probably round up to the nearest focal length for which you find a table.

In looking at these numbers, notice that there is always more depth of field behind the focus point than in front of it. This phenomenon has given rise to the ⅓-⅔ **rule**, which states that one-third of the depth of field is in front of the focus point and two-thirds is behind it. As a rule of thumb, keep in mind that there is always more depth of field behind the focus point than in front of it.

The shallowest depth of field is always in the lower-left corner of the table. Factors that maximize depth of field are in the upper-right corner. Note, however, that the maximum depth of field is not actually in the farthest upper-right box; it is actually down the column where we are focused at 10 feet. Here everything from 4 feet 7 inches to infinity is in focus. This is because as we draw the focus point closer to the camera, we continue to include infinity in the depth of field. You can easily see this on the depth-of-field markings on the lens barrel. If you are shooting at *f*/11 with focus set at infinity, the far end of depth of field will extend well past infinity. **(SEE 6-17)** You do not need to consult a philosopher to realize that the concept of "well past infinity" is absurd.

The point at which you are focused as close as you can be to the camera and still include infinity in the depth of field is called the **hyperfocal distance**. Each *f*-stop on each length of lens has its own hyperfocal distance because the depth of field expands and contracts with different *f*-stops. Hyperfocal distances are listed on most depth-of-field tables, and knowledge of them can be handy, particularly in documentary work, where many things may be happening spontaneously

6-17

Depth of field and focusing at infinity

© Cengage Learning

at different distances from the camera. Setting an arbitrary focus point for a specific depth of field, one that either includes or excludes objects in the frame, is a common practice.

Depth of Field and Setting Focus

In pragmatic terms, you should determine the depth of field in virtually every shooting situation. Let's say that you are shooting a scene in which one person is in the foreground at 8 feet and another is in the background at 15 feet. **(SEE 6-18A)** You have determined—though this, of course, is not always the case—that you want both people in focus. A light meter reading determines that you will be shooting at f/5.6. You consult the depth-of-field table and find that if you focus on the person in front, everything from 6 to 12 feet will be in focus. In this situation the second person will be out of focus. Conversely, when focused at 15 feet, the depth of field will be from 9 feet 3 inches to 40 feet, and focus will exclude the person in the foreground.

What would the options be if the goal was to have both figures in focus? As any clever person would be quick to point out, you can simply move the characters closer together. This is obviously a reasonable approach, and many minor difficulties can be solved in this manner. That said, do not get in the habit of allowing technical limitations to determine the content of your compositions. If for some narrative or aesthetic reason you wanted the character positioning to remain as designed, what would be some other options? The first would be to shoot at a higher f-stop, but that would require more lights. This is a relatively common solution, though we will skip over it for now.

The easiest solution here would be to pick a focus point that included both people. Another look at the table determines that if you set the focus at 10 feet, you will achieve the desired depth of field: both subjects will be in focus. **(SEE 6-18B)** There might be no object in the image that is actually 10 feet away, but the focus setting is arbitrary to achieve a specific depth of field.

Conversely, there may be situations in which you do not want both subjects to be in focus. If a situation has subjects at 10 feet and 14 feet and you focus on the first figure, the depth of field includes the second figure as well. **(SEE 6-18C)** If you want the second figure out of focus, you would consult the table and find that focusing at 8 feet would reduce the depth of field to everything from 6 feet to 12 feet, thus achieving the desired effect. **(SEE 6-18D)**

So the focus point can be set arbitrarily to achieve specific effects. If you wanted the foreground figure out of focus, you could find a focus point that would bring that about. All of this must be done in consultation with a depth-of-field table

6-18

Depth of field and setting focus.

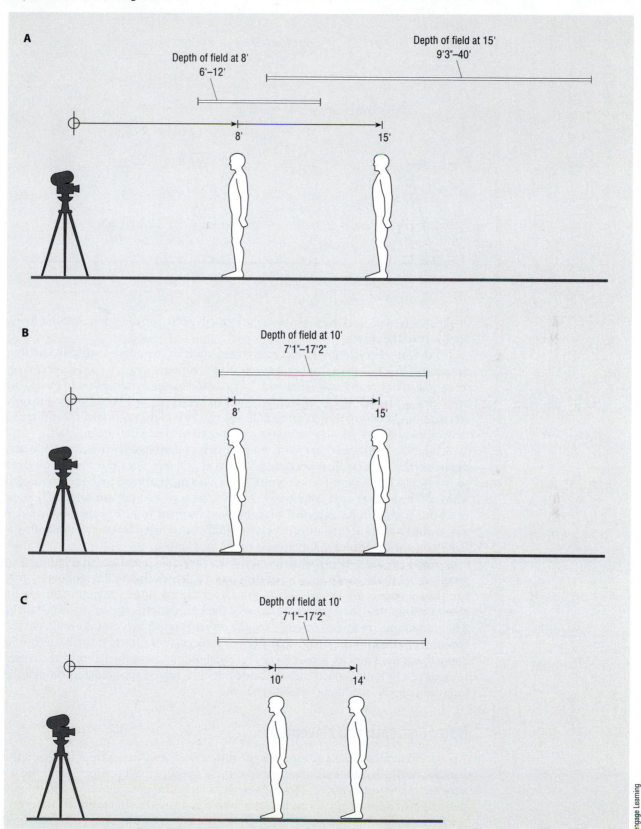

A

Depth of field at 15'
9'3"–40'

Depth of field at 8'
6'–12'

8' 15'

B

Depth of field at 10'
7'1"–17'2"

8' 15'

C

Depth of field at 10'
7'1"–17'2"

10' 14'

6-18

Depth of field and setting focus. *(continued)*

© Cengage Learning

or the hatch marks on the lens. Never arbitrarily shift a focus point without being very sure of the result.

As with everything, subject movement complicates these issues. In the first example, if the person in front moves toward the camera, a rack would be necessary to keep him or her in focus. That rack focus would certainly cause you to lose focus on the background person. If your goal was to keep both figures in focus, the only solution might be to bring in more light to achieve a higher f-stop. Consulting the table would tell you which f-stop you would need to create the effect.

The key concept is that focus points can be set arbitrarily to achieve specific depth-of-field effects. Just because a subject is at 8 feet does not mean you have to focus at 8 feet. As you set up your shots, you must always be concerned with what will be in focus and what won't. As suggested, you do not automatically want everything to be in focus all the time, but you do want to be in control of what is and is not. Achieving the effects you want takes extensive reference to depth-of-field tables and complex manipulation of the focus point.

For beginners, depth of field may seem more like an effect that happens to you—one of those characteristics of the nature of lenses that buffet and batter you. But the more control you are able to exert over the medium, the more you will be able to manipulate the variables to achieve the kinds of effects you desire. Often as a beginner you are forced to settle for the effect you can get; you do not have the resources to control the image that a larger project would have. If the background comes back out of focus, it may be because you did not have the lights or the lenses to achieve a different effect. This outcome might be largely unavoidable, though the long-term goal is to attain complete control.

Notes on Depth and Movement

An issue that requires clarification is the difference between depth of field and the concept of depth. Students often confuse them because both the terms and the issues are clearly interrelated. *Depth of field* is a technical consideration with highly defined parameters; it may be manipulated for aesthetic effect, but its determinants are technical. *Depth* is an aesthetic consideration in which you decide how you want your two-dimensional image to suggest space. If you want a decidedly

three-dimensional feel to an image, you must consciously manipulate elements in front of the camera to suggest depth. Lighting is a factor. Placement of objects in the foreground and the background is a factor as well. Depth of field is simply one more factor.

Movement is also affected by lens length. Wide-angle lenses are better for obtaining smooth handheld shots as well as complicated moves done on camera supports. The telephoto lens magnifies both the subject and any movement on the part of the cameraperson. Handheld shots done with very long lenses can be almost unwatchable when projected, even though no significant movement was detected while shooting. On the screen the image jumps all over—an effect that can cause symptoms similar to seasickness in the viewer. If you have to shoot some distance from the subject, such as when filming animals in a zoo, it can be difficult to use a wide-angle lens. A tripod is indispensable for this kind of filming. Normal lenses are simply in between the extremes of telephoto and wide-angle in both focus and the ability to be handheld. If both normal perspective and deep focus are desired, a lens on the low end of normal may be required.

Prime Versus Zoom

Although less true now than 25 or 30 years ago, prime lenses are still used more than zoom lenses because they have better optical qualities. Zoom lenses are complex, comprising a number of elements; and the more surfaces the light has to pass through, the more it deteriorates. Because of their relative simplicity, prime lenses generally give sharper images. This said, it should be noted that zoom lenses have been steadily improving, and some of the new zooms are billed as being the optical equals of their prime brethren. Cinematographers seem to be split pretty evenly on this issue. When you are going to be zooming, only a zoom lens will do. When the shot is static or if the camera is doing the moving, the prime lens is still the most common choice.

Cinematographers sometimes prefer a zoom lens because it gives them more compositional flexibility. If they want a slightly closer shot, they can just zoom in and not have to go through the time-consuming process of moving and releveling the camera. A zoom lens also can be handy for moving from medium shots to close-ups without having to change the setup, although there are some pitfalls when you do this.

The biggest concern is how the two lens lengths represent space. In the medium shot, a wall may appear to be several feet behind a subject, whereas in the close-up, when zoomed in to a longer focal length, it can appear to be just off the subject's shoulder. It can be disconcerting to have shots with differently represented backgrounds included in the same scene. Some cinematographers, usually with director input, will change the setup to maintain consistent spatial relationships. How this is handled will be your decision, and you will no doubt see scenes that approach it in both ways.

A further deterrent to the use of zooms is that rack focuses executed on zoom lenses can have a slight zooming effect. The moving front element of the rack focus does the same thing as the moving element of the zoom, only to a lesser extent; this is called **breathing**. It is difficult to see as the shot is being executed, but the effect can be quite disconcerting if it is not desired. Some of the newer zoom lenses have corrected this problem, but these are expensive and may be out of reach of novice filmmakers.

Zoom lenses can be attractive to many beginners; nowhere can you push or turn anything and get such immediate results. But because of this, zoom lenses tend to be overused. Infatuated with this minor but gratifying feature, students will zoom in and out ad nauseam. I discourage beginners from doing more than a couple of

zooms in their first films—and doing those only to get it out of their systems. When you start looking for zooms in films, you will be surprised by how few you see. Few directors use them intelligently, Robert Altman and Sergio Leone being notable exceptions.

Lens Mounts

Lens mount refers to the method by which the lens is attached to the camera. As with many situations in which manufacturers are competing for markets, lens mounts are not standardized. Arriflex has one mount, Bolex uses *C-mount* lenses, and the CP-16 has a different mount altogether. Both the Arri and the CP mounts are called *bayonet mounts*. The part of the lens that is inserted into the camera is called the **flange**. C-mount lenses have threaded flanges, and attaching them is a simple matter of screwing the lens in. Bayonet mounts have an extended pin that interlocks with the lens. Some lenses can be adapted to other makes of cameras, whereas others cannot be. For example, an adapter is available that allows some Arriflex lenses to be used on the CP-16 but not vice versa. The relationship of the rear element of the lens to the body of the camera is just too different to be matched.

The lens mount that has become somewhat of a standard was introduced by Arriflex with the first SR. The **PL** (positive lick) mount has become the closest thing to a universal mount around in the diverse world of camera manufacturers. It is an insert, turn, and click-lock into position approach that has proved durable and been adopted by companies beyond Arri, most notably Aaton. The high-end video world has seen some remarkable advances here. Many manufacturers have gone to an interchangeable lens mount system, particularly on several of the new digital cameras described in chapter 8. With the RED DIGITAL CINEMA cameras you can purchase the lens mount of your choice be it Canon, Nikon, PL, or RED's proprietary mount. If you have a variety of lenses available, you can buy the appropriate mounts and interchange mount and lens as necessary. The Black Magic Cinema camera includes a Leica mount as well, although it does not have proprietary lenses. There are obviously many different choices.

Whatever mount approach you choose, the area where the flange meets the camera is crucial. There is virtually no room for error in the flange-to-camera connection because it will affect the highly critical distance between the rear element of the lens and the film plane. If a lens is improperly seated—even slightly—whatever film is shot will most likely be out of focus. This leads to one of the fundamental rules of camera care:

■ **RULE** Never pick up a camera by its lens.

Picking up a camera by its lens puts undue stress on the flange area and will eventually cause the lens to be loose in its mount, leading to rear-element-to-film-plane difficulties. "Rear-element-to-film-plane difficulties" is code for disaster.

Many lenses, particularly zooms, are so heavy that they put undue stress on the camera's lens mount. These lenses generally have a **lens support system**, consisting of rods that extend from the body of the camera, to support the weight of the lens. This is a common strategy in 35mm shooting. A lens that is too heavy may damage the lens mount if not properly supported.

When deciding on lenses, make sure you have an appropriate match of lens and camera. When you are using equipment from a rental house, they will know the appropriate lenses, even though it is still your responsibility to make sure everything works together. Low-budget filmmakers often borrow equipment, such as a special lens, from a friend of a friend and the camera from some other source altogether. You can run into trouble in this sort of situation. To be sure the pieces match, shoot a test roll.

The lens should not be mounted on the camera when it is being transported. Again, the flange area is critical, and any shocks to the camera while the lens is mounted can jar the lens position. A bumpy ride in a car might cause significant focus problems. The lens should be packed in a material that will absorb as many shocks as possible.

Front-Filters and Matte Boxes

Virtually all lenses have some method of front-mounting filters. Most **front-filters** for 16mm lenses are round, thin glass pieces that can be mounted in rings that screw into the front of the lens. **(SEE 6-19)** Several lenses use rectangular filters that are mounted in a holder that attaches to the front of the lens, an approach more common in 35mm. **Series 9** filters (*series* refers to a size) and their attendant ring adapters are the most common in 16mm, particularly for zoom lenses. These rings are designed to screw into each other, so a director of photography can sandwich as many filters together as desired. The more surfaces the light passes through, however, the more its quality degrades. When multiple filter effects are needed, DPs generally prefer single filters that combine effects, or they sandwich no more than two filters at a time.

A **matte box** is an accordion-like bellows attachment that is mounted on the front of the lens. **(SEE 6-20)** It can be used to mount filters or to shade the lens from direct light. A **sunshade** is also used for this latter purpose. The matte box was originally designed to create shots that matte out (block light from) certain areas of the frame. The mattes are generally made out of heavy board or metal and are inserted in the front of the matte box. They can be used to create a variety of patterns (keyholes, binoculars, question marks, and such) or, in conjunction with a camera's backwinding function, to make multiple passes on the film, blocking out areas intended for other information in later passes. The most common example of this is the split-screen effect, in which you see two separate images side by side on the

6-19

Most front-filters for 16mm are round, thin glass discs mounted in rings that screw into the front of the lens.
© Photo courtesy of Bruce Mamer.

6-20

A matte box is an accordion-like bellows attachment mounted on the front of the lens.
© Photo courtesy of AbelCineTech, Inc.

screen. You block off one side of the lens on one pass and then block off the other side on the next pass. As attractive as this feature might appear, this type of matting is done infrequently. Most matte shots are now done with blue or green screen mattes, on optical printers, or with the aid of computers.

Care and Maintenance

All modern lenses have a purplish antireflection coating. This coating reduces stray light bouncing around in the lens—a phenomenon that reduces **contrast**, the play between light and dark in a photographic image. If a lens is cleaned unnecessarily, that coating will eventually wear down. Clean a lens only if there is some noticeable mark, such as a smudge or fingerprint—then clean the lens immediately. The oil from your finger can etch a permanent pattern in the antireflection coating if it is left for any significant amount of time.

■ **RULE** If a lens is not dirty, don't clean it. If it is dirty, clean it immediately.

When you do have to clean a lens, use only the materials specifically designed for the purpose: commercially produced lens-cleaning tissue and lens-cleaning fluid. The tissue should be used first, the drops only as a last resort. If there is substantial dust or grit on the lens, clean it off with a camel-hair brush before using tissue; otherwise the dirt can get into the paper and scratch the coating and possibly the lens itself. I roll up the tissue like a cigarette, then swirl the end around the mark until it's gone. If this doesn't get rid of the mark, then, and only then, I use lens-cleaning fluid in conjunction with the tissue.

When you have to use the fluid, put a drop on the center of the lens and use the tissue as just described. This should get rid of most anything. Be careful that the fluid does not run down into the area where the glass meets the barrel of the lens. All lenses are cemented into position, and the fluid, if not used carefully, will eventually start to break down that cement. If the cement gets broken down, any shock to the lens could cause an element to shift. The distance between the elements and the film plane is precisely engineered, so movement of even a fraction of a millimeter will seriously degrade the image. Shocks to the lens should be minimized, but transportation is the biggest culprit; excessive heat can also weaken the cement and cause problems.

These recommendations also apply to filters, and their care is also a significant issue. It would be foolish to spend half an hour cleaning a lens only to put a dirty filter in front of it. If anything, you will see the AC spending more time with filters than with the lens itself.

There is substantial disagreement about the role of dust on the lens and filters. Some people claim it reduces contrast; others say that a modest amount has no significant effect because it could not conceivably be in the range of focus. It is virtually impossible to eliminate all dust, but cleaning is called for if there is a substantial amount of it. The camel-hair brush is the tool of choice for this job.

As important as the front element of a lens is, always check the rear element as well. Given that the lens is removed frequently to check the gate for hair or to mount a new lens, dust and marks can be a factor here as well. In fact, something on the rear element degrades the image more dramatically than does a front-element mark. Anything that may degrade the quality of the light must be avoided at all costs, so be sure to check both ends of the lens.

The flanges of both the lens and the mount on the camera should be cleaned as well. If a piece of dirt or grit gets lodged between the lens and the camera, it can actually change the distance between the rear element of the lens and the film plane. Again, even the slightest shift can jeopardize the sharpness of the image. Alcohol and a sponge-tipped swab are the accepted materials for cleaning these critical areas.

Don't make the mistake of cleaning a lens with alcohol and swabs, even though these items are part of a standard cleaning kit. This would make the antireflection coating look like the swirls on a poorly cleaned window. It is extremely important to use the appropriate materials on the appropriate parts. Do not use facial tissue. Do not use a corner of your shirtsleeve. Do not attempt to blow the dust off with your breath; no matter how hard you try to avoid it, you will get spit on the lens. Watch how ACs take care of their lenses, and develop your own good habits from the start.

Any discussion of lenses can get quite complicated. Optics is a highly developed science, and lenses are extensively researched and tested. You will eventually hear such terms as *astigmatic aberrations*, *coma*, and *longitudinal chromatic aberrations* as well as an endless list of technical reasons why what's in front of the camera never arrives at the film plane in perfect shape. To avoid these problems, remember that any lens is an amalgamation of compromises. The manufacturer had to give up one thing to get something else. Older zoom lenses in particular can sacrifice quite a bit of sharpness to get longer zoom ranges. The molded-plastic lenses in cheap cameras give up just about everything. These kinds of optics will simply not do for motion pictures. If you start with an impoverished image, there may not be much left by the time it has been projected 90 feet.

Still, there are lenses that yield beautiful results and, with proper use and care, will serve your needs for many years. Cinematographers tend to latch on to specific lenses and go to great lengths to hold on to them and care for them. Start thinking about how you want a lens to perform and which lenses live up to your standards.

Capturing the Film Image

Film Stocks and Processing

In the heyday of motion picture origination, the film that was shot on-location was always workprinted after processing; a **workprint** is a frame-for-frame contact-printed copy made from the original film. All of the work in the editing room was done with these hardy stand-ins, which absorbed the punishments (scratches, dirt, and breakage) of the editing process. When it came time to finish, a project returned to the original film for the creation of final prints. There are still some reasons to workprint your original film, and they are still made occasionally in the feature world. Their role in the editing process has diminished with the complete acceptance of digital editing. The role of the original has evolved as well. Many times it is never returned to after initial transfer, or it is used only for a further upstream transfer to video.

Construction of the Film Stock

Film stocks are distinguished by a number of factors. These include the stock's general construction; the *exposure index (EI)*, which rates the film's responsiveness to light; the *color balance*, which is the way the stock responds to different colors of light; and the *latitude*, which is the range of lighting values within which a film stock will produce a usable exposure. Although latitude is important in choosing a film stock in a limited way, it is intrinsic to discussions of lighting and is covered in part IV. All of these other elements are primary factors in choosing a film stock.

Motion picture film is a strip of celluloid covered with a light-sensitive emulsion. As discussed in chapter 5, it has **sprocket holes**, which facilitate the movement and thus the exposure of the film. The construction of color stock can be quite complex, but black-and-white film is relatively simple. Black-and-white film has several layers of coatings and adhesives but is essentially made up of three basic elements: emulsion, base, and antihalation backing. **(SEE 7-1)** Film that has not yet been exposed is referred to as **raw stock**.

The **emulsion** is a solution of **silver halide crystals** suspended in a gelatin bath. When these silver halides are struck by light—that is, exposed—their properties change. Their properties are further changed when the halides are subjected to chemical developers. In the case of negative film, the exposed halides harden and become opaque. In reversal film, the film is bleached or re-exposed to reverse the areas that would be opaque in a negative. Either way, the film is barely touched by the light as it leaves an imprint. The analogy of a fingerprint can be invoked here. The chemical

processing brings out the latent qualities of this "fingerprint." The emulsion side of unexposed film is a neutral color, usually tan or light green.

The most significant difference in the construction of different film stocks is the size of the silver halide crystals and how closely they are packed together, which determine the film's sensitivity to light. Film stocks with large, loosely packed silver halide crystals respond better to low volumes of light. Film stocks with smaller crystals and tighter construction require more light to expose them. Again, this is what the EI rates.

If the silver halide crystals are large, they can be discernible to the viewer as shimmering building blocks of the image, called **grain**. Grain is similar to **pixels** (short for *picture elements*) on a video screen. The smaller the grain and the smaller the pixel, the less likely a viewer is to notice that the image is made up of dots. In the majority of commercial films, substantial effort is devoted to making grain as unnoticeable as possible. Larger grain is used to good effect in many films with a highly expressive image, calling attention to the construction of the photographic image and enhancing its abstract qualities.

The **base** is the celluloid medium on which the emulsion is laid. The opposite side of the film, the **antihalation backing**, is a dark and shiny coating that minimizes reflections that can cause bright areas to bleed into adjacent parts of the frame. In the early days of still photography, film had no antihalation backing, and the camera operators, under a light-tight hood, actually looked through the base of the film as they were filming. Before the development of modern viewing systems, this was the way photographers checked composition. The antihalation backing is completely removed in the developing process.

Color film stocks have a much more complicated construction. Although there are a number of different processes for making these stocks, the industry-standard color negative stocks are probably the best example. They work on the principle of separating colors into three different layers of emulsion, with dye couplers and interlayer filters incorporated into the design. Each layer is sensitive to one segment of the color spectrum, although the segments do not break down simply into the three primary colors of light: red, green, and blue (referred to as **RGB**). The top layer records the blue record, the next layer the blue and green record, and the final layer the blue and red. The base and the antihalation backing are the same. There are other designs, but this one is fairly typical.

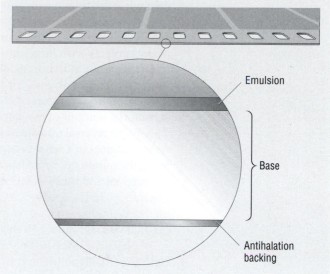

7-1

Black-and-white film stock is composed of emulsion, base, and antihalation backing.

Emulsion

Base

Antihalation backing

© Cengage Learning

Negative and Reversal

Raw stock for cameras comes in two forms: negative and reversal. Most readers are familiar with **negative film**, which has all of the lights and darks reversed from how they are normally perceived. **Reversal film** is the opposite: all colors and shades are rendered normally, photographic slides being a common example. As you get further into studying general production, you will also want to learn about the great variety of print stocks and other specialty stocks.

Negative stock cannot be used as a primary projection medium but must be transferred to another vehicle. In the case of film it must be printed onto a second piece of film that is a frame-for-frame replication of the **original**—that film that

actually ran through the camera when shooting. Obviously, transfer to video is the other option, and in this day and age a more common alternative. In the conventional film editing stage, duplicate prints are again called *workprints* and are made by a motion picture processing laboratory, or **lab**. Because of the possibility of damaging the fragile emulsion, the original is touched only when absolutely necessary. Except in a few limited applications, the original is never projected. A film's original also serves as the source to produce the final product—a **projection print**. Many projects with larger budgets and wide distribution plans also employ intermediate prints. When transferred to video in initial stages, many projects used to return to the film original for high-end video finishes or film prints. Finishing from high-resolution transfers or electronically writing the video to film has eliminated a substantial amount of this later-stage postproduction use of the original film.

With reversal film, the reversing process is another level of manipulation. The reversed original in a sense becomes the second generation of the negative, a **generation** being the number of copies away from the original. A workprint is one generation from the original and thus is a second-generation print. A print of a print would be a third generation. In the analog world, the farther one gets from the original, the more the quality degrades, which is why so many versions of early films have lost much of their original visual grandeur. In this process, grain and contrast increase.

Negative stock is the professional standard. It generally yields an image with tighter grain structure and is responsive to a wider range of light values. Negative film stock also provides a higher-quality transfer to video, further cementing its dominant position. Virtually all commercial features are shot on negative film.

Negative stock being the standard has led to some confusion in terminology. In the press and trade journals, the camera original produced on-location is often referred to as the "negative," leading one to think that *negative* and *original* are synonymous terms. But if one shoots reversal film, an admittedly infrequent occurrence these days, the piece of film that ran through the camera is an original as well. Even when the original is on reversal film, which can be projected without a print, workprints are made when protecting the original is desired.

Color Balance

Before covering raw stocks, a discussion of color is in order. All types of light sources have their own color qualities. Daylight is generally somewhere close to white. Tungsten light, is reddish orange (referred to here as *amber*). CFLs are generally slightly more amber than daylight. Standard fluorescent light is, ugh, green.

The film stock and our eyes respond to the colors of these light sources differently. When we are under tungsten light, do we perceive it as amber? When we are under fluorescent light, do we perceive it as green? If you look carefully, you actually will perceive these colors. In reality, though, you probably don't pay much attention and instead average everything as a relatively even color—white.

Film, of course, does see the difference. Video does as well. If a light source is amber, amber is the color of the light reaching the film plane. **Color balance** refers to the way that color film stocks are designed for different types of light sources. If you are shooting in amber light (tungsten), the film stock must be appropriately balanced so that viewers of the film see that light as white.

The distinct color of a given light source is rated by its **color temperature**. Color temperature is measured on the **Kelvin (K)** scale, which refers to the temperature at which a black-bodied object—a surface that does not reflect light—changes color as it is heated. Most people have seen films on making steel and know that as metal is heated it changes color: first to amber, then yellow, then white, and finally blue. The temperature at which the black object turns a specific color is arbitrarily assigned to the color of a light source. **Tungsten (T)** lamps rated for motion picture photography produce light at 3,200K (they produce the same color as a black-bodied surface when heated to 3,200 degrees F). **Daylight (D)**, or photographic white, is considered to be 5,500K.

Other light sources produce light that falls at different points on the Kelvin scale. Standard household tungsten bulbs (60-watt, for example) are less—say, 2,800K to 2,900K. Fluorescent light, lacking a true color temperature because its light consists of many wavelengths of the visible spectrum, reads at about 3,800K. An overcast day will actually be blue and can range from just above 8,000K to 20,000K.

Tungsten and daylight color temperature are the two that are most significant in photography (T = 3,200K; D = 5,500K). All color film stocks are balanced to one of these two temperatures—color temperature is not an issue when shooting with black-and-white.

Shooting under the wrong light with the wrong film will yield strange results. Many of you have probably seen this in personal still photographs. If you shoot with daylight film under tungsten light, the film will come back with an orange cast. If tungsten-balanced film is shot in daylight, the film will come back with a blue cast.

So what is going on when you shoot under tungsten light with a film stock balanced for tungsten light? The color of the light is amber, but you want the film to read it as white or normal. The manufacturer has simply made the red component of the film less sensitive than the green and blue layers. There is physically less emulsion that responds to the red area of the spectrum. Being less responsive to the red segment, the film stock will read amber light as white light. **(SEE 7-2)** Daylight stock is simply balanced to see white light as white.

The practical application of this seems obvious: just shoot with the right stock in the right situation. Of course, nothing is ever that simple. The first problem arises when you have to move from a tungsten situation to a daylight situation. Switching rolls can be time-consuming and can require too much handling of the film, so a method was devised to use a stock balanced for one source under the other source. That is, there had to be a way to use either a film stock balanced for daylight under tungsten light or a film stock balanced for tungsten light in daylight.

For a variety of reasons, mostly having to do with versatility, the latter approach (choosing tungsten film and adapting it to daylight) is prevalent. To use tungsten-balanced film stock in a daylight situation, the adjustment is straightforward: simply use an 85 filter, which is amber colored. **(SEE 7-3)** The 85 filter takes the white light of daylight and adds an amber component to it. The tungsten-balanced film, which reads amber light as white light, then renders that light as white.

7-2

The red layer of tungsten-balanced film is less sensitive than the green and blue layers; hence it is less responsive to the red area of the spectrum.

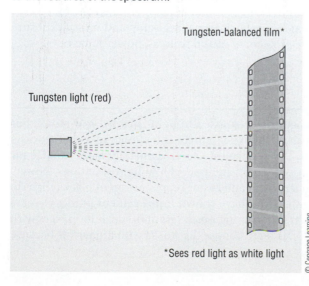

Tungsten-balanced film*

Tungsten light (red)

*Sees red light as white light

© Cengage Learning

7-3

Using an 85 filter when shooting tungsten-balanced film in daylight turns the white light red, which the film then reads as white.

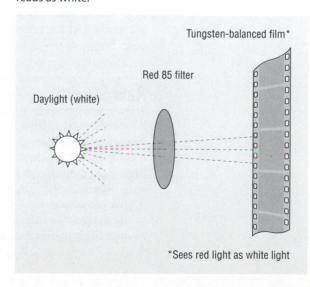

Tungsten-balanced film*

Red 85 filter

Daylight (white)

*Sees red light as white light

© Cengage Learning

To state it another way, the 85 filter turns the white daylight to amber, and the tungsten-balanced film stock then reads it as white.

Why bother going through all of this? The reason is that the alternative has tremendous drawbacks. Shooting daylight-balanced film stock under tungsten light requires the use of a deep-blue 80a filter. All filters reduce the amount of light reaching the film plane. The 80a filter cuts out two and two-thirds stops of light, whereas the 85 filter cuts out just two-thirds of a stop.

The problem with using an 80a filter becomes apparent in almost any situation in which you try to take a daylight stock into a tungsten situation, a circumstance in which you are usually going from a bright area (outside) to a darker area (inside). If you lose two and two-thirds stops of light to begin with, you may not have enough light to get an exposure. Add to this the probability that you started with a pretty low-EI stock, needed for exteriors, and you can see how untenable the situation becomes.

Thus, the 85 filter makes much more sense because of its versatility. For that reason a majority of color film stocks, particularly those designed primarily for professional use, are balanced for tungsten light. For several years 16mm daylight-balanced color negative film stocks were not available from the most prominent manufacturers. This lack has been rectified, but tungsten-balanced film still dominates the field.

Most manufacturers recommend a different EI that automatically adjusts for the two-thirds stop lost by using an 85 filter. On the film's packaging, you will find one EI for tungsten light and one EI for daylight. After the daylight EI, it will always say "with 85 filter." The daylight number is always lower than the tungsten number, and the 85 filter is the reason why. The manufacturer is simply compensating for the lost light in the EI.

To make the correction from tungsten to daylight, glass front-filters can be mounted on the lens. Virtually all lenses have ring adapters that screw into the lens. Rather than use the front-filter method, some cameras have a filter slot directly in front of the film plane into which you can insert a small piece of **gel**—a colored, cellophane-like material that changes the color or quality of the light.

This is all still relatively uncomplicated. If you are outdoors shooting with a tungsten-balanced stock, you use the 85 filter. If you are indoors shooting in tungsten light, you do not. This issue would appear destined for the minor-details department except that complexity is added when you encounter a mix of several light sources with different color temperatures. Lighting crews spend a substantial amount of time on this, and it is an issue that eventually will have you jumping through hoops, too. (See chapter 15 for further discussion.)

Video has a different and in some ways simpler way of dealing with this. (This will be discussed further in chapter 8.) Many cameras, particularly DSLRs, simply offer a menu setting where one can choose a specific color temperature, ranging from household bulbs to overcast days. Barring that, the camera can be white-balanced by putting a white card in front of it and adjusting the electronics to see the card as white. Front-filters are unnecessary, making setup and messy exposure considerations much easier. The problem of mixed sources, however, persists.

Raw Stocks

As stated earlier, film that has not been exposed to light is called **raw stock**. For beginning cinematographers the primary factor in the choice of a raw stock is usually the film's speed—the EI. Lower-speed stocks are generally more suitable for high-light conditions; higher-speed stocks are used in low-light situations. Lower-speed stocks have tighter grain structure and better reproduction of blacks than do higher-speed stocks, although the latter have shown improvement in recent years to the extent that this distinction is becoming much less an issue. Filmmakers with limited resources and smaller lights often choose the stocks with higher EIs because

of their versatility when working with low volumes of light and the greater depth of field achieved with the resulting higher f-stops.

Color Stocks

The bulk of commercial work is done in color and is shot predominantly on negative. The preponderance of general black-and-white shooting is done on reversal, although negative should be seriously considered for advanced projects.

Color reversal film stocks were very popular prior to the advent of video because they did not require printing to be viewed. Applications where scratches and permanency were not major issues, such as television news and amateur sporting events, used miles of reversal film because the film would just be slapped onto a projector or *telecine*, the latter used to transfer film to video and soon to be a key player in our discussion. If destined for a projector, the film would be shown as frequently as needed and then put on a shelf or in a garbage can, never to be seen again. Once this "shoot and show" function was taken over by video, the higher quality of negative stocks ensured that they would become the standard for professional work, at least in color.

A few color reversal stocks are still being produced, but lower image quality and inadequate lab support make them less desirable. Indeed, Kodak discontinued production of four of its five color reversal stocks at the end of 2004, leaving Kodachrome and a new Ektachrome 100D as its only options. Sadly, but probably unavoidably, Kodak discontinued Kodachrome a few years later, ending close to 80 years of rich color and muting a popular Paul Simon song. Kodachrome was actually never much of a player in motion picture film, because it did not print well to downstream stocks. Either way, with the discontinuation of many reversal stocks, the world has become a negative place, at least for color film.

There is currently only one major producer of color film stock being sold in the United States: Kodak. Fuji was a long-term producer but got out of the camera original motion picture film market in 2012. Kodak is struggling to emerge from bankruptcy, but its raw stock is still being produced and hopefully will be available long into the future. When Fuji was still a player, each manufacturer's film stocks had a slightly different look, both boasting excellent color rendition, tight grain structure, and good reproduction of dark areas in the frame. Now Kodak is the only choice, albeit one with many excellent stocks and a reputation for serving the industry for well over a century. The best way to learn about the characteristics of individual stocks is to shoot the film and talk to labs and DPs who have dealt with the specific stocks. Check with Kodak about student discounts.

The film stocks that these manufacturers produce change according to technological developments and are driven by the demands of the industry. Any list of stocks will eventually become out of date, although some considerations remain constant. Film stocks are usually referred to by their numbers—for example, Kodak 7230. Although 35mm has a more significant share of the market, the following discussion focuses on the 16mm stocks frequently used by students and independents. Most 35mm stocks have 16mm equivalents and given the ease of applying an emulsion to a smaller stock, should be available indefinitely.

The chart in figure 7-4 shows the stocks designed for tungsten that are available as of this writing. **(SEE 7-4)** All stocks come with the two EIs; the lower rating is for daylight, reflecting the compensation for the light lost when using the 85 filter.

7-4

Available tungsten-balanced stocks, including Kodak's Vision camera films.

	Kodak		
	Vision3	Col Neg	EI
Midrange Speed	7213		200 (T) 125 (D)
High Speed	7219		500 (T) 320 (D)
		7230	500 (T) 320 (D)

© Cengage Learning

7-5

Available daylight-balanced stocks.

	Kodak		
	Vision3	Col Neg	EI
Low Speed	7203		50 (D)
		7201	50 (D)
High Speed	7207		250 (D)

© Cengage Learning

The most surprising trend in film stocks has been the resurgence of daylight-balanced negative film stocks. Selection was very limited for many years, but demand evidently convinced manufacturers that there was a market. In fact, many years ago Fuji discontinued its low-rated tungsten stock, F-64, which was commonly used by filmmakers outdoors with an 85 filter. Modern higher-EI stocks had tight-enough grain structure for interior use and the daylight stocks eliminated exterior use. Kodak now offers three daylight-balanced stocks, one high-speed version and two low. **(SEE 7-5)**

The other big trend is the introduction of more archival, print, and Digital Intermediate (DI) stocks. As suggested in the preface, one of the big growth areas in film is as an archival medium for projects shot originally on video. Kodak has a Color Asset Protection film and a Color DI film stock, both designed for transfer from video either from tape or from files. They also have new print stocks, several in color and one for black-and-white. **(SEE 7-6)** While discontinuing its shooting stocks, Fuji continues to produce its archival stocks as well as ones designed specifically for the DI process. **(SEE 7-7)** Both Kodak and Fuji's archival stocks can be used for the three-strip process, in which one roll of film is devoted to each of the primary colors of light—red, green, and blue. Both companies promote archival properties that will last at least for 100 years and suggest the possibility of longer. Again, asset protection is becoming a huge issue. If our ancestors are still watching *The Office* in 2112, well, more power to everyone involved.

The manufacturers generally do not list tungsten ratings on daylight film stocks because the 80a filter needed reduces the EIs to such an extent (two and two-thirds stops) that the stocks become virtually impossible to use. The higher-speed daylight stocks are actually difficult to use in bright exteriors because the high EIs yield higher *f*-stops than many lenses have. They are primarily designed for arena and stadium shooting, where the lighting produces 5,500K or thereabouts. The high-speed Vision stocks have become extremely popular with students and indies as well as throughout the industry. Fuji also offers one high-speed color reversal stock.

7-6

Kodak's archival and intermediate stocks.

Color Asset Protection Film 2332

Color Digital Recorder film that offers affordability, high quality, and excellent dye stability

VISION3 Color Digital Intermediate Film 2254/5254

Color Digital Intermediate Recorder Film that also offers excellent dye stability

© Cengage Learning 2014.

7-7

Fuji's archival and intermediate stocks.
© Cengage Learning 2014.

Black-and-White Stocks

The situation with raw stock is the opposite in black-and-white, with reversal getting more extensive use. Although a few notable exceptions come to mind, such as Martin Scorsese's *Raging Bull* (1980), Spike Lee's *She's Gotta Have It* (1986), and Jim Jarmusch's *Coffee and Cigarettes* (2003), the majority of black-and-white stocks are on nonprofessional projects. These include early student exercises and projects by producers who have not switched over to video, such as at high schools that do not have adequate stadium lighting to support low-end video cameras. Thus, reversal is dominant and more plentiful than negative, and filmmakers will have an easier time finding competent processing for reversal. If the final product is going to be a film print or a high-end transfer to video, however, negative should be considered. You may have to do some modest searching for both the stock and high-quality laboratory services, but if image clarity is a goal, negative is the better choice.

Kodak is, and has been for many years, the only manufacturer of black-and-white films, although their offerings have been reduced to one negative and one reversal stock. Black-and-white film stocks list an EI for both tungsten and daylight, with the tungsten rating being lower. This, of course, has nothing to do with color temperature. Black-and-white film is less sensitive to the red area of the spectrum mostly due to darkroom use of red lights, and thus the lower EI means that the manufacturer is recommending slightly more exposure under tungsten light. Black-and-white stock generally costs about two-thirds the price of color. **(SEE 7-8)**

Product catalogs list several other choices you need to make. One is whether to buy the film on core loads or daylight spools. This decision depends largely on the camera you are using and, to a lesser extent, the size of the shoot. Smaller cameras generally require 100-foot daylight spools. Although most magazines can be loaded with daylight spools, 400-foot core loads are the professional standard for magazine-loading cameras in 16mm; 35mm is available in 100-, 400-, and 1,000-foot loads. Another choice in 16mm is between single-or

7-8

Available black-and-white stocks.

	Kodak			
	Negative		**Reversal**	
	Film Stock	EI	Film Stock	EI
High Speed	Double-X	200 (T) 250 (D)	Tri-X	160 (T) 200 (D)

© Cengage Learning 2014.

double-perf film. Kodak has reduced its offerings in double-perf film at least partially because of the greater demand for Super 16.

Catalog numbers and ordering information can be found online and in product brochures. The film business being what it is, manufacturers are wary of sending stock without a 100 percent guarantee of payment. Establish credit if possible or be ready to pay up-front. Personal checks generally must clear before products are shipped. Unencumbered credit cards open all doors.

Edge Numbers

In a conventional film edit, the workprint is used for the hard work of editing. The original is then "conformed" to what the editor has done in the edited workprint. This process of matching the original to the workprint is generally done by a contracted professional called a **negative cutter** (see chapter 18). Clearly, reference points are needed between the workprint and the original. **Edge numbers**, also referred to by Kodak as *key numbers*, are latent information that each manufacturer photographically imprints between the sprocket holes on all raw stocks. As the image is processed, the numbers develop as well and are printed through to the workprint, serving as critical guideposts for conforming the original film to the edited workprint. All films now are also barcoded, giving the edge numbers as well as other information.

Edge numbers come every 20 frames (6 inches) in 16mm and every 16 frames (1 foot) in 35mm. **(SEE 7-9)** There are actually three sets of information. The first set of letters and numbers (κM63 in figure 7-9) refers to the date produced and the emulsion batch. The other two sets (0646 and 6104) are part of a sequence of ascending numbers that go from the head of the film to the tail. The frame that is 20 frames toward the tail would be identified as 0646, 6105. Twenty frames farther on would be 0646, 6106, et cetera. Kodak also identifies what is referred to as the **zero frame**, the frame on which the counting of each sequence of 20 frames starts, by a small dot above the κ (for Kodak) in the first set (κM63 in figure 7-9). On Fuji stocks, which one may still run across in postproduction, it is similarly placed above an F. The zero frame is important for the negative cutter in counting frames for matching the original, and it has become even more important in preparing for a transfer to video.

Barcoding, called Keycode by Kodak and Mr. Code by Fuji, is mostly used for referencing between videotape and film. Along with the still-present edge numbers, the barcodes are located between the sprocket holes and provide an electronically readable output of the corresponding edge numbers. The barcoded edge numbers can be referenced with a video's *time code*, video's version of edge numbers, in the process

7-9

Edge numbers are used primarily as guideposts for conforming the original to the edited workprint.

Zero frame

of transferring the film to video. Once a video edit is completed, the time code can be translated back to edge numbers, and a film print can be made. This system is very workable, but it has a number of pitfalls that are explored in chapters 9 and 15.

Processing

Motion picture film must be taken to a professional lab for processing. Although the services required of a lab can become quite complex, initial services on a film usually consist of processing the original and possibly making a workprint. Unlike home-based still photography, where a short piece of film is loaded onto a small reel to be developed, motion picture film processing requires large tanks to accommodate the longer camera loads. The film is moved on rollers and dragged through the processing chemicals. This procedure ensures that layers of film do not become sandwiched together, which would impede the chemical process.

Today finding the processing services you need may mean dealing with a number of far-flung labs; students and independents outside of major urban centers may have to do some searching. Lab services are generally expressed in cents per foot; processing might cost 10 cents per foot, for example. Although the figures look small on paper, they add up quickly enough. A number of labs have student pricing, a boon to any on-the-edge producer. You might find one lab that charges 45 cents per foot for processing and workprinting and another that charges 30 cents with a student discount. The difference between these two prices may not amount to much for a commercial project, but for a student it can be significant.

Working with labs is one of the realities of the field, although jury-rigged processing can be done to create extraordinary effects. It is said that the North Vietnamese processed their propaganda films in garbage cans during the Vietnam War. One of the most beautiful student films I have ever seen was self-processed, with the sandwiching causing the sprocket patterns on the unprocessed layers to swirl in abstract designs. The approach is not useful, however, unless you are willing to accept the attendant effects.

Printing

The processed original is then loaded on a **printer** to make the workprint. A piece of raw stock is sandwiched with the original, and the workprint is thus a frame-for-frame **contact print**. **(SEE 7-10)** Printers have one high-wattage bulb that shoots a single piece of bright light toward the film gate. In the path to the gate, there is an upper and a lower level of filters and front-surfaced mirrors, each positioned at a 45-degree angle. The upper level separates the light into its three primary colors—red, green, and blue. The now three separate paths of light have a shutter-like device that can be opened and closed to individually control the volume of each color in the print. These valves are generically referred to as the **printer lights**, and their role throughout the entire photographic process is essential. The path of the light generally resembles the illustration. **(SEE 7-11)**

The first filter on the top row diverts all of the red light down through the light valve. It allows all of the blue and green light to pass through to a second filter, which diverts the green light down to its own light valve. A front-surfaced mirror diverts the remaining blue light to a third valve that controls its volume. The bottom row recombines the three lights to expose the film at the printer gate. The intensity of the three primary colors of light in the printer can thus be adjusted to achieve an effect the DP is trying to obtain or to compensate for any mistakes in exposure or color. The control of each RGB color is broken down on the printer into what are called **printer points**. The points run from 0 to 50; a nominal perfect exposure theoretically is right in the middle at 25, with less light below and more light above.

7-10

Making a contact print involves sandwiching the processed film with a piece of raw stock.

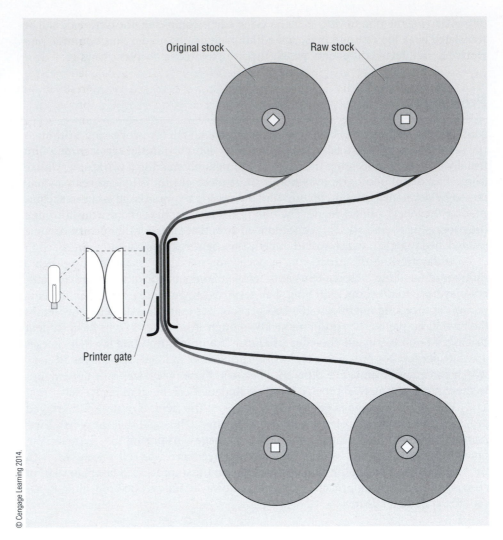

Original stock

Raw stock

Printer gate

© Cengage Learning 2014.

7-11

Path of light in film printing.

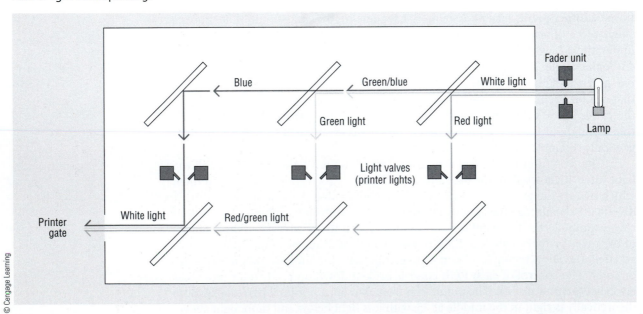

Fader unit

Blue Green/blue White light

Lamp

Green light Red light

Light valves
(printer lights)

White light Red/green light

Printer
gate

© Cengage Learning

If you are willing to pay for it, prior to workprinting the original can be put on an analyzing machine, where overall color and exposure are evaluated. The machine used for this is generally a **Hazeltine**, though other companies have produced equipment designed for this purpose as well. The original is loaded into the Hazeltine, which shoots light through the original and gives a video representation of the image. Just as on the printer, this light is broken down into RGB components. A lab employee, the **timer** or *grader*, can go through the entire film and analyze each shot for color and exposure.

The printer lights—the actual volumes of red, green, and blue—are thus determined on the Hazeltine. In the workprinting phase, these controls are mostly used very generally. If a roll was consistently underexposed on-location, the lights can be dialed to compensate. If a roll is too blue, for example, the appropriate light can be dialed to reduce the amount of blue. The manipulation of these printer lights is also a critical element in the creation of the final print, with the timer analyzing each individual shot. Further applications are covered in detail in chapter 18.

As stated, most labs price their services in cents per foot. Processing for 16mm may cost 15 cents per foot, and a workprint may cost 25 cents per foot. Labs usually list prices for three types of workprints.

- **One light.** Also called *standard light*, this type of workprint is the least expensive, with the lab using its accepted norm in the printer. Standards vary from lab to lab, with temperatures and processing times being the major variables. The film is not analyzed on the Hazeltine. This is often not the best choice for beginners, who may have exposure difficulties.

- **Best light.** This type of workprint is more expensive and indicates that the timer will look through the negative on the Hazeltine and, given their experience, choose the best light for the entire roll. This is often the best approach for newcomers, who are learning the complexities of exposing and processing film.

- **Timed.** In this type of workprint the timer checks the original and determines the best printer light for each individual shot. This option is very expensive and is used only infrequently, even for projects that might potentially have the budget to support it.

Communication about such issues should be as clear and unambiguous as possible. Mistakes are costly and could jeopardize the integrity of the exposed film itself. Other information that needs to be communicated to the lab is covered later in this chapter.

There are fewer motion picture laboratories today than there were 30 years ago, and finding the right one will take some research. The video revolution has reduced the demand for processing and, particularly, workprinting. This loss of business eliminated most of the labs that processed limited amounts of film, particularly in small urban areas. Only labs in the largest and most film-active American cities have been able to stay in business. Start collecting lab brochures, online information, and price lists to determine which ones provide the services you need at a price that is acceptable. All labs have Web sites where this information can be found. As labs become more dependent on big jobs from commercials and feature films, finding high-quality processing and reliable service is becoming increasingly difficult for students and independents, a reality sadly complicated by irresponsible independents who fail to pay bills. Despite this there are still many labs that wisely see newcomers as the future of the business. Try to talk to film teachers or independent filmmakers in your area to find out which labs have provided good service.

Projectors

Thomas Edison and W. L. K. Dickson are generally credited with creating the first motion picture camera, but it was the Lumière brothers, Auguste and Louis, who resolved the dilemma of an appropriate presentation device. In Paris on December 28, 1895, they projected a motion picture on a screen to a paying audience for what is recognized as the first time. The notion of seeing something "on a screen," a relatively rare experience in 1895, has become a fundamental cultural reality of the twentieth and twenty-first centuries. In many ways, it may be one of the dominating differences of modern life.

Things have evolved to the extent that a student in a film program, even one shooting extensive amounts of film, may never have to put his or her hands on a projector. Everything is transferred to video, and the film may not even be handled much less projected. Despite this technological reality, the projector remains a wonderful mechanical beast that can be of great service. One resistance to digital projection that has not been mentioned is the tremendous reliability of theatrical projection. Projectors break down occasionally, and any theater owner can tell you stories of going in with a screwdriver and pliers and making the darn thing work. If a server goes down, screens go dark—a worst-case scenario for any theater.

In design, a **projector** is very similar to a camera: the film is driven by sprocketed rollers; each frame is pulled in front of the gate by the pull-down claw; and the shutter hides the movement of the next frame as it is moved into position in front of the gate allowing viewers to see the next frame. Just as with the camera, the film must form top and bottom loops for the reciprocation between the constant motion of the sprocketed rollers and the intermittent movement of the claw. The biggest difference is obviously that a projector generates light whereas the camera captures it.

The other major difference is that most projectors have a sound playback assembly through which the film generally needs to be threaded. Some projectors have a means of bypassing this sound head, but it is often a good idea to thread through the sound path to take advantage of its loop-restoring capabilities. Be sure to turn off the sound if you are analyzing a workprint. The sound head will pick up the shape of the sprocket holes and make a machine gun–like popping sound.

Some older projectors are *channel loading*, an automatic-threading feature. You slip the film into a slot, and the projector is closed on it. These projectors are generally not acceptable for viewing an edited workprint because they tend to chew up films with splices. Try to get a manually threading projector, such as the Kodak Pageant, as it will be gentler on your film. **(SEE 7-12)**

The tips for cleaning a camera apply to a projector. Be sure to keep the projector free of dust and dirt. Even when you are handling a workprint, keep the film as clean as possible. The dirtier the film gets, the more difficult the evaluation of the overall quality

7-12

Older, manually threading projectors are useful in editing stages.

Kodak Pageant 16mm projector / © Photo courtesy of Bruce Mamer.

of the project becomes. Projector cleanliness is particularly relevant when you finally get a print of your film that can be shown in a theater—a projection print. Projection prints are very expensive, and one major, lengthy scratch can render any print unwatchable.

It is essential to view your raw footage many times before starting to cut. When you get the film back from the lab, the original film should be rolled emulsion-out. Workprints should be wound emulsion-in for correct projection.

Viewing Dailies

There is nothing quite so exhilarating as watching **dailies**, the footage from the previous day's work. All of the painstaking effort that went into execution has a concrete representation in the final product. Viewing dailies, also called *rushes*, can be a tension-inducing experience as well. This is where you see any unpleasant surprises that were not anticipated during the shoot. With experience you should be able to avert any outright disasters, but there are almost always things that you wish were better.

Dailies should be watched with a critical eye from several perspectives. The first time through, thoroughly check the condition of the workprint and, by extension, the original. If there are flaws or damage, they should be identified and addressed at this stage. If you do not find the problem on the workprint, have the lab check the original. Damaged or dirty film is generally discarded and the material reshot, so be completely conversant with any flaws and identify their source immediately. If the problem is caused by the camera, early identification may avert further damage during subsequent shoots. Probably most important, the more the film is handled in editing, the more it will show stress. If you notice damage later in editing, you may be stuck in the unpleasant position of wondering at what stage it occurred. Check the workprint thoroughly at the start and locate all problems.

As you view the uncut footage repeatedly before actually starting to cut, take extensive notes about which shots you want to use and how you want to cut the film. Evaluate the quality of your shots from a purely "plastic" standpoint; consider quality of camera movement, efficiency of timing, overall composition, lighting, and so forth. Minor defects are often difficult to see on editing equipment. Lack of awareness about flaws in shots can lead to unpleasant surprises when you get a final print back.

A Note on Conventional Film Finishes

Although full details on conventional (read old-fashioned) film finishes are provided in Chapter 16, a few notes on the path to a film print are in order. As suggested, sound is recorded separately on location when film is being shot. For editing, audio was, and in limited applications still is, transferred to **magnetic film stock**, a sprocketed medium with magnetic coating that is the same size and dimension as the film itself. All sync was determined and maintained by passing even numbers of frames across playback heads and the visual gate. When all editing is finished, the sound is mixed down to a single track and converted to an **optical master**, a narrow track of diamond shape patterns that is the photographic record of the audio for the project.

On the visual side as stated earlier, the original film is "conformed" into an entirely new version of the film using the edge numbers in the workprint as a guide. In essence, a whole new version of the film is rebuilt with the original duplicating exactly what was done in the workprint. For reasons that will eventually be made clear, the picture is actually cut into a number of rolls. Once the optical master is created and the negative is cut, these components can be used to create multiple prints of the project. Pretty bare bones for now, but this will be helpful in understanding some of the terminology in coming chapters concerning the creation of film prints in the digital age.

On the Set

The execution of the setup is a complex process of confronting and solving the many problems that will inevitably arise. Many concerns regarding the overall quality and character of the image must be resolved before the camera can roll. This section delineates some of the necessary considerations for individual setups. When shooting film, sound is recorded on a stand-alone audio recorder. Sound is covered briefly here, but the particulars of on-set practicalities are addressed in chapter 10. Many of the issues described herein apply to video as well. Obviously, sound can be recorded right to the videotape, although there is a strong rationale for using a separate recorder here also.

Procedures and Equipment

The **setup** is the basic component of a film's production. It can be referred to in a number of different ways—camera position, placement, angle—but it is where you have to set up the camera to cover a certain amount of action. Each setup generally represents hours of preparation and the devotion of extensive resources, both off the set and on and in terms of effort and monetary expenditures. Conventional theatrical films usually evaluate a day's work by the number of script pages completed, but they also evaluate their efficiency in terms of number of setups executed. A feature film crew that averages 12 to 15 setups a day will generally be considered acceptably efficient. Episodic television crews must work much faster. Given the small number of shots and the intense expectations invested in television commercials, crews shooting them often work much more slowly. Independents, due to restricted budgets and limited time with locations and talent, often have to average twice as many setups (or more) per day as a standard feature film.

Just as a day's work can be measured in terms of setups, an entire film can be similarly measured. Films with slow, contemplative editing might average somewhere around 800 setups total for the entire film. An action film with fast-paced editing can easily have double that number. Robert Rodriguez's *El Mariachi* (1992) reportedly had almost 3,500 setups, an extraordinary number given the film's minuscule budget. Woody Allen's *Annie Hall* employs slightly fewer than 400 individual shots in its final form. Although Allen reportedly shot substantially more material than this, the figure illustrates much about his working method. Some of the film's most famous scenes—the film critic in the ticket line, Alvy and Annie chasing lobsters in the kitchen—are done in single, extended shots. Jim Jarmusch's *Stranger Than Paradise*, in which every scene is done from a single camera position with no cuts, consists of roughly 70 setups.

The Take

A **scene**—the basic unit of a script—is broken down into shots, which translate to setups for shooting. Each setup is referred to as a "scene" when being identified during shooting (not to be confused with the broader definition of *scene* just presented). These setups are numbered so that they can be marked and logged. Each setup is then covered in **takes**—the number of attempts at each shot needed to produce at least several usable versions.

The Slate

The **slate** is used for organization in shooting, easy identification of shots in editing, and, most critical when shooting film, matching location sound and picture. It consists of a board on which pertinent information is written and a striped bar across the top that is slapped at the beginning of every sound take. **(SEE 7-13)**

There are two common methods of numbering scenes on the slate. The first is to number all shots sequentially from the first day of shooting. Slate numbers would run from #1 for the first shot on the first day of filming to the last shot on the last day, the final number depending on how many individual setups the film had had. This method is perfectly acceptable, although it can become difficult to manage for those inexperienced with dealing with many days of shooting. The second method is to combine the scene numbers, as listed in the shooting script, with letters designating the position of the shot within the scene, probably a more logical system for novices. The opening master for scene #80 might be listed as #80A. A close-up in the middle of the scene might be #80F. The closing master might be #80R. Whatever the numbering method used, the shot is identified by both scene and take when the clapper/loader (2nd AC) marks each scene. "Scene 80C, take 5" would denote the fifth take of scene #80C in the shooting script.

The science of slates and slating has advanced dramatically in recent years. Time code slates are common, with LEDs providing a constant, rolling readout of time. Tie-tack or lapel slates are also popular. Worn by the sound person, they emit a light when a button is pressed, with a matching tone being sent to the recorder. The camera operator must pan to the sound person to photograph the light. The old-fashioned slap-style slate, however, remains in wide use.

7-13

The slate is used for organization in shooting, easy identification of shots, and matching production sound and picture.
© Photo courtesy of Bruce Mamer.

Executing the Shots

The sequence of events to initiate a shot may vary slightly from set to set but is usually something like the following. The director, or the AD on most sets, will call for sound. The sound recorder is started, and upon seeing the appropriate speed indicator on the recorder, the recordist will yell out, "Speed." The director will then call for camera. The 1st AC hits the trigger and calls out, "Rolling," once the speed indicator flashes (a red light on most cameras). The director will then call for the slate. The person with the slate, the clapper/loader, will call out the numbers and hit the slate. The director will then call for action. Each scene ends with a "Cut" from the director.

Hollywood tradition dictates that the scene and take numbers be said before hitting the slate, but it is recommended here that this information be stated after the hit if you are editing on film. This approach is slightly unorthodox, but it makes syncing sound and image a little easier for the novice. On commercial shoots this sequence will be preceded by the AD's request to "put on the light and bell"—a visual and audio cueing device that tells the crew that the camera will be rolling and that they must be quiet until it is shut off.

Marking a scene appears to be a straightforward matter, but a number of factors must be considered to ensure that the appropriate people can see the slate. The entire slate should be recorded, but the hit of the bars is the crucial piece of information. This is what the editorial staff needs to match sound and picture. All of the issues that are important to the shot itself are essential here: exposure, clarity, focus, framing, and so on.

If the scene is low-key, the slate could potentially be held in an area too dark for adequate exposure. In this situation the gaffer will set up a slate light, the sole purpose of which is to illuminate the slate as the scene is being marked. The light is switched off before action is called.

Having the slate numbers large enough to read is also an issue. The general rule is to keep the slate 1 foot from the camera for every 10mm of lens length; for example, the slate should be 5 feet from the camera for a 50mm lens. When the action is some distance from the camera, this can lead to focus issues, usually resolved by having the AC rack focus from the slate to the action after the scene is marked.

The bars at the top of the slate are again most important. Shooting them is usually a simple matter, but mistakes can be made in tight close-ups or when "running and gunning"—shooting quickly due to a lack of time or because of involvement in a spontaneous event. In the first case, a pan or zoom from the slate to the subject may be necessary after the scene is marked, often requiring a rack focus in the process. In the second case, taking a few seconds to get the slate right will prevent headaches for the editors. Whatever is necessary, the bars must be visible.

The clapper/loader should be in position, ready to hit the slate when the camera starts rolling because trying to find the correct position while the camera is running wastes precious film. The camera operator uses hand signals to guide the clapper/loader into position before the take starts, spoken directions being superfluous for two people facing each other. Once the scene is marked, the clapper/loader should know where to go and should get there quickly. When exiting, the clapper/loader avoids casting a shadow on the scene or walking in front of the camera, as well as making excessive noise while moving.

Some shots require different methods of slating. Because the slap of the bars can be disconcerting for inexperienced talent, particularly documentary subjects and children, the **tail slate** is done at the end of the shot. Sometimes it is simply more convenient. The clapper/loader inserts the slate at the end of the shot and marks it there. The slate is held upside down and the bar is slapped up to denote the tail position.

Sync and MOS

All shots are done either **sync**—with sound or *MOS*—without sound. The legend for the term *MOS* is that, shortly after the introduction of sound, a German director replying to a question about mic placement said something to the effect of "Oh, no, vee do dis vone *mitt out sound*." Thus **MOS** became the abbreviation for shots that are done without the sound recorder rolling. A surprisingly high percentage of shots can be done MOS, from reaction shots to action shots that will have sound added later. Feature productions often roll sound on virtually everything, however, because it is easy to do and makes post-syncing less complicated.

MOS shots are slated similarly to other shots except that the bars on the slate are not hit. The clapper/loader will simply insert the slate, and the 1st AC will "squeeze off" a few frames of it. The shot will then be initiated with a simple "Roll camera" and "Action."

When shooting video, recording sound on a separate recorder is common as well. This allows the sound person to get closer to the action and be more flexible, as in not tied to the camera, in recording and miking. Despite this, also recording sound on your deck or camcorder is highly recommended. You never know when it might provide just the result you want or can be a good guide for matching up wild sound in the editing room.

Camera Reports

The **camera report**, or *log*, provides a daily chronology of shooting. It is indispensable as a record of all the shooting activity on the set, but is most valuable in keeping the many rolls of film organized during editing. The 2nd AC is usually responsible for filling out the log after every take. Blank camera report forms are available from commercial sources, but you can work up a basic camera report quite easily by simply providing places for the key information. **(SEE 7-14)**

Date		Scene #		Title				
Film stock		Emulsion #		Director				
Processing instructions				Camera				
Scene	Take	Remarks	MOS/sync	Begin footage	End footage	Camera roll	Sound roll	

7-14

A basic camera report form should include all of the key information.

The main headings are used to list the particulars of the shoot. Manufacturer and stock numbers are written in the middle. Emulsion numbers are taken from the label on the raw stock. The magazine's number is recorded here so that any problems (scratches, light leaks, and the like) can be traced later. The first two columns are for the scene and take numbers. These come from the shooting script or storyboard and are provided by the script supervisor. They are also replicated in the lined script.

Beginning and ending footage is recorded to keep track of where specific shots are on the rolls. Barring any camera runs for testing, the ending footage number is transposed to the beginning footage for the next take. Beginning and ending footage is important for **spot printing**, a common practice on feature films, in which the desired takes are circled on the camera report for later identification and printing or transfer to video.

Remarks generally pertain to the quality of the take, noting deviations from other takes—different positioning of performers, different line readings, slightly different camera strategies, and so on. The notation *NG* (no good) obviously designates spoiled takes.

The sound mixer keeps a **sound log** as well, with the same information as the camera report except the beginning and ending footage. Some form of designation for all camera and sound rolls is important. At the beginning of a project, the 1st AC and the sound mixer will start a numbering system, usually numbering tapes sequentially from the first day. Recording to a hard drive creates specific challenges, with the necessity to name all files and organize them for transfer into the appropriate bins in the nonlinear editing system. The camera roll number is written on camera tape and is kept both on the film's packaging and on the magazine itself. This helps the 1st AC keep the rolls organized for appropriate marking for the lab.

As suggested, camera reports are important for keeping track of rolls in the editing room. If the editor wants to try another take of a shot, the assistant editor can consult the camera report, determine the appropriate roll, see if it was printed or transferred (if applicable), and find it among the **outtakes** (the unused shots). Beginning and ending footage is important here as well for determining exact locations on the rolls or drives. Similar logging of sound allows for easy location of desired takes.

The camera report is also used to keep track of the camera's performance. The AC will indicate in the remarks column when the gate was last checked and whether problems were found, irregularities on the camera's part such as excessive noise, and any other problems that may have been noticed.

Camera Assistant

Many of the 1st AC's duties are covered in earlier chapters, but several other considerations are essential to producing a clean product as well as general efficiency on the set. Although this section details advanced production practices and magazine-loading cameras, ambitious learners will want to take them into account from the start.

Camera Preparation

The AC's first responsibility is to pick up the camera package and get it ready for use. Whether you are picking up a camera from a friend, a school equipment room, or a rental house, it is imperative that you ensure that the camera package has everything you require. Failure to have necessary pieces or to check key features can result in canceled shoots or, worse in its own way, unpleasant surprises when you get the film back.

In addition, practice the threading procedure many times before attempting to load that precious celluloid gold. Use a **dummy load**—a ruined roll of raw stock; labs, schools, and rental houses are potential sources. Become completely conversant with the camera's loading procedures as you practice. Mistakes in threading account for more ruined footage than any other single cause.

Magazines and Loading

Each camera has its own unique magazine design and threading pattern. Knowledge of the basic mechanism should make every camera an open book to you, although one should never be arrogant when learning a camera. Finding either a manual or a person to walk you through loading is, again, the best approach. Because all cameras have at least slight differences, it is impossible to give specific loading instructions. Despite this a few general principles will be helpful.

When working with core loads, a **photographic darkroom bag**—the changing bag—is used to load the film, although some experienced ACs have light-tight boxes or more sophisticated arrangements. Using the bag can be disconcerting at first. Become familiar with what is supposed to happen in the bag and how to respond to any problems that arise. Individual magazines have their own idiosyncrasies, particularly on older cameras: the light trap might be very tight on one magazine; the counter arm may not be locking out of the way on another. Learn to anticipate all difficulties.

Once you feel completely comfortable with threading the magazine from practicing in the light of day, you are ready to use the bag. The traditional changing bag is black and rectangular, although a tent-shaped bag, which keeps the folds of material off your hands and is quite popular with ACs, is available. Changing bags have two compartments, each with a separate zipper, to make sure no light gets in. The bag has two armholes with elastic that makes the sleeves tight against your arms. Once the film is out of its packaging, you cannot remove your arms from the holes without risking ruining the film. If you have to get out of the bag, put the film back in its packaging or in a closed and locked magazine.

Core-loaded film comes packaged in a metal can. Inside the can a black plastic bag acts as an inner layer of protection from light. This plastic bag is not designed to protect the film outside of the can, and *a can should never be opened outside of the changing bag.* A piece of blue tape secures the unexposed roll. After loading the magazine, save the can and the plastic bag for downloading the exposed film. The tape that secures the roll should be carefully preserved inside the bag and is discarded when finished. Make sure that it is not left in the magazine, where it could cause a camera jam. Bring extra cans with black bags for **recanning** (repackaging)

the **short ends**—the film that remains in the magazine at the end of the day or when a change to different stock occurs.

In the changing bag, feed the film through the light trap before you mount the load on the spindle. Once the film is through the light trap, close the film compartment and lock it shut. Most magazines need only the feed side set up in total darkness, so the mag can be removed from the bag and the take-up finished in the light. Tape the feed side of the mag immediately after removing it from the bag.

Thread the camera. Always test the threading with the inching knob, then run the camera to make sure the loops remain consistent. If the camera's design allows it, run the camera to make sure that the take-up core is operating correctly.

When you are threading the camera, the emulsion must be facing the front. Although this is obvious, it seems like just about everyone makes this mistake on an unfamiliar camera once in their career. If the antihalation backing is toward the front of the camera, something has been done wrong. The diameter of the hole in the center of a core is larger than that of a daylight spool. The spindles in the magazine require **core adapters** to make up the difference. Core adapters mount and lock onto the spindles—and they can be accidentally removed when downloading and sent off to the lab. Be sure the magazine has all of its core adapters when you take the camera on-location. You won't be able to shoot if one is missing and you are unable to cannibalize one from another magazine. Sometimes the smallest things can bring a shoot to a standstill. You will also need a core for take-up. Be sure to bring extra cores because you may have to download unfinished rolls. The extras will be needed when you reload a new magazine. Use only 2-inch cores because larger ones do not allow room for take-up of the entire 400 feet of film.

Become completely familiar with as many cameras and magazines as possible. A person who knows cameras and can load them quickly, accurately, and cleanly has some very marketable skills. Many entry-level positions in film are on the camera crew, which is a good way to get some experience on the set. It can also pay bills as you pursue other interests. You may have to work into it slowly because no one is going to be hired to load magazines without proven ability. Loading appears to be a small cog in the system, but it is far too critical a cog to be left to someone with limited knowledge. I knew an aspiring AC who scratched several thousand feet of film on a project because he did not know a specific loading peculiarity of one camera. He had a hard time finding work for quite some time thereafter. Know your camera.

Racking Focus

As with so much else, racking focus is something that is worked out and rehearsed in advance. On pro sets rack focuses are usually electronically controlled, but in a manual **rack focus** the AC stands by the camera and physically rotates the focus ring as the shot is being executed. To set up a rack focus, you need a roll of **film tape** (also called *white paper* tape), a permanent marker, and some *gaffer's tape*. Film tape is available at camera supply stores, and no substitute should be used. You put the film tape on the barrel of the lens. The gaffer's tape is used to mark the talent's position on the floor.

Using a character moving toward the camera as an example, the AC has to ascertain and mark on the floor the talent's position at the beginning and the end of the movement. **(SEE 7-15)** If it is a long move, the AC also measures and marks on the floor several arbitrary points in between. A piece of film tape is placed on the movable part of the focus ring, across from the hatch mark. If distances of 15, 10, 8, 6, and 5 feet have been measured, a mark is put on the film tape at the appropriate distances. These marks will be lined up with the hatch mark by turning the focus ring as the shot is being executed. **(SEE 7-16)** During rehearsals, the AC

7-15

When a character will be moving toward the camera, the AC marks the talent's beginning and ending positions as well as several positions in between.

7-16

Marks on film tape corresponding to measurements on the floor are aligned with the hatch mark on the focus ring as the rack focus is being executed.

will practice the focus move as well, hitting the specific focus points as the talent hits the corresponding marks on the floor.

Marks are used in dolly movements as well. **(SEE 7-17)** Though dolly moves can incorporate both subject and camera movement, we will use the example of the camera moving in on a stationary subject. Rather than measure to points in the subject's movement, the AC bases the measurements on the distance from the subject to the dolly. The measurements are the same as in the previous example (15, 10, 8, 6, and 5 feet), so these distances are marked on the floor with gaffer's tape along the path of the dolly. As the dolly shot is being executed, the AC will rack focus to the appropriate distance as the dolly passes the marks on the floor.

Good ACs become very sensitive to how to move the focus ring and keep the subject in focus, though even they make occasional mistakes. Actually, some of the great shots with rack focuses, such as the crane shot in Alfred Hitchcock's *Notorious*, drift slightly out of focus toward the ends of their movements. That just shows that the shot was made by human hands.

Racking Focus and Depth of Field

The 1st AC must be aware that the depth of field changes when racking focus. As the focus point shifts farther from or closer to the camera, the depth of field also shifts. If a character moves from 10 feet to 5 feet from the camera, the depth of field changes as you do the attendant focus rack.

The example from Mike Nichols's *The Graduate* discussed in chapter 1 illustrates this point. Dustin Hoffman's long run toward the camera clearly incorporates a substantial rack. **(SEE 7-18)** While the 1st AC is racking focus, the depth of field travels toward the camera, becoming increasingly shallow. Focus your attention on an object in the background as you watch the shot, the car is maybe the best example. By the time Hoffman reaches the turn, the background is completely out of focus. The numbers in the figure are purely speculative.

You will notice that objects, the car in particular, go soft slowly at first. As Hoffman approaches the turn, the rate at which the car becomes soft increases.

7-17

When marking dolly movements, the AC bases the measurements on the distance from the subject to the dolly.

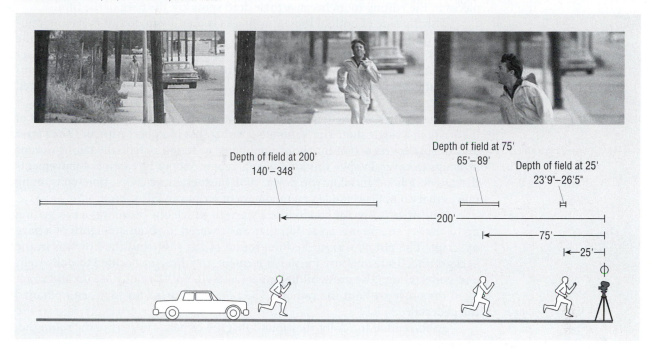

7-18

During the rack focus in this scene, the depth of field becomes increasingly shallow.

Mike Nichols's *The Graduate* (1967) © Photo courtesy of Bruce Mamer.

By the time the camera pans, the car is a completely abstract shape. In the final position, we are dealing with at least two elements that are minimizing depth of field: long focal length and close focus. Because it was a sunny day, we can presume a high *f*-stop, bringing to mind the potential problems of doing a similar shot in low light. Significantly, when the zoom-out is executed, we suddenly see all of the elements that maximize depth of field. The shot now incorporates a wide-angle lens, a high *f*-stop, and, we would presume, a relatively far focus point.

Although this outcome may not be noticed by the average viewer and cannot be categorized as any kind of aesthetic effect, it clearly must be considered while shooting. You can tell that it is a technical by-product of attempting to achieve another effect. Everything is give-and-take.

A Note on Movement and Efficiency

Intricate moving shots are quite attractive to first-time directors. Both the time devoted to them on the set and the internal pacing of the shots themselves, however, pose significant challenges. Movement is essential to a film, but specific camera moves need to be weighed in terms of their value in the script versus the time it takes to execute them.

Activity on the set slows down whenever you start moving the camera, particularly with inexperienced crews. Focus marks must be set, dolly track may need to be laid, and the movements have to be practiced. The talent must be thoroughly drilled on what the boundaries of their movements are. Lights and the microphone boom have to be carefully considered so they are not in the shot.

Timing and pacing of the shot are also critical. What is on-screen should always be visually interesting. If it takes too long to move from one key composition to the next, the travel time will slow the pace of the finished product: material that should logically occupy a few seconds of screen time fills double or triple that. Editing allows you to condense time, eliminating the less interesting aspects of

getting a subject from here to there. If the camera covers action that would otherwise be eliminated, the viewer is forced to watch action that is not germane. Many carefully planned and painstakingly executed moving shots wind up being cut into pieces in the editing room because their dead spots kill the pace of the film.

The flip side of both of these drawbacks is that if you do not move the camera, the film will usually be flat and static. Also be aware that movement is the lifeblood of the actors' performance. Deprived of the ability to move, performers can become stilted and unnatural. It is one of the great paradoxes that the movement that is so essential to the performer is a complicating factor for inexperienced camera crews.

One of the beauties of movement is that you can cover significant portions of the script in a single shot. The 8-minute opening shot of Robert Altman's *The Player* presumably covers action for about eight pages of script, potentially taking dozens of setups to cover. Despite this kind of apparent economy, be careful of movements that are peripheral and slow you down. With inexperienced crews, time-consuming moves that do not cover at least a modicum of script can kill a shoot.

One novice director had to film a scene in which one detail was a boy getting up to answer the phone, an action that was covered in about an eighth of a page of script. The phone was in the foreground of the shot, and the boy was in the background. To recompose for the movement, the director decided to dolly right and pedestal up. The crew, all beginners as well, got the dolly set up and practiced the move without the camera. Then they measured for focus and planned the pedestal.

At the end of the dolly, they found that the camera saw part of the room that had not yet been lighted. Two hours after starting, they had a few usable takes. After the shot was finished, I took the director aside and pointed out that he had spent almost half a day shooting a small fraction of a script page. At that rate his 10-minute film would take 20 days to shoot. Weigh carefully whether the material in the script warrants the kind of time devoted to the proposed shot, balanced with the abilities and the efficiency of your crew.

This is one of the fundamental albeit subtle differences between commercial features and low-budget independents. The previous example might take a professional crew about an hour to work out and shoot, so may have been worth the time devoted to it. Independents are often stuck in the position of needing to accomplish more script pages with a less experienced crew, a primary reason why independent films do not have the production values that commercial features enjoy. The thoughtful expenditure of limited resources—human, temporal, and physical—is a fundamental aspect of successful shooting.

Lens Flares

With any type of camera—video, still, or motion picture—the 1st AC needs to check for **lens flares,** which are produced by light shining directly into the lens, causing either washed-out areas or multifaceted patterns on the image. Backlights and the sun are particularly notorious for causing flare problems. Flares can be seen as small points of light, called *kicks* or *hits*, on the front element of the lens. The effect can sometimes be seen by the camera operator, but just as often it will not be visible when looking through the viewing system. Thus potential problems are identified by standing right in front of the camera and looking straight "down the throat" of the lens. Flares are tricky because not all kicks cause a problem.

The AC is responsible for checking the front of the lens. If a problem is seen, something must be set up to block the offending light source from hitting the lens. Identifying which instrument is causing the problem can be tricky, with turning off or blocking the suspected culprit being the best method. While the offending ray of light can occasionally be cut at the instrument, the flare is usually blocked by a

flag—a rectangular piece of black material—on a stand at the camera. This is the AC's call, and a grip sets it.

Moving shots present more complex problems. Flares might be eliminated at the beginning position but then appear at a later point in the camera's movement. Checking for flares requires at least one **run-through** in which the AC walks in front of the camera, watching for problems. Obviously, a stationary flag on a stand is useless in this situation. A **French flag**, a small flag on an articulated arm that mounts on the camera, is particularly helpful with these kinds of flares, as is a *matte box* or a *sunshade*.

The multifaceted patterns caused by flares from the sun are occasionally incorporated into shots as stylized effects. Most flares, however, are unacceptable and require some effort to eliminate them on the set. The AC does this as a matter of course, disrupting the set as little as possible in the process.

Scratch Tests

Scratched film is a significant problem, particularly when working with older cameras. Scratches are usually caused by dirt, improper loading, or a problem with the camera. Whenever possible, the AC breaks off the first few feet of film that are run through the camera while loading is being checked. Left on a core, the piece is labeled with the camera roll number and stored for future reference. If there is any scratching, the scratch test can be processed to see if the problem was with the camera or was caused by the lab.

Lab Instructions

The 2nd AC is also responsible for marking all of the film cans and shipping them to the lab. The film is often either shipped to a distant lab or left in a late-night drop-off box, so marking the cans accurately is essential to avoiding misunderstandings at the lab. Even if the AC drops off the film in person, verbal instructions need written reinforcement. Mistakes in communication can have disastrous results and are almost always the filmmaker's fault for giving poor or inadequate instructions. The film cans should be labeled with the following information:

- **Production title and camera roll number.** These are necessary for keeping footage organized in editing.

- **Production company and billing information.** The lab likes to know who is going to pay. Advance payment is generally required from customers who do not have a credit history with the lab.

- **Stock number.** Even if the film is in its original packaging, write the stock numbers in prominent places. Leave no room for error.

- **Footage.** Write down the amount of footage in each can. Shooting less than a full roll is common, and the lab needs to know the approximate totals to plan its processing runs.

- **Printing and processing instructions.** Identify the type of workprint desired—standard or best light are the two common choices. Obviously, transfer to video must be indicated and the transfer facility, whether it is the processing lab or not, must be identified. Beyond that, the lab needs to be alerted to any specific requirements such as force processing or any of the other "tortures" covered in chapter 15. Complex instructions may require a separate sheet. The AC often turns in a copy of the camera report that lists any desired lab manipulations and any spot printing to be done. Be sure that these instructions are explicit, making the lab aware of any special effect—such as color, exposure, and so on—done on the film.

■ **Phone number.** If any questions about exposure or printing instructions arise, the lab may need to get in touch with you on short notice to facilitate a quick turnaround on the job. You will want to answer any questions the lab staff have.

The rolls should be marked clearly, and the instructions should be unambiguous. An AC on one shoot was labeling two rolls of film that were being pushed one stop for effect. He carefully labeled the two cans, put them on top of two other cans that were to be processed normally, and taped them all together to ship to the lab. The lab saw the labeling on the top can and force-processed all four cans. The film was not completely ruined, because exposure was well within the latitude of the film, but there were heated denunciations of the lab among crewmembers when the news of the error arrived. In a private moment afterward, however, the DP castigated the AC for packaging the film in a way that left the potential for misunderstanding. Clarity is absolutely essential in all communications with the lab.

7-19

These checklists include equipment essential for a location shoot.

Camera package
- ☐ Camera
- ☐ Lens and lens cap
- ☐ Film
- ☐ 2 to 3 magazines
- ☐ Core adapters
- ☐ Cores
- ☐ 85 filter
- ☐ Neutral density filters, 0.3, 0.6, and 0.9
- ☐ Proper filter ring adapters
- ☐ Sunshade
- ☐ Batteries (check for charge)
- ☐ Battery cables (plus backup)
- ☐ Changing bag
- ☐ Extra 400' cans (with black plastic bags)
- ☐ Camera tape and film tape
- ☐ Slate
- ☐ Tape measure
- ☐ Light meters
 - ☐ High slide
 - ☐ Incident disc
 - ☐ Reflective disc
 - ☐ Flat disc
- ☐ Chip chart
- ☐ Pens and permanent markers
- ☐ Log sheets and clipboard
- ☐ American Cinematographer manual

Tripods
- ☐ Head and legs
- ☐ Tri-downs
- ☐ Quick release
- ☐ Bushing for mount adapters

Lighting
- ☐ Complete kits—barn doors and stands
- ☐ Extra bulbs for each light
- ☐ Extension cords
- ☐ Cheaters
- ☐ Clothes pins
- ☐ C-stands and arms
- ☐ Modifying materials
- ☐ Blue gel
- ☐ Gaffer's clamps
- ☐ Gaffer's tape
- ☐ Electrician's tape
- ☐ Practical bulbs
- ☐ Shims
- ☐ Leather gloves
- ☐ Gel cutter
- ☐ Electrical tester
- ☐ Rope
- ☐ Sandbags
- ☐ Spare fuses (if applicable)

Repair kits (camera and sound)
- ☐ Pocketknife
- ☐ Flashlight
- ☐ Flat- and Phillips-head screwdrivers
- ☐ Jeweler's screwdrivers
- ☐ Solder and iron
- ☐ Scissors
- ☐ Set of Allen wrenches
- ☐ Battery tester with ohms meter
- ☐ Needle-nose pliers
- ☐ Wire cutters and strippers
- ☐ Tweezers
- ☐ Electrician's tape

Sound
- ☐ Recorder and supplies
 - ☐ Audiotape or storage media
 - ☐ Spindle locks (Nagra)
 - ☐ Crystal plug (Nagra)
 - ☐ Extra take-up reels (analog)
- ☐ Microphones (plus backups)
- ☐ Mic cords (plus backups for every mic)
- ☐ Boom
- ☐ Shock mount (with adapter)
- ☐ Wind zeppelin
- ☐ 2 headphones (monaural)
- ☐ Y adapter for above
- ☐ Headphone extension cord
- ☐ Log sheets and clipboard
- ☐ Extra batteries
- ☐ Gaffer's tape

Cleaning kits
- ☐ Lens-cleaning tissue and fluid
- ☐ Denatured alcohol
- ☐ Cotton swabs
- ☐ Compressed air
- ☐ Camel-hair brush
- ☐ Orange stick
- ☐ Small flashlight

Miscellaneous
- ☐ Pens and pencils
- ☐ Permanent markers
- ☐ Notebooks
- ☐ Polaroid camera and film
- ☐ First-aid kit

© Cengage Learning

Equipment

Having the necessary equipment on-location is essential. Forgetting important pieces of equipment can slow down or, in extreme cases, even terminate shoots. Always delineate who is responsible for bringing what. I have seen inexperienced crews arrive on-location missing everything from tripods to the film itself because everyone thought someone else was going to bring it. On professional crews this virtually never happens because responsibility has been delegated in clear channels, often organized around union regulations: the AC always organizes his or her package; the key grip handles anything to do with dollies and the like; and the gaffer obtains the lights and the necessary gear to rig the lights.

Equipment Checklist

The time to be focused on equipment needs is when you are preparing for and picking up the gear at the equipment room or rental house. Know what you need, check that it works, and be sure that you leave with everything required in hand.

The following figure includes the equipment often available at schools and media arts centers. **(SEE 7-19)** An experienced AC or gaffer could list dozens of other useful items. Commercial features bring gear by the semi-load. Some things, such as cleaning and repair kits, a beginning professional will want to start acquiring. Every experienced crewmember seems to have accumulated several cases of tools that are commonly used for specific jobs. Lighting and sound gear are clarified in their corresponding chapters.

Do not hesitate to think big in terms of obtaining equipment, but be prepared to make do with what you can get. Rental houses are often beyond the means of noncommercial producers. Still, the fact that your primary time with busy talent is often on weekends may be in your favor. This is the rental houses' slow time, when much of their gear is sitting on the shelf. Get to know people at the rental houses and try to impress them with your knowledge and responsibility. If you make the right impression, rental houses will on occasion cut deals, particularly if you are working on the weekend. On the other hand, if they perceive you as someone who neither understands nor is concerned with the care of equipment, they will do anything to avoid letting you use their gear.

8

Video Cameras

Video has essentially undergone three great transformations in its relatively brief history. Occurring at roughly 20-year intervals, each has had a significant impact on how the film world operates. The first great period is the initial years—the "golden years." Basically occurring in and around the 1950s, this is when television established itself as the dominant medium of public entertainment and information. This era is symbolized by *Leave It to Beaver* and *Father Knows Best,* with shows like *The Twilight Zone* and *The Alfred Hitchcock Show* bringing up the darker side. The primacy of the theatrical experience was challenged by potentially paying viewers staying at home and getting their news and entertainment on the small screen. The second period started in the late 1970s, as **analog video**—tape-based recording and playback media such as consumer VHS—became portable and obviated the newsgathering and informational aspects of film. The third revolution is the ongoing digital one. Each of these transformations has impinged on the once-dominant world of film. The first forced Hollywood to find a way to be competitive with the highly attractive new medium. The second made film even more specialized, with film still providing the key impetus when image quality and complex editorial design were critical issues—analog video systems had profound limitations in many situations. Digital changed all that.

Most video cameras, with the exception of DSLRs, are similar to film cameras in both dimension and weight. The major difference is that the film camera captures light photographically and a video camera turns the light into an electrical signal—the *video signal*—that is either stored as a digital file or recorded on a magnetic tape in a manner analogous to sound recording. The internal workings of the film camera are impressive, yet they are in reality a nineteenth-century technology, a relic—a good relic—of the mechanical world. There is nothing wrong with that. The car and the airplane, as well as many everyday appliances, are also nineteenth-century technologies. Yet, as with film, they continually evolve to reflect the most recent trends. Recording video to tape is a twentieth-century technology (follow the history of the Ampex company if you need an example of American exceptionalism), with digital and recording data to hard drives and cards being a technology that has initiated the exciting beginning of the twenty-first, albeit overlapping a few years into the last century.

In the earliest days of television, the broadcast programs existed only as signals, with no method of recording except filming off a monitor with a motion picture camera, a setup called a **kinescope**. The first studio recorders were developed in the mid-1950s by Ampex, and widespread portable video became only a dimly envisioned possibility in the mid-1960s. The first portable video recorders

(ones that were also available to the average consumer) were half-inch reel-to-reel machines—quaint museum pieces now. Efficient and affordable portable video began transforming the entertainment industry in the late 1970s. TV news stations, which shot millions of feet of film per year and had in-house processing labs, quickly converted to the newer, cheaper, more immediate medium, and whatever primacy film had left at that time was soon over. I remember seeing a small-market news reporter at an event with a CP-16 in 1980 and thinking, what a marvelous anomaly. Is this the last guy in the country shooting news on film? All the video cameras must have been in use. Even two years before, it had not been uncommon. But the floodgates were open.

The biggest initial difference between film and video is in what happens to the light. Rather than strike the film plane, in video the light strikes a *charge-coupled device (CCD)*, generally referred to as a chip. The **chip** is a flat board covered with thousands of light-sensitive **pixels** that convert the light into a complex electrical signal. Many high-end video cameras used to have three chips, devoting one each to the primary colors of light—red, green, and blue **(RGB)**. Time has proven one chip to be more than adequate and indeed maybe the better approach, so cameras like the Alexa and the RED ONE are all one-chippers. Chip size is a key factor because it determines the amount of pixels devoted to the image. It also has a big impact on depth-of-field characteristics. Most consumer/prosumer cameras have a one-third-inch chip size, a size akin to the Super 8 frame in film. Sony's Cine Alta line was the big innovator of the two-thirds-inch chip and continues to employ it. It has very wide depth-of-field characteristics, which is a plus for newsfilmers but less so for the narrative world.

The technology to convert light into an electrical signal has been around for years and, in fact, is the basis of the traditional approach to film sound. One of the most exciting aspects of the encoded electrical video signal is that it can be almost endlessly manipulated. While color correction is reasonably flexible in film, in most other ways the film image is written in stone. While there are complicated and potentially costly reprinting options, a film image is photographically imprinted and must be essentially changed manually from one print to the next. With the potential for electronic manipulation, the recorded video signal can be modified in many different ways both before it gets to the tape in initial recording and, particularly, as it is being edited in postproduction. As such, it can be seen as a starting place for a complex and highly refined image. The ease of implementing optical effects and the increased creative possibilities have brought a new dimension to the process of creating a finished work.

The video image can be obtained in three different ways: image that originated on a video camera, image that was transferred from shot film, and **computer-generated images (CGI)**. As suggested, CGI is a world unto itself and is beyond the scope of this textbook, although basic things like the creation of simple titles are relatively straightforward. So, primary image is obtained either by shooting on video in the first place or by shooting film on-location and having it transferred to video. This chapter discusses the cameras and general properties of video itself. The relationship between the two media and transfer is further explored in chapter 9.

A few initial observations, however, are in order. Beyond issues of shooting on film or video, the whole relationship between the two media requires careful consideration even in the initial steps of preproduction. If you choose to shoot on video, your workflow can be relatively simple. If you want a high-end finish, however, it can be every bit as complex and demanding as any film finish. If you shoot on film, you have a host of options available to you. The most common route is to transfer the film to video and edit it with a digital **nonlinear editing (NLE)** system, the norm with digitized video edited on computer. The entrance

into the computer is the point of divergence between the old-fashioned but virtually bulletproof world of the conventional film edit and the bright new but occasionally treacherous world of NLE. There are many producers of NLE software and hardware. Avid Technology dominated the professional world for many years and now makes consumer software as well. Apple's Final Cut Pro and Adobe's Premiere Pro are both used by students and independents and are making inroads into the professional world as well. Sony has an excellent family of systems, called Vegas, and other producers have excellent systems as well. Proprietary systems like Apple's iMovie are not considered robust enough for prosumer applications, although Sundance recently premiered a successful video edited in the program.

As suggested earlier, the two most significant trends in video camera selection are the new breed of **Digital Single Lens Reflexes (DSLRs)** or **High-Definition Single Lens Reflexes (HDSLRs)**, and the new generation of full-color space, high-end cameras from Arriflex, Red Camera, Sony, Panasonic, Black Magic, Silicon Imaging, and others. Manufacturers of DSLRs include Nikon, Sony, Pentax, Olympus, Leica, and others. In terms of video capabilities, Canon, as suggested earlier, is generally considered to be leading the way with its EOS Mark series. Given the advantage this has given Canon, other manufacturers are improving their video functions and are quickly catching up. The high-end camera manufacturers are largely independent producers, with the exceptions of Sony and Panasonic, looking to be significant players in the big-budget markets. In addition, there are still many midrange video cameras that produce a highly useable image. Most of them now write to video files, with these being used primarily at TV stations, by independents, and by local commercial users. Some very good tape-based cameras are still out there, but unless you already own one it is not a technology that probably has much of a future. For all editing, whatever is shot on tape has to be converted to a digital file for editing anyway, so the tape step has become largely anachronistic.

The DSLRs pretty much inhabit a fully contained world of their own. As long as you grasp how to transfer the video files they create into your editing system, you can go to a final product with the camera and any of a variety of reasonably advanced NLEs. Of course, pros who are using DSLRs need to have a full understanding of how it all interfaces with the broadcast standard and finish for video projection worlds, but for the independent or amateur, understanding a few basic concepts is all that is required to create a reasonably polished final product.

DSLRs

DSLRs are, of course, primarily designed to be still cameras. **(SEE 8-1)** Most of them can record still images in what is called RAW technology (see page 188), but RAW is too demanding for the storage and instant retrieval of 30 frames per second on cameras of this design. High-end video cameras that shoot in RAW do exist, but the DSLRs are consumer and prosumer tools and are not intended to perform to those specs.

We do not really need to go through many issues to get into DSLRs. Chip size, which will be covered later in this chapter, is one of the key upsides of the DSLR. Being a still camera it has a full 35mm-size chip devoting substantial pixels to the image. Pixels are familiar to almost all readers, but the word *pixel* is short for "picture elements," and they are the basic building blocks of the digital image. Aligned in a grid, some have suggested that anarchic suspension of crystals in a nonuniform emulsion is a major reason film and video continue to look different. It may all be academic in that digital has so firmly established its presence that the look may be immaterial. While a video image's format (1080, 720, etc.) determines resolution, the real estate devoted to a DSLR image starts as a very complex

entity. Another important distinction is that most
video runs at 30 frames per second (or thereabouts),
unlike the 24 of film. This will make for a number
of exposure considerations and a number of other
technical concerns.

The other critical thing to remember about
DSLRs is that they take a whole-ball-of-wax approach.
With motion picture film everything technical has to
be addressed separately and in its own time. With
a DSLR, the myriad technical issues are right there
in front of you from the get-go. Matters like shutter
speed, exposure, color balance, and ISO are front
and center demanding attention. These have all been
briefly addressed in the logical, sequential approach
of this text but the complexities will not get the full
treatment until we start discussing lighting. A rem-
edy for all this is that a DSLR can be used in fully au-
tomatic mode. Everything can be set for you. This is
fine for now, but an ongoing theme of this text is that,
although automatic can be useful for initial efforts,
mastering the manual approach to shooting is re-
quired for the eventually more complex projects. We
recommend just putting the darn thing in automatic for now; future discussions of
technical foundations, exposure, and lighting will expand on the more complicated
issues.

The word *acquisition* may require some introduction. In the days of film, the
word was never used: You shot film. Though there were a myriad of concerns, the
bottom line was that you were creating the film image which all ended up at that
unforgiving space—the film plane. You could shoot 35mm, 16mm, or a variety of
specialty formats, but at the end of the day a frame of film was projected at 24 fps.
Video image acquisition and transfer into NLEs is far more complicated. There are
all types of formats, codecs, color spaces, frame rates, and the like. Once we get to
the high-end cameras, more extensive table-setting will be required.

The high-end cameras are probably entities that most novices will not see for
a while, although the Black Magic Cinema camera may change all that. Still, this
is not a medium that has much use for people who are not up to thinking big and
looking to the future. Small thinkers need not apply. Always stay familiar with and
keep your thoughts on the next step up. The only thing I can promise is you won't
be making YouTube videos for the rest of your life.

One consistent design aspect of all digital still cameras is that they are created
to be used, if desired, in automatic mode. That is, the camera can analyze the scene
and set exposure, focus, color temperature, ISO, and a variety of other options
for you. On the Mark III, *Scene Intelligent Auto* is Canon's title for its shooting
position that is *fully automatic*, the term used hereafter to describe this approach.
However, the problem with fully automatic systems is in how they address the
key-complicating factor of movement. What happens to focus when a character
moves closer to the camera? What happens when you pan from a light area to a
dark area? As we have seen, film sets employ many technicians to deal with these
issues. Camera assistants measure focus points and set up marks to accommodate
both camera and subject movement. Lighting crews even out the amount of light
in plotted points in a camera's move from here to there. How to deal with all these
issues on a DSLR is a central concern here.

Simple switches are generally employed to toggle between automatic and man-
ual modes. Toggling between still-mode and movie-mode is handled by a switch
as well. On the Canon Mark III it is to the right of the viewfinder (all directions

are from the operator's perspective) and the symbols pretty much serve as the universal ones for still and movie. **(SEE 8-2)** Menu choices and LCD panel selections are also standard. Before shooting video on a DSLR you should choose what is often referred to as the "movie recording size." The typical choice is between 720 and 1080. Both are high-def formats with 1080 devoting more pixels to the image than 720. You can also choose frame rates and compression methods. More on this later.

Autofocus

DSLRs can operate in either automatic or manual mode for focus. On the Mark III, the autofocus (**AF**) switch is on the lens or on the body of the camera for easy selection of one or the other. **(SEE 8-3)** In manual, the operator focuses as described in the chapter on lenses—either zoom in if possible and rotate the focus ring until the subject is sharp to the eye or measure. Most cameras include the universal symbol for the exposure plane described in chapter 6. In automatic mode, on most models you press the shutter button halfway down and the lens will set focus to whatever object is at a factory preset point in the viewfinder, which is usually whatever is in the center of the frame.

Manufacturers, of course, realize that selecting one central focus point will satisfy only the least discriminating of amateurs. Setting focus on something other than what is in the center of the frame is not uncommon, and subjects often have the bad habit of moving during the shot. In still mode, the solution has been to center your subject in the frame, push the **shutter release button** halfway, where it locks at one distance, recompose, and take your shot. Realizing that this could be a usable strategy for only the simplest of shots, camera designers have created systems where the operator can change and program where the automatic focus point is in the viewfinder. They have also set it up so there are functions that can plot out a number of different focus points during a shot.

On the Canon Mark III, focus is represented by a single or series of points in the viewfinder. By using the **Area Selection Mode** function you can change the area of critical focus to the left side or the right side or up and down to accommodate the subject you are shooting. As suggested, those points can be changeable during the duration of a shot. You can plot out that, for example, at five seconds the focus point changes to the lower left quadrant or whatever.

Undoubtedly, there are shooters who are extremely skilled at making auto focus systems adapt to very complicated movement. However, eventually you will run across a shot that would really be better suited to a guy/gal sitting at the lens rotating the focus ring. This can either be done manually or mechanically assisted. Folks who come from a film background have probably already incorporated manual focus shifts into their shooting approach. The more ambitious you get in terms of shot complexity, the greater the need to manage focus points.

Automatic Exposure

DSLRs are set up to deal with a variety of exposure approaches. The ubiquitous one is the fully automatic exposure combined with other technical issues that are addressed concurrently. On the Canon Mark III, there is a mode dial on the left top of the camera (again, all directions are from the operator's perspective). **(SEE 8-4)** The A+ position is the one referred to as Scene Intelligent Auto. It sets everything for your shot—you just point and shoot. Selective focus issues suggested above apply. Otherwise, the camera decides everything.

The Mode Dial that selects exposure approaches on the Mark III.
© Cengage Learning 2014

The next position (P) on the dial sets auto exposure only—focus is done as you choose. The next two positions (Tv and Av) are of most interest to pro still photographers and videographers. Tv is shutter priority and Av is aperture priority. In Tv the operator sets the shutter speed and the f-stop will automatically adjust to create a normal exposure. Av is the opposite: you set the f-stop and the camera's electronics will swing to the optimal shutter speed. If acceptable exposure levels cannot be achieved at specific shutter or aperture settings, some type of warning light will show through the viewfinder. Adjustments may be necessary.

Shutter speed in video acquisition requires some discussion. Still photographers will often lock in a high shutter speed to freeze some action or create a low depth-of-field. In video the ability to randomly change shutter speed is almost, but not quite, as hampered as it is in film. The rule with shutter speed is the same as that with film: The formula is one over two times fps. Thus the video shutter speed is 1/60th of a second. However, shutter speed for video is deceptively easier to manipulate than is the case in film, because you can set the shutter speed any way you want in Tv—but then you may get movement artifacts similar to those discussed with film. High shutter speeds simply cause jumpier reproduction of the action. In video, the common practice is to set your shutter speed at 1/60th and see where the f-stop falls in in Tv on the Canon. If you get a usable f-stop you can go ahead and shoot. If not, there are numerous strategies to obtain a usable exposure (see lighting chapters).

Av priority is not as common in video photography because of the variable shutter speed issues. Still photographers use aperture priority to lessen or increase depth of field as desired. If you are fiddling with shutter speed issues with full knowledge of the consequences, some interesting effects can be achieved. Otherwise, stay with 1/60th. A 60th can cause problems in that there may not be an f-stop within the camera's range in high light solutions. Trying to broker a low f-stop in high-light conditions may yield a shutter speed that will create unacceptable effects. There are solutions for all these problems. Artificial light in low-light situations is clear. Neutral density in high light is often the best solution (see page 310).

Automatic metering is usually factory-set to give greater weight to the center of the image. Called *center-weighted average metering,* this metering system will focus on elements in the middle of the frame and give little or minimal weight to peripheral areas. As with focus, camera designers realize that not all metering needs to be center-balanced. In menus, other metering options will be available. On the Mark III, you can choose between metering modes that gives different weights to different parts of the frame. This includes spot metering, center-weighted averaging, and a number of other approaches.

All DSLR cameras have a fully manual position—usually the **M** position as it is on the Mark III. Here you can lock both shutter and aperture. The proper exposure can be determined either by monitoring the DSLR's metering system in A+, Tv, or Av and then choosing what you think is the best overall exposure. The alternative is to use a handheld lightmeter. The **lightmeter** (see chapter 12) is a standard tool for film folks; understanding its use can yield a bounty of information for videomakers. Many videographers light to what they see on a camera's screen or, more frequently, a portable monitor. Having a more fundamental understanding of the light in front of the camera can yield information that is more useful, particularly when matching other shots in continuity shooting.

As with autofocus, the key-complicating factor for automatic exposure is movement—mostly camera movement. If you leave the camera in any of the automatic modes, exposure can shift as you move from light areas to dark areas causing an often unacceptable lightening or darkening of the scene. While dealing with different amounts of light in front of the camera may at first appear to be an issue of manipulating shutter speed and aperture, you will eventually see the solution as being the control of the amount of light in front of the camera. Again, bringing in artificial light and a couple of people who understand technical lighting issues will eventually become as much of a priority as it is in film shooting. Obviously, the more you understand about technical lighting issues the better.

ISO

ISO, which is referred to as Exposure Index (EI) in film, rates the sensitivity of the digital camera's electronics to light. It is settable and can be used to control the camera's responsiveness in different lighting situations. As with most everything else, this function can be handled entirely in automatic. The discussion of EI in chapter 7 may be a useful elaboration and later lighting chapters explore further complexities. However, a few initial concerns should be addressed and, again, an initial understanding of the hows and whys of moving beyond automatic will be useful.

ISO is a little more slippery in video than it is in film. EI (ISO) in film rates how sensitive a film stock is to light. Higher EI stocks are more sensitive to light and thus designed to be shot in low light. Lower-rated stocks are less sensitive and thus get more use in high-light situations such as outdoors in daylight. In video, ISO is a variable number that controls how a video camera's electronics deal with light. It is settable, generally in a menu or an LCD panel. **(SEE 8-5)** The general rules are the same: high ISO in low light, low ISO in high light. In film the EI number is *the* number for a specific stock and, while advanced cinematographers have learned some variables, novices should stick to the manufacturers recommendation. In video, however, you are simply altering the responsiveness of the electronics rather than fiddling with the responsiveness of the chemical formulation of an emulsion on a film stock.

Arbitrary changes to ISOs, however, can cause unwanted side effects. The lower you go, the greater the chance that white (or overexposure) areas will be rendered without information. Without information, there is not much you can do with that part of the image in post. On the other end, the higher the ISO, the more potential there is for muddy and "pixelly" darker areas—the blacks and the grays can become unacceptable. Different cameras devote different amounts of pixels to the image, and they are usually

8-5

The LCD panel on the Mark III, with the ISO selected expressed in the middle right.
© Cengage Learning 2014

switchable as well, so results can vary substantially depending on a given camera's design. The volume of light that the lens transmits is the same at a particular *f*-stop, but the camera's response to that light varies on a camera-to-camera basis, again based on the quality and design of the chip(s), as well as the amount of pixels.

It is generally agreed that the native ISO for consumer/prosumer video, including DSLRs, is somewhere in the neighborhood of 200 to 320, but you need to become familiar with how specific cameras perform under different lighting conditions. Many high-end cameras, like the RED ONE and the Alexa, are considered to perform optimally at an ISO of 800. For those of us who come from film, it is not so very long ago that Kodak came out with a 500 rated color film stock, a number that seemed virtually impossible for many years but revolutionized color's ability to shoot in low light.

White Balance

White balance is to video as color balance is to film. Film depends on the design of the stock, front lens filter alterations, and manipulation of lighting sources to manage color balance. With a video camera, many color balance issues are handled electronically. The only issue video cannot address is the problem of matching different light sources in front of the camera, although you can come up with compromises the efficacy of which are up to the individual maker. Color temperature for film was introduced in chapter 7 and matching sources is addressed in depth in chapter 14. For now simply note that, unlike in photographic mediums, the video signal can be trimmed electronically to conform to light of virtually any color temperature—to "see" almost any light source as white. This is referred to as **white balance**.

Although these issues can be frustrating, the method of handling *color temperature* is substantially easier in video. It all comes down to how a shooter manages the color quality of differing lighting sources. Daylight is white or close to it during the balance of the day. Tungsten lights fall in along a variety of shades of reddish tones. Fluorescent is the already disparaged green. And so on. The video camera's settings must correspond to whatever type of light you are shooting under or you will get potentially unacceptable color effects. Admittedly many of these can be fixed in post, but this may limit your flexibility in other areas. Getting it right in shooting is always the best solution, although it is not always possible. The more vexing problem is when you have differing light sources, say tungsten and daylight. This is a situation where life gets more complicated in both film and video.

DSLRs can be programmed to the color temperature of your choice in degrees Kelvin. There is also a menu function that allows you to switch between a number of common choices—daylight, cloudy sunlight, tungsten movie, tungsten household, fluorescent, and whatever else the manufacturer feels is pertinent. **(SEE 8-6)** If none of the standard options work, most DSLRs and video cameras permit manual adjustment to any desired light source. This is done by holding a white card in front of the camera. Under tungsten light, for example, the white card will reflect the light's amber color. The camera will see this and, when prompted, adjust the levels of the individual colors (RGB) until it sees the card as white. Thus everything shot under the tungsten light will read the light as white. This eliminates the need for color balance filters, particularly film's omnipresent

8-6

Standard color temp choices in the White Balance menu.
© Cengage Learning 2014

85 filter. The 85 filter is not really a significant burden, but more difficult lighting situations—fluorescent, mercury vapor, and so on—can be easily addressed in video.

This brief discussion may appear to oversimplify the entire issue of color temperature, but it actually omits only a modest number of basic differences. You must still consider the more significant issue of matching light sources in front of the camera to each other, which is explored in detail in chapter 15.

Support

It is difficult to communicate how central support equipment is in the grand scheme of things. The tinkerers who have hovered around the edges of the industry have had more than a hundred years to design all manner of doodads to help execute the most complicated of shots. From supports to mount heavy lenses on lightweight cameras, to French flags to block unwanted light from the lens, to apparatus to mount the camera on virtually any object desired, to body braces that even out handheld shots—all manner of mechanical and now electronic devices have been designed to allow you to create the quality of shots you want.

A good example is trying to execute handheld shots. People coming to a DSLR hoping to use it just like a still camera only with movement are likely to be disappointed. DSLRs are not really ergonomically designed for creating high-quality handheld shots. Handheld has become very popular in recent years, but without a carefully considered approach it generally looks sloppy and amateurish. This is a place where film experience can be handy and a full knowledge of support equipment to guarantee image stability can add many tools to your kit. Of course, high-end video has its own sophisticated support gear, but the pragmatic aspects and logic are largely based on its film ancestors.

For those who have been in the field for a while, it can be quite disconcerting to come onto a set and see this essentially teeny camera mounted on, by modern standards, a massive dolly, replete with tracks and a battery of technicians attending to the camera's needs. The kind of substantial, heavy support that is required for 35mm or even 16mm is overkill for a DSLR, but still the functions are pretty much required. Again the tinkerers and the thinkers at the rental houses have filled the void. It is all about creating what you want and exploring the sidebar stuff that will get you from here to there. Starting at a rental house is a good choice. Nurture friendships with those guys (and they are usually guys) who love to build things. I went to school with a guy who used two-by-fours to build an upside-down T and put secretary wheels on the bottom. We duct-taped (not a good idea) a cheap tripod on the upright and had an instant dolly. It was an unstable piece of junk, but I was able to extract a few seconds each of usable footage out of a number of otherwise sloppy shots and put them to good use.

Lenses

Most of the early video cameras came with a **fixed lens**, that is, a lens that was not detachable. Interchangeable lenses are one of the hallmarks of professional practice in both still and motion picture technology with the choice of lens, as suggested earlier, being an aesthetic decision. For the Canon Mark III, pretty much the full line of Canon still photography lenses are available to the maker. The same is true of all other DSLR manufacturers—Nikon, Pentax, and others. Canon, with its AF function on the lens, makes it hard to use lenses from other manufacturers. Despite designs like this, many lenses can be adapted to different cameras. Most still camera manufacturers are quite proprietary in what lenses go on what cameras, but check around and see what all the options are. Once you get into high-end cameras, lens interchangeability is a larger issue.

Cards

All DSLRs can write the image to either **CF** (Compact Flash) cards or **SD** (Secure Digital) cards or, most commonly, both. There is a compartment outfitted with two slots, one for the larger CF card and one for the smaller SD card. **(SEE 8-7)** Each card type has its advantages, with the SD cards maybe having a slight edge with many newer computers having SD ports. Either way, it is easy enough to set up a card reader. Many high-end cameras records to **SSD** (Solid State Drives), but the output of DSLRs generally have not been robust enough to support using external drives. The Canon Mark III has an **HDMI** (High-Definition Multimedia Interface) port, but it is not a "clean" output and thus does not guarantee a high enough quality signal to support SSD recording. Newer models of Nikon DSLRs, the D700 in particular, have come out with clean HDMI functions that allow the use of SSDs for primary recording and backup. There is a lot of buzz on the Nikon and future models of the Canon's designers will see the wisdom of the advance and presumably "clean" up their act, as it were.

The CF/SD card compartment on the Mark III.
© Cengage Learning 2014

With the Canon, it is best to either have enough cards along to record all the material needed or be set up to transfer chunks of material into the computer as you go. Many makers will have a crew member transfer a body of clips into the computer throughout the day, erasing clips from the cards as they go to free up space for more shooting. The need to erase the card after transfer leaves many of us uncomfortable. Theoretically the only version of each clip now resides in your fragile computer, but the solution is to back up the contents of the cards as needed after transfer. The computer used on set should be equipped with two hard drives, one serving as a primary backup and the other for archiving.

A computer file is a funny thing, with its existence being a slightly shadowy entity. As they move from drive to drive and into and out of NLEs, losing track of or just plain losing one or more files is always a possibility. Scrupulous data management is absolutely essential; for a clip to turn up missing somewhere in post-production is disastrous. Just as with the original in film, the data file that a DSLR or any camera creates is a precious commodity. It is endlessly reproducible but also easily erasable or otherwise lost. It is media that must be managed and secured. Entire companies have come forth to fill the void in data management.

Protecting against loss often requires a new dedicated person on the set (new at least from the film days of old) whose primary responsibility is overseeing hard drives and proprietary equipment. In the professional world a dedicated assistant in the editing room is now de rigueur and a good idea for independents as well. Film editing rooms had a number of assistants and they are equally important in the digital world. To expect one person, the editor, to manage it all is a recipe for disaster.

Editing Concerns

When working with a DSLR, one of the most important issues you have to keep track of is how computer files are converted in order to be worked on in an editing system. This is where codecs come in. A **codec** (which comes from "coder-decoder") is essentially a translation program or device that decodes data so that

undifferentiated streamed material can be viewable and editable. Issues of resolution, compression rates, and file renaming are also chosen. Codecs can also encode data, but our object here is decoding. You can shoot 24p or whatever but that does not mean there are still not a plethora of options in terms of how the clips are treated in an NLE. Here you really have to understand what workflow you want to pursue to make sure the clips are in the same configuration that you want them to be in the final program. In earlier digital videotape configurations, we might have called these Timeline Options or presets. Much material was at standard 29.97 NTSC. Anything shot to different standard had and still has to be entered at that standard.

The Canon Mark III creates .mov files, a file type proprietary to Apple's Quicktime. Even so, if you import a .mov file into Final Cut Pro (FCP), the program needs to know how the clips should be handled—they need to be "translated" so they can play and be edited. If you just drag the files in, FCP will require that they be rendered (see page 404), a laborious (for the computer) and time-consuming process. In addition, the image may go to a default resolution, unless you had the foresight to choose a different preset when you initiated the project. In my experience another possible complication is that rendering can occasionally produce an unstable image with more potential for downstream problems. Rendering also takes a long time to process—not only for a small number of files but particularly an entire day's shoot. Get it right or life may become messy down the road.

The High-End Video World

The world of high-end video stands in stark contrast to the DSLR world, but if you eventually go the all-manual route with a DSLR, you will find that the similarities will increase. High-end video is essentially an all-manual world. The image is, or rather can be, a much more complex entity requiring a robust NLE system, tremendous processing power, and extensive storage space. The cost of the cameras start approaching that of the best film cameras, both in terms of purchase and rental, but new manufacturers are leading the trend of creating cameras that sport a much more affordable price tag.

Video Standards

At present the two standards for shooting, displaying, and editing video are **interlaced video** and **progressive video**. Interlaced was the international approach for video scanning systems since TV's inception. The interlaced standard in the United States is the **NTSC (National Television System Committee)** signal, the approach taken by a diminishing minority of household TV sets and consumer video recorders. While NTSC has been largely supplanted, its interrelationship with American power standards and the existence of so many older sets casts a long shadow over the modern video world. There are a number of international standards, following NTSC, but the two dominant ones are *PAL,* the standard in England and much of Europe, and *SECAM,* the standard in France and a smattering of other countries around the globe.

Progressive video was the initial and long-standing standard for computer monitors, and for many years it caused a number of viewing conflicts between the broadcast world and the computer world. Over the last couple of decades, progressive has been incorporated into most consumer TV sets including LEDs, LCDs, and flat-screen plasmas. As such, it has found its way into more video shooting as well since the mid-1990s.

High-definition television (**HDTV** or **HD**) has essentially replaced NTSC as the industry standard and has for all intents and purposes replaced it in the consumer world as well. It is an umbrella term for higher-resolution video that is presented in a widescreen format. *Pixel aspect ratio* is the standard way of delineating formats, with the two aforementioned HD standards for DSLRs and prosumer models being 720 and 1080 vertical pixels. Image resolution can be much higher in professional world shooting. HD can be shot either interlaced (i) or progressive (p). In practice, progressive HD is dominating and becoming the mastering standard internationally as well as the display standard for high-end plasma and LCD screens. HD has had enough of an impact that a new term, **standard-definition** (*standard-def* or *SD*), was introduced to distinguish the old NTSC signal from HD. PAL and SECAM are also SD. SD was the industry standard for the first 60 or 70 years of the television industry. It employs the standard 4:3 (1.37:1) aspect ratio in which all the early movie classics, as well as all pre-HD TV shows, were shot.

HD incorporates a **widescreen** format with an aspect ratio of 16:9 (1.85:1 or thereabouts). Specialized formats often go wider than that, usually around 2.35:1. The history of widescreen actually dates back almost to the beginning of film history, although it did not come into extensive use until after World War II, when it was employed as a way to differentiate theatrical film from its new TV competitor. Since roughly 2007–2008, widescreen has become the most common approach not only in consumer sets but in computer screens as well. Whether interlace or progressive, 1080 and 720 use the 16:9 aspect ratio.

Just as film is shot in frames per second, video is broken down into video frames per second; but whereas film frames are arranged consecutively down the celluloid, the video frame does not have such discrete boundaries. In the NTSC/interlaced approach, the video frame is recorded diagonally on the tape, with each frame composed of two diagonal lines—called *fields*—of information. Each **video field** represents every other horizontal line of visual information in the video image, the first field being the even-numbered lines and second the odd-numbered. They are presented alternately in succession and thus interlaced to create the image. Although the video frame is not a distinct entity viewable to the eye like the film frame is, the editor can examine and identify a single video frame in playback just as with film.

Standard NTSC video runs at 29.97 frames per second, usually stated as 30 fps. The story goes that true 30-frame video led to some consistent, undesirable visual artifacts, and when slightly slowed down they disappeared. 29.97 is an integrated aspect of the American electrical system so the story is probably not true, but maybe a good myth for why such a strange number, at least in regard to film interface, became the standard. Whatever its genesis, the term **slowdown** became part of the vernacular and all video was regarded, again at least in terms of film, as being slowed down from 30 by .01 percent. This slowdown can be a big issue when you get into transfer of film to video. The original recording method for video was similar to that of analog audio, but it required much higher speeds to record a stable, usable image. Therefore the record head rotated in the direction of tape travel to multiply the speed of the tape. This is referred to as **helical scan recording,** an approach that was used in both digital video and audiotape.

The old standard consumer-grade half-inch analog VHS videotape employed four separate tracks and is representative in simplified form of the track configurations of many tape and digitally encoded formats. The image track is in the center and takes up the largest portion of the tape. The audio is on two narrow tracks at the top of the tape. **(SEE 8-8)**

The bottom of the tape was reserved for the fourth track—the **control track**—which was recorded during shooting. Composed of a series of pulses, the control

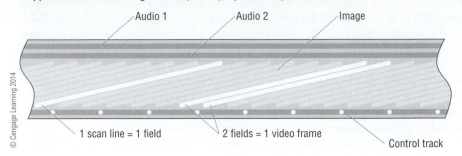

8-8

A typical half-inch analog videotape employs four separate tracks.

Audio 1 Audio 2 Image

1 scan line = 1 field 2 fields = 1 video frame

Control track

© Cengage Learning 2014

track and its emulators are central to the way video works. As with a film camera with a crystal motor, the pulses are referenced in playback to reproduce perfect speed. Any imperfection in the control track (and, by extension, the speed of the tape) will cause image breakup. There is 1 pulse per video frame, or 30 *pulses per second* (*pps*). While functional for a while, the pulse system proved to have overwhelming shortcomings.

On older analog video-editing systems, the control track allowed the easy identification and marking of video frames for determining the length of shots. Video frames were assigned a time reference in hours, minutes, seconds, and frames (e.g., 1:32:12:26) on an **editing control unit** (**ECU**)—the main edit controller. The pulses were essential in referencing frames in editing, although the critical shortcoming of the simple control track was that it did not provide a permanent address for individual frames. Time could be assigned to frames, but that changed whenever the counters were zeroed, tapes were ejected, or the machines were turned off and on again. Time code (discussed in chapter 9), whether in an analog or a digital environment, addressed that drawback.

Progressive video is in some ways similar to film in that all of the information for the image is included in one frame, rather than the two fields of interlaced video. The entire image is presented at one time, and then the next image is presented, and so on. For technicians trying to deliver the highest-quality product, progressive video is becoming the preferred medium, but there are still many NTSC TV sets in general use even with the general conversion to digital broadcast. However, the horrors of the diabolical "conversion box" probably persuaded a lot of holdouts into finally springing for something digital. While those familiar with modern TV standards could make the infernal boxes work, the many elder folks who had seen the digital revolution pass them by found the things impossible to negotiate. NTSC sets remain common in the United States, Canada, and Japan, but as older equipment is replaced, digital production and exhibition standards have prevailed.

Resolution and Image Size

The term *resolution* refers to how many pixels are devoted to each individual image. This is configurable on virtually all video cameras and DSLRs, and the standard choices are generally found in menus or LCD panels. Resolution is essentially determined by vertical and horizontal pixels. Compression (see page 188) has an impact in image size but the choice you make in how to shoot your video is the primary factor. The standard choices on DSLRs, plus most prosumer cameras, are the aforementioned 1080, 720, as well as the probably anachronistic inclusion of 480, the latter being the old 3 × 4 SD aspect ratio. The term "1080" refers to 1080 vertical pixels by 1920 horizontal pixels, and "720" is 720 vertical pixels by 1280 horizontal pixels.

The 720 × 1280 standard is formally referred to as *HD VIDEO 720.* Using a calculator, the number of pixels (height times width) comes out to 921,600 bytes per frame, which is nearly one megabyte. Thus shooting at 30 fps translate to roughly 30 megabytes a second. *HD VIDEO 1080* is 1080 × 1920, which multiplies out to 2,073,600 pixels, or 2 megabytes a frame or 60 megabytes a second. The latter thus is 3,600 megabytes a minute. When you factor in standard compression rates, you get about four minutes of video per gigabyte in 1080. SD is 480 × 720, called *SD VIDEO,* and it multiplies out to 345,600 bytes, which is a little more than a third of a megabyte.

The contribution of high-end cameras is obviously the potential for higher resolution images. While this all dates back at least ten years, the "newest" wrinkle has been 2K and 4K images, with 5K images on the horizon. In this instance, the number refers to horizontal pixels with the 2K image being 2048 × 1556 (they round things off). In reality 2K is not that much bigger than a 1080 image, 1920 × 1080, but it has become a common shooting and mastering standard. A 4K image is 4096 × 2160 pixels and is substantially larger than the 2K image. And so on with 5K and the future. While originally being more of an editing and mastering issue, particularly in writing the video image to the film image, high-end cameras are shot almost exclusively to these standards. As suggested, 2K and particularly higher rates require substantial processing power and extensive storage capacity.

Video Formats

Given file acquisition and the ability to finish within the NLE of your choice, formats have become somewhat less important. Once you are in, as it were, you never have to return to an upstream source. Tape-based equipment is fast becoming obsolete, and I have heard complaints that it is getting harder for the holdout users to find blank tapes at the rental houses and commercial retailers like Best Buy. Despite this, a few notes on tape-based formats are in order. MiniDV in particular revolutionized media production, and there are enough of them out there in people's hands that they still get some use.

MiniDV, the most popular initial tape-based digital medium, was the result of a number of manufacturers getting together in 1993 to create a standard for digital consumer shooting and editing gear. The MiniDV system, which when introduced in 1996 used the NTSC standard, was a stunning bit of electronic design in which a camera is interfaced with a desktop or notebook computer. MiniDV employs a very small cassette, roughly 2 inches by a little less than 3 inches, allowing for a compact and lightweight camera. **(SEE 8-9)** This flexible format, like many other digital formats, records its information in the same configuration on the tape as does analog video, but the information is encoded digitally.

The earliest incarnations of MiniDV were interlaced and in SD. The final trend was toward **high-definition video (HDV)**. HDV was the newest and last member of what has generally been called the **Digital Video (DV)** family, with MiniDV cameras and tapes being the foundation technology. The term *Digital Video,* when capitalized, refers to gear designed to a specific set of industry standards, including the **FireWire** interface with NLE programs like Apple's Final Cut Pro.

Until being largely replaced by file acquisition cameras, HDV and MiniDV were considered robust

8-9

The MiniDV cassette is roughly 2 by 3 inches.
© Photo courtesy of Bruce Mamer

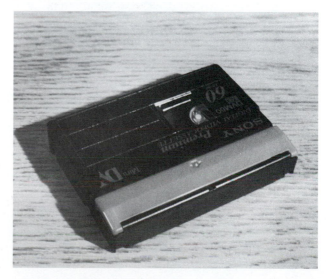

enough to make the grade for some industrial-level work. Indeed manufacturers saw the possibilities in stepping up from MiniDV and went on to create more-advanced systems. Sony and Panasonic introduced the next two DV formats to join MiniDV: **DVCAM** and **DVCPRO**, respectively. Each still receives some use in the production world. When this seems confusing, just remember that *DV* refers to these four specific formats—MiniDV, DVCAM, and DVCPRO—plus now HDV as well. With names so similar, it is easy to become confused about HD, DV, and HDV, not to mention throwing DVD and a few other abbreviations into the mix.

The initial upgrade was Panasonic's *DVCPRO*. It had a slightly faster recording speed, devoting more space and thus more information to each frame. DVCPRO allowed the user to shoot three separate cassette sizes, with the tape compartment having channels to negotiate the different cassettes. DVCPRO can record the standard MiniDV, and there is also an intermediate and a larger size, both specific to DVCPRO. The second is roughly 3 by 5 inches, and the biggest is close in size to a standard VHS cassette, although much thinner.

Introduced after DVCPRO and also incorporating improvements on MiniDV, *DVCAM* also proved popular. **(SEE 8-10)** It recorded on two different cassette sizes: standard MiniDV tapes as well as a cassette similar to the intermediate DVCPRO one. None of the larger cassettes is interchangeable between different formats. With MiniDV and its bigger siblings, substantial consumer and, particularly, industrial work drifted upward in this chain. The MiniDV family, however, still requires extensive compression, and the feature film and network broadcast worlds worked to higher standards. All tape-based media requires capture into your NLE, converting your clips into Quicktime, or different NLE-appropriate, files. Tape can be directly converted to files, but unless it is more efficient, this is a redundant step.

Digital Betacam, referred to as *Digibeta*, was Sony's portable and studio professional end of the digital world. When Sony lost out on the initial Betamax-versus-VHS consumer battle (kind of like the Blu-ray/HD DVD conflict), the company went after the high-end analog market. **Betacam SP**, Sony's improvement over Betamax, was introduced in 1982 and was used extensively in TV stations and industrial production. Beta SP camcorders (the *SP* stands for *superior performance*) were common and used throughout the industry, although not in the feature and episodic broadcast worlds. It apparently remains in very limited use as the only significant broadcast-quality professional analog standard, mostly in sharing tapes and archival applications. Digibeta was introduced in 1993 to be the digital replacement for SP, but wound up being more of a mastering standard than a production tool. As such it has been and continues to be an important player, particularly in creating tapes for ad agencies and submissions to festivals.

Sony's **D-1** is a step up from Digibeta and was the initial version of what is referred to as the *D series* of formats. These are high-end recording systems that are generally studio-based and used for high-quality mastering of field tapes and film transfers. It also received use as a studio record deck. Initially an industry collaboration, D-1 was followed in short order by D-2, D-3, and D-5—from coming Sony as well as competing manufacturers: Panasonic, Bosch, Hitachi, and Ampex among them. Of these, D-1 and **D-5** have been the biggest players. D-5

8-10

DVCAM cassettes come in two sizes.
© Photo courtesy of Bruce Mamer

has been adapted for HD and was the most widely used format in mastering for broadcast. D1 and its emulators master to 4:2:2 compression which was the highest level of compressed video up to its time. Mastering decks and cameras that shoot to a full 4:4:4 are now common in the high end of the industry and, while the D series still receives use, fully uncompressed video is now the feature and high-end commercial broadcast standard.

Probably the most discussed digital system of the last ten years was **24p**. Sony introduced it with its CineAlta camera line and it quickly gravitated into the consumer and prosumer world. It briefly dominated the high-end video camera world with products that became industry standards for shooting. In addition to the 24p CineAlta camera, Panasonic weighed in with a marvelous addition, the DVX100 in 2004 which many consider to be the first progressive midrange camcorder. **(SEE 8-11)** In addition, a number of other formats are proprietary to either individual manufacturers or specific broadcasters' criteria, Panasonic's M1 system being a prime example.

8-11

Panasonic DVX100A 24p MiniDV camcorder.
Courtesy of Panasonic Corporation of North America

Until about 2000, the majority of episodic TV shows continued to be shot on film. A significant, though diminishing, number still are. There have always been, at least since the age of videotape recording began, a lot of shows done on tape, particularly sitcoms, game shows, talk shows, and the like. However, 24p is indeed the format that first started making inroads into the previously exclusive world of episodic TV. The trend will continue.

A number of other, older digital tape formats and cameras held on for a while but they have lost the battle. For a while there were even cameras that ground out DVDs, but it is all mercifully gone. Some grandfatherly types, myself not included, probably have VHS cameras in their closets, and decks to trot out to watch the grandchildren. However, while one occasionally sees prerecorded VHS tapes in the bargain bins at the big box stores, as big a consumer player as it was, its life is essentially over.

Technical Specifications

Reading video specifications and technical manuals can be somewhat like tackling treatises on physics (which to a certain extent they are). The complexity of much of the discussions of video technology is daunting. The following are a few basic technical considerations with which you should at least be familiar.

The interlaced NTSC standard was arrived at in the early years of TV because sequential presentation had the potential to overtax the available bandwidth. One recent distinction between interlaced video approaches is that between composite video and component video. Composite video is the earlier of the two, and though many systems still incorporate this approach, component video became the preferred standard in high-end production. The major difference is that **composite video** breaks down the signal into a relatively simple mix of RGB—red, green, and blue—elements. **Component video** further breaks down the signal into these color components mixed with a luminance (brightness) component. All progressive video is component.

RAW Technology

In addition to the standard 1080, 720, and 480 shooting choices, RAW technologies have been introduced into the high-end video cameras world. RAW has a long history in still photography, but it really took off when Adobe Photoshop incorporated its **DNG** (Digital Negative) file format in 2004. There are many different RAW file types, and while DNG has been widely adopted, many manufacturers use competing formats. It remains a top-end standard for still image acquisition and particularly processing, and over the last five years has made major inroads into professional video imaging. Virtually all high-end video cameras have RAW capabilities.

RAW is so named because it brings largely undifferentiated data into the acquisition of the image. Resolution is generally selectable with the RAW video image in that you can shoot it 2K, 4K, or whatever options the camera has. Exposure and focus are still important but otherwise within the parameters of image capture, all the information is minimally processed giving the photographer and now the video team great control in post. We say "video team" because the videographer often has limited influence in postproduction. So much can be done to the image after initial shooting that the final look of the image may depend on a group of techs in postproduction studios. As one might suspect, this has caused major conflict on a number of projects with some videographers, as suggested, preferring DSLRs and the like because the image is less malleable.

Despite this, RAW imaging provides tremendous control. Focus has to be on. Software can offer "sharpening" capabilities, but these tighten up the image, not correct the focus. You don't want excessive over- or underexposure leading to parts of the image lacking detail, but quite a bit of simple correction can be done. White balancing is very fluid. Color correction is probably where the biggest changes can be made. Video's equivalent to film's timer, the **colorist** has wide-ranging control over virtually every element of the image and can substantially correct or change the entire look of the project. Many advanced NLEs have color correction functions that allow the ordinary user this substantial control. Make sure you know what you are doing.

The RAW image has some similarities to the film negative in that it is not a viewable entity. It must be processed or "decoded' before it can be viewed or corrected in a software package like Adobe Photoshop. Most still cameras come with software that has a function that translates a RAW image into a usable form. In RAW video imaging, the user has to select a menu choice that will translate the raw clips into an NLE. These are the aforementioned codecs that will be further discussed in the next chapter.

As suggested, all of the cameras discussed in coming sections are capable of shooting in RAW. They also have many of the other standard choices, but RAW has pretty much taken over the top end of the industry.

Compression

Although few of the technical issues discussed so far are particularly pertinent to the average filmmaker, they do have a bearing on compression and sampling rates, which are important issues in digital video in terms of broadcast standards and overall quality. The huge amount of information required to compose even a single frame of video means that storage, instantaneous retrieval, and broadcast become challenges. Compression and the use of sampling rates represent two approaches to signal management and the glut of data. They are often confused, and rightly so, because they are both ways of managing, and thus reducing, this unwieldy amount of information. In essence, they work together to get the best-quality image without overtaxing bandwidth.

As most computer geeks know, **compression** is a way of reducing the amount of data by discarding information that appears redundant, such as most of the blue pixels found in a clip of a blue sky. This gets into a host of other issues too complex for this brief discussion, but suffice it to say that component digital formats with 3:1 compression were the minimum standard for high-end feature and broadcast work. Now there are high-end digital formats that require no compression, and they have far surpassed the 3:1 standard. MiniDV compressed the image so much—5:1—that, while it still looked great to the eye, it posed many problems in postproduction if you wanted to do color effects, create computer-generated images, or transfer to upstream formats. There are also approaches called *lossless* and *lossy* compression. The former compresses without throwing anything away by expressing repeating information in multiples and not an almost endless string of numbers. The latter is more random in its selections.

Color Space

Although compression and related topics have their complexities, it is reasonably simple to grasp the major concepts. *Sampling rates— generally referred to as a format's* **color space**—are a much more challenging issue. They are an aspect of component video and not an issue in the composite approach. Issues of color space have to do with the relative mix of luminance and chrominance (color) components. Component video samples for luminance and color, and the result is expressed as a ratio. Luminance must be completely sampled to give the full range of light-to-dark aspects of the image. Color can be sampled at lower rates and still produce a usable, often excellent, image. Component video samples blue and red, with the green encoded in these two. MiniDV, as well as DVCAM and most DVCPRO, samples at 4:1:1, meaning 4 samples of luminance for every 1 sample of the other two signals. DSLRs do not identify their color space, but it is less than 4:1:1.

This is all fine for consumer and prosumer work, but it is not ideal for professional applications. Color correction, in particular, is harder at lower sampling rates. Many high-end formats sample at 4:2:2. This has led some writers to refer to both 4:1:1 and 4:2:2 sampling as creating a "crippled color space" in that there is not a full representation of the color (as there is in film) in either. The case against sampling at 4:1:1 has validity: 4:2:2 less so.

Obviously, as computers become faster and faster and are able to deal with more and more information, sampling rates across the board will increase. Sony introduced the first 4:4:4 camera system in its early CineAlta models which have led to many other companies emulating and improving on compression issues. The concurrent introduction of 4:4:4 studio mastering equipment was also highly significant; and though it is still extremely pricey, 4:4:4 gear has worked its way into a majority of postproduction facilities. While the feature world obsesses on 4:4:4, essentially with good reason, 4:2:2 is more than adequate for a high number of applications.

Frame Rates

The choice of a frame rate has become a major factor in video shooting. At one time, the standard 29.97 NTSC frame rate was the only option. Actually, 24-frame video has been around for more than 30 years, but cameras that shot video at 24 fps have been in widespread use since the late 1990s. The previously mentioned Sony CineAlta was soon joined by a host of other cameras which recorded 24p on DV tapes. This has all moved over to file-based shooting. Now that it is widely adopted, all but the most basic NLE systems can be switched to 24-frame in their preferences or now choice of codecs.

Still the NTSC world casts a long shadow over modern video standards. In progressive, what we call 30-frame video still actually runs at 29.97. Most high-end

cameras allow you to select between true 24-frame video and 24-frame video with the slowdown. The slowdown yields 23.98 fps. The only people shooting true 24 are those making an essentially immediate 1:1 conversion to film—probably a diminishing, although very high-end, number of makers. The 23.98 folks want an easy up-conversion to 29.97—which is difficult in true 24—and a more subjective level consider 23.98 to have a more subtle film look. This still provokes argument, but many suggest that 29.97 simply has a more inherent video look and that 23.98 better emulates how we perceive film. Everyone will have to form their own opinion on this, but the use of 23.98 is very widespread in the industry.

There is a report involving Peter Jackson's experiment with shooting 48-frame video on *The Hobbit* (2012). He showed the 48-frame material to a test audience and they loved the content but a majority suggested it did not look very good. The editorial staff went through and had the software electronically pick out every other frame and audience response was much more positive. There is something about 24 and 30 that defines their mediums respectively. Enough pros have come to this conclusion to warrant serious consideration.

Other frame rates have been introduced that are intended for real-time shooting—true 30, the previously mentioned 48, 59.94, 60, and a few others that have specialized uses. Other than 24 fps and its permutations, however, video has pretty much remained a 29.97 medium. Film, of course, can be shot slower or faster for fast-motion and slow-motion effects, respectively. In video most motion effects were produced electronically, but Panasonic's VariCam and Arriflex's Alexa can be run at different rates for slow-mo and fast-mo. More cameras are being developed to address even higher frame rates. Sony has released a camera, the NEX-FS700U, that can shoot up to 960 frames a second. Compression and color space are issues with the Sony camera compressing substantially at 960. Arri's Alexa can shoot at twice normal speed but must drop down to a 4:2:2 color space. Reports on footage from both cameras have been good. There have been many debates, however, about video slo-mo results, and many filmmakers who are shooting a lot of slow-mo are still shooting film—NASA and NFL Films being the best examples. The late Steve Sabol employed film as NFL Film's dominant sidelines presence and, while there were forays into digital video, well over half NFL Film's shooting is still on film. We will see what the future brings.

Cameras

While much of what has been said about film cameras in previous chapters applies to the general approach to shooting video, there are a number of additional considerations. There are distinctions amongst film cameras, but the final destination of that light coming through the lens has always been the motion picture film—a commodity with nominally exceptional consistency. In the video world, there has been a distinction between *consumer* gear, *industrial* gear—often referred to as *prosumer* gear and used for things like news, corporate, and training videos, and *commercial* gear for the high end of the business. The world of **DV** (Digital Video) blurred the first two categories as file-acquisition cameras continue to do, but the distinctions remain useful.

There are essentially two approaches to video shooting and recording: with a **camcorder**—a video camera and recorder, whether tape or file, combined in one unit—or with a video camera and a separate recording deck. So many cameras have some form of card or internal or external hard drive recording that the external record deck is less common, but for the Lucas-echelon folks who need to produce the highest-quality images and are shooting huge quantities of material, recording to digital studio decks is a common approach. The consumer/prosumer world tends toward the camcorder and the professional world tends toward external hard

drive recording and studio decks. All the highest-end cameras record to external SSDs, and a few even have on-board SSDs.

Notes on the Consumer/Prosumer World

DSLRs have captured the public imagination, but there are still many excellent choices in the standard camcorder world. Many manufacturers are producing midlevel digital video cameras, although Sony, Panasonic, Canon, and JVC have been responsible for the most ambitious models. Virtually all of the manufacturers have eliminated their tape-based cameras, although a few, like Canon, still list their previously successful lines. All manufacturers have a wide variety of file-based cameras, with most having onboard 16 or 32 gig memories. Cameras range from the inexpensive "automatic everything" consumer cameras to the lines with many manual features and overrides. All the cameras mentioned are current to 2012 but will undoubtedly be replaced by newer, more advanced models.

The Canon XF305, for instance, sports a 4:2:2 color space, which is exceptional for a small camcorder. **(SEE 8-12)** Its retail price is not substantially more than the Canon Mark III and its features and design are more video friendly, particularly for hand-held applications. On the downside, it does have a fixed lens but it is of high quality and has proved great for newsfilming. Panasonic started a revolution with its small tape-based DVX100, the first progressive scan camcorder and an early popularizer of the 24p format. The file-based version is the AG-HVX200, a 4:2:2 fixed lens version that is competitive price-wise with the Mark III. **(SEE 8-13)**

The present top of the line Sony 4:2:2 version is the HXRNX5U, part of what they call AVCHD family. The retail price is a little more than the Mark III. All of these cameras are remarkable pieces of equipment, and while features and their brethren work to a 4:4:4 standard, the 4:2:2 world produces incredible imagery. The DSLR world works to a lesser color space but it is no also-ran in the race for image quality. JVC also has a number of cameras that get significant use. Their Everio line serves the consumers and GY-HM150U is the anchor in a sophisticated midrange line. **(SEE 8-14)**

The choice of a digital camcorder should be made carefully, whether consumer or prosumer. Cameras that interface with computers are marvels of digital/electronic design, but to achieve a consumer-friendly price they are frequently flawed by compromises in some of their image-gathering qualities. Cheap lenses are probably the biggest problem, with many consumer cameras coming

8-12

The Canon XF305.
© canon.com

8-13

Panasonic HV-HVX200.
Courtesy of Panasonic Corporation of North America

8-14

The JVC GY-HM150U Camcorder.
© jvc.com

with previously mentioned fixed lenses, often plastic. The search for a camera that comes with or can be outfitted with a good lens being critical, a colleague suggests the "rule of 3500"; that is, if the camera costs less than $3,500, odds are that it does not have a very good lens. Obviously, the top end of the video camera world comes with switchable lenses. With the newest professional models you are frequently faced with the choice of a variety of interchangeable lens mount, a reasonable new wrinkle in all this. Thus the user has a wide array of excellent lens possibilities—a sometimes bewildering but eventually advantageous set of choices.

The High End

Until a number of years back, Sony and Panasonic were the leaders in the high end of the digital video camera world. Sony has its previously mentioned CineAlta F23, a 4:4:4, two-thirds-inch chip camera that is widely used. **(SEE 8-15)** Panasonic had their AK-HC3500, again a two-thirds-inch chip workhorse. Since roughly 2007, they have been joined by a number of completely new players as well as some industry stalwarts that have put in their own claim on the digital future.

8-15

The Sony CineAlta F23.
© sony.com

Three companies, one better known in studio TV and postproduction circles and the other two coming completely out of left field, have introduced cameras that have or will change the high-end landscape. Thomson Grass Valley, a producer of studio switchers and other products, has created the Viper FilmStream, which was used on Mel Gibson's *Apocalypto* (2006) and Michael Mann's *Miami Vice* (2006), as well as many other projects. **(SEE 8-16)** It can shoot at 2.37:1 widescreen and, while shooters suggest it is cumbersome in the field, has received very positive reviews.

Coming pretty much out of the blue in 2007 was a camera simply called the **RED ONE** from the Red Digital Cinema Camera Company. It was revolutionary in that it employed RAW technology, the image format that previously was the sole province of still photography. It writes individual frames to a hard drive in 4K or lower sizes. It has switchable chips that allow a choice of widescreen formats and switchable lens mounts allowing their own proprietary lenses, as well as PL mount lenses, Canon, Nikon, and Leica lenses. Fully tricked-out, it weighs only 9 pounds, offering much greater portability than many competitors. Most remarkable, the camera with a good set of primes starts at around $40,000. (The CineAlta line averages in the $100,000 neighborhood.)

8-16

Thomson Grass Valley's Viper FilmStream camera.
© Courtesy of Grass Valley

Following the amazing success of the RED ONE, Red Digital has come out with two alternative models, the EPIC and the SCARLET. Each are more compact than the RED ONE, but offer many new features: the EPIC is a step up and the SCARLET a simpler and more affordable camera. The EPIC has moved up to 5K images. Peter Jackson's *The Hobbit* was shot on the EPIC in 3D. **(SEE 8-17)**

Just as the RED ONE broke five years ago (2007), the **Black Magic Cinema** camera is breaking as this text goes to press. **(SEE 8-18)** From a new-to-the-field manufacturer and released in September 2012, the camera is making waves not so much for what it can do (which is apparently exceptional) but, not dissimilar from the RED ONE, as much as what it will cost. The body is listed without a lens at $2,995—an unheard of price in the high-end world. The price goes up with lenses, viewing systems, and other support equipment, obviously, but it still represents the cost of production to the outsider continuing a remarkable downward trend. I have to admit that this camera has the most un-film-like look of all the new cameras. It is small and squarish, having the least streamlined look of any camera I have ever seen, but there is no reason to hold onto a nostalgic vision if the functions required have changed. Just from its look, however, it appears that it may be difficult to handhold without significant modification. Indeed, trade journals are already advertising dedicated body braces and the like. Reports on field tests have been positive so far and the Black Magic may well be another game changer. It shoots a maximum 2.5K image, which may be smallish for the feature world but certainly adequate for many, many applications. It also has an on-board removable SSD.

Along with these new players, a number of heavy hitters from the storied past of film history have weighed in with digital video cameras worthy of their manufacturer's much revered names. Arriflex has brought out the Alexa, which is getting extensive use on features and particularly premium cable series. **(SEE 8-19)** The producers of *Game of Thrones* went with the Alexa for its image quality and its efficiency in their production circumstances. Word on the street has been quite amazing, even for a product that, after all, comes from one of the world leaders in professional equipment. Some have gone so far as to say that it is "the final nail in film's coffin." This from cinematographers who have great experience in both the film world and the video world and who have continued to champion film in circumstances where it is appropriate. While film remains a great product, when video indeed can completely emulate and equal its look, the end may indeed be near in the shooting world.

Panavision, which has supplied cameras to the feature world for decades, has gotten into the game as well. As suggested earlier, they usually do not produce new cameras: they "panavise" other manufacturers' cameras. In this case, it is the Sony F23 that has been the subject of their tender ministrations, being optimized for the rigors and technical demands of the feature world. However, their top of the line

8-17

The RED EPIC, without lens, what is called the «Brain Only.»
© red.com

8-18

The Black Magic Cinema Camera.
© blackmagicdesign.com

8-19

Arri's Alexa digital camera.
© ARRI Film & TV Services GmbH

The Panavision Genesis.
© Courtesy of Panasonic Corporation of North America

camera, the Genesis, is primarily an in-house Panavision product although it is based off of a Sony camera body. **(SEE 8-20)** Panavision does not sell cameras but only rents them and the Genesis and F23 Digital Cinema Camera continue the company's longstanding traditions. In the final analysis, it is all about combining the features—eyepieces, adaptability to support equipment, and the like—that streamline a camera's efficiency in the studio or location production world. Panavision has been in the game for a long time.

Last but not least, Aaton has also weighed in with their Delta digital camera, part of their Penelope line. (As Penelope waited for Ulysses, we have not waited in vain for these cameras—so sayeth Aaton.) **(SEE 8-21)** It shoots in RAW if desired, has a Super 35 chip size, and most of the features of the other top-line cameras. All shoot in 4:4:4, can produce files with higher resolution than the standard 1080 approach, and have features consistent with high-end production practice.

8-21

Aaton's Penelope digital camera.
© Photo courtesy of AbelCineTech, Inc.

3D

The 3D format has garnered a great deal of attention over the last few years, with the obvious focus on the feature world and theatrical presentation. There has, of course, been a parallel movement in shooting home 3D and the beginnings of 3D home theater equipment. All the manufacturers of midlevel cameras have models devoted to 3D and a number of cameras can be modified to it. **(SEE 8-22)** On the high-end, 3D cameras are available and many of the key players (EPIC, Alexa, etc.) can be modified as well. The question, one which provokes much discussion in the industry, is what exactly is the future of 3D? Is it a passing

8-22

Panasonic's AG-3DA1 digital 3D camera.
© Courtesy of Panasonic Corporation of North America

fad—a novelty—as it was in its initial incarnation in the 1950s? Or is working in three dimensions with the possibility of significant viewer interaction the wave of the future? Will 3D capabilities come with all consumer TVs just as they have evolved to color, HD, progressive, and a host of other advances? If interactivity progresses in a vital and involving way, I suspect 3D will be part of the package. If interactivity winds up being primarily a rush for adolescents, 3D may wind up being a nostalgia item occasionally trotted out for curiosity impact like it's a ancestor of 60 years ago.

Final Notes on Using a Digital Video Camera

In many of its functions, the video camera is, of course, similar to the film camera. As suggested, many consumer and a few prosumer cameras are flawed by their automatic-everything approaches. Video equipment must address the same technical issues, yet filmmakers are often frustrated by the lack of clearly defined technical parameters in low- and midrange video. Automatic features are designed to appeal to the home video shooter, and aspiring pros will run into more problems the more they try to get away with the deceptively easiest approach. Automatic focus and exposure are fine for the amateur but untenable for professional or upper-level independent applications. Most consumer cameras have some crude manual overrides, whereby focus and exposure can be changed but often in relation to undefined settings. You may have a function to raise or lower exposure or change focus points, but these are not calibrated in any way. When a lens is not calibrated in feet or meters but leaves it to the operator to determine sharpness, it is difficult to execute the thoughtful rack focuses that are common in feature films and many other applications. In addition, when a lens is not calibrated in stops, it is difficult to establish light values that exist in relation to a certain exposure. Matching for continuity becomes very difficult. Clearly, much videography is justifiably lit to the human eye in conjunction with the video monitor, but an understanding of how light relates to an exposure can be an advantage.

Midrange video cameras have a focus ring, some form of exposure control, and a lens with something akin to a focal length—usually a zoom lens. Other factors that are reasonably concrete in film—particularly exposure index, depth of field, and color balance—become somewhat more slippery in video. All three of these factors are in some way dependent on the construction of the chip for individual video cameras, not necessarily on the technical quantification of light as they are in film. Videotape does not have an EI as such, with sensitivity to light based not on the formulation of the tape in a way similar to the construction of the film emulsion, but rather on the number and the design of pixels. Recall that pixels are the imaging-sensing devices on the video camera's chip that translate the light it receives into an electrical signal. Theoretically, each model of video camera creates its own EI, although most are in similar ballparks.

So midrange video camera lenses have a focal length and an f-stop that are based on mathematical formulations, just as in film. Despite this, depth of field and exposure are not generally taken into account in a similar fashion. In video as in film, depth of field is dependent on the size of the format being used—in video's case, the chip size. Wide-angle, normal, and telephoto focal lengths can be identified for each chip size. Otherwise, depth of field is dependent on the f-stop and focus as it is in film. However, video manuals rarely list depth-of-field charts, because videographers tend to track depth of field and focus effects by eye as the shots are being set up. This is a perfectly acceptable method except that it does hamper the ability to plan for focus effects. For those who have a hard time abandoning the film approach, the three chip sizes roughly translate to the three basic film formats: a Super 8 chart is close to a one-third-inch chip, a 16mm chart could be used for a two-thirds-inch chip, and DSLRs are close to 35mm. Many cameras are close to 3-perf 35mm and that would require a chart of its own. Note that these are only

rough equivalents; depending on a film depth-of-field chart for precise focus parameters for video would be a mistake.

Chip size and number (one or three) are also critical issues. It is interesting because as beautiful as the DSLR design is, some consider the larger chip size to be a hindrance to certain approaches. As with film formats, the larger the chip size the shallower the depth-of-field characteristics. Again, depth of field has become a paramount topic in discussions of the quality of the film versus the video image. Depth-of-field effects are primarily the province of the expressive image. Shooters of nonfiction media, if we can use that umbrella term, want to maximize their focus so subjects will stay in focus through spontaneous movements, viewers will maintain a sense of space, and no one will be distracted by "arty" focus effects. The smaller chips of many of the midrange cameras do a better job of providing the security and "protection" they need. The number of chips, although debates rage about this, affect overall image clarity (resolution). As suggested in earlier discussions, beginners often work with the depth-of-field effects that they wind up getting given their inability to fully manipulate all the elements. Controlling focus is a huge issue that novices often overlook.

Sound is also a concern. Most video cameras, whether digital or analog, cheap or expensive, have excellent sound-recording specifications; they can record very high-quality sound. That is not the problem. A large percentage of good audio recording depends on microphone quality and placement (see chapter 10). Keep in mind that the built-in mics on most cameras will not produce the high quality sound needed for a project that you hope to get screened and distributed—largely because the mic is frequently too far from the subject. Most cameras have a jack for an external mic; consider using it and employing someone to monitor both mic placement and overall sound quality. You may want to route the sound through a mixer first—or more commonly, record it on a separate unit altogether—but be sure that you understand the technical capabilities of the gear before moving forward.

The Canon Mark II in particular had well-documented sound issues. It did not have a standard way of monitoring sound, thus handicapping the setting of appropriate levels and the monitoring of good mic placement. Both issues can easily fall by the wayside if the approach is haphazard. While the Mark III shows a tremendous improvement, the more complex your project the more you will see a need for a separate recorder (and operator).

In a more global sense—and there will undoubtedly be those who strongly disagree with this assessment—one of the major problems with beginning video is that much of the initial shooting is undisciplined; that is, inexperienced shooters produce images that lack weight, internal pacing, or dramatic power. Video is so cheap and so immediate that it is easy just to turn on the camera without thinking about scene structure and the logic and the clarity of shots. The great debate (albeit perhaps one-sided) between Hollywood and independents is that the typical Hollywood image is so slick and expensively mounted that it is devoid of any intrinsic relationship with reality. Independents certainly have their points, but one can also think of spectacular images from Hollywood films, and we should include international films in this, that have profound emotional impact and dynamic power. There are also Hollywood images that look as if they are coated with a plastic layer of light and color, and there are a multitude of images in indies that are so devoid of engaging qualities as to render the projects visually uninteresting. Excellent films at any level are generally filled with remarkable images. How do you make an image remarkable?

A camera is made to express ideas. A simple camera can be used to express what you want, but it will present challenges that constantly put you in "workaround mode." Workaround mode makes you frustrated, frustration makes you angry, and anger means you eventually wind up in a roadside ditch, or so the commercial goes. Don't wind up in a roadside ditch. Learn and incorporate the basics as you would be forced to learn them in film. Many of us may pine for film but *there will be no*

going back. Maybe there will be a nostalgia movement, like kids liking LPs, but the cost structure is not remotely comparable. We suffered through many years of hearing that video was fast approaching the film look and it just may finally be coming true. You will be forever stuck in YouTube mode if you do not recognize that there is a technical body of material to be mastered and, more important, you must learn the fundamentals of scene structure and dramatic construction to create involving work. I once had a professor who made a striking observation. He said people do not love film purely in and of itself, as *pure film*. They like film for its incredible ability to tell stories. This is fine for a film aficionado, but as a maker you must understand film from its ability to tell a story visually. Without this fundamental knowledge, success is, at best, rare.

Part III
Shooting

9

File Acquisition and Film Transfer

As suggested earlier, the video image can be obtained in basically three different ways. Discounting CGI as a world unto itself, primary image is obtained either by shooting on video in the first place or by shooting film and having it transferred to video. In the past, all transfers were done on a telecine, a standard, relatively straightforward, approach but one with complications in frame conversions and speed changes, both issues that are discussed later in this chapter. With the new dominance of file acquisition the telecine has been largely replaced by the **datacine**, a studio transfer machine that creates digital files. We will use the term datacine although the habit of referring to film transfer as telecine is so ingrained that it may persist for many years. While the output is different—file vs. tape—in many instances the conversion issues remain the same. If you are going to progressive video, these complications can be initially avoided. But the NTSC world casts a long shadow. If you are going to an interlaced format, problems persist. Either way, entrance into the remnants of an NTSC environment is eventually unavoidable. Whether it be older consumer televisions, aging broadcast equipment, or making DVDs for client/audience viewings, every project will have interlaced versions. NTSC remnants will eventually be gone and life might, given the constant possibility of new wrinkles, become easier. But that is far, but not too far, in the future.

Digital Editing and Film-to-Video Transfer

Before we tackle the many paths of the video image, a brief discussion of some postproduction issues is in order. Beyond questions of whether to shoot your project on film or video, the whole relationship between the two media requires careful consideration even in the initial steps of preproduction. If you choose to shoot on video, your workflow can be relatively simple. If you want a high-end video finish, however, it can be every bit as complex and demanding as any film finish. If you shoot on film, you have a host of options available to you and issues which you must address.

If you shoot film, the most common route is to transfer the film to video, import or capture it to a digital environment, and edit it with a nonlinear editing (NLE) system. With the advent of hard-drive and card recording as well as technologically advancing transfer, video and audio files can be dragged and dropped onto any computer's drive. They will probably need translation and this is where codecs come in. If you understand the issues, transfer is relatively simple. Depending on how you want to finish, life can proceed simply or the challenges of high-end video or film finish will require executing at the highest level. And lots of money.

Origination on video proceeds about the same way. Once you are in your NLE, finishing again becomes the question. A friend makes training and customer-use videos for a national fitness chain. They will be shown in the workrooms and gyms of the local franchises. A good clean presentation is all that is required and a finish in Final Cut Pro (FCP), or any other suitable NLE, is more than adequate. Again, the capability to finish at a very high level in many NLEs is steadily increasing. That said, features, commercials, episodic TV, and host of other projects usually have to be finished to a higher standard.

Basic Definitions

With any finish on video, a number of key considerations and technical issues need to be addressed and understood. Some may not be pertinent to makers like my friend who makes fitness videos, but most of these will be present or future concerns.

Broadcast Quality

Broadcast quality refers to the incorporation of a video image that meets certain emission standards. In a manual, equipment fulfilling this requirement is listed as meeting *RS-170A standards*. Although these standards are based on objective technical specifications—including signal-to-noise ratio, resolution, and color accuracy, among others—just what constitutes a broadcast-quality signal can be a matter of some disagreement. The problem is that most professional equipment exceeds the established standards to the extent that many people in the field subjectively establish higher standards. Although a hard-and-fast definition of *broadcast quality* is elusive, amateur video is not generally considered of sufficient quality to gain wide use. There are, of course, the home-video-clip TV shows, and the lower image quality of the submitted clips clearly demonstrates the differences.

Off-line and On-line

The distinction between *off-line* and *on-line* concerns the working methods in finishing a project. An **off-line editing** system is used to make all of the basic editorial decisions; an **on-line editing** system is used to finish the project, with broadcast quality being one potential major issue. Again, this distinction has started to blur but the on-line world offers many advantages, particularly the wisdom and knowledge of technicians who have a working lifetime of experience.

When working on an off-line system, you generally work with a low-resolution image. Off-line editing systems are less sophisticated, often lacking the hardware and the software designed to manipulate the image and create optical effects. Their primary advantage is that they provide a low-cost place for the time-consuming process of making all editorial decisions, great and small. They also require less space on the computer, allowing the editor to store more material from which to choose or to work on bigger segments or entire projects. Thus the intention is to return to a higher-quality image and finish on a more sophisticated system—an on-line system.

Some production companies have on-line facilities, but more often than not finishing means going to an expensive professional studio. Working off-line saves the time with the expensive gear for when many of the decisions have already been made. Though the idea of not working on a finished product may seem peculiar, it is worthwhile to remember that film editing is essentially an off-line process. You are editing a workprint that must be returned to the negative and then taken to a lab to create a finished product.

Debates about whether a system like FCP, or even Avid, can produce an on-line product still simmer but are starting to quiet. The answer is evolving with

Time code is the rolling clock that identifies individual frames.
© Photo courtesy of Bruce Mamer.

the capacity of standard NLEs to work with higher-res video constantly improving. A few years ago, material went straight out of programs like FCP to broadcast, but it was mostly from television news departments and cable access. The work looked fine but would probably not fly for episodic television, commercials, or music videos. Virtually all of this latter kind of work was returned to an on-line environment for a high-end finish. As the ability of many commonly available NLEs to handle a project from beginning to end expands, the on-line world will come under more and more pressure and probably start to contract. This is not necessarily a good thing but it does not necessarily have to be a bad thing. As with so much else in the digital world, it just is.

Time Code

Time code is video's strategy for keeping track of frames and is simply a perfect-time rolling clock that is recorded on a track on the video. Time code reads in hours, minutes, seconds, and frames. **(SEE 9-1)** You can base this rolling clock on the hour of the day, determine an individual start point for each tape, or have new start points for whatever you choose while shooting on-location. The advantage of time code is that when a frame is identified, it can be returned to at any point during postproduction. Unless removed for some unknown reason, the numbers are consistent throughout the life of the tape.

For datacine transfers, a hole punch is put at the first legible edge number of the first camera roll and time code is then started usually from the one hour mark. Introducing time code in the datacine process is common practice, with much of the downstream tracking requiring its employment. Subsequent rolls are punched as well. Time code starting times are chosen by the client. The applications of time code are a constant consideration in the editing room.

Whether introduced during shooting, when transferring to video, or elsewhere, time code is the driving force of all things video. When a video frame is chosen in the edit as either a start point or an end point for a shot, that frame's time code number can be recorded and tracked for later retrieval. When an edit using an NLE system is finished, the start and end numbers can be assembled in the computer into a list called an **edit decision list (EDL)**. This list is printable or, more commonly, can be imported into other environments to rebuild the project from **upstream media**, that is, original data files or transfers. For film applications, the EDL can be translated into edge numbers. EDLs can store other types of information as well and are critical players in the editing and completion of all levels of projects.

Transferring into an NLE

Getting footage into the computer has in certain ways become more complicated in the file-based age. In the DV days videotape was captured into an NLE and that was that. Of course, you had to select your preset correctly, a requirement for beginners that could occasion bad choices. However, once you had that sorted out, and with DV it was often a default choice, you were set to go. Now, we need to consider codecs and we are not even sure what to call the process. Is *transfer* enough? Is *acquisition* too big a mouthful, not to mention having a number of other associations? Some still call it *capture*. In fact, one company has employed the name as part of a holistic strategy for managing data on the set and in postproduction. Codex Digital has hardware, developed in conjunction with Arriflex, that will process and archive data on the set and then is integral in managing everything throughout the edit.

Other companies are in the hunt as well. *Import, transfer, acquisition, capture:* it all refers to the critical management of your precious media.

Other than data management, there are two issues when bringing clips into an NLE: one is efficiency and the other is making sure that the clips are in the format in which you intend to edit the entire project. In the first case, the solution is to bring files in as a batch. There are a number of ways of doing this. A variety of applications are available, some of which will cost and others are free downloads. One that was particularly recommended to me early on was MPEG Streamclip (www. MPEGStreamclip.com), an excellent program although there are undoubtedly many other good candidates out there. Streamclip is also immensely valuable in giving you a laundry list of codecs to translate your picture into your NLE. Knowing what to pick may be bewildering but hopefully you find it in your camera or NLE documentation, on-line, or, that most valuable of resources, somebody who knows what they are doing.

First, open the MPEG Streamclip program. **(SEE 9-2)** The basic program window opens and it will remain in the background throughout the process. **(SEE 9-3)** One of the pleasures of this new approach is that most new computers have a slot for the SD card and, rather than setting up a camera or deck and a wire, the card can be removed from the camera and inserted directly into the computer. Be sure the camera is off when you remove the card. Warning: If you are working quickly on location, be sure the last shot has been fully written to the card before removing it. It can take a few moments to write a complex image and there is usually a blinking light indicating that data is still being recorded.

Insert the card in the computer or reader. With the Canon and most other cameras, if you have installed the proprietary transfer software an opening screen will appear asking if you want to do an immediate transfer. Click exit. The order of these first few procedures is not critical but once you get into selecting clips for the batch list, everything is a firm sequence.

An icon for your card will appear on your desktop. Double-click on the icon and a window will open showing the folders on your card. There are separate folders for the video clips and any still images. Navigate through the folders until a list of your clips appears in a window. Click on the *MPEG Streamclip* window in the background and go to *List>Batch List* in the menus. **(SEE 9-4)** A window titled MPEG

9-2

The MPEG Streamclip icon.
© Cengage Learning 2014

9-3

MPEGStreamclips's opening window.
© Cengage Learning 2014

9-4

Choosing List>Batch List in Streamclip.
© Cengage Learning 2014

9-5

Add Files will allow navigation to the files to be converted.
© Cengage Learning 2014

9-6

Select the desired files and click To Batch.
© Cengage Learning 2014

Streamclip Batch List will appear and click *Add Files*. **(SEE 9-5)** Navigate back to your clips, select them, and click *To Batch*. **(SEE 9-6)** A dialogue box will ask for the conversion, in the case of FCP it will be *Export to Quicktime*. **(SEE 9-7)** Obviously other NLEs will require different conversions.

The next window is *Select the Destination Folder*. **(SEE 9-8)** You will probably want a new folder or navigate to whatever folder holds the raw footage for your project, be it FCP's Capture Scratch folder or whatever. The window may default to your SD or CF card, so be sure to select a destination of your choice be it the *Desktop* or something else on your computer's hard drive. It can always be moved later. In FCP, captured footage defaulted to *Capture Scratch*, but creating the file structure of your choice has always been an option. As long as your NLE understands how to navigate to your clips, the files can be wherever you want them. If you create a new folder go ahead and name it, call it the date or some element of your project, and select it. **(SEE 9-9)**

From there, the process will return to the *Batch List* window. All the clips will be designated as *waiting* indicating that they have not yet been converted. **(SEE 9-10)**

9-8

Streamclip requires either navigation to a destination folder or creation of a new one.
© Cengage Learning 2014

9-7

Select Export to QuickTime.
© Cengage Learning 2014

9-9

Name, if necessary, and select the desired folder.
© Cengage Learning 2014

9-10

The selected files will come up in the Batch List window designated as Waiting.
© Cengage Learning 2014

You can click on *Go* and a window will open asking you to make the critical decisions about clip information which will start the conversion process. **(SEE 9-11)**

While there are a lot of choices here, two are critical. The first, in no particular order, is *Quality*. Using the slider bar, set it to 100 percent. **(SEE 9-12)** Some editors I know maintain you can keep it around 90 without any significant loss, but this is something you should test for yourself and make up your own mind. The next is much more critical. Listed as *Compression* this is the choice of codecs. You will find over 100 choices, listing just about every compression rate, NLE, frame rate, format, and international standard known to man. **(SEE 9-13)** In FCP, a very common standard choice, particularly for my friend who edits fitness tapes, is *Apple ProRes 422*. The 422 stands for a 4:2:2 color space, although it works with less. You see choices for 444 and further down the list you see choices for many things discussed elsewhere in the book : PAL, DVCPRO, 1080 60-frame, and myriad others. Again, your codec should be available in documentation or other potential sources.

The batch list will return and simply press *Go*. A progress bar will appear which will go through your batch clip by clip, detailing the status of the conversion. **(SEE 9-14)** When done, the clips will be listed as *Completed* and are then ready for import into the NLE of your choice. **(SEE 9-15)** In FCP, go to *File>Import>Files* and navigate to what you want in your bin. **(SEE 9-16)**

As suggested, it is not uncommon to erase all the files on your card before ejecting it. Frequently you need room on the card to accommodate new clips and real estate on all media is a precious commodity. Again, bring a second external hard drive to "archive" all the data that you have just brought onto your computer. As with everything from writing to photos to clips, having a single copy without backup is a recipe for cyberworld madness. Losing anything, much less the efforts of an entire location

9-11

The Movie Exporter window will appear with codec and other choices.
© Cengage Learning 2014

9-12

A slider allows the image quality to be selected.
© Cengage Learning 2014

9-13

A list will come up with the many choices of codecs.

© Cengage Learning 2014

or studio crew, actors, and every person laboring in the background, is unthinkable. Protect your assets even if you have to triple back them up.

My editor buddy makes one last very wise recommendation. When you erase a card, after transfer of data, erase everything except the very last clip on the card. Then as you start to shoot again, the numbering system will start from that last unerased clip. Otherwise the numbering will restart from the first clip number of the day. Having different clips with the same number in the editing room will cause endless confusion. As horrible as losing a clip might be, fighting through confusing organization can waste precious time and test tempers and desire. I have a friend who can sort out most any organizational disaster that people bring his way. The more he has to sift through data and unorganized clips, however, the more savior work he has to do on the next data set. It is a spiral that consumes more and more inexperienced makers. Try to put yourself around a community of people who know what they are doing and understand the stakes.

Conversion can be time consuming. Converting a one-minute clip can take upwards of two minutes. Fortunately it is time that can be devoted to other things, be it a coffee break or organizing other card or SSD material. If shot at high resolution, a number of clips can take up a lot of real estate. 1080 at 4:2:2 can add up to as much as 4 gigabytes for 5 minutes of video. Be prepared for the time and more importantly the hard drive space. A project that brings in a couple of hours of footage one day is likely to do the same the next. You have to stay on top of things and not get behind.

Once you have all the material properly converted, editing can proceed unhindered. Again, once you have everything into your NLE at the resolution et. al. you desire, it can frequently be completely finished in that environment. High-end projects may well wind up being processed in advanced systems, but 9 times out of 10 postproduction can go from beginning to end within the confines of your office, home workspace, or corner in your bedroom. Take a look at your footage and start having fun.

9-14

Press Go to begin the conversion process.

© Cengage Learning 2014

9-15

As each file is converted, its status will change to Completed.
© Cengage Learning 2014

9-16

The files can now be imported into the NLE of your choice.
© Cengage Learning 2014

The Film/Video Interface

The discussions of film and video cameras have pretty much covered your shooting options: a small number of choices within the film set (35mm, 35mm 3-perf, 16mm, Super 16, et cetera) and a larger number in video (HD, SD, 24p, tape, tapeless, et cetera). Virtually everything shot on film is transferred to digital video and edited on computer. A few admirable holdouts still have their features edited on film (Steven Spielberg and Clint Eastwood among them), but 99.99 percent of the work has gravitated to NLE.

Once transferred to video, much of what is shot on film stays in the video postproduction world and is exhibited on television, at digitally-equipped theaters, or on the Web. Again, a significant amount of work in episodic television, commercials, and music videos still originates on film. A smaller amount of material shot on film and finished within an NLE is transferred back to a film print—work that is destined for that percentage of theatrical distribution that still occurs on film. Producers can either return to the film's original elements—the negative—to make a print or can convert the finished NLE edit to a film print, a process that frequently involves the creation of a *Digital Intermediate (DI)*, a transfer from a video version to a film print (discussed later in this chapter).

It used to be that a project shot on video was generally destined for a television broadcast or the Web. Now, any video can be converted to a film print for theatrical release in the same DI process just mentioned. This is an expensive step reserved for high-end features—Mel Gibson's *Apocalypto* and any of the recent work of Robert Rodriguez being good examples—and the occasional indie that gets picked up for wide release. An ever-increasing percentage of TV shows are being shot on video, episodes of *The Office* being a good example. The reality programs are all shot on video as it would make absolutely no sense, given the number of cameras being used, to shoot them on film.

The Big Question

Whether shooting film or video, we can revisit that question touched on earlier in the text: *Do you want your end product to be a film or a video?* Now, this is almost becoming an afterthought issue. However, do not confuse the two. A film is a film,

and a video is a video. Each has its advantages and disadvantages, although needing to do a high-end video finish is standard operating procedure and a waystation to creating any exhibition option. If someone has produced a feature that has a shot at theatrical release, is it going to be necessary to have it in theaters still equipped with only film projection? If it is going to be direct-to-video or shown on cable channels, a film print is probably not necessary. If a project is going to get wide domestic or international release, a print may be necessary just to cover the theaters that have not made the transition. This is largely a question of exhibition and audience, although budget and of course aesthetics are major considerations as well.

For many years, the general feeling was that having a film print in hand put one in a better position in the festival and general exhibition world. There may be some minor validity to this still, but having work available only on video is certainly no longer a deterrent. Digital Video and its successors have been the genesis for an explosion of new works from independent and amateur producers. This is both a wonderful thing and somewhat of a problem. There is a proliferation of work, but not all of it is good. Sorting it all out is a major undertaking. Festival producers will undoubtedly confirm that if they put out a call for video projects, they will get a thousand entries, of which only a handful are possibilities for acceptance. No group of screeners on a festival committee has the time to sort through a thousand submissions. If the submitted project has been successful elsewhere, if the producers or other participants are known quantities with a good reputation, or if the work has created some other kind of buzz, that may initiate consideration whether the project is on film or video. Otherwise, if a video project is from an unknown or untested source, the selection process can be brutal and if your work does not grab immediate attention—have a hook as it is called—it may only get a few minutes of playing time before being consigned to the reject bin.

One trend is for low-budget producers to shoot on video with the intent of eventually transferring to film from a finished video once a distributor recognizes the commercial viability of the project. The list of films transferring from an NLE finish continues to grow, and the DI process has been widely accepted. And yet is it really an alternative for an independent? Even with a finished video product in hand, what distributor is going to put up the $70,000 to $100,000 to bump it over to film? And a true DI is much more expensive than the quoted figures, making it a possibility only with adequately budgeted films. For the low-budget producer, this scenario has happened—*The Blair Witch Project* (Eduardo Sanchez and Daniel Myrick, 1999) probably being the most famous example—but can you realistically count on it? This text's unapologetic bias toward film notwithstanding, the odds are against you.

Barring transfer from video to film, if the decision is to have a finished film, you are faced with the one question: should you edit on film or edit in a digital environment and return to film for a print? The reality is that, even though film editing is still viable, the world has gone NLE. Film editing was hard, slow, painstaking work. NLE is popularly seen as being sexy, easy, fast, inexpensive, and what everybody is doing. Yes, it is sexy. In many ways and for many functions, it is easier. It is probably not any faster than other methods. No, it is doubtful that it will be any cheaper. And, yes, everybody is definitely doing it. To get to a film print from an NLE edit, you are either talking about matchback or transferring from video to film.

Digital Intermediates

The **Digital Intermediate (DI)** is the newest wrinkle in the postproduction world. It is not really a new wrinkle, given that feature films have used some form of the process since the late 1980s. Its ancestors (tape-to-film transfers) being prohibitively expensive in early incarnations, among other issues, made it unsuitable for anything but short special-effects sequences like those in the early *Terminator*

movies. At that point the process involved a high-quality import of the film image into a computer environment, some special-effects work, and then writing the image back to film. As storage and scanning technology improved, the potential of this process for overall image control for an entire feature—color, exposure, and a host of other possibilities—captured the imagination of both production and postproduction personnel.

Prior to roughly 2000, if a project was edited on a computer the only viable way to get back to a high-quality film print was to return to the negative through the matchback process and strike a film print. A number of features went through a video-to-film process that was simpler than the DI, but it was generally agreed that the image quality was not up to the exacting standards of the typical commercial feature. Ethan and Joel Coen's *O Brother, Where Art Thou?* (2000) was the groundbreaking work that used the true DI process final for the entire film. It was quickly followed by Anthony Minghella's *Cold Mountain* (2003) and Jean-Jacques Annaud's *Two Brothers* (2004), the latter integrating both 35mm and HD footage for a hybrid of what could be accomplished in a DI. Since then the number of films using the DI process has exploded.

Material that will be the source for a DI can originate on either film or video. If shot on film, the original goes through the standard datacine approach: the film is transferred to a file-based format. Once the film image is in this form there are many things that can be done to it. Extensive manipulation for special effects and simple changes in composition are obvious possibilities. Moreover, the most common application of the digital file is for correcting and manipulating color and exposure and doing all of the "sweetening" that needs to happen before a film can be released to a theater.

Once the film is corrected at a file level, each individual frame can be written back to a film frame, and film prints can be struck for theatrical screenings. The DI process has proved to be highly useful in that the image can be manipulated much more in the video stage than the standard film image; it also puts a project in a form in which it will see a number of economic lives: digital projection of the video finish, a digital version for DVD release, and/or a source for clips and streaming on the Web. Since the small number of features that were done in the first few years of this century, now almost all commercial features, if film prints are required, are done in the DI process. Although this is a fait accompli in the upper stratosphere of commercial features, be aware that it is an expensive alternative and not always a realistic option for low-budget producers.

Matchback

Although the general acceptance of the DI has reduced the importance of the matchback process, a number of films still take this approach, particularly among producers who cannot afford a DI. Even features going the DI route often have matchback information generated as a safety against potential data problems later in postproduction. Episodic television shows that want to protect their assets also frequently generate matchback information. If doing a standard matchback, life can get decidedly complicated.

Matchback—the creation of the information needed to return from a digital edit to the camera-original negative—requires a set of operating principles that need careful consideration. Speed and frame rate conversions are the chief villains here, with the intrinsic differences between film and video creating as many challenges as film editing.

If you are operating under the assumption that matchback for a film print is the final destination, there are two primary considerations when transferring. The first is to generate the information that will establish an interface between the film and the video. The second is to maintain synchronization of the sound with the

film. As we shall see, making both of these happen can be a daunting task for the novice. The DI process casts some of this information in a somewhat different light, so be sure to follow that thread as well.

A substantial part of the battle is won or lost with the initial transfer from film to file. If you do not get the project started properly, matchback information will be flawed all the way down the line, and the end product will be riddled with unacceptable errors that are very expensive to correct. Technical aspects of the film finishing process are complex and require comprehension before exploring matchback. Therefore the bulk of the information on matchback is in the context of general editing in part V. Be sure to read all pertinent material. What follows here are a few of the initial concepts, procedures, and complexities involved in returning to film. There is much in the digital realm that requires extensive technical study and is not feasible to present in this context. The object here and in later chapters is to make you aware of potential problems so that you can ask the right questions when you start working with the lab personnel and technicians who will be involved in the process. The following discussion may at times make the whole matchback relationship appear untenable, but many filmmakers are making it work even on very small budgets.

Before committing to either a film finish or a video finish, carefully think out your options here, with the potential audience and the type of exhibition you can honestly expect your piece to receive as your major considerations. Dealing with edge numbers, frame rates, slowdowns, color accuracy, and a host of other issues will become your lot in life if you choose matchback.

Datacine

A *datacine* is a very expensive piece of studio equipment. There are a number of ways to transfer film to video, from the mom-and-pop home movie transfer shops to the video dupes businesses. But when we say *datacine,* we are referring to a high-end, industry-level transfer, usually at rates that can make film costs look reasonable. Unless you are after some specialized visual goal, the standard approach is to shoot color negative film on-location with the image being reversed in the datacine process.

If you are working in progressive HD, you theoretically do not have to worry about some of the following issues, but such users inhabit the top end of the industry. In fact, if the world were an entirely progressive place (note no political intent), the complications that will presently be covered would not be an issue. Frame rates, slowdowns, pulldowns and the like do not apply to progressive video. However, somewhere in your projects life it will encounter NTSC and interlace and accommodations will have to be made somewhere in the chain. Be aware that the need to make your program playable on a wide selection of monitors may force you to enter this messy world regardless.

Again, the datacine has largely replaced the telecine, which was used throughout the industry for the entire history of broadcast and transfer up till now. The telecine employed essentially two practical ways of transferring film to video. The **flying spot scanner** approach, employed on the majority of professional transfer machines, uses a strong piece of light that is shot through the film; it rapidly scans each frame, separating out the RGB and luminance components to create the video image. The second method employs a charge-coupled device (CCD/chip) arrangement, with light shot through the film striking a chip with thousands of light-sensitive pixels. The receptacle here is relatively similar to the configuration in a typical video camera, with the high-end systems also separating the light into RGB components.

The crudest CCD systems essentially shoot a video camera into a film projector with a five-bladed shutter—a common approach for consumer mom-and-pop-shop transfers. These are not very costly and are unusable by professional standards. Typically, professional datacine or telecine sessions cost in the neighborhood of $600 to

$700 per hour, with the most in-demand Southern California and New York houses commanding substantially more.

The datacine transfer is similar to the former transfer, only the data is written to a file. The datacine is operated by the video **colorist**, a role akin to that of the timer in a chemical lab. A datacine session can be either supervised or unsupervised, depending on the level of participation the client requests of the colorist and, obviously, price. In an **unsupervised transfer**, the colorist creates global settings for the transfer, then sits back and monitors the tape. In a **supervised transfer**, the colorist does **scene correction**, stopping and analyzing every scene for color and exposure. Just as with the film printer, the colorist has full control over RGB characteristics as well as a host of other sweetening options. Possibilities for image manipulation here abound, but if the project is returning to the film negative for a final print, you'll need to know if the effects can be duplicated in the printing process.

Although supervised sessions are usually only slightly more expensive on a facility's rate sheet, the critical difference is how much footage can be transferred per hour. Supervised transfer may typically go through about 400 feet of 16mm per hour, whereas unsupervised might go as high as 1,200 feet. Many facilities offer good discounts for students, and customers can attend unsupervised transfers, if willing to pay a little extra—they (we) by nature can slow things down. The client or appropriate production personnel are almost always present for supervised transfers.

Observant readers will realize that a supervised transfer is akin to the rarely requested timed workprint, and an unsupervised one is an equivalent of the best-light approach. The supervised transfer is much more common than a timed workprint because the video that the colorist creates will in many cases be the source for the final product whereas the workprint will not. Given extensive attention in the initial phase, the video will require little extra attention during the project's completion; still, it will go through more correction at the end. With a conventional film finish, on the other hand, all fine correction happens in the last stages.

Supervised transfers are a matter of creating, at the very beginning, a product that you can finish from, rather than going back to the film in the final stages. Much of what is said here applies to the datacine as well, although in this transfer process there is nothing akin to an unsupervised transfer given that the highest-quality image possible is almost always the goal of transfer to a file.

Some projects will still use this high-quality, or **high-res**, initial transfer in the editing room, but such is not always the case. It is not uncommon to edit with a lower-quality, or **low-res**, video copy, with the intention of returning to the original to finish. While there are some definition issues here, low-res initial transfers are often called **video dailies**, much in the tradition of workprint.

Film-to-Video Transfer and Matchback

Understanding what happens on the datacine is imperative to making sure that you are able to finish the project the way you want when you are taking the matchback path. If you can keep everything in a progressive environment, then conversion worries can be kept to a minimum. However, some entrance into interlace will happen sometime in the project's life although it may be after the project is out of your hands. Otherwise, information must be created, and film frames must be correctly correlated with video frames. Beware that misinformation and inadequate information is still out there, particularly among video-trained postproduction personnel who finish within a digital environment and do not have to deal with the complex film stuff. When you start talking to filmmakers and lab personnel, you will hear legions of horror stories about films coming back with the sound out of sync or with the wrong shots or parts of shots inserted. The initial years were a painful process

of working out the bugs. We are at last approaching the bulletproof nature of the conventional film finish, but there are still many problems and not many "happy accidents" here. A number of photographic considerations are handled in later chapters; the following is a brief overview of the many issues that must be considered.

Three: Two Pull-down

The first significant complications in interlaced datacine transfers is the conversion from the 24 frames per second (fps) of film to the 30 fps of NTSC video. Film frames must be converted to distinct video frames, and the numbers simply do not add up. The strategy that has become the industry standard to resolve this difference incorporates a change in the fields, not in the frames—what is called **three:two pull-down**. The strategy is for the datacine to print a third field of every second film frame, thus alternately printing two video fields of one film frame and then three fields of the next film frame, hence the name. **(SEE 9-17)** In this fashion 60 video fields become divisible by the 24 frames of film: 12 film frames are printed twice for 24; the other 12 frames are printed three times each for 36; 24 plus 36 equals 60.

The irregular duplication of fields is generally not visible to the eye. The problems occur when attempting matchback to film. In film one-sixth of a second is divided into 4 frames, whereas in video one-sixth of a second is 5 frames. The video thus has a frame that does not correspond to a film frame. We could potentially make the cut on that frame in the video edit and, when we go back to the film, find that there is no corresponding frame. We could move our cut to the next frame, but the whole thing plays havoc with timing. In addition, any frame of video that corresponds to a film frame (two-field or three-field) represents a different fraction of a second from that of a film frame. Systems have found ways to resolve these issues, but not without some complex maneuvering.

9-17

In three:two pull-down, four film frames are converted into five video frames.
© Cengage Learning

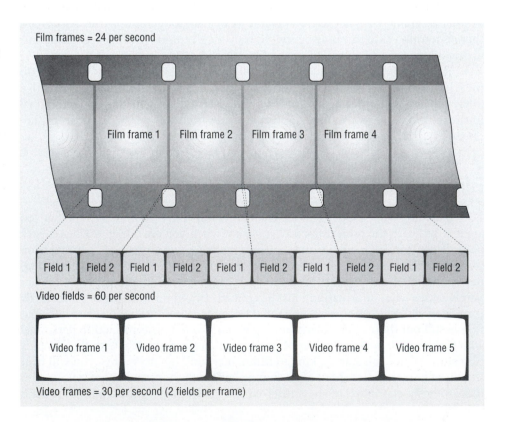

A, B, C, and D Frames

As suggested, the great complication of three:two pull-down is that it creates information that does not correspond directly to the film frames. Fields unfortunately only complicate this issue. If field/frame relationships are not addressed in setup, the datacine does not necessarily start printing on a first field of a frame on the video. The first frame transferred from a film roll could land on a second and first field, respectively, causing further confusion as to its relationship to its sister or brother film frame. With some film frames occupying three fields as opposed to two, the confusion multiplies. To sort this out when transferring from film, video frames are referred to by the type of frame they are in terms of their relationship to the fields. They are designated as **A, B, C, and D frames**. The *A frame* is two video fields, starting on a first field. The *B frame* also starts on a first field but is three fields long. The *C frame* starts on a second field and is two fields long, and the *D frame* also starts on a second field and is three fields long. **(SEE 9-18)** As suggested, if the datacine is started randomly, the first film frame could potentially fall on the second field of one video frame and the first field of the next, making it a C frame; or it could also be three fields long, making it a D frame.

As troublesome as this conversion appears, the whole system will be unacceptably flawed if the transfer is not done correctly. It is critical that the first frame of film on a roll—or, more accurately, what we designate as the first frame of film—has a direct relationship with a video frame. The only frame where this is the case is the A frame, so the datacine must start on a designated first film frame and transfer to an A frame of video. To prefigure ensuing discussions, the solution to this has been to punch a hole in the frame with the first legible edge number on the film roll—legible both in terms of being able to see it and to have the barcode readable. Legibility is crucial because the light-struck portion at the beginning of a roll may obliterate some numbers, causing them to be unreadable by the datacine. The punched frame allows the datacine operator to start the transfer in a way that will make these critical relationships understandable later. Check with your datacine operator to make sure that you fully understand these issues. The relationship among A, B, C, and D frames is important only to matchback; it is not an issue in general video editing.

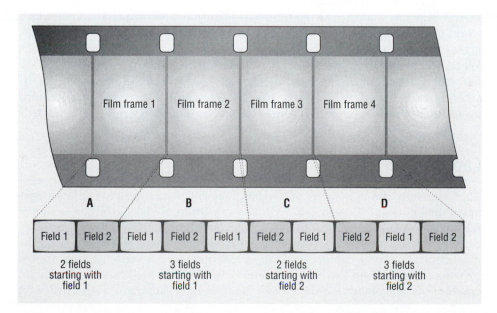

9-18

Types of converted film frames are identified as A, B, C, or D frames.
© Cengage Learning

Film frame 1 Film frame 2 Film frame 3 Film frame 4

A B C D

| Field 1 | Field 2 | Field 1 | Field 2 | Field 1 | Field 2 | Field 1 | Field 2 | Field 1 | Field 2 |

2 fields starting with field 1

3 fields starting with field 1

2 fields starting with field 2

3 fields starting with field 2

Pull-up/Pull-down

Not only does the frame conversion have to be reconciled but there are speed issues as well. This has caused many otherwise strong-minded people, from the innocent neophytes to the most-seasoned technicians, to want to pull their hair out. The speed conversion issue is referred to as *pull-up* and *pull-down,* and it is not to be confused with three:two pull-down as it is a completely different, albeit related, concern. As stated earlier, we refer to video as running at 30 fps, but it actually runs at 29.97 fps. The story goes (and this may be more media mythology than video vérité) that when color came in, the technicians found that the technical character of the color video signal caused an unwanted artifact in video playback. Some anonymous technician, whose memory shall live in infamy, experimented and found that if he slowed the tape slightly (by 0.1 percent, to be exact), the problem disappeared. At that point video speed became 29.97 fps.

Herein lies the source of the great quandary. When film is transferred to video, it is slowed down by 0.1 percent. Clearly, the change in motion is not visible to the eye, but the slowdown can have many repercussions and is most problematic in the synchronization of sound, which is recorded separately on-location. One-tenth of 1 percent does not sound like a great amount and does not generally become apparent in syncing up individual shots. However, it can add up over the course of a longer show to the extent that the project will be substantially out of sync when final versions are made. It amounts to 1.8 frames per minute (a problem but not a show-wrecker) and thus 18 frames every 10 minutes (almost a full second out of sync in a film print and obviously unacceptable). The solution is to slow down the sound by that same 0.1 percent when it is either transferred to video or digitized from its original source, hence **pull-down**. When it is later returned to film, the sound must be speeded back up, hence **pull-up**.

Postproduction facilities that are experienced with matchback are very familiar with this issue, but you must make sure that everyone down the line understands what both the final and the intermediate destinations are. Failure to address this at any step will result in sound drifting unacceptably out of sync. You must also understand how the playback of the primary sound format (such as DAT, quarter-inch, or cassette) is going to be manipulated to facilitate the slowdown. Most newer recorders, particularly those with time code capabilities, are set up for this; but there are some, particularly older gear, with which the audio may require expensive manipulation in postproduction.

When you start interfacing film and video, you get into a conflict between a world of whole numbers (film) and a world of fractions (video). The bottom line is that you have to keep track of which environment is film and which is NTSC. When you exit the film world—that is, transfer film to video—you enter NTSC. Everything drops down by 0.1 percent, with the synchronization of sound being the critical consideration. When you reenter the film world, everything must be sped up again. Every time you go back and forth, pull-up/pull-down must be addressed.

Capturing Video

Capture, while used in a variety of contexts, is essentially a concept specific to tape-based digital media. As such, it is becoming anachronistic due to the conversion to file-based media. If you have shot on a camera that records to some kind of memory card, capture is unnecessary. Otherwise, the tape must be logged and captured. The most common way to capture is to use an external video device that is controlled by your computer and the NLE software. Referred to as *deck control,* the system employs the videotape recorder (VTR) function on a camera or a standard VTR

designed for the purpose. The functions of the source deck essentially becomes peripheral, with the standard functions of the deck (*play, pause, fast-forward,* and so on) taken over by the appropriate features in the software.

On computers, whether Macintosh or PC, the data are transferred from the camera to the computer via FireWire. The home desktop situation will employ the camera as the external video device for maximum efficiency. **(SEE 9-19)** Many excellent NLE systems are available. This text uses Apple's FCP as the source for examples. **(SEE 9-20)** It is an excellent system with a very good pricing structure, particularly for students, but many other systems are at least its equal. Find what is best for your situation. In addition, this discussion will use Apple's FCP 7 as its example. Apple has since introduced FCP 10 but it is both a radical retooling of FCP and a controversial approach to digital editing. One of the more controversial aspects was that FCP 10 completely eliminated the capture element of the software, thus committing its future to file acquisition media. This was not entirely unwarranted but did cut out a number of users working on older projects. The outcry was fairly extensive and Apple introduced some upgrades, but the commitment to FCP's future and the break with the past was clearly delineated.

Apple originally designed FCP for professional users but presumably finally figured out that this was at best a small and competitive market. Their iMovie product was used by millions of amateur makers. Designing an advanced version of iMovie would be of interest to a much bigger market. Thus FCP 10 has been of less interest to pros and more interest to the general user. The architecture is completely different from that of any previous versions of FCP and the apparently lengthy learning curve has produced a "why bother" response from many high-end users. Despite all this, an upside of FCP 10, and a number of other programs do this as well, is that it manages all these codec issues "in the background." The programs will do all the translations according to user-determined initial presets. Thus translations for viewability and editability do not require as much attention and time.

As detailed in previous sections, the first step is to have your film transferred to video if you have shot on film. Either way, each individual tape is loaded into the deck used in your desktop setup. Capture is generally a function in one of the menus in the NLE software. In FCP, the process is found at *File>Log and Capture,* indicating the importance of both getting media into the computer and properly organizing it. You will find that scrupulous organization is paramount, maybe even more so than in film editing. The Log and Capture window will open, and you will be presented with a variety of options. **(SEE 9-21)**

Under Clip Settings in FCP, you select the media you want to input. The choices are generally between capturing video and audio together, video by itself, or audio by itself. The first option would typically be for material that originated on video because picture and sound are together on the tape. Because sound and picture are recorded separately on a film shoot, capturing the two together is not pertinent. Once captured individually, sound and picture must then be synced up just as in the conventional film approach. This said, many datacine facilities offer the service of syncing up the location audio

9-19

Rear view of the Sony VX-1000 in VTR mode with a FireWire cable attached.
© Cengage Learning

9-20

Final Cut Pro HD is an NLE system commonly used by students and independents.
Copyright © Apple Inc. All rights reserved.

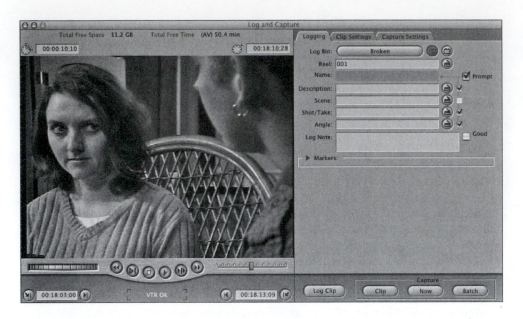

during the datacine process; and if you had chosen this rather expensive option, you may be capturing them together.

Farther down under Audio Format will be a choice of how to input the sound. Most NLE timelines open with two initial tracks of audio. Generally, the choices are to input the sound in stereo, left channel only, right channel only, or both. Some software will have this option elsewhere, but in many programs the capture window will also have a setting for the desired resolution.

When you select Log and Capture from the FCP menu, a screen will appear with a play function and markers for in- and out-points. Shots, called **clips** in most NLE software, are generally captured individually rather than in sequences or groups. Sound is typically handled in a similar fashion. You simply **scrub**—move slowly frame by frame—to the first frame of the shot and click the in-marker, then scrub to the last frame of the shot and click the out-marker. It is usually a good idea to capture the entire shot.

Once you have marked the in- and out-points, the capture window offers a logging function. **(SEE 9-22)** This gives you a place to identify the clip, establish its location on tape rolls, and register any pertinent information.

Once the clip is logged in FCP, an icon with a diagonal red line through it appears in the **bin**—the window where unedited shots and audio clips are stored. This means that the clip has been identified and logged but not yet actually captured. FCP has three methods of capturing, all essentially duplicated in most other NLE software. The choices are Clip, Now, and Batch. *Clip* is for capturing individual shots

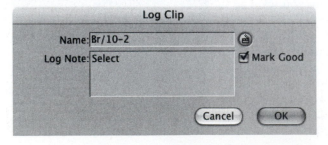

and/or sounds, *Now* is for capturing on the fly, and *Batch* is for capturing a number of previously logged clips. Capturing on the fly, of course, precludes previous logging and is for capturing a bunch of material quickly. It is often good for finessing in material that does not have appropriate time code. **Batch capture**, the most common approach, is used when you have logged a number of clips and want to capture them all in one process. Batch is the preferred method, with the editor logging quite a few clips, then allowing the software to do the rest.

Once you have logged a number of clips, you click Batch. The software prompts you for verification;

then, when you click OK, the capture process begins. The software instructs the camera or VTR to back up and cue the first shot logged; that shot is then captured, and the camera will cue up the second clip, and so on. The same process occurs for sound although there are other methods of importation.

When you have everything in the computer, editing can proceed. Depending on what you shot, you may have to do some syncing up (see chapter 16), but otherwise you are set to go.

Flex Files and Organization

In film transferred to video, an important aspect of the film/video relationship is the role of the **flex file**—a data file that logs the beginning and ending time code numbers of the shots and interrelates the edge numbers of the film with the time code of the transferred video. Flex files essentially have two purposes. They are used to drive the capture of clips, and they supply the information to build the database that will be used to create a **negative cut list** for matchback or transfer. Both of these functions can be created manually if you do not have a flex file, but the flex file simplifies life and in theory eliminates the human error of manual data entry.

Flex files are created in the transfer process. Numbers are read electronically, or a staff member inputs into a data file the starting and ending time code numbers of each individual shot. The lab should give you the flex file on a disc or e-mail it to you, and it should be transferred to your hard drive. When you go to capture your transferred footage, you can import the data from the flex file into your bin; and, given that it is essentially the information you would input in a standard manual capture—the beginning and ending time code numbers of all clips—it can be used to drive a capture of your footage. All of the clips will show up as off-line in your bin (with the red line through it in FCP), and batch capture can be initiated. You can walk away, and it will all be done for you.

Once footage is captured, the information from the flex file will be tracked by Cinema Tools, FCP's bundled matchback program, or by your NLE's dedicated software. **(SEE 9-23)** FCP 10 does not support Cinema Tools, and by extension cannot be used to set up a matchback process. However, people who continue to work with 7 can find it quite handy. Obviously, whether done manually or in datacine, this data encoding must be done properly or everything down the road will be flawed. Not all NLE software supports the flex file concept.

In summary, both three:two pull-down and pull-up/pull-down require that you carefully control all issues of frames and sync if you wish to go back to film. This control must be established in the initial transfer. Once the data are transferred, different NLE systems have devised strategies to further address these complications. Some of the specifics are discussed in part V of this text. Once you enter the video world, you are there for good if you have not created the appropriate information in the datacine process. Unless you do a very expensive video-to-film transfer or go back upstream to redo an expensive transfer, you will be trapped forever in the confines of video.

Nonlinear Editing and the Film Print

As suggested, the major goal of an NLE edit when going for a matchback film finish is to produce a usable list of *edge numbers* that will guide the negative cutter in conforming the original or instruct the transfer to video. In terms of sound, the goal is to produce a *master mix* of the audio tracks that is full and rich and in sync. This last requirement seems

9-23

Cinema Tools is Final Cut Pro's proprietary matchback program.

a no-brainer, but can be tricky given the pull-up and pull-down issues discussed earlier in this chapter. Major commercial producers have the process down, but smaller and newer producers may be in for some rude surprises if they are not on top of every stage.

The routes to a final print differ from the path described for film, although essentially the same things have to happen. The primary picture is acquired just as it would normally be, with sync cameras and sound recorders. The picture is transferred to digital video and then captured. The location sound may be digitized from the analog source and captured, or it can be captured or transferred straight from a digital source. If you do not have a good means to capture from digital audio, you may want to record it on the VCR function of a digital camera and then capture it.

In the transfer, *time code* numbers are generated that provide a permanent address for all video frames. The time code numbers must be interrelated with the film's edge numbers. When a video frame is chosen in the edit as either a beginning point or an end point for a shot, that frame's time code number should be translatable to an edge number. When the digital edit is finished, the translated edge numbers are printed out in a *negative cut list,* sometimes referred to as just a *cut list,* which is used to guide the negative cutter's work. Many films, particularly features, have adopted a slightly modified approach, but the end product must be the same: information for the negative cutter. There are many other complexities of this deceptively simple operation.

With sound, the path to an *optical master* can take a number of directions. Most NLE systems have the potential to mix projects internally. Even so, many editors output the sound to software specifically designed for audio, where more tracks will be built and eventually mixed. It is also common to build the audio in an NLE or a proprietary environment and then take it to a mixing facility, where the filmmakers can avail themselves of the services of professionals who can bring an extra dimension to the quality of the sound.

Preparations

Now comes the hard part. While the DI has taken much of the mystery out of video to film conversions, the whole relationship still requires understanding. Matchback is not as big a factor as it was five years ago, but the fundamentals may play into your figuring. And the details of the route to a film transfer from a video origination project may not be something you need right now, but the more you know the more versatile you are. To do a nice finish job on a project originated on a DSLR camera may be quite straightforward, but it is not the final stop on your road. This chapter will cover both straight video finish and video/film conversions but it is recommended you learn them both.

It was suggested earlier in this chapter that in the changeover from 30-frame video to 24-frame film, the 0.1 percent slowdown and the inexact relationship of frames are the chief complicating factors. Everything in the broadcast world and most everything in the computer world runs at 30 fps and has this slowdown, whether progressive or interlace. So the problem is when film is in the mix. Essentially, there are two ways to edit a program and then convert between the separate mediums. The first is to cut in NTSC (30-frame video), making frame adjustments along the way as well as in the finishing stages of the project. The second is to start from or convert to a 24-frame format after import or capture. The former has a number of inherent complications, and the latter, at least for now, is very expensive. The bottom line is that both the DI process and matchback are very expensive. Again, arm yourself for the future.

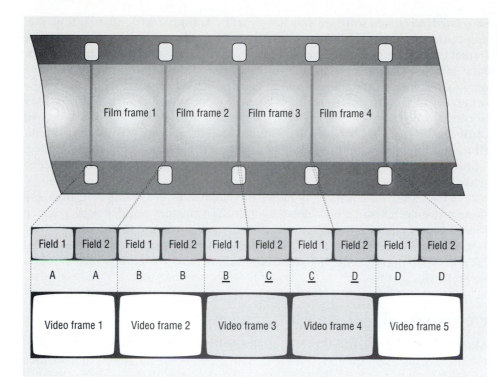

9-24
Some NLE systems identify video fields that do not translate directly to film frames by underlining their corresponding letter.
© Cengage Learning

NTSC

The biggest problem with cutting NTSC and interlaced formats in general is that after *three:two pull-down* there are video frames that do not correspond with film frames. Although there are some guerrilla filmmaking ways around this, it is recommended that you cut on a system that does the interrelated job of reconciling the difference between film and video frames and stops you from cutting on bad fields. Toward this end, the offending fields must be identified and avoided. The general strategy for accomplishing this is to designate the individual fields by the letters of their corresponding video frame types. **(SEE 9-24)** In the display of the editing system, the letter designation can be shown for every field. The letters corresponding to *phantom fields*—fields that do not correspond directly to a film frame—are underlined. If you attempt to cut on a phantom field, some systems invoke a dialog box that tells you to move the cut a field or two in one direction or the other. Other systems simply indicate bad frames with the underline and leave it up to the editor to cut correctly.

Temporal Accuracy Versus Frame Accuracy

The larger problem with this approach is that although there are now "honest" video frames that correspond directly with individual film frames, they still represent 1/30 second whereas the film frame represents 1/24 second. Even if we take the film frame represented by two fields, there is a difference of 1/30 second for video versus 1/24 second for film. We can edit honest frames but still come up with some time differences. The bottom line is that an absolutely frame-accurate matchback between a 30-frame video system and 24-frame film print is not possible. You will simply have slight slippage between the two. Make no mistake, we are still talking about fractions of a second here.

Although this is a problem, it is dangerous to overstate it because you should not lose sight of the fact that if a shot is five seconds plus some fraction of a second in real time, it is going to be that length whether it is film or video. As

suggested, advanced software systems protect you from any significant time discrepancies, recognizing the problem and either making, or prompting the editor to make, the necessary adjustments. Most systems thus give you temporal accuracy, but there can be problems in frame accuracy. If a show is 20 minutes long on video, it will be 20 minutes on film. Frames, however, may slip one way or the other. Throw in the notion of the 0.1 percent slowdown, and this discrepancy becomes even more complex. Any imperfection in the sequence of events will cause major sync problems with the sound. There are, again, many stories about films coming back with the sound out of sync and with the wrong shots pulled. These bugs are being worked out, but you have to be on top of every aspect to make this work.

Most editors are justifiably rather flip about this. Is a frame shift here and there really a problem? Who is going to notice? The feature world, however, which sees its films magnified 300,000 times, is loath to allow sync to slip around and has largely stayed away from NTSC. The reason that feature editors have abandoned NTSC is more far-reaching than this, but frame accuracy is nevertheless a fundamental factor.

Progressive and 24-frame Video

Most progressive video still shoots at 30 fps and has the .01 percent slowdown (30 fps is really 29.97 fps and 24 fps is actually 23.98). One solution is to work on a system that cuts 24-frame digital information, which can be done on all advanced systems. Many systems can capture 24-frame video, but a frequent approach is to down-convert video from 29.97 to 24. This leaves you with the 29.97 option for video distribution. Many NLE systems can down-convert, with FCP and Avid's Film Composer being typical examples. The key is that after you import the datacined video, you "process" it through a **reverse datacine** function that reverses the frame conversion that occurred in datacine. **(SEE 9-25)** It undoes the three:two pulldown by removing the third field of every other frame. In FCP 7, the reverse datacine function is found in Cinema Tools, Apple's proprietary matchback program, and all of the footage would be processed through it. FCP 10 has it in the standard package.

If you cut in 23.98, you still have issues of slowdown. The solution to that is to work in true 24 fps video. Reverse datacine also can remove the 0.1 percent slowdown. With everything at a true 24 fps, a real one-to-one frame relationship between film and video can occur. Theoretically, the output of edge numbers could be completely honest, eliminating the necessity of a workprint. This is in the process of changing, but it has not always been the approach adopted. For a number of years, most makers of features were generating a workprint, transferring the sound to mag stock, and doing a conventional sync-up of the sound. Transfer to video for editing is then done from this synced workprint. Because matchback returns to the film negative, the less-than-perfect video transfers are of no concern.

Otherwise, the process proceeds in the same way. Rather than interrelate time code and edge numbers, the film is given the independently introduced set of *code numbers* discussed in "Coding and Edge Numbering" in chapter 17—a system that has been standard practice in Hollywood for years. The

9-25

Footage at 29.97 is processed through the reverse telecine function in Cinema Tools.

edit is done in a 24 fps digital environment, and the editing crew uses time code and code numbers to conform not the original but the workprint to what is done in the NLE edit. The workprint is used for screening and eventual conforming of the original. As suggested earlier, correct transfer to video is absolutely essential for this approach to work. With more films going the DI route transferring from high-resolution datacine or video originals, the workprint approach is not quite as prevalent. More on this later.

This does, however, bring up a question: Why create a workprint? The creation of the workprint has become a center of some debate in the feature world. Producers, understandably, want to limit costs, and workprints do not have the same central role in editing that they had in the days of old. They are a significant budget line item, and dispensing with them is a major savings. Cinematographers, however, wanting and in many cases needing to see the true fruits of their efforts, find workprints indispensable; but producers hold the purse strings, so many films go straight into the digital realm. Still there are many in Hollywood who have experimented with this and have concluded that operating without a workprint has many drawbacks. There are many reasons, but the following are three critical ones.

Camera crews found that they needed a workprint to check their work. The camera crew needs to be able to evaluate the condition of the film, looking for scratches, dirt, light-struck sections, focus problems, or any flaws that might not show up on a video representation. The struggle between high-resolution and low-resolution transfers continues and, to save hard-drive space, many features still work with low-res material. This exacerbates the problems of evaluating the technical quality of the shots. The producers of one independent feature film that went the NLE route without a workprint were horrified when they got their answer print back, a few days before the premiere, and found some shots that were slightly, though unacceptably, out of focus. The low-res transfers had hidden the problem. At that point there was no recourse. Substituting other shots would require replacing sound, remixing, and striking new prints—an impossibility both economically and temporally, given that their premiere was looming.

Equally important, the camera crew and everyone else involved need to keep track of how the film has exposed. Latitude issue of the video image can misrepresent the shadow and bright areas recorded on the film. Understanding these differences is critical. Maybe more important, video colorists can often create color and exposure effects in the transfer that are not possible when the final print is made (the reverse is true as well). On the previously mentioned film, the colorist thought he was helping the DP by compensating for some missed exposures. But when the compensations could not be or were not duplicated in the final film print, lighting continuity was compromised in a number of scenes.

In the early years of the matchback procedure, negative cutters generally found printed lists to be a problematic guide to conforming the original. Although most of them have adapted to this new reality, the bottom line is that mistakes are simply more likely without the very real edited workprint sitting in front of you to check your work against. The negative cutter can use a tape of the show as a guide if the project has a **window burn**—a small window in the video frame where time code and edge numbers are visible—but it is still not as bulletproof as having an edited workprint. Without a workprint, the negative-cutting process can be akin to being lost in the woods without a compass. The sun may give basic guidance, but you are never 100 percent sure of your bearings. If a negative cutter starts to question the accuracy of the list, there is nothing real to check the work against. The feature world is thus integrating NLE edits with conventional film finishes.

Workflows

The notion of **workflow**—the path a producer chooses to take to a finished product—has become a critical aspect of the production process. For the many initial years of film history, the method of completing a feature film, or anything on film, was pretty much set in stone. There were accommodations for color, format innovations, the introduction of sound, and a variety of other advancements, but the system for finishing a film was in place. You transferred to mag stock all of the sound recorded on-location, synced up sound and picture, and went through the necessary steps leading up to a cut negative and a final print.

Today's producers have their hands full, although it is not as bad as it was a few years ago. With the plethora of options that have developed in shooting, mastering, and finishing, having a clear grasp of the path from beginning to end is crucial. One of the primary questions developed in this text—and potentially one of the most arguable ones—is one posed and answered earlier: how many makers do indeed want their final product to be a motion picture print that can be projected in a theater? The answer for the typical reader is: probably not. This question, however, does not necessarily have quite so simple an answer. Is a film print really going to be useful? Will festival screenings require a film print? Would theatrical video projection be a possibility, or is your project's final destination going to be television showings, the Web, or rentals in video services, online or otherwise? The latter three scenarios are instances in which a video finish is all that is required, and it is usually a decidedly less expensive option.

So that is the choice, whether shooting, editing, or finishing: *film or video?* Again, while distinctions have blurred, from a production standpoint, one does not equal the other. As you get farther into the film world, you will find the lower echelons of the business populated by a significant number of semidelusional people, and the ability to make realistic assessments about your project's possibilities is essential. I have seen far too many people buy their figurative tickets to Sundance without a frame of film or video under their belt. Some have even arranged flights and booked motels.

This section lays out a framework for making the initial choices about where you are heading. It will not, however, remove the uncertainty that often goes hand in hand with those choices.

Essentially, there are six possibilities for how you initiate, proceed with, and complete a visual project:

1. Shoot on film, edit on film, and finish on film.

2. Shoot on video, edit on video, and finish on video.

3. Shoot on film, edit on video, and finish on video.

4. Shoot on film, edit on video, and finish on film via matchback.

5. Shoot on film or video, edit and finish on video, and transfer to film.

6. Shoot on film or video, edit on video, create a Digital Intermediate, and finish on film.

Because so much work is destined for a television or computer screen, most projects employ methods 2 or 3. This is clearly where the bulk of the action is. From episodic television shows to news to industrials to direct-to-video, the majority of work in the industry revolves around video presentation. Even this list of six workflows leaves out some possibilities, specifically productions created in virtual environments and projects that are shot on film but not really finished for theatrical projection, such as motion analysis experiments, NASA launches, and the like. But these are the most common choices.

This chapter and the editing ones devote energy to all six approaches plus the details of finishing. Several, however, are given more attention. Numbers 5 and 6 have blurred over the last few years, but some distinction is still required. The fifth option includes finishing on video and converting the video to a film print. The technology for transferring film to video has been around for many years, but improvements to the process of converting the video image to film have made it a more significant possibility. The DI is essentially a variation on this fifth approach and, while beyond the budget of most independents, should be considered as well.

Shoot, Edit, and Finish on Film

Minimal details of the conventional film edit are explained in chapters 16 and 17. As stated, cutting actual film pieces and their attendant sound tracks is a rare enough occurrence that some might question its inclusion. While a case can be made for doing postproduction on film-editing equipment, NLE has become so pervasive that tracking down the appropriate equipment and the services required for a film edit may be an issue, particularly in smaller markets.

Disregarding the issue of access to resources, the argument for film would be limited but twofold. First, if you want a film print, it is still a viable way to get there. Incorporating video in postproduction on the road to a film print can be complicated and expensive. The system for matching a film negative to a video edit has become pretty bulletproof for experienced editing crews working on big projects. For the inexperienced independent, however, it can be a veritable minefield, replete with hidden expenses that can derail a project. That said, almost everybody is still going the NLE route.

The second reason, as has been argued elsewhere, is that cutting film is a great learning experience. Again admitting room for disagreement from my videophile brethren, I feel that nothing focuses you on the lengths and the positioning of shots more than actually handling film. Understanding the film edit is particularly important for people who eventually want to make film prints. Trying to do *match-back*—the process of using the time code of an NLE edit to go back and cut the film negative—without a clear knowledge of how film prints are made invites extensive problems. In the best of all possible worlds, you hire someone who can walk you through each stage—not always a possibility for those with limited budgets. For students, many schools may still have the equipment sitting around, just waiting for someone to start whittling away at those lovely little frames. So, if you want to make film prints, you might as well start learning now.

Shoot, Edit, and Finish on Video

This is the most common approach. The options for shooting on video have become so advanced and diverse that digital origination is by far the norm. NLE approaches are the long-established standard as well. Using the higher-end Avid editing systems like Media Composer is still industry practice, but powerful low-cost softwares like FCP, Adobe Premiere Pro, Avid's own Xpress DV, Sony's Vegas and a host of other programs have seen widespread acceptance throughout the industry and extensive use in education and home applications. There will undoubtedly still be semiannual upgrades and improvements, but the uncertainties that accompanied so many new, untested options are being assuaged by the growing track records of reasonably rock-solid programs. Indeed, the concerns that attended the introduction of so many new video formats and refinements are becoming easier to sort out, particularly with the impending end of tape. Although more-consumer-oriented technology may not support the image quality required for high-end production, it has already absorbed virtually all midrange and amateur work.

For any individual just learning the field, a working knowledge of one or more of these powerful editing software programs is fast becoming essential. Even if your intent is to become a shooter or otherwise fill a crew position that has no connection with the daily workings of the editing room, somewhere along the line you will want to be at least moderately proficient. Whether putting together a reel to hawk your wares, to do experiments related to growth in your craft, or to showcase your own personal work, you will find that competency with assembling the many pieces will come in handy down the line. It is always nice to be able to hand it over to those whose talents lay more in the editing realm, but that is not always practical or possible.

Shoot on Film, Edit on Video, and Finish on Video

This next approach is relatively straightforward, at least until you factor in high-end broadcast requirements. For reasons of image quality, stability of medium, and "if it ain't broke, don't fix it," a significant although diminishing percentage of work destined for television is still shot on film. The general path here is to shoot on film, transfer the film to video, then cut on an NLE system. Given a number of finishing scenarios, the final product is output to tape or file video and broadcast or otherwise distributed. Next to originating on video to begin with, this is the most common approach. In essence, everything that was said about digital editing in the previous section and chapter 16 applies here as well.

For many years episodic television shows, commercials, and music videos were most frequently finished in a process referred to as **film-to-tape**. Low-resolution transfers—*video dailies*—were made from the negative immediately after shooting, and the editors did their work. Once they were finished, matchback information was used to go back to the original film negative and retransfer at high resolution the shots used in the editors' cut. The shots were pulled "from flash to flash," indicating that the entire shot was pulled from the beginning flash frame to the end flash frame. The part of the shot used in the final show was laid to a master tape, and the show was thus rebuilt from these high-res transfers. Retransfer from the negative was done for a variety of reasons but mostly because of storage issues, with inputting all the material shot on location at high resolution being an impossible burden on the then-limited systems. Low-res video did not overtax the computers, and the quality inherent in the negative would be reintroduced in the final transfers.

As extensive storage solutions evolved, **tape-to-tape** finishes replaced film-to-tape as the norm. Of course, all is now file-based. In this approach the highest-quality transfers are done from the original negative immediately after shooting. The project is essentially done with the negative at this point, although it is stored as a backup and for any potential transfer to new formats for future screenings or syndication. Low-resolution clones are made for the editors, they do their jobs, and then EDLs are used to rebuild the show from the high-res transfers originally made from the negative. Episodic television shows are now mastered in an HD version for delivery to the networks. I had the privilege of sitting in on one of the last film-to-tape transfers on *NYPD Blue*. It included a lengthy cleaning stage where all the dust spots and scratches from the negative were electronically eliminated. *NYPD Blue* is a receding memory and it was one of the last shows using the process to boot. To my knowledge, film-to-tape is no longer done.

Video projection is also a factor when considering finishing on video. For many years the quality of the image produced by video projectors was severely lacking. The amount of definition in the image and the overall contrast were based on the limitations of the NTSC signal. Obviously technological advances, particularly digital projection, have eliminated the gap between film and video projection. The

transition to digital projection is upon us, and while not entirely complete, well on its way to being so.

Shoot on Film, Edit on Video, and Finish on Film via Matchback

This is matchback and is the domain of a diminishing number of feature films and certain archival practices. It is employed particularly in an environment where film prints are still required although, again, the DI is more common here. It is also where things get very complicated. Film and video are somewhat like squabbling siblings: they look as if they want to talk to each other and they can be made to talk to each other but only if you lay the groundwork carefully. Complications have already been covered earlier and finishing details are covered here and later in this text. Separating this approach from the next two approaches is becoming a bit of a false distinction, but it is important to understand how the technical considerations differ.

Matchback, wherein the project is cut on an NLE system, provides the information required for a negative cutter to conform the film that was originally shot in order to create a final film print. This translation between film and video is based on establishing and maintaining a relationship between the edge numbers of film and the time code of the video (other types of coding are used as well). Although it is premature to stress this particular aspect, the setup and data encoding for this relationship must be established scrupulously. Any flaws in the numbers will cause major problems later in the process.

The primary complications in the relationship between film and video are the aforementioned conversion from the 24 fps of film to the nominal 30 fps of video and the accommodations that must be made because video actually runs at slightly less than 30 fps (see earlier in this chapter for a review of these issues).

In a perfect world, one film frame would translate to one video frame, but, alas, perfection and matchback are hard-fought end products. The pros have matchback down, but it is a lot to keep track of for novices and those who have done only video. Film schools and labs have countless horror stories of projects that had a breakdown somewhere in the chain, the result being an expensive film print in which the sound starts to slowly drift out of sync and winds up being several seconds out by the end of a lengthy project. This can be fixed but only at further expense.

Again, the starting point is to interrelate the edge numbers of the film with the time code of the video. This is generally established in the *datacine* process, and both the datacine operator and the editorial staff must ensure that all information is entered correctly. Although not all NLE systems can handle matchback, many Avid systems do, and FCP has a proprietary program called Cinema Tools. Regardless of the system used, the two critical goals are to create a sound track that will remain in sync and to provide a negative cutter with the information needed to go back to the original film. The details are presented in the following sections, but be sure that you understand the issues and that your system and software are compatible to handle all the stages of production.

Shoot on Film or Video, Edit and Finish on Video, and Transfer to Film

This method used to be a bit exotic, but it is becoming more common. Many students and independents would be hard-pressed to afford it, but because shooting and finishing on film have their own rather expensive aspects, this method is not beyond consideration. In essence the process follows a shoot on film or video/edit/finish-on-video model, but the wrinkle is that the final video product is transferred to a film print by a lab.

This wrinkle is by no means new. Video broadcasting actually predates video recording, and the only reason that some of the earliest television shows still exist is that early engineers used a *kinescope,* a type of motion picture camera that filmed the picture directly off of a television as it was being broadcast. Although different technologies have been developed and employed, an advanced version of the kinescope-style approach is still widely used. The difference between this approach and the following DI is that the transfer is in real time and the film is photographed off of the playing video. In comparison to the DI, it offers fewer image controls, is substantially cheaper, and is not of the same quality.

The older kinescopes of TV shows are not particularly attractive, and kinescope and related technologies did not progress much until the mid- to late-1980s. Occasionally, in feature documentaries video was handy and inexpensive to shoot, and the small amount that was used in the final product was converted to film. A few specialty films, such as Emile de Antonio's *In the King of Prussia* (1982), used this approach, but the image quality was too limited to meet Hollywood standards—a hierarchically imposed standard but a standard nonetheless. One of the bitterest truths for independents is that Hollywood filmmaking will always be a benchmark for the majority of moviegoers.

The major development that improved results was the refinement of cathode ray tube (CRT) recorders, an approach that evolved from the old kinescopes. Steve James's *Hoop Dreams* (1994) was one of the first feature documentaries to successfully incorporate this model. The appearance of films that originated entirely on video—Thomas Vinterberg's *The Celebration* (1998) and Lars von Trier's *Dancer in the Dark* (2000), both part of what has been called the Dogma 95 movement—however, was the real beginning of this significant trend. The approach has become much more common, with established filmmakers like Spike Lee using quite a bit of video in his film *Bamboozled* (2000), Mike Figgis making the formally innovative *Timecode* (2000), and indies like Miguel Arteta's *Chuck and Buck* (2000) gaining national attention.

Many labs are providing video-to-film transfer services, most employing some kind of CRT-style approach with the video master being essentially shot with some semblance of a film camera in real time. The results range from amazing to unacceptable. The kinescope approach can yield excellent results, but certain types of movement and lighting can still prove challenging to reproduce. Rates are high. Most labs transfer only to 35mm and charge from $250 to $1,000 per minute. Labs that transfer to 16mm charge from $200 to $250 per minute. Many of the previously mentioned films, such as *Dancer in the Dark,* have employed this approach. Using the higher-end transfers, a two-hour feature would cost about $100,000. Given that audio tracks may require attention to be viable in a theatrical presentation, costs can only escalate.

Outside of CRT transfers, the next step up is laser and related technology. Sony has been a leader in this field with its *electron beam recording (EBR)* system. Some form of this process has been around for a while, dating back to the excellent results in James Cameron's *The Abyss* (1989) and other films, and improvements to the technology have created results that, in many eyes, equal film. The most recent episode in George Lucas's *Star Wars* saga has been a major test of this video-to-film approach. But, once again, we are really getting into DIs here, which are next.

Shoot on Film or Video, Edit on Video, Create a Digital Intermediate, and Finish on Film

The DI approach is distinguished from the previous process only in the complexity, and the expense, of the final transfer from video to film. Rather than shoot the video in real time, each video frame is written to film one frame at a time by a

high-quality scanning instrument. Some form of the DI process has been in use for quite a few years, but only in the past few has it become widely accepted as a viable option for entire features. It is a way of incorporating the positives of working in a digital environment and winding up with a high-quality film print. Many films have had elements of the DI process for special effects, but only recently have these elements taken the place of conventional film timing and printing for control of color and exposure. Again, a feature like Ethan and Joel Coen's *O Brother, Where Art Thou?* was put through the DI process to achieve a look that could not be created with film and conventional timing.

There are a number of ways of heading toward a DI, but the one used initially followed the basic route suggested in the foregoing section on matchback. (We describe here workflows with film origination, although you can go to a DI whether originating on film or video.) In the initial years after *O Brother,* most projects employed a film-to-tape style of workflow: creating low-res clones initially and using them to edit, and then going back to the neg and doing high-res transfers to build the video version from which the DI was created. The project is cut in Avid or FCP (or any other program that supports negative cut lists). Once the picture is locked and the cut lists are created, either the negative can be conformed (as described in the context of film editing) or selected pieces can be transferred from uncut rolls.

The negative, whether cut or uncut, is taken to the datacine and each film frame is scanned and then stored on a hard drive as a digital file. In the pioneering efforts, the transfers created 2K-resolution files, with this file size providing acceptable results. Knowing that bigger file sizes would overcome limitations, the norm has increasingly become the 4K file. The increase in the use of 6K files is ongoing and will be incorporated even more in the future. Transfer to 8K files is not just something on the distant horizon in 2013 but is just starting to see limited initial use.

Recent approaches have evolved toward the tape-to-tape workflow, with high-res transfers on the datacine from the outset and the negative having an early exit from the life of the film. Low-res clones are made from the high-res transfers, and editing proceeds on them. With this approach negative cut lists are unnecessary because once picture is locked, time code is used to return to the frame files created on the datacine. All film frames are thus written from these files.

Whereas telecine transfers were executed in real time, albeit often a shot or sequence at a time, datacine transfers can take substantially longer. There are now companies that can do 2K scans in real time, but the often preferred 4K scans can, as of this writing, be done at around 6 to 8 fps. That is, 1 second in 35mm takes roughly 3 to 4 seconds to scan. These times will come down, but when the extensive footage of a feature is being processed, input can be a time-consuming affair. A 2-hour feature on 35mm is around 4,000 feet. Although the slowness is at least partially a time-crunch issue, the fact that the transfer is done in a very expensive studio environment makes costs add up quickly, as well.

In the computer, the files—and thus each individual shot—can be color-corrected or manipulated to create the desired look and effects. The electronic manipulation of the image allows for possibilities far beyond conventional timing for film prints (see chapter 18), affording the cinematographer a whole new vista of opportunities for manipulating the color palette to create looks that heretofore were virtually impossible. A by-product is that resulting prints will have a more stylized feel to them, losing some of the old-fashioned warm, deep look of printed film.

Characteristically, many cinematographers rue the loss both of that look and of the power and the control over the image that they have on a film set. Indeed, the look of the film to a certain extent is taken over by postproduction personnel, a situation that has many DPs either losing control in the final stages of their film or putting in extensive, often unpaid time into digital color correction. The correcting of color used to be a pretty solitary affair, with a lab employee and the DP

taking a few days to go through the film on a piece of equipment that did not invite monitoring of the process by a crowd. Now it is done on a large screen in a studio, potentially with seating for many. The possibility of more cooks—color correction by committee—can leave the cinematographer outnumbered, fighting for his or her vision among competing agendas.

Once the shots have been corrected or manipulated as desired, the frames are written to film on a film recorder. It is done frame by frame in an almost animation-style process, using the EBR and laser recorders discussed in the previous section. The Arri film recorder is also commonly used to write the video image to film. Although the color correction is done in a digital environment prior to being written to film, there may still be issues of how color and exposure are represented. In other words, more correction may be necessary before acceptable film prints are created (discussed further in chapter 18).

One of the earliest incarnations of this process was its use in a significant number of sequences from James Cameron's *Terminator 2: Judgment Day* (1991). As with many early applications, the purpose was to create animated special effects in individual shots. Certain sequences (like Robert Patrick oozing through the gate) were scanned into the computer frame by frame at what were then very high resolutions. There a battery of animators worked their magic, and the effects were created. The video frames were then written back onto film, and final prints were struck. This was great for short sequences, but three major problems were present in those early days that made the process unusable for longer forms.

First, the expense was enormous. Scanning back to film was about $25 per frame. At 24 fps that amounted to $600 per second. And that, of course, was just the tip of the iceberg in terms of costs: original scanning and time on elaborate workstations and with expensive people creating desired effects must also be factored in. Prices have since dropped to roughly $0.35 per frame—$8-plus per second and $500 per minute—but these costs are still prohibitive for small budgets.

Second, the amount of time it took to scan a motion picture frame by frame was, and to a certain extent still is, an issue. As suggested above, some datacines can scan 2K files in real time, but a 4K file size is becoming a preference for many producers. With 4K you wind up in a whole new arena in terms of time and expense. In addition, scanning into 4:2:2 is much quicker than scanning into 4:4:4. Scanning a frame at the highest resolution takes about 4 seconds but in 1991 it was even longer. To scan selected takes as was done in *Terminator 2* was feasible, but to do the entire cut negative for a feature was unthinkable. Standard telecine work was $600 per hour and up, and the datacine is even more expensive.

The third shortcoming of the process was that, even if the previous two problems could be overcome, storage limitations were a deal breaker. Now we are used to the many gigabyte hard drives, piggybacked by as many external hard drives as necessary. Terabytes have made even that obsolete. In the early 1990s this sort of data storage was just a glimmer on the horizon.

So, this third problem is essentially gone, and prices and timings have come down to where using the DI process for an entire feature is not only feasible but has pretty much become the norm. There are no statistics on its overall use, but it is probably part of the workflow on a majority of theatrically released feature films. As digital projection becomes the norm, the approach taken in the DI process will still be a critical one until the last film projection theater is eliminated. It may take a lot of bake sales but, unless there is an outpouring of nostalgia, it is not too far in the future. Though coming down in price substantially since its earliest incarnations, the DI is nevertheless beyond the budget of the average student and probably out of reach of the majority of independents. A cash-strapped filmmaker is faced with the issue of how to produce a film print if their exhibition plan so requires. As long as film prints are a coin of commerce, however, the DI will continue to grow in popularity and will be the norm for the foreseeable future.

Potentially the biggest problem that filmmakers have to face now is how to choose the workflow that is right for any individual project. Confronted with so many bewildering options, making initial decisions can be problematic and can lead to expensive regrets when complications arise down the road. Unfortunately, the only solution is to do your homework and learn as much as you can so that your decisions are as informed as possible. As suggested earlier, many decisions hinge on the plan for the film's distribution—hard choices to make when you are just learning the lay of the land in the first place. The key is to be realistic—not necessarily a common commodity in an art form driven by dreamers. It is crazy to generate a whole bunch of expensive film prints when you later have to come to grips with the fact that your project is going to get either minimal or no release in theaters.

Although understanding the many technical options is critical, that is in a way only a small part of the story. If there was a general shortcoming during the great period of digital innovation, it was the notion that technology is an end in and of itself. It is talented, creative *people* who make good movies, and experience in the craft is paramount. Directors from Steven Spielberg to Spike Lee are frequently noted for stating that it simply takes about 10 years of working at it to get where you want to go. Too many people want to be there without the process of getting there; too many people think that they can become instant winners in the feature filmmaking sweepstakes. To quote the great final line from Jake Barnes in Ernest Hemingway's *The Sun Also Rises,* "Isn't it pretty to think so?"

10
Sound

Serious consideration of sound often gets postponed to the end of the filmmaking process. Students usually do not get to the subject until later in their academic careers, and independents often lack the resources or support staff to give it consistent attention from the beginning of a project. Even many professionals often give it little attention until late in the editing phase. No matter how strong the visuals, sound is a critical component of any film and is often one of the glaring weaknesses in student and independent projects.

Alfred Hitchcock is often referred to as one of the great visual directors, yet his films could never effectively be played without sound. Small segments of his films, such as the museum and cemetery scenes from *Vertigo* or the cornfield sequence from *North by Northwest* (1959), work without words. These scenes, however, are still highly dependent on music to achieve their effects. And his films certainly contain equivalent stretches that are dialogue driven. The often-observed fact that many works, particularly episodic television programs and soap operas, can be followed just as easily with your back turned to the picture may speak to a weakness in conception. But few films can be equally powerful with their sound shut off. Even the pre-1927 "silent" films had titles and were designed for and always had musical accompaniment.

Just as with the picture, the controlling factor in recording sound for later use is determining and producing what the editors need to cut the sound tracks. Nothing is more instructive in grasping recording mistakes than trying to cut sound that is inadequate in quality, insufficient in length, or conceptually flawed in terms of continuity. As with so much else, understanding the how's and the why's of generating material that meets the needs of the editing room is the goal of learning good audio-recording technique.

Toward a Final Sound Track

On a film shoot, sound and image are recorded separately, and synchronization between the two is critical. There are a number of approaches to recording location sound for film, but in commercial production, as with everything else, digital has become the standard. For many years speed-controlled conventional audiotape was the norm, with the by-modern-standards heavy, expensive Nagra being the standard. Made by the groundbreaking Kudelski company of Switzerland, the monaural Nagra was around $6,000 in 1980 and when stereo machines later became popular, the price went up. Multi-track exhibition was the product of the editing room, not location recording, but editorial staff saw advantages in stereo recording. Now, you

can buy a small, plastic digital recorder for under $300 and set up shop. Obviously you need a few other doodads. While most video cameras have very robust audio capabilities, the trend toward recording sound separately is ongoing.

Final Cut Pro defaults to four tracks of audio.

As suggested earlier, if you have that rare project that is going to be edited on film, the sound recorded on-location, as well as the sound effects and the music, are then transferred to *magnetic film stock*. Called **mag stock** or *fullcoat*, it has sprocket holes of the same size and pitch as film and is covered with magnetized oxide coating. This is the medium of sound editing in conventional film. If the edit will be performed on a computer, the sound is input into a nonlinear editing (NLE) system.

Building sound in an NLE system is a matter of layering the sound throughout the **audio tracks** available in a **timeline**. Recorded sound can be brought into a system in a number of ways (see "Import/Sound Transfers" later in this chapter), and individual takes are represented as clips in the bin, just as the visuals are. Most NLE systems open with either two or four tracks for the audio. **(SEE 10-1)** More tracks can be created in all but the most basic systems, and audio can be built as simply or complexly as the project dictates. Final Cut Pro (FCP) can handle a total of 96 tracks. It is very common to build the basic dialogue tracks within an NLE system like FCP and then export them for finishing in proprietary software.

During an edit on either film or digital, the editor creates multiple tracks of edited sound, layering effects on top of one another to create the complexity of sound desired. In film, these are called **mixtracks**. Either in film or digital, if you foresee needing the sound of a dog barking mixed with trains rumbling by in the distance, you would never record the two sounds together. *Premixed sound*—sound that is already combined on one piece of film or track—is generally too inflexible for the elastic demands of the editing process. If sound is premixed, the timing of the audio elements tends to dominate how you cut the visuals to match, an approach that usually compromises optimal picture efficiency. You would record the train and the barking dog separately; the elements then can be moved against each other on separate tracks as well as against the picture. You want to be able to move any piece of sound against other sound as well as picture to facilitate optimal positioning.

All these separate tracks are eventually mixed down to produce the final **sound track** for the project. In the conventional film approach, the edited film and the mixtracks are taken to a commercial audio-mixing facility, where each individual mixtrack is assigned to a channel on a studio mixing console. It is at this stage that the loudness of each individual sound in the final sound track is set. In addition, each channel has, or can be patched into, various *signal-processing* equipment—equalization, reverb, echo, and so on—that offers many opportunities to manipulate the quality and the character of the sound.

In NLE sound can be mixed internally on most systems, but there is a substantial argument for taking sound to a commercial facility for polish and finish. Volume and signal processing can be introduced anywhere along the way, but they can be changed at will and must be finalized at some point. Whether the edit is done with film or NLE, if the original recordings are of sufficient quality, sound can be almost endlessly manipulated to create many different desired effects. For this reason *the goal in initial recording is to record every sound at the optimal quality, no matter what it is supposed to sound like in the final film.*

To a certain extent, you do what works to create the desired sound. If you find a multilayered piece of sound that suits your needs, you would never hesitate to use it. But if any effect needs to be manipulated against another, that is, needs to change positions against other sound, it must be recorded and transferred to the

appropriate medium as a separate entity. Thus it is imperative to collect sounds individually and to have each one be as clean as possible, meaning that it is optimally recorded and free of interfering recording-system and background noise.

Applications

There are two distinct approaches to collecting sound for films: sync and nonsync. **Sync sound** is recorded as the camera is rolling on-location or on the soundstage; it is also referred to as *production sound* and is generally, though not exclusively, dialogue. **Nonsync sound** is recorded at other times and includes effects that the location mixer collects, effects recorded later in a sound studio, library effects, and music that was prerecorded or specifically designed for the film. *Nonsync sound* is somewhat of a misnomer because eventually all sound is precisely positioned against the picture and ultimately is "in sync."

A distinction is often made between recording production sound in a studio and on-location. As with virtually everything else, doing sound is much simpler in the studio, although the recording crew may have to contend with some of the contraptions that are required for the picture (such as fog machines and fans) as well as with their operators. Locations can present extensive challenges. Given the goal of clean dialogue and effects, responding to horrible acoustics, passing airplanes, traffic noise, air conditioners, heating systems, refrigeration, and a host of other complicating factors can make recording on-location a real nightmare. A measure of a good **sound mixer**—the person who operates the audio recorder and is head of the sound crew—may well be the ability to deal with difficult situations.

Because of considerations like this, the production sound is often replaced in postproduction editing, particularly on features and episodic television shows. **Postdubbing**—rerecording the dialogue in postproduction with the intent of editing it into the sound track later—is a relatively frequent reality, although it takes a healthy budget to support the needed studio time and additional time with talent. Independents and students should be encouraged to get the sound right on-location, even though they often have limited control over locations precisely because they have limited funds.

The Analog World of Yore

While the analog world is in full and hasty retreat, a few general considerations will shed light on how the film world operates.

Single- and Double-System Sound

Single system and *double system* refer to methods of achieving sync sound in film. For a generation brought up on confrontational video journalism, the notion that achieving lip and picture synchronization requires some effort may catch many off guard. Sound became a viable commercial entity in film only in the late 1920s. Any student of film history knows that the early sync-sound cameras were very big, requiring their own soundproof closet-like booths. These early limitations were actually overcome quite quickly, although the cameras and the sound gear used to make feature films during the early years were far from portable.

Outside of instructional and educational filmmaking, sync-sound equipment was not readily available to non-Hollywood filmmakers until the early 1960s, with the introduction of lightweight, portable sound and camera equipment. Just as video has created its own revolution, the introduction of the lightweight *crystal camera* and portable sound recorders also revolutionized the way films were made. These developments, along with film stocks with greater sensitivity to light, allowed filmmakers to work in almost any situation.

It would seem at first that the most sensible solution to the problem of how to incorporate sound would be to put the sound along the edge of the film. This is the approach in final film prints and its incorporation during shooting appears logical. While it has major drawbacks, this is indeed one approach. With the **single-system sound** method, film chambers are outfitted with a record head, and the microphone is connected directly to the camera; the sound is then recorded on a magnetic stripe along the edge of the film. **(SEE 10-2)** You may even find some older cameras that record optical (light-based) sound. **Single-perf** film is used, with the area normally devoted to the second set of perfs taken up by the sound. Film with this magnetic track is called *striped film*. It is no longer being manufactured, although you might find a company that would stripe some raw stock for you.

The most significant drawback to this approach has to do with the different types of movement needed to both record and reproduce the two media. The film image requires intermittent movement at the gate, and sound must move continuously across the heads. Because the two types of movement required cannot be reconciled, they cannot be recorded in the same place on the film. The solution is for the record head to be displaced from the gate, with the sound being recorded and played back separately from the picture. **(SEE 10-3)** Thus the sound is displaced by 28 frames, reconciling the two types of movements. Projectors also employ this displacement.

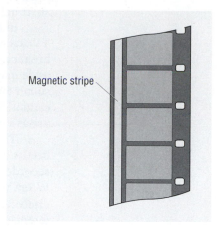

In single-system sound, audio is recorded on a magnetic stripe along the edge of the film.
© Cengage Learning

Magnetic stripe

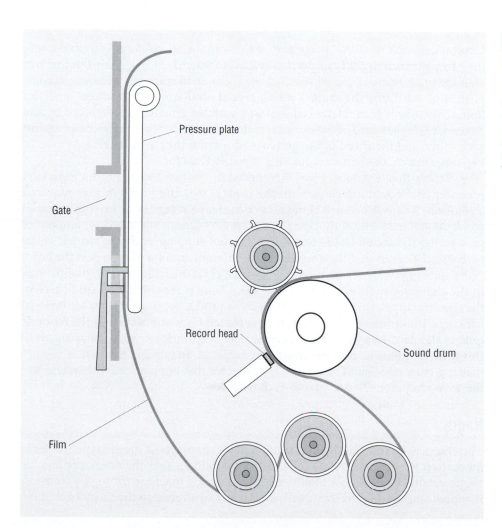

10-3

Because the movement of the film image must be intermittent and that of the sound must be continuous, the record head is positioned below the gate area and controlled by the sprocketed rollers.
© Cengage Learning

Pressure plate

Gate

Record head

Sound drum

Film

Although fine for recording and projecting, this displacement is untenable for editing. If you cut the picture at a particular frame, you affect a different part of the sound track. Thus, critical editing is impossible with single-system sound. In addition, adding sound such as music or effects to a film is impossible because the recorded sound occupies the entire track. The whole system is too inflexible for anything but the crudest editing.

In the days when television news was shot on film, a receding memory at best, TV stations shot miles of single-system sound film. The film was shot for immediate broadcast, with no intention of editing. It was slapped on the telecine and then set aside maybe never to be seen again. This approach was also quite popular with consumer Super 8 cameras. Again, the displacement was awkward for any editing applications. Single-system sound is no longer used extensively, although it gets occasional use as a portable medium when the intention is to transfer to and finish on video.

These drawbacks are why double-system sound was, and still is, the accepted method. In the **double-system sound** approach, the camera and the sound recorder are separate entities. The problem lies in synchronizing the two media. When you set a *wild camera* at 24 frames per second (fps), it does not run at precisely 24 fps; it will run at some percentage above or below 24 with no visible difference in the reproduction of movement until you get three or four frames away. When you set a conventional tape recorder to 7 1/2 inches per second, it will have some fluctuation as well. When you add in the variable of inexact projectors and sound playback systems, the possibility of sound and image playing back at the same rate is statistically improbable.

Synchronization

Crystal cameras were the image part of the solution to synchronization because they run at precisely 24 fps—precise at least to the extent that their fluctuations amount to at most a 1-frame variance every 10 or so minutes. This was accomplished by outfitting the camera with a crystal oscillator that produces a perfect tone. This tone is then referenced against a variable tone that is produced by and dependent on the speed of the camera's motor. The two tones are referenced against each other, and the speed of the motor is adjusted if they are different. When the two tones match, the camera is running at precisely 24 fps.

Before this technology was introduced in the late 1950s, producing a tape recorder that could interlock with the camera was the problem that required a solution. There is no such thing as a crystal tape recorder, at least in terms of conventional magnetic audiotape. Tape recorders cannot run a precise amount of tape across the sound heads because of capstan slippage and tape stretch; if the tape stretches even slightly, it would run a different amount of tape past the head. The solution was to design a recorder with a crystal oscillator that, like the one in the camera, produces a perfect tone. This tone is recorded on a small area of the tape, usually down the center. When these production sound tapes are brought back into the studio, the recorded tone is played back and slaved to the 60-cycle tone in standard 120-volt electric current. The mag stock recorder is also slaved to this tone, and thus a real-time transfer is achieved. In editing, the slate is used to match picture and sound manually. The recorder that popularized this system was the once-ubiquitous **Nagra** quarter-inch recorder.

Nagra

The Nagra held a virtual though largely benign stranglehold on the sync world for more than 30 years. **(SEE 10-4)** While digital recording is now the norm, the humble Nagra retained its role as a highly functional analog machine through a transformational stage in film history. Now, it is largely consigned to the dusty back shelf.

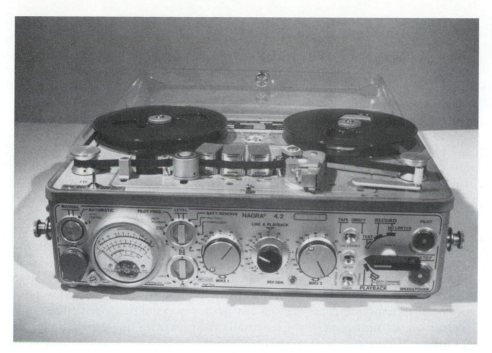

10-4

The Nagra recorder became virtually synonymous with sync-sound recording.

Nagra 4.2 recorder/© Photo courtesy of Bruce Mamer.

Although *Nagra* is a product name, this quarter-inch reel-to-reel recorder was so central to the development of portable sync-sound filmmaking that it at one time was virtually synonymous with sync sound. The Nagra was designed to be carried on the shoulder with a strap or set up in convenient spots on-location.

Magnetic recording tapes are composed of a magnetic oxide solution applied to a polyester or acetate backing. The electrical signal created by the microphone is arranged as patterns in the magnetic oxide at the record head. The conventional head configuration on a professional recorder includes an erase head, a record head, and a playback head. **(SEE 10-5)** Most consumer cassette recorders combined the record and playback heads in a single head. Recorders designed for sync sound, such as the Nagra, have a fourth audio head that lays the tone needed to generate the reference on the tape for synchronization. **(SEE 10-6)**

This slaved-tone approach was the standard for many years. Video and digital technologies have introduced other methods of producing speeds that are perfect in that all video, even the analog ancestors, are by definition perfect speed recorders. Any speed fluctuations or breaks in time code or control tracks would cause image breakup and unacceptable disruptions. The much-maligned **Digital Audiotape (DAT)** recorders that were popular around the turn of the century were essentially video recorders outfitted with only the audio functions. The bottom line is that any analog or digital video recording device is a perfect speed machine.

A student of mine once got out on-location and found that his DAT recorder was not working

10-5

The conventional head configuration on an analog professional recorder included three heads: erase, record, and playback.
© Cengage Learning

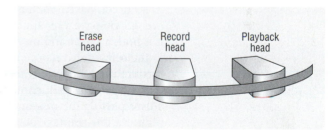

10-6

Analog recorders designed for sync sound generally had a fourth audio head that laid down the reference tone.
© Cengage Learning

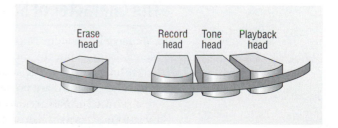

properly. He happened to have his father's old VHS camcorder with him on the set, and he just patched his mike into it and recorded all of his audio onto a VHS cassette. It was then a simple matter of digitizing it and getting it into FCP. It was not the best solution given how awkward the VHS camera was when put to that use, but it was more than adequate technically, and he did not have to scratch his otherwise carefully prepared shoot—check all gear carefully before you get out on location.

Perfect-speed recording is not essential for effects and music, although, given that most audio recording is now digital, virtually all work is done at speeds that can be duplicated anyway. Nonsync material is generally fitted to the picture, and production sound is the only thing that truly must be in sync in initial recording. If any of what you are doing has an analog phase in it (such as recording effects on a cassette recorder or using mag stock in a conventional film edit), be aware that speed shifts can occur in the audio if you are not watching sync issues.

Double system sound, camera and audio recorder separate, was the norm for many years and for a variety of good reasons the practice has persisted into the digital age, not by all, but by many on the pro end. The double system approach has many benefits. Mics that are factory-built attachments to the camera do not have the flexibility in positioning to always obtain the best sound. In addition, the type of mic—wide pickup pattern, narrow pickup pattern—may not be appropriate to your subject material and action. If you have multiple speakers, a single directional mic may leave some dialogue inadequately recorded.

Patching a mic into camera's independent input has the possibility of producing good results but the umbilical cord relationship can hinder the mobility of the sound person, limiting his or her ability to find a better position or use multiple mics. If you have a long shot but want close-up sound, the running and amount of cabling may cause unnecessary complications and just plain hazardous, to people and equipment, setups. For many consumer and prosumer cameras, the mic inputs are not very durable ones with unanticipated tugs jeopardizing the signal or, if a less fragile connection, pulling over the camera. In addition, the constant presence of someone always plugging into the camera can be an irritant to independence-loving camera crew. Monitoring the sound also becomes an issue with headphones into the camera being another potential constraint on the mobility of the operators. There are workarounds on this but mutual freedom is simply less complicated.

If you have a factory-attached mic, go ahead and record the sound anyway even if you have a separate sound person and recorder. Often called a **scratch track**, it is both a safety and may have some unanticipated qualities that add a dimension to the separately recorded track. The double system sound must also be synced to the picture. I recently read a rather tortured article about someone going through the raw footage and "chorusing" the separate sound to the scratch track. That involves pasting the new audio as close as you can in a separate NLE track and slipping it a few frames one way or the other until any displacement goes away. My response was: why not just use a slate? People have been using them for a lot of years and they are pretty much foolproof. Syncing to slates will be covered in the editing chapters. However you approach it, having a separate recorder and a full audio crew produces higher-quality sound and makes for a less stressful set.

The Character of Sound

Extensive knowledge of sound and its reproduction is not necessary to make simple recordings, but the more complex the challenges, the more a lack of knowledge will result in inadequate sound. Therefore some basics about the character and the recording of sound are presented here.

Sound emanates from a source and becomes the vibration of elements in a transmission medium, usually molecules in the air. **Sound** is air

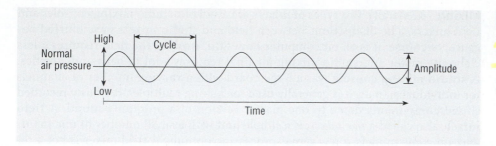

10-7

A sound wave is a representation of compressing and separating air molecules.
© Cengage Learning

molecules compressing and separating, generally represented as a wave. **(SEE 10-7)** The frequency with which the signal fluctuates above and below normal air pressure is called *cycles per second (cps)* or, more commonly, hertz. **Hertz (Hz)** represents the *pitch* of the sound, that is, whether it is a low, midrange, or high tone. Sounds with rapid rates of fluctuation are higher, such as the sounds produced by a soprano singer or a flute. Sounds with slow rates of frequency are low, such as those produced by a bass singer or a tuba.

Frequency range refers to the spectrum of audible and inaudible sound, represented in hertz. The average adult human ear hears frequencies from roughly 20 to 16,000 Hz. Sound exists above and below these parameters, but it is inaudible to humans. The distance of variance from normal air pressure represents **amplitude**, or the strength of the signal; the more the air is disturbed, the louder the sound.

Musical notes are at specific frequencies measured in hertz, with the audible spectrum easily divisible into octaves. Middle C is about 260 Hz. The sounds of someone singing bass would be in a range roughly from 60 to 200 Hz; a soprano's singing would be around 2,000 to 3,500 Hz. Despite the general accuracy of these two statements, wherever in the audible spectrum a particular human voice is, that voice has elements of other frequencies in it. Even if a person has a very low voice, that voice includes elements of high frequencies. Conversely, a high voice has elements of low frequencies. This is true of all sound, from distant thunder to the piccolo. When one starts manipulating sound with equalizers and other signal processors, this becomes a significant consideration.

Frequency response refers to how evenly and completely a specific recorder or playback format reproduces the audible range. High-quality recorders reproduce almost the entire spectrum of human hearing. Consumer recorders may record only within a relatively narrow range. Some recorders have poor low-frequency reproduction, whereas others fail on the high end. A recorder's frequency response can be checked in the machine's *specs*, a list of its technical specifications. Find a recorder that reproduces as much of the sound spectrum as possible.

Frequency response is based on technical considerations. In the analog world, the most notable of which are the quality of the electronic circuitry, the tape speed, and the area on the tape devoted to the signal. Quality is much more consistent in the digital world but is again dependent on the quality of the circuitry and other electronic considerations. Due to the nature of photographic reproduction, optical sound on 16mm film prints is notoriously limited—reproducing the range of frequencies from about 70 to 7,000 Hz. Sound for 35mm is significantly better because the film is running at a faster rate and has a larger area devoted to sound.

The following terms and concepts are necessary to understanding some of the fundamentals of sound.

Decibels A decibel (**dB**) is an increment of measurement of the amplitude, or loudness, of sound. Decibels are logarithmically based and defy simple explanation. Most recorders represent decibels either as a unit of amplitude in the recording of an audio signal or as a percentage or increment away from an optimal recording.

Mixing Generally, two types of mixers are available: studio mixing consoles and field mixers. The distinctions between field and studio mixers have blurred because, of course, it is all on computer now. Still, work in the field requires a less elaborate mixer and studio mixing for final requires a lot of bells and whistles. A **studio mixing console** was a large board with a varying number of channels for individual signals. It is generally used for mixing multiple previously recorded sound components down to one master version of a program's sound. A **field mixer**, also called a *mic mixer*, is a simple unit with a small number of mic inputs and, on some models, a few signal-processing options. A field mixer is not a requirement for location recording, but it has advantages and is necessary when a particular setup requires more than the standard two-mic inputs on most professional recorders. A field mixer converts the **mic signal**—the electric current—to a **line signal**, which is then fed to the recorder.

Signal processing The idea that an audio signal can be changed and shaped is important. When dealing with sound coming from a microphone, you are faced with an electrical or digital signal that can be altered as desired. Signal processors such as equalizers are frequently used to "clean" or "brighten" sound that was recorded in less-than-optimal conditions. Other signal processors, such as reverb units and echo chambers, can add specific character to sound.

Signal path The route an audio signal travels—the **signal path**— is significant to understand both for troubleshooting and for determining what processes the signal is undergoing. The microphone converts sound into a signal that is directed by the mic cord toward the recording mechanism. The signal goes into a mic input on the recorder, where the weak microphone signal is boosted by a **preamp**. In a simple recording system, the signal is then fed to the recording chain. In a complex recording system, the signal may be routed through a number of internal circuits.

Virtually all audio equipment—recorders, mixers, signal processors, and so on—comes equipped with *line inputs* and *outputs.* The audio signal can be routed through a **line-out** of one machine to the **line-in** of another. You might choose to route the signal through a variety of sideboard signal processors. If you send it to an equalizer, it has to come out again. If you send it to a field mixer, you should be able to find out where it is and how to send it where it needs to go. With some basic knowledge of how signals travel, you should be able to route a signal wherever you want.

As a sound person, you should also be able to follow the often-labyrinthine path of virtually any signal in any setup, including the path of a video signal. When the path of the audio signal for a specific setup is understood, the various factors that affect the signal become less mysterious. There are also many points in the recording chain where the signal can get waylaid, and understanding the concept of how a path works can be helpful in audio troubleshooting, a skill all too frequently needed on the set.

Ambience The quality and the character of the underlying sound in any given location is called **ambience**. The **acoustics**—or total effect of sound and how it travels in a given space and particularly how it reflects off of surfaces before arriving at the microphone or the ear—give the sound a distinct character, whether it is an echo-filled school gymnasium, the muted sound in a plush bedroom, or the cavernous sound of Grand Central Station. This ambience colors the dialogue and the effects you are recording as well and will have a specific character in even the briefest silent stretches in a scene. Even if no discernible audio is occurring, every space has distinct acoustic characteristics.

One generally attempts to exclude as much ambient sound as possible. Ambience is distinguished from **background noise**, such as distant traffic, heaters, fans, and similar interfering sources—all of which must also be addressed (both concerns are discussed later in this chapter).

Generation The term *generation* refers to the "family tree" of an image or a piece of analog sound. With the advent of digital sound, it has become much less of a concern in that there is essentially no degradation in successive copies. It is an issue nonetheless that people should be familiar with because some distribution is still done on analog formats. It relates to how the quality of recorded sound deteriorates as it is transferred from the original to various levels of copies. Successive *dubs* eventually degrade noticeably from the original. In a finish on analog equipment, recorded sound has to go through a number of generations to get to a final product. Although sound holds up well through this process, this is another reason why the original recording must be as high quality as possible.

Sync Sound and Picture

All video cameras come outfitted with either built-in mics or mic input connectors or both. Mics on the camera generally do not allow the mic proximity for the highest-quality recording. Mic cords attached to the camera can be adequate but the tethering of the mic and the sound mixer to the camera can be awkward and an unnecessary complication.

Digital/Analog Recorders

The key distinguishing feature of digital recorders is the near absence of any noise in the recording system. Analog recorders have inherent system noise, usually referred to as **hiss**, and digital all but eliminates this unwanted presence. Digital recorders provide an exceptionally clean recording; however, some critics have said it is *too* clean, lacking the warmth and the ambient character of analog. Despite this most sound mixers have opted for the security that a trouble-free signal provides. Probably the key positive of digital recording—one that relates to system noise—is that it is again not subject to generation loss. Although some limitations are being discovered, digital information can be copied many times without degradation of the signal. This is a particularly beneficial feature because sound is recorded and rerecorded a number of times in postproduction.

Beyond the issues of recording approach there is usually an extensive campaign for recording effects and music. This can be as simple as someone recording a local band or whipping up funky effects in the kitchen in the middle of the night; or it can be a highly sophisticated studio recording of a full orchestra or producing complex effects in a Foley room. These can be recorded on anything handy and digital, but they can also be recorded on older analog gear—results will just have to be digitized. Again, having a sync recorder is not absolutely necessary for collecting sound effects. This phase of postproduction can also involve narration sessions and the replacement of bad or inadequate dialogue. (See "Automated Dialogue Replacement" later in this chapter.)

Card and Hard-Drive Recorders

Beyond the critical requirement of recording sound that can be synced with picture, which all digital recorders can, a key to recording high-quality sound is to have as strong a technical system as possible. As important as such things as mic position are, the recording equipment must be equal to the task. Do not use an inexpensive consumer recorder or, worse yet, an inferior microphone. The sound will be only as good as the weakest link in the chain. You can go almost anywhere with a good, strong signal, but a weak or inferior signal leaves you with limited options.

The Tascam DR-100 portable recorder.
© Cengage Learning 2014.

Just as in video, the most recent trend in sound is the *file-based digital recorder*, a tapeless system that writes the audio signal directly to a card. There are hard-drive recorders as well, but the majority are card-based. Using SD cards is pretty much the standard, with audio not taking up nearly the real estate as video. Doing a day's shoot on a 2 gig card is not unheard of. Once a recording is made, it exists as a digital file on the recorder's flash card or hard drive. With hard drives, the recorder is connected to the computer with a FireWire or USB cord. With the SD card, one uses a port on the computer, a card reader, or cord connection. The recorded files show up on the computer desktop, and the files can simply be downloaded and imported into an NLE system.

There are a number of companies that are making card recorders. Tascam, for example, is producing products that are receiving wide acceptance. In addition, Zoom, a division of Samson Technologies, and Sony have lengthy product lists giving many options for location and studio recording. Aaton has also weighed in with an excellent recording system, the Cantar X-2, although at a higher price point than many competitors. It is also one of the few hard-drive recorders. The fabled Nagra/Kudelski company continues to produce location recorders while branching out into digital television.

The Tascam DR-100 is representative of Portable Digital Recorders (PDRs) and is widely used in the industry. **(SEE 10-8)** It is the size of a paperback book, weighs less than a pound, has a plastic body, and is under $300. If you wear baggy clothes, it may even fit in a shirt pocket—maybe even with your cell phone. It records on an SD card that can be removed or the recorder can be connected to a computer. In my experience, these recorders chew through batteries. Have a bunch of AAs around and/or have a number of backup rechargeables. Many of the features are consistent with recent digital recorders as well as many analog models but a few issues require attention.

The DR-100 offers recording to two different file types. It defaults to the WAV file, a Microsoft/IBM creation that has become a common audio extension. Apple uses this file type in FCP and it also has many consumer applications as well as being standard for a number of other NLEs. The files can be imported directly into compatible programs—no codecs are needed or anything. The DR-100 can also record to MP3, a file-type more appropriate to consumer applications and file sharing. If you need different file types, Tascam and the other manufacturers have different similarly priced models. The determining factor is what file-type is compatible with your NLE. Check before you invest in a machine.

Like video, audio has sampling rates. Here the standard choices are pretty simple. Audio can be sampled at either 44.1 kHz or 48 kHz. Most everything in the digital world is sampled at 44.1 and most recorders default to this rate. It is switchable by pressing the menu button on the face of the recorder. **(SEE 10-9)** With wheel on the middle right scroll down to record settings and press ENTER/MARK. Use the wheel to choose between 44.1 kHz and 48 kHz. Press HOME to return to go back to the default/main display called, of course, the Home screen.

The menu button gives you access to technical settings.
© Cengage Learning 2014.

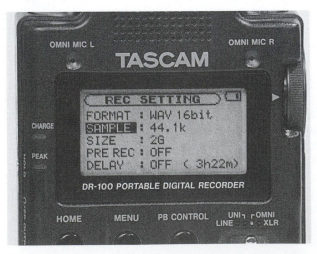

10-10

Press the record button once for standby and a second time for actual recording.
© Cengage Learning 2014.

10-11

Along the bottom of the display, total files recorded are listed next to Folders.
© Cengage Learning 2014.

The RECORD button is at the bottom of the machine's face. **(SEE 10-10)** Press it once to place it on standby. Here you can evaluate levels and listen to and analyze the sound on headphones. Press RECORD again to record and STOP to end the recording. The science and art of recording is more than pressing on and off and complexities will be developed as the chapter progresses.

The main display will list the number of files you have recorded. **(SEE 10-11)** If you want to arrange the files more by category, date, or some other system, different file organization and folders can be selected in the menus. Capacity of the card can be monitored in the displays as well.

Monitoring volume levels will be covered in the next sections, but many digital recorders, the DR-100 included, give different tiers of recording. The DR-100 has a three-tiered recording mechanism. On the back of the recorder, there is a MIC GAIN switch with L, M, and H positions indicating the character of the sound you are recording. **(SEE 10-12)** If you are recording a very loud sound, the L (low) position is appropriate, a low sound would require the H (high), and so on. There is still the standard volume knob on the right side of the recorder that gives you discriminations with the MIC GAIN positions.

The Tascam unit has two pairs of on-board mics, one a wide pattern pair and the other a more directional pair (see page 245). There are also two mic inputs, the connections on the bottom to obtain a more controlled miking approach. **(SEE 10-13)** Recording dialogue with picture requires the highest standard of miking, with mics on booms with the critical goal of getting as close to the subject as possible. General miking from a distance, again, just does not cut it.

10-12

The Mic Gain switch on the back of the recorder.
© Cengage Learning 2014.

10-13

The DR-100 has stereo XLR mic connections.
© Cengage Learning 2014.

Volume Levels

Recording, of course, is much more than setting the correct volume levels on your machine's displays. It is a complex interplay of understanding and addressing all the complicating factors, allowing your ears to evaluate the general quality, and making sure all the technical quantifications are within appropriate parameters. While the cinematographer gets all the attention, an almost, but not quite, equal artist on the sound gear can bring dimension and character to film's sound approach.

Recorders generally have twist knobs to control the record level of the sound. These are called **potentiometers** (**pots**) or *gain controls*. A **fader** is the sliding control found on most mixing consoles. On the digital recorders, record level monitoring functions are almost exclusively digital LED meters with ascending vertical bars representing the fluctuations of record levels. The old analog volume-unit (VU) meters and Peak Program Meters (PPM) are essentially a thing of the past although a few recorders emulate their design. Stereo and multi-track machines have separate pots for each mic channel.

Digital LED meters Digital recorders have peak meters for monitoring volume levels with a digital display having the previously described ascending bars. **(SEE 10-14)** The major difference between these meters and earlier versions is that, although there is substantial wiggle room with a VU meter and a little less with a PPM, zero on a digital meter represents an absolute threshold. If the meter peaks above the zero point, rather than distorting, the signal simply collapses. Most recorders have an LED peak indicator that will light when the signal verges over into the "hot" zone. The mixer must be exceedingly careful to avoid this usually red indicator light. Fortunately, the character of the recorded signal in the digital realm assists in accomplishing this. With virtually no system noise, there is nothing inherent in the recording to cover up. With a conventional recorder, consciously underrecording to avoid distortion can have dire consequences in the form of the noise in the system. With digital recording, however, you can slightly underrecord with the knowledge that it should not negatively affect the final product. Be careful in that drastic underrecording will leave such a weak signal that it may be unusable. The general practice is to keep the recording around –12 on the meter.

Most of these meters also have a very useful *peak-hold* feature. The vertical bars give a representation of the most recent peak and holds in that position for a few seconds. If you are surprised by a sound or look away for a second, you can look back and tell immediately if the peak is going to present a problem. There is also a *margin* feature that can be quite useful. It tells you exactly how close in decibels the signal has come to absolute 0 and holds that value for as long as needed. This ensures that short-duration level peaks are not missed. By monitoring the margin readout, you can set overall levels so that you always have a margin of safety below absolute 0 for peaks. Later in postproduction the level of the entire recording can be brought up to just under absolute 0 in a process called *normalization*.

VU meter The **VU** (**volume-unit**) **meter** is found on older machines and is the familiar scale on the front of all but the most rudimentary analog recorders. **(SEE 10-15)** The microphone turns sound into electric energy, which triggers the needle on the VU meter. The needle registers the high-amplitude points—the *peak*—and the low-amplitude points of the audio signal as it is expressed in electric current.

10-14

Horizontal ascending bars indicate volume on the left and right channels.
© Cengage Learning 2014.

10-15

The VU meter shows the level of the audio signal being fed to the record head.
© Cengage Learning

Zero VU (0 VU) is often presented as the point the signal should not exceed to avoid distortion, although this is not a completely accurate assertion. VU meters are imperfect tools because they are peak-averaging meters; they do not show all of the high points of the recorded signal, but only an average, so that they are in position to respond to the next signal. This has led designers to leave **headroom** in the meters, that is, room above 0 VU where the recorder still reproduces an undistorted signal. Although there are different theories for recording various sounds, professional sound people frequently record certain sounds substantially above 0 VU.

Peak program meter The **peak program meter (PPM)** was generally considered an improvement over the VU meter. It was featured on many high-end analog machines, most notably the Nagra, on which it is referred to as a *modulometer*. **(SEE 10-16)** The ballistics of its needle are delicate enough to respond to all fluctuations in volume,

10-16

The modulometer on the Nagra.
© Cengage Learning

giving an accurate reading of the signal at all times. Modulometers do not have a 0 VU point as do standard VU meters; they have instead a 0 dB point that displays how far off the nominal distortion point the audio signal is. Unlike 0 VU, the 0 dB point on a modulometer is the effective limit past which distortion occurs. An occasional swing over 0 dB on a modulometer may be acceptable because, given that distortion is not an absolute concept, there may still be slight headroom. Sound mixers generally keep the signal around the middle of the meter.

Although zero on either meter represents a significant point in the consideration of distortion on an analog machine, it also represents an important qualitative measure: it is roughly the point at which the recorded signal best covers the inherent noise of the recording system. Many beginning sound mixers are so terrified by 0 VU on the meter that they tend to underrecord the signal, assuming that anything is better than the dreaded distortion. If the recorded signal is too low, the sound may be overwhelmed by what is called the *noise floor* of the recorder and can eventually become unintelligible. Although the effect of system noise on the tape may not be immediately audible, sound has to go through a number of generations to reach a final sound track; any hiss on the tape will be magnified in this process. Underrecording is actually worse than having the signal occasionally go above peak levels, with slight distortion on a peak often not a problem because it can replicate how we hear loud sounds.

Microphones

Microphones are classed by their **pickup pattern**, or *polar pattern*, which refers to how a mic picks up sound from different directions in relationship to where the mic is pointing. The two types of mics that are generally available to students are omnidirectional and cardioid.

Omnidirectional mics pick up sound in a spherical pattern, that is, equally in all directions. **(SEE 10-17)** This approach is not particularly useful because of the more focused recordings required for sound in motion pictures. These mics do, however, have occasional applications. They can be useful for picking up the general sound—the ambience—of a scene or location. When held close to the mouth, they can also be used for voice in a reporting or interview situation. The Electro-Voice 635A is a typical example of an exceptionally durable omnidirectional mic used in field recording.

Cardioid mics, also called *unidirectional mics*, pick up sound in a heart-shaped pattern, hence the name. They pick up sources in front of the microphone to the general exclusion of sources behind. **(SEE 10-18)** In the familiar "shotgun" variation, cardioids are designed to pick up sound in a narrow angle. Because of the need to focus on specific sound, these short cardioids (*short shotguns*) and supercardioids (*super shotguns*) tend to be the mics of choice for location recording. **(SEE 10-19)** Sennheiser, AKG, and a number of other companies make high-quality shotguns that are in common use.

Many different types of microphones are used in film production, but mics with narrow pickup patterns have obvious advantages. Traditional voice mics, such as the ones used by rock bands, are not suitable for film applications. They are meant to be

10-17

An omnidirectional microphone picks up sound in a spherical pattern.
© Cengage Learning

put close to the mouth, which is not feasible in most filming situations. The long shotguns, though physically impressive, are usually too much for interiors, their weight and size making them difficult to use in the often-tight quarters of locations. Using a short shotgun indoors and a long shotgun outdoors is a common approach.

Shotgun mics are also used because their narrow pickup pattern excludes some amount of unwanted ambience or background noise. This has led to certain misunderstandings, however. Just because a sound originates from behind a microphone does not mean that it does not exist in some form in front of the mic. Sound is like water—or light for that matter: it flows into any area it is not completely blocked out of. If a sound is emanating from behind a microphone position, elements of it will be recorded no matter how dissipated. Shotgun mics do not eliminate unwanted sound; they simply lessen the impact.

Lavalier mics, or *lavs*, are small clip-on microphones that are frequently used for interviews, although they have a wide variety of applications in film. Lavs are not truly a class of mics as they can be omnidirectional or cardioid, although most of them pick up in a cardioid pattern. One complication of using lavs in many film applications is that they must be hidden. Many filmmakers leave them in plain sight in interview or documentary situations, but they must be concealed in other circumstances. This can lead to problems of muffling and the rustling of clothes.

Wireless mics—wireless what a concept—also called *radio mics*, have been around for years and have become increasingly popular recently. A wireless mic is usually a lavalier plugged into a radio, now wireless, transmitter, which is clipped onto the back of the performer's waistband, taped to the body, or placed in a pocket. The radio signal is sent to a receiver that feeds it to the recorder, usually into a mic input. These mics can be handy for long shots where effective conventional miking is impossible or when the subjects are moving through tightly confined spaces.

Radio mics are useful for many applications, but their convenience must be balanced against their recording capabilities. The quality of the signal they produce is arguably lower than that produced by a conventional mic, mostly because of muffling and rustling of clothes. Their use is also complicated by the interference of other radio signals. Many locations are so saturated with radio frequencies that other signals, such as radio stations, CBs, and cordless phones, can get thrown into the mix. The higher-end mics have many of the bugs worked out, but the rental costs of these may be beyond the means of many independents and students.

10-18

Unidirectional, or cardioid, mics pick up sound in a heart-shaped pattern.
© Cengage Learning

10-19

Mics with narrow pickup patterns, such as supercardioids, have obvious advantages in film production.
© Cengage Learning

Though there are a number of other approaches, dynamic and condenser mics are the two most common types found in schools and arts centers. In a **dynamic mic**, the electric current—the mic signal—is produced by air movement within a magnetic field. The moving air created by sound hits a membrane in the head of the mic, and the resulting vibration generates the signal.

Condenser mics, also called *capacitor mics*, require a source of power, usually a battery, that supplies the microphone head with a consistent electrical signal. In this case the consistent electrical signal is altered by the movement of air against a similar membrane.

A common method of powering condenser mics, as well as several other types, is the phantom powering system. **Phantom mics** are powered by the batteries in the recorder rather than an internal battery. In many applications mic cords have to be specially wired with the polarity reversed for the current to reach the mic. The phantom design is one you will encounter frequently. Phantom mics are generally identified as 48-volt (48v) mics and inputs are switchable on your recorder. Check the documentation of your equipment for implementation.

Sound people tend to find a small number of mics with which they are comfortable, and they can be very opinionated, with arguments about what constitutes the best mic getting emotional and vehement. You need to get past the hype to pick the right mic for a given situation. Try out as many mics as you can. Listen to mics side by side to get a sense of which one produces the cleanest and highest-quality signal. Remember that the recording chain is only as strong as its weakest link, and a good microphone is essential to a high-quality recording.

Audio Connectors and Microphone Cords

Four basic types of audio connectors are used in the United States: quarter-inch, mini, RCA, and XLR. You will occasionally find others, such as the banana plug, but they are generally associated with foreign-made, mostly European, equipment or specific brands. Japanese and American recorders tend to conform to the same standards.

Audio connectors and cords are all based on a simple connection. Most connectors have positive-to-positive and negative-to-negative contacts. On the standard plug-style connector, the tip of the pin is the positive, or "hot," contact and the shaft is the negative, or ground, contact. **(SEE 10-20)**

Microphone cords are equally straightforward. A simple cable has a single conductor surrounded by *shielding*—a metal mesh that encases the conductors for the length of the cable. The single conductor is connected from one hot contact to the other, and the shield is used to connect the grounds. All connections are soldered. The plug end of a connector is traditionally referred to as the male end, and the input end is referred to as female. Though some may find this usage of language peculiar or uncomfortable, it nevertheless remains the terminology of choice among audio people.

Two types of audio inputs are in general use in filmmaking applications: microphone and line. Mic inputs, of course, accept the signal from the mic. A line signal is of higher voltage and is exchanged either internally or between two machines. All of the connections among recorders, mixers, and signal processors are line connections.

Mic and line connections are differentiated by the voltage level of their signal. Inputs are rated by their *impedance*, which refers to the designed resistance to voltage in the line. Low-impedance microphones and thus inputs are standard. Line inputs are generally high impedance. Mic and line connections are not interchangeable. You cannot plug a mic into a line input, or vice versa, unless you use an *impedance transformer*. These are usually available for circumstances in which gear

10-20

Most audio connectors and cords are based on a simple negative/positive connection.
© Cengage Learning

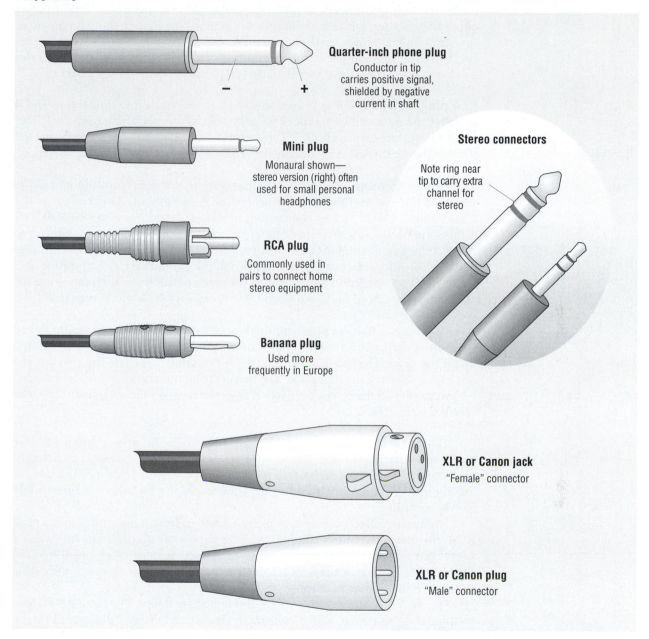

Quarter-inch phone plug
Conductor in tip carries positive signal, shielded by negative current in shaft

− +

Mini plug
Monaural shown—stereo version (right) often used for small personal headphones

Stereo connectors
Note ring near tip to carry extra channel for stereo

RCA plug
Commonly used in pairs to connect home stereo equipment

Banana plug
Used more frequently in Europe

XLR or Canon jack
"Female" connector

XLR or Canon plug
"Male" connector

does not have the output or input needed. In filmmaking applications, however, most inputs are used for the purpose for which they were designed. The only other signal impedance of interest is with speaker connections.

Quarter-inch or phone plug The durable and heavy **quarter-inch plug** receives extensive use as both a mic connection and a line connection. Professional headphones are also usually equipped with a quarter-inch plug, which is also called a *phone plug*. The input requires quite a bit of dedicated space in the interior of the record deck, a possible reason why phone plugs are not as popular as they might be in consumer equipment.

Mini plug A **mini plug** looks like a smaller version of the quarter-inch plug. It is generally used as a mic input on consumer cassette recorders and video cameras. Its major drawback is that it is not very durable, particularly on the input end, which is on the recorder or camera. The mini plug is also prone to being accidentally pulled out of the recorder. It is also a common headphone plug as well, though only occasionally found on professional equipment. A black ring on the shaft denotes a stereo configuration and multiple rings carry more signals. A second ring often indicates a video signal carrier; these are often used on portable DVD/Blu-ray players.

RCA plug The **RCA plug** is used almost exclusively as a line connection and is probably the most common type of plug. It is found on everything from consumer stereos to videocassette recorders. The center pin is the positive connection, and the sleeve is the negative connection. The sleeve also allows for a tight fit on the line input.

XLR or Canon plug The **XLR plug** has a three-pin configuration and is the standard mic connection on most professional equipment. Also known as the *Canon plug*, it is used for line connections in high-end studio gear as well. The XLR is the norm because the three-pin configuration incorporates a second conductor to connect the grounds and uses the shield to protect the signal from electronic interference. The hot contact carries the signal, and the ground carries its opposite. It is a very durable connection as well, with a click lock position that guarantees against accidental disconnection. The Tascam DR-100 employs these mic connections.

Banana plugs **Banana plugs** are used more frequently on European-produced equipment, particularly the Nagra. In a banana plug, the two leads are separated into individual plugs. The plug has a flexible sleeve that constricts when inserted into the line input, thus holding it in place. The banana configuration is one of the key connectors used with the Nagra, although it does not show up that frequently on other recording equipment.

There are a number of other specialized pins. *Tuchel pins* are used with the Nagra and often come with a threaded sleeve—a loose-fitting sleeve on the connector that screws into the body of the recorder. The *DIN pin* is a European connector found on older equipment, including the Uher recorder, which was used extensively in sync recording.

Adapters convert one type of plug to another, from a male mini to a female RCA, for instance. Anticipating all needs is always the goal, and having a good selection of adapters on hand can get you out of many tight situations. Bear in mind that as indispensable as adapters are, certain makeshift connections are unreliable and can become a potential trouble spot.

Stereo and monaural (mono) are also important issues. The separate-channel configuration of **stereo**, which consists of two separately recorded tracks on the same tape played back simultaneously, has become such a standard in home audio systems that the old single-signal mono has almost been forgotten by consumers. Until recently, recorders designed for films recorded in **mono** because all individual sounds are treated separately in editing and the final product is usually mono. Advanced theatrical sound systems and transfers to video have complicated this issue, but sound for film is still frequently recorded in mono. Given that so much audio equipment is set up for stereo, this can cause problems in matching equipment so that the signal is both transferred and monitored properly.

In line connections the stereo signal is handled by two separate conductors, particularly the familiar, paired stereo RCA cords. There are single cords designed to carry the stereo signal, particularly quarter-inch and mini headphone plugs. As with a mono connector, the tip carries one channel, and a band just below the tip of the connector shaft is the contact for the second channel. The stereo cable has a

separate conductor connected to this second contact. Stereo headphones plugged into a mono headphone jack will produce sound in only one ear. Adapters that convert the mono signal so that it can be heard on stereo headphones are handy to have when different pieces of equipment are being used.

Stereo recorders have seen increased use in professional production in recent years because there is a growing feeling that a stereo recording allows more options in editing. The mono system remains an adequate approach, although a wide release on video requires a stereo signal. If stereo separation is an issue, it is always part of the audio design in the final mixdown. Nagra produced both a stereo and a mono model, and many schools have the older, traditional mono machines.

Recorder Features and Accessories

Sound recorders come with a variety of features, all designed to aid the sound person in creating the highest-quality recording possible while on the set. Although these features aid in controlling and manipulating the technical quality of the audio signal, your ear should be the final arbiter of the sound. You can make everything look fine on the recorder's displays, but if the mic is too far away, the result will be inadequate sound. If it doesn't sound good to your ear, it won't sound good when you try to plug it into your film. The same is true of the ear as of the eye in lighting: just because it sounds good to the ear does not mean that you are getting the best recording possible. It has to be happening with both the ears and the displays. Being sensitive as well as attentive to the evaluative tools is one mark of a good sound person.

Mic inputs Professional recorders generally employ the XLR plug. Occasionally, you will find a professional deck with quarter-inch inputs. Stereo machines have separate mic inputs, with each mic signal being fed to its own individual track. The older mono Nagras also have two mic inputs, with the signal being mixed internally. Some recorders have switchable mic inputs that can change to other impedances or microphone-powering methods.

Line inputs and outputs Line connections are an important feature on any recorder. When recording subjects that are being amplified or that require multiple mics, such as a rock band or someone speaking at a meeting, it is preferable to patch into the sound system being used. This should give good, clean sound, avoiding the acoustic effects of the amplified signal.

Tape/direct Only a feature on professional analog recorders, this offers a choice of how to monitor the sound as it is being recorded. Recorders with separate record and playback heads have a **tape/direct switch** that allows you to toggle between monitoring the sound as it comes to the record head (direct, which is labeled *source* or *input* on some machines) or off the playback head (*tape*). When monitoring in the *tape* position, the sound is recorded at the record head, then played back next to it at the playback head. Because of this you will hear a slight delay between the actual live sound and the playback sound, which can be quite disconcerting for beginning mixers. But because there can be some difference between the microphone signal and the signal that is actually recorded, many mixers monitor in the *tape* position. They get accustomed to the delay and can feel confident in the quality of the final product. On a more mundane level, it also lets you know when you are out of tape. This is handy when you are on the move, working on documentaries, or in difficult locations.

Headphones Be sure to obtain a pair of headphones that gives a complete representation of sound and that isolates any confusing external noise. This means not getting consumer models. Do not hesitate to pay for a high-quality set. Few things

are more foolish than using a $15 pair of headphones to monitor the recording of critically important sound on a $10,000 recorder.

Use headphones for all film applications, whether recording key production sound or seemingly innocuous background effects. The internal speakers on most production recorders, including the Nagra, are not of sufficient quality to monitor sound, and you probably won't have the time to go back and listen to something you have just recorded anyway. Without headphones there is no effective way to detect minor flaws in the recording.

Two pairs of headphones are needed for the sound crew: one for the person recording and one for the person handling the mic. A simple Y adapter that splits the signal at the headphone jack is generally used, although you have to be careful that the signal fed to the headphones is not adversely affected.

Headphone volume controls and jacks Headphone volume controls and jacks are relatively straightforward parts of the recorder but warrant a few comments. While recording on a set, be careful not to overcrank the headphone volume. The sound can bleed through and disturb the recording, particularly if you are monitoring in the *tape* position with the delay. This extra sound may render location recordings unusable; even if the bleed-through is quiet enough that it is not recorded, it may be disconcerting to the talent. Set the volume to a level that is both comfortable for you and an accurate reflection of the sound, without being audible to other people on the set.

When organizing the equipment for a shoot, check to see if you need stereo or mono headphones. Mismatched headphones and recorders will leave you with sound in only one ear and may cause volume-level problems. Adapters are available to convert a mono output signal to stereo headphones, and having a few on hand is helpful if you need to plug into various pieces of equipment.

Automatic gain control The **automatic gain control** (**AGC**) reads the signal being fed to the record head and automatically adjusts the record level appropriately. On the Tascam DR-100, there is simply a button on the bottom of the face of the recorder that says AUTO. It is referred to as the *automatic level control (ALC)* on the Nagra or similar names on other recorders. As with all things automatic it generally gives disagreeable results although the digital world has improved on this largely consumer function. The drawback is that AGCs tend to over-respond to peak and low signals, with frequent wide and seemingly uncontrolled swings of the record level, particularly with complex sound. The result can have a mechanical sound to it. It is somewhat like automatic exposure on a camera; you want to control the record levels just as you want to control the exposure. As suggested, a number of high-end recorders have very sophisticated AGC features that anticipate these difficulties and minimize negative side effects. Even so, they are not used extensively. A good AGC feature can be useful in documentary situations, when you are working with a small crew and may have to leave the recorder unattended or cannot keep your eyes on the meter (a situation that generally should be avoided).

Limiters A **limiter** adjusts peak signals that are liable to be distorted. It is used while manually setting the record level and kicks in during the occasional peaks that you cannot anticipate or respond to adequately. It is something like a cap that will not allow the signal to be recorded above a certain level, usually 0 VU or 0 on the PPM. If used carelessly, it can lend the same mechanically manipulated quality to a recording as the AGC. When the levels are being carefully monitored, however, it can knock the top out of a signal that would otherwise be distorted.

Equalizers An **equalizer** is commonly used to manipulate the quality of sound, cutting or boosting it at specific frequencies. Equalizers are used either to clean

up sound that has unwanted elements or to add brightness or character to the production sound. Though the goal is to record perfect production sound, conditions often prevent this. Equalization can add dimension to the sound that was impossible to obtain in the location recordings, although there are limits to what can be done.

An equalizer consists of controls that either boost or cut the amplitude of frequencies at specific pitches. The equalizer divides the sound into *bands*, each of which centers on a specific frequency that is controlled by either a fader or a pot. **(SEE 10-21)** The unit portrayed in the figure equalizes the sound at 27 different frequencies. Just as with the spectrum of audible sound, equalizers are frequently broken down into octaves.

Though the faders control amplitude at a specific frequency, those on either side of the selected frequency are also affected. Equalizers with more bands offer finer discriminations in affecting individual sounds and are generally more useful in film as well as most other audio applications. The equalizer shown in figure 10-21 separates the audible spectrum into many increments. Each band thus controls a narrow range of frequencies, having a relatively small effect on adjacent frequencies. Equalizers that separate the sound into a small number of bands affect an often unacceptably wide range of adjacent frequencies at each band.

Equalization is an important tool in transferring production sound to mag stock and in the mixing stages of a film. Equalizers are occasionally brought on-location, but even then it is a good idea to save most signal processing for post-production. If you have an unwanted low-frequency sound—traffic rumble in the background, for instance—you could equalize certain low frequencies and limit or eliminate the sound. If there was an unavoidable high-pitched hum from fluorescent lights, you might be able to make it less objectionable by equalizing some high frequencies. These problems, however, can be partially or completely eliminated in the transfer and then further addressed at the mix if necessary. Conditions on the set are generally not optimal for effectively going back and monitoring all of the sound that has been recorded, and thus it is difficult to be consistent with how the sound is manipulated. In addition, like a DP's eyes, a sound person's ears can change over the course of a long day.

Slavishly attempting to create the desired audio effect in the original recording is one of the biggest mistakes a mixer can make. A certain amount of this is all right, but the mixer must first and foremost produce a usable recording. If you want someone to be speaking from the other side of a closed door, the sound should be recorded clean. If the sound is recorded through the door, it may not be intelligible

10-21

An equalizer divides sound into bands, each of which centers on a specific frequency.
© Cengage Learning 2014.

by the time it gets to the final sound track. As suggested at the beginning of this chapter, if the recorded sound is good, you can go almost anywhere with it, making extensive adjustments in the mixing process. But if the recorded sound is poor, the ability to manipulate it will be severely limited.

Unaltered sound can be disconcerting for uninitiated viewers of the dailies and rough cuts, so sound mixers occasionally find themselves recording sound "for the dailies." This approach reflects an understandable fear of those unfamiliar with the process, often clients or potential funders. A friend tells the story of being called on the carpet by an inexperienced producer and client "to explain himself" for a clean recording of a sound that would be manipulated later. When he launched into a lengthy technical explanation, he was cut off and told to do better next time. Most people on an experienced production team do, however, understand the technical requirements of sound.

Filters The term *filter* has several connotations. The controls on equalizers are often referred to as filters, although they are used primarily for controlling the amplitude at desired frequencies. When spoken of outside of this usage, **filters** are the options on the audio recorder that affect a wide range of frequencies above or below a certain point. Recorders often come with a few filtering options. The following are common choices, each cutting out a certain range of frequencies. Where exactly they start cutting the signal is dependent on how the individual filter is set by the manufacturer.

- **High-pass filters** filter out low frequencies, allowing high frequencies to pass through to the tape.

- **Low-pass filters** do the opposite, allowing low frequencies to pass while cutting high frequencies.

- **Low-frequency attenuators (LFAs)** cut low-frequency signals, *attenuation* being a common technical term for cutting.

- **High-frequency attenuators (HFAs)** cut the sound above a preset level.

Most location sound mixers do not do much filtering while recording sync takes. Filters affect quite a bit of the audio signal, changing the character of a wide range of sounds. They tend to be coarse controls, used as broad remedies for big consistent problems in the sound, such as traffic, fans, heating systems, and the like, that cannot be addressed by other means. If, however, you can get to the source of the sound and shut it off, that is far preferable to filtering.

Running speeds Are only an issue with analog recorders, which give a number of options for running speed, measured in **inches per second (ips)**. A typical professional quarter-inch recorder might offer speeds of 3¾, 7½, and 15 ips. Cassette players run at 1⅞ ips, with many professional decks offering a higher speed as an option. Higher running speeds produce higher-quality sound. The major reason for this is that a higher speed devotes more magnetic material to the sound per second. Another major consideration is consistent speed and stable transport across the head. Slower recording speeds are harder to keep constant; the tape tends to wobble on the heads, causing "wow" and "flutter."

Most analog recording is done at 7½ ips for dialogue scenes. The 15 ips speed runs through tape at high rates, but the extra speed does not translate to significantly higher-quality sound in terms of the human voice. The difference, however, between 7½ and 3¾ is substantial, so the slower speed is rarely used. For the most part, the slow speed is present on professional recorders to facilitate disposable recordings that are not film related—recordings of meetings and similar events that may not even be saved much less used in a final product. Music is usually recorded at 15 ips as the reproduction of extended tones and notes requires the highest

quality possible. Sound effects are usually recorded at 7½ ips, although they are often the least needy in terms of perfect reproduction.

To a certain extent, the acquisition format is somewhat irrelevant. The critical factor is obtaining a recording that both fulfills technical specifications and is free of unwanted additional sound. Beyond these two considerations, the most critical arbiters are your ears. Does it sound good and does it sound like something we want on a sound track?

The Production Sound Crew

The sound crew has one of the more frustrating jobs on a film set because sound is rarely afforded the attention that camera and lighting receive. Because so many fellow crewmembers are devoted to the picture—camera crew, gaffer and grip crews, design people, makeup, script supervisor, and so on—the sound crew can feel substantially outnumbered and overwhelmed by the picture people. A saying in the business—*An hour for picture, a minute for sound*—is often an accurate assessment of the weight given each endeavor in shooting a film. Because of this attitude, the sound crew may occasionally have to assert the importance of its endeavors in the general scheme of things.

Although this lack of acknowledgment can be exasperating for the sound crew, there is a certain amount of justification for it. If the sound recorded on-location is not good, there are a number of viable remedies. If you do not get the picture, however, you have nothing. As suggested, location dialogue recording is often done with the knowledge that it will be replaced. Most sound effects are also done in postproduction. Despite all of this, everything should be done to get high-quality location sound, particularly for filmmakers with small budgets. When working with limited resources, dealing with inadequate sound can be an expensive, messy, and time-consuming process. Whenever you find yourself saying, "I can get that sound later," it will usually prove easier to get it right then and there.

The sound crew is usually asked to do its job without disrupting the set. As shots are set up, the sound crew cannot expect the lighting crew to arrange the instruments in a way that facilitates sound work, nor should it. If lighting, usually from above, makes it virtually impossible to use a microphone boom, the sound crew may have to try a different approach to miking. All this does not mean, however, that the sound crew should not be assertive when elements are conspiring to make recording high-quality sound next to impossible. There is a certain "deal with it" attitude on the part of many picture people that occasionally requires some forceful behavior modification.

The sound crew is generally composed of two people: the previously mentioned sound mixer and the boom operator. On larger commercial productions, the sound crew may have the luxury of a third person, who is generally listed in the credits as a cable puller. The **cable puller** helps with setup, keeps the mic cords out of the way during the shot, and often takes care of the **sound log**—the log of the daily activity of the sound crew.

The *sound mixer* has four primary responsibilities: determining microphone positions for the best sound reproduction, addressing any excess noise that is interfering, determining how best to work with the acoustics of the shooting space, and monitoring the audio levels for optimal recording.

At the direction of the sound mixer, the **boom operator** generally handholds the mic on a boom above the heads of the talent. If characters are moving or if more than one person is being recorded, the boom operator may have to incorporate substantial mic movement during a shot. As one might suspect, booming can be physically demanding, requiring stamina and good upper-body strength. The physical stress is somewhat mitigated by the boom's needing to be in position only for the

generally short duration of the individual takes. The mic cord should be cradled gently in the hands, making sure that cable noise does not become a problem.

It is the sound mixer's responsibility to formulate a miking strategy for each shot. The three keys to successful miking are the same as those to establishing a successful restaurant: location, location, location. Get the microphone as close to the subject as possible. Given the complexity of many shots, this can be quite tricky. If the subject is too far from the mic, the mixer has to crank the record level; and when the mixer has to crank the volume, the acoustics of the space and unwanted extraneous noise become stronger elements. The closer the mic is, the more the recording can be focused on the subject.

The assistant director lets the mixer know what the next shot is going to be and what setups are being considered for the near future. As the scene is being blocked for the camera, the mixer should determine where the boom operator can stand and what mic movement will be needed. An experienced boom operator will have worthwhile input into this planning. Essentially, the mixer observes the entire shot and designs the miking so that the subject is always optimally recorded.

The boom operator needs to be aware of two problems of which he or she may be the source: casting boom shadows on the scene and allowing the boom to drop into the frame. The sound crew should handle as much of this as possible, but these concerns frequently require consultation with the camera crew.

Boom shadows in a shot are unacceptable, and their presence demands that alternative miking positions be found. In conjunction with the mixer, the boom operator should pay attention to the lighting of a scene to find the "path of least resistance" to the subject—that is, where the boom can be positioned without casting shadows. Frequently, the boom operator's best path is to come in from around the fill light. This keeps the mic out of the path of the key light, staying near the softest and most diffuse light. (The types of lighting instruments and their uses are discussed in chapter 12.)

The boom will always cast some shadows, and it is the camera operator who will identify which ones are in the shot and which ones fall harmlessly outside of the frame. But be aware that many elements in the frame demand the camera operator's attention; subtle shadows may be missed. If concerned about a shadow, the boom operator should tell the camera operator, who will check the shot or do an entire **walk-through**, an initial rehearsal in which the technical personnel and the actors walk slowly through a shot to identify potential problems, in this case looking specifically for errant boom shadows.

Boom mics dropping into the frame were a staple on old late-night talk shows but are unacceptable in film applications. With the goal being to get the mic as close to the subject as possible, the boom operator must know exactly where the top of the frame is and have the mic hover just above it. Knowing some basic compositional principles helps in this regard. Individual DPs generally have consistent approaches to headroom. If you know what that approach is, you should be able to determine boom position without too much consultation. Inexperienced boom operators may be tempted to hold the boom so high that it could not possibly be in the shot. This mistake amplifies room ambience and compromises the quality of the sound. Simply find out what the limits of the frame are and stay just outside of them. In my booming days, I became so familiar with one DP's shooting style that we rarely spoke to each other on the set except to determine where to go to relax after the shoot.

In the final analysis, it is the camera operator's responsibility to identify both boom shadows and encroaching mics in the shot. It is the boom operator's responsibility to eliminate them. Both concerns are complicated by the shifting frame and the necessity to follow moving subjects with the boom. The shot has to be checked from beginning to end to ascertain that the boom is not presenting a problem anywhere. The camera crew will of course expect minimal interference from the

boom operator, but to achieve sound of the highest possible quality, the sound crew should be assertive if the need arises.

Recording Strategies

While this is not as crucial in digital recording as it was in analog recording, shifting the volume level during each recorded take to respond to changing levels of sound is known as **riding gain**. In digital, the wiggle room in underrecording may make avoiding ambience shifts a more important consideration. If audio fluctuations are extreme, however, some adjustment will be necessary. Most modern digital recorders are not as well set up for this eventuality as older analog machines but some accommodation may be necessary. Either way, volume levels have to be set and monitored for each individual take. Whether the sound is an actor's voice or a special effect, its volume within a shot and the position of the mic will most likely change between different setups. The sound mixer must constantly monitor the input level bars to keep them as close to the appropriate record level as possible. The mixer's attention should be completely devoted to the meter during takes. If you can see a mixer's eyes during rehearsals or takes, he or she may not be doing the job properly. Adjusting the pot to obtain an optimal recording at all times is central.

Just as there are rehearsals for the actors and the camera, recording of the sound needs practice as well. After getting a description of the shot from the AD, the mixer uses the first walk-throughs to ascertain what is occurring in the sound. In conjunction with the mixer, the boom operator develops a plan for booming the scene and then must be ready for the rehearsals. If other mics are needed, setup must be swift and unobtrusive. Just as the mixer has a plan for miking each setup, he or she must formulate a strategy for recording as well. By the time shooting starts, the mixer should have any adjustments finalized and be able to anticipate all fluctuations in amplitude. Obviously, there can be differences in individual performances by the talent, but the mixer should be able to keep the bars within accepted tolerances.

Most volume adjustments require only small if any movements of input level, but occasionally a more dramatic response is needed. I was once recording an actor who whispered a line and then broke into a loud laugh. Even though I could get quite close with the mic, I had to turn the pot up almost all the way to obtain a usable recording of the whisper. When the loud laugh came, I had to turn the pot almost 180 degrees to get an undistorted signal. After several rehearsals I had a sense of the actor's timing and was able to shift the pot at the right moment. The boom operator helped me by moving the mic slightly away from the actor just before the laugh came, although this response to a louder sound may not always be the best one.

The approach to riding gain is very similar to that of anticipatory camera except that the boundaries are less distinct. There is no frame line to watch through the viewfinder; the representations of the bars are the only guide—one that can start to feel quite abstract even though it represents something very real. Just as the camera leads subject movement, the recording of the audio should lead the fluctuating levels of sound. As with many elements, proper audio recording goes largely unnoticed; the listener recognizes that the sound recording has not been done properly only when there is a glaring error or something is unintelligible.

Keep in mind that the goal is always an optimal recording. Fear of distortion, again, often causes beginning mixers to mistakenly underrecord. Although the bars and the meters give an accurate depiction of the technical quality of the signal, your ear should be the final judge. If it does not sound good on-location, it will not sound good when the editor starts trying to incorporate it into the film. The biggest challenge in recording sync sound is the issue that has complicated so much of the task:

continuity. Producing a clean, well-recorded signal clearly serves the requirements of continuity, and a "dirty" signal causes problems. Beyond that, if mic positions are wildly different or record levels fluctuate, consistency will suffer and production sound may prove uncuttable. Most "smoothing" of ambience differences happens in postproduction, but creating reasonably even tracks makes the process easier.

Recording a Scene

As with everything else in film and video production, creating usable sound for a scene takes careful preparation and a measured and thoughtful approach. Many things complicate what appears to be, but of course isn't, a simple task.

Complicating Factors

Effective recording of a scene requires an understanding of how all of the individual elements of sound are going to interlock. With the exception of perspective and phasing, the following discussion outlines problems associated specifically with location filming. The controlled atmosphere of studio shooting eliminates many of these potential headaches.

Ambience The sound crew is concerned with ambience in two different ways. The mixer generally wants to exclude as much ambience as possible in the original recording. The less ambience present in a take, the less likely it is to interfere with consistency. Ambience can always be added, but it is problematic to take out. The second concern is that even though you have attempted to eliminate as much ambience as possible, the editors need some recorded ambient sound to cover silent or empty spots in the sound track. As suggested, every place in which you shoot will have its own distinct sound characteristics. Just as darkness is not the absence of light, silence is not a total absence of sound. Any gaps in the dialogue tracks—and there will always be some—must therefore be covered by recorded silence matching the ambience level that is under the dialogue. In addition, this ambience can be used to lay under dialogue in takes where, for whatever reason, the level of ambience is lower than in other shots. Variously called **presence** or *room tone*, several minutes of uninterrupted silence should be recorded by the sound mixer in each location.

Background noise Of even greater concern is background noise, which often causes substantial problems with the consistency of sound in editing. Problematic background interference is relatively common on-location and must be found and eliminated. Sometimes this simply requires locating the source and shutting it off. Other problems may cause lengthy delays while the source gets out of hearing range. Some unsolvable problems may force replacement of the dialogue during postproduction.

Air-conditioning and heating systems frequently cause problems, as do fluorescent lights, which make a highly undesirable hum—another reason to avoid shooting under them. Shooting in a restaurant or a kitchen necessitates turning off refrigerators and other noisy appliances. Noisy neighbors may need to be quieted, and the guy mowing his lawn down the street may need some incentive to postpone the job.

More permanent problems can impose even greater demands. Shooting near heavy traffic areas or airport approaches can ruin sound takes and cause lengthy delays. As a sound such as that from an airplane recedes, the mixer lets the crew know that the sound has diminished enough to try a take. Given the odd path that reflected sound can often take, however, this can be a risky proposition. Such

circumstances can turn four-hour shoots into eight-hour nightmares. As suggested, postdubbing the sound may be a foregone conclusion when working in completely untenable locations.

Camera noise Camera noise can also be problematic, particularly when working with older cameras. The new generation of sync cameras, such as the Aaton and the Arri SR, generally do not pose a problem, although in the pin-drop quiet of a set even they can be picked up on a sensitive microphone. **Camera noise** can be muted with a **barney**, a padded slip-on hood designed for a specific camera. In the absence of a barney, sound can be reduced by *blimping* the camera—wrapping it with a heavy jacket or other noise-deadening material. Unfortunately, the camera lens tends to act like a megaphone for camera noise, shooting it right out in front of the camera which, as luck would have it, just happens to be right where the subject you are recording is. Although my suggestion of putting a sock over the lens has always fallen on deaf ears, the glass filters used to protect the front element of the lens can help with sound problems as well.

If the camera is noisy, its sound must be recorded as part of the space's ambience. Recording room tone without the camera noise is pointless if camera noise is contributing significantly to the sound in a space. And it must be recorded with the camera loaded because a camera running empty does not sound the same; bringing dummy loads in anticipation of camera noise is not unheard of. Barring this, recording sound during shots that do not require sync sound can be a good source of this recorded ambience. The editor can then make the offending source consistent rather than having it irritatingly drop in and out.

Wind noise Wind noise is a different type of unwanted sound that is frequently problematic. Wind is similar to sound in that it is moving molecules in the air. If not taken into account, **wind noise** can play havoc with microphones, causing such a strong signal to be fed to the recorder that distortion is unavoidable. A **wind zeppelin**, also called a *wind shield*, has a baffle design that cuts much of the interference from wind. **(SEE 10-22)** Many zeppelins have an additional *windsock* that fits around the exterior for high-wind situations.

Moving air in interiors can be an issue as well, mostly through air-passage systems associated with heating or air conditioning. Using a zeppelin or a simple slip-on foam wind shield to protect against moving air is common. Be particularly careful of wind noise in spontaneous shooting situations—documentary shoots, for instance—where you cannot monitor the recorder's meter. In the *direct* position, the distortion caused by wind noise will often go unheard although it does show on the meter. When wind is an issue, be sure to monitor in the *tape* position, hearing the actual signal that has been recorded.

Acoustics As stated earlier, *acoustics* refers to the way sound travels in a given space and how it reflects off surfaces before arriving at the microphone or the ear. **(SEE 10-23)** Dealing with acoustics is one of the greatest challenges to the sound crew. Spaces are frequently referred to as being either "live" or "dead." A *live space* has many hard surfaces off of which the sound bounces. The sound thus comes to the microphone at different rates and from many different directions. Although the sounds reaching the mic are only milliseconds apart, this accounts for sound that has a boomy, echo-like character. Gymnasiums and museums are classic examples of

10-22

A wind zeppelin, or wind shield, has a baffle design that cuts much of the interference from wind.
Rycote™ wind zeppelin / © Photo courtesy of Bruce Mamer.

Working with acoustics is one of the greatest challenges to the sound crew.
© Cengage Learning

live spaces, as are bathrooms and tiled kitchens. Dead spaces usually have many absorbent surfaces, such as plush couches, draperies, and, particularly, carpeting. This substantially reduces the reflected sound arriving at the microphone.

In most instances, the mixer wants the space to be relatively dead. As with ambience, some liveness can always be put back into a recording but it cannot be effectively taken out. To this end acoustic characteristics can be altered. The sound mixer hangs sound blankets or other acoustic material to deaden live spaces. Hang them on stands and put up as many as possible; if you have only a few, putting them directly in front of the speaker is the most effective position. Hardwood floors are notoriously difficult surfaces. If the floor is not in camera view, laying down blankets or spare carpeting can be effective. Miking as tightly as possible is also important. The resultant lower record level will lessen the recording of the lower-amplitude reflected sound.

Sound perspective The way we expect to experience sound at specific proxemic positions is known as **sound perspective**. In a close-up, the viewer expects to be very near to the sound. When a character is in a long shot, the expectation is that the voice will sound more distant and the ambient sound of the location will be a more significant factor. The voice of an actor speaking from the other side of a door will have a specific character.

The key is to remember that the sound should always be recorded cleanly, whatever the perspective characteristics desired for the final product. Excessive distance from the mic may produce an unusable recording. Having some perspective in a recording, however, is unavoidable and is not necessarily negative. Long shots often have more headroom than close-ups; and, barring using wireless mics, getting a mic the same distance away as the close-ups may not be possible. Just plan to get the mic as close as you can, and slight differences in perspective will probably be acceptable.

Phasing The complex phenomenon in which specific frequencies are canceled out and thus not recorded is known as **phasing**. It can affect sound waves before they strike the microphone; or, when more than one mic is used, it can affect the electrical signal as it passes through the recorder's circuitry. In the first case, when a sound wave is met by a wave of the opposite shape, they balance out movement in the air pressure, thus negating each other. This kind of phasing, from the source

to the microphone, is uncommon in most film recording and is difficult to control anyway. The second case, phasing in the electrical signal, occurs when signals from separate microphones meet in the recorder's circuitry and cancel each other out. This is dependent on how mics are positioned in relation to each other. Though controlling phasing can be a sophisticated science, trying the mics in different positions is a solution whenever a problem is heard.

Phasing is one reason why mixers try to use a single microphone whenever possible. Using two mics with similar pickup patterns, particularly the shotguns, can create some of the most baffling phasing effects. Phasing is not always a bad thing: highly skilled sound technicians can position microphones to set certain frequencies, such as those associated with ambient traffic sounds, "out of phase." For the beginner, however, phasing is generally a negative factor, eliminating important frequencies that can dramatically alter the character of the sound. With the goal being consistency, anything that changes the character of the sound poses a problem.

Any one of these concerns can cause major headaches when trying to produce usable production sound, so potential problems must be addressed before effective recording can occur. The need to cope with unwanted sound is the common thread. As the film is being edited, the presence of unwanted sound in itself is not so much the problem; rather, it is the inconsistency of that sound. The variety of different mic positions and record levels employed will mean that ambience, background noise, and camera noise will sound different from one setup to the next. Listeners may accept some background noise, but when its amplitude and character jump at every cut, it becomes very unnatural and noticeable. Many of these problems can be covered by music or some other consistent effect, but when music or effects are employed to cover things rather than to follow some internal logic in the script, they can be a distraction as well.

Location Recording

Like the crews of other departments, the sound crew must be prepared for all eventualities. Although not always afforded the luxury of doing so, the mixer can evaluate a location and plan out an approach that will ensure optimal sound. If this preparation is possible, the mixer should be able to deal with acoustical problems, quickly identify and eliminate unwanted sound, and determine a strategy for miking the scene. And though there are as many miking strategies as there are setups, a few common approaches should give direction.

Again, the primary goal in sync-sound location recording for motion pictures is to get the microphone in the optimal position for recording the source. In practice this goal presents many complications and obstacles. The more complicated the shot, the more difficult the boom operator's job is. As suggested earlier, the sound crew will mike each setup with a single mic on a boom whenever possible. Avoiding phasing is a major reason for this strategy, but a single high-quality mic simply produces a cleaner, less complicated signal. The mixer will try to employ just one mic for entire scenes as well. Using mics from different manufacturers or with different pickup patterns to record different setups in the same scene can cause consistency problems. If another mic needs to be incorporated, it is generally done with the first mic kept slightly open to give the sound the same character as the rest of the scene.

Booming from above is preferred. It gives the cleanest, most natural sound and, with the mic pointed down, excludes excessive noise from the background of the shot. Booming from below is an alternative when lighting or location interference necessitate it, but this position usually amplifies bass frequencies. **Plant mics**, which are camouflaged or "planted" in the shot, can be useful; wireless mics are also employed.

Barring difficulties with unwanted sound, booming and recording a single, stationary subject is relatively simple. Just as the camera operator needs to adjust for body position, the boom operator must be prepared for the minor movements

10-24

Pivoting a single mic back and forth between two characters is usually the best approach.
© Cengage Learning

conducive to a fluid performance. The boom should be held above the talent's head, and the mic brought in as close to the mouth as possible. To avoid clicking and swallowing sounds, the mic should be pointed several inches in front of the talent's mouth rather than straight on. Sound flows out of the mouth, and the mixer should receive a good strong signal no matter how loud the talent's delivery.

When movements or multiple characters are introduced, the challenge increases. If characters are close to each other, pivoting and gently swinging the mic back and forth between them for each line of dialogue is usually the best approach. **(SEE 10-24)** To facilitate movement, the mic is cradled in a **shock mount**, a suspension system that absorbs any moderate shaking of or shocks to the boom. Even with a shock mount, move the mic gently to reduce excessive rattling of the mic and thus the likelihood of producing unacceptable sound.

Be careful of wind-like noises as well. If the mic has to be swung so fast that it creates noise, a different miking arrangement should be tried. A wind shield may help with quick movements, but there are limits to how fast you can go. The mic cable must be gripped so it does not rattle against the boom, but neither should it be tightly stretched across the boom. It should be loosely wrapped around the boom, but not so loose that it flaps around.

When characters are separated by some distance—which, oddly enough, does not occur that frequently—it may be necessary to mike them separately. Using shotgun mics together is generally a mistake (due to phasing), so two booms would not be employed. Putting one character on the boom and the other on a plant mic is one viable solution. Hide the plant mic where it can pick up the needed dialogue. A **boundary layer microphone (BLM)** is a small, flat mic that can be set on a piece of furniture or taped to the wall or ceiling. Although BLMs are quite expensive, they are expressly designed for this purpose. High-end versions have interchangeable mic heads that control the shape and the direction of the pickup pattern. In lieu of a BLM, a simple lavalier planted at a specific location on the set can accomplish roughly the same thing.

Subject movement requires the boom to follow or, more accurately, lead the subject through a space. **(SEE 10-25)** Just as with anticipatory camera, boom operators use the rehearsals to monitor subject movement and find a way to always have the mic in front of the performer(s). Except for minor adjustments, as a boom operator you should never react to anything that happens; you should always lead the movement. You may be able to mike small movements from a single position by simply

extending your arms. Larger movements require that you move along with the situation.

When a character moves from one position to another, you have to lead the subject from the first point to the next. This is easiest when you can incorporate a swing of the boom with your own small movement. To maintain the correct mic position, you must keep your eyes on the performers as the shots are being executed. Given the "grip jungles" that are often created, planning your footing so you don't trip or run into things is a necessity. In walk-throughs, as a boom operator you must quickly determine where you are going and how to get there. If the movement is broader—for instance, characters moving in front of a dollying camera—you will have to walk backward or sideways when leading. **(SEE 10-26)**

Cabling can be tricky on these kinds of shots: the slack created during the move can trip you. A cable puller is in charge of coiling the cable as the shot is being executed, making sure that no one gets fouled up in the excess. On small crews, the mixer may have to pull the cable with one hand while riding gain with the other.

Despite the need for some fancy footwork, these movements are still relatively straightforward. Talent movement, however, can occasionally put the actor in a position where effective booming is impossible. One scene I mixed began with a character saying several lines of dialogue in a standard medium shot. He then turned away and started shouting while pounding his fists on a table, venting his anger. The table was up against a window, and the shouted lines were delivered directly into the tabletop, making booming impossible. My solution was to hide a lav on the windowsill, positioning it so it was pointing directly at the actor's mouth. The boom handled

10-25

Subject movement requires the boom to lead the subject through a space.
© Cengage Learning

the first lines, and the lav, with the pot turned very low, handled the shouting. In a situation like this, the pot for the boom is turned down as the pot for the lav is brought up. In this particular case, the boom mic was left partially open to maintain a consistent quality in the ambience.

Another similar example was a scene I boomed that took place in a hospital room, involving a woman talking to her ailing husband. **(SEE 10-27)** To portray the tension, the actor playing the wife wanted to have full freedom to pace around the set. The director wanted to shoot the entire three-minute scene in master (an irritating quirk of first-time directors that places heavy physical demands on the boom operator). The whole scene could be boomed with some movement on my part, except for a brief segment in which the actor nervously fiddled with a plant as she spoke. With the woman's back to the mic and her face virtually buried in the plant, the boom was unable to pick up her dialogue. We ran a lav under a window curtain and pushed it right up the middle of the plant. The actor was told not to be too rough with the plant, and her lines were picked up perfectly.

These are just a couple of representative examples. Many setups are easy to boom; others will test your skills. Recording and miking are about anticipation and problem solving. The sound mixer has to determine the best way to mike a scene and then practice the best way to record it. The mixer is generally not as vocal as

10-26

For broad movements, such as characters moving in front of a dollying camera, the boom operator has to walk backward or sideways when leading.
© Cengage Learning

10-27

In cases of complicated movement, a subject may need multiple mic setups.
© Cengage Learning

the DP but will on occasion have to speak up. If, for instance, the latch sound from a door closing is interfering with a line, be sure the door is muffled in some way. If the door's hinges are squeaking, have them oiled. If an actor's shoes are making too much noise on a hard floor, have the shoes removed or lay down a blanket. Anything causing a problem with the sound must be addressed.

Automated Dialogue Replacement

Once referred to as *looping*, **automated dialogue replacement (ADR)** is a method of creating and replacing dialogue in postproduction. This is done when recording high-quality production sound is not possible, when a better reading is desired from the actor, or when script deficiencies can be cured by a choicely added line. The shot or shots that need this treatment are cut (digitally these days) into a loop with a set of visual cues. The actor sits in a soundproof booth, with the loop projected on a screen. The actor has a set of headphones that play back the original sound preceded by three short tones that correspond to the visual cues. With these cues, the actor can anticipate the visual and time the reading of the lines to the film. The actor does as many readings of the line as the director of the session feels are necessary. Each reading is dropped onto a synced tape, and the editor can later choose the desired take.

If ADR is not feasible, the sound mixer should have the talent to read the dialogue in a quiet place. The director may want to be present to ensure that the delivery conforms to expectations. The editor will later position this new sound against the appropriate visuals. Although this is the hard way to approach it, a talented editor can generally make it work.

Whether using ADR or the latter method, recording the previously mentioned **scratch track**—a conventional sync track that serves as a guide in editing—should be done on-location. This means that the mixer records normally, even though the result will not be used in the final film. It is recorded to serve as a guide for the actor in postdubbing or for the editor, who positions specific words and effects against the picture.

A number of years ago, I worked on a film in which a lovely spontaneous shot happened during a lull in shooting. In the film's story, a young boy was stranded on a broken Ferris wheel. As we were in one of the often unavoidable delays, the AC asked the boy if he knew any songs, and he launched into the Beach Boys standard "Help Me, Rhonda." The boy was much too far from my mic to get any usable sound, but I recorded it anyway, knowing it would be useful. I later took the boy aside and had him sing the song into the microphone. The editor was able to use the scratch track as a guide to matching the words recorded later to the visuals recorded on-location.

All this said, it is important to get high-quality production sound, particularly when working on independent or student projects. Replacing dialogue is expensive and can be difficult for novice talent. The experience of being in an ADR booth can be somewhat akin to spending a day in a sensory deprivation tank. There is no input except seeing and hearing the same lines repeated over and over. When the actor starts having out-of-body experiences à la *Altered States*, you know that that is all you are going to get done that day. Recording usable production sound at the outset reduces costs and hassles in the editorial process.

Sound Effects

Although **sound effects (SFX)** often go virtually unnoticed by the viewer, most films would seem lacking without them. Their frequency and employment is, of course, up to the postproduction team. Some situations require sparse, minimal sound, whereas others demand highly dense and layered sound. Hampered by limited time

and experience in editing rooms, sound-effect studios, and mixing houses, student and independent films often have sound that is thin, particularly when compared with the dominant trend of lush sound tracks in commercial feature films. Of course individual films call for different approaches, but creating sound that is full and logical is usually the goal.

On-location, mics are usually positioned to record dialogue, often leaving sync effects, such as doors opening, footsteps, and so on, dull or indifferently recorded. Recording quality aside, the real sound of things is often not as vital and dynamic as one might at first assume, so there is need for some dramatic heightening in postproduction. Replacing effects recorded on-location is common, and going into the sound studio to improve something is almost the norm. In addition, virtually all off-screen effects—those that are not generated by some action in the shot—are recorded later and positioned by the editor in the appropriate place against the visuals.

Recording Effects On-location

On large commercial projects, the producers may be planning a sophisticated sound-effect campaign, and the need for the mixer to consider sound effects on-location may be limited. On smaller films, on the other hand, it is sensible to get the effects then and there, when all of the elements needed to produce the sound are assembled. Planning to record effects later and using sounds from an effects library are perfectly good approaches if the resources and the personnel to do the work are available. But when resources are limited, creating sound in postproduction can be difficult. In addition, acquiring sounds from effects libraries can require extensive searching, and, once found, the sounds often lack authenticity.

The sound mixer should be familiar enough with the script to anticipate needed effects and, as shooting proceeds, should make a list of everything required. The sound crew is rarely afforded the luxury of stopping the whole production to collect sound. Some effects can be recorded during a lull in the shooting, just after a shot as the camera crew is checking the gate, or after the day's shooting has wrapped. I once worked on a film that was set in the 1840s, with shooting plagued by the sounds of a nearby modern urban center. All kinds of effects, from ax chops to footsteps in the forest, were on my list. We simply set our alarms for three in the morning and went out and got all we needed while the city slept. To go back later and re-create these effects would have meant the investment of substantial time as well as creating the potential for delays in the editing process.

Foley

The **Foley** room is similar to the ADR room but with more space for the active process of creating effects. The activities of the Foley room surely resemble those of crews for the old radio programs, a variety of voice artists and sound-effect people banging garbage can lids and running in place. The Foley room has numerous materials and objects for creating different sounds, from creaking doors to breaking glass to squeaking chairs. It is also outfitted with a variety of surfaces on which to re-create footsteps, such as on carpeting, gravel, tile, and so on. The Foley artists watch the projected picture and create an appropriate effect at the precise moment. What they produce is recorded on a synced tape that is easily dropped into the film. They also have access to a variety of prerecorded effects, which can be tested against the projected picture.

Although commercial films may achieve effects through Foley, many filmmakers simply go out and create the needed effects. In the absence of a soundproof booth, it may be hard to find a quiet place to do the effects. Again, it is not a bad approach to record effects at three in the morning in an acoustically appropriate

space when passing traffic is limited. It is amazing what tasty effects you can whip up in your kitchen late at night.

The sound-effect campaign in independent and student films is often neglected and left for last. In many situations someone, often the editor or an assistant, goes out with a recorder and tries to drum up a few quick effects. It is no surprise that these effects are often inadequate. Get someone who understands the requirements involved in successfully creating and competently recording sound effects. If you are in a city with an active professional filmmaking community, you may find a Foley artist who will cut you a deal. The services of a competent professional could mean the difference between effects that sound bland and fake and effects that add flavor and character to your film. Just like the backgrounds of shots, this underlayer of sound often constitutes the difference between a one-note, single-dimension film and a rich and complex work.

Import/Sound Transfers

Importing audio into NLEs is generally simple, although occasionally can be a modestly tricky affair, depending on your source, software, and computer configuration. Material recorded on a card or hard-drive recorder is the simplest to transfer. The card is removed, again the recorder should be powered down, or the recorder and the computer are connected. Files are easily shared—the files can be transferred onto a computer hard drive and then imported into an NLE. With the Tascam DR-100, as with virtually all cards, an icon appears on the desktop and on your hard drive window. **(SEE 10-28)** Double-click on the icon and the folders on the SD card will appear. Follow the path to your media. This particular Tascam machine's formatted card will display your WAV files with a music icon. **(SEE 10-29)** Despite suggesting it is a music file, it will be brought in as any other compatible file. In FCP the menu sequence is *File> Import> Files.* **(SEE 10-30)** The sound clips will be represented by the speaker icon. If erasing files from your card, it is again recommended to leave the last audio clip on the card so the numbering system starts from there. On larger projects, to have duplicate numbers can be nightmare-inducing. Organization and backup/archiving are every bit as important with your audio files as with video ones. The loss of anything can be disastrous.

Although it may sound like a lot of steps, transfer to a thumb drive or burning to CD is a common way of moving audio around as well as storing it. If any of the original recordings were done on an analog machine, like those on the Nagra, that analog signal must be digitized on its way into the computer, again requiring software and/or hardware solutions. When you have analog material or incompatible file types is when life gets complicated.

Sound for Film

In a conventional film edit, sound is transferred to the magnetic stock. Recording to mag stock is a specialized process that can be done only with the appropriate equipment. This transfer is usually made at a professional facility although tracking one down may be moderately tricky in smaller markets. The mag stock recorder is set up like the camera, with a set of sprocketed rollers that feeds the mag stock across the record head—resembling the arrangement of a camera minus the pull-down claw. **(SEE 10-31)**

An audio signal from any source can be transferred to the mag stock. Flash card, cassette, quarter-inch, CD, and even those funny round things with the hole in the middle are common source media, although any equipment with an audio line output, from a video deck to a synthesizer, could be used. First record any original narration, effects, or music digitally or onto audiotape, rather than straight onto the

10-31

The mag stock recorder is set up like a camera, with a set of sprocketed rollers feeding the mag stock across the record head.

Moviola/MagnaSync mag stock recorder / © Cengage Learning.

mag stock. All sounds are transferred separately to magnetic stock, with no premixing or layering. Transferring everything except the clearly unusable recorded sound is standard procedure. This leaves the selection of individual sounds to the editor. Although it means transferring quite a bit of material, the selection process is done only once rather than twice and by the most qualified personnel.

Again, the transfer is often a good time to do some initial manipulation of the sound. Equalization may reduce or eliminate some significant problems. The goal is to eliminate as much as you can here, with the final mixdown being another place to address problems. Though unwanted sound should be addressed on-location, the transfer houses and mixing personnel can do some amazing things. The noise created by a huge generator at a carnival once caused me major headaches. I recorded the generator by itself for a minute, and from this the transfer house was able to isolate the frequencies and eliminate most of the noise. Transfer house personnel must be alerted to problems in the production sound. This is done on a sound report and by clearly marking the tape's packaging.

There are, of course, limits to manipulating recordings. Sound people occasionally get into the bad habit of depending on postproduction equalization to eliminate blemishes that may be addressable during recording. If the offending sound is too loud or covers too wide a frequency range, equalization may be a small bandage on a big wound. When you equalize at a specific frequency, you affect not only the desired sound but all other similar sounds as well.

If you have an actor with a particularly deep voice, for example, equalizing the low frequencies to eliminate traffic ambience may create an unwanted change in his voice. Remember also that a wide range of frequencies exists in some form in any sound, and excessive equalization will change the character of a sound even when you are working on entirely different frequencies. Bass voices devoid of high frequencies may turn muddy and unintelligible. High sounds are less affected by the absence of low frequencies, although voices can sound tinny and shrill.

Many schools and media arts centers have individual transfer machines, which can save substantially on transfer costs. Be aware, however, that most of these machines cannot be serviced and maintained at a level comparable with those at a professional facility. With sound that requires the best reproduction possible—dialogue and music in particular—it is generally better to spend the money for a professional transfer.

Cleaning and Repair

Cleanliness is important in the digital world but not quite the same as it is on analog recorders. There are really no serviceable or cleanable parts on a digital recorder—no record heads, no tape transports, no rollers. Still, you want to keep the recorder free of dust and watch for exposure to big temperature changes as humidity and condensation can cause problems.

For analog, cleanliness is as crucial in sound as it is in other realms. The biggest concern is keeping the record head and the other heads clean. There are commercial cleaning solutions that can be applied with a sponge-tipped swab. This should be done before shooting every day, and maybe once more on a busy day. These solutions should not be applied to the rubber capstan roller as they will eventually dry the rubber out.

For both digital and analog applications, mic cables must also be kept clean, and connections must have integrity. Dust on dirty mic cables can actually build an electric charge that can disturb the signal. Connections are equally important. Being able to troubleshoot audio takes a basic knowledge of signal paths. The theory behind a mic cable is quite simple. The cable can be checked with a *multimeter*, an inexpensive meter that tests batteries as well as having other useful functions.

Using the meter function for testing **ohms**—the units of measurement of the resistance to a signal passing through a line—you can check for resistance and thus whether you have a connection. This function can be used to check virtually any electric or electronic connection. When touched together, the ground and the hot leads from the multimeter give a reading on the display, indicating that you have completed a circuit.

To test any other circuit, you put the connection to be tested in sequence with the ground and the hot leads off the multimeter. Touch one tester lead to the hot lead on one end of the audio plug, and then touch the other tester lead to the hot lead on the other end of the cable—from the tip of one quarter-inch plug to the tip of the other end, for instance. You can find adequate multimeters for around $30, although good ones cost three to four times that much. Many electrical functions will have dedicated meters for testing that will be used in professional settings.

When you are just learning the vagaries of sound, it is not uncommon to set up the recorder on-location and get no signal on the meters. This is particularly true of gear from school and media or cable access sources—anyplace where maintenance may be suspicious. Being able to follow and test the logic of the signal path will help you go into the chain and identify the problem. A kit with jeweler's screwdrivers, a soldering iron, and solder is useful to have around in case a connection has gone bad. Always bring extra cords for quick testing and replacement. As suggested earlier, the quality of your sound is only as strong as your weakest link. From mics to mic cords to adaptors, make sure everything is working at optimum level. As with everything, thinking out the process of recording is part of that chain and what goes on in your head may in the final analysis be the most important part of all. To paraphrase an earlier mantra, keep in mind that "ya gotta know yer sound gear."

11
Composition

As in the graphic arts, **composition** in film refers to the arrangement of shapes, volumes, tones, and forms within an artistic frame. It is a key—possibly *the* key—element in a film's overall visual design. Although there are many films in which the composition is formulaic and uninspired, more often than not it is thoughtful and workmanlike. On a few celebrated occasions the composition is inspired, taking the film into that rare arena of visual poetry. Whether or not it reaches this lofty status, effective composition is rarely noticed. But poorly composed films leave the viewer unsatisfied, with the uncomfortable feeling that something is amiss—that the film is creating a world that not only is out of balance but also lacks internal cohesion.

Whereas a painter has the ability to thoughtfully predetermine the positioning of elements in a composition, the filmmaker has a more complicated task because of the added dimension of movement. The key to composition for the film frame is founded in the awareness that composition is dynamic, always in flux, ever changing. Whether you are dealing with camera movement, subject movement, or both, the elements in the frame will almost always be changing position, and you have to think out each composition in terms of what is occurring at all times. You can start out with a perfectly balanced frame, and one small movement by a character—something as simple as shifting body weight—can make the composition fall apart, the framing becoming completely untenable. Thus the person shooting has to plan a response to the movement of both the subject being filmed and the camera itself.

The Director of Photography

Effective filming can be done by a single person with a camera or by a full-scale feature crew. Whether working on your own or with extensive assistance, the creativity and the care needed for effective shooting remain consistent. The **director of photography (DP)** has two primary responsibilities: composition and lighting. There are also many unstated expectations. Primary among these is the ability to evaluate whether the individual shots work within the greater context of the film (speed is a big one as well). This responsibility can range from simply making sure the shots look good and making sure that they have the appropriate pace and dynamic visual energy to—most important—evaluating on a shot-by-shot basis whether the shots will cut together. A DP with experience in the editing room brings a valuable perspective to the process.

When you view a film, you are looking at the DP's conscious approach to composition. He or she has had to *line up the shots*—that is, look at what is in front of the camera and decide how to arrange it in relation to the boundaries of the film frame. Beginners quickly learn that there is a big difference between looking through a camera and shooting. Anyone can look through a camera, but it takes a creative eye to produce framings that are both consistently dynamic and part of a cohesive vision of the whole.

The DP's role is obviously central. Many beginners venture into filmmaking with an innocently formed intent to become a DP. Indeed, there is a certain romance to the camera. It sits at the center of attention on a set, almost like a throne, with its minions scurrying about, ministering to its needs. Once you learn a little about the camera, however, you realize that a DP has to be part mathematician, part magician, and part personnel manager. It soon becomes clear that people have high expectations of you. Beyond ensuring serviceable composition, the unwritten expectation is that you will bring life and animation to the subject—even if that subject is somewhat less than spellbinding on its own. I know DPs who cannot sleep the night before big shoots, with butterflies created by the tension associated with high expectations. There is no substitute for getting it right, and hundreds of things will conspire against the easy execution of even the simplest shots.

The Frame

Beyond content issues that can be analyzed on an interpretive level, the formal elements of a **frame** demand equal consideration. The term *formal* refers to the choices you must make beyond the narrative structure of a film—the lighting, the camera angles, the employment of movement, and all of the other resources discussed in the menu in chapter 2. In a sense, *structure* is the straight line of the narrative, and *form* is the variation in the presentation of details from that line.

When Jim Jarmusch uses single takes to cover scenes in *Stranger Than Paradise* (1984), the scenes themselves and their order are the structural elements, and the single take is the formal approach. When cinematographer Haskell Wexler pre-exposes film to create a milky, old-feeling image in Hal Ashby's film biography of Woody Guthrie, *Bound for Glory* (1976), that is a formal approach. Mira Nair's *Mississippi Masala* (1992) is suffused with red, creating a visual analogy for the ease and the warmth with which the people live.

Color, shape, the play between light and dark, the texture of the image, the dynamics of movement, and a host of other formal elements—all add immeasurably to the impact of an image. More than simply establishing atmosphere or mood, formal elements shape the way we perceive characters and events.

Composition should never be looked at schematically or as being dominated by unbreakable rules. There are, however, a number of commonly accepted principles that need to be considered. Examples that illustrate these principles could go on forever, as could examples of exceptions—compositions that play against accepted conventions. The goal here is to put forth a few straightforward ideas that can serve as an impetus for further exploration on your own.

Balance and the Rule of Thirds

The dominant compositional principle, the *rule of thirds,* is a guideline for creating a balanced frame by drawing four lines that divide the frame into thirds horizontally and vertically. **(SEE 11-1)** Areas and objects of visual interest are then put on these lines to balance the composition. The rule of thirds goes by a variety of names, like *the golden mean* and others, but it has been a key compositional approach since the ancient Greeks—Pythagoras and those guys.

Balance is a key to and a natural component of composition. Both human perception and movement are dependent on a sense of equilibrium. Observation has shown that human beings want to impose order when either confronting visual phenomena or moving through them.* The human eye—actually, the processes of the mind—relentlessly attempts to impose balance on natural phenomena. The mind can find balance in triangles, abstracting a center point or finding an axis that balances the weight of the form. Rectangles and squares immediately suggest their own internal balance. Trapezoids and a number of other shapes lend themselves to similar treatment.

Other shapes announce balance less openly but still lend themselves to the eye's desire for equilibrium. Circles have no immediate balance, yet the eye will be drawn to the center, create an axis, and thus suggest balance. Even completely freeform shapes will often have some center of balance. Forms that do not suggest balance are said to have stress.

Just as the eye looks for order in abstract shapes, it desires to impose order on an artistic frame—a composition. The rule of thirds simply gives artistic form to this natural human ability or desire to create balance. Whereas balance in painting and still photography is at least superficially straightforward, balance in film is complicated by movement. Many framings that look unstable by themselves are balanced by movement. Still, some relatively straightforward examples can be shown. Terrence Malick's *Badlands* is an engagingly visual film. One scene, roughly halfway into the film, has Kit (Martin Sheen) aimlessly walking across the plains. **(SEE 11-2)** The horizon is on the bottom thirds line, with the moon in the upper left, balancing Kit on the right.

Fritz Lang's *Scarlet Street* (1945; Milton Krasner, DP) has a wealth of examples of classic balanced compositions. One scene has a group of reporters questioning the main character during a train ride. **(SEE 11-3)** The balancing of the three faces—the two characters on the vertical thirds lines and the faces and the hands with the cards on the horizontal thirds lines—is a classic balanced composition and also a common strategy for handling a shot with three people.

It may be difficult for the experimental part of our nature to admit, but the rule of thirds is the basis for much film composition. Its application can be so conventional and lead to so much predictable composition that one almost wishes there were another starting point. The rule of thirds is a natural reflection of human perceptual experience, however, and must be given careful consideration.

11-1

The rule of thirds is a guideline for creating a balanced frame.
© Cengage Learning

11-2

A typical rule-of-thirds framing.
Terrence Malick's *Badlands* (1973), © WarnerVideo.com

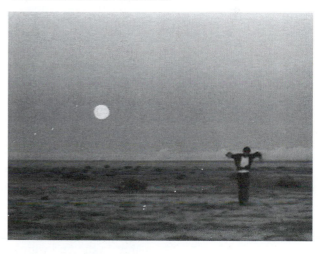

*Much of the experimentation regarding the psychological ordering of perceptual experience has been done from the perspective of Gestalt psychology. Donis A. Dondis's *A Primer for Visual Literacy* (Cambridge, MA: MIT Press, 1974) and the work of Rudolph Arnheim are excellent sources for those interested in the studies of perceptual experience.

11-3

This classic balanced composition is a common strategy for handling shots with three characters.

Fritz Lang's Scarlet Street (1945)

If you were to take four strips of *film tape* and put them on your television screen according to the thirds lines, the results would be stunning. You could marvel at the power of a simple straightforward composition or agonize over the depressing sameness of it all. Whether you are looking at a routine television show, a studio-age Hollywood film, or the most on-the-edge narrative piece, the lines would almost invariably intersect obvious areas of interest within the compositions. Although one may want to venture past this fundamental principle, the rule of thirds remains a starting place.

An acquaintance of mine sniffed when I mentioned that I teach students the rule of thirds. "A recipe for boring composition," she intoned. Despite the snootiness of the comment, there is a certain amount of truth in it. Composition should be arresting and dynamic rather than formulaic and conventional. The past 100-plus years of modern painting have been a direct reaction against conventions dating back thousands of years and further formalized during the Renaissance. And yet, as Picasso is reported to have said, you have to learn how to draw a straight line before you can draw anything else. The notion that anything goes can be an even more disastrous recipe for composition. There is a big difference between composition that is new and challenging and composition that comes out of nowhere and is bad. Like it or not, a high percentage of the composition you see derives from some form of the rule of thirds.

General Design Characteristics

Working DPs frequently invoke the names of great painters when discussing their approach to specific films. With the goal of creating rich, complex, and subtle images, a study of the historical development of the graphic arts—painting, graphic design, and photography—provides valuable schooling for the inexperienced cinematographer. Knowledge of the breadth of approaches to the arrangement of elements in a composition, the handling of line and shape, the shaping and the direction of light, and the incorporation of content elements to produce meaning informs the framing and the arrangement of any image.

Student images are frequently criticized for concentrating on the subject of a shot to the exclusion of foreground and background elements—an idea that is more complex than simply what is behind the subject. It is that extra information, that detail, that gives an image its context and character. This does not mean that cinematographers need to imitate specific works, nor should their work become static and arty. Just as there are books of painting and still photography designed for the coffee table, there can be "coffee-table" movies. But the sense that a composition can have a painterly quality is a key first step in moving toward a necessarily complex approach to the image.

A short list of conventional design characteristics will necessarily leave many things out. Images dominated by horizontals tend to be restful and suggest stability. Verticals suggest strength and power. As might be suspected, diagonals tend to suggest imbalance, although when employed in highly structured arrangements, diagonals can create powerful images as well. The German expressionists, in their fascination with heroic myth, created paintings and films with dominant vertical elements. Leni Riefenstahl's famous and notorious *Triumph of the Will* (1935), an ode to Adolf Hitler and the Nazi party, is an excellent example of a film that uses vertical and diagonal compositional elements to suggest strength and power.

Color is a key element in creating associations and tone. Blue is considered a cool color, both emotionally and physically. Red is hotter, suggesting warmer emotional content. Browns and greens are earth tones, suggesting naturalness and security. Lushness and brightness play a significant role in the texture of an image, as do muted and desaturated tones.

Compositions can also be arranged to direct viewer attention to specific parts of the frame. This can be done with lighting, the arrangement of shapes, and design elements such as costumes and makeup. Pools of light can also be used to direct attention to specific areas. An example of two of these elements can be found in Milos Forman's 1984, *Amadeus* (Miroslav Ondricek, DP). **(SEE 11-4)** As Salieri hears Mozart conduct a recital for the first time, he advances through the audience in awe. The composition is designed to direct our eye to Salieri. The dark costume makes him stand out from the other concertgoers, and the arrangement of peripheral characters creates lines that, when followed, lead the eye straight to Salieri.

11-4

Costumes and the arrangement of peripheral characters direct viewer attention.
Milos Forman's *Amadeus* (1984), © WarnerVideo.com

Composition and Content

The foremost consideration in composing for film is that the image should be a meaning-producing instrument. This is difficult both to accomplish and to discuss. The concept of images producing meaning has long been analyzed in painting, graphic design, and photography, but no single discussion could ever be definitive. This is as it should be, for the potential for any artistic expression is unlimited. It is not simply what is in the frame that creates meaning; it is also the way the subject is framed, arranged, and lighted, using all of the resources discussed in other chapters.

On purely a content level, a few typical examples will be helpful. Terrence Malick's *Days of Heaven* (1978; Néstor Almendros, DP) recounts a romance between a poor migrant worker (Brooke Adams) and a wealthy young farmer (Sam Shepard). Many of the film's images are dominated by the farmer's house, an impressive but isolated structure (based on a painting by Edward Hopper) designed to suggest some of the same emotional qualities in its owner. Frequently, the house is framed in the background of the migrants' activities, serving as a constant reminder of both the workers' reduced circumstances and the vast gap between them and the owner. One particularly telling sequence has the Brooke Adams character surprising the farmer as he sits in the tall grass, watching the sunset. As the two characters speak, the farmer's opulent home in the background dominates the space between them. **(SEE 11-5)** The visual arrangement of the shot itself suggests the relationship—the chasm—between the two characters. The house—and all it represents— will always separate them, no matter what events occur later in their relationship. What might appear to be an innocent encounter is literally overshadowed by this dominating symbol of class distinction.

11-5

The visual arrangement of elements symbolizes the relationship of the characters.
Terrence Malick's *Days of Heaven* (1978), © Criterionco.com

Visual subtext is meaningful information not present in the narrative but implicit in the visual presentation.

Ivan Passer's *Cutter's Way* (1981), © mgm.com.

Compositional stress gives a sense of a world in which something is very wrong.

Joseph H. Lewis's *Gun Crazy* (1950), © WarnerVideo.com.

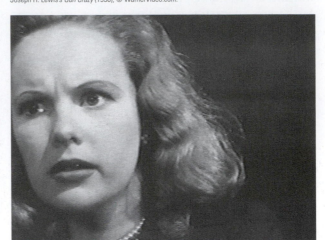

Ivan Passer's *Cutter's Way* (1981; Jordan Cronenweth, DP) provides a similar example. The story involves several friends, living on the fringes of society, who suspect a rich man of committing a murder. At one point two characters go sailing to escape the mounting tension. **(SEE 11-6)** As their boat plies the waves, an oil rig dominates the background of virtually every shot. As a symbol, the open sea generally suggests freedom and openness, a place where people can escape the ever-present demands of a complicated social existence; but here the placement of the oil rig continually reminds us otherwise. It is omnipresent. The employment of **visual subtext**—information not present in the content and the structure of the narrative but implicit in the visual presentation—is crucial in creating a complex image.

Composition and Stress

Whereas many shapes suggest internal balance, the imbalance of some shapes cannot be resolved. These shapes and arrangements are said to have compositional **stress**. Sometimes stress, also referred to as *tension,* can be resolved by either implied or actual elements moving in the frame. At other times that stress is purposefully unresolved, creating an artwork that challenges conventional formal interpretation.

Although most American films of the studio age relied on balanced compositions, **film noir** was the first style in commercial features to exploit compositional stress significantly to give a sense of a world in which something was catastrophically wrong. Joseph H. Lewis's *Gun Crazy* (1949; Russell Harlan, DP)—a classic independent, low-budget film noir—has many images that lack conventional balance. The film chronicles a couple's fascination with guns. Their eventual descent into criminality ends with the couple (Peggy Cummins and John Dahl) fleeing the police by car. In this final scene, the characters' mental strain has a reciprocal representation in the imbalance of the composition. **(SEE 11-7)**

Although the impetus for the film noir sensibility faltered in the 1950s, the importance of compositional stress was rediscovered by cinematographers of the sixties, seventies, and beyond. Robert Dominik's *The Assassination of Jesse James by the Coward Robert Ford* (2008; Roger Deakins, DP) has many compelling compositions. This shot toward the end of the film, is a stark visual representation of the mounting tension between the two main characters of the title. **(SEE 11-8)**

Bernardo Bertolucci's *The Conformist* (1971; Vittorio Storaro, DP), a film that extensively influenced modern visual style, has many intriguing examples of unbalanced

11-8

Stark, unbalanced compositions can reflect ambiguous content.

Andrew Dominik's *The Assassination of Jesse James* by the Coward Robert Ford. (2007), © WarnerVideo.com.

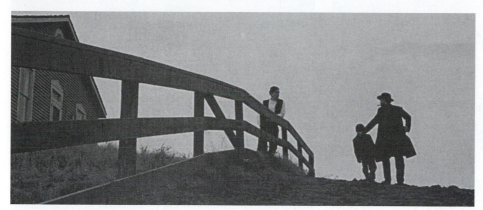

compositions. One famous composition demonstrates a very unorthodox kind of imbalance. **(SEE 11-9)** The lines of the image are very symmetrical, yet the face has too much weight to balance the other elements in the frame. In this case there is a rule of thirds—like division, and yet the weight given individual elements creates a very unsettling image.

Compositional stress often creates the expectation of resolution. When a space is left open, the expectation is created that it will be filled. An example of this is a shot of an individual sitting at a bar. If the empty bar stool next to the person is included in the shot, the expectation is created that the seat will be filled. If the shot is more conventionally balanced, someone forcing his way into the composition might be perceived as intrusive.

Horror films take particular advantage of this tension. Space is used to create the expectation on the part of the audience that something, usually bad, is going to happen. The open door behind the unsuspecting character is going to be filled by whatever representation of our inner fears the film is exploiting. Our expectations can be either fulfilled or frustrated. John Carpenter's *Halloween* (1978) has several situations in which the viewer is aware that the killer is near. Characters oblivious to the danger are shown in shots that have space left for the killer to enter. But the film purposefully increases tension—keeps us on the edge of our seats—by not delivering. When we get the relief of a more conventionally balanced composition, apparently signaling the passing of danger, Carpenter increases the shock by having the killer appear, violating the equilibrium.

11-9

Compositional stress caused by elements with disproportional weight.

Jean-Louis Trintignant in *The Conformist* (1970), © Paramount.com

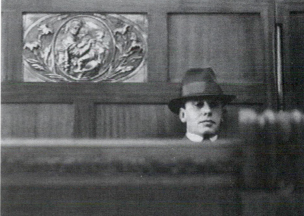

Stress and Photographic Factors

Images can achieve stress through methods other than simple compositional imbalance. For example, elements specific to the technical nature of photography can be employed to create tension. Leaving elements out of focus can cause confusion and frustration, particularly when the image is designed to make us want to see the subject. Distorting lenses can be a contributing factor as well, showing objects that are out of proportion in relation to the size of the other elements in the frame.

Wide-angle lenses are frequently employed to create this type of stress. The bending of foreground elements in combination with the elongation, making background images appear smaller, can create exaggerated effects. The couple from *Gun Crazy* are often presented in shots that fragment their presence between the foreground and the background. **(SEE 11-10)** This is an issue of **scale**—the size of objects in relation to one another in the frame. Although it might be argued that these shots have some internal balance, the distortion of relationships definitely adds an element of stress. Also from *Gun Crazy*, the companion shot to figure 11-7 is a good example of distortions of scale. **(SEE 11-11)** The steering wheel is so distorted in relationship to the face that, despite some internal balance, compositional stress is clearly an issue.

Long lenses too can create a confining and distorting perspective. The prelude to one of the key musical sequences in Bob Fosse's *Cabaret* (1972) has an excellent example of this. **(SEE 11-12)** The song "Tomorrow Belongs to Me" is set in a beautiful alpine beer garden. The establishment of this setting, however, which conventionally might be shot with a wide-angle or normal lens to give a complete view, is shot entirely with a long lens. The subtle claustrophobia—the lack of expected openness—creates apprehension that is borne out when the deceptively bucolic atmosphere turns menacing as it evolves into a pro-Nazi songfest. In Jane Campion's *The Piano* (1993), the long lens is a factor in the scene where the note from Ada to Baines (played by Holly Hunter and Harvey Keitel) falls into the wrong hands—a prelude to the film's violent action. **(SEE 11-13)**

Filmed along a fence line in the hills, the squashed and angular compositions are so distorted that the scene is invested with an undertone foreshadowing the impending conflict.

Lining Up the Shots

As mentioned earlier, lining up the shots consists of looking at what is in front of the camera and deciding how to arrange it in relation to the boundaries of the film frame. This conscious approach to composition is one of the responsibilities of the director of photography.

Headroom and Eyeroom

The predominant content elements in the majority of shots in narrative films are most frequently people. When a person is the focus of compositional interest, where is the viewer's eye drawn? Usually to the eyes. When people are composed on film, the eyes are almost always on the top thirds line. (**SEE 11-14**) If the eyes are lower, you will probably have problems with **headroom**—the amount of space above the head. Too much headroom tends to diminish the subject. (**SEE 11-15**) This example obviously overstates the effect; less exaggerated effects diminish to a lesser degree.

Individual cinematographers handle headroom differently, but they generally keep the top of the head close to the top of the frame. Headroom is more critical in close shots; close-ups with an inordinate amount of headroom definitely diminish the subject. A little more headroom can be allowed in longer shots, although putting the eyes below the top thirds line can produce disagreeable results. Some cinematographers maintain that you can err on the side of too little headroom as well. Cropping that is too tight can make a character look constrained, as if in a room with a low ceiling.

Eyeroom, or *looking room*, refers to the practice of giving characters space in the direction they are looking. A character looking frame-right would be composed

11-13

The squashed and angular composition foreshadows impending conflict.

11-14

People are almost always composed with the eyes on the top thirds line.
© Cengage Learning

11-15

Too much headroom diminishes the subject.
© Cengage Learning

around the left thirds line and vice versa. If a character is not given eyeroom, the shot will feel confined, as if sight is somehow limited or the character's face is pressed up against something.

Many cameras have viewing systems with crosshairs or ground-glass centers. Beginners occasionally mistake these for compositional aids, thinking that they are supposed to put the crosshairs right between the subject's eyes. I like to call this the "assassination theory of composition." I once saw this theory applied in a video-tape of a man giving a powerful speech. It was shot by an obviously inexperienced camera operator, who consistently kept the speaker's eyes right in the center of the frame. Given the limited options of taping a speech from a fixed camera position, the operator did about the only thing one can do: zoom in and zoom out. When the lens was zoomed in, the effect was bad, though not entirely unacceptable. But when the lens was zoomed out, the cavernous space above the speaker's head made him appear tiny and unimpressive, completely subverting his powerful oration.

Cleaning the Image

It is usually necessary to "clean" the image of any elements that draw the viewer's attention to undesired parts of the frame or that make for an odd visual presenta-tion. In the first case, this refers to objects that are an unwarranted distraction or are hovering around the edges of the frame. If an object, say, a chair leg, is barely protruding into the frame, it will draw attention to itself. The viewer's eye will un-consciously search it to see what it is. The more difficult it is to read, the bigger the distraction and the more it will disrupt the frame. The solution is to position the object entirely outside the frame or enough in the frame that the viewer can un-consciously recognize it without effort. The longer an image is held, the more the viewer will search the frame. If the viewer's attention is held by an element in the frame that is confusing, it can detract from simple involvement.

Josef von Sternberg, one of the greatest visual directors, once stated that when presented with a shot of a character seated in a chair, he would be sure that all four chair legs were in the shot. His assumption was that the chair would appear to be on the verge of collapse if proper support were not evident. Although this may show a lack of faith in the viewer's ability to understand images, the point is nevertheless made. That which an image needs, it must have. That which an image does not need should be eliminated.

The latter case refers to background elements and, to a lesser extent, foreground elements that are peculiarly positioned, such as telephone poles coming out of people's heads, and light switches, household plugs, and similar objects that because of their positioning appear attached to the body. Mel Stuart's *Willy Wonka and the Chocolate Factory* (1971) has an effective parody of the problem. **(SEE 11-16)** A television reporter is framed in such a way that the antlers of a trophy in the background appear to be coming out of his head. Although this example is a good gag, this sort of positioning can create peculiar effects when not desired. My favorite example was cre-ated when a student inadvertently positioned a distant highway on a level with the ears of an interview subject. Cars entering one of the subject's ears and exiting out the other, though hilarious, completely destroyed the credibility of the shot.

Cheating

Shifting elements in the composition to balance the frame, thus improving an otherwise problematic

11-16

The distracting background object creates a peculiar effect.

Mel Stuart's *Willie Wonka and the Chocolate Factory* (1971), © WarnerVideo.com

11-17

This example of cheating in positioning the characters defies logic but often goes unnoticed by the viewer.

Alfred Hitchcock's *The Man Who Knew Too Much* (1956), © universalstudios.com/home

shot, is called **cheating**. Most cheats are relatively simple: moving items on a table, shifting furniture, or relocating artwork on a wall is frequently enough to fix an untenable frame. Continuity is a key concern when cheating, although experience helps in understanding what you can get away with.

Cheating applies to the positioning of characters as well. If a character is blocked in a specific way for one angle, there may be a difficult background element that creates a problem—say, a door frame or light switch—in another angle. To eliminate the problem, simply move the actor in the appropriate direction either to cover up the offending object or to allow recomposition to exclude it.

Alfred Hitchcock, who seemed to delight in these simple manipulations, did a cheat in *The Man Who Knew Too Much* (1956; Robert Burks, DP) that defies logic but still goes largely unnoticed by the audience. The scene involves two couples sitting across from each other at a table. **(SEE 11-17)** Although both couples are shoulder to shoulder when facing the camera, they are several feet apart in their respective reverses. Shooting a conversation like this is always a challenge because of questions of the line and shifting perspective. This example represents an adventurous solution, one that may have left a less prestigious director making explanations to studio chiefs.

Directors of photography are always adjusting things, fussing with the set, and rearranging props to get the perfect composition. With an eye to the camera, a camera operator's asking a props person or set dresser to slide things a little bit one way or the other is common. Sloppiness is acceptable only in a few specific applications, and DPs will generally work hard to achieve an image that is clean and not confusing.

Movement and Anticipatory Camera

As mentioned in chapter 2, much of the camera movement in film is not noticed by the viewer. It is movement that responds to or, more accurately, anticipates subject movement. **Anticipatory camera**—an approach to cinematography that is particularly associated with classic Hollywood cinema—is structured, highly choreographed camerawork that leads rather than follows movement, making adjustments for the movement of characters in the frame or the entrances of others. Not all camerawork is this formal, but the approach so dominates cinematography that it influences the way any DP thinks about shooting.

The bottom line is that the DP must respond intelligently to shifting elements within the frame. A common example is a two-shot in which one of the characters exits. The initial frame can be balanced for two people, but that balance falls apart

once one person leaves. The solution is to pan slightly in the appropriate direction to rebalance the frame. Whenever there is movement in the frame, the DP is confronted with a question: what should be done to compensate for the movement? Generally, failure to adjust results in poor framing.

Just as performance is rehearsed, camerawork is rehearsed as well. During the final blocking of the scene in rehearsals, the actor's movements should become consistent, and a plan for shooting can be devised and rehearsed. If the actor shifts her weight or turns to face a new direction, the responding movement of the camera can be perfectly timed to anticipate that action. If the actor is going through a bigger movement, the camera can accommodate it by drifting or moving boldly in the appropriate direction. The key is rehearsal so that the camera operator knows the movement and has a planned response.

The concluding scenes of Fritz Lang's *Scarlet Street* have many excellent examples of camera movement used to create a balanced composition and anticipate movement. In one scene, where the main character, Christopher Cross (Edward G. Robinson), is overwhelmed with guilt, he begins hearing the voices of the people whose deaths he has caused. In one shot he tears away the canopy on his bed to find the source of the voices. The camera starts with a balanced composition of the bed sheets, shielded by the canopy. **(SEE 11-18A)** In an exceedingly subtle move that is a perfect demonstration of this concept, a quick tilt is done to create room for Chris as he enters the frame. **(SEE 11-18B)** The camera does not react *after* Chris enters the shot; it starts the movement just before he enters the

11-18

Using camera movement to create balance and anticipate subject movement.

Edward G. Robinson in *Scarlet Street* (1945)

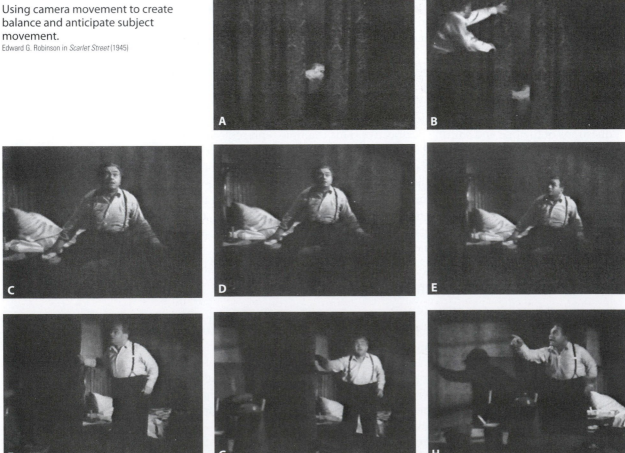

frame and is finished by the time he reaches his final position. On the surface a move like this appears to be almost inconsequential, but it is with responses such as this that camerawork achieves much of its subtlety and fluidity.

Broader movements benefit from thoughtful planning as well. A shot following the one just described leads Chris through a complex movement. The shot starts with Chris seated on the bed. **(SEE 11-18C)** The camera starts to dolly out to give him room to stand. **(SEE 11-18D)** Before he stands, Chris looks frame-left. **(SEE 11-18E)** The camera anticipates this by drifting left to create eyeroom, also anticipating the direction Chris will go when he rises from the bed. The camera does not give full headroom for his final position when standing, as that would create too much headroom while he is still on the bed. The top of the frame is completed in a tilt timed to his rising. **(SEE 11-18F)** The camera then continues to drift frame-left as Chris advances through the room. **(SEE 11-18G)** Both camera movement and character movement are then perfectly timed for an ending composition, allowing room for a striking shadow of Chris as he points to something. **(SEE 11-18H)**

Anticipatory camera movements are the result of choices that must be made constantly while preparing each shot, working out strategies for covering the action in front of the camera. A camera operator must respond to all subject movement. Failure to do so results in compositions that may begin well but wind up out of balance.

On a set there is constant dialogue among the director, the DP, the camera operator, and the talent regarding the inclusion and the arrangement of elements within the frame. Although most movements of this nature are planned in advance, the camera operator should be ready for minor adjustments. One of the biggest mistakes novice operators make is finding a good beginning composition and then locking the pan and tilt controls as though it were the framing the world should have forever. The camera operator generally wants to keep these controls unlocked (usually both on *tight fluid,* that is, with greater resistance) to respond to subject movement.

Planning and executing movements that are assured and decisive are important goals for a beginning cinematographer. You can always tell when a cinematographer has not quite decided what to do in a specific situation. There is a tentative quality to the movements that betrays the operator's lack of confidence. Part of maturing as a camera operator is building confidence in your judgment and showing conviction in the effects you are trying to accomplish.

Movement and Compositional Balance

Frequently, camera movement is necessary to create balance in a composition that has been disrupted by or simply needs to follow the action. DPs will often use elements in the foreground or background to balance compositions. As characters move, however, these balancing elements can become liabilities unless appropriately managed.

The opening of the previously discussed scene from *Scarlet Street* has Chris entering his rented room. Elements on a table in the foreground are used to create balance as he walks through the room. As he comes in, he is balanced by a bottle frame-right and a wall light fixture frame-left. **(SEE 11-19A)** As he moves across the room toward a window, the camera dollies left while panning right. **(SEE 11-19B)** In the resulting composition, Chris is balanced by a coffeepot and a cup at frame-left and the window at frame-right. **(SEE 11-19C)** Balance is a key goal here, but these elements are also used to create a sense of depth in the image. Why the dolly? Could a pan have been done instead? Although this movement may have been a feature of a grand plan on Lang's part (as befits the main character's name, there is much crossing imagery in the film), it also could have been just one of those things that was worked out on the set. Within the confines of the set, a pan may not have created the final composition that Lang and DP Milton Krasner felt was appropriate.

11-19

Using camera movement and foreground and background elements for compositional balance.

Fritz Lang's *Scarlet Street* (1945)

Subject Movement Toward or Away from the Camera

A subject moving toward or away from the camera almost always requires some adjustment. If the composition is correct at the beginning of the shot, a character would move out of the top of the composition as he or she approaches the camera if no correction is made. **(SEE 11-20)** A tilt is usually in order, often with a pan incorporated for any horizontal changes. The key to executing a good move is finding some aspect of the composition that will remain relatively stable; in this case, keeping the appropriate headroom would be a key issue.

The previously mentioned shot from *Amadeus* concludes with a stunned Salieri approaching the camera. **(SEE 11-21A)** As Salieri comes closer, the camera is subtly and fluidly tilted to give the appropriate headroom for the new composition. The timing is immaculate, with the headroom kept perfectly even throughout the move. By the end the camera is at a low angle that exaggerates Salieri's features and diminishes the peripheral characters in the background. **(SEE 11-21B)** Movement like this requires rack focusing as well.

Camera Movement Toward or Away from a Subject

The same principles that apply to subject movement also apply to the movement of dollies and zooms toward and away from a subject. A tilt is almost always necessary and often a pan as well. **(SEE 11-22)** Despite the aesthetic differences between a dolly and a zoom, they become virtually synonymous when compositional adjustments made necessary by their use are considered.

Movement to Create Space

Moving the camera to create room for a character's entering the frame is a common approach. Director Nicholas Ray has garnered recognition for the fluid and thoughtful use of the camera in his films. Ray's *In a Lonely Place* (1950; Burnett Guffey, DP) has many examples of the camera's being used to accommodate character entrances and exits. A typical shot features a literary agent (Art Smith) being joined by the female lead, Laurel (Gloria Grahame). Again, timing is everything. The camera starts with a composition of the agent. **(SEE 11-23A)** The composition starts to drift right and slightly up to anticipate Laurel's entrance. When she enters the frame, the composition is completing as she reaches her final position. **(SEE 11-23B)**

11-20
A character approaching
the camera moves out of
the top of the composition,
necessitating a tilt.
© Cengage Learning

11-21

Tilting to give appropriate headroom as the subject approaches the camera.

F. Murray Abraham in *Amadeus* (1984), © WarnerVideo.com

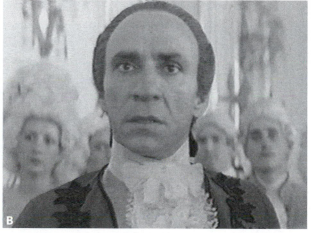

11-22

A dolly or zoom toward a subject usually requires a tilt.

© Cengage Learning

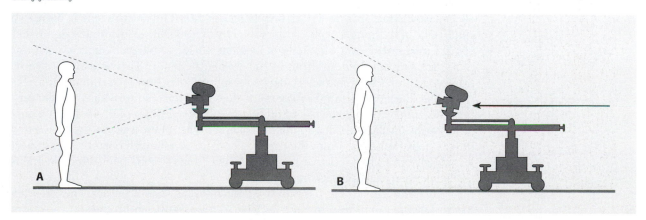

11-23

Gradually moving the camera to accommodate a subject's entering the frame.
Nicholas Ray's *In a Lonely Place* (1950), © SonyPicture.com

11-24

Using character movement to fill compositional voids.
Fritz Lang's *Scarlet Street* (1945)

Character Movement to Balance Composition

Having a character move to fill a compositional void is also a common approach. Rather than plan some extensive and time-consuming camera move, simply have the talent move to positions that fill out the composition. *Scarlet Street* has an excellent, though almost comically transparent, example of this. The scene immediately following the previous example involves two police officers rousting the now derelict main character from a park bench. **(SEE 11-24A)** The entire scene is done in a single take and, though many viewers might not notice it, incorporates significant camera movement. Still, character movement is used to balance out compositions to reduce drastic compensations as the elements change. This sequence of three frames illustrates how characters can be regrouped after they are set in motion.

The shorter officer in the foreground does all of the talking, while the taller officer is essentially a shill to be played off of. As Chris starts to get off the bench, the first officer steps toward him, disrupting the balance of the frame. **(SEE 11-24B)** The second officer steps frame-left—into the empty space—to re-establish balance. **(SEE 11-24C)** It is clear from its stiffness that this movement is done at someone's direction and is solely intended to rebalance composition.

Such movements are the subject of much discussion on the set. The DP often has to ask the talent to move to specific positions to be in proper composition.

11-25

Creating emotional space with a pragmatic use of movement.
Fritz Lang's *Scarlet Street* (1945)

Again, this is what marks are for. If beginning film actors share a common short-coming, it is in neither understanding nor accommodating the requirements of composition. Occasionally, directors have to take young performers (particularly stage-trained ones) aside and explain "the rules of the road." Shots are effective only if certain principles are considered while shooting.

Movement and Meaning

We have mainly been detailing the practical considerations of movement, but many thematic issues depend on movement as well, incorporating the creation of space for meaning. The end of the park bench shot from *Scarlet Street* provides an example of both: the creation of emotional space intermingled with a pragmatic use of movement. After the police officers have rousted Chris, he shuffles off behind them. **(SEE 11-25)** The camera drifts left to allow him space to leave. Not only is this a practical necessity, but it also allows Chris to disappear miserably into the distance.

One final note: Although camera operators are given rehearsals for complicated moves, they are usually expected to handle simple ones on their own. It may be considerate to allow beginning DPs several practices, but this may not be the case in much standard production.

Practical Considerations

As always, practical considerations shape many of the decisions made about shooting. Whatever is planned will have complications, and being able to readjust effectively is essential.

Composition and Compromise

Composition often requires compromise; that is, either to avoid some bothersome element or to integrate a difficult camera move, a framing that is less than perfect must be made. The camera might have to be tilted down to avoid a hanging light in a tight location. It might have to be panned in one direction or the other to avoid an undesired background element. How do you respond when there is a substantial difference in the heights of the characters, or if one character is seated and the other

is standing? Do you tilt up to make room for a character who is entering the frame, or do you start with too much headroom and let the character fill it?

A previously discussed shot from Nicholas Ray's *In a Lonely Place* is a good example of a typical compromise (figure 11-23). The initial framing of this shot is easy to criticize as being too loose, having unnecessary headroom in particular. The logic of the composition, however, is made apparent when the second character enters. The move to the final composition would have been too extreme—the tilt would have covered too much distance too quickly—if the first framing had been tighter. The movement would not have been fluid, particularly when matching movement from other shots. As in this example, framings occasionally have to be left loose to incorporate some other element that is entering or exiting the frame. In this case the first composition is left loose to facilitate a subtle move to the second, tighter composition.

Often such compromises have to do with avoiding undesired elements in the foreground or background. If there are television antennas on the homes in a period piece, framing will have to be adjusted so that they are not in the shots. If a room has a low ceiling, high camera angles may have to be used to avoid light fixtures or microphone booms. Myriad obstacles make slight changes in shots necessary.

Compromises are a necessity in situations in which achieving complete control of all of the elements is impossible. (This notion is explored further in a variety of contexts.) On amply budgeted films, a great deal of time and money goes into securing shooting spaces that can be manipulated according to the filmmakers' needs. The production likes to "own the location." If something is posing a problem, it will simply be eliminated. This strategy can be used to eliminate a wide range of obstacles, many of them beyond the question of compositional challenges—from television antennas to unattractive paint jobs to bothersome people. Without the money or time to change things, independents and students wind up shooting, in some cases literally, around obstacles. It is often a matter of what you are willing to give up compositionally to create something that is workable.

Camera and Performance

The dialogue between the DP and the talent is critical, although in many cases it is funneled through the director or the AD. The performers often have specific expectations of the DP, and the DP always needs the talent to respond to compositional requirements. Communication is constant and is essential to the visual shape of a film.

One expectation is that the DP must make the talent look good. There are legendary stories of actors who insisted that they be filmed and lighted in specific ways. Although you might prefer not to be a slave to some cultural beauty stereotype, you must recognize that there are indeed angles on performers that do not do them justice. A certain amount of cinematography is still based on the old glamour approach of the studio age. Making sure that all of the elements display the talent at their best can affect a wide range of decisions. Using knowledge of the actor's "better side" to determine which side of the line from which to film is a typical example.

Performers' movements must be integrated into the needs of a balanced frame. Usually, this is a matter of setting up marks for the talent to hit as they move through a scene, the approach representing a tightly choreographed interplay between camera and subject. In the great Hollywood films of the golden era, there is almost a dance between camera and characters. A good example is when the director wants a moving subject in a close-up, in which case the DP has to make the performer move within tightly controlled parameters. The DP will draw a frame in the air that will give the boundaries of a performer's possible movements: "If you move too far this way, you will be out of composition. If you go too far that way. . . "

One potential concern is that if the space is too defined, actors can become so absorbed in the mechanical aspects of their movements that the performance

gets lost. Being able to work within the technical demands of the medium, however, depends on the ability and the professionalism of the actor.

Alfred Hitchcock's *Notorious* (Ted Tetzlaff, DP) has many shots of characters in movement that are so tight that it obviously took much communication among talent, DP, and director to achieve the desired stability of composition. Shots of Alicia nervously pacing in the midst of a party as Dev plans a search for clues in the wine cellar are particularly good examples of moving shots that are very tightly controlled. One can clearly visualize the DP indicating the boundaries—imaginary lines of a frame drawn in the air—of her movement. This tight control is purposeful in emphasizing the tension Alicia feels while trying to aid Dev's clandestine activities. To allow a wider frame for greater freedom of movement would have diluted the claustrophobic effect. Despite the constraints, Ingrid Bergman's performance is one of the most luminescent in film. Every emotional shading shines within the tightly controlled technique that displays it. Considering all of the technical adjustments that must have been transpiring, Bergman maintained focus on the smallest elements of her performance.

Still, inexperienced performers may have difficulties keeping compositional considerations from affecting their performance. Some actors may rebel at the tightly controlled parameters. Being sensitive to the performers' concerns is a necessity, but being firm about the demands of the medium is also important. Talent who cannot hit marks or understand abstract parameters will be the source of sloppy compositions.

Informal Camera Styles

The classic approach to camerawork is one more convention to be questioned and tested. The 1960s and 1970s saw a movement toward a more informal image in films—a movement that had its genesis in post–World War II Italian film and the French New Wave of the fifties and sixties. In American films ranging from the work of Robert Altman and John Cassavetes to that of a new generation of experimental and documentary filmmakers, there was an attempt to create an image that was more spontaneous than the highly choreographed Hollywood prototype.

In such films as *Faces* (1968) and *Husbands* (1970), Cassavetes was a true innovator. The most striking feature of these films is their improvisational tone. The majority of the scenes were shot with a handheld camera, and one gets a sense that the camera operator was given the camera and told to do the best he could, not knowing what was going to happen next. The films have an almost documentary shooting approach, the camera being used to film a narrative with improvised elements. Be aware, however, that recent interviews with Cassavetes's collaborators have indicated that the spontaneous look was the result of a carefully planned aesthetic approach.

The handheld camera can create less structured and less static imagery, but informal imagery and the handheld camera are not synonymous. Robert Altman's early masterworks *McCabe and Mrs. Miller* (1971) and *The Long Goodbye* have images and sequences of shots that were largely undreamed-of prior to these films. Altman and his cinematographer, Vilmos Zsigmond, specifically planned for the camera to be always moving in *The Long Goodbye*. The actors were also allowed great freedom, making the compositions feel less arranged. After his work in *The Long Goodbye*, actor Sterling Hayden remarked how much he enjoyed the freedom this approach allowed the actor. He was not constantly annoyed by having to hit the marks that are required in a more structured approach. That said, it is not to everyone's taste.

The style of films like these can be quite engaging, though it did not necessarily gain wide acceptance by audiences. Jean-Luc Godard was systematic in his theoretical and filmic assaults on the shackles of the old, highly choreographed style.

In the United States, Dennis Hopper's *Easy Rider* (1969) was a key work in paving the way toward a less structured approach. Gordon Willis's shooting in Francis Ford Coppola's *The Godfather: Part II* (1974), however, and John Alonzo's in Roman Polanski's *Chinatown* (1974), among others, marked a return to more-formal, structured imagery. The impulse for a more spontaneous approach remains, but the revolutionary fervor has diminished. With his ability to integrate both formal and informal styles, Martin Scorsese is one of the few directors to incorporate different styles effectively over the long term.

Notes and Suggestions

One critical thing to remember is that there is a big difference between just looking through the camera and "shooting." Anyone can look through a camera; shooting is an art. Many young camera operators bring to shooting too much of their experience of viewing film. When looking at a shot, the eye is generally drawn to a specific area of the frame, and awareness of the rest of the frame is limited. If it is a shot of a person, the viewer's eyes are generally drawn to those of the performer.

In a classroom exercise several years ago, I asked a student camera operator for a medium shot of an actor. A crewmember hit the slate that marks each scene and stepped to the side. I thought he was standing too close to the actor for the composition I had called. I assumed that the camera operator was doing the right thing. When we got the film back, there was the guy with the slate, standing a few feet away, smiling and enjoying the performance. Everyone ribbed him mercilessly until I pointed out that this was really the operator's responsibility. The camera operator was shooting like a movie viewer. He zeroed in on the performer's eyes, completely unaware of the rest of the frame. He was watching content when he should have been watching form. A camera operator needs to maintain a whole-frame awareness when shooting film.

A good DP is going to find a way to make the composition arresting and interesting at all times. It is not a matter of coming up with a decent composition occasionally. If you set up a camera on a busy street, a decent composition will wander by every once in a while. But this is not filmmaking. The tension between the edges of the frame and its contents is of paramount importance. There must be a symbiotic relationship between the contents of the frame and the "rightness" of their arrangement.

Again, a primary responsibility is an awareness of whether what is being shot will cut together. It is clearly the director's responsibility to make sure that what is shot works; but the DP monitors exactly what the pieces will be and should be able to extrapolate to an edited finished product. Many students have heard the famous story of Orson Welles's encounter with a balky DP. While shooting a scene, the DP was constantly interjecting his opinion about what shots would cut and arguing about shots he felt would not cut. In exasperation Welles finally told him that they were filming a dream sequence. By Welles's account the DP was putty in his hands from that moment on. Whether or not this story is true (anyone familiar with the day-to-day practical aspects of production would have to be dubious), it is repeated too frequently by people who do not have the experience and, potentially, vision that Welles had. The knowledge that a good DP has about cutting should be seen as an asset, not a source for confrontation. There will always be technical people who are overbearing and too schematic in their approach. But an equal number of directors should be listening when they are about to make a mistake. As suggested, a DP with some editing-room experience is often a real ally.

Part IV
Lighting and Exposure

12
Concepts and Equipment

The Importance of Lighting

One shock for aspiring filmmakers is the high percentage of films that make extensive use of artificial light for both interior and exterior shooting. The necessity for interior lighting surprises no one, but the number of lights and the complexity of their implementation often do. Beautiful exterior light—natural light—has always been found by still photographers, but it occurs too unpredictably and changes too rapidly to be a good ally of filmmakers. On his film *Ran* (1985), it is said that director Akira Kurosawa kept a cast of thousands standing by for several hours, waiting for just the right cloud formation. Kurosawa was one of the greats, and his cast, crew, and producers would give him that latitude to create incredible images. Most filmmakers do not have that luxury. Because the light in any situation may not exist in the volume or with the highlights or qualities desired, a filmmaker must know how to evaluate existing lighting situations and must become completely conversant in the uses of artificial light.

Just as a painter starts with a blank canvas, a filmmaker starts with an unlit space. Light is the filmmaker's brush and palette. Phrases such as "painting with light" or the "painterly qualities" of light suggest the power of light, dark, and color to establish mood, suggest psychological states, and communicate the tactile qualities of observed objects. **Lighting** can accomplish much more than this, but it is clearly a key building block of the photographic image.

Despite the fundamental importance of light and lighting, industry professionals often express frustration with the poor preparation that students receive in the area of lighting, a distressing situation given that many entry-level positions are on lighting crews. Although there are a number of reasons for this, the major one is that students cannot possibly duplicate the Hollywood model for lighting. Limited in financial resources, schools cannot afford the sophisticated equipment that makers of features and commercials use daily. And if the equipment were available, the complexity of setup would stymie even the most ambitious student. Achieving the production values of commercial features requires a commitment of time, equipment, personnel, and access to locations beyond the means of any individual, particularly an inexperienced one.

The last reason is probably the most decisive. Although the story and content elements will always be the hardest parts of making a film, a mastery of lighting and exposure is one of the most difficult things for students at all levels to achieve. The novice lighting person is going to make many mistakes. Unless you know a few

tricks of the trade, it is hard to use the lights to create the effects that you want and that you see achieved so apparently easily in other films. There are many technical specifications to learn, and there are significant safety issues. The equipment is heavy and bulky, and unless you have strong and compassionate friends, just getting it from here to there can be a struggle.

The key to getting the lighting results you want is control. Every beginner, sweating through that seemingly interminable period between turning the film in to the processing lab and getting it back, is vexed by the question, *Is the film going to turn out the way I want?* What the following chapters address, and what you will have as a long-term goal, is the elimination of that query. Lighting is presented here in a systematic way that, albeit technical, does not intimidate the reader. Before beginners can usefully move to advanced technical lighting manuals, they must understand some key concepts clearly and unambiguously.

The following is a simple, step-by-step introduction to how to think about lighting. That is not the same as teaching you how to light. The only way to learn that is by actually doing it. There are no quick fixes, no way to be there without the process of getting there. The getting-there part not only is what teaches you the craft of lighting but also is central to the process of maturing as a creative individual. And, besides, getting there is all the fun.

Basic Three-point Lighting

The basic lighting setup described here is so fundamental that people have a tendency, when it is first presented to them, to dismiss it as too simplistic. The **three-point setup** is the textbook approach to figure (character) lighting, comprising a key light, a fill light, and a backlight. Most everyone knows that lighting is generally more complicated than this. To some small degree, they are right. Most lighting is far more complicated, with many more lights used than in the three-point setup. But that setup is still the starting point for most lighting. Whatever else you are doing, you almost always have to consider these points, particularly the first two. **(SEE 12-1)**

Key Light

The **key light** is usually the major source of illumination. It is generally, though certainly not always, a hard beam of light that casts harsh shadows. It will create a deep nose shadow on the side of the face away from the light. The rest of that side of the face will be dark. It is usually the main source of light in a shot. The viewer identifies it, though probably unconsciously, as the direction from which the light is coming. When we are outside during the day, the key light is, of course, the sun. At night it might be the moon or some artificial source. Indoors it may be a window, a lamp, or a ceiling fixture. You can think of the key light as the "source" light or the "main" light, but it is usually referred to as the key. Some lighting people prefer the term *point source*. The key light is frequently, though not always, the light that is used to determine the *f*-stop.

12-1

The basic three-point setup is the textbook, logical approach to lighting.
© Cengage Learning

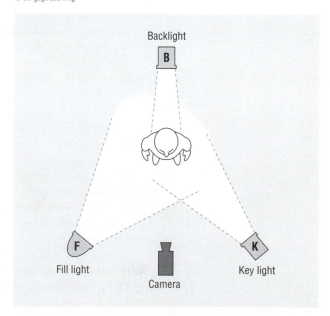

Fill Light

The **fill light** is usually on the opposite side of the camera from the key light. It is generally softer than the key, and, as its name suggests, it "fills in" the harshness of the shadows created by the key. To a large extent, the intensity of the fill light in relationship to the key light controls the dramatic quality of the shadows. If the fill is close to the key in intensity, the shadows will be soft. If the fill is much lower than the key, the shadows will be deeper.

Backlight

The **backlight** is generally above and behind the subject, shining down and hitting the subject on the back of the head. Its use can be more general than this, hitting a more substantial part of the body. In recent years, though, the term *backlight* has come to identify what used to be called a "hair light." It provides texture and definition to the hair and also helps separate the subject from the background. The lack of a backlight will often leave the subject's hair shapeless and looking like a single mass sticking straight up out of the head. The backlight is often considered the least essential of the three points. Its presence is open to a certain amount of debate, as it is often difficult to determine what its source is.

If you think about it, these three points of light, particularly the first two, are very logical and are going to exist in some form in most images. All light has a source, and we can think of that source as the key light. A cinematographer friend likes to use the example of "sun and sand." Sunlight hits a person and casts harsh shadows on the side away from it. This light continues to the sand, which reflects the light back to fill in the harsh shadows created by the sun. The same is true indoors. The source light's reflection off of other surfaces in the room, such as the walls and the ceiling, fills in the side away from the source. Generally, we refer to this bounced or reflected light as **ambient light**. Not only does the key light have a source (it is the source), but the fill light also has a source that can be identified.

This is where the backlight becomes somewhat controversial: there is often no identifiable source for it. Most people who light for film like to think of a light's source in terms of there being some *justification* for a light that is hitting a subject from a specific direction. Sometimes DPs are every bit as careful about establishing where the source of light is as directors are in establishing the spatial characteristics of the scene. There are DPs who will not use backlights for this reason. For the many who do, however, the major justification is photographic. Without it the hair can look characterless and flat. This idea of justification is a significant one and is discussed further in this and subsequent chapters.

It was stated above that one of the controls of the dramatic quality of an image is how intense the fill light is in relationship to the key light. But why is it necessary to have a key side and a fill side? It is essential to have a shaded side of the face (or object) because it aids the perception of depth in an image. The film image is two-dimensional, and achieving a sense of three-dimensionality requires some work. If the key light and the fill light are even in intensity, facial features will be flattened—the nose will appear to be pushed flat against the face.

Using a key and a fill does not necessarily mean that one side of the face must be in shadow. In several scenes of Ivan Passer's *Cutter's Way,* cinematographer Jordan Cronenweth essentially exposed for the traditional fill side, allowing the key side to overexpose dramatically. **(SEE 12-2)** The effect is the same, but with the bright side being responsible for dimensionality.

Eventually, you may not even think about lighting in terms of these discrete points, but the key/fill/backlight system will remain central to the process of lighting. The three-point setup is so basic that people tend either to be too dogmatic

with their application of it or to disregard it altogether. The latter is by far the greater sin. Invariably, I get at least one student per semester who wants to skip over this dry, textbook stuff and get on to the exciting business. Get out the fog machines! That approach is somewhat like jumping into trigonometry before learning how to add. You must have a starting point, and the three-point system is just that, in terms of learning not only how to light but also how to approach many of the other elements in the scene.

The key/fill concept works because, just as in daily life, there has to be some source of light. This does not mean that there is just one source or just one key light; there may be many. There may not be just one fill—there may be two or 20. There may not be a backlight as we have defined it. There may be a light used for that function as well as others. But these basic lights are going to exist. All of them will not necessarily be in every shot, but the concepts are nevertheless fundamental.

12-2

Exposing for the fill side overexposes the key side.
Ivan Passer's *Cutter's Way* (1981)

I once worked on a film in which a group of characters walked down a carnival midway at night. What would be the source of light? Obviously, there was more than one. As they passed every hotdog stand and ring toss parlor, we created some kind of light to expose them the way we wanted. Sometimes the light from the hotdog stand was filling while the ring toss keyed. Occasionally, the characters passed through a darkened area. And this was only the starting point.

When you approach the lighting of a shot, you generally have something in the frame that you consider most important. Often you want that subject—let's say it's a person—to be normally exposed; and if you do not want the person normally exposed, the same reasoning applies. The amount of light you have on the person you want normally exposed is then going to become the dominant light value. Thinking of the key light as being this dominant value helps us plot out all the other values.

In other words, once you have set the key, you have established the value for which you are exposing the scene. If you key someone to $f/5.6$ and want that person normally exposed, you are going to shoot at $f/5.6$. This may seem like backward logic, but once the f-stop has been determined, you can decide where you want all of the other values. If you have another area or object that you want normally exposed, you will light that to the established value, and so on. Once you figure out what you want normally exposed, all of the other values will fall in line. How do you want to fill it? What do you do for backlight?

High-key and Low-key

The terms *high-key* and *low-key* refer to types of lighting (not to the position of the key light) and have standard definitions that you should know.

High-key

Even, fairly flat lighting is known as **high-key** lighting. One could call it nonjudgmental lighting. There is little contrast between the darks and the lights in the image, a large part of which exists within a fairly neutral range. Writers on films usually associate high-key lighting with musicals and comedies. It is used when we

do not want the quality of the light to dominate what is occurring in the image or to imply judgments that are not associated with the subject. In other words, we do not want the lighting to contradict what the image is doing. Some have called this lighting Rockwellian because it gives an even sense of well-being and normalcy, like the works of the American painter Norman Rockwell.

Low-key

The opposite of high-key, **low-key** lighting is moody and atmospheric and might be considered judgmental. There is contrast within the image and therefore a significant play between the lights and the darks. **(SEE 12-3)** Low-key lighting is often associated with horror films, mysteries, psychological dramas, and crime stories. The German filmmakers of the 1920s were pioneers in their experiments with the expressive qualities of light in film. Certainly, the apex of low-key lighting in American film came in the 1940s and 1950s with a group of films called *film noir* (discussed in the next section).

Again, these are basic definitions. These types of lighting are the conventions, and their use has become somewhat clichéd, from the moody lighting of Dracula's castle to the sunny atmosphere of a romantic comedy. Still, at least in terms of conventional narrative films, high-key and low-key are the choices, and nearly all variations at least recognize these limits.

More-adventurous directors will stretch the conventions—witness many of the family scenes from Alfred Hitchcock's *Shadow of a Doubt* (1943). The high-key images of uncomplicated small-town life are undermined by the viewer's— and eventually one of the characters'—knowledge that the beloved Uncle Charlie (Joseph Cotten) is a killer. One scene that takes place on the family's sunny front porch could be an image from any Rockwell tableau. **(SEE 12-4)** In Hitchcock's hands the scene is invested with a dark undertone. The parameters of the conventions are being played with. It is not so much whether the conventions exist as what you do within them and how you manipulate them.

Occasionally, you will see European cinematographers break down light into three distinct categories rather than the two that Americans use. Low-key remains the same, but what Americans call high-key is referred to as *normal-key*. When Europeans use the term *high-key*, they are referring to overly bright, or *overexposed*,

12-3

The contrast between light and dark in a typical low-key image.
Orson Welles's *Touch of Evil* (1958)

12-4

Stretching the conventions of lighting.
Alfred Hitchcock's *Shadow of a Doubt* (1943)

images. Ingmar Bergman's *Persona* (1966) uses this approach to great effect. Virtually the entire film is shot slightly overexposed. This **overexposure** gives the film an unrealistic tone, and the characters, as well as the audience, always seem to be squinting, almost overwhelmed by the act of trying to see. The final sequences of Stanley Kubrick's *2001: A Space Odyssey* (1968), in which the aged astronaut wanders around his brightly lit living quarters, is another example of an expressive use of an overexposed image. The last shot of Oliver Stone's *Platoon* (1986), in which the main character is lost in the sun as the helicopter flies away, is also a good example.

Given American filmmaking's fascination with pictorial realism, the use of significant amounts of overexposure has not found wide acceptance. On the other hand, **underexposure**, which yields dark areas in the shot, replicates common perceptual experience and is frequently employed. Overexposure does not mimic routine perceptual experience, an exception being the painful adjustment to strong light after emerging from a dark space (such as a theater). As such, the strongest association with overexposure is probably pain, so its relative exclusion is understandable if not entirely justified.

In discussing low-key and high-key lighting, we in some sense return to the key/fill relationship. Intensity of the fill light in relationship to the key light goes a long way toward determining the general character of the image. If the fill is close to the key in intensity, the shadows will be light and the shot will be high-key. If the fill is much less intense than the key, the shadows will be darker and thus the shot more low-key. The distinction suffers somewhat because key and fill are generally discussed in relationship to figure lighting, whereas high-key and low-key are used in terms of the whole image. Nevertheless, the relationship of all light values, particularly the fill, to the dominant value is a factor in determining the overall character of the image.

Lighting Styles

Lighting styles are difficult to categorize. The possibilities are so limitless that even within a single film there may be many different approaches. Certainly, such terms as *high-key* and *low-key* are helpful. Terms like *texture* and *mood* may also apply. Depth and dimensionality play a role in a film's overall approach to the subject it is covering. Lighting can also be used to direct viewer attention to bright areas of the frame and to focus it on specific parts of the image.

The most significant trend in lighting has probably been film noir, a style that advanced the use of an expressive image in American films. Noticing a trend in the films that flooded their screens just after World War II, the French coined the term *film noir*, roughly translated as "dark film," to describe a body of films that were very dark and pessimistic in both their content and their low-key look. **(SEE 12-5)** These films created a claustrophobic, nightmarish universe filled with guilt, hysteria, and moral ambiguity. Film noir's use of dark and foreboding visuals and stark, unorthodox compositions put Hollywood film in the same arena, albeit belatedly, with many of the radical formal concerns of modern art.

Highly influenced by the detective fiction of Dashiell Hammett, Raymond Chandler, and James M. Cain, film noir has been identified as a style and trend that appears in a wide variety of genres.

12-5

Classic film noir created a dark, claustrophobic visual environment.
Edward Dmytryk's *Crossfire* (1947)

In films ranging from Michael Curtiz's *Mildred Pierce* (1945) to Joseph H. Lewis's *The Big Combo* (1955), noir represents Hollywood's most extensive experimentation with an expressive image. What was being expressed was much stronger on a visual level than the stories, which were still bound to a certain extent by the Hollywood tradition of the happy ending. The grim visual and moral world that such films created largely negated any neat narrative closure or cheerful conclusion.

Film noir is possibly the most chronicled of Hollywood's stylistic and thematic trends. It has also been of great interest to modern cinematographers, particularly after a period of generally bland productions in the 1950s and early 1960s. Many American and international cinematographers have been greatly influenced by noir stylistics because the approach allowed them to do their most challenging work. The image in classic Hollywood film prior to noir, in its own way a high point in the art of cinematography, was still generally a vehicle for performance, setting, and action.

In film noir the image became such an integral and expressive part of the presentation that it often overpowered content elements. The interest in noir and the expressive image on the part of a new generation of cinematographers produced what might be called the great age of modern cinematography, a period in films that stretched from roughly the late 1960s to the early 1980s.

Bernardo Bertolucci's *The Conformist* has examples of some of the most adventurous images in color cinematography. The film's dark tone gives a nightmarish visual representation of fascist Italy in the late 1930s. Cinematographer Gordon Willis was responsible for great modernizations of noir stylistics, particularly in Alan J. Pakula's *Klute* (1971) and Francis Ford Coppola's *Godfather* films.

Jeff Cronenweth's cinematography for David Fincher's *The Girl with the Dragon Tattoo* (2011) has many exceptional examples of noir color cinematography. **(SEE 12-6)** An excellent blend of content and formal approaches, the film is a great exploration of modern film noir stylistics.

This trend toward modern noir interpretations seems to have been followed by an equal interest in color and design, as represented in such films as Ridley Scott's *Blade Runner* (1982) and television series like *The X-Files* or the *CSI* franchise. The pursuit of an expressive image remains consistent and fuels much of the work of the lighting crew and the DP. The light that you create will always be an important factor in defining the content and the character of the image.

12-6

Modern film noir color cinematography.
Daniel Craig and Christopher Plummer in David Fincher's *The Girl with the Dragon Tattoo* (2011)

Types of Lighting Instruments

A tour of a lighting equipment rental company would probably leave you struck by the sizes and the variety of lights available. In the industry, lights are called **instruments** to distinguish light-producing equipment from the light itself. Although there are many specialized instruments, only a few need be known from the outset. Most conventional instruments are standard movie tungsten lights. They have a rating of 3200 degrees Kelvin and have the standard tungsten filament within a enclosed glass sleeve. The sleeve should never be touched, but handled with paper or foam packaging.

The biggest recent trend in portable lighting is the LED instrument. It incorporates multiple small LED bulbs within a housing that groups and directs their light. **(SEE 12-7)** They create a good hard directional light and are immensely efficient. A 650 watt instrument produces twice as much light as a Tweenie, a similarly rated tungsten instrument. For those concerned with carbon footprints, these new lights promise to bring moviemaking to a new level of energy efficiency.

These instruments are really quite remarkable in a variety of ways. They produce minimal heat, making for a far more comfortable shooting environment. Many makes have fully controllable color temperature adjustments, with a dial on the back of the instrument to pinpoint within a few degrees your desired number. Matching color sources becomes a more simple process than that which will be described in later chapters. Many makes also can be WiFi controlled, so you can set color temperature values and program light values from almost any mobile device. They have not yet broken the barrier of the really big movie lights but they are great for small effects and small shoots and will continue to get substantial use as their capabilities increase.

Another advancement that has made dealing with color temperature easier is the development of **HMI lighting**, a line of daylight–color temperature instruments. Their use by professional crews has increased dramatically over the years even though the instruments are complicated and expensive to use. Most of them run on 240 volts and can be used only with crystal cameras. Although you probably will not have a chance to use them as a novice, you should be aware of their existence.

Generally speaking, lighting instruments are either focusable spots or floodlights. This distinction parallels the difference between two types of light: specular and diffused. Focusable spots and floodlights have characteristics respectively that make them useful for establishing key and fill. Key light has been defined as a strong beam of light casting harsh shadows, and fill light as a soft piece of light brought in to fill those shadows. Focusable spots are frequently used as key lights, and softlights as fill lights, but these are traditional roles, not hard-and-fast rules. There are many situations in which a filmmaker might use a softlight as a key if that is the quality of light desired. So although the key/fill distinction between spots and floods is useful, remember that it is not ironclad.

Specular light is direct light and is generally produced by focusable spotlights. The best example of specular light is the sun. Light rays from the sun are parallel, and on a clear, bright day they create harsh shadows with well-defined edges. **Diffused light**, on the other hand, is light that has passed through a medium, such as clouds, or that has reflected off of a textured surface. It is indirect and is generally

12-7

LED instruments have multiple bulbs for a large accumulated value.
© flolight.com

produced by floodlights. Some hard surfaces, of course, do not diffuse light. If the light hits a uniformly smooth and reflective surface, such as a mirror, it will remain specular. If the surface is rough or absorbent, the light will be diffused.

The DP is responsible for determining the type, size, and quantity of instruments needed. In this, he or she is assisted by the **gaffer**, a key crewmember who heads the lighting crew and is responsible for the technical implementation of the DP's lighting plan.

The following discussion outlines the types of lights available to most small projects. Again, if you go to a rental house, you will see a number of other types as well. As your projects become more sophisticated, you will use more-specialized instruments, although most of them are either so specialized or so big that you will not have access to them while you are learning the field. The bigger lights usually have substantial electric power requirements, requiring a trained electrician and/or a powerful generator.

Focusable Spots

There are two types of **focusable spots**: open-faced and lensed. Lensed instruments have a glass lens through which light passes; open-faced instruments do not. Focusable spots of both types have a single bulb called a **lamp**, which is usually seated in a ceramic base. The lamp and its base are mounted in a spherical reflector coated with a polished silver material. Most open-faced and lensed focusable spots come with **barn doors**, adjustable black metal doors that are mounted on the front of the instrument. They are used to cut and shape the light as well as eliminate unwanted **spill**, a term you will hear quite frequently that refers to excess light from an instrument.

Both open-faced and lensed focusable spots are called focusable because the operator has the ability to spot and flood the light's beam. In the *spot* position, the energy of the lamp is focused in the center of the beam, where it is narrow, intense, and hard. Away from that intense center, the volume of light drops off rapidly. This drop in intensity, from either the center of the beam or the instrument itself, is called **falloff**. In the *flood* position, the energy of the lamp is spread out more evenly; it is wider, not quite so intense, and softer than in spot, so the falloff is considerably slower.

A knob on the instrument, usually on the back, controls the movement of the ceramic base and the lamp against the reflector. Turning the knob back and forth controls whether the light is spotted in or flooded out. As the lamp moves away from the reflector, the instrument floods out. As it moves closer to the reflector, it is spotted in. A small number of instruments employ the opposite strategy, and in some designs both the lamp and the reflector move. **(SEE 12-8)** Spot and flood are important ways of manipulating both the quality and the volume of light from a focusable spot.

Open-faced focusable spots *Open-faced focusable spots* are characterized by a bare lamp with no lens. **(SEE 12-9)** The light they produce is a little more difficult to control than that from a lensed instrument. Open-faced instruments create a big, hard, fairly general beam of light and are often used when precise manipulation of light is not critical. They are difficult to use, however, when the goal is to cut out part of the light for a shadowy or low-key effect. In such cases open-faced spots require a great deal of work for the desired effects.

A minor drawback of the open-faced design is that direct light from the lamp mixes with light bouncing from the smooth, hard reflector. **(SEE 12-10)** Light thus hits the subject from several different directions, creating shadows that are not hard enough for some applications. A subject lit by an open-faced instrument has a harsh

12-8

Basic mechanics of lighting instruments.
© Cengage Learning

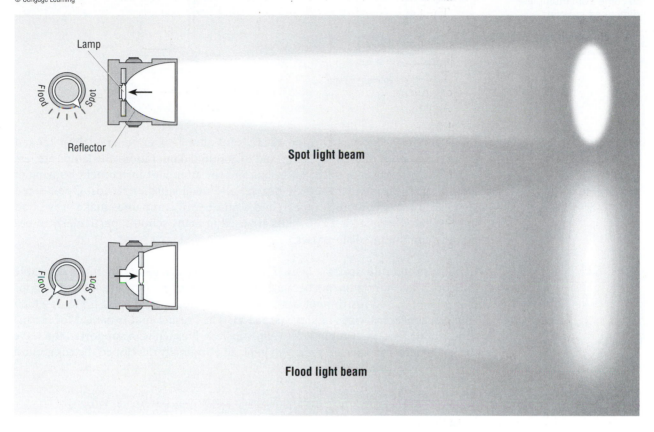

Lamp

Flood

Spot

Reflector

Spot light beam

Flood

Spot

Flood light beam

12-9

Open-faced instruments produce a big, hard, fairly general beam.
© Cengage Learning

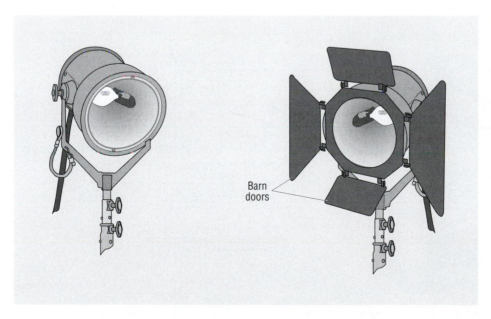

Barn doors

shadow mixed with less distinct shadows caused by light from the reflector. Light appears to bend and wrap around objects, though it actually does not. Open-faced instruments produce harsh shadows but without the hard edges associated with light from a single source.

12-10

The reflector causes light to come from multiple directions, creating indistinct edges to the shadows.
© Cengage Learning

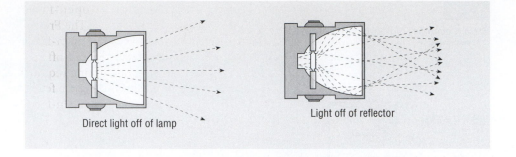

Direct light off of lamp Light off of reflector

On the other hand, open-faced spots are less expensive than lensed instruments both in original outlay and in continued operation (the lamps are less expensive). The weight of the glass lens and the attendant instrument housing of lensed lights means that they are heavier and need sturdier stands. Open-faced spots are generally more compact, and a number of companies make very good lightweight, portable kits. These kits are used in many schools, particularly in beginning and intermediate classes.

Lensed focusable spots *Lensed focusable spots* are generally more desirable than open-faced instruments because they are easier to manipulate. The most popular type of lensed instrument has a **Fresnel** (pronounced "fre-NEL") lens, which employs concentric rings of glass. **(SEE 12-11)** The Fresnel spot is named for the inventor of its lens, French physicist Augustin-Jean Fresnel, who supported the wave theory of light, investigated polarized light, and originally developed the compound lens for use in lighthouses.

12-11

The most popular lensed focusable spots use a Fresnel lens, named for its inventor.
© Cengage Learning

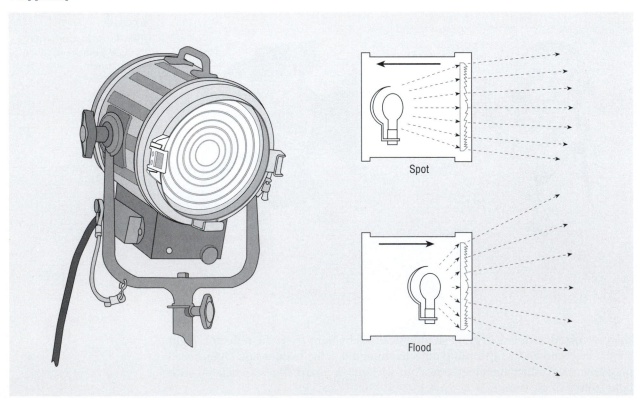

Spot

Flood

Lensed lights have the same bulb and reflector design as open-faced instruments, but the lens redirects the light into a single specular beam. The Fresnel lens eliminates the multiple sources and the indistinct shadows of the open-faced instruments, allowing easier manipulation for hard shadow effects (fast fall-off).

Whereas open-faced kits are usually satisfactory for general lighting requirements, lensed instruments are relatively inexpensive to rent, and obtaining a few of them for the more discriminating effects can be a good approach, using open-faced instruments to light peripheral areas if necessary.

Floodlights

Floodlights, so called because they produce diffused, indirect light, are of three basic types: scoops, broads, and softlights. Scoops and broads have limited uses in filmmaking, whereas the softlight is popular and can be used very effectively in location shooting. One important characteristic of floodlights is that they create indistinct shadows or almost no shadows at all.

Scoops Big instruments with large parabolic reflectors, scoops have a single bare lamp but present so much reflecting surface that the light emitted has no single source. **(SEE 12-12)** Scoops produce a big, general piece of light that is difficult to control. Because they are large, heavy, and difficult to manipulate, they are not very popular in location film production, but they are often quite useful as permanently mounted lights in studios.

Broads Broad lights are somewhat more common than scoops in film production. Broads are characterized by a long, bare, cylindrical lamp seated in a shallow reflector. **(SEE 12-13)** Although this design would seem to produce direct light, broads actually create diffused light because the filament is long, creating many sources. Focusable spots, in contrast, have a pear-shaped lamp with a single

12-12

Scoop lights incorporate such a large reflecting surface that the emitted light has no single source.
© Cengage Learning

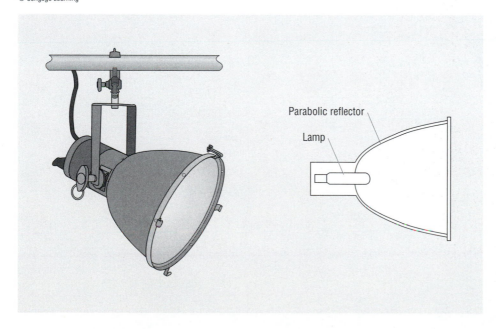

Parabolic reflector

Lamp

Broad lights produce a large, fairly diffuse light.
© Cengage Learning

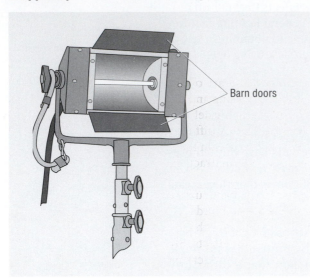

Barn doors

filament, creating a single source. Many broad lights diffuse their light further with a frosted glass lamp or a textured reflector.

Of all the lights, the broad is probably the least controllable—it just creates a large, diffuse piece of light. Yet it is more popular than the scoop because of its small size—usually less than a foot long—and because it can be shot into a variety of reflective surfaces. Used in that way, a broad light can create a nice general fill for a shot. Broads are much better for bouncing than are focusable spots because they distribute their heat across the length of the lamp. Focusable spots concentrate their light and heat in the center of the beam; and if the instrument is spotted in all the way, materials can actually catch fire. By comparison the broad has proved itself very effective and safe in shooting into a variety of materials.

Softlights The compact size and the portability of softlights, by far the most popular of the floodlights for filmmaking applications, make them ideal for location work. *Softlights* are similar to broads in the design of the lamp housing—a long, cylindrical lamp mounted in a shallow reflector—but, unlike a broad's lamp, the lamp of the softlight is hidden from view in the base and it shoots light from below into a spherical white or silver reflector, called a *shell*. **(SEE 12-14)**

Light from the softlight comes from reflections off of the shell and is very diffused. Softlights produce a soft, even, almost shadowless light, which can be handy when trying to avoid the multiple shadows that plague lighting crews.

12-14

Softlights emit a very soft and even, almost shadowless light.
© Cengage Learning

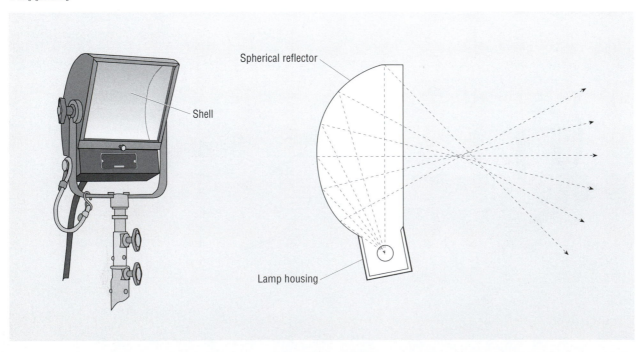

Spherical reflector

Shell

Lamp housing

Other Sources of Light

Three other light sources—ellipsoidal spots, practicals, and reflectors—are not as common as focusable spots and floodlights but can prove quite useful.

Ellipsoidal Spots

Commonly referred to as *lekos, ellipsoidal spots* are barrel shaped and are often, though not always, equipped with Fresnel lenses. Due to their lamp housing and reflector design, ellipsoidal spots produce hard, specular light, creating highly defined shadows. **(SEE 12-15)** Even Fresnel instruments create shadows with slightly diffused edges, but the leko allows virtually no diffusion. Lekos are difficult to use on foreground subjects, however, because the light they produce is hard and unattractive, at least for people or objects of interest.

Lekos are generally used to create hard-edged lighting effects, particularly patterns and designs on backgrounds, such as prison bars and venetian blinds. To accomplish this, there is a slot just behind the shutter for inserting plates with cut-out designs. With filters in the pattern slot, lekos can also produce color effects. Ellipsoidal spots get more use in television studios and traditional stage productions than in film, but there are many applications for them on-location.

Practicals

Resembling standard light bulbs in shape and function, *practicals* are bigger and more powerful than their household counterparts. There are several types of practicals, but most are in the 250-watt to 500-watt range, with the bigger ones usually the bell-shaped photoflood type.

12-15

Ellipsoidal spotlights (lekos) produce hard, specular light and highly defined shadows.
© Cengage Learning

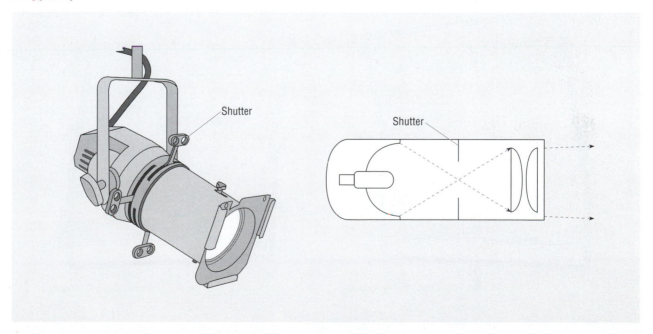

Practicals are screwed into standard household sockets, such as table and floor lamps and ceiling fixtures, and are used to duplicate the light emitted, for example, by a typical living-room lamp or other ordinary fixture. Practicals are necessary because standard household bulbs burn redder than do standard motion picture lights. If they do not match the color of other instruments, color quality would be problematic. (See the discussions of color temperature in chapters 8 and 15.)

Although they are most often used in lamps, practicals are also handy for screwing into fixtures outside of the frame for general fill in a scene. If there is a ceiling fixture in a room, a DP can screw a practical into it to give a certain level of light in the room. Practicals can be employed for a variety of purposes, particularly in location shooting.

Reflectors

Not instruments per se, *reflectors* are used frequently, especially in exteriors. The most sophisticated are called *reflector boards,* which pivot in a U-shaped holder. **(SEE 12-16)** One side of the board is a hard surface that reflects specular light; the flip side is often divided into sections or is textured to provide a softer fill.

Reflectors are most often used to reflect sunlight into shadows when shooting outside. They are particularly handy for producing fill light for characters. Small reflectors are popular for many situations, and some very large ones are generally used on wider shots.

There are other types of reflectors, including handheld boards. *Foam core,* a material used in picture framing, is one of the most popular inexpensive "bounce boards." On-location it is common to see a grip following a scene with a board in hand; light coming from the board punches up the characters just a little bit. Reflectors can be handy for saving the time and the bother of setting up an electric instrument to accomplish a simple fill effect.

12-16

Reflector boards are two-sided, to provide both hard and softlight.
© Cengage Learning

Hard side (smooth surface) Soft side (textured surface)

Light Meters

In the age of digital photography and video, the need for the good old-fashioned handheld light meter has fallen off dramatically. If you are shooting motion picture film, however, they are an absolute necessity. A number of videographers continue to find them useful as well, although waveform monitors (see chapter 15) are often the tool of choice for high-end videography. Demand has fallen off for handheld light meters to the extent that there are only a few manufacturers—Spectra, Sekonic, Kenko, and Gossen—that still provide the ones commonly used in the industry. Minolta, which got out of the photography industry in 2006, used to produce a spot meter and a color temperature meter that, if you can find used ones, are very much worth getting your hands on. Kenko has picked up the manufacturing of these, so they are available new as well. There are also meters available for specialty shooting, such as underwater meters (yes, you have to measure light underwater).

There are two approaches to light measurement: one measures incident light and the other measures reflective light (many meters also have flash and ambient capabilities). In measuring **incident light**—light that falls on a subject—a light meter is held at the subject and pointed toward the camera. From this position the meter determines how much light is falling on the subject. In measuring **reflective light**—light that bounces off of the illuminated subject—the opposite approach is taken. In its most simple application, the meter is held at the camera to determine how much light is being reflected from the subject back to the camera lens.

Many cameras, particularly still-photography cameras, have light meters built into the viewing system; these internal meters are called *through-the-lens (TTL)* metering systems, and they read reflective light. Such metering systems have shortcomings that make them of limited use to film professionals as well as still photographers. The kind of general light readings they produce—readings of large areas, that is—do not provide particularly useful information in interpreting both how to set exposure and what lights need to be setup. For this reason incident meters are the standard on virtually all film sets. Once you learn how to understand reflective readings, however, they can be quite helpful.

The *spot meter,* a type of reflective meter that measures light in a very narrow angle, can provide valuable information and is used extensively on professional sets. The user sights through a viewer, much as a gun is sighted, and reads the light in a very small area. The target in the viewer is usually a small circle, and the angle in degrees of the area read is called the *angle of acceptance*—usually around one or two degrees. While many people get by fine with just an incident meter by itself, incident-light readings in conjunction with spot meter readings give a very well-rounded snapshot of light values in determining lighting and exposure.

Except for spot meters, handheld light meters can usually measure either reflective or incident light. In the incident approach, there is a white hemisphere that measures light in a 180-degree radius, the bulb simulating the shape of a human face. Many light meters also employ a white, flat incident disc or some similar strategy for measuring individual light sources. Though measuring the light produced by individual instruments is standard procedure, I rarely use the flat disc, preferring to turn off the offending source or shade the bulb from it. Meters typically come with the white bulb for reading incident light, as well as an interchangeable flat grid for reading reflective light. You insert either the bulb or the grid, depending on which kind of light you need to measure. Gossen has a number of meters that come with a white disc that slides out of the way when you want to do a reflective reading.

Light meters have two significant functions. The first is to measure light; the second is to compute that measurement into an f-stop. Older analog meters have a computer (primitive by modern standards) to translate the reading. Modern meters have an actual on-board computer to do the same. Most contemporary light meters are digital or at least give their displays in LED readouts. The Spectra Digital Pro IV

12-17

Spectra Digital Pro IV light meter.
© Cengage Learning

12-18

Sekonic L-508 incident/spot light meter.
© Cengage Learning

is a typical example. **(SEE 12-17)** The display area gives an LED reading of all pertinent information. The Sekonic L-508 meter, which combines the functions of an incident and a spot meter, is also very popular. **(SEE 12-18)** The function is switchable between the white disc of the incident meter and the side sighting through the spot meter.

Although very few analog light meters are still available, learning on one can be highly useful. All of the responses to light and the figuring are right there on the front of the meter for the user to observe and comprehend. A number of digital meters do not display the full range of light values—they skip over numbers—and all translations are hidden in the works. As with many things computerized, however, digital meters are highly satisfying. You stick the meter out, and it gives you an f-stop that, unless you have really messed up, is always in the ballpark. As we will come to see, however, being in the ballpark is useful only in the most unsophisticated approaches. Understanding lighting requires a high-level comprehension of how all of the elements on a light meter interrelate. Once you understand the fundamentals of lighting, digital meters give you all you need to know, but a holistic understanding is required. Spend a few days on an analog meter and you will not regret it.

12-19

The Sekonic L-398 is a typical, analog-display light meter.
© Cengage Learning

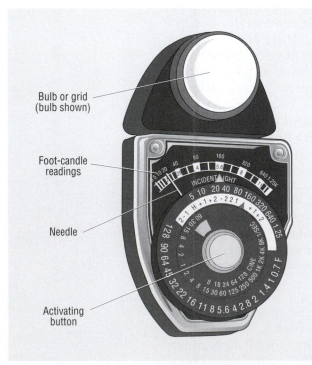

Bulb or grid
(bulb shown)

Foot-candle
readings

Needle

Activating
button

Analog meters typically have a highly sensitive mounted needle that shows the response to the variations in light. The sensitivity of the needle is referred to as the meter's *ballistics*. The Sekonic L-398, shown with the hemispheric incident bulb, is an analog light meter that is still produced. **(SEE 12-19)** The scale in the middle of the light meter displays the measurement of the amount of light present in the scene. The button in the center of the dial activates the needle, which renders the amount of light in foot-candles.

The term **foot-candle (fc)** refers to the amount of light that falls 1 foot in any direction from a

burning candle. A foot-candle is a standard unit—like an ounce, a pound, a foot, or a mile—for measuring a volume of light. If the light meter reads 20 fc, it means there is 20 times the amount of light as can be found 1 foot from a candle. People sometimes have a hard time grasping the fact that light is measurable, but measuring the light in a room and finding 20 fc is just as certain and objective as measuring the width of the room and finding it to be 12 feet across. It is certain and objective, at least once you understand the complexities of using the light meter.

Although digital-display meters that provide a quick *f*-stop are attractive for beginners, an understanding of foot-candles is critical to an integrated comprehension of the fundamentals of lighting. Many high-end digital meters can be programmed to display in foot-candles; and while it is quite instructive to watch an analog meter's needle physically respond to different amounts of light, a digital meter is more than adequate. Either way, learn to measure and think of light in foot-candles because you will eventually be required to understand them and it helps you think about light in terms of shifting volumes. Once it is ingrained, reading in foot-candles will generally be unnecessary, and you will eventually find that most crews communicate in *f*-stops (or, actually, in *t*-stops, which are discussed in chapter 12).

The Computer

As stated, the first function of an incident-light meter is to measure the amount of light in an area. The second function is to translate the foot-candle reading into an *f*-stop, usually one that will produce a normally exposed image. On the Sekonic L-398 light meter, the dials on the bottom are used to set the EI and eventually to determine the *f*-stop and the shutter speed (for still photography). Manufacturers call this the light meter's *computer;* again, digital meters have actual ones on-board with all of the variables programmable. The EI is the first thing to set on any light meter. The meter usually has a window that displays the range of EI numbers, and you simply dial to the number that the film stock's manufacturer recommends. **(SEE 12-20)**

Many light meters are also used by still photographers and thus have a scale with the full range of shutter speeds. Because shutter speed in motion picture photography is determined by frames per second (fps), a scale with fps numbers, generally called the *cine scale,* is either provided or interrelated with the still-photography numbers. The numbers pictured here are the frame rates commonly used in filmmaking. **(SEE 12-21)**

12-20

The film stock's EI is the first thing to set on a light meter.
© Cengage Learning

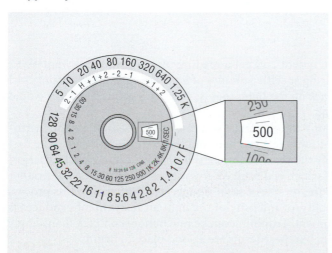

12-21

The cine scale gives the frame rates commonly used in filmmaking.
© Cengage Learning

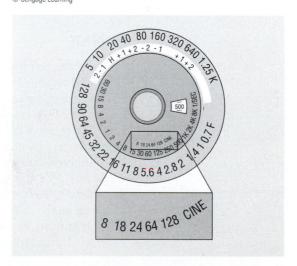

12-22

To find the *f*-stop, set the foot-candle reading; the cine scale moves against the *f*-stop scale to yield the value for a normal exposure.
© Cengage Learning

CINE	8	12	18	24	36	48	72	96				
2		2.8		4		5.6		8		11	16	22

To find the *f*-stop, the L-398's computer has a moving scale to set the foot-candle reading that the light meter has given. As this is set, the cine scale moves against the *f*-stop scale. Once the foot-candle reading is set, the *f*-stop that will produce normal exposure for that foot-candle value is displayed directly below the frame rate. **(SEE 12-22)** Many meters also have functions to memorize and/or average a series of readings.

Although this procedure yields simple *f*-stops, the process of metering and determining *f*-stops is far more complicated than this. The goal, which is developed in the following chapters, is to be able to evaluate and control a complex image that has a wide range of lights and darks.

Manipulation of Lights

Manipulating the lights means changing the volume, the pattern, or the quality of the light to suit your purposes. A common example of a situation in which you might want to manipulate a light is when you want to soften or diffuse a hard light without going all the way to a softlight. Another case is when you want the light to have a different feel, say, warmer or multifaceted. The most common situation is when you simply have too much or too little light to achieve the desired effect.

The primary way to manipulate light is in your initial choice of instruments. You will be working with the two basic types—focusable spots and floodlights—which produce two different kinds of light: direct and indirect, respectively. Once you have the instruments, you still will be constantly changing and adjusting them to create the exact effect you want. Taking an example of an instrument that is producing too much light for a scene is a good starting point.

Problem

Let's say you setup an instrument and get a reading of 160 fc but you want 40 fc. (Potential reasons for desiring specific volumes of light are covered in chapter 14.) In this case you want to *back off* the light, that is, make it less intense. How would you deal with this situation?

There are many options and materials you can use to manipulate the instruments. Seven potential solutions are given here, but there are many others. The first three solutions are probably the most common; the last four can create a variety of side effects, the severity of which is discussed. If you want to *bring in* a light rather than back it off, simply do the reverse of what is suggested. Either way, this process of changing the shape, quality, or intensity of the light an instrument produces is called **trimming** the instrument. Trimming can be much more complex than simply backing off and bringing in, but these terms are a good place to begin.

Solutions

Move the light back This solution is straightforward. Have an assistant stand at the subject with a light meter, keeping the activating button depressed. As the instrument is moved back, the needle or readout will respond to the lower volume of light. Just move the instrument back until you achieve the desired foot-candle value. This is most easily accomplished with an assistant, as are most things in lighting. If you try to do it alone, you will find yourself running back and forth from light source to subject—a physically wearing and unnecessarily time-consuming proposition.

Flood out the light If you are using a focusable spot, it will have a spot/flood capability. In the spot position, the greatest amount of light is concentrated in the center. When you flood the light out, you widen the beam and, consequently, have less light in the center. Keep the activating button depressed as you flood the light out, and the meter will tell precisely how much the light falls off. Just flood it until you get the reading you want.

Use modifying material in front of the light Modifying materials come in many forms and work in various ways, from simply cutting down the amount of light to significantly altering its quality, which most manufacturers call *redistributing* the light. Wooden clothespins are used to attach materials to the barn doors; such materials can be used to cover all or part of the light. Commonly used modifying materials include the following.

■ **Scrims** Made from a metal screenlike material, scrims cut down the amount of light without significantly diffusing it. Usually, these are designed for a specific make of instrument and slip into a holder between the barn doors and the lamp itself.

A C-stand rigged with a net, used to cut down the volume of light.
© Cengage Learning

■ **Silk** A white artificial material that resembles its namesake, silk cuts down the volume of light and strongly diffuses it. Coming in a variety of sizes, silks have metal frames and are usually set in front of the instrument on a **C-stand** *(Century stand),* one of the key pieces of equipment used for setting things in front of lights. Silks made out of real silk fabric are available but are very expensive and require careful handling.

■ **Nets** This material looks like mosquito netting. Nets are similar to scrims, and sometimes the terms are used interchangeably. Constructed like silks, nets are also used on C-stands. **(SEE 12-23)** They come in different shapes and sizes that have exotic names such as *fingers* and *dots.*

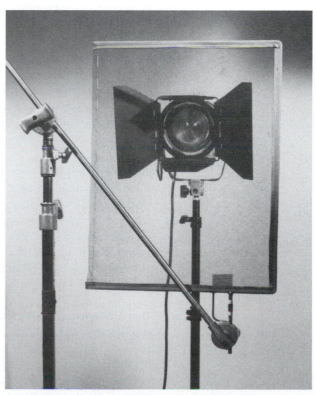

■ **Spun** An artificial spun glass–like material, spun is one of the most popular light-modifying materials for beginners. It cuts down the light as well as diffuses it.

■ **Frost and tough-white diffusion** These are milky-looking diffusion gels (consisting of a cellophane-like material). The use of 216 (one of the tough whites) is common. Both 216 and frost are popular ways of softening and giving a warm feel to lights.

■ **Opal diffuser** This type of diffusion softens the light and is also quite popular. An opal diffuser is similar to frost, but it gives the light a slightly harder feel, as though it were broken down into the facets of an opal gem.

■ **Rolux** Denser than opal, this material cuts down the light tremendously and can make the light source very indistinct. This solution is effective when you want an unlit feel to the image. Because it cuts the volume so dramatically, Rolux is used mostly on larger lights.

■ **Shower curtain** This material, which looks similar to its namesake, is less dense than Rolux but affords the same soft feel.

■ **Tracing paper** Also called *trace,* tracing paper is used for many purposes, but particularly on backlights to diminish the harsh quality of the shadows they create.

■ **Flags** Made of black opaque material, flags are similar in design to silks and nets. Flags are not true modifying materials because they *cut,* or block, the light from individual instruments. Nevertheless they are used in much the same way as many of the other materials, and their role in manipulating light is significant. Like nets, flags come in a variety of shapes and sizes that have names such as *cutters* and *solids.*

■ **Cookies** Cookies—also called *kooks,* short for *cookaloris*—are similar to flags but with cutout designs that break up the light. They are generally selected to lend texture to a background. They are difficult to use on foreground subjects because shadows from their cutouts would be noticeable, but they are very effective in breaking up flat and uninteresting light in other areas of the frame. Like flags, cookies are not true modifying materials but, again like flags, are used in enough situations to warrant a mention here.

Change the wattage of the lamp Within the limitations of the manufacturer's recommendations, almost all lighting instruments accept different wattages of lamps. Lamps with lower wattage obviously produce less light. This strategy is less attractive to many users because taking apart hot lights on-location consumes valuable time and can be dangerous. It is better to think about this in planning a lighting setup. A competent gaffer will think out what kind of space the crew is working in and plan in advance the lamp sizes needed. In addition, manufacturers provide charts that give detailed information about the amount of light produced at different distances in both spot and flood. It is not unheard of to switch lamps on-location, but efficient use of time advises that such decisions be made earlier rather than later.

Bounce the light Bouncing the light is a possible solution, but it carries some liabilities in that the quality of the light is so different from what you started with that it significantly changes the shot. That said, there are many surfaces that serve as good vehicles for bouncing, from white walls and ceilings to specially designed reflectors and the previously mentioned foam core. The practice of bouncing light is very common, but more as a source of light than a modification of it. If your goal is to modify a light from 640 fc to 320 fc, bouncing the light could create a more radical change than you want in terms of both amount and quality.

Use a neutral density filter A gray gel that cuts down the amount of light passing through it, a *neutral density (ND) filter* does not change any color quality, nor does it diffuse the light—it just cuts the amount of light from the instrument. ND is available in filters rated at 0.1, 0.2, 0.3, and so on; each tenth represents one-third of an f-stop. Thus, a 0.3 equals one stop, a 0.6 equals two stops, and a 0.9 equals three stops. Usually, people just drop the point, so a 0.3 filter is called an ND3.

Although a few professionals use ND on lights, it is much less useful than may first appear. One general rule of lighting is that the more you put on an instrument, the harder it is to use other modifying materials on it. Neutral density winds up being cumbersome particularly when you put other things in front of the light as well, and its use is not widespread. ND does have many other important applications, however, such as in window gels (see figures 15-12 and 15-12) and as front filters on lenses.

Focus the light so the subject is off center By closing the barn doors or panning the light, you can position the light so that the subject is not in the center of the beam. This is often the first thing people want to try, yet it is not a particularly viable solution. Most often the subject simply looks unlit, as if the light is shooting past it or it is sitting outside of the beam (which, of course, it is). This is the kind of effect that calls attention to lighting and can appear to be very artificial.

Another technology that is available is theatrical *dimmers*. Though they may seem useful for backing off lights, their application in film is somewhat limited. The big problem with dimming is that when voltage to the instrument is reduced, the color of the light—the color temperature—changes. On occasion, filmmakers use instruments on dimmers very successfully to create peripheral light, that is, light on the background and/or foreground. But if dimmered light is used on the main subject, particularly people, unwelcome effects may result. You need to know your way around color temperature to work with dimmers effectively. That said, there are many cinematographers, Vittorio Storaro being perhaps the best example, who use them extensively. Understanding what you are doing with them is the key.

These are some of the main options available for manipulating light. Once you get the instruments setup, the object is to adjust them until you get the values and the quality of light you want. Keep working with the instruments and the materials. Experience will be your best teacher.

13

Exposure and Latitude

Exposure Index, Foot-candles, and *f*-stops

Although there are a number of considerations in choosing a film stock, *exposure index (EI)*—the rating of film's sensitivity to light—is often the determining factor for beginners and those with limited resources. It harks back to the key distinction made earlier: use a film stock with a high EI when filming in low light and, conversely, a stock with a low EI in high light. Given their ability to manipulate light in almost any way imaginable, however, experienced DPs can use whatever film stock they want and simply light for it.

The EI of the film stock that was chosen is the key variable in the relationship between a given amount of foot-candles and an *f*-stop. Once the film stock is determined and the EI on the light meter has been set, the translation of specific foot-candle readings to *f*-stops becomes automatic. With this in mind, we can look at a chart that gives the foot-candle–to–*f*-stop relationship for a number of potential film stocks. **(SEE 13-1)** These exposures are the manufacturer's recommendations, all made with normal exposure as the stated goal. There are, of course, other possible EIs.

13-1

The foot-candle–to–*f*-stop relationship for potential film stocks

Foot-candles	EI				
	32	100	125	250	500
5				*f*/1	*f*/1.4
10			*f*/1	*f*/1.4	*f*/2
20		*f*/1/1.4	*f*/1.4	*f*/2	*f*/2.8
40	*f*/1	*f*/1.4/2	*f*/2	*f*/2.8	*f*/4
80	*f*/1.4	*f*/2/2.8	*f*/2.8	*f*/4	*f*/5.6
160	*f*/2	*f*/2.8/4	*f*/4	*f*/5.6	*f*/8
320	*f*/2.8	*f*/4/5.6	*f*/5.6	*f*/8	*f*/11
640	*f*/4	*f*/5.6/8	*f*/8	*f*/11	*f*/16
1,280	*f*/5.6	*f*/8/11	*f*/11	*f*/16	*f*/22
2,560	*f*/8	*f*/11/16	*f*/16	*f*/22	*f*/32

© Cengage Learning

If you are shooting with a film stock that has an EI of 500 and your light meter gives a reading of 320 fc, you would shoot at ƒ/11 to produce normal exposure. If you are shooting with 100 EI film and get a reading of 160 fc, an ƒ/2.8/4 would produce normal exposure; that is read as "2.8 slash 4," and you set the ƒ-stop ring between those two stops.

As suggested, you should probably use the manufacturer's recommended EI, although you will eventually discover that this number is not written in stone. DPs often rate film stock differently because they know they will achieve a specific effect if they do or they will have the lab correct for a different effect. If you rate a film stock higher or lower numerically, you are just building in a consistent level of over- or underexposure. There are limits, of course.

Using the Light Meter

The choice between an incident-light meter and a reflective-light meter represents different approaches to metering a scene. Each approach has its own advantages and disadvantages. For film applications, however, the incident meter is far more useful than the reflective meter.

A hypothetical situation with a person standing in front of a window can illustrate the difference between the two types of meters. Outside the window in the background, a street is awash in sunlight and a building is in the shade. Inside the room on the table is a lamp that is turned on. The room itself is not receiving any direct sunlight, but the left side—that is, the person's back and the bookcase—is receiving strong ambient light. **(SEE 13-2)**

Given the assumptions of the situation, you should see an immediate problem: there is a wide range of light values in this scene, with a relatively dark subject against a brilliant background. Because a standard **reflective-light meter** can be pointed only at

13-2

A wide range of light values in a given scene necessitates the use of an incident-light meter.

the scene as a whole for an average, its readings will not indicate the various amounts of light in different parts of the scene. If you shoot at the *f*-stop suggested by the meter, whatever is lit to that value will expose correctly, but everything else will come in at different and potentially unacceptable exposures. Keep in mind, however, that the spot meter, which is a type of reflective meter (discussed in chapter 12), can be very useful.

So the problem is not how much light is present in the scene as a whole but how much light is on each subject or area. Furthermore, as subjects move in a composition, they also move through exposure. Does the subject get too dark over here? Is the backlight more than we want over there? These questions suggest why the incident-light meter becomes not only the tool of choice but the tool of necessity.

With the **incident-light meter**, you can go through a scene and measure the light in specific areas. The meter can indicate precisely how the light is increasing or falling off. If you walk through the scene with the activating button depressed, as the needle or readout responds you will actually be able to see where the light is above or below the desired amount. Steps can then be taken to compensate.

Although a few film cameras offer a through-the-lens (TTL) reflective-light meter with an automatic exposure option—the camera automatically sets the *f*-stop for the user—few if any professional camera people use it. Automatic reflective meters are too random in evaluating the information they collect. They may work for basic still photography but do not perform to the exacting standards necessary in most filmmaking applications. When you move into video, automatic meters are more prevalent, particularly with DSLRs. This is primarily to serve the knowledge base of the user population with a large number of novice users. As skill increases, control of exposure should evolve into the manual world. Automatic exposure meters do have their uses, particularly in documentary filmmaking, but their value is limited and they should not be used beyond formative efforts.

The example of the person in front of the window provides an instance where training in the use of light meters pays off. To show some simple metering techniques, consider the previous example but eliminate the window. The image is by no means simple, however. Even here it is easy to make some basic mistakes. Again, the lamp is turned on. **(SEE 13-3)**

With the incident-light meter, you measure how much light there is in any one spot. Remembering what has been said about key and fill lighting, go to the person and take individual readings on each side of his face. **(SEE 13-4)** The side toward the lamp is the key side, and the side away from the lamp is the fill side. With the activating button depressed, move the meter around; let's say that the readings shown in the figure are found. In this case, point the meter toward the source rather

13-3

A single source may not provide the light levels required for a usable exposure.

© Cengage Learning

13-4

To take readings on the key and fill sides of the subject's face, point the meter in the direction you want to measure.

13-5

Light levels are measured by moving the meter through the scene.

than toward the camera as was suggested earlier. Generally, when trying to find out what a specific instrument is accomplishing, point the meter right at the source.

As suspected, the reading on the fill side is very low, because it is getting no direct light. When you measure an individual instrument as you have measured the fill here, you have to be careful that the reading is not being skewed by another instrument. Sometimes just blocking the offending source with your hand or a card is all it takes to eliminate the problem. In many situations you can just turn off the instruments that you don't want confusing the reading. Because the lamp is the sole source in this instance, you can't do that here.

The readings around the lamp are also significant. **(SEE 13-5)** You do a general reading and find 320 fc right under the lamp. Let's say you find 640 fc halfway between the lampshade and the table. The light is stronger as you move toward the lamp and weaker as you move away.

Going back to the foot-candle chart in figure 13-1, translate these readings into *f*-stops. If you are shooting with a film stock with an EI of 500, the reading at the top of the lamp base (1,280 fc) translates to *f*/22. That is, if you shoot at *f*/22, the top part of the lamp base will be normally exposed. The 320 fc on the table translates to *f*/11, which would give normal exposure there. It is *f*/22 at the top of the lamp base and *f*/11 on the table.

It is important to note that this is not an evaluative process at this point; it is a measurement process. It does take modest experience and skill to do it correctly, but once you are aware of the pitfalls this is essentially no different from checking the oil level in your car or weighing yourself on a bathroom scale. If there is *x* amount of light in an area, there is *x* amount of light. That does not mean that the light will not or cannot change; it just means that at the time the measurement is taken, there is *x* amount of light. Once you get these readings, you have some decisions to make.

The ability to evaluate, of course, precedes the ability to control, or manipulate, the light. Clearly, if you can find out what a specific light source is reading, you can also introduce an artificial light source and manipulate it to a specific value.

13-6

Anything less than the plateau level (*f*/5.6 in this case) can be thought of as a valley, and areas falling into a valley will be underexposed.

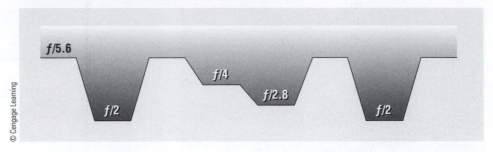

13-7

Additional instruments can illuminate the valleys, bringing those areas up to the appropriate level.

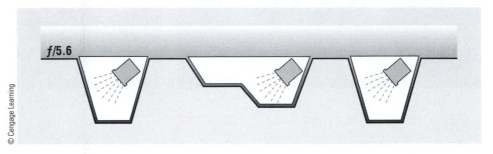

A cinematographer friend tells the story of a mistake he made on one of his first big jobs—lighting a convention hall for a political figure whose speech was getting network coverage. The advance men told him they wanted the hall lit for *f*/5.6. With an incident meter as a guide, one can go through and manipulate the lights to an even *f*/5.6. The cinematographer went into the huge convention hall and proceeded to light the podium. On the evening of the speech, two Secret Service types showed up, took one look at the hall, and angrily stated that my friend had been hired to light the entire hall, not just the podium. In unison, they reached inside their trench coats, and my cinematographer friend had visions of his career coming to an abrupt and violent end. To his relief, rather than producing the anticipated instruments of mayhem, the agents produced light meters. The two men then proceeded to go through the entire hall, reading all the light values. Aha, *f*/2.8 here. Here we drop all the way down to *f*/2. In a sense, *f*/5.6 was the plateau he was supposed to achieve, and anything less was a valley. And by falling into the valley, the shots of the audience and peripheral areas would fall into underexposure. **(SEE 13-6)**

My friend lived to light again, but with more instruments he could have easily accomplished what was wanted of him. With the incident meter, he could determine where the exposure level dropped below *f*/5.6, and he could then set up additional instruments to bring those areas up to the appropriate level. **(SEE 13-7)** He could fill in the holes, as it were. In the areas where he found *f*/4, he needed a relatively small amount of light. Where he found an area registering only *f*/2, he might have to bring in a number of instruments.

You will rarely want lighting that is this even. This is television news lighting—what is often referred to as *illumination*. The point is that you need to go through any scene and determine all of the lighting values present. Second, and of much greater importance, the incident meter is your best guide for manipulating the instruments to achieve the levels of exposure desired. A conventional reflective-light meter can

give only an average of a complex situation, but an incident-light meter allows you to check every source and determine how much light it provides. Again, a spot meter can read specific areas, but interpreting the results takes experience.

The incident meter allows you to be reasonably precise. It gives you more control not only in evaluating but also eventually in manipulating the values that will create the dramatic quality of your images. There can be tricks to evaluating readings but that will be explored later.

Halving and Doubling

So far, the light meter readings used in the illustrations have been either halves or doubles of each other. This has been deliberate to illustrate another important concept:

■ **RULE** Virtually everything to do with the measurement and the transmission of light is based on halves and doubles.

The reason why the numbers that have been presented are the f-stops is that each one represents the discrete and identifiable point at which the light halves or doubles from the previous stop.

Reciprocally, every doubling or halving of foot-candles represents a one–f-stop change. If you get a foot-candle reading in a specific area and then find either half as much or twice as much light in another, there is a one–f-stop difference between those two areas. This means that there is a one–f-stop difference between the 320 fc of the table and the 640 fc halfway to the lampshade. There is a two–f-stop difference between the 20 fc of the key side of the face and the 5 fc of the fill side. The concept of halving and doubling pertains not only to the light in front of the camera but also to the f-stops. Assuming a consistent amount of light in front of the camera, every sequential change from one f-stop to another represents a halving or a doubling of the amount of light reaching the film plane. Thus, if you are shooting at $f/4$ and change to $f/5.6$, half as much light is reaching the film plane as before. If you change to $f/2.8$ from $f/4$, twice as much light is reaching the film plane.

As you may have noticed from figure 13-1, this doubling and halving also includes the EI.

■ **RULE** Every halving or doubling of EI represents a one–f-stop difference.

If you are shooting with an EI 160 film stock and getting a light reading that calls for $f/5.6$, what would happen to the f-stop if you reloaded (and DPs do not make arbitrary changes like this) with a film stock that has an EI of 320? You could, theoretically, reset the f-stop without remetering. What would the new stop be? Would you *open up*, that is, choose a lower-numbered f-stop? Or would you *close down*, that is, choose a higher-numbered f-stop?

Because the EI is going up numerically and the film stock is more sensitive to light, you need less light to expose it. You would close down to $f/8$. If you were to change to a film stock with an EI of 80, you would do the opposite: the film stock is less sensitive to light, so you need more light to expose it; you would open up to $f/4$. In both examples you need to either double or halve the volume of light provided by the f-stop to produce a normal exposure.

Halving and doubling the light may sound drastic, but it is actually a relatively small change in terms of the image. The primary goal at the outset is to achieve a usable image, and a deviation of one f-stop is relatively minor. It is a noticeable change, however, and the difference can be significant when shooting scenes where matching the lighting from one shot to the next becomes an issue.

How this relates to the concept of normal exposure is explored in succeeding sections, but you can see that already you are presented with a choice. When there are so many f-stop values present in the scene, how do you expose the image? Or, more to the point, what foot-candle value do you choose to expose for in this, or any, complex image?

Although the rule of halves and doubles may seem like a trivial detail at this point, it is crucial to remember it when evaluating the different exposure levels in any image.

The Central Confusion

Up to this point, we have referred to light and f-stops in two different senses. Earlier it was shown that higher f-stops on the camera mean less light reaching the film plane. But higher f-stops also mean more light at the subject—the exposure level is $f/22$ closer to the lamp and $f/11$ farther away. This is what I like to call the central confusion, and the fact that we use the term f-stop in two different ways must be clearly understood before proceeding to advanced lighting techniques.

Put simply, the term f-stop is used to refer to *both the light in front of the camera and the actual setting on the aperture ring*. The term is used to refer to light in two different places: at the subject and in the camera. Up to this point, we have measured the light in front of the camera in foot-candles. So far so good. But once we have the EI, we can convert our readings into f-stops. So, for example, if we get a reading of $f/8$ at A and then go to B and get $f/11$, which area has the most light? B must have more light because we need to use a smaller diaphragm opening to get a normal exposure. Areas with greater volumes of light require smaller openings, that is, higher f-stops. Areas with smaller amounts of light require wider openings, that is, lower f-stops.

Of course, f-stop also refers to the diaphragm on the lens. If we get a reading of $f/8$ at the subject and set the lens to $f/11$, less light is going to reach the film plane than if we set the diaphragm to $f/8$. Smaller openings allow less light to reach the film plane and are the appropriate response to greater volumes of light.

We have, then, two different ways of talking about the same thing. One is the amount of light at the point of metering. The other is the amount of light reaching the film plane. Getting a reading of $f/2.8$ at a subject by definition means that there is a small amount of light there; that same $f/2.8$ on the camera means more light reaching the film plane than with a higher f-stop. Conversely, getting a reading of $f/11$ at a subject means there is a large amount of light there; that same $f/11$ means less light reaching the film plane than with, say, $f/2.8$.

These less-and-more distinctions may baffle you for a while. It can be quite confusing to hear people talking in f-stops all the time on the set. Until you learn the language, listening to people speaking in f-stops can be like listening to people conversing in an unfamiliar tongue. But the language of light is a fundamental part of filmmaking, and the sooner it is understood, the sooner you'll be able to communicate with the rest of the crew.

Evaluating Existing Light

Now the big question: How do you determine your f-stop? The answer is not necessarily an easy one, but the starting point is measuring and evaluating the amount of light present in the scene you want to shoot. This ability to evaluate a shooting situation is essential to predicting what the image is going to look like. The fact that you evaluate a scene, though, does not mean that you won't change things. The process of evaluation by its very nature precedes manipulation.

Not only are there different volumes of light in most scenes, but these volumes of light are sometimes changing and always changeable. If you go into a room that is too dark, you turn on a light. When you do this, you change the physical amount of light in the room. Hence, there is more light. If there is a window in the room and it is sunny outside, the situation becomes more complicated. When we return to our original scene of someone in front of a window on a sunny day, this becomes evident. **(SEE 13-8)**

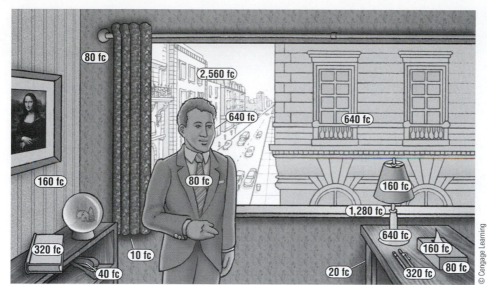

13-8

To evaluate a scene, use an incident-light meter to measure the light falling on different objects and areas.

With the light meter, you can determine most of the light values within this scene. Let's speculate that you find the foot-candle values shown in the figure; the numbers used here behave nicely, all relating to specific *f*-stops. In real life the values you find would presumably settle in at many different levels: full stops, half stops, and such. For the sake of simplicity, the numbers given here will not complicate the issues.

For evaluation purposes, you can go through this scene and group the objects and the areas in terms of the amount of light falling on them. **(SEE 13-9)** That is, you can group together all things lit to 640 fc, all things at 80 fc, and so on. As you examine the scene, you find that there are nine different exposure values: 10 fc through 2,560 fc. (*Exposure value* means simply that this value of light, as we have measured it, exists within the proposed frame.) There are then nine different choices for exposing this image, each exposure value relating to an *f*-stop that is yet to be determined. Again, complicating factors like half stops are being left out, there being an infinite number of values in real life.

The variable in how all of this relates to the *f*-stop is, of course, the EI. For this example we will choose a color film stock that has an EI of 500, a stock that is currently manufactured by Kodak. Keep this film stock in mind; it will be our example throughout the text. Step 1, as always, is to set the EI on the light meter. **(SEE 13-10)**

Once you have decided on the stock and thus the EI, you've established a constant relationship between foot-candles and *f*-stops. By looking at the chart in figure 13-1, you see that the 640 fc of the shaded building converts to *f*/16. If you want the shaded building to expose normally, you would shoot at *f*/16. Anything at 2,560 fc is going to translate to *f*/32 at 500 EI. The 80 fc on the person in the room translate to *f*/5.6. If you wanted the person to expose normally, you would shoot at *f*/5.6.

This is straightforward. If you want something normally exposed, you shoot at the *f*-stop that corresponds to that foot-candle value. It is also important to note that when you shoot at a specific *f*-stop, only the things that are at that foot-candle value will expose normally. Everything else will come in at some level of over- or underexposure. These deceptively simple statements are the key to understanding how to produce almost any lighting effect.

When you decide to shoot at a specific *f*-stop, you have in effect chosen a specific group to be normally exposed. If you decide to shoot at *f*/5.6 to normally expose the person, you have also chosen to normally expose the other elements in

13-9

For evaluation purposes, objects and areas can be grouped in terms of the amount of light falling on them.

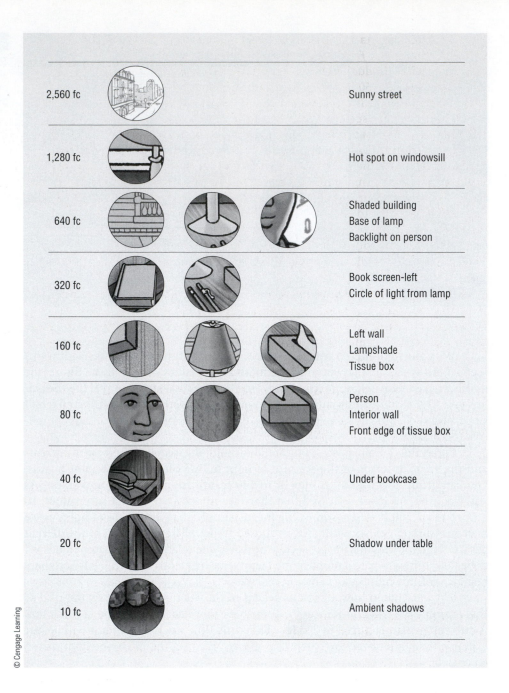

2,560 fc	Sunny street
1,280 fc	Hot spot on windowsill
640 fc	Shaded building Base of lamp Backlight on person
320 fc	Book screen-left Circle of light from lamp
160 fc	Left wall Lampshade Tissue box
80 fc	Person Interior wall Front edge of tissue box
40 fc	Under bookcase
20 fc	Shadow under table
10 fc	Ambient shadows

© Cengage Learning

13-10

When using a light meter for any purpose, the first step is always to set the EI.

© Cengage Learning

the 80 fc group. **(SEE 13-11)** Hence, choosing the objects at 80 fc and shooting at *f*/5.6 means that all of the variables come together to produce a normal exposure. You have already chosen the EI (500), so that is one variable out of the way. Another variable is the shutter speed. If you decide to run at 24 frames per second (fps), the shutter speed also becomes a constant. **(SEE 13-12)**

There is a third variable that we will, at least for now, posit as a constant: the final exposure. All that has been discussed so far is normal exposure, but the possibility remains that you are pursuing something else. In fact, you will eventually come to see normal exposure as only part of the goal, as one part of the entire image. You will regard normal exposure as somewhat of a mythical beast, nice to scare and teach the children with but only one element of a rich and multifaceted image.

The next two variables are the ones over which you have the most control: the *f*-stop and how much existing light is in the proposed frame. The *f*-stop is clearly a key variable. At this point you are just evaluating an existing situation, so you will not be changing the amount of light on anything. (This is an artificially imposed condition on the discussion and will change soon.)

Given the group of objects you have chosen—the ones at 80 fc—the next figure shows the elements you are combining to achieve a normal exposure. **(SEE 13-13)** We will call this a formula, though the + and = signs are somewhat misleading. It is not so much that you add these elements together to get this result but that when these elements are present you get a specific result.

What would happen if you shifted the *f*-stop in this formula? If you shift the *f*-stop to—say, *f*/8—things would change; something has to give somewhere else. Because you have established the first three elements as constants, the part that gives has to be the result. **(SEE 13-14)**

When you decide to expose at a particular *f*-stop, that decision is going to affect what happens to objects and areas that have different foot-candle amounts falling on them. What would happen to objects lit to 160 fc? Because 160 is twice 80, there is a one–*f*-stop difference. **(SEE 13-15)** Elements at 320 fc would overexpose by two stops. Elements at 40 fc would underexpose by one stop, and elements at 20 fc by two stops.

As suggested, the result can also be considered a variable. In that case you would just look at the formula in a slightly different order. If you wanted to underexpose for an effect, you would change the result variable first, and something else in the line would have to change. In this case the *f*-stop would have to change to get the desired result. Although this seems to be just a case of inverted logic, this is an important point: if you want something in the scene to be dark—underexposed—the result is indeed the starting point.

This suggests that the formula may be a helpful concept. Though as a metaphor it is somewhat problematic because you are not actually adding things, it does suggest a method of evaluating virtually everything in the frame. There are five variables here: EI, shutter speed, amount of light on the subject, *f*-stop, and the final result: exposure. If you lock in four of the five—and remember that two are constants, given certain preliminary determinations—the fifth has to be where the change is going to occur.

At this point the formula has just five variables. These are the basic variables for any image. The variable list will not necessarily be this short, however, as many things can complicate your considerations. As new topics are introduced, the list will get longer and more complex. We have demonstrated how to determine what is happening in terms of how specific elements in the image are exposing. The next step is understanding how this affects the way the film stock is going to render the image.

13-11

Shooting the 80 fc objects at *f*/5.6 produces a normal exposure for that group.

80 fc

© Cengage Learning

13-12

After you have decided on the frame rate, shutter speed becomes a constant and can be plugged into the formula.

© Cengage Learning

13-13

The elements that, when taken together, produce a normal exposure.

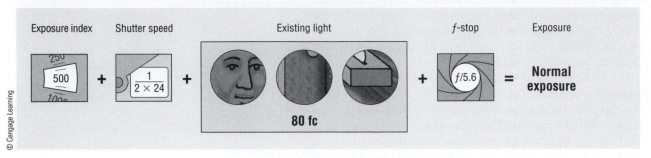

13-14

Because the first three elements are constants, changing the *f*-stop affects the final exposure.

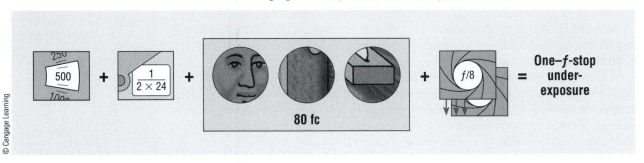

13-15

When the *f*-stop is set to normally expose the 80 fc group, the 160 fc group is one *f*-stop overexposed.

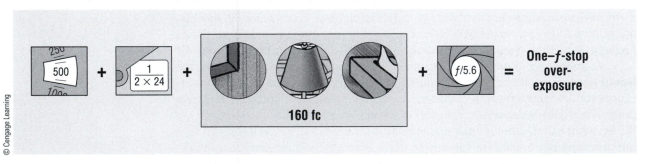

Latitude

The concept of latitude is absolutely crucial to an understanding of how light, and the image, is registered on film. **Latitude** can most easily be defined as the "seeing range of the film." *It is the amount of under- or overexposure that the film stock can accept and still render objects with detail.* The best way to explain this is to compare the film with the human eye. The eye can take in a wide range of lighting values and average them so that you see all aspects with detail. If a person is standing in front of a bright light source, you have no trouble seeing detail in any area in which you look. (The eye also has an iris that facilitates taking in a wide range of lighting values.) The film stock cannot do this. It can see only within a

relatively narrow range of lighting values. That is, it can reproduce objects only to a certain level of under- or overexposure before it renders them completely black or clear, respectively.

Latitude varies from film stock to film stock, and it can be quantified. The manufacturer includes a graph in the product information, called a **characteristic curve**, that tells you how the film stock performs, by plotting the density of grains on the negative against rising exposure. **(SEE 13-16)** It shows the gradual consistent rise of exposure, called the *straight-line portion*, while also showing the precipitous drop-offs to under- and overexposure, called, respectively, the **toe** and the **shoulder**. Characteristic curves are quite difficult for beginners to interpret, and simple discussions with a knowledgeable source should tell you what you need to know. A working filmmaker or someone at a processing laboratory should be able to give you a good idea. The majority of film stocks have latitudes ranging from two stops to three and a half; that is, most stocks produce detail anywhere from two to three and a half stops on either side of normal exposure.

When learning exposure technique, many people find it useful to think of latitude as the "mistake factor." In other words, how badly can I miss on the f-stop and still get a usable shot? How badly can I be off and still get some detail in the subject? This is OK for starters, but eventually you will have to think of latitude in the more complex terms presented in this section.

To apply the concept of latitude to our example, you have a light meter reading of 80 fc (f/5.6) from the person in front of the window. There is substantially more light outside (2,560 fc). In just looking at this scene, your eyes have no trouble taking in these two extreme values and rendering a composite image. The film, however, can see only within a relatively narrow range of values; and, more to the point, it will expose normally for only one value at a time. What would be the likely result if you did shoot at f/5.6? Obviously, the person in front of the window would be rendered normally, and the outside would be totally overexposed (blown out). The only other areas that would be normally exposed would be those also lit to f/5.6. Everything else would be lit, and would respond on the film, to some degree of over- (+) or underexposure (−).

Your immediate response might be that you don't want that. If you think about it further, though, remember that you usually *do* want some form of gradation in terms of light in the image. If everything is normally, that is, evenly, exposed, the image will look flat and characterless. We expect areas to look shady (−) and bright (+). The point is that with knowledge of latitude, you can begin to control which areas are over- and underexposed and to what degree. The film stock renders detail in the shaded and highlighted areas only to a certain point. The varying degrees of detail in over- and underexposed areas depends on how radically different the values are from the f-stop at which you are shooting.

Today's color negative film stocks have a latitude of roughly three to three and a half stops; that is, they render detail anywhere from three to three and a half stops on either side of normal exposure. If you shoot at f/5.6 with your proposed stock, the film will see objects that are lit to the values in roughly this range. **(SEE 13-17)**

An area that is lit to f/11 (320 fc) will be two stops overexposed, and an area lit to f/32 (2,560 fc) will be five stops overexposed. An area that is lit to f/4 (40 fc) will be one stop underexposed, and if there were an area lit to f/1.4 (5 fc), it would be

13-16

The characteristic curve plots the density of grains on the negative against rising exposure.

© Cengage Learning

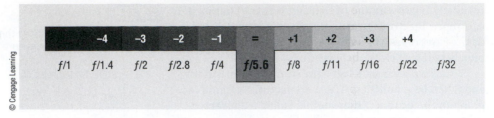

13-17

Color negative stocks have a latitude of roughly three to three and a half stops.

	−4	−3	−2	−1	=	+1	+2	+3	+4	
f/1	f/1.4	f/2	f/2.8	f/4	f/5.6	f/8	f/11	f/16	f/22	f/32

four stops underexposed. Now, positing the latitude described, you can predict with a fair amount of accuracy what would happen in these four areas. An area at 320 fc will be two stops overexposed; but, because it is within the latitude of the film, it will be bright but rendered with at least some detail. The sunny street in the background (2,560 fc) will be five stops overexposed and, being outside of the latitude, will be totally overexposed. Areas at 40 fc will be one stop underexposed but rendered with substantial detail. Anything at 5 fc or less would be totally underexposed.

A good example of the interrelationship between latitude and exposure is a streetlight. (This is a hypothetical example because you may never find a streetlight that gives you readings like these, even though you might sometimes wish that you would.) Let's say that your shot will be of a person walking from right to left under the light. With the activating button depressed, you just walk through the scene. The meter will respond as the light gets stronger and falls off again. To simplify things, go ahead and translate the foot-candle readings into f-stops. Again, there would be gradations, half stops, and so on between these readings, but we'll show just the full stops, assuming that the brightest spot is directly under the center of the light. **(SEE 13-18)**

If you shoot at $f/8$, what is going to be the likely effect? The subject will be exposed normally only for that very brief point in the center of the light. With knowledge of latitude, you can also predict where the subject is going to drop off

13-18

A hypothetical streetlight is a good example of the interrelationship between latitude and exposure.

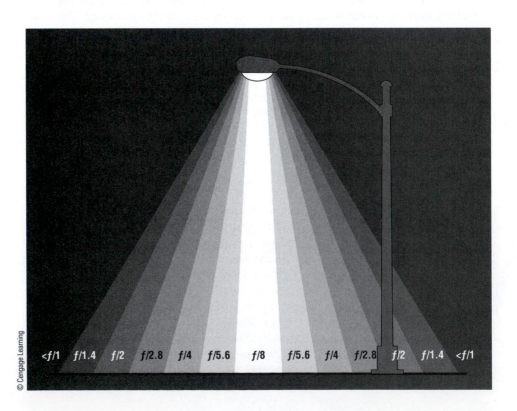

to underexposure. The next figure delineates the final exposure, given the various light readings of the different areas. **(SEE 13-19)** Although you can see to the edge of the light and beyond with your eyes, you will find that the subject is lost much earlier on the film.

What would happen if you decided to expose this scene at $f/5.6$ instead? Now you get a larger area of normal exposure, but $f/5.6$ overexposes by one stop in the very center. It also extends the area of exposure one more stop at the edges. Where you lost the subject just above $f/2$ before, you now keep him to just above $f/1.4$. The subject, in a sense, traverses more area of exposure. Would that one stop of overexposure be acceptable in the center? That is always your decision, but if there is a strong top light, you can almost always expect its effect to be more amplified in the center. You can speculate that not only would it be acceptable, but also you might like the effect more than the previous shot.

What would happen if you shot at $f/4$? By following this method of evaluation, you can make what might be called an "exposure pyramid" with which you can predict what will happen at virtually any f-stop at which you choose to shoot. **(SEE 13-20)**

Are any of these possible exposures—that is, results—usable? Any of them might be usable, depending on what you want to achieve with the image; the emphasis is on *depending* because that is the key. If realism is the goal, the $f/8$ shot might be acceptable. As suggested, with a realistic shot still your goal, the one stop of overexposure at $f/5.6$ might be preferable. Would you accept the two stops over in the center that you would get with $f/4$? That has to be your decision. Lower stops yield an effect that would be decidedly less realistic ("Beam me up, Scotty") but might fit into some dramatic contexts. Remember the example of the astronaut's brightly lit quarters in Stanley Kubrick's *2001: A Space Odyssey*.

The question of exposure is dependent on what the filmmaker wants to achieve with a given image. If the image serves to provide dramatic context for the narrative (that is, if the image is at the service of the narrative), that may be the determining factor. If you want something more expressive or subjective, that becomes the determining factor. The effect you achieve should always be the effect that you want for the particular situation.

Armed with an understanding of latitude and an ability to evaluate a given situation, you can predict what will happen to any image at any exposure. You can meter any situation and set up an exposure pyramid. Then you have some decisions to make, each yielding an image that is a little different and has a different dramatic impact.

With a wide range of volumes of light in front of the camera, the f-stop must be used so that these volumes expose at the levels at which you want them. Think of this in terms of the filmmaker (you) using the f-stop as a response to a volume or, more accurately, volumes of light. The f-stop controls the light so that the correct amount of light for the desired exposure reaches the film plane. The choice of f-stop thus becomes one more creative tool in that its selection involves decisions as to the character and the dramatic context of the image you are creating. If you do not treat exposure as a major consideration, you are saying—and I have heard it from people who should know better—that the image is unimportant to you.

If we return to the original example of the person in front of the window (figure 13-8), some significant points become evident: As you evaluate shooting at different f-stops, you know what is going to happen to objects lit to the stop you are

13-19

The subject exposes differently while moving.

When the subject moves into an area where the light reading is:	The person is:
$f/5.6$	one stop underexposed
$f/4$	two stops underexposed—the subject is getting dark, but you still see detail
$f/2.8$	three stops underexposed—the subject is almost completely dark, nearly at the edge of the latitude
$f/2$	four stops underexposed; positing the latitude of three to three and a half stops, the subject has gone entirely to underexposure

© Cengage Learning

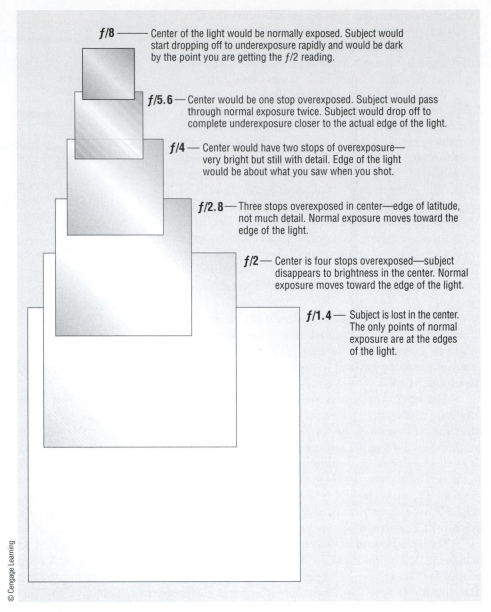

f/8 —— Center of the light would be normally exposed. Subject would start dropping off to underexposure rapidly and would be dark by the point you are getting the *f*/2 reading.

f/5.6 —— Center would be one stop overexposed. Subject would pass through normal exposure twice. Subject would drop off to complete underexposure closer to the actual edge of the light.

f/4 —— Center would have two stops of overexposure— very bright but still with detail. Edge of the light would be about what you saw when you shot.

f/2.8 —— Three stops overexposed in center—edge of latitude, not much detail. Normal exposure moves toward the edge of the light.

f/2 —— Center is four stops overexposed—subject disappears to brightness in the center. Normal exposure moves toward the edge of the light.

f/1.4 —— Subject is lost in the center. The only points of normal exposure are at the edges of the light.

© Cengage Learning

considering. Then, with knowledge of latitude, you can predict with accuracy what is going to happen to objects lit to other stops. Are they within the latitude of the film?

If you can peg specific exposures to objects that are lit a certain way, you can make a graph of the relationships among a given *f*-stop, objects lit to that *f*-stop, and side effects of other things being over- or underexposed. Again, you are shooting with the EI 500 film stock. The following figure represents what will happen if exposure is decreased. **(SEE 13-21)** The lengths of the vertical lines represent the suggested three- to three-and-a-half–stop latitude. To see what and where things will fall into the latitude, extrapolate from the line to the left side of the chart.

Again, if you decide that you want the subject normally exposed, you would choose *f*/5.6 and would select the group shown in the following figure. **(SEE 13-22)** Areas at 640 fc—the shaded area on the building, the backlight on the person, and the base of the lamp—would be three stops overexposed. This would put you in the unenviable position of having a shaded area three stops overexposed at the edge of the latitude. Would this be an effect you like?

13-21

The vertical lines represent the latitude at each individual exposure.

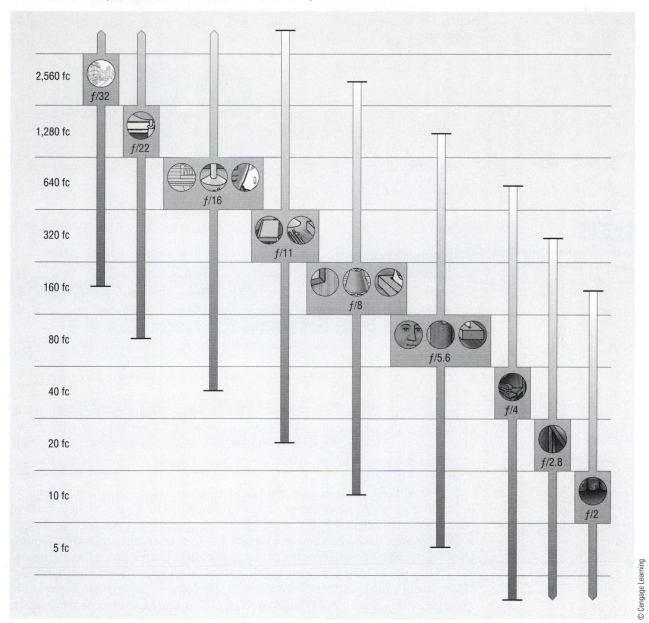

If you think about how you might perceive a scene like this normally, you might expect a person standing in front of a very bright background to look slightly dark, as if he were in the shade. How could you achieve this effect? If you want to see something as being dark, you underexpose it; so, rather than $f/5.6$, what would happen if you shot at $f/8$? The subject would be one stop underexposed and look more as though he were in the shade. Doing this, however, would change how all of the areas lit to other values respond. In effect, you would shift the whole exposure range to the right on a standard f-stop scale. **(SEE 13-23)**

When you shot at $f/5.6$, the objects lit to $f/2$ were at the bottom end of the latitude. As you can see, they fall off the bottom when exposed at $f/8$. All of the objects lit to $f/16$ were three stops overexposed when you shot at $f/5.6$. They are only two stops overexposed when shot at $f/8$. It begins to appear as though exposure is

13-22

When an *f*-stop is chosen, everything lit to other values will come in at different levels of exposure.

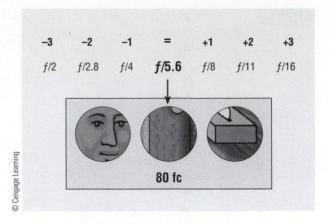

13-23

As the *f*-stop is changed, the parameters of the latitude change.

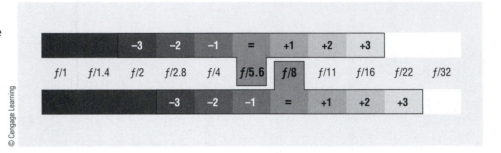

a structure imposed on a space, imposed on the scene you are shooting. When you expose at *f*/5.6, you are imposing a structure on the scene that will bring a specific result on the film. If you change to *f*/8, in a sense you just pick up that whole structure and move it to the right. If you were to shoot at *f*/4, you would move the structure to the left.

You will often hear people talking about lenses in terms of how they "collect" light. When you expose at a specific *f*-stop, you are collecting what is in front of the camera in a certain way. If you expose at a different *f*-stop, you are collecting in a different way. And when you choose one *f*-stop over another, you are making a choice as to what you consider important in the image—what you value.

After postulating a possible lighting scenario, people often ask the question, "How would you expose this?" Or, worse, "How do you expose this?" I answer the question with a question: "What do you want?" You are not after some abstract, one-size-fits-all, perfect image. You are going for what you want.

It might help to think about latitude as being like a rectangular table. You can think of the range of exposures in the scene (that is, the range of light readings you have made with the meter) like objects spread out across this table. Call the center of the table "normal exposure" because normal exposure can be thought of as being halfway between total underexposure and total overexposure. One end of the table represents underexposure, and the other represents overexposure. As you near either end of the table, you get closer to total over- or underexposure until you drop off the edge. You should recognize this table analogy as a representation of the characteristic curve—the toe and the shoulder being the ends of the table.

If your film stock has a latitude with a total of seven stops (three and a half stops on either side of normal exposure), the table is seven stops wide. If the film stock has a total latitude of roughly five stops (most black-and-white reversals would fall into this category), the table is five stops wide. Be aware that stocks may have a little more nominal latitude to one side or the other, usually on the underexposure end.

If you shoot the person in front of the window at *f*/8, the objects that read 160 fc are in the center of the table, normally exposed; *f*/8 is also right in the center of the exposure values for our hypothetical scene. In this example the ambient shadows and the sunny street fall off the edge of the table. **(SEE 13-24)** If you shoot at *f*/22, different objects or areas are going to fall off the table. In this case a large part of the exposure range is dropping off the latitude table. **(SEE 13-25)**

With enough people and equipment, you could light any proposed image, including the person in front of the window, to the center of the table. In fact, that was precisely the goal in the story recounted earlier in this chapter about the Secret Service agents with their light meters. There are many reasons, most of which have already been discussed, why you would not want to do that. The image would be flat. This is why normal exposure is referred to as being a mythical beast. We talk about normal exposure, and it remains central to the discussion, but most of the images you see in films encompass a wide range of exposures. Yes, there will usually be areas that are normally exposed, but most images—and this is just common

13-24

The latitude "table".

13-25

Shot at *f*/22, many areas fall off the edge to underexposure.

sense—have a wide range of values. As a beginner you may develop an abject fear of the edge of the table, but this is where you will want to learn to live. It is, simply put, where the texture and the character of the image resides.

The scenario of the person in front of the window is an image that essentially has nine different exposure possibilities, from ƒ/2 to ƒ/32, and nine distinctly different outcomes, again leaving out the fact that the readings have been simplified so that they fall exactly on the ƒ-stops. Obviously, real life is not so cooperative.

If you can look among these results and find one of those many exposures that does precisely what you want, you are fine. The discussion, at least in terms of this image, can end here. But if your goal is to produce something that looks roughly like what you would see with your eyes, one can safely predict that none of the choices here would be acceptable. This pursuit of producing an approximation of human perception is generally referred to as *realism,* a concept that keeps the film world scrambling and thousands employed. *Ahhh,* realism. One might think that with all the interest in modernism and postmodernism, things would be different. But now, oddly enough, realism's hold on film is probably stronger than ever. However much artists and critics may rail at it, realism remains the stuff that fuels the engines of a substantial percentage of films, both in America and internationally.

This part of the discussion can be concluded by saying that if your goal is realism, the person in front of the window represents an image with incompatible extremes. There are simply too many differing values to get an acceptable compromise. The obvious answer to the problem is to use artificial light and/or to manipulate the existing light.

13-26

The gray scale consists of a sequence of discrete reflecting tones, from black through shades of gray to white.

13-27

If you underexpose the gray scale, you essentially shift the entire scale to the right.

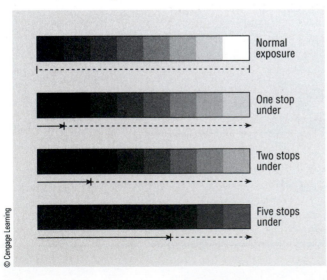

Luminance

The conversation so far has left out one key ingredient. The way objects and materials reflect light is referred to as **luminance**, or *reflective quality.* Most people know that light objects reflect a high percentage of light, and dark objects reflect a small percentage. This, of course, is why we perceive them as light or dark. It stands to reason that objects that are highly reflective—light objects—are going to photograph differently from objects that do not reflect as much light.

Many people know that all objects can be measured and categorized according to the **gray scale**, which represents discrete points in how surfaces reflect light. The standardized gray scale represents all of the possibilities, from the smallest amount of light (black) to the greatest amount of light (white). The gray scale starts from black and goes through a number of shades of gray before it gets to white. **(SEE 13-26)**

Both the relationship of the gray scale to exposure and the general issue of how objects reflect light are of critical importance. If you light a gray scale to ƒ/5.6, what will be the result if you then set the lens to ƒ/5.6 and film it? It will be a normal exposure, and you will see the scale as you see it here. But what happens if you over- or underexpose the gray scale? If you underexpose it, you essentially take the whole scale and move it to the right, the darkest grays shifting over into the black area. Medium and light grays, as well as white, shift to grayer tones. **(SEE 13-27)** A similar shift occurs with overexposure,

except the scale shifts to the left. **(SEE 13-28)** It should be noted that the gray scale will not respond in this way at five stops of under- or overexposure, latitude being the complicating factor.

When you change the *f*-stop, you shift all reflectance values on the scale. With the gray scale lit to *f*/5.6, if you racked the *f*-stop all the way from *f*/1.4 to *f*/22, the whole scale would shift from overexposure to normal exposure to underexposure. Simply stated, this means that darker subjects will drop off to underexposure much more quickly than lighter ones. The same is true of lighter subjects at the overexposure end.

Thus luminance obviously complicates any discussion of exposure. It should also be evident that latitude is not written in stone. Latitude is a general guide, and different subjects respond differently to over- and underexposure. This is also where a spot meter can help, although you really have to know how to evaluate the information it provides. To a certain extent, an understanding of the general characteristics of how objects reflect light is best gained through experience. You have to look at and shoot a lot of different materials to be able to predict how things are going to respond.

The way this issue affects exposure decisions has wide-ranging implications. This is particularly true when filming subjects with dark skin tones. You will quickly find out that most technical recommendations for exposure and light have been, to a certain extent, calculated with the Caucasian face in mind. This is explored further in chapter 14.

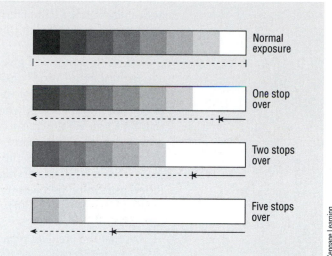

13-28

If you overexpose the gray scale, you essentially shift the entire scale to the left.

Normal exposure

One stop over

Two stops over

Five stops over

© Cengage Learning

t-stops

Although we have encouraged the use of *f*-stops and foot-candles to measure and evaluate light, you will find that most film crews actually communicate in ***t*-stops**—a circumstance that requires some explanation. The *t* in *t*-stop stands for *transmission.* It might be useful to think of the term as meaning the "true" stop. The *t*-stop takes into account the light that is lost in passing through a lens. Almost all lenses lose light due to lens complexity and *aberrations*—the failure of a lens (or any refracting surface) to produce exact correspondence between an object and its image.

In a perfect world, an *f*-stop, let's say *f*/5.6, will let in a specific amount of light under given lighting conditions. But in our less-than-perfect world, if some light is lost in the lens, you are not getting a "true" *f*/5.6's worth of light to the film plane. If not compensated for, this results in a slight underexposure. The *t*-stop compensates for the lost light by using a slightly larger aperture.

The manufacturer calibrates *t*-stops for each individual lens. Virtually all professional lenses are calibrated in *t*-stops rather than *f*-stops. They are simply the point where a true *f*-stop's amount of light reaches the film plane. You use them just like you do *f*-stops. If you get a reading of *f*/5.6 and the lens is calibrated in *t*-stops, you set it to t/5.6.

By definition *t*-stops provide a slightly wider opening. This occasionally prompts the question of why one would bother to compensate when the change is well within the latitude of most film stocks. Just so you are forewarned, I've been on film sets where the DP was talking about light in terms of fifths of a stop. Needless to say, DPs are very exacting in determining how the film is exposed. This is partly an issue of maintaining consistent photographic quality, but it is mostly because different exposures produce different effects. Eventually, you will be the one making such choices.

A Note on Spot Meters

With an understanding of latitude and luminance, the advantages of the spot meter can be clarified. The fundamental difference between a spot meter and an incident-light meter can be characterized by the way they relate to neutral gray. While this difference may be difficult to grasp, it is a fundamental distinction in how light is measured.

An incident meter gives an exposure reading that will expose a neutral gray as a neutral gray—usually just what we want. Things that reflect more light veer toward white, which is what we want. Things that veer toward black render as darker grays and black—again, what we want. In contrast, a spot meter gives a reading that tells you what exposure will render the object you are metering as a neutral gray. Again this is a critical difference. If we point a spot meter at a white object under a given lighting setup, we will get a reading that will render it as a neutral gray. If we meter a black object under the same lighting, we will get a completely different reading that will render the black object as a neutral gray. Neither is necessarily what we want, but we need to know how to interpret and implement this information.

What the incident meter does not tell us is what happens to specific objects of differing shades when we start to under- or overexpose things. As we try to build varying levels of exposure into a complex scene, understanding exactly how things fall off on the top and the bottom will be very handy. Spot meters have many uses, but this is where they are incredibly handy. A brief example should clarify this.

Early in my lighting career, I was shooting a scene with a young couple sitting in a bar, with a man waiting for them in a brightly lighted doorway in the far background. I lit the couple to $f/5.6$ and the doorway area to $f/11$ to achieve that effect. I wanted the middleground between them to be dark but with limited detail. This area had that dark, textured plywood paneling familiar to all. Not having a spot meter that day, I lit the area to $f/2$ and $f/2.8$, using my incident meter to check all of the areas. Shooting a film stock with roughly three and a half stops of latitude, I thought the area would be dark but have a small amount of detail.

When I got the film back, I was surprised to find that the middleground area had no detail at all—it was completely black. I understood my mistake immediately. The plywood was so dark that it would not accept two and a half stops of underexposure and still render detail—the plywood literally soaked up the light. A spot meter aimed at the plywood would have told me that the exposure to render it as a neutral gray was way beyond the latitude of the film, thus predicting the actual result. It undoubtedly would have given me readings around $f/1$, $f/1.4$, and so on. Using more lights, I could have brought the area into the range I wanted. It should be noted that none of these areas was lighted to a flat stop, say $f/5.6$ at the couple and $f/11$ at the doorway. You are almost always looking for gradations of light to give character and interest.

The bottom line is that we often find ourselves using incident meters for our subjects and key areas and using spot meters in peripheral areas—monitoring shadow and highlight areas for how they will be read on film. With our person in front of the window or by the lamp, the application of all of this should be fairly clear. While putting the meter under the table or against the back wall as was illustrated would give us information that was in the ballpark, we eventually see the approach as inadequate because the tonality of those areas is not taken into account. Again, there are many uses for the spot meter, but the one described here is critical, making the tool virtually indispensable on the set.

14

Planning the Lighting

Thinking Out the Process

From the exposition of basic principles in the previous chapter, we can move to some pragmatic examples of specific lighting setups. We can start by reiterating that when you are exposing an image, that is, choosing an f-stop, you are exposing for a dramatic effect that is important to you. Cinematographer Vilmos Zsigmond has made an interesting observation in this regard.[1] He states that misguided beginners often set up their lights and then stick out their light meter to get a reading. They then shoot at what the light meter tells them. This is a backward method. What most DPs do, particularly those involved in making narrative films, is start with the light meter reading that they want to achieve. They start with a value, in terms of an amount of light, and all subsequent decisions flow from that one piece of information.

On a less pragmatic level, you will hear many claims about the kinds of effects that lighting can achieve. Lighting produces feeling. Lighting produces mood. Lighting creates visual text and subtext. You will hear many a cinematographer waxing philosophical, and sometimes a bit romantic, about all of the things that lighting can do. This is as it should be. You have to be a bit of a romantic to want to express yourself with light, particularly when there are so many other attention-grabbing elements of film. But, on a gut level, *lighting is achieving the image that you want.*

Producing the lighting that creates your desired image is both a technical process and a creative one. It is a matter of knowing what you want and how to manipulate the materials to get it. The processes are inseparable. You cannot get one without the other. Combined, these processes are what has been referred to as *technique:* the application of the technical to produce the desired effect. Eventually, you will probably be able to do much of your lighting to your eye. For now, however, you need to wrestle with the lights and the light meter to get them to do what you want.

Lighting: A Basic Strategy

Before we get into an extended discussion of lighting, it should be stated in all honesty that thinking out the lighting of a scene is essentially an easy process. Granted, this is an oversimplification, but there is a certain amount of truth to it. The following strategy constitutes an easy way to think out your lighting.

1. Larry Salvato and Dennis Schaefer, *Masters of Light: Conversations with Contemporary Cinematographers* (Berkeley: University of California Press, 1984), p. 337.

1. Start by choosing an ƒ-stop. There are many reasons to choose a particular ƒ-stop (see the next section for an introduction to this critical aspect), but choose one that makes sense in terms of what you are trying to achieve. Once you have this fundamental piece of information, everything else falls into place.

2. Ask the question, *What areas or objects do I want to be normally exposed?* Then light those elements to the desired ƒ-stop. Remember, you rarely want everything normally exposed. That would make for a flat and uninteresting image.

3. Then ask yourself, *What areas or objects do I want underexposed?* and *How underexposed do I want them?* Light the areas that you want underexposed, including the fill side of faces, to values less than your chosen ƒ-stop. How much less is determined by how dark you want them to be, always remembering that eventually they will slip outside of the latitude of the film.

4. The last question is, of course, *What areas do I want overexposed?* You light those areas to values greater than the chosen ƒ-stop. As with the previous step, the amount of overexposure depends on how much you want, remembering again the latitude of the film.

With both underexposure and overexposure, you may want to exceed the latitude of the film for effect. The important consideration is to know where all of the other light values are registering in relation to normal exposure, keeping in mind the latitude of the film.

That is it in a nutshell. It sounds easy, but of course it is not. The pragmatic part of executing a lighting setup is hard enough, but there are all kinds of side issues—such as quality, continuity, and coverage, to name just a few—that complicate the task. But consider this a good starting place.

ƒ-stop Choice

This is slightly premature, but the notion posed in step 1 above that the ƒ-stop might be determined in advance needs some clarification. What factors might go into choosing a specific ƒ-stop?

- There is an existing light value to which it would be expedient to conform.

- There are shots that require a predetermined amount of depth of field.

- A preferred ƒ-stop gives you the quality of light and the lens resolution desired.

- There are situations in which a specific value is easy to achieve and simply makes sense. This could be because of the type of instruments you are using, the size of the location, the way instruments that are going to be balanced against the key can be set, and a number of other reasons. There is simply some value that makes sense in the given situation.

Elaboration of these issues will continue as this discussion progresses, mostly in chapter 15. Be aware that frequently the choice of an ƒ-stop is, as cinematographer Zsigmond suggests, determined in preplanning rather than by getting the lights up and simply sticking out a meter to get a reading.

Lighting Applications

Some of these basic principles can be demonstrated if you start with some simple tests that involve the key light and the fill light. Go ahead and load up a camera and shoot this test. Before you shoot, though, there are a few general guidelines with which you should become familiar.

Guidelines

☑ **Two basic movements are used in trimming the instruments: panning and tilting.** These terms are used in the same way as with the camera. When you move a light from side to side so that the beam is sweeping horizontally, you are *panning* the light. When you move a light up and down so that the beam is sweeping vertically, it is called *tilting*. These movements are done frequently as you set up and make choices. The height of the instrument also has a huge impact on the effect of the light.

☑ **When using a focusable spot on a subject, always find and use the center of the light.** If you aim one of these lights at a wall, you will notice that it throws a round pattern. You should be able to discern its center: it's where it is the brightest. It is easiest to find the center of the pattern when the light is spotted in. Put it right on whatever you are lighting. Nine times out of 10, you'll get yourself in trouble if you start some other way. If you pan the light off of the subject and/or area to get a lower reading, it will just look like they are not in the light, like the light is going past them.

☑ **Remember that lighting is time-consuming.** You will often be working with people who are new to film. Be sure to prepare both crew and talent for the kind of time that you are going to have to take. Lighting is a deductive process in which you keep creating and solving problems until you get what you want. You just have to be patient and go through the necessary steps. The most time I have ever seen go into lighting a single shot is about three hours, but in comparing stories with other film people that is pretty tame. A friend loves to tell about the time a crew he was on took eight hours to light a potato chip bag. The client did not like anything they set up. An efficient film crew can light a simple shot in 10 to 15 minutes, but the more complicated the shot and/or scene and the more area involved, the more time it takes. To get the result you want, the preparation and the time have to be invested.

☑ **Take notes.** Without a guide for analyzing your test, you may have a difficult time reconstructing all of the things you did. A sheet with columns for the footcandle (fc) readings of all your lights is probably the best approach. Have columns for the key, fill, backlight, and so on. Also have a column for the f-stop. Most of these tests should be shot at the f-stop you get for the key. This is the usual, though by no means uniform, approach. I also recommend that you try shooting some of the setups you create at different f-stops. It can be instructive to see what happens when you expose for the fill light or the backlight. Experiment.

Learn these basic terms and practices because, if you get on a lighting crew, you will be expected to execute some straightforward tasks. Fellow crewmembers have little patience with anyone who slows them down.

Tests

Start the test by setting up a key light to 160 fc, which translates to $f/8$ with stock with an exposure index (EI) of 500. We are choosing 160 fc for several reasons. First, it is a relatively easy value to achieve with the kind of lights you will probably be using. Also, there is plenty of room on either side of it for experimentation with over- and underexposure. Light meters, particularly inexpensive ones, do not always read small amounts of light with the kind of accuracy needed for an effective test. We will use values that you should be able to reproduce and measure with ease and accuracy.

If possible, use a focusable spot for the key. To achieve 160 fc, it is easiest to have an assistant move the light while you are at the subject with a light meter. Holding the meter at the subject, point it at the key and have the assistant move the light toward or away from you. Stop when the meter shows the desired value. Using the spot/flood capacity of the light is another easy method of getting the value you want.

Nose shadows receive significant attention. DPs generally try to have the light above and to the side of the subject so that the shadow will go down into the lines to the side of the nose. Other light positioning can make this shadow go to strange and irritating places, such as into the mouth, straight across the face, or even into the eye.

Next, set up the fill light and move it until you get a reading of ƒ/5.6 (80 fc). This is easiest to do with the key light switched off. Before shooting, check the total with the key and the fill on by taking another reading at the subject toward the camera. Sometimes the fill can add to the total, and you may have to back off the key light to reestablish 160 fc. What will be the result if you shoot at ƒ/8? The fill light will underexpose by one stop—well within the latitude of the film—so the fill side of the face will be slightly darker but will be rendered with a fair amount of detail. Thus the shadows are not very harsh, so you have an even, high-key image. **(SEE 14-1)**

This relationship between the key and the fill is called the **lighting ratio**, or *contrast ratio* (see "Lighting Continuity" in chapter 15 for the specific formula). Remember that the intensity of the fill light in relationship to the key is what controls the dramatic quality of the image, and a ratio between the key side and the fill side of the subject can be calculated.

What happens if you walk the fill light out to ƒ/4 (40 fc)? Remember to recheck the total for 160 fc before shooting. The fill light is now underexposing by two stops. **(SEE 14-2)** Again, the shadow areas are well within the latitude of the film but darker than in the previous shot. It is not quite as flat as the previous image but is still high-key. Continue backing off the fill light in this manner, always rechecking the total.

When backed off to ƒ/2.8 (20 fc), the fill light is underexposing by three stops, and, though still within the latitude of the film, it is getting close to the edge of the table from our earlier analogy. At this point you have moved into lighting that would be considered low-key. **(SEE 14-3)** The shadow area is very dark, though retaining some detail. The image has much more contrast.

14-1

When the fill is underexposing by one stop, lighting will be high-key.

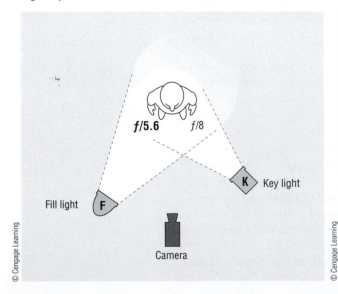

14-2

As the fill is drawn back, shadows on the fill side will become deeper.

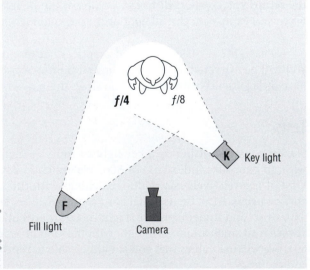

14-3

At 20 fc the fill is underexposing by three stops—still within the latitude of the film but very low-key.

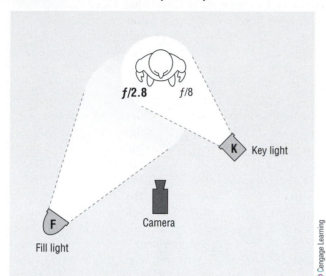

14-4

At 10 fc the fill will underexpose by four stops and will have little or no effect on the film.

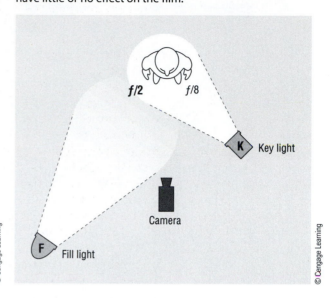

If you continue and back off the fill to $f/2$ (10 fc), you will fall off the edge. **(SEE 14-4)** The fill is going to underexpose by four stops, and at this point we can predict—and all of this is about being able to predict results—that it will have virtually no effect on the resulting film. In fact, you might want to try switching the fill light on and off while filming to see if there is any effect at all. Remember that latitude is not an absolute. There may be some effect, but you can be assured that if there is, it will be small. Skin tones will have a big impact.

Try to keep a visual record of how you see what you are shooting. When the fill is at $f/2$, it is definitely producing an effect visible to the eye. The point is that the film will not see it. With this in mind, consider the following basic rules of lighting, which, at first glance, appear to be contradictory.

■ **RULE** If it does not look good to your eye, it will not look good on film.

This is common sense. If you are getting ready to film a shot and there is something about it that just doesn't look right, it is still not going to look right when you get the film back. Are there too many shadows? Can the viewer see everything that is important? Are there shadows in the eyes that make the subject look as if he has a black eye? Is it just ugly light?

■ **RULE** Just because it looks good to your eye does not mean it will look good on film.

This is clearly a question of latitude. The light values have to fall within a relatively narrow range to show up on film. As you look at the last test with your eyes, the one filled to $f/2$, you might say that it looks fine, but the film sees only a segment of what we see. The light meter and knowledge of latitude are the keys.

Essentially, you treat the rest of the lights as you have the key and the fill. To start, try introducing a backlight. The light is usually set up above and behind the subject, pointing directly at the crown of the head. How do you use the light meter to read it? The meter, in this case, should be pointed directly at the light, not toward the camera. **(SEE 14-5)**

The light meter will be used in this fashion with more and more frequency. In many cases we are not so much interested in how much light is being seen from

14-5

The backlight is measured by pointing the light meter at it.

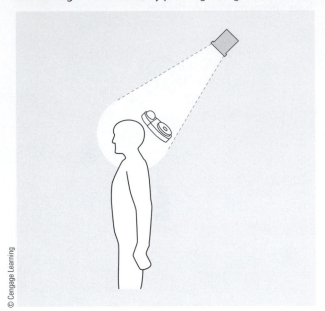

14-6

Trimmed to ƒ/16, the backlight overexposes by two stops.

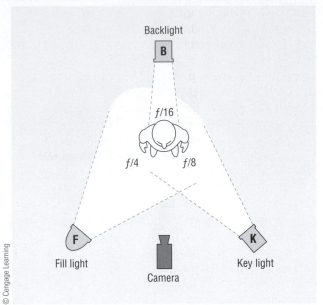

Backlight

B

ƒ/16

ƒ/4 ƒ/8

F K

Fill light Camera Key light

the camera position as we are in how many foot-candles are being produced by a particular lighting instrument. Each instrument is set up to accomplish a specific purpose—to light a desired area or subject, to create a certain effect—and its intensity is set to achieve a specific level of exposure. The goal may be as general as to give an overall fill to a large area or as specific as highlighting a glass on a nightstand.

The intensity that you want for the backlight depends somewhat on the color of the subject's hair. These are very general guidelines, but if the subject has brown hair, many DPs like to keep the backlight the same number of foot-candles as the key light. If the subject has black hair, they go higher; if the subject's hair is blond, they go lower.

To make the test interesting, trim the backlight to ƒ/16 and move the fill light back to ƒ/4 so it is having an effect. **(SEE 14-6)** As you set up the backlight, try to make its beam hit only the back of the subject's head and not spill onto the face.

If the backlight is at ƒ/16 and you are still shooting at ƒ/8, the backlight will overexpose by two stops, which will create a halo effect. Is this something you might want on occasion? Of course.

At this point there are three different values in the shot: ƒ/4, ƒ/8, and ƒ/16. What would happen if you shot at these ƒ-stops or others? If you shot at ƒ/16, you'd be exposing for the backlight. The only thing that would expose normally would be the subject's hair. The face would be two stops underexposed. Could this be interesting? You may want to do something with the fill light, which is now out of the latitude of the film, but the overall answer is probably yes. What would happen if you shot at ƒ/11? The possibilities are pretty much limitless, but you can continue to manipulate volumes of light and exposure to create different effects. Try shooting some different exposures and intensities on the three lights, as well as setting up other lights for other areas of the frame—the background, for example.

Remember that lighting is a deductive process, particularly when you are just learning it. You can start with a question: What are the central points of interest in this image, and where do I want the viewer's attention focused? These are usually,

though not always, the areas that you want keyed and normally exposed. Set up a key light (or lights) for these points. Once you've done that, you will see that you have some problems. You don't like the shadow created by this key or whatever. Manipulate the lights until those problems are at least superficially solved. Do not overdo it; the other lights will cause problems, too.

Once keys are set up and reading at the foot-candle values you want, you then decide what you want to fill and how you want to fill it. Set up the appropriate lights. Again, this will create problems. Solve them. Then do the same thing with the back-lights and the other lights. You just keep trimming the lights and adjusting for their side effects until you get what you want. Remember the methods for trimming instruments: repositioning, moving spot/flood, using modifying materials, and so on.

Clearly, character movement complicates these simple tests. Have the subject turn his or her head to the left and right, turn to see what the fill side looks like, and so on. Characters rarely look directly at the camera, so position the subject however you like. I generally prefer to have the key on the camera side of a subject's face, although this is more apt to leave the subject's shadow in the background of the shot. Many cinematographers take the easy way out and make the key side away from the camera, although this can make the nose shadow stand out.

Sometimes the hardest thing to do is to get started. You have all these lights and may not have a clear conception of what to do with them. These tests should give some basic direction. Be forewarned: learning lighting is an experiential affair (isn't everything?). As a gaffer friend likes to put it, the best teacher is just spending a few years "putting it up, shooting it, and taking it down."

Problems and Solutions

The approach so far has been essentially evaluative. We have looked at several situations, such as the person by the window, the table lamp, and the streetlight, with one question in mind: What can I do with what exists here? Although evaluation is clearly part of the process, the approach has to be much more active in terms of changing things. The way to look at a shot or a scene is not to say, "What can I get?" but rather to say, "What do I have to do to get what I want?" The only reason a DP will walk through an unprepared location with a light meter is to find out what has to be changed to create the desired effect.

Shooting an Existing Situation

We will start with several relatively simple situations and, for now, talk less in terms of specific instruments and more in the general terms of keys and sources. Let's say you're shooting in a room that has natural illumination from windows. You want to do a camera pan from person A to person B. **(SEE 14-7)**

With the light meter, you find that person A has 40 fc falling on him. Using the 500 EI stock, that is $f/4$. Person B has 320 fc and $f/11$. Consider the possibilities and make some determinations.

If you shoot at:

$f/4$ Person A will be normally exposed, and person B will be +3, three stops overexposed.

$f/5.6$ Person A will be −1, and person B will be +2.

$f/8$ Person A will be −2, and person B will be +1.

$f/11$ Person B will be normally exposed, and person A will be −3, three stops underexposed and rendered with only a small amount of detail.

14-7

Setup #1: using natural light from the windows.

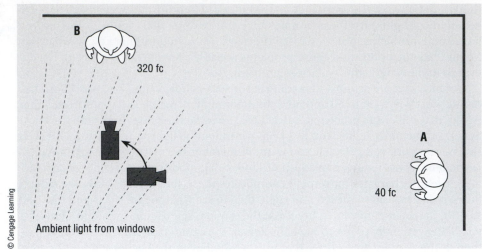

If any of these choices represents the effect that you desire, you can go ahead and film. If your purpose is different, and it usually is, you have to bring in lights.

Let's say that you decide you want normal exposure on each person. The question always comes up: Could you simply rack *f*-stops? That is, could you rotate the *f*-stop ring from *f*/4 to *f*/11 as you are executing the pan, just as you would with a rack focus? That way you would get normal exposure on each person. If you did this, though, you would have an unwanted by-product. Think back to the discussion of luminance and the gray scale (see chapter 13). You are crossing over the wall as you execute the pan. If you change the *f*-stop, you shift where the wall is read on the gray scale. If the wall is white, as you close down you are shifting the white into the gray area, and the quality of the white wall will become darker. This effect can be very pronounced, depending on how radically different the values are.

Because of the three-stop difference between the two people, one must assume that there is also a shifting amount of light on the wall. Attempting to calibrate an *f*-stop rack to the changing values on the wall, however, would be an exercise in futility; it would be virtually impossible to execute. Racking *f*-stops is extremely rare.

So, again, given the desired result, you find irreconcilable extremes. If you want a normal exposure on both people, the best solution is to use an instrument to light person A to 320 fc.[2] There are other possibilities (and complications), but this is probably the most straightforward solution. So set up a light and modify it to 320 fc. **(SEE 14-8)** That will even out the two extremes, and you can shoot at *f*/11.

Another example of the problems involved with several different exposure values is shooting in a car. Several years ago I was involved in a film that had many daytime shots inside a car. Step 1 was to read the exposure values already present in the scene. First the DP metered outside and got a reading of 640 fc (*f*/16). Then he went inside the car and got a reading of 40 fc (*f*/4) from the shaded backseat. These readings presented him with several choices. If he shot at *f*/4, the subject in the car would be normally exposed and the outside would be—what?—overexposed, but by how many stops? *f*/5.6 is 1, *f*/8 is 2, *f*/11 is 3, and *f*/16 is 4. Positing the latitude of three to three and a half stops, the outside would be totally overexposed.

If we shot at *f*/16, the outside would be normally exposed, but the subject would now be four stops underexposed and merely a silhouette. Each solution might be acceptable, given the dramatic approach of the scene, but in this case the director wanted detail in both areas. He essentially wanted a realistic look, even

2. This recommendation is complicated by the color temperature of artificial lights. (See "Matching Color Sources" in chapter 15.)

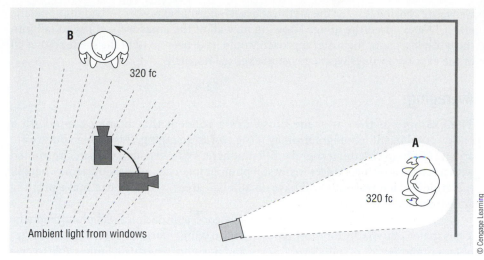

14-8

Setup #2: lighting person A to 320 fc.

though the subject being filmed was a rather bizarre character. As much as people discuss breaking out of realistic modes of representation, it is amazing how often we find ourselves discussing pictorial realism.

Without manipulating the situation, what were our other choices? If we shot at:

f/5.6 The figure would be −1, one stop underexposed, and the exterior would be +3, three stops overexposed, on the edge of the latitude.

f/8 The figure would be −2, and the outside would be +2. This is a possibility but, in my opinion, the worst of all possible worlds—neither one nor the other.

f/11 The figure would be −3, on the edge of the latitude, and the outside would be +1.

None of these seemed acceptable, given the desire for a realistic image. The obvious solution was to bring artificial light into the car. In a film with a larger budget, there probably would have been a generator that the car could tow. But with the limited budget on this project, we simply wired some small lights onto the car's battery (you have to know what you are doing to do this!). The temptation might be to pump the interior light up to *f*/16. This would be a real trick in pragmatic terms. Even if we could have done this, what would have been the result? A normal exposure inside and out—and it would look as though the sun were shining not only outside but also next to the subject in the backseat of the car. I have seen this done, and the results are spectacular—spectacularly bad.

The idea here is to manipulate the lighting values so that there is gradation that maintains the viewer's visual expectations—a gradation that, if you will, maintains our visual stereotypes. We perceive light and shadow in life; the absence of it on film makes the image unrealistic. Our solution was to light the person in the car to *f*/8 (160 fc), which is pragmatically much simpler. We then shot at *f*/11. The interior of the car and the subject were one stop underexposed, thus looking somewhat shadowed. The outside was one stop overexposed, giving it a bright, airy feel. **(SEE 14-9)**

The foot-candle value that translates to *f*/11—320 fc—may not have even existed in this image. It probably did somewhere, but that is not what is relevant here. The point is to expose to achieve a specific effect. If there were no points at 320 fc in the image, the final image simply would not have had any elements of normal exposure. Again,

14-9

Manipulating values to produce gradation maintains the viewer's visual expectations—a bright exterior and a more shadowed interior.

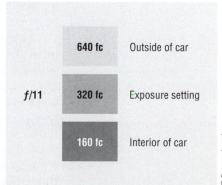

	640 fc	Outside of car
f/11	**320 fc**	Exposure setting
	160 fc	Interior of car

we were exposing less for the mythical beast—normal exposure—than for a specific effect. We exposed the image knowing how all of the areas were going to fall into the latitude. Again, the worst approach would have been to light the scene so that all of the exposure values were equal and exposed normally.

Averaging

The example of the car scene illustrates a concept that many people with a background in still photography may recognize as averaging. It is similar, but we are accomplishing something slightly different here. With *averaging*, when confronted with a range of *f*-stop choices many still photographers choose a stop somewhere in the middle. That way they will have detail in all areas, and they can make printing adjustments in the darkroom.

Although averaging can be a reasonably good approach for still photographers, it has major drawbacks for most types of filmmaking. Films, of course, are made up of tens of thousands of individual frames, and it would be virtually impossible to give them all individual attention. Each shot is analyzed before a final print is made, but it is analyzed for color and exposure correctness in the entire frame, not to find problems in small areas. The digital age has changed this somewhat, but needing to chase every exposure would become prohibitively expensive. The more you get right on-location, the fewer messy and costly corrections you have to make in postproduction.

People occasionally ask me, "In such and such a situation, should I just average these different exposures?" My answer is an emphatic "*No!* You should be choosing an exposure for a reason!" That said, averaging can be useful in some situations; documentary shooting in particular has many circumstances in which you are unable to control the light. In general, however, the answer is no.

Working with Artificial Light

A good example of an exposure problem comes from a film that I directed several years ago. It called for two actors to come around a corner, stand in front of a door, and exchange dialogue. Then, still in the same shot, they approached the camera, stopped, and exchanged some more dialogue. The action took place in a dingy furnace room and was to initiate a segment of the film that was dark and mysterious.

I wanted the characters to enter a strong, narrow beam of light and have their first discussion. Still in the same shot, they exited the beam, approached the camera, and had the second discussion in the darkened area of the furnace room. Setting up the beam of light was relatively simple. The problem became the darkened area outside of the beam. The figure on the following page illustrates what the proposed action looked like from overhead. **(SEE 14-10)**

We set up the beam and trimmed it to the foot-candle readings shown in the next figure. **(SEE 14-11)** Once we had the beam, we were able to check the other areas and see how all of the other values settled out. The areas outside of the beam—and we were measuring just ambient and bounced light because the only light was the beam—were at 10 fc and less, mostly less.

I wanted the center of the beam to overexpose by one stop because it would intensify the slash effect. We decided to shoot at the *f*-stop we got for 160 fc: *f*/8 with the 500 EI stock. The areas at 10 fc translate to what *f*-stop? *f*/2. The areas below 10 fc range below *f*/2. Even though the maximum aperture on the lens we were using was *f*/2.3, light exists at these levels and can have an effect on the film. In this case, however, this is four or more stops less than *f*/8, outside of the latitude of the film. I wanted the characters to have detail but still look as though they were in the darkened area—essentially a realistic image.

The solution was to set up a small light (F2 in figure 14-10) that filled in the front area. I wanted a look that replicated the indirect quality of the ambient light,

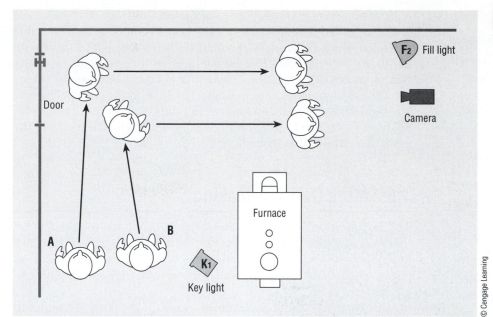

14-10

Proposed character movement for the furnace room scene.

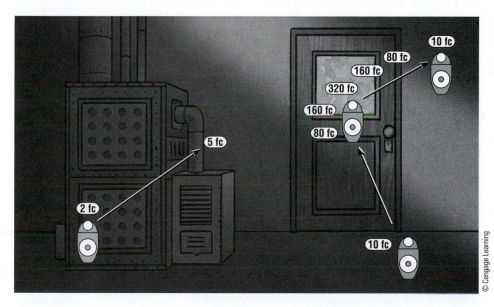

14-11

The foot-candle readings after setting up the single light source.

so we used a softlight. But how strong did we want it to be? We wound up trimming it until we got 30 fc right by the furnace. That is two and a half stops less than the stop at which we were shooting. Always thinking in terms of what the film is going to register, that was within our proposed latitude. We could predict that the characters would be rendered very dark but still with some detail when they reached their final position. This was precisely the desired effect. It is not quite so clear-cut as the example with the car, but again the areas of normal exposure in this image are exceedingly small—the edge of the beam. Think *effect*.

When I first started trying underexposure effects like this—and ones that were even more extreme—it took a lot of courage. I counted a few new gray hairs while I was waiting for the film to come back from the lab. In a sense what you are doing with this effect is plumbing the edges of the latitude. Occasionally, particularly as a beginner, you cross your fingers, hoping you have not fallen off the edge. Again, spot meters can give you some steadiness at the edge of the precipice.

14-12

This complex exposure incorporated a range of six stops.

	320 fc	One stop over
f/8	160 fc	Normal exposure
	10 fc	Four stops under

© Cengage Learning

In the example in chapter 13 of the man in front of the window, it was suggested that the range of light values represents irreconcilable extremes for a realistic image. But here there is a range of six stops—10, 20, 40, 80, 160, and 320—that are put together for a complex exposure. **(SEE 14-12)** Actually, there were more than six stops because the fill for the dark segment of the shot was not a flat 10 fc across the whole space. It would have looked abnormal if the darkness were totally even. So, here we see a very wide range of exposure levels that works in the particular situation we created.

The Setup: Decision-Making

The big question is: how do you work with individual lights? What follows is a lighting-plan walk-through. As stated, lighting is a deductive process, and this discussion will elaborate on as much of the reasoning process as possible. You start with a basic premise about what you want the scene's lighting to accomplish and go from there.

Knowing just what you want to accomplish is one of the hardest hurdles to clear. There is no single answer; and regardless of what is said here, the answers have to come from you. Every scene is different. It is not as simple as saying that you have to do the right thing for a specific scene or that the material is going to determine the light. That leads to clichéd and stereotypical answers. Sometimes you have to play against type or create some kind of visual subtext. Sometimes you want to highlight specific subjects or areas. Maybe you want to hide something. Sometimes you just want to cheat conventional expectations.

The effect should nevertheless be appropriate to the context. I have a friend, an experienced director who closely supervises the lighting in his films, who was filming a scene in an all-night restaurant. The scene had a number of offbeat characters and ambiguous action. He had the scene lit in an atmospheric, low-key way. A couple of months later, I noticed him hunched over the editing table with his head in his hands. He was looking at the scene and all he could say was, "How could I have done this? It's a @*#&%! all-night restaurant, not the Film Noir Café."

Our walk-through will start with a person and a table lamp. **(SEE 14-13)** The lamp is on, and a bookcase is about 5 feet behind the person. This is still a complex image. We will see many early mistakes with an image like this, particularly when

14-13

The starting point for the lighting walk-through.

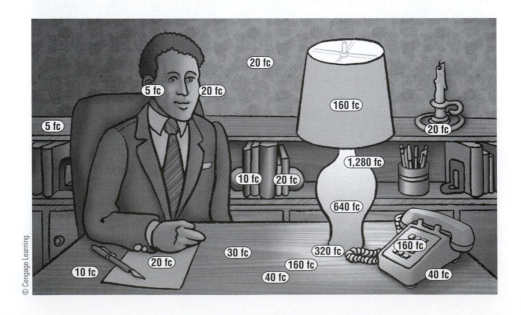

© Cengage Learning

using the automatic meters in some cameras. Let's say that we went through the scene and got the readings shown in the figure.

Notice the area just on the edge of the circle of light from the lamp, showing readings of 40, 160, and 320 fc. This represents someone's moving the meter along the surface of the table with the activating button depressed. **(SEE 14-14)** This response is common when there is a strong light with a hard edge. You get a strong reading in the center, which drops off a little toward the edge; then you see a precipitous drop outside of the circle. This is quite straightforward: we are just doing the necessary measurement of what is plain to see with our eyes. What is important to note is that there is a three-stop difference between the first and last positions.

With this three-stop difference in mind, it is easy to see why so many beginners make mistakes when using the automatic meter on a camera. Again, the automatic meter does not know what to read in this image. Undaunted by getting no reading when the camera is pointed at the face, the novice will pan over to the light. The needle will respond with some kind of exposure; let's say f/8. The novice will lock the f-stop, shoot the scene at f/8, and be disturbed when it returns looking like the figure shown at right . **(SEE 14-15)**

What happened is fairly obvious. The meter responded to, and the scene was exposed for, one of the brightest values. When the latitude of the film takes over, you are left with nothing. Looking at the scene with the naked eye, everything probably looked fine. Even through the camera, everything probably looked fine. But there was a rude awakening when the film came back. This kind of mistake is one of the most common exposure errors, and automatic light meters will do it to you with fair frequency. It is a prime example of the second rule of lighting: just because it looks good to your eye...

Using more-accurate metering methods, you can determine that there are a number of possibilities for exposure in this example, none of them good. As with the first example, if pictorial realism is your goal, what you see here represents irreconcilable extremes. If you expose to get one thing right, something else in the frame is going to be at an unacceptable level. If you expose the person's face correctly, the lamp is going to be totally wrong—and so on.

Applying the method described earlier in this chapter, you should first determine the exposure at which you want to shoot. Looking over all of the values, what would you choose? We will go with f/8, which is what we get for 160 fc at 500 EI. Sometimes you want to choose values that are read from sources that pose problems. Part of the reason we are choosing f/8 is that it is the reading off of the lampshade. Lampshades are difficult to manipulate to other values. You could put in a lower-wattage bulb, but this could create color problems and would change all of the other readings in the scene. Another possible solution is to wrap the interior of the lampshade with spun and tape it in. This is a relatively simple procedure,

14-14

The range of readings represents someone's moving the meter along the surface of the table with the activating button depressed.

40 fc 160 fc 320 fc

© Cengage Learning

14-15

The result of basing the readings of this scene on an automatic light meter pointed at the light.

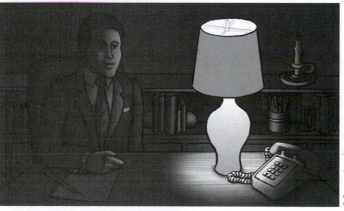

© Cengage Learning

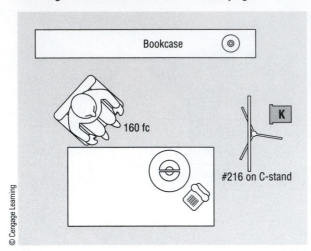

14-16

To duplicate the soft light coming through the lampshade, use tough-white diffusion in front of the key light.

but it must be done carefully or seams and tape will show through the shade. Probably the most effective method is to bring your own lampshade, one that allows the amount of light that you want to pass through it. I have a number of lampshades around that I use for just such purposes.

With all of that said, the reading off of the lampshade is fairly reasonable, so there is really not much cause to manipulate it. I can look at that 160 fc (ƒ/8) and feel comfortable with it. The lamp is one element that you might fear would jump out at the viewer if you shot at ƒ/8, but it is actually the one thing you are going to leave alone. When you shoot at ƒ/8, the ring of light on the table will overexpose by one stop, the base of the lamp will overexpose by two stops, and the very top of the lamp base will overexpose by three stops. This may seem to call for some attention on your part, but you will be surprised at how normal it will look on film. In a sense, we expect these areas to overexpose and we expect them to overexpose in this way. If you were to manipulate all of these values to ƒ/8, the effect would look pretty silly. Lamplight is not flat.

For simplicity's sake, let's say you want a fairly even feel to the image—not flat, but not deep low-key either. You already know what would happen if you shot at ƒ/8 without changing anything else. Where do you start with the actual lights?

As suggested earlier, start with the key(s). Set up an instrument, and light the person to 160 fc. Even here you have some room for maneuvering. If a person is sitting some distance from a lamp, might you expect him to be a little dark? Rather than light the subject to 160 fc, you could light him to 120 fc, a half stop less. You would still shoot at ƒ/8, and the subject would underexpose by a half stop, looking slightly dark. This is not a bad option, but we will stay with 160 fc.

All of the light on the subject is coming through the lampshade, so you can safely assume that it is fairly soft light. To duplicate that soft, warm light, we are going to put a piece of tough-white diffusion (#216) in front of the key light. You can still get 160 fc by spotting in the light or moving it forward. **(SEE 14-16)**

You have to be careful that the light from the key does not hit the lampshade. You should be able to accomplish this with the barn doors, though you could also bring in a flag on a C-stand. If light from the key does hit the lampshade, there could be a shadow of the lamp on the table, an effect that would look peculiar. Another reason to be careful of light hitting the shade is that it would actually boost the shade's nominal foot-candle reading, which would then expose differently. You also want to control the spill from the bottom of the instrument onto the table. Light spilling onto the table could ruin the circle of light from the lamp. You should be able to accomplish this control, again, with the barn doors.

The Setup: Fine-Tuning

Next you have to set up the fill light and the other lights. Once they are up, obtaining the desired effect is a matter of fine-tuning, or **tweaking**, the lights. You want an even feel to the image, so the fill should be relatively close to the key light in terms of intensity. Again, the lower it is in relationship to the key, the more contrast there will be in the image. I have found that having the fill light one stop less than the key creates an image that is too flat; it does not have enough texture and definition, even when I am going for a high-key image. Use a softlight and set it to 40 fc, two stops less than the key. **(SEE 14-17)** You still want a slightly darkened-room effect, and this should give the image

some character. Occasionally, the shadow from the fill can cause a problem even though it is very soft and diffused. You can generally put the light up high or move it until the shadow is hidden or out of camera range.

Next comes the backlight. **(SEE 14-18)** Because the person has dark hair, you probably want about 160 fc on the crown of the head. You have to be careful with spill coming from the backlight. You may want to use either aluminum foil or **black wrap**, a foil material specifically designed to wrap around the barn doors of lighting instruments.

People occasionally get the impression that spill from the backlight can or should be used to illuminate the background as well. Generally speaking, this is a bad idea. You will find that spill is hard to control because you are attempting to use what is spilling off of the bottom of the light. It is a good idea to keep the beam fairly narrow and have the backlight do just what it is supposed to do. If the background needs something, which it often does, supply it with other lights, called **set lights**.

This pretty much settles the lighting on the person. If you like it, you are done … with this part. Now it's time to take a look at the scene as a whole and see what else needs to be done. Because you have changed a number of things, use a light meter to check the ambient background light again. Let's say you get a range of low readings, 30 fc being the highest; 30 fc is going to underexpose by two and a half stops. This is getting toward the edge and may be darker than you want, particularly if the bookcase has a dark finish.

One solution would be to use a set light to throw an even 80 fc across the back wall. A softlight could be used if you want the light to be diffused and relatively even. What is the best position for this instrument? The fill for the person has been from frame-left, but is that the correct place for the set light? No, because the light from this softlight is designed to appear as though it is created by the lamp; it should come from the lamp's direction. Set it up fairly close to the key light. **(SEE 14-19)**

The instrument is positioned close to the wall so that its throw will not affect the person. Doing this, however, puts the right-front corner of the instrument too

14-17

Adding the fill constitutes the first step in fine-tuning the lighting setup.

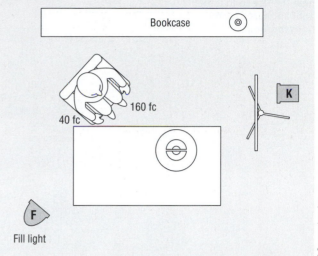

14-18

The backlight beam should be fairly narrow and aimed at the crown of the head.

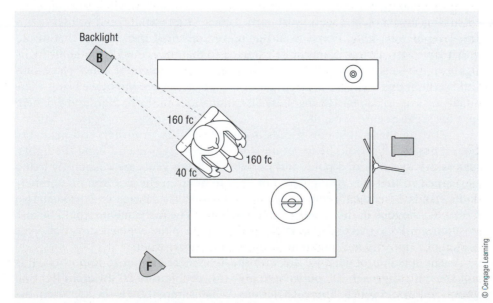

14-19

To boost the ambient background light, use an instrument positioned near the key so that the light appears to come from the lamp.

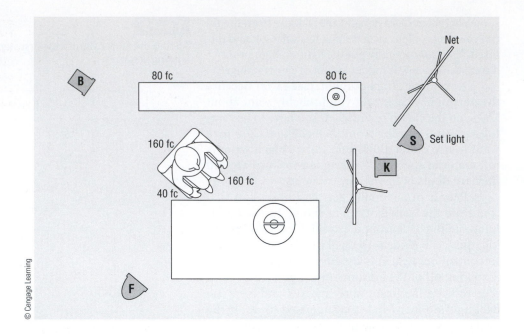

close to the background. Setting up a net to cut down that side of the light is one potential solution. If you position it expertly, you should be able to get an even 80 fc across the entire background. Spun is also handy for cutting an instrument in the manner described; it is frequently used to cut a corner of a light or to knock out some unwanted spill.

Are you done? Again, step back and look. My guess is that your criticism will be that the scene looks too even, too flat. The lamp is the major source, and the light should fall off as you move frame-left. Now you could move the net and the instrument so that the light will fall off from 80 fc on the right to 50 or 60 fc on the left. Even with this adjustment, the scene may still look too uniform—it would lack character. The execution here was right; it was just the idea that didn't work.

Don't hesitate to abandon an idea when you determine that it is not going to work. Every filmmaker will have the experience of sitting in a screening room, shaking his or her head, wishing that just a little more time had been spent to get it right. You cannot go in and do a little housekeeping without incurring major expenses.

So, what do you do? My recommendation would be that rather than junk the fill arrangement you had set up, just move it back. **(SEE 14-20)** It could still serve as a low-level fill, say, 40 fc. Then I would set up several small, direct lights that would either have very narrow beams or be trimmed so that they could throw some highlights on the background. The books behind the person might be a nice place for a little slash of light. The clock might be a good place as well. Might we bring a few small areas up to 320 fc? Having these discriminations in the background will help give the scene a sense of depth.

Putting these lights on stands is one possibility. Another, and probably better, possibility would be to set up some kind of rigging and hang the lights. **(SEE 14-21)** Sophisticated poles and portable lighting grids are constantly being developed so that everything does not have to be from the side and on cumbersome stands. I frequently run a 2 by 4 with holes drilled in each end between two C-stands; the tops of the stands go into the holes. The instruments would be in a position similar to that of the backlight, only pointed in the opposite direction. This is kind of a "poverty row" solution, but you do whatever works.

The specifics of what we did with the lights here are not so important. It is not the only approach. If you were to give this problem to 20 different lighting crews, you would get 20 different solutions. What is important is the approach, the

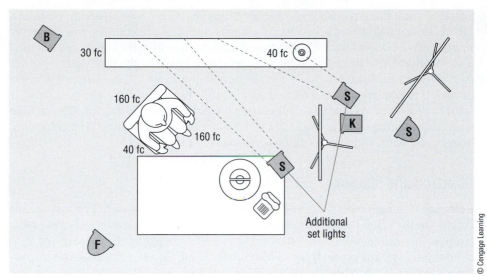

14-20

To add character to the otherwise uniform background, move back the fill arrangement and add several highlights.

process. What questions are being asked? What problems are being solved? You decide on a goal, you put up an instrument to achieve that goal, and then you trim the instrument until you get what you want.

There are other options and other types of instruments. It is possible that you might want to use a kicker. The **kicker light** is always on the fill side and behind the subject. It comes in and brushes or rims the cheek when the fill is not covering the area as adequately as you would like. It also helps separate the subject from the background. There are **eye lights** that come in to highlight just a subject's eyes. You will hear many other kinds of lights mentioned—rim, side, underneath, special-effects, and so on. These lights tend to characterize direction or achieve specialized goals rather than identify overall function (for example, an instrument creating the glow from a cigarette). *Underneath light* is usually key light. *Rim lights* and *side lights* are just types of key lights or backlights. Oddly enough, there are not that many identifiable overall functions of lights. This simplifies things somewhat, but for starters we'll stick with the four most important ones: key, fill, backlight, and set. You'll have your hands full with these.

Success with lighting is a matter not only of problem solving for specific setups but also of being able to reflect on the context of what you are shooting and come up with the appropriate response for a given situation. Remember what my gaffer friend said about learning to light: you need to spend quite a few years "putting it up, shooting it, and taking it down." This means you need to acquire the ability not only to manipulate the technical aspects but also to develop a vision of what you want things to look like. Your influences in this area are numerous: other films, painting, still photography, graphic design, and a variety of other media. Learning the technical and pragmatic aspects of working with lights is not an end in itself. You need to learn to do something with them.

That said, learning the technical side of lighting is an essential first step in the process of producing images. In the final analysis, that's all that is up there on the screen—light. You will not be served by ignorance of the tools available to you. A lack of knowledge necessarily limits your understanding of what is

14-21

Set lights can be suspended from rigging.

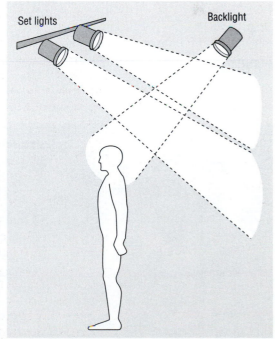

possible, much like a painter who has only two primary colors on a palette. Without a full understanding of and access to the range of technical possibilities, you can never reach the fullest expression of your ideas. If a painter has all of the colors and still produces works of little interest, it is the artist who is lacking, not the materials.

Get out there and light. Too many people put it off. "The equipment is too heavy." "I'm not interested in the technical stuff." "I'm afraid I'll make mistakes." "I want to be a director." I've heard all of the excuses. A fundamental, incontrovertible truth about filmmaking is that it is a process of producing images. To produce the images you want, you have to know what you are doing.

Direction and Shadow

Refer again to figure 14-17. Why did we put the key where we did? The instrument is setup to the screen-right side of the subject because the shot establishes the table lamp as the source of light. If you were to put it to the left of the subject, the shot would not make any sense. If the light is not justified, the shot can evoke an unconscious feeling of something being wrong or out of place.

This issue of justification is a central concern. Reynaldo Villalobos's cinematography in Eugene Corr's *Desert Bloom* (1986) has an excellent example of light that creates a dramatic effect and is also justified. A scene involves a father (Jon Voigt) having a confrontation with his daughter (Annabeth Gish). In the master shot, we see light streaming through the window, creating a bright pool right in front of where the father is standing. **(SEE 14-22A)** When we see the close-up, the father has very ominous, horror-style lighting from underneath. **(SEE 14-20B)** This eerie light makes sense to us as viewers, however, because we have seen its source.

You will hear substantial discussion on sets regarding shadows. Some crews devote an inordinate amount of time to trying to get rid of them. Sometimes a shadow can draw attention to itself and detract from the image, but the point is not that a character should have no shadow but that the shadow should be in a logical place—and there should be only one. A hallmark of low-budget films is the multiple shadows wandering over every wall in the shot when characters move. Start watching how films treat shadows. I have seen beginning filmmakers run themselves ragged, trying to get rid of each and every one of them. Except for multiple shadows, it is often time and energy wasted. You will have to decide how to handle these constant companions, but beware of shots that are unintentionally otherworldly because the characters have no shadows.

14-22

The dramatic underneath lighting of the close-up was justified by the master shot, showing the source.

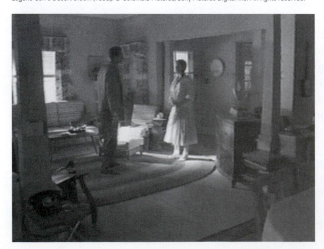
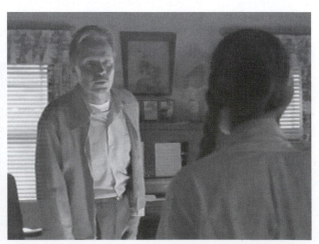

Although trying to kill an unwanted shadow with another light is tempting, never solve a problem created by one light with another. The reasoning seems clear enough: if you don't like the shadow, just overpower it with another light, usually an instrument down low or up high. The effect, however, is an image that looks as if somebody tried to overpower a shadow with something down low or up high. Solve the problem by either redirecting the original light (setting it higher is sometimes a good solution) or, often more to the point, changing the background. Faced with an ugly shadow on a wall behind a character, you can simply put something dark on the wall to cover it or soak it up. Find a poster or a plant—something that will break up the background and make it easier to work with the wall. Beware of the blank white wall. It is not a filmmaker's friend.

Natural Light

Beginning filmmakers often choose to shoot outdoors, wishing to avoid the issue of lighting altogether. They quickly find out that they have made a big mistake. The sun is not as loyal a friend to the filmmaker as might at first be imagined. If anything, shooting outdoors can be more complicated than shooting indoors. The foremost concern is understanding light well enough to know when what you are shooting is going to provide the results you want. Again, this is a process of evaluation. You will often hear of film crews "waiting for the light," and you will have to develop the skills to understand just what it is they are waiting for.

This is also an issue of being able to evaluate the *quality* of light. A good example of the difficulties you can experience regarding quality of light is filming when the sun's rays are the most direct. From roughly 11 A.M. to 1 P.M., the light is harsh, and you can get extremely dark shadows.

Let's say that you are filming a medium shot of a person in bright sunlight. You want the image to read "nice sunny day," so you desire a pleasant, bright feel. You take a light meter reading and find that you have $f/16$ in the direct sun. The immediate concern is the quality of all of the shaded areas, particularly the fill side of the subject's face. How dark is it going to be? You measure the light in a shaded area—or just shade the incident bulb with your hand—and get a reading of $f/2.8$. You do the standard computation: $f/11 = -1$; $f/8 = -2$; $f/5.6 = -3$; $f/4 = -4$; and $f/2.8 = -5$. The nose shadow is going to be five stops underexposed and therefore totally black. Will this be a pleasant effect? No. The darkness of the nose shadow, and of all the shadows in general, will probably be too harsh for an appealing image.[3]

One solution is to bring in artificial light to fill in the shadow. Bouncing existing light off of foam core or a reflector also works quite well. Obviously, you don't want to bring up the shaded areas to $f/16$ because that would be flat and textureless. How far you bring them up depends on what you want the image to look like. Another solution is to shoot at a different time of day when the sun's rays are not so direct. We all know the dangers of sunbathing during those hours, and you can get burned, in a figurative sense, by filming then, too. Only mad dogs and Englishmen go out in the midday sun, as the saying goes. Filmmakers, even when unhindered by budgetary and scheduling concerns, generally try to stay away from it as well. Being totally unhindered, of course, is rarely the case.

Another equally important issue is *continuity*. Just as you have to think about objects and body position within the frame, you must be conscious of the consistency of light from one shot to the next. Still photographers and filmmakers less interested in conventional narrative scene breakdowns sometimes have the luxury of waiting a long time to get the right light. But when you have to execute a number

3. Cinematographers will "light for black" to stay away from this peculiarly unpleasant phenomenon. That is, they will light a dark area to just outside of the latitude of the film so that they get a richer black.

of shots and you want them to appear to be occurring in real time, the activities of the sun and the sky can present many obstacles. Of course, we do not usually think of the sun and the sky as having activities, but there are times when I have thought of them as unruly crewmembers whom I would fire in a minute if I could.

The sun has a nasty habit of rising in the east and setting in the west. If your subject is facing north or south, the fill and key sides will change from morning to afternoon. If the subject is facing east, the sun will go from being in front of the subject to being behind. Things change so rapidly that matching the light of individual shots can be substantially problematic.

Even more difficult are the vagaries of weather and clouds. California is the home of a substantial percentage of the film business largely because of the quality of the light and the consistency of the weather. For those of us who work frequently in distant locations, a partly cloudy day can wreak havoc, making scenes that should have been shot in a few hours take twice as long. A rainy day can put you behind schedule, disrupt continuity from a previous day's work, and, in extreme cases, even change the environment in which you are working, such as by encouraging the growth of underbrush. I once worked on a film in which we had to hand-dry a rain-soaked wooden wagon with hair dryers so it would match shots from the previous day. Another time a location was completely flooded out. Snow, wind, haze, fog, and smog can all work their special magic to make your life miserable.

There are all kinds of ways to cheat the elements, such as bringing in instruments, shooting from a high angle to exclude the sky, and moving people so that they face different directions. Sometimes you have to wait it out. This happens to everyone, but larger-budget films are able to handle delays more easily than those precariously close to the financial edge. For lighting continuity, you have to know and understand the materials that are going to help you work despite the elements.

Finally, these issues of light quality and continuity can be interrelated. If there are harsh shadows at noon, the shots will not match those made at a different time of day when the light was less direct. For anyone who has seen production stills from films that are largely shot outside—a John Ford western is a good example—it soon becomes apparent why there are often banks of lights and reflectors on the hills above the location. A high percentage of the time, the shadows that the sun creates and the fill necessary for a good photographic image do not go hand in hand. John Wayne needed some consistent fill light in some of those famous rides through Monument Valley.

Natural light can obviously be extraordinarily beautiful. There are two important points to remember about natural light, though. First, you have to know enough about light to understand when it is going to photograph the way you want. Second, you have to be able to add to it when necessary to match individual shots to other shots. When working "in continuity," the consistency of light is an issue whether you are working indoors or out. And it is particularly difficult to achieve lighting continuity when the quality of light can change unpredictably.

Night Shooting

In the golden age of the Hollywood studios, much night shooting was done in a process called *day for night*, in which black-and-white film was shot with a combination of underexposure and red filtering to create a dark effect that represented night. Day for night is a lovely curiosity; some people love it and some people hate it, but it has rarely been seen in recent years. It does not really work in color, and newer, faster film stocks have made night filming quite practical. Now we do what people call *night for night*.

The key to night filming is understanding that even at night there has to be a source of light. Darkness, as we generally experience it, and an absence of light are not the same thing. When there is an absolute lack of light, you cannot see your hand in front of your face. Night shooting must establish or incorporate some

14-23

The strong side sources give both characters shape and definition while maintaining what night "should" look like.

Bob Rafelson's *The Postman Always Rings Twice* (1981), © WarnerVideo.com.

14-24

The character of the light emphasizes the subject's indecision. Jessica Lange in The Postman Always Rings Twice.

Jessica Lange in *The Postman Always Rings Twice* (1981), © WarnerVideo.com.

source of light. It might be a simulation of the moon or light from a storefront or streetlight. Once you have determined the source, it becomes a matter of deciding how you want the elements to expose, just as in any other situation. Here, though, being willing to work on the edge of the table can produce remarkable effects.

Of course, the movement that fully explored night cinematography was film noir. The dark city streets and their claustrophobic interior counterparts fully incorporated all of the shades from white to gray to black. Bob Rafelson's *The Postman Always Rings Twice* (Sven Nykvist, DP) has numerous examples of what can be achieved in color night cinematography. The sequence in which Cora (Jessica Lange) and Frank (Jack Nicholson) first try to kill her husband shows exceptional mastery of both interior and exterior shooting. Frank is outside talking to a policeman who happens by, as Cora paces nervously through the dimly lit restaurant. The exterior shots have two strong side sources, one established from a sign and the other from instruments by the gas pumps, which give both characters shape and definition while maintaining the logic of what night "should" look like. **(SEE 14-23)** The slight amount of detail that can be seen on the fill side of the characters' faces (particularly the policeman's) is evidence of the careful approach. This low fill would not be there had someone not wanted it there. The interior has Cora turning off the restaurant's lights as she builds up her nerve. Small sources inside have her passing from light to dark areas, emphasizing the indecision and heightening her dilemma, while light from outside casts stark patterns on the background. **(SEE 14-24)**

Night shooting, much like any shooting, entails determining the sources and, given the latitude of the film, how all of the other values are going to fall in. Some boldness on your part is necessary because many of the effects have to be around the edge of the latitude, with the idea that cinematographers often "light for black" complicating the job. It takes some experimentation with underexposure to achieve truly exceptional effects. Often, early experiments wind up having a too-bright foreground subject against a too-dark background. Do not let this deter you. Working with low values can be intimidating, but effective night shooting incorporates many different levels of exposure.

15

Executing the Lighting

A Checklist

To aid in lighting a scene, we can start assembling a checklist of questions to ask yourself about every image. Everyone involved in lighting asks all or most of these questions for every shot, whether consciously or not. Eventually, you will internalize these concerns, but in the meantime do not hesitate to simply go down the list before every shot. (You can be flexible in the sequence in which these issues are addressed.) What fundamental questions can be posed from the topics that have been covered in preceding chapters?

- ☑ *What do I want to achieve or accomplish with the image?*

- ☑ *What is the source of light? What direction does the viewer expect the light to be coming from?*

- ☑ *How am I going to expose the subject(s)? Am I going for normal exposure? Overexposure? Should the subject be darker, a little underexposed?*

- ☑ *What quality of light do I want? Soft? Hard? Should it be diffused?*

- ☑ *What goal(s) is each instrument accomplishing?*

These questions represent a starting point. What follows is a laundry list of all of the other things you need to think about as well.

Lighting Continuity

You will find that it is not necessarily difficult to create beautiful and arresting images. Learn a few basics and you can do some great things. What is difficult is creating beautiful and arresting images that cut to other similar images. The task is formidable if your wish is to create the hallmark of conventional narrative film: a seamless sense of continuous time and space. This goal is referred to as **lighting continuity**.

If a shot that looks like it was done in the early morning is followed by a shot that appears to have been done at another time of day, when edited together the resulting images will not maintain the fiction of continuous time and space. Given the lengthy amounts of time required to execute shots, lighting for continuity is less the exception than the norm that has to be wrestled with every day.

Early in his career, one cinematographer shot a scene that had two characters sneaking up on a house as the sun was rising. The scene took about two hours to shoot, and the light was changing so rapidly that the first shots had an entirely different look from the last shots. The edited scene proved challenging to print due to the inconsistent quality of the light. The lab was able to fix it somewhat, but all DPs have to be able to come up with solutions in such situations.

The issue of lighting continuity has to be confronted not only when you are subject to the whims of the sun but also when you work in interiors with artificial lighting. A good example is a simple shot/reverse shot sequence, the most common way to treat a dialogue scene between two characters. **(SEE 15-1)**

The foot-candle (fc) values below the two subjects (both 320 fc) represent readings off of the key lights. The values above (160 fc and 40 fc) represent readings from the fill lights alone. Again, reading the instruments individually is the most effective way of

15-1

A standard shot/reverse shot setup illustrates the importance of lighting continuity.

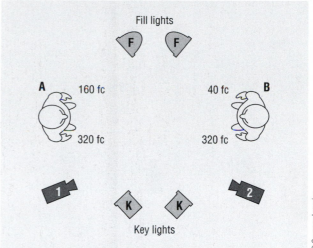

finding out what each one is accomplishing. With a hand or a card, you can block out the instruments that confuse the reading. Turning off the intrusive instruments can be equally effective.

As this scene is set up, you should immediately see a problem that is central to lighting continuity. The lighting on person A is even, with 320 fc key and 160 fc fill. The fill is one stop less than the key, thus underexposing by one stop. The fill side is rendered with a high amount of detail and would be considered high-key. Person B has the same 320 fc key but is filled by only 40 fc, three stops less than the fill on person A. This is just on the edge of the latitude, and the fill side would be very dark and the image low-key. When the two images are cut together, they will have such different visual qualities that the people may appear to be in two totally different places. The difference may be something like trying to cut from a claustrophobic film noir to a romantic comedy. The two characters may not appear to inhabit the same universe.

It should be fairly obvious now that if you simply match the two fills, depending on which universe you want, you will be much closer to a continuous sense of space; the ratio between the key and the fill would be the same in each shot, and the look would be similar.

Comparing the key and the fill is what has been referred to as the *lighting ratio*, or *contrast ratio*. It is obtained by measuring the lights and plugging the foot-candle readings into the following formula. (Do not use *f*-stops in the formula because the answer you get will not make any sense.)

$$\frac{key + fill}{fill\ alone}$$

Take a light reading at the subject with the key light and the fill light turned on. Then turn off the key and measure the fill alone. Divide the first figure by the second figure. We did this with person A and got the readings shown: 320:160 = 2:1, a two-to-one ratio. The ratio for person B (320:40) is eight to one. The lower the ratio, the flatter the image (high-key); the higher the ratio, the more contrast in the image (low-key). A four-to-one ratio is generally considered the rough dividing line between high-key and low-key.

15-2

A low-key lighting setup.

15-3

An outdoors lighting setup for the same low-key effect.

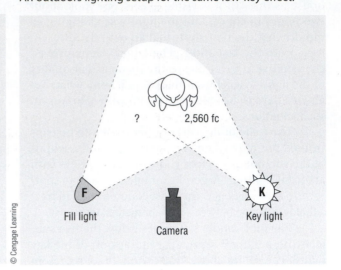

What is at issue here is how much the fill light is underexposing. In a two-to-one ratio, it is underexposing by one stop. In an eight-to-one ratio, it is underexposing by three stops. It should be evident that this sort of calculation can be done with other instruments. How much is the backlight overexposing? How much is the set light underexposing? Most of the time, however, you will hear ratios discussed in terms of key and fill.

Some variation in the ratios can be tolerated. An audience, unless it is composed entirely of filmmakers, is not going to catch minor errors or deviations. Audiences generally do not perceive this kind of thing on a conscious level. But if foot-candle values and exposure deviate very much, general continuity will suffer.

Lighting ratios are valuable for continuity, but they also can be helpful when you want to light a character consistently throughout a film. What would happen if you wanted the villain to be consistently filmed with low-key shadows? If you were indoors, you might consider the setup shown in the figure. **(SEE 15-2)** Later in the shooting, you are outdoors and want to be consistent with previous shots. The sun gives 2,560 fc. How would you fill the subject to get the light to match? **(SEE 15-3)**

In the first example, the fill light is underexposing by three stops. What do you need off of the fill to get it to underexpose by three stops? 1,280 fc is one stop under; 640 fc is two stops under; 320 fc is three stops under and is your answer. When you shoot at the appropriate *f*-stop, the fill light is underexposing by three stops in each shot. This leaves the quality of the light out of the quotient, but you have achieved at least some level of photographic consistency between the two images.

Probably most importantly, this is where the automatic metering approach starts to fall down. There is a story in the next section of this chapter of filming a woman approaching a bed (see next page), if you used the metering system in a DSLR the scene would come back all over the map. The walls would pop from one shade of blue to another. A person who should be in the darkness would come out normally exposed. Clearly for a complex scene, some managing of exposure is necessary.

Again, determining what you want normally exposed is the starting point. If you want the woman on the bed to be normally exposed, then you need to get in with your camera's meter and determine what the best exposure should be. Using shutter priority would be appropriate, so set shutter speed at 1/60th. Move into the

subject closer than you intend for the final framing and get a sense of what the best *f*-stop would be. Changing ISO may be appropriate, but work your variables to determine what the optimal *f*-stop would be. Once you have it, flip over to manual and lock it in for the rest of your shoot. If the subject approaching is a little darker than you want from the initial lighting setup, pop her up with an extra light (or lights). We can cheat a little with facial tones, but if the backgrounds jump all over the map, even the most unsophisticated viewer will find the results unsettling.

Lighting continuity, and the more general issue of photographic consistency, is not the goal in every film, but films that employ it are more numerous than one might at first imagine. Even films that deconstruct conventional narrative structures, such as Maya Deren's great experimental film *Meshes of the Afternoon* (1943) and Luis Buñuel and Salvador Dalí's surrealist film *Un Chien Andalou* (1928), incorporate lighting continuity and tonal consistency extensively.

☑️ *Is lighting continuity important to what I am doing? Does the shot I am executing need to match other shots?*

f-stops and Consistency

I frequently get the question: "Should I always shoot at the same *f*-stop within a scene?" My answer, which I then go on to qualify, is yes. It is yes because I have seen too many mistakes from people who are not aware of the problems that can occur if a scene is shot with a number of different *f*-stops. The qualification is that once you truly understand what you are doing, there is room to maneuver, but you really have to be clear on what you are trying to accomplish.

A good example of this is a scene from a student film made several years ago. It was a relatively simple scene: a woman crosses a room and stands by another woman who is sleeping in a bed. **(SEE 15-4)** It was a night scene, and the filmmaker

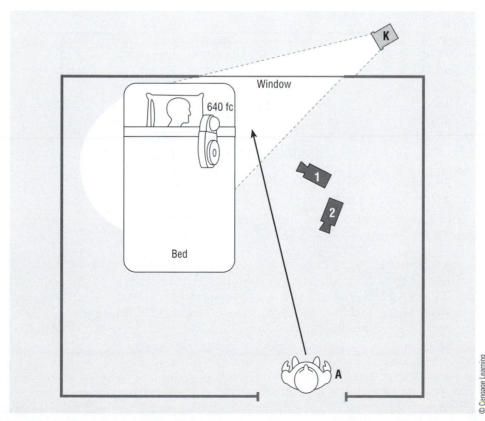

15-4

Initial setup for streetlight effect.

© Cengage Learning

wanted to simulate a strong beam of light from a streetlight illuminating the bed. To accomplish that effect, he set up an instrument outside the window, throwing a big beam of hard light.

The filmmaker wanted the beam to overexpose by one stop, so, given his reading of 640 fc on the bed, he decided to shoot at *f*/11 with stock with an exposure index (EI) of 500. He then metered the rest of the room. The only light in other areas was the ambient light created by the instrument he had set up for the streetlight effect. As you might expect, the readings were quite low, 20 fc and lower. Given the *f*-stop at which he wanted to shoot, he anticipated that everything lower than roughly 30 fc was going to drop off to underexposure. He wanted the room dark but not black, so he decided to put in a low-level fill. In a corner he set up a bounce card and shot an instrument into it. **(SEE 15-5)**

From this the filmmaker got a nice, even fill of about 40 fc throughout the room, three stops underexposed—dark but not entirely lacking in detail. So far, so good. All of the material of the woman in bed was shot from setup #1. Then he turned around to shoot from setup #2 the other woman approaching the bed. He already had a meter reading of 40 fc in the area through which she was moving. That translates to *f*/4 at 500 EI, and he proceeded to shoot this part of the scene at that stop. Therein lay his big mistake.

Let's consider the scene. We have established that the woman is passing through a dark area. If we shoot her at *f*/4, how will she expose? She will be exposed normally. But she is supposed to be dark. You might actually be able to get away with some slipperiness in the way she is exposed. Viewers might accept, if not demand, a slightly higher exposure in a close-up or a reverse angle than they did in a wider shot. The woman crossing the room is the main focus of the shot, so we

15-5

Adding low-level fill by bouncing a beam off of a card.

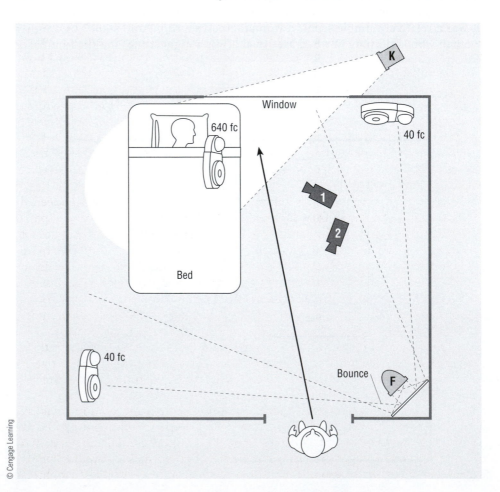

expect to see her in more detail than in a shot where we see only her back. What happens to the character, however, is not the major problem. What is?

As is so often the case in situations like this, the problem is the background. In shot #1 we established that the walls are very dark, underexposing by three stops. If we expose shot #2 at $f/4$, what happens to the walls? They are suddenly at, or are very near, normal exposure. The walls in this particular example were light blue. From the exposure the student did at setup #1, the walls were underexposed and thus a deeper blue. At the higher exposure of setup #2, the walls were a very light and airy blue, almost normally exposed. When he later attempted to cut the two pieces together, it just did not look as if they were shot in the same room at the same time. The pieces did not look continuous, and the student had to reshoot that side of the scene.

The more experienced and confident you become, the more you should be able to shift f-stops without making mistakes. A normal exposure is a normal exposure, whether it is shot at $f/2.8$ or $f/22$. One filmmaker was shooting in an office building on a late winter afternoon and began losing the exterior light as evening approached. He could see on the meters that the exterior light was dropping a half stop every 15 minutes or so. Because the outside was in the background of every shot, he merely had to trim each instrument (about six altogether) the same half stop every 15 minutes. He started at $f/5.6$, and by the time the shoot was over the exposure was at $f/2.3$, the lowest stop on the lens.

If shifting the f-stop becomes unavoidable, you too can simply manipulate the light to the appropriate value. All experienced DPs know how to shift values around to match what has happened in other shots. Given a choice, however, a DP would probably opt to keep things at the same value just to prevent unnecessary complications.

A final point that refers back to the discussion at the beginning of chapter 14 about how we might choose a specific f-stop: Most DPs will go into a scene with an f-stop already in mind. This stop is not necessarily based on a value that they know is in the scene, the approach that was demonstrated in chapter 14. Rather, it is based on the fact that most DPs have an f-stop of choice—a preferred f-stop. The choice of f-stop has to do with their personal preference for the quality of light and the way the lens resolves at specific stops. Different DPs have different preferred stops, but they usually fall in a range from $f/2.8$ to $f/5.6$. There are situations, say, outside on a sunny day, where they may not be able to achieve their stop of choice; but when full control is theirs, they will almost always light to that particular stop.

There are two major reasons for this. Simply stated, the quality of light needed to achieve $f/2.8$ is different from that needed to achieve $f/8$. After years of experience, most DPs simply prefer certain qualities of light. Given scenes that do not need dramatic extremes, they will go with what they like. The second reason is more complicated: the image is sharper, with higher resolution, at lower f-stops. Even though there is greater depth of field at the higher f-stops, light refracts against the closed-down diaphragm, reducing sharpness. You may have more things in focus, but the overall image is a little softer. Sharpness and depth of field are different issues, and many DPs will sacrifice some depth of field for greater image clarity.

The idea of lighting for a specific f-stop seems to depart from the calculations presented earlier. Beginning with a given f-stop removes the f-stop as a variable. But eventually you will come to see that the true variables in the formula are the amount of light in front of the camera and the desired exposure.

The idea of a given f-stop casts a different light on our decision-making process, particularly when considering the basic strategy of lighting proposed in chapter 14. It was suggested that determining the f-stop is the starting point, and having an f-stop of choice makes this part of the decision-making process appear more arbitrary. If we go into a scene with a predetermined f-stop, the emphasis

15-6

The modified formula after changing the *f*-stop from a variable to a constant.

$$\boxed{\begin{array}{c}250\\500\\1000\end{array}} + \boxed{\dfrac{1}{2\times24}} + \boxed{\textbf{Number of foot-candles}} + \boxed{f/5.6} = \textbf{Exposure ?}$$

shifts to the manipulation of other variables in the formula—most specifically the amount of light present. The *f*-stop may not be quite as much of a constant as the shutter speed and the EI, but many professional cinematographers treat it as a given. Thinking of the *f*-stop as a constant changes our formula somewhat. **(SEE 15-6)**

Most DPs will light for the *f*-stop of their choice. Many people on the West Coast love *f*/5.6. Other filmmakers will shoot only at *f*/2.8. A DP's preferred *f*-stop can vary depending on the format—16mm, 35mm, and so forth.

Some DPs are extreme enough about wanting a specific *f*-stop that they will control situations that appear uncontrollable. If you are shooting exteriors and get a reading of *f*/16, is there any way you can shoot at a preferred *f*/5.6? Could you use neutral density as a front-filter on the camera to get there? The permutations become dizzying.

The question of lighting continuity does not have to be posed solely in terms of a preferred *f*-stop. It can be posed in a way that has already been suggested in the discussion of the table lamp and the lampshade in chapter 14. Is there something in the image that will be difficult enough to manipulate that you are better off just shooting for that stop? For example, neon exposes well at *f*/4 with 500 EI film. If there is going to be a neon sign in a shot, you can base the way you light everything else on that fact.

The specter of consistency will haunt you in almost everything you do. Exposure can be understood, though not mastered, relatively quickly. Matching shots is the tricky part. It is recommended here that as a beginner you try to shoot at the same *f*-stop in a given scene. It can possibly prevent some very difficult matching problems, and it is also good discipline to manipulate instruments to specific values.

☑ *Do I want to shoot at a particular f-stop?*

Controlling Focus

The *f*-stop is a major variable in the plastic quality of the image, but it is also a major variable in depth of field. It is often necessary to light to achieve a specific depth of field. When you plan out a scene and do storyboards, you can begin to anticipate difficulties presented by specific shots. If there is a shot with two people on opposite sides of the room, you will have to consult the depth-of-field charts if you want them both in focus.

One film several years ago had a good example of this problem. One shot called for a man to be sitting on the edge of a bed while a woman in the background sat at a dressing table. Owing to the dimensions of the room and the action that had to occur, the closest they could be to each other was just under 20 feet. The man needed to be as close to the camera as possible. The DP was working with a lower-rated stock (EI 100) as well as small instruments and limited electricity. Thus he had to light the shot with a relatively low number of foot-candles.

To maximize depth of field with focal length as a variable, the DP chose the widest-angle lens available: 12mm. This lens did not have the perspective characteristics he desired, but he needed the depth of field. He consulted a depth-of-field

chart and found that his best option was to shoot at *f*/4 and focus at 6 feet. This would bring into focus everything from 3 feet 5 inches to 27 feet. He planned to put the man a little less than 4 feet from the camera, just for some margin of error. The woman would be about 22 feet from the camera.

Thus the DP needed to produce *f*/4 on-location. To do the same, you essentially read the light meter backward to find out how many foot-candles you need. Start on the bottom of the meter with the *f*-stop, match to it the frames per second (fps), and go up to see the resulting number of foot-candles. In this case the DP needed 250 fc. That became the base foot-candle value on which he planned the lighting of the entire scene.

When anticipating specific shots, you know you are going to need a certain *f*-stop to produce the necessary depth of field. Although all levels of production deal with lighting for depth of field, the complications described in this scenario, such as inadequate space, too short a focal length, limited electricity, and so on, are common on smaller projects. Filmmakers with more resources are less likely to paint themselves into corners. The solutions devised are typical of the kinds of compromises that often have to be made when you don't have complete control, compromises that affect the visual quality of the film.

☑ *Am I lighting to achieve an f-stop that will give a specific depth of field?*

Matching Color Sources

Matching the **color temperature** of light sources can be an almost overwhelming aspect of location shooting. As explained in chapter 7, it is an issue only when shooting color film, a not insignificant reason why students often choose to shoot in black-and-white.

The scene with the man in front of the window, introduced in chapter 13, is an excellent example of a situation in which there are different light sources. **(SEE 15-7)** We have not yet actually put any artificial light on the person; we most certainly will, but for now we have only the lamp and its area of illumination. Assuming the use of tungsten-balanced film, what will the result be if we shoot this scene without an 85 filter? The area under the lamp will be normal, and the outdoors will be blue. If we shoot with the 85 filter, the area under the lamp will be amber and the outdoors will be normal.

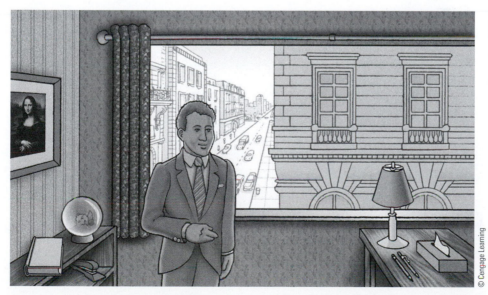

15-7

There are two common ways of matching color temperature when mixing daylight and tungsten sources.

© Cengage Learning

The problem is matching these two sources. There are two standard ways to do it. The first takes substantial experience to do correctly, is quite costly, and is the better approach. The second method is less expensive, requires fewer skills, and is less preferred. The second way, however, is probably the approach most students will take, at least at the outset.

The first method is to put rolled 85 gel on the window, the same material that you use in front of the camera lens. It comes in large rolls and can be laid smoothly against windows. The 85 adds an amber component to the light coming into the room from outside, as well as to the exterior light the camera sees. The tungsten film then reads this amber light as white light. **(SEE 15-8)** Do you use the 85 filter on the camera in this situation? No. What you are doing is bringing the color temperature of the daylight down to the color temperature of the tungsten instruments so that it will read correctly on tungsten-balanced film.

These filter rolls are quite expensive. You'll need experienced people to put up the 85 material because if it's not applied properly you can be plagued by reflections, glares, ripples, and bubbles.

15-8

Reddish gel on the window brings the daylight color temperature down to match that of the tungsten instruments.

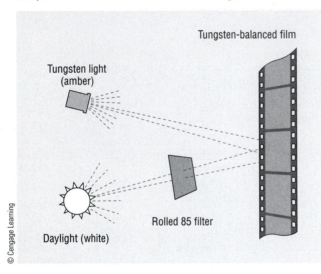

Tungsten-balanced film

Tungsten light (amber)

Daylight (white)

Rolled 85 filter

© Cengage Learning

The second method is effective but slightly more cumbersome. Rather than adding a color component to daylight, you can add one to the tungsten instruments. The material is called full-blue gel, and you will put a piece on each of the instruments. The **full-blue gel** also cuts the instrument down by one f-stop. In terms of color, the gel adds a blue component to the amber tungsten instruments, bringing them up to the daylight color temperature. Do you use an 85 filter on the camera? In this case, yes. **(SEE 15-9)**

This is getting complicated, but here you take the amber of the tungsten light and add blue to match it to the white daylight. You then take this white light and, with the 85 filter, turn it amber again so that the tungsten-balanced film will see it as white. Confusing? Perhaps, but it does make sense.

If it sounds as if the light is getting digested one too many times, you see at least one reason why the first method is so attractive. A general rule of lighting

15-9

Full-blue gel on the tungsten instruments brings their color temperature up to match that of daylight.

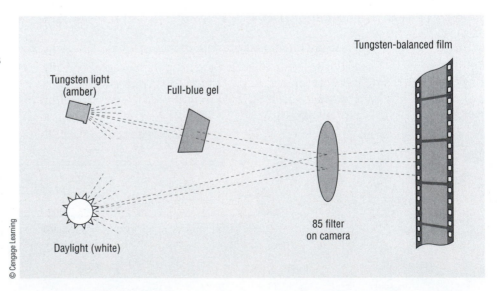

Tungsten-balanced film

Tungsten light (amber)

Full-blue gel

Daylight (white)

85 filter on camera

© Cengage Learning

is *do not encumber an instrument unnecessarily*. Often enough you will be doing other things to it, and putting on blue gel makes other adjustments more difficult. Along these lines, whenever you put something on an instrument that cuts the light in half (one stop), you are not using the instrument to its full capacity. You do not always want or need the full capacity of the instrument, but, again, you don't want to impose limitations before you even start. There are always plenty of constraints built into the process without creating new ones unnecessarily. Anytime you want to do something with the instrument, such as pin spun on a corner, you have to deal with the blue gel as well. The blue gel just complicates your task.

The use of the 85 filter also presents complications. As stated earlier, it cuts out two-thirds of a stop, so you use the lower EI. You will be getting less light through the lens as well as less light from the instruments. The smaller output from the instruments makes matching light levels between the interior and the exterior more difficult. All of these factors only complicate your task and place an unnecessary limitation on your work. It will make achieving any significant depth of field more difficult as well.

Having stated these negatives, we can reiterate that, for the time being, the blue gel method is probably the way you will match the color temperatures. The expense and the experience that it takes to use the first method may be beyond your means. It also takes substantial preplanning to use the first method. The gaffer, electricians, and grips have some of the earliest call times for any shoot to deal with issues like this. Setting aside the evening before or the early morning to put the materials in place will allow you to make better use of actual shooting time.

Given what has been said, you might consider your choice to be a toss-up between the two methods. The detail that tips the scale toward using 85 on the window is that it also provides the ability to use *mixed gels*. This is where a neutral density (ND) filter really comes in handy. Like an 85 gel, ND also comes in large rolls and can be applied to windows. More significant, it can be mixed with 85 in a single gel.

Going back to the example of the man in front of the window, not only do you have to solve the color temperature problem but you still have a major exposure problem. Assuming you want a realistic image, it would not be feasible to set up enough light to bring the foreground close, in terms of exposure, to the background. The solution is to bring down the background with ND.

A roll of 85ND3 gel would change the color temperature to tungsten color temperature (85) and the neutral density component would cut out one stop of light (ND3). An 85ND6 gel would cut out two stops. Also remember that the 85 cuts out two-thirds of a stop, so the total light cut on an 85ND6 would be two and two-thirds stops—one and two-thirds for 85ND3. There are many other mixes; these are just a few examples.

To go back to the example of the formula, the ND and 85 filters become yet another variable. The following figure depicts the configuration you originally had on the shaded building (640 fc) of the man-and-window example. **(SEE 15-10)**

You will not always think of it like this, but when you put an 85ND6 on the window, you are reducing, at least from the camera's perspective, the foot-candle readings you found outside. Obviously, the actual readings on the shaded building

640 fc

15-10

The original formula for the shaded building in the example of the man and the window.

© Cengage Learning

15-11

The nominal change in foot-candle readings caused by the filter can be treated as a subset within the formula.

© Cengage Learning

15-12

The change caused by the 85ND6 filter on the window.

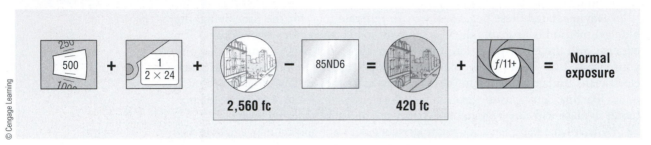

© Cengage Learning

and the street remain unchanged. You are simply putting a block between the filmed object and the camera, cutting down these areas by two and two-thirds stops. This can be treated as a subset within the equation: –1 = 320; –2 = 160; and –3 = 80. The new reading would be a nominal 100 fc. **(SEE 15-11)** Although normal exposure may not be your goal here, changing the amount of light reaching the camera means that you have to change the ƒ-stop for a normally exposed image. You consult the EI chart (figure 12-1) and find that 100 fc corresponds to a little over ƒ/5.6. You can do the same thing with the street, taking into account the 85ND6 filter on the window. **(SEE 15-12)**

It becomes evident that ND filters give you substantial control of the light outside and coming through windows. The material comes in enough gradations that you can even keep up, at least to some degree, with changing volumes of light as a day progresses. The ND approach allows you to bring down the values into a reasonably narrow range, eliminating the irreconcilable extremes identified earlier.

A **color temperature meter**, which resembles and is handled just like a light meter, is an aid to sorting out issues of matching color; with it you can measure the color temperature of any light source. Most color temperature meters also have a chart or an onboard computer that tells you what kind of filter is required to bring a given light source to the color temperature you want. Color temperature meters are complex and expensive tools but are a necessity in professional production.

Again, this entire discussion applies solely to color film, as color temperature is not an issue with black-and-white. Pay attention to it, though, because even the most ardent black-and-white enthusiasts will eventually find some circumstance in which they want, or need, to shoot color.

☑ *Will I have to make adjustments to match color temperatures? If so, what materials and skills will I need?*

Electricity

Knowledge of electricity—how to use and respect it—is mandatory when working with motion picture lights. Even the smallest instruments draw a substantial amount of electricity, so you need to know how to evaluate your power requirements and set up safely.

When the subject of electricity comes up, it's amazing how many people admit to sheer terror at even the simplest of applications. It seems as though everyone has, or has heard, at least one horror story. We treat electricians as bearers of some mystical, dangerous secret, when knowledge of electricity is actually quite accessible. It is not necessary to become a highly trained professional electrician, but you do need to exercise common sense. Specifically, you need to be able to determine your power needs and identify their source.

Access to electricity will always be an issue. At this point it means learning how to evaluate standard wall power—household outlets. Large-budget productions invariably bring large noiseless generators or go through a process called *tying in*, which requires the gaffer to use clamps that look like standard automotive jumper cables to tap into the main power of a building. This job should be handled only by a qualified technician, but it eliminates the time-consuming process of identifying the outlets and running extension cords all over the place.[1] Identifying outlets is the approach that, at least for now, you will have to take.

Every house or commercial building has multiple series of outlets referred to as **circuits**, which are tied to the main **breaker box**, often found in the basement or near where the electrical service enters the building. Most people have seen a breaker box, as found in most newer or rewired homes. Older homes often have fuse boxes instead, with the old screw-in round fuses. Breaker boxes and fuse boxes essentially amount to the same thing. The term *breaker* is used here. A typical breaker box is shown in the adjacent figure. **(SEE 15-13)**

Each breaker in the box represents a circuit. The numbers—15 or 20—on the breakers refer to the amount of **amperes**, or *amps*, that can be drawn from the circuit. Everyone knows that if you overload the outlets, you blow a circuit breaker. If you blow a breaker, you go to the breaker box, find the blown one, and put it back in service. In the type shown in the figure, the breaker simply snaps toward the *off* position and you have to flip it back on again. For the older, screw-in fuses, you must replace the fuse, which means that you should plan for that possibility and have spares on hand.

Obviously, you don't want to be constantly blowing fuses as you are filming, so you apportion the instruments among the outlets so that excessive power is not being drawn from any one circuit. To do this you have to know how many amps each lighting fixture draws. There is a simple formula for this calculation:

A typical electrical breaker box.

© Cengage Learning

1. In many localities tying in is highly regulated or, in some cases, illegal. Failure to check pertinent electrical codes may result in stiff fines or problems with insurance carriers.

$$\frac{watts}{volts} = amps$$

In standard U.S. household circuits, *volts* are a constant: 120.[2] Virtually everything you plug in is based on 120 volts, except for some large appliances that have different plugs and receptacles and are 240 volts. *Watts* vary according to the specific lamp or appliance. Everyone has heard of 60-watt bulbs. If you had a motion picture instrument with a 1,000-watt bulb, and that is a pretty standard small lamp, you would use the formula to find out how many amps it required.

For a much simpler figure with which to work, 120 can be rounded down to 100 and used in a formula that is much easier to remember:

■ **RULE** For every 100 watts, you need 1 amp of power.

This is a simplification of the more complex formula. For a 1,000-watt lamp, you need 10 amps (1,000 ÷ 100 = 10). A 15-amp circuit cannot support two 1,000-watt lamps; you'd trip a breaker. Eventually, you will want to use the more complex formula shown above, but the simpler rule both yields the information you need and gives you a margin for error.

So how do you go about determining which outlets are on which circuits? You have to go to the fuse box and do some testing. It is a fairly simple matter, but for some reason this is where people start to get cold feet. You turn off one breaker and see which outlets are no longer working. It is important that you turn off only one breaker switch at a time. If you are lucky, someone will have written on the faceplate which rooms each breaker controls; it might say "bathroom" or "east bedrooms," for example. If there is nothing written, you'll have to go through the whole house.

Once you have turned off one breaker, you can use a *circuit tester* to find out which plugs are not working. Circuit testers, also called *pigtails*, have two prongs with a small bulb on the end. You can buy one at any hardware store for about $2. You stick the prongs into an outlet; if the bulb does not light, the outlet is on the circuit you have turned off. Most multitesters, which are multifunctional battery testers, also have a position to test AC (alternating current). Other functions of the multitesters come in handy for other applications. If you have neither type of tester, you can use a small appliance, such as a radio, to identify which outlets are "hot."

By this method you can go through the entire structure and determine which outlets are on which circuits. As you do this, you should make a map, an overhead similar to that used for planning shots, that details the location of circuits and where the sources might be for the instruments you want to use. This is a time-consuming albeit necessary process.

Once you've determined where everything is, you can apportion the instruments to the outlets so that you never draw more power than a circuit can hold. If you find that a room has one 20-amp circuit, the most that you can plug into that room's outlets is a total of 2,000 watts; if two rooms are served by a 15-amp circuit, the most you can plug in is 1,500 watts, and so on. By the end you may have a tangle of extension cords running from many different sources.

In the industry the size of instruments is spoken of in terms of **kilowatts (k)**. This should not be confused with the *K* that represents Kelvin degrees. A 1k lamp is a 1,000-watt lamp; a 2k lamp is a 2,000-watt lamp, and so on. It is not uncommon, particularly when working in large spaces, for commercial productions to use 10k lamps and larger. If you plug 10,000 watts into the simple formula, you will find that you need 100 amps for a 10k lamp. It is clear that no standard household circuit,

2. Identifying 120 volts as a constant can be done only in terms of its use in a formula. Voltage as supplied from a local power company can vary from roughly 110 to 125 volts.

and barely the whole house for that matter, can meet those power requirements. In fact, the use of any instrument larger than 2k necessitates an alternative power source. Again, large productions use generators almost exclusively.

Power limitations are an important issue because they force the novice to work with smaller instruments. Crews on bigger-budget films use large instruments—4k, 5k, 10k, and so on—fairly regularly, but it's virtually impossible for beginners to use them. This is probably fortuitous because it takes a good bit of knowledge to deal safely with larger instruments, considering their heat, weight, and voltage requirements. This situation should never be used as an excuse or seen as a limitation because you can do some wonderful things with small instruments.

That said, you can do things with big instruments that you just can't do with small ones. If you shoot a 1k through a silk, you won't have much light left to work with. If you want to add a deep color, you have the same problem. If you want a certain depth of field, you may not be able to create enough light to get the stop you want.

A substantial part of evaluating electrical requirements should occur in pre-production. As you become more secure with lighting, you will be able to anticipate the size, type, and number of instruments you will need. In fact, you should be prepared to the extent of knowing where almost every instrument will be placed. Drawing a map of your overall lighting design can be incorporated into an overhead that indicates the location of all circuits. Planning may be hard at first, but keep it as a long-term goal.

☑ *Have I determined how much electricity I need and identified the source?*

Printing, Processing, and Exposure Manipulations

There are a number of ways to manipulate film images, and these methods, of course, have a direct bearing on light and exposure. Techniques include under- and overexposure, color effects, and actually manipulating the film stock and the processing. Although most of your effort should be toward mastering basic exposure, you can still create some interesting effects, and you may want to start experimenting with some of these techniques. In any case it is important that you learn how to communicate to the processing lab what you have done.

Reference Charts

Gray scales and chip charts are used as references to communicate to the lab any changes. The gray scale is described in chapter 13. The **chip chart** is a series of colors on a chart—the photographic equivalent of color bars in video. Whichever you shoot, charts serve as a printing reference for the lab if you are making workprints. You should shoot one of these reference charts at the head of every roll. To make the workprint, lab people analyze the chart and use it as a guide in exposing the workprint. Film manufacturers generally recommend the gray scale, and a number of labs and practitioners prefer the chip chart. Charts are important in video transfer as well.

When your shooting is straightforward in terms of exposure, the chart is not quite so important. The lab will look at your shots and should be able to give you a reasonably good print or transfer. When you are trying for a difficult exposure or a color effect, however, it is crucial that you have a chart and that it is shot correctly. Without a good reference, the lab may have no idea how to print your film.

Several years ago one student was shooting an exterior scene at night. As mentioned earlier, people tend to associate the color blue with night. The student decided to try for a blue moonlight effect by putting the same full-blue gel that

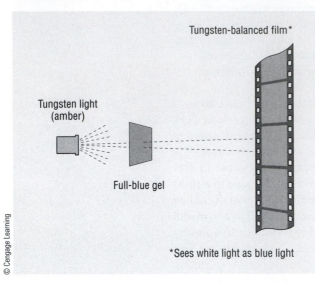

15-14

Setup for creating a blue moonlight effect by putting a full-blue gel on the instruments and omitting the 85 filter on the camera.

Tungsten-balanced film*

Tungsten light (amber)

Full-blue gel

*Sees white light as blue light

corrects for daylight on the instruments, omitting the 85 filter on the lens. **(SEE 15-14)** If there is no filter, the film will read the light as blue.

The student sent the film to the lab with the perhaps too standard request for a best-light workprint. He was pleased with creating an interesting, albeit unbeknownst to him relatively common, effect. The people at the lab took one look and said, "too blue," so they filtered out the extra blue. He got his film back and hit the ceiling. The lab had murdered his beautiful blue effect. He made noises about never using that lab again until he was pulled aside and told what had happened. It was not "the lab's fault." It was his for not communicating to the lab what he was doing. Also, all was not lost, of course, because the student's blue effect was still there in his camera original. When he went to a final print, the lab brought out the blue effect as it could have done from the beginning.

If the student had shot either a gray scale or a chip chart at the head of the roll, he would have been all right. In this case you just throw some light on the chart and shoot at the f-stop that the light meter tells you. You might ask if the student should have put the same blue light on his chart because that was the effect he wanted. The answer is no. The lab dials the lights on the analyzing machine until the scale appears as it should. If there is blue light on the chart, whether it is a gray scale or a chip chart, the lab will dial out the blue to get to a normal representation—exactly the opposite of what you want. If you shoot the chart normally, no changes will be dialed in, and your blue will make it to the workprint.

Many exposure manipulations bring up similar questions. One student wanted to do a number of underexposure effects. She knew that if the lab saw this without being informed, it would overexpose the workprint, or "print it up," in the printing process and take away the effect. So the filmmaker exposed a chart normally at the beginning of the roll. The lab set its printing lights normally, and the underexposure effects made it to the workprint. Conversely, another student wanted the grainy effect of underexposed film printed up to look normal. She had underexposed her whole roll by one stop. If she had shot her chart normally, the workprint would have been one stop underexposed, which was not what she wanted. Instead, she underexposed her chart by that same one stop. The lab looked at the chart, dialed the lights up, and pumped more light through to the entire workprint. This was exactly what she wanted.

■ **RULE** If you want the lab to preserve your effect, shoot the chart normally. The lab will set the printer lights to normal exposure, and your effect will be printed.

■ **RULE** If you want the lab to manipulate your print, shoot the chart with whatever modification you are attempting. The lab will make the necessary adjustments to correct the reference chart, and you will get the correction you desire.

There is certainly a lot more to this, but these are some good general rules. If you shoot a reference chart, be sure to write on the packaging in big letters: "PRINT TO GRAY SCALE [or CHIP CHART] AT HEAD."

In addition, be aware that manipulation of exposure will cause different effects in the final film. These effects vary between reversal and negative film stocks. With negative, underexposure causes greater visible grain and desaturation of

color; colors will be more muted. Overexposed film will have less visible grain and greater color saturation. There is an old rule to this: When in doubt, overexpose with negative film. When going for commercial norms, which generally require tight grain and rich color, negative film stocks are more forgiving with overexposure. The rule is simply the opposite with reversal film: When in doubt, underexpose.

Force Processing and Flashing

There are several other types of manipulations, the two most common being force processing and flashing.

Force processing, also called *pushing*, is the more common of the two. The easiest way to explain this is that if you find yourself in a situation where you don't have enough light, you can underexpose the film and then ask the lab personnel to "push" it. They would leave the film in the developer longer, overdeveloping it. The staff at most labs have substantial experience with this and can be quite precise in how they match up what you have done with how they process the film. Care must be taken when you do this, however, because the quality of the image will change from the film that has been normally exposed and normally processed. The film will have a different look. Leaving the film longer in the *soup* (slang for the developing chemicals) generally increases contrast and creates more visible grain. As always, you have to think about how the pieces will match up with other things you are shooting.

Most DPs push film because they are trying to achieve a specific effect. It is great for producing a grainier, more abstract image. In cases like this, you build that stop (or stops) of underexposure into your filming by changing the film's EI. This relates to the concept of halving and doubling that was discussed earlier. Every doubling or halving of EI represents an *f*-stop, and you change the EI rather than make the mental computation each time. If you have a film stock normally rated for 500 EI and you want to push it two stops, what would the new EI be? One stop would be 1,000, and two stops would be 2,000. If you rate the film stock at 2,000, you will automatically be building two stops of underexposure into everything you film. You then tell the lab to push the film two stops, and the lab compensates for what you have done by leaving the film in the soup longer.

A couple of notes of caution: First, consult the lab before you attempt any experiments. The lab will have limits and recommendations on how much you should push specific film stocks. If you exceed these limits, you might not like what you get or the lab may flat-out refuse to process it. Second, shoot tests before you commit a lot of time and footage to the concept. This is the only way to find out if the effect is what you want. Third, it costs more to push film. Labs have specific charges for pushing, generally additional cents per foot. Make sure it is in your budget. Fourth (and this should be obvious), if you want your film pushed, you have to do the effect consistently for the entire roll. A lab cannot push part of a roll or a single shot; it's the whole roll or nothing. You can break the roll and shoot short ends, but the piece of film you have marked will be pushed.

It is also possible to *pull* film, that is, build in overexposure. In this case you "underprocess" the film. Most labs will tell you that the resulting film will be flat and characterless and not worth the effort. I have seen people do a lot of odd things to their films, but the effect of pulling film is generally unpleasant, and I have only occasionally seen anyone who was pleased with the result.

Flashing, a procedure that the lab does to your unexposed film stock before you take it on-location and shoot, is somewhat more complicated and not quite as common as force processing. At your request the lab runs the unexposed film past a low-intensity light on one of its printers. This light builds an increment of exposure into the film. It is not quite this simple, but it adds a small number of foot-candles to your total. That increment of exposure brings up the shadow areas while significantly affecting the highlights. If you add 5 fc to an area that has 10 fc, that is a half stop. If you add that same

5 fc to 160 fc, the change is marginal. Again, DPs do this for effect. It gives the image a foggy feel, making the dark areas look milky and gray and the light areas washed out.

Vilmos Zsigmond, on Robert Altman's *McCabe and Mrs. Miller*, flashed everything that was shot. The resulting film has a washed-out, old look that is central to the elegiac tone of the film's action. He did similar work on the same director's *The Long Goodbye*. Another good example of flashing is Hal Ashby's *Bound for Glory* (Haskell Wexler, DP), the story of Woody Guthrie in the 1930s. The effect gives the film a worn-out, old feel that adds immeasurably to its texture. To put it more accurately, these films were *preflashed* because the exposure was done before shooting. You can also *postflash* film—that is, flash it after you have shot it—but the former technique is more popular.

Again, manipulating the EI of the film stock builds the desired exposure effect into your filming when force processing. This can be a dangerous piece of information, but the EI that you find on a film's packaging is only the manufacturer's recommendation. The number basically states that if you have a certain level of light, a specific f-stop will usually produce the best results. After years of shooting a specific film stock, many cinematographers will simply rate it slightly differently. By doing this they build in some level of underexposure or overexposure, at least relative to what the manufacturer says. They rate it differently because they like the way the film stock exposes at that EI. Some cinematographers will rate the film stock differently and have the lab process it differently; for example, they will rate a 100 EI stock at 150 and have the lab process it for 150 EI. You may be scratching your head at this and for good reason. To understand this you have to have substantial experience with labs and film stocks. The important thing to remember from this discussion is that all of the things that we earlier established as constants start to have more-indistinct boundaries.

That said, you should treat the EI as a constant until you feel confident that you fully understand it. Pushing and flashing are done to achieve specific effects and are just two ways of doing what DPs like to call "torturing" the negative. Characteristically, beginners often want to get right out there and apply their own thumbscrews. Remember, it is incumbent on you, as a novice, to master basic exposure before anything else. One student, after reading some Martian film book, baked his film in the oven for several hours. He then proceeded to go out and expose the whole roll poorly. Not only did this experience give him nothing to work with, but it also failed to communicate to him—because there was no viewable footage—what a terrible idea the whole thing was to begin with. Before you try out all of the settings on your microwave, figure out what exposure is all about. Then you can start playing with it.

The Digital Intermediate has changed this somewhat in that many "tortures" can be digital in origin. There is another whole layer of manipulation that can occur from what was shot on the set to what the final product can look like. Still, cinematographers tend to like to create as much of the look as they can in the field. Again, it cuts down expenses in postproduction and obviates somewhat the resultant loss of control as more and more films are being finished by video colorists.

 ☑ *Am I doing anything for an effect—in terms of exposure, color, or stock manipulation—that I should communicate to the lab?*

Slow Motion and Fast Motion

We have questioned the EI as a constant, and now it is time to turn our attention to shutter speed. This is not as slippery a topic as the previous one. Shutter speed is tied to frames per second, and it changes only when you change the frame rate. You do not change the frame rate arbitrarily but only when you want slow or fast motion. Recall that frame rates slower than 24 fps produce fast motion and those faster than 24 fps produce slow motion. Again, some cameras come with variable shutters that affect shutter speed, but this usage is specialized, and this discussion is confined to the standard 180-degree shutter.

15-15

The modified formula after changing the shutter speed.

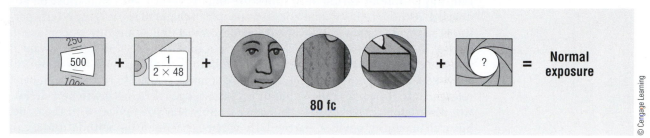

15-16

To yield twice as much light, you open the diaphragm one stop.

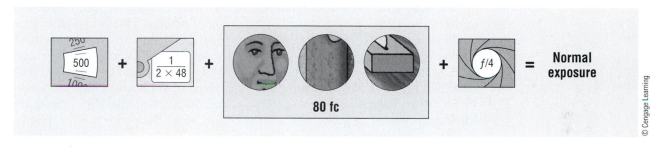

15-17

To yield half as much light, you close the diaphragm one stop.

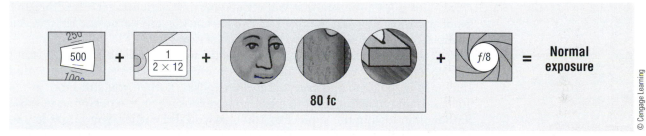

Consider the example of the man in front of the window. What would happen if you decided to shoot the scene at 48 fps? In this case you would change the shutter speed variable. If your desired result was still normal exposure on the person, how would the formula change? Something would have to give in the *f*-stop. Most light meters have a function that will tell you, but remembering that everything is expressed in halves and doubles, you should be able to figure it out arithmetically. **(SEE 15-15)**

In this example *f*/5.6 produced normal exposure when running at 24 fps. If the film is running faster, less light is reaching it—but how much less? Plug 48 into the shutter speed formula. The new shutter speed is 1/96 second, as opposed to the normal speed of 1/48. So you are getting half as much light from the shutter speed. What shift in the *f*-stop will yield twice as much light? Wanting twice as much light, you change one stop. Which direction? If you want more light, you open the diaphragm (a lower *f*-stop numerically). You open up one stop, which would be *f*/4. **(SEE 15-16)** If you take the shutter speed in the opposite direction to, say, 12 fps, you would have to close down one stop. **(SEE 15-17)** Again, the light meter will tell you. But if you can do fractions, you should be able to figure out the *f*-stop for any frame rate.

☑ *Am I shooting at standard sound running speed, 24 fps? If not, have I made the necessary adjustments?*

Filming Various Skin Tones

Filming people of varied skin tones presents several issues that must be addressed. Although this matter concerns people of many races, it is especially pertinent to filming many people of African descent as well as any other people with dark skin—individuals who will probably not have the facial detail you want if you use conventional exposure recommendations. Dealing with this issue will provoke a fair amount of discussion in the coming years. There have been brief references to it here and there, but to my knowledge there has yet to be a definitive discussion. Experienced DPs have certainly learned to deal with the issue, but well-meaning novices, particularly when experimenting with latitude, can make mistakes that may have results they do not intend. The solution I recommend here is on the simplistic side and is not meant to be definitive. It will be helpful if it leads to a long-overdue discussion that could give beginners some direction in this area.

As stated in the context of luminance in chapter 13, dark subjects respond to underexposure much more quickly than do light subjects. This is obviously true of people as well. Without pointing fingers or laying blame, we can say that most photographic recommendations were designed considering surfaces that reflect an average amount of light, which includes the white face. This makes a modicum of sense because most things in nature and many things that humans create fall within this range. At the manufacturer's recommended EIs and f-stops, white objects are white, gray objects are gray, and black objects are black. The problem is that photographic black represents a lack of detail and, unless you are going for some effect, you always want detail in a face.

This requires some clarification, but to create normal exposure on a dark-skinned person, open up one stop more than standard recommendations; that is, overexpose by one stop. If the conventional translation of 160 fc is $f/8$, expose at $f/5.6$. This does not mean that you set up your instruments, get a reading, and shoot at a lower stop. It is not that you should choose a lower exposure but that you manipulate light values to create higher levels of exposure.

Once again using the example of the person and the table lamp, it is not that you shoot at $f/5.6$ rather than the recommended $f/8$ because that would change how the lamp and everything else exposes. Rather, you still shoot at $f/8$ but just manipulate the light to create more exposure on the person. **(SEE 15-18)** Rather than keying the subject to 160 fc as you did earlier, you might key to 320 fc. You will notice that the fill and backlight values have changed as well. In general, dark hair needs more backlight, so don't hesitate to go as much as a stop or two higher than the exposure. The fill is actually at the recommendation for normal exposure (160 fc).

This discussion is complicated by the obvious fact that dark-skinned people nevertheless have a tremendously wide range of skin tones. Again, experience will teach you, but try varying levels of overexposure. An African American with very dark skin will take the full stop that I have recommended. The image of a person with lighter skin might respond well at a half stop. There are some people with very light skin for whom the standard exposure recommendations will work just fine.

This becomes a bigger issue when you have a number of people with a variety of skin tones. A film on which I worked as the gaffer called for the staging of a discussion group. Persons A and D were African Americans with very dark skin, person B had somewhat lighter skin, and persons C and E were white. The room was quite large, so the scene presented many challenges, particularly for the wide shots. **(SEE 15-19)** There was a drop ceiling, so I started by pushing away some of the panels and rigging several broad lights shooting into foam core. This gave me a general fill of 80 fc in the area where the table was. I decided that this would be a

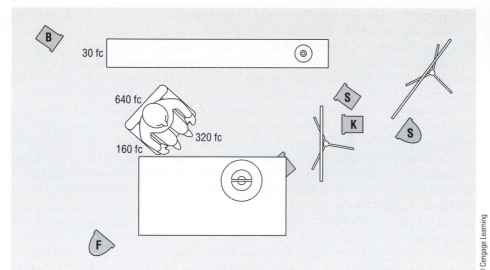

15-18

For better facial detail in a dark-skinned subject, set the key light one stop higher than standard recommendations.

© Cengage Learning

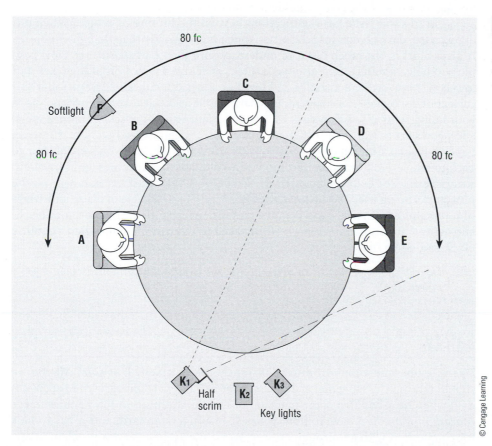

15-19

Lighting setup for a discussion group that featured panelists with a wide range of skin colors.

© Cengage Learning

nice level of fill if we were shooting for the *f*-stop that translates from 160 fc (*f*/8). We set up three instruments to serve as keys for the five participants. Persons A and B were keyed by instrument #3. I wanted person A to have 320 fc and person B to be a half stop less. This was accomplished by positioning the instrument in such a way that person B's distance from the instrument accounted for the difference. Person C had his own key (instrument #2), trimmed to 160 fc. Persons D and E were keyed with a single instrument (#1). In this case we put a half scrim on the right side of the instrument to cut the intensity on person E. Because the instruments that were

rigged in the ceiling did not illuminate the back walls, we rigged set lights to bring the back wall up to 80 fc. We used several other instruments to accomplish specific purposes, but this was pretty much it.

In this setup persons A and D were overexposing by one stop, and person B was overexposing by a half stop; persons C and E were exposing normally. When we moved in for close-ups and medium shots, we did a little more with backlights. We also used a traveling softlight on a rolling stand to give us the same consistent 80 fc on the background that we had previously accomplished with set lights. In setting up the entire shot as we did, we accomplished different levels of exposure without an overall change in the *f*-stop. Unless you are in a documentary situation, you do not accomplish this overexposure technique by simply getting a reading and opening one stop. As with everything, it is a matter of manipulating the lights to get the levels of exposure that you want.

Though perhaps not definitive, this approach has yielded good results. It arises from using conventional exposure recommendations and having been disappointed with the results. Anyone with substantial experience filming African Americans will probably find this approach somewhat formulaic and simplistic; there are many other considerations, including the use of color gels. Be aware, though, of the issues identified here and the general guidelines provided.

Clearly, this issue has ramifications beyond the filming of people. When underexposed, dark objects lose definition much more quickly than do lighter objects. A black shirt is lost much faster to underexposure than a white shirt is. How people and objects reflect light also has a direct effect on any notion of high-key and low-key. If you attempt a traditional low-key situation with an African American subject or, for instance, a character in a dark leather jacket, the results may not be to your liking. This discussion goes back to reflectance and gray scales. From experience, you start to learn how different subjects and materials read on film. This is an issue with color film but even more so with black-and-white. If you were able to go back to an old Hollywood studio shoot, the colors of the costumes and sets might surprise you. The colors were often chosen because they read a certain way on the film stocks being used. Few people with this kind of knowledge of black-and-white film remain. For financial and creative reasons, many students like to shoot black-and-white, but some of the biggest mistakes in exposure occur when shooting black-and-white film.

☑ *Do any subjects, objects, or areas in the shot require adjustments in light levels or exposure?*

Safety

There is one question you must constantly ask yourself: *Is it safe?* Maybe we should take on the same menacing demeanor of Laurence Olivier with his dentist's drill when he asked that same question of Dustin Hoffman in John Schlesinger's *Marathon Man*. You have to hold yourself to a high standard, and it has to be a tough question with a thorough answer. Work-site accidents are a problem in any field, and beginners rarely notice, if they even think about, some of the potential hazards they face.[3] When working with instruments and on films in general, you are routinely exposed to the following hazards.

Enough heat to cause fires and burns Shooting instruments into walls, boards, or other materials can build up heat that can cause problems ranging from serious burns to spontaneous combustion. Most materials made specifically for film work

3. Even very small shoots should be insured against accidents and other potential legal complications.

are designed to be nonflammable, but if used improperly, a few can still catch fire. You also never know what is inside of a wall. On one film, I was shooting an instrument into a wall until I was told that a previous owner had used shredded newspaper for insulation. It is generally recommended to use broad lights when bouncing light off of a surface because they distribute the heat across the length of the bulb. Focusable spots concentrate their light and heat in the center of the beam and, particularly when spotted in, can burn many materials. I have been on a number of sets where clothespins or foam core have started smoldering. Keep a fire extinguisher handy.

Always wear leather gloves when working with lights. They protect your hands from the heat. I have gotten burns that required first-aid treatment and a few that even left scars. Always have a first-aid kit on the set.

Be aware that heat will melt the glue on many adhesive tapes. Gaffer's tape is indispensable on the set. You can use it to fix or put up anything. But if you put it on or near something that produces heat, it will lose its bond and not hold. Some companies make "tape-up" brackets with **spuds** (the mounting pieces on most small light stands), and you can tape them to a wall and hang an instrument. If this is not done correctly, however, the tape can loosen and the instrument can fall. I was on a set where the gaffer taped up a backlight that fell and missed an actor by about a foot. This does not endear the crew to the talent—or to the insurance company. Be careful.

The sprinkler systems in many buildings can also present a problem. They can be triggered by heat, and if you place an instrument too close to one, you are in for trouble. I was on a shoot where a system triggered, and the sprinkler heads put out a tremendous amount of water. I try to keep my instruments at least 3 to 4 feet away from any sprinklers. This may constrain your lighting design, but the consequences of not taking these precautions can be worse.

Enough electricity to cause potential harm It would be impossible to go into all of the potential hazards associated with electricity, and it is assumed that everyone has a healthy respect for what it can do. Electricity should be dealt with only by trained technicians. I stated earlier that basic electrical knowledge was accessible to everyone, but that was in terms of small lights on student or independent shoots. Once you step into bigger arenas, the gaffer and his or her electricians must be completely conversant with the requirements, operation, and maintenance of all things electrical. Independent shoots unfortunately are often forced to employ crewmembers with less-than-stellar qualifications. Do not let them do anything foolish. Some people can be quite convincing when marketing their skills, but always check with others who are familiar with their work to verify competencies.

On smaller shoots with less defined channels of authority, use common sense with anything to do with electricity. Don't fiddle with a light or change a bulb unless the instrument is unplugged. If you are unsure if it is "hot," turn it on to find out. Always wear rubber-soled shoes. If somehow the worst happens and a crewmember is getting a dose of electricity, never touch the person. Grab something that does not conduct electricity—a 2 by 4 will do quite nicely—and knock the person or the offending source away. Don't worry that doing so might hurt the person; that person is already getting hurt. If you are working with lights around water, take precautions to ensure that the two do not mix. Students thinking about shooting around swimming pools or in bathrooms should be either admonished to be extremely careful or discouraged entirely.

Heavy instruments on high, potentially unstable stands Many lighting instruments are heavy, and when you get them up high on a stand, they can be unstable. Put sandbags on the base of the stand for stability. You can find them at any lighting rental house, or you can improvise. Never put a heavy instrument on

a stand that is inadequate for its weight. Never build something with C-stands and extension arms that has the potential to fall over. Secure everything so that it cannot fall accidentally or be tipped over by a careless crewmember. You will hear the term *balanced weight* quite frequently on a set. Whenever there is uneven weight on a stand, be sure to use something to balance it.

When shooting outdoors, be prepared for weather-related problems. On one shoot, we were filming a family sitting around a table and eating lunch. As is so often the case, the beautiful natural light flooding through the windows was being provided by two 10ks outside. While we were shooting, some nasty-looking thunderheads appeared on the horizon. Always prepared for something like this, the gaffer and the key grip rigged up a tarpaulin to protect the lights from rain. As the thunderhead approached, the wind picked up. With ropes and tent stakes, the crewmembers secured the instruments more firmly to the ground. When the storm drew nearer, it became obvious that it was not going to be an average downpour. The gaffer advised the director that they had better strike the exterior lights. Not wanting to lose a moment's shooting time, the director asked if it was absolutely necessary. When apprised of the potential danger, she ordered the lights struck immediately. The storm was short and violent, and we were back shooting within 20 minutes of its conclusion. We later heard that a tornado had touched down several miles away. The images of film gear being carried away in a flood in Keith Fulton and Louis Pepe's *Lost in La Mancha* (2002), the documentary on the train wreck of Terry Gilliam's Don Quixote film, should be indelibly burned into your memory. Do not take chances, and be prepared for the worst.

People working up high on ladders, grids, and Genie lifts Ladders are standard equipment on film sets, and you must learn how to be comfortable and work safely on them. Have someone steady the ladder and assist you with moving heavy equipment. I have seen people standing on all kinds of silly things to reach instruments. Be sure to stand on something stable that will hold your weight, and have someone steady you. Location work can require numerous skills, from mountain climbing to the ability to do what almost amounts to high-altitude heavy construction. Learn how to work cooperatively in difficult situations.

Studio work also requires care. Most instruments are hung from grids; and though many studios have the traditional theater catwalk, most grids require ladders or *Genie lifts* to reach them. A Genie lift has extensions that allow it to elevate straight up. With this piece of equipment, you can reach instruments from below. Genie lifts are handy, but they can tip over if not properly secured. They should be used only by people trained in their operation.

So many extension cords and stands on the floor that the potential for tripping or stumbling is a constant danger Lighting crews love to make what they call "grip jungles," where stands and modifying materials are so thick that you feel as though you need a machete to get through. I have seen setups that make it hard to get from one side of the room to the other. Everyone on the set must recognize that they have to be careful. That said, you should attempt to limit potential hazards. Gaffer's tape should be used to tape down extensions or any other cords. If you are not taping down cords, at least try to get them out of the way of high-traffic areas. Keep walkways open, or cover the cords with mats. Do not have head-bangers sticking out into areas that people are going to be moving through. Again, use common sense.

Filmmaking requires a measured and careful approach that includes making sure that everything you have set up is properly secured. Watch how experienced crewmembers do things. Everything is done for a reason. Putting a heavy instrument on a stand is a two-person job and is done in a specific way. This is the easiest and, more important, most predictable way—both people understand what they are

supposed to do. I once saw some Three Stooges imitators drop a 10k, and they were just lucky it didn't land on someone's head. Know your limits and learn how to work cooperatively. Do not take shortcuts.

☑ *Is it safe?*

Planning and Preparation

It should be evident from these discussions that a substantial part of the battle is won or lost in the planning and the preparation. If you know what the challenges are and what is going to be asked of you, you can be equipped for, and do, virtually anything. If it happens to you only once, you will be lucky, but it is all too easy to back yourself into corners. You do a really beautiful shot that establishes a specific quality of, or direction to, the light. When it comes time to do the shots that have to match, you don't have the proper materials to create what is needed.

Early in my career, I worked on a scene that was being shot in a kitchen. The director wanted the scene to have a sunny feel, and, as always seems to be the case, the day turned out to be overcast. The improvised plan was to have a 2k outside the kitchen window, supplying the sunlight—the key for the scene. We set this up and proceeded to fill in the areas that needed it. We shot all of the material from setup #1, which had character A standing at an open refrigerator talking to character B. This all went fine. We had a 2k behind character B, again to simulate strong morning light, and did some over the shoulder (OTS) shots from setup #1. **(SEE 15-20)**

The problems started when we turned around to shoot character B. Because we had established a strong morning light creating a nice backlight on B, the background from setup #2 had to be bright. It would have been impossible to light the entire exterior background, so the DP intended to draw the curtains in such a way that we saw only a single shrub just outside the window. We could then light the shrub with our tungsten lamps, thus simulating sunlight. We got everything up and then noticed an untenable problem: the bright light for the exterior was causing the backing of the curtains to reflect in the window. The reflection was large and unattractive, surely a distraction to anyone viewing the finished product. We scrambled while the talent waited . . . and waited.

Our solution was to tear down what we had done to the shrub, set up a large silk behind character B, and blow a lot of light into it. This also blew out the reflection. The character then had a very bright background that completely lacked detail. The director convinced himself that this solution would be adequate. The DP was less sure.

And that is all it was—adequate. The real problem was that by the time we had a solution, our time with the talent was limited and we had to rush through the shots. Almost invariably, you do your worst work when you are

15-20

The reverse of setup #1 posed significant lighting problems.

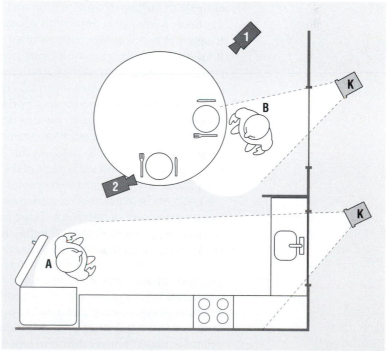

© Cengage Learning

rushing. People are hired and money is spent to ensure that directors have the appropriate, but by no means limitless, time to accomplish the task at hand.

In working with the footage later, the questionable quality of the image and the difficulties in editing the scene together reflected the conditions under which it was produced. Had the execution of the scene been completely thought out, we could have anticipated and dealt with the problem in a timely manner. Because the second setup was the more difficult of the two, it probably would have been better to shoot the material from setup #2 first. If we could not have found a workable solution to the background problem, we could have done different lighting for setup #1. I suppose the director and the DP didn't even consider the possibility that what they had figured out for setup #2 would not work. Remember Murphy's Law: Anything that can go wrong will go wrong. Part of becoming adept at the craft of filmmaking is learning how to negate that law. If something can go wrong, you have to anticipate the problem and cannot let it stop you dead in your tracks.

On a more pragmatic level, you must be able to anticipate your equipment needs. Clearly, you have to know what instruments you will be using. This sounds more difficult than it is. One rule is to always bring more instruments than you think you are going to use. This anticipates malfunctions, and, more to the point, you will always have that one little instrument necessary for perfecting the image.

Not only do you need to anticipate the instruments, but you also need to know how you are going to rig them. If they will all be on stands, you need those as well. If you are going to hang them, you need the right kind of clamps. There is a great array of **grip equipment** to aid you in this task. From simple C-clamps with spuds to sophisticated specialized clamps, there is something to help get that light just about anywhere you want it. Some pieces of grip equipment have exotic names, such as *Mafer clamps* or *Baby Matth pipe clamps*. On occasion it almost appears as though such complex names are a foreign language designed expressly to exclude you. Do everything you can to learn the lingo.

Failing to anticipate all of your needs can slow you down or, in some cases, stop you altogether. Even the lack of something as simple as a *cheater*—the plastic adapter used to insert a three-prong plug into a two-hole outlet—can delay a shoot. Working quickly and efficiently is crucial because your time with talent and locations is almost always limited. Again, experienced camera and lighting crews are able to anticipate and be prepared for just about any contingency. Many productions, particularly those with adequate budgets, will rent a *grip truck*. These are trucks that rental houses have outfitted with virtually everything you could possibly need: instruments, grip equipment, heavy-duty extension cords, and **expendables** (such as spun, gel, cheaters, gaffer's tape, and so forth). Usually, you are charged both by the day and for what you take off the truck.

DPs often have longstanding working relationships with specific gaffers and key grips; they come as a team. If you are working with people who know what they are doing, they are thinking about more than the shot being done at the moment. They are thinking down the line to the shots that have to cut to what you are doing now. Is this light right for the emotional content of the image? Will the lighting continuity be correct? They should know all of the right questions—and they should know some answers too.

All of these practical considerations are related to what is probably the most important aspect of lighting a scene: having a plan. Always visit a location before the day of the shoot. If natural light will be incorporated into the lighting scheme, try to visit the location at the general time of the shoot and chart how the light changes over the course of the day. As has been suggested, draw an overhead of the positions of outlets and circuits. The overhead can serve a dual purpose to plot out an overall lighting plan as well. In conjunction with the director, sketch where the action is going to occur and how the instruments will be set up. At this stage figure out electrical requirements, justification of light source, depth of field, and modifications for color temperature—in other words, just about everything.

These questions are, perhaps, the actual starting point. They will be presented again at the end because having a plan includes consideration of all of the previous items on the checklist. Call it Murphy's Law or whatever, but every possibility must be considered and, however you start, it all boils down to preparation.

☑ *Do I have a plan? Am I prepared for all contingencies down the line in terms of both equipment and thinking? Am I asking the right questions?*

Video Origination and Transfer

Video origination and transfer pose some issues for cinematographers and video-graphers. Most shooters find that they need to light slightly differently for video, even finding the need for different approaches among the various cameras and formats. Clearly, one of the chief advantages of video is the potential for having a high-quality field monitor available to get a clear assessment of the lighting. It should be reinforced how important it is to have the monitor appropriately calibrated in terms of both color and brightness.

One issue that does not go away is the perceived harshness in the high-definition (HD) image. Filming actors has brought about new challenges, with the clarity of the HD image being blamed for bringing out every imperfection in a performer's complexion. Actresses in particular have found HD to be a cruel taskmaster. Some observers of the scene have been unkind enough to suggest that actors who have gone the Botox/facelift route are particularly susceptible to poor rendition. DPs have found that they often need to soften lights and/or use camera filters to combat the ravages of a suddenly too-honest image. Arguments persist here and you will have to make up your own mind on how the medium renders subjects.

In terms of transfer, the film image can change anywhere from significantly to slightly when it is transferred to video. The notion that the image may be returning to film complicates this process in that the final product should show no net loss. Finishing in nonlinear editing (NLE) with the intent to finish on film, however, means an important question must be posed. Even when finishing on film, video versions are always part of a film's exhibition future. Do we shoot for the video transfer or the finished film? The answer depends on what compromises you want to make between film look and video look. In addition, editing with an image that is a less-than-perfect representation of the original can cause problems in the quality of the final product.

Video and Latitude

One of the most significant early raps against video was that it did not have as much latitude as film. In the early days of video, experienced film shooters often found that their darker, shadow areas, in particular, were lost in the transfer. The visuals in Francis Ford Coppola's *The Godfather* (1972; Gordon Willis, DP), which explored the deepest valleys of underexposure, are not quite as power-ful when video represents its darkest elements poorly. Great advances have been made in committing the image to tape or file, and in some instances video cam-eras can dig into the shadows even better than film. Kodak claims a 14 stop dy-namic range of film. When posed against the 7 stop latitude proposed earlier, the 14 stop range includes the outside ends of over- and underexposure. Something very bright might accept 7 stops of underexposure but never that on the over side. The opposite on overexposure is true as well. Maybe making this a moot point, the Black Magic Cinema camera claims a dynamic range of 13 stops. Other high-end cameras make similar claims. Certainly studio transfer equipment has similar

range. For videographers, cameras in the mid and low range may still have latitude issues.

How it all sorts out will be up to individual testing and lengthy experience, although at the rate things change, experience may be in constant flux. It does take experience to determine how visual information will make it through the transfer. But problems on the bright end remain, as do issues with shadows for all but the highest-end cameras.

Despite all this, if you are transferring film for video finish or shooting on video, the knock on video about latitude is largely specious. As the preceding chapters have demonstrated, you position the values of the instruments to the available latitude. This may pose difficulties because the discriminations between different light values have to be closer together, but videographers rapidly determined that they could light "film-style." When the final product is going to be video, some cinematographers have employed a two-and-a-half-stop window for exposure deviation from normal exposure. This assumes that everything outside of that parameter is going to fall off at one edge or the other. This may be anachronistic, but it might serve as a guideline for tests. The only arena where video's potential shallow latitude can truly be problematic is when you do not have control of the light. These situations include documentary and newsfilming, ironically two approaches in which film was largely doomed from the moment video became portable.

Video and the Characteristic Curve

Another criticism has been that video responds poorly in the toe and the shoulder of its latitude. (The toe and the shoulder are parts of the characteristic curve described in chapter 13.) This issue is the most difficult to dismiss. The toe and the shoulder are those areas in a frame just before the image drops off to complete over- or underexposure—the edges of the metaphoric table. In video the information in the toe and shoulder areas can become muddied. This is particularly true of the toe—that is, underexposure—resulting in a grayish, almost milky tone in the shadow areas.

Although this is a significant complication, much as with latitude, crews have simply had to take it into account when lighting. Values are placed either within the straight line of exposure or outside of the latitude altogether. This clearly relates to the concern listed previously, where low-light situations are by definition going to be in the toe of exposure. You simply have to view it as one of the characteristics of video and come to appreciate it as part of the look of the medium. The only alternative is to add light or . . . to shoot film.

The quality of the transfer will have an impact on this limitation of video as well. Inexpensive transfers will exacerbate the situation, yielding substantially more grain-like results in the shadow areas. A good transfer on state-of-the-art equipment with knowledgeable personnel should yield a dramatically improved image. It just costs an arm and a leg.

Video Image Manipulation

When the film is transferred, a video *colorist*—the video world's equivalent of the *timer*—has access to controls similar to, although much more extensive than, those found on a film printer. A significant consideration is that the datacine can be far more forgiving about exposure problems than film can be. The colorist can address much more drastic exposure problems than can be addressed in a film workprint or final print. The colorist can also address individual parts of the frame, whereas the film frame can be addressed only as a whole. Any correction is fine so long as the final destination is video; problem shots will stay corrected to the end. But if you are going

back to film, that is, doing matchback, suddenly shots that the colorist made look great on the video monitor turn up looking terrible in the final film print.

One low-budget film that I was somewhat involved in had extensive problems in this regard. The inexperienced DP was missing on exposure in some scenes, and the colorist was covering up the problem in the video transfers. Without a work-print no one could anticipate how poorly the shots would print. When the director saw the first answer print, she was very disappointed in what the film look had given her. The colorist and the unit producer protected the DP in the video transfers, partially from a lack of knowledge about eventual problems and partially to keep the show on schedule, and the chickens came home to roost in the final print. Video dailies are often a bad predictor of the look of the final film.

DSLRs and Managing Exposure

The last and maybe most difficult issue for the novice is: How do we manage exposure with an automatic metering system? The unfortunate answer for those who want life to be easy is to learn how to manage manual exposure. All DSLRs have this option and, as discussed, before, you have to find a way to determine the best f-stop for your scene and stick with it. Obviously bringing an incident meter and possibly a spot meter are the clearest choices but many makers do not have the resources or the time to incorporate these trustworthy friends into a shoot. The other option is do what was suggested in the section on consistency: get in close to your subject with your camera and, watching the swings of metering through the viewfinder, determine the optimal exposure. If you want the subject a little darker or lighter, choose a slightly higher or lower f-stop respectively.

Lighting for video, as well as lighting film for transfer, has evolved to the extent that it is not substantially different from lighting for film finish. You may have to soften the light if facial features may turn out harsh. Latitude effects may be slightly different so some compensation may be required although dynamic range has expanded for video to the extent that it is very close to film. Still, there is always the potential for image-quality issues, particularly when murking around in the low-end of the industry. Keep the following questions in mind.

> ☑ *Does shooting on video require any adjustment in approach? If shooting on film, is it being transferred to video? What additional issues must be considered?*

f-stop Choice and the Checklist Revisited

The notion that we will choose an f-stop prior to shooting is critical because we need to consider the following reasons.

- Conforming to an existing light value would be expedient.

- Some shots require a predetermined amount of depth of field.

- A preferred f-stop yields the lens resolution and the quality of light desired.

- Using a particular value simply makes common sense given the situation.

Lighting is about posing and answering questions. Addressing the checklist questions will eventually become almost automatic for you; they all point to issues that must be considered. Until the day when they become part of your subconscious, do not hesitate to just go down the list before you shoot. Be flexible in the sequence in which you address the questions. Different concerns will jump to the

top of the list in specific situations. This list is not meant to be all-inclusive. You will certainly find many other things that demand your attention as well.

- ☑ *What do I want to achieve or accomplish with the image?*

- ☑ *What is the source of light? What direction does the viewer expect the light to be coming from?*

- ☑ *How am I going to expose the subject(s)? Am I going for normal exposure? Overexposure? Should the subject be darker, a little underexposed?*

- ☑ *What quality of light do I want? Soft? Hard? Should it be diffused?*

- ☑ *What goal(s) is each instrument accomplishing?*

- ☑ *Is lighting continuity important to what I am doing? Does the shot I am executing need to match other shots?*

- ☑ *Do I want to shoot at a particular f-stop?*

- ☑ *Am I lighting to achieve an f-stop that will give a specific depth of field?*

- ☑ *Will I have to make adjustments to match color temperatures? If so, what materials and skills will I need?*

- ☑ *Have I determined how much electricity I need and identified the source?*

- ☑ *Am I doing anything for an effect—in terms of exposure, color, or stock manipulation—that I should communicate to the lab?*

- ☑ *Am I shooting at standard sound running speed, 24 fps? If not, have I made the necessary adjustments?*

- ☑ *Do any subjects, objects, or areas in the shot require adjustments in light levels or exposure?*

- ☑ *Is it safe?*

- ☑ *Do I have a plan? Am I prepared for all contingencies down the line in terms of both equipment and thinking? Am I asking the right questions?*

- ☑ *Does shooting on video require any adjustment in approach? If shooting on film, is it being transferred to video? What additional issues must be considered?*

Some of these questions, particularly the first one, will be real head-scratchers for many beginners. If you do not have the answers right now, don't be intimidated. Experience is the key. The more lighting you do, the more solutions will suggest themselves not only in the pragmatic aspects but also in what happens in your head—the creative part. The process will be frustrating, time-consuming, and expensive, but you will never learn it unless you get out there and do it. It all leads to the most rewarding part: creating images of value and expressive power.

The checklist topics included here should eventually become internalized to the extent that you consider them automatically, or your approaches become so sophisticated that the basic language becomes almost obsolete. When I mentioned the three-point system as a starting point in a recent conversation with some colleagues, one DP remarked that she didn't think in terms of key and fill any longer. She went on to talk about lighting with a 5k and shaping and feathering the instrument with flags and silks and other modifying materials. Still, she had a source and needed to create detail in the shadows. On further questioning she admitted that she still worked with all of the same issues; it was just that her language had changed. In addition, you are not going to have access to 5ks much less any way to power them up. You have to face the fact that you will be working on a more

limited scale than the "bigs." Use your creativity and ingenuity to find ways to be productive on that level.

Again, the key to lighting on a given location is not to ask, "What can I get here?" but rather to ask, "What do I have to do to get what I want?" Once you understand how light and exposure interrelate, you find that there are many things, small and large, that you can do to improve the image in a substantive way. To produce on a high level with limited time and resources, you need to analyze a situation in advance, create a workable approach, and develop a plan to implement your ideas quickly and efficiently. Quick, however, does not mean instantaneous. Lighting takes time, and production management needs to allocate enough to do it right. Still, if you can envision the end product and work toward it logically and cooperatively, you can be productive without wasting time.

Martin Scorsese's most significant early feature, *Mean Streets* (1973), was shot in about three weeks. Richard Linklater's *Slacker* (1991) was shot in a similar time frame. Given a creative and organized approach, producing shots of weight and value is both a worthy and an achievable goal. You can create tremendously beautiful images with a few well-applied resources. Moreover, the crucial concept to grasp is that virtually all images of character and interest are composed of complex levels of light and exposure.

A Typical Scene

By this point we have presumably generated some narrative force for the contention that an extensive investment of resources is required to create the images that so effortlessly reflect back at us from the motion picture screen. Once students get enough background to understand some of the complexities, I recount a story that a friend likes to tell. It is quite illuminating in terms of the process you have to go through. One of his clients, a hospital, was designing a commercial that included a slow-motion close-up of a drop of water falling into a pool. My friend had been around long enough to understand immediately what producing an image like this would entail. The client felt that the shot was a metaphor for the beauty and the fragility of the small things in life. My friend was unable to dissuade the client from this horrible cliché, nor could he faze the client by quoting an estimated cost.

The first issue is the camera. You do not need a sync camera because sound is not an issue, but would a standard camera like a Bolex do? The top frame rate on general-use cameras that can vary speed is at most 72 fps. A drop hitting the water takes a split second. A camera running at 72 fps expands the action two and a half times. The action would still effectively take a split second. He knew he needed a specialized high-speed camera, the top rate on the cameras commonly available being 150 fps. This suited his purposes, expanding the motion more than six times. There are cameras that run at 10,000 fps, but these would break most any local commercial budget and were overkill anyway. He wanted a normal lens with close focusing powers because a wide angle would push him farther from the action and a telephoto would reduce depth of field unacceptably. Although rental rates on high-speed cameras vary, the package with the lens he wanted was around $600, and prices have gone up since the events occurred. Although my friend had used such a camera before, he wanted a qualified AC to ensure against problems—another $500.

Preliminary decisions like this choice of camera set off a chain reaction of considerations. Moving one element shifts all of the others. When you run at a different frame rate, what changes? The shutter speed. Shooting at 150 fps, the effective shutter speed is $1/300$ second. When you lose light to the shutter, you have to regain it through the f-stop. He also wanted very tight grain structure, so he chose a stock with a low EI, further minimizing the f-stop. Thus, he was looking at two factors that minimized depth of field: close focus and a potentially low f-stop. The

technical particulars tended to indicate a shot that would have a very narrow range of focus.

There was not much he could do about focus, but the ƒ-stop is always flexible. To address this situation, he decided to light the scene with a 5k plus a few other smaller lights. A 5k was the smallest instrument that would create enough light to produce an ƒ-stop that would give usable depth of field. This solution was fine except that the 5k demanded that the scene be shot in a studio, no other space providing enough power to fire up the instrument. He rented a studio and brought in a gaffer to assist him with the lighting and electrical needs. The gaffer brought in one electrician and one grip.

The last consideration was something that could reliably produce a drip on demand. The bottom line is that you have to make the action happen in front of the camera. If you don't have the right tools, you do not want to be waiting for something to create a drip while running at 150 frames per second. A camera running almost 4 feet of film per second can churn through a lot of film very quickly. He was able to find the appropriate piece of equipment at a medical supply store. A few PAs were also needed to help run this. Before long the costs and the logistics of this "simple" image had escalated to where it became a major undertaking.

Though this image presents special problems, almost all images require the devotion of extensive resources. Every filmmaker has stories of lengthy shoots that began with someone claiming, "We're just going to do a few simple shots that won't take any time at all. You'll be home by dinner." I've had more than my share of cold dinners. Even the apparently simplest of shots require the time to get it right.

Part V

Editing

385

16

Principles, Procedures, and Equipment

Digital Nonlinear Editing and Film Editing

Digital *nonlinear editing (NLE)* systems have become the norm, with the vast majority of all professional, independent, and amateur media editing occurring within a computer environment. Few projects are edited on film in today's binary world of 0's and 1's. Concurrent with this reality, when planning for theatrical exhibition the final goal is now a digital version, although there often remains a need for a film print to be projected on a screen. Given this continued need for film prints, an NLE edit and then the generation of a print is common, whether going the Digital Intermediate (DI) route (see chapter 9) or taking a more traditional path to the final product.

This section presents an overview of both routes: the NLE system edit as well as the traditional film edit, although the discussion of the latter is not as detailed. Learning film editing has many benefits, and, although this is arguable, it remains the most comprehensive and intensive introduction to visual media editing. On whichever side of that fence one falls, the approach of video-editing systems is modeled on most of the features of the conventional film edit. The goal—the cutting of the shots to the right lengths and the building of sound—remains the same. As such, an understanding of film editing broadens the discussion and the use of NLE systems. In addition, if creating a film print is anywhere in your future, understanding the issues around finishing on film is critical.

With the vast technical whirlwind surrounding the designing, modifying, and mastering of complex NLE systems, one simple fact can easily get lost by beginning and advanced technicians alike. Editing is far more than just putting pieces together and is much more than becoming proficient on complicated software. One can be exceptionally skilled on Final Cut Pro (FCP), Avid, or any of the others and still be a mediocre editor. There is a complex and dynamic art to shaping and trimming the visual and audio bits into a compelling whole. That is where we will start.

Purposes of Editing

The inevitable clichés about editing are true: this is where the real magic of filmmaking happens. This is where the film comes alive. The proverb that you can't make a silk purse out of a sow's ear applies to film, yet stories abound of films botched in their conception and shooting that were made substantially better in the editing. The flip side of this is the film that had great potential but was edited indifferently. **Editing**, also referred to as *cutting*, is the process of selecting the parts

of the shots that are good and that serve the needs of the film and eventually discarding the rest. Editing with facility and authority in the film world requires extensive knowledge of the mechanics of cutting, an initially daunting though eventually mastered undertaking. In the digital domain, learning curves for software can be quite time-consuming, but once mastered editing is a reasonably streamlined affair.

Though this is a terrible oversimplification, there are essentially three mechanical decision-making areas in cutting a project: cutting picture, cutting sound, and determining optical effects (dissolves, fades, special effects, and the like). For the picture, editing entails going through the shots and determining their specific order, then deciding on the precise transition point from one shot to the next. The order of shots may be predetermined in a narrative film, though that order may not be as rigid as first assumed. In documentary and experimental film, you may have to devise the order yourself. Cutting sound includes a number of approaches, such as cutting sync tracks in conjunction with the picture, determining the relationship between music and picture, and building complicated, layered sound effects after the picture is mostly or completely cut. Optical effects are discussed later in this chapter; these choices relate to planning the available range of visual effects.

In his book *Cinema: Concept and Practice*, the late film director Edward Dmytryk has a chapter that should be required reading for all aspiring film and videomakers, titled "About a Forgotten Art."[1] In it Dmytryk posits the notion that anyone who wants to direct a film should spend time as an assistant in an editing room. No one learns better the kind of material that is necessary to edit a film than those who actually have to make the film work. If a director failed to get a significant close-up or botched a camera angle, it is the editor who both understands the problem and has to struggle to find a solution.

Thus it is imperative that you undertake editing your images from the outset. The production of images is a meaningless enterprise without the process of trying to fit them together. You can create beautiful images, but if there is no plan to their organization and employment, the outcome will generally be flat and uninvolving. To paraphrase Mr. Bernstein in a famous line from Orson Welles's *Citizen Kane*: It is not hard to produce beautiful images if all you want to do is produce beautiful images. A friend is fond of saying that editing is "the process of falling out of love with your footage and into love with your film."

One of the great beauties of film is that it can take the chaotic and random nature of human perception and give it shape and form. The great Russian documentarist of the 1920s, Dziga Vertov, was fond of making grand emblematic statements on this subject:

> The starting point is: use of the film camera as a cinema eye, more perfect than the human eye for fathoming the chaos of those visual phenomena which evoke spatial dimension.[2]

> Freed from the frame of time and space, I coordinate any and all points of the universe, wherever I may plot them. My road is towards a fresh perception of the world. Thus I decipher in a new way the world unknown to you.[3]

Although Vertov's words were formulated for the revolutionary politics of his time, they can serve as a definition of the incredible ability of film to unite many wildly disparate visual universes—of creating worlds possible only in the imagination. But that is what most all art does.

1. Edward Dmytryk, *Cinema: Concept and Practice* (Stoneham, MA: Butterworth Publishers, 1988), p. 144.

2. Dziga Vertov, "Film Directors, a Revolution," *Screen* 12 (1971–72), p. 52.

3. Dziga Vertov, "'Kinoks Revolution' Selections," in *Film Makers and Film Making*, ed. Harry M. Geduld (Bloomington: Indiana University Press, 1970), p. 86.

General Editing Principles

A number of key principles that influence both shooting and editing—the 180-degree rule, dramatic emphasis, and so on—have already been addressed, but a few additional concerns merit discussion, as they have such a strong impact on shooting that they must be considered from the very start.

Transitions

Shots that bridge one setting to another or that mark the passage of time are called **transitions**. This term covers a wide range of approaches, but often transitional shots have the added burden of being establishing shots as well. The common approach is to show a setting, establishing both the place and, by extension, the time of day. If a scene that takes place in a dilapidated cabin in the mountains at night needs to be established, the approach can be very general or very specific. The scene might start with a shot of mountains at dusk, rather than of an individual cabin. A cut from the mountains to the interior of an appropriately appointed cabin would be accepted.

This kind of employment of the long shot (LS) can be useful, but it can also become predictable. Several years ago I was hired for a day to camera-assist on a feature film that had finished principal shooting several months earlier. We started the day by shooting the exterior of a warehouse. We then shot the exterior of a hospital. Next came a shabby bar. It soon became clear what we were doing. We were collecting transition shots for a film that was not connecting very well. I saw a rough cut of the film several weeks later, and the establishing shots were not helping. The shot of the shabby bar preceded a scene in a shabby bar; the shot of the hospital was shown, then its interior. This sequence became painfully predictable. The film's problems were in the script, and no amount of transitions was going to make it more coherent. There was no apparent logic to the sequencing of the film's scenes, and no amount of establishment was going to change that.

Nevertheless, transition shots establishing location can be useful, although there are many ways to establish a shabby bar or a hospital without going outside— from planting some rationale in the script to focusing on details or employing wider interior shots. There are many ways to handle transitions, and you should find those that are effective but not predictable.

Economy and Pace

The concepts of economy and pace are extremely difficult to quantify, and yet they are absolutely central to the aesthetic success of a film. Each individual film, scene, and shot demands its own pace. Often these concepts refer to employing each of the individual shots for the shortest time possible—their economy—while still allowing them to achieve their purpose. This goal is generally attained through control of the physical lengths of the shots, though many other elements affect the sense of a film's internal rhythm. Usually, it is a question of the editor's consciously deciding how long each individual piece of film should be on-screen. While cutting, you can almost start an internal rhythm by snapping your fingers when shots are getting too long.

Pace also has cultural determinants. One of the hallmarks of American commercial film is that all of the parts and the whole itself are exceptionally efficient in the way the material is presented. The approach mimics the culture from which it emanates; any useless or redundant shots, scenes, or sequences are trimmed down or eliminated. Shots are pared down to their shortest possible length, creating as lean and effective a presentation as possible. American commercial features rarely hold shots longer than absolutely necessary, and the scenes of which they are composed

are played to their maximum efficiency. This attitude implies that if a point cannot be made in two seconds, it certainly does not need 10 seconds devoted to it. Occasionally, subtle nuances of performance are sacrificed to move the narrative forward.

Lingering close-ups of the character force the viewer to identify with her isolation and alienation.

Monica Vitti in *Red Desert* (1964), © Criterionco.com.

This efficient approach has long been prevalent in American films, but it has been effectively challenged by numerous filmmakers, with films reflecting different cultural assumptions often having a more leisurely pace. A slower pace forces the viewer to contemplate the meaning of the material more, particularly when coupled with an ambitious use of proxemic effects.

The late Italian director Michelangelo Antonioni was one of the most adventurous filmmakers in this regard, exploiting both a slower pace and the psychological intensity of the close-up. In *Red Desert* (1964), he employed long, lingering—some might say too long and too lingering—close-ups of the main character (Monica Vitti), forcing the viewer to identify with her intense isolation and alienation. **(SEE 16-1)** Antonioni was quite remarkable in that he purposely held his shots well past what would be deemed their natural ending points by traditional American standards. In Antonioni films, scenes take two or three times longer than they would in conventional American films because of the inclusion of extensive visual detail and lengthy pauses between lines of dialogue. The approach has a much more contemplative and "environmental" effect, emphasizing the spaces within the conventional vehicle of meaning—the dialogue. A number of American commercial features of the 1960s and 1970s attempted a much slower pace, but such experiments were soon overwhelmed by the lightning-fast editing of music videos and blockbusters and all that they influenced.

Keeping a film lean and efficient brings up the concept of **visual shorthand**, which refers to accomplishing an action visually in a minimum of images, again as economically as possible. It is an idea reminiscent of the old *Name That Tune* television series, in which contestants attempted to identified a tune after listening to just a few notes. Likewise, we can attempt to communicate an idea in the smallest number of shots.

John Huston's *The Maltese Falcon* (1941) is often cited as an example of the efficient "Hollywood classical style" at its best. Its terse pacing is crucial. The second scene of the film is an excellent example of this. It depicts the murder of Sam Spade's partner, Miles Archer, an action undoubtedly represented by a few sentences of description in the script. As always, this simple action can be thought of in terms of choices. It could be covered in an infinite number of ways—in one shot or 30—all depending on the desired visual presentation and the amount of weight the scene should have in terms of the rest of the film.

The scene opens with a shot of a street sign (Bush Street), the setting having been mentioned in the previous scene. The background is dark and we see lights in the window, so we assume night. **(SEE 16-2A)** Next is a medium shot of Archer walking into the frame. A gun, held by an unseen hand, comes up in the right corner and is fired at Archer. **(SEE 16-2B)** The next shot is of a body crashing through a barrier and rolling down a hill. **(SEE 16-2C)** The entire scene is composed of three shots. The first shot establishes location and approximate time, the second is the action, and the third shows the result of that action. The scene could have been drawn out to heighten suspense or emphasize other elements, but none of that was necessary. The action is a minor albeit significant plot point—one to be established quickly and then on to more action.

16-2

The terse pacing of this scene establishes, initiates, and completes the action in three quick shots.

John Huston's *The Maltese Falcon* (1941), © WarnerVideo.com.

 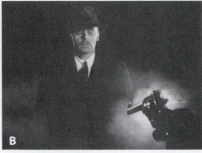

Visual shorthand is primarily a film-specific concept, although the idea of economy and pace exists in most media. Writers frequently speak about the necessity of presenting their ideas as efficiently as possible, of getting straight to the point. Filmmakers such as Antonioni purposefully challenge that style. Although experimenting with any convention is encouraged, understanding and then mastering the conventional efficient approach to pacing are equally, if not more, important.

Structuring the Edit

The vast majority of American films are cut so that their editing is as seamless as possible, what's known as **invisible editing**. In this approach any cut that is abrupt or calls attention to itself is considered a bad cut. The rules that follow have their genesis in this conventional method. As always, these rules apply not only to editing but also to how you approach shooting a scene.

Though rules often are meant to be broken, the following represent years of acquired folk wisdom by many talented editors. As such these concepts should be clearly understood. How they are applied is up to you. An acquaintance once told me that she felt that her editing ability had almost been ruined by being forced to learn conventional editing techniques. Being polite, I held my tongue. If you consider yourself "ruined" by learning other people's approaches, you may be shutting off some important creative avenues. Listen to and learn from other people's experiences. Rather than instantly treading new and exciting ground, most novice editors unfettered by conventional techniques wind up simply reinventing film editing.

The Basic Rule

Before going into specific concepts, the primary axiom of editing bears discussion.

■ **RULE** There has to be a reason for a cut.

This is the great overriding, unbreakable rule. When you cut from one image to another, you must have a purpose for that choice. Often it is a narrative reason: a response has to be shown or an action must be emphasized. But do not get locked into the notion that a cut necessarily needs narrative justification—as something that moves the story forward. Often the reasons are kinetic—to keep the shots from being too long or too static. Sometimes, as in many experimental films, a cut explores an element of film technique or an aspect of a character's subjective experience. Whatever the reason, when you are looking at a piece of film in the editing room, there must be some positive reason why you feel one shot should end and another should come next.

16-3

The cut from the long shot to the two-shot is masked by cutting on the action.

Alfred Hitchcock's *Notorious* (1946), © Criterionco.com.

Cutting on Action

A term that you will hear frequently is *cutting on action*. This refers to *match cuts* and basically means that when you are choosing to cut from a long shot to a closer shot, or vice versa, the cut can best be masked by cutting on a character's movement. If a sequence requires a cut from a wide shot of a person taking a seat to a closer shot of her speaking when seated, the point to cut would be during the action of her sitting. Cutting on movement usually occurs on emphatic rather than subtle character movements.

Once alerted to this technique, you will see it in almost everything you watch. In the scene from Alfred Hitchcock's *Notorious* mentioned in chapter 2, the cut that leads to the lengthy two-shot is an excellent example. **(SEE 16-3)** In a long shot, Alicia comes out on the balcony and is talking to Dev. The problem is how to get from this LS to the two-shot. The cut is masked by cutting on the action of Alicia's throwing her arms around Dev. If the shots were cut anywhere else, the cut would not appear as fluid as this particular choice makes it. Editors consistently cut on movement like this to create a fluid transition from one shot to the next.

The 30-degree Rule

The 30-degree rule is tangentially related to the 180-degree rule but is not nearly as rigid and is less well known. It is more a matter of common sense than of the diagrammed schematic associated with the 180-degree rule. Simply stated, the **30-degree rule** says that if you want to cut to a closer shot of a subject, the second shot should vary by at least 30 degrees from an axis drawn from the original camera position to the subject. The bottom line is that you should not move the camera toward the subject in a straight line; the possibility of a disagreeable jump is great if you do.

When you shoot a master shot, it is general practice to move in for closer shots. If you are doing a master shot of two characters, do not cut from setup #1 to setup #2, or it will look as though you are leapfrogging toward the subject. **(SEE 16-4)** The problem is compounded if you repeat the sequence.

16-4

Cutting from setup #1 to setup #2 would look as though the camera were leapfrogging toward the subject.

16-5

In a cut from setup #1 to setup #3, background and character position change enough that minor continuity issues would go largely unnoticed.

If you jump in and then jump back out again, it will look even more like the camera is leaping forward and backward. A more common sequence of cuts is to go from the master to setup #1 and then to setup #3. **(SEE 16-5)**

The other key issue is continuity. If a character has his hands at his side in the long shot and at his waist in the close-up, the jump will stand out in a same-angle cut. Because so much else changes—the background, and the character's position within the frame—when the angle is shifted by 30 degrees or more, minor continuity flaws like this are much less noticeable. Small differences in body position during performance are unavoidable. The implication here is that if you can just get the continuity right, a same-angle cut will work. Most editors, however, would maintain that it is still a poor cut, even if the continuity matched. A good example of this is the scene previous to the last one described in *The Maltese Falcon*. Watch Bogart's cigarette through the scene and you will get an abject lesson in what you can get away with continuity-wise, particularly when following the 30-degree notion. Again, continuity people love the antismoking campaign.

A critical point to make here is that even if you do not cut from setup #1 to setup #2 in figure 16-4, you may nevertheless have angles that come in on a straight line in your storyboards. Setups that appear to break the rule are almost always in the shooting plan and are executed during production.

Looking at the breakdown of the scene from Jonathan Demme's *Something Wild*, you will notice that the overhead appears to have camera positions that specifically break the 30-degree rule. **(SEE 16-6)** The close-up of Ray (#3) is at the same angle as the over-the-shoulder shot of Ray (#2)—it comes in on a straight line to the character. The same is true of both Lulu (#4 and #5) and Charlie (#4 and #6). But as you analyze the scene, you will see that at no point does the editor cut from an over-the-shoulder shot to a close-up of the same subject. If we see a shot over Ray's shoulder (#4), the next shot we see is of another character from another direction. It is important to be somewhat emphatic about this because, once the 30-degree rule is learned, I will catch people on sets saying that they cannot shoot a setup because it will break the rule. This is not the case. You simply have to plan shots that go between shots that appear to break the rule.

16-6

Although several camera setups are at the same angle to a character (#2 and #3, for example), cuts are never made between them without an intervening shot from another direction.

Emphasis

Cutting on a subject or an action exaggerates the significance of that subject. In essence the implicit message is that this subject is important enough to warrant more than a single perspective. If there is a shot of an object on a table—say, a knife—followed by a cut to a close-up of the knife, the implication is that the knife is an important element.

Sergei Eisenstein explored this idea in his landmark film *Battleship Potemkin* (1925). The sequence has a dissatisfied sailor responding to rancid food on the ship. He looks at a plate inscribed with the motto "Our Daily Bread." Angered, he smashes the plate against a table. Clearly, this action could have been shot from one angle and been reasonably effective. But Eisenstein wanted the action to achieve much greater significance. He did a number of shots from the same camera angle of the plate being broken. He then started the motion in one shot and cut to the same action from another shot. Under normal circumstances the resulting cut would simply match. What he did differently was to start each new shot at a substantially earlier point in the movement than he had left it in the previous shot. This created overlaps of movement, exaggerating and intensifying the action.

I once had a student who, given the assignment of creating several matched action cuts, decided to have some fun. She took the action of a car coming down a street and pulling into a driveway. She broke it down into about 20 separate setups, each covering a small part of the movement of the car. That this simple movement was given so much attention created the assumption that it was an immensely important part of the film. The anticipation was so great by the time the car finally came to a stop that when the occupants just got out and walked into the house, the letdown was comical.

Visual Interest

You must go through the unedited footage to find the meat of the shots. What you have shot will inevitably have stretches that are not visually interesting. If you film a dance rehearsal, for example, there will be parts in which the dancer is turned from the camera or is framed poorly or parts in which the action is just not engaging. Select the segments in which what was in front of the camera interrelates with the film frame in a visually exciting way. You should find moments when the physical makeup of the frame, the arrangement of shapes, the kinetic elements, and the tension created by the parameters of the film frame all make a shot speak.

In the best shots, not only is the subject exciting but also the way it is filmed increases visual interest. Find these points. As a beginner the infrequency of these moments can be discouraging, but they should increase as you gain experience. The goal of a cinematographer is to have exciting moments happening all the time. Great cinematographers have the ability to find the frame that gives the material an edge. As both an editor and a cinematographer, you must be able to recognize those moments when something is "happening" in the film frame.

Variety

Your shots must employ a variety of approaches. Vary between close-ups and long shots, low angles and eye-level shots; images with different balances of compositional interest; moving and static camera; and so on. In other words, use the camera resources available to you.

If a film is composed entirely of long shots, it risks becoming visually dull and predictable. If the area of interest in all of the compositions is in the same part of the frame, the same problems can occur. Obviously, there are exceptions. Several films that were done largely in long shot have been successful, such as Jim Jarmusch's

Stranger Than Paradise (1984) and Chantal Akerman's *Jeanne Dielman: 23 Quai du Commerce, 1080 Bruxelles* (1974). There are also films shot almost exclusively in close-up. But these are the exceptions; they do not represent the kind of explorations and experiments that provide useful learning experiences for beginners.

As with almost every facet of editing, camera perspective requires consideration during shooting. If you have not used a variety of perspectives, options in editing will be very limited.

Continuity Problems

While cutting, you will occasionally find continuity mistakes that were made in shooting, from minor problems to ones that will make you want to tear out your hair. If you have two shots with a bad continuity jump, for example, it may be possible to use a **cutaway**—a neutral shot between them that would mask the problem, such as a reaction from another character. Some call it "the-dog-under-the-table" shot. When the editor starts cutting to the dog—or the kid or the whistling teapot— you realize there were major conceptual errors in the scene. Cutaways do have the potential to work, but they can also have unfortunate side effects. The first is that they can destroy the pace of the scene. Extra shots frequently slow down a scene; and though you may improve the individual cut, the overall shape of the scene suffers. The second problem concerns the logic of the visual presentation. It often just does not make dramatic sense to slip in a reaction shot or, more significantly, some detail of the set. By cutting to it, that reaction or detail takes on an importance that it may not warrant. In both cases the operation is a success, but you lose the patient.

The bottom line is that sometimes you simply have to brazen your way through some of these minor continuity difficulties and just make the cut. In the rush of frames, the dislocation for the viewer will be momentary, and new shots will quickly take center stage. As an editor you look at a cut with poor continuity over and over, in slow motion and frame by frame. It grates on your sensibilities. You must realize, however, that the viewer is going to see it briefly and only once, and unless it sticks out like a sore thumb, it will generally go unnoticed.

Basic Terms

The following terminology applies to the basic principles and procedures of editing. Many of these effects can be created "in camera," but the norm is to plan them in editing and have them executed by the lab in the final print (see chapter 18). This gives greater control in positioning the effects and avoiding the inexactness that comes with being created by hand.

Fade-out and fade-in A **fade-out** is simply where the picture fades to black. A **fade-in** is the opposite, where the image comes up from black. Fade-outs and fade-ins are generally used as transitional devices, either to get from one location to another or to signify the passage of time. Occasionally, filmmakers fade to shades and colors other than black. Ingmar Bergman fades to a brilliant red in *Cries and Whispers* (1972), amplifying the film's concerns with the symbolic aspects of blood. Films also occasionally employ a fade to clear or to white. These can be popular, though they tend to have a very stylized effect.

Dissolve A **dissolve**, also called a *lap dissolve,* is a common technique in which one shot is faded out while the next shot is faded in on top of it. Similar to the fade-out, this is often used to signify a change of time or place. Although dissolves are immensely attractive to the novice, they are not used as frequently as you might imagine. There is an old put-down among editors: "If you can't solve it, dissolve it."

As this suggests, the dissolve is frequently used to soften an otherwise terrible cut. Despite this drawback it also can be used to extraordinary effect, such as in Basil Wright's great British documentary *Song of Ceylon* (1934). The film dissolves between long tracking shots across temple ruins to create a poetic vision, emphasizing the timeless quality of setting and place.

Superimposition Also called a *super*, a **superimposition** is composed of one shot overlaid on another. This effect is not particularly common in features, but it has long been a staple of experimental films. Supers can be achieved in the camera while shooting or, more common, in the editorial and final printing processes. In the former case, the camera must have some backwinding capability. You make one pass on a section of film, wind the film back, then make a second pass on the same section. Each pass must be underexposed by roughly one stop so that the overlay does not result in overexposure. Tests should be shot to determine exact exposures, as different situations can present different problems.

Optical effects The umbrella term *optical effect* indicates a graphic effect that is created in the lab. **Optical effects** include split screens, keyholes, freeze-frames, spins, wipes, and a host of other effects executed by the lab at the filmmaker's instruction and done prior to the final printing. They are difficult to get right and may take several tries to obtain the precise effect. They are also expensive.

Prior to the digital age, these effects were produced on an optical printer. Used to rephotograph existing footage, the **optical printer** is essentially a projector that has a camera shooting straight into it. Both the camera and the projector can be advanced one frame at a time. The camera can also be repositioned to focus on specific parts of the projected frame. The projected image can be manipulated in terms of both coloration and the speed of the film going through the gate.

If you wanted to create a slow-motion effect, for example, you could shoot two camera frames for every one projector frame. Any more than two frames creates a staggered effect between the frames, an effect that can also have applications in creating time and image distortions. If you shoot seven or eight camera frames for every projector frame, the result will be a staggered, almost ballet-like distortion of the original movement. Ernie Gehr's *Eureka* (1974) uses this effect on a piece of film originally shot in 1908, in which the camera was mounted on the front of a trolley car. The effect created by the optical printer turns the content abstract, making it a play of shapes and form in stylized movement.

Optical printers were, and to a certain extent still are, used most frequently to create optical effects—such as **freeze-frames**, in which multiple frames are made of an individual frame, thus "freezing" the action, special effects, and titles in the editing stages of a film. A complicating factor is that film produced on a printer looks slightly different from the original film because it is one generation away. If footage from the optical printer is mixed with first-generation footage, the difference will probably be apparent even to undiscerning viewers. The famous freeze frame at the end of George Roy Hill's *Butch Cassidy and the Sundance Kid* (1969) had to be very carefully managed so generation problems did not spoil the effect. The freeze frame slowly drifts into other effects—sepia, tintype, etc.—all which required very careful planning.

Effects that take extensive calculations on an optical printer are now, of course, easily executed on digital video. Dissolves, which were not always seen until the final print in film, can be dragged and dropped in the timeline and looked at and changed to your heart's content. The NLE approach also completely eliminates generation problems. Although use of the optical printer has diminished, it is still used in creating many visual effects and can be an exciting tool for beginning filmmakers, particularly those interested in formal experiments.

Approaching the Edit

In an NLE edit, the video files must be imported or, in the case of videotape, *captured* into the computer, the audio must also be imported or captured, the sound must be synced to image if needed, and the bins organized. Then the process of picking the desired takes and assembling the project from the beginning can start. With film the sound must be synced up and the desired shots picked, pulled, and reassembled. You must also code the film and, in some instances, A & B roll the sync audio tracks (see chapter 17).

Project or otherwise view your unedited footage many times and make as many preliminary determinations as possible about the choice of shots. In a conventional film edit, you will eventually go through the raw footage and take out the shots you want to use. Generally, you want to label or extract the entire shot from first frame to last frame (unless there are parts of the shot that are absolutely unusable). With film, either workprinted or telecined, the beginning and the end of each shot are easily identified by one or more **flash frames**, frames that have more exposure—look thinner—than the rest of the shot. These frames are created because, while shooting, it takes a split second for the camera to get up to speed at the beginning of each new take as well as to come to a complete stop when cut is called. In these brief periods, the entire mechanism is moving slowly, thus giving the first and last few frames more exposure from the slower rotation of the shutter. Although at first appearing to be an irritant, these flash frames are extremely useful in identifying the beginnings and the ends of takes in the workprint, the original, and the video transfer. (The notion of *pulling from flash to flash* is addressed in chapter 17.)

You start with the raw footage and keep rearranging it and whittling it down until you have a fluid and thoughtfully ordered piece of work. The first advanced cut of a film is called a **rough cut**, from which you identify any superfluous material and work toward a **fine cut**.

Editing on Film

As suggested, the conventional film edit—that is, cutting actual film pieces and their attendant sound tracks—is rare. Although those who wish to create final products on film must understand film postproduction processes, this fundamental reality has altered the approach to this text from its original version. Gone are the sections on how to do overlapping picture/audio cuts and the like. Nonlinear editing, or computer editing, has largely supplanted it, but aspects of the conventional film edit nevertheless play a significant role in general production. In particular, the feature film world still frequently integrates film editing with NLE in the postproduction phase and, again, students and independents may find it a viable approach. What is described in the following discussion is essentially the way films were finished, with some minor variations, from roughly the commercial introduction of sound in 1926 to the relative consolidation of the digital revolution over the past few years.

In all stages of a conventional film edit, a project exists as a number of pieces. You do not really get to see the whole thing together until the film is finished and you have a print that can be projected. Editing is a process of moving toward an **answer print**—the first attempt at creating a final print of a film. The answer print is checked to make sure everything is correct—color, exposure, and a host of other considerations. Once an acceptable answer print is achieved, it is used as the guide to make all subsequent prints, called **release prints**.

The *original* film—the film that ran through the camera while shooting—is never handled or projected in the editing process. All work is done on the workprints, the frame-for-frame duplicate copies of the film. Original film, often though not always referred to as *negative*, is used only as a printing source. The version

16-7

Moviola M-77AH flatbed editing table.

© Photo courtesy of Bruce Mamer.

16-8

The most common flatbeds have three film transports—one picture and two sound.

© Photo courtesy of Bruce Mamer.

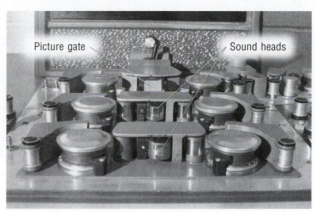

Picture gate Sound heads

of the film that you are working on during the actual editing process is called the **edited workprint** (**EWP**). All the truly creative editing work is done at this stage.

Sound complicates editing immensely. Although sound and picture are edited at the same time, all sound is handled on separate pieces similar to the film. Sound is generally recorded on-location or in the studio on a conventional magnetic medium or, more frequently now, on a digital audio recorder and then transferred to magnetic film stock, which is the same size, dimension, and construction as the film itself. This is referred to as **mag stock** or *fullcoat*, the latter being a name that actually implies a specific type of mag stock.

The small percentage of editing that is still done on film is done on **flatbed** editing machines. **(SEE 16-7)** There is, however, a small but hardy cadre of editors who still work on older upright editing machines. There are bigger versions of flatbeds, but the most common ones in general use have three film **transports**, one picture and two sound. **(SEE 16-8)** The **picture gate** is where each individual frame is projected. The sound transports have magnetic playback heads that correspond precisely with the picture gate in terms of frames. The film and the sound can be run at 24 frames per second (fps) and in fast and slow motion, both forward and in reverse. The transports are locked together so they run at precisely the same speed, passing image and sound past their appropriate gate and heads respectively. They can be unlocked, but this is only done in specific circumstances.

Once the sound is transferred to magnetic film stock, it is represented as a specific length of film. If we were to take an example of, say, someone reading Lincoln's Gettysburg Address, we could build images against that transferred piece of sound. **(SEE 16-9A)** Indeed this figure is based on an oft-cited scene from Leo McCarey's *Ruggles of Red Gap* (1935), where Charles Laughton reads the address in a saloon filled with grizzled cowboys. If we wished to have specific images positioned against specific events in the speech, we would simply find the sound we wanted and cut the image we wanted on the picture roll across from it. If we wished to have some music in the background, it would be transferred to a separate piece of stock and positioned on another roll against the image and existing sound. **(SEE 16-9B)** The process of editing sound requires creating a number of separate rolls of mag stock, called **mixtracks**, to create the desired layering of sound. If the sound effect of a clock chiming in the background is desired, another track is required. **(SEE 16-9C)** This sound can also be precisely positioned wherever it is wanted. If you want the sound of horses galloping by outside, that too is handled separately. **(SEE 16-9D)**

16-9

Compiling mixtracks enables sound to be manipulated against picture and vice versa.

Picture

Laughton	Cowboys	Bartenders	Ruggles	Over the shoulder (Laughton)	Old men	Laughton

Sound

A Fourscore and 7 years ago, our fathers... the last full measure of devotion... and for the people, shall not perish from the earth.

B Honkytonk piano...

C Clock chiming

D Horse galloping Horse galloping

© Cengage Learning

Any sound that you want layered in requires another mixtrack. The final product is one picture roll—the edited workprint—and a number of mixtracks, all the same length as the picture. The number of mixtracks depends on how complex and layered the sound is. A music video may have only one track—the music track. More-complex sound requires more-complex track building.

Once every element is where you want it, you start the final steps of finishing a film: **audio mixing**, or *final audio mixdown* (the creation of the final sound track); **negative cutting**; and the actual **printing** of the film. Although the filmmaker has substantial input, these three processes are handled either in a laboratory or by experienced professionals; all are expensive. When you start these processes, all of the creative decisions of editing have already been made. There is almost no turning back. These processes are a matter of locking all the elements into place and combining them onto one piece of film—the answer print.

The final mix requires that the picture and the mixtracks be taken to a professional mixing facility, where the many tracks of sound are mixed down to a single sound track—the master mix. It is here that you finalize the volume levels, any manipulations of sound quality, the sound fades planned by the editor, and so on. The **master mix** represents the final sound for the film. This used to happen with mag stock as the standard recording medium, but digitized sound has changed the procedure significantly.

Whether the master mix is on mag stock or in a digital format, it is quickly turned into an **optical master**—a piece of film that is blank except for a narrow strip of diamond-shaped patterns opposite the side with the sprocket holes. **(SEE 16-10)** These patterns are the sound for the film, all sound in film being handled photographically. The optical master is used to print the sound track on the final film, where it is called an **optical track**.

You then return to the original footage for negative cutting; that is, you have it "conformed" to what you did in the edited workprint. The film is usually given to

© Cengage Learning

16-10

The optical master is a piece of film that is blank except for a strip of patterns opposite the sprocket holes.

a professional, listed in the credits as the **negative cutter**, who makes a master version of the film out of the original, using the edited workprint as a guide. The film has latent **edge numbers**, usually referred to as *key numbers*, which are exposed onto the original film by the manufacturer and then printed through to the workprint. They serve as a reference for the negative cutter. This is generally the only time the original is handled and cut. This conformed original is still only a printing medium. Everything projected on a screen will be a print made from this edited original. These latent edge numbers are also a critical component in any interface that we may contemplate between film and video.

In the negative matching process, the original film is actually cut into two separate rolls called **A & B rolls** (there can be more than these two). In the A & B rolls, the picture is set up with the odd-numbered shots on one roll and the even-numbered shots on the other. (This process is explored in chapter 18.) This step is done mostly to achieve color and exposure control in the printing process and to facilitate dissolves, fades, and a few other effects. A & B rolling is standard procedure in 16mm but not necessarily in standard 35mm film.

The process of finishing a film can be represented as a flowchart. **(SEE 16-11)** The sound and the image have two separate paths; they are cut at the same time but not represented on the same piece of film until the very end. An answer print is also descriptively called a **married print**, where the two entities are finally joined together.

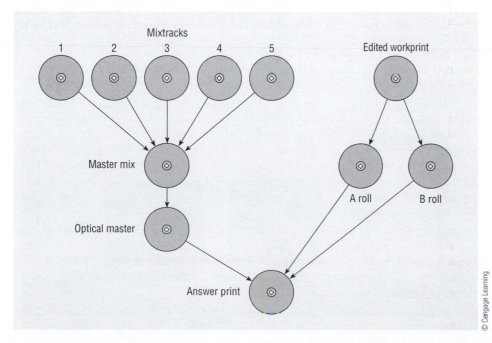

© Cengage Learning

16-11

Flowchart representing the process of finishing a film.

To summarize, the mixtracks and the edited workprint are created in editing. The mixtracks are mixed down into a master mix, which is then converted into an optical master. The edited workprint is used as a guide to re-create the film out of the original, making the A & B rolls. The A & B rolls and the optical master are then used to create an answer print. Unless there are complications, the answer print is the guide for all subsequent release prints.

Hollywood commercial films generally do not cut the precious original. The original starts to deteriorate after a small number of printings, so it is used as the head of a family tree of printing and projection versions of the film. Often what you see at the theater is many generations away from that original piece of film, particularly when films are released in numerous theaters simultaneously.

The final processes of completing a film, including conforming, mixing, and printing, are costly. The following estimates assume that you are finding vendors that will provide services at reasonable rates. If you want to mix the sound where George Lucas mixes his, multiply your costs by about 5. The mix on a 5-minute 16mm film might cost $160 to $250, assuming reasonably uncomplicated sound. If your film has an average number of cuts and you can find a negative cutter who will negotiate, you might get conforming done for $300. A final print of a 5-minute color film would be around $200 to $250, including the creation of the optical master. Black-and-white is cheaper. This does not include titles and a host of other hidden costs. Few students take their first films all the way to a final print. It is far more expensive than most tentative first efforts warrant.

In today's world mag stock is almost a thing of the past. The whole concept of conforming the original and matching the sound track remains, however, unless the production is going the DI route. Even then, matching of audio tracks must nevertheless be done. Workprints are still preferred by many production crews, but mostly so the camera crew can check its work and the marketers can have something to project at test screenings.

Editing on Video

Although high-end gear remains expensive, reasonably priced editing software has allowed people to easily complete low-budget productions entirely on their own. *Digital Video (DV)* technology and now file-based picture and audio has made a powerful production tool available to students and independents of modest means. **(SEE 16-12)**

16-12

A basic NLE station.

Macintosh G5 CPU and Sony DSR-11 DVCAM deck / © Photo courtesy of Bruce Mamer.

The $60,000 (or more) digital editing systems have largely been undercut by software like FCP, Adobe Premiere Pro, Avid Xpress DV, and a host of other powerful low-cost programs. There will undoubtedly be semiannual upgrades and improvements to these software packages, but the uncertainty that attended the introduction of so many new video formats and refinements may at last be abating. Although this technology may not necessarily support the image quality required for high-end productions, it has already absorbed an enormous amount of midrange work. Even the idea of needing to work with low-res images has changed with many NLEs capable of finishing in a pseudo or real online environment.

The individual NLE software programs identify and exhibit their operations and functions slightly differently, but they all have reasonably similar approaches; the idea is to trim down the shots and get them cut into the program. A good starting point is to first understand that digital editing emulates film editing. Although no one ever handles physical pieces, shots are trimmed and sound tracks are built using the same considerations

NLE programs usually have four key windows (often referred to by different names): a bin, a viewer, a timeline, and a preview window. Final Cut Pro is typical, with the addition of a toolbar—found in the lower-right corner—for common editing functions and an Audio Meters indicator to monitor sound levels. (**SEE 16-13**)

The **bin**, called the *browser* in FCP, is where all of the shots, referred to as **clips** in most systems, are stored. (**SEE 16-14**) Each clip is represented by a brief written description, a title, or an icon (often a frame of the shot). Sound, whether in conjunction with a shot or as a separate entity, is stored in the bin as well.

When a clip is selected, that is, double-clicked, it will appear in the **viewer**. (**SEE 16-15**) This window will have the standard playback controls: *play, pause, reverse,* and so on. In the viewer you can analyze the shot to determine where it

16-13

A representative desktop for NLE systems.

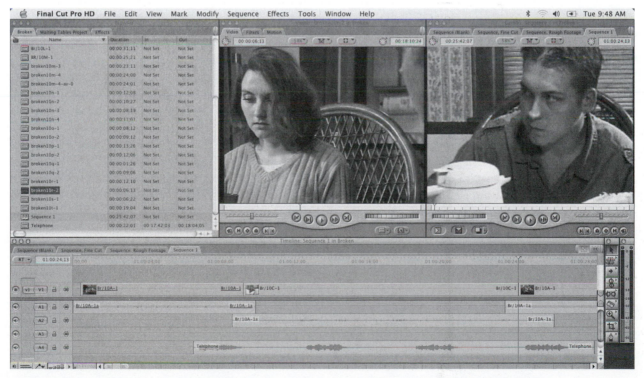

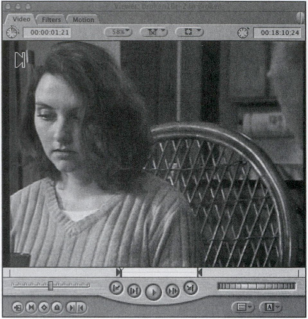

should begin and end. The software has the capability to **scrub** through the shot, that is, move over it frame by frame. Sound is played and scrubbed on just as the picture is. The various NLE systems handle this differently, but sound is often represented as some type of waveform. **(SEE 16-16)**

Each clip has rolling time code numbers, either created by the software in datacine or generated by the camera during shooting. Using these timings the editor determines the in- and out-points for the shot. The editor sets the edit points, then inserts the shot into the edited project.

The edited project, with the selected sections of clips, is represented on some form of **timeline**. **(SEE 16-17)** Shots and sounds are dragged (or otherwise moved) into the timeline and placed in the desired positions. The timeline usually has a zero point, representing the beginning of the show, and indicates how the show unfolds in hours, minutes, seconds, and frames. The editor can zoom in and out on the timeline to focus on anything from micro-representations of short segments of the project to the complete show.

The software's menus provide typical effects such as superimpositions, fades, dissolves, and many other transitions. Virtually all systems now have what is referred to as **nondestructive editing**, which means that, rather than going back to the bin to get the shot and reset your in- and out-points, you can control the length of the clip in the timeline. If you decide to make the shot longer, you can simply drag it out as far as you want.

16-17

A representative timeline for NLE systems.

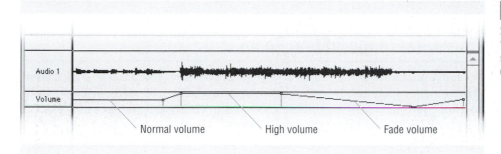

16-18

Some NLE systems use the "rubber band" method of setting audio levels.

Normal volume High volume Fade volume

Timelines generally open with two to four audio tracks, with the option for more. The various programs handle volume control differently, but many use a method that one software producer calls *rubber bands.* **(SEE 16-18)** With the vertical spread of the track representing a volume scale, you click at the bottom of the effects bar, "lasso" the sound, and drag it to the desired volume level. Most software also includes fairly crude to quite sophisticated controls for sound equalization and signal processing, giving the potential for cleanup and general manipulation of the sound. With the possibility of multiple audio tracks, equalization, and audio processing, an entire complex sound track can be built. Most NLE software allows the editor to mix the audio internally, thus bypassing an expensive commercial mixdown, although a strong rationale will be made later to take the audio into a professional environment at some point.

As the picture and the sound tracks are built in the timeline, the edited show can be viewed in the **preview window**, called the canvas in FCP. **(SEE 16-19)** The finished program can be output to videotape and then broadcast or shown in whatever venue you desire. Again, taking advantage of a commercial video postproduction facility may add further dimension to the project.

NLE systems have a plethora of other capabilities. Novices, faced with so many options, will often make ill-informed decisions that have a negative

16-19

Called the canvas in FCP, the preview window for NLE systems is where the editing decisions made on the timeline are played.

impact on the project down the road. Talk to people who are using the programs, and stay as well informed as you can about every step of the process. Perhaps the only downside of the digital revolution is that computers are by no means infallible, with crashes and bugs causing no end of headaches and heartaches. Learning curves on many of these systems can be quite lengthy, so be prepared to spend time mastering the extensive potential of some of these powerful programs.

This path is relatively straightforward, although ambitious goals can create unavoidable complications. NLEs usually have the capability of layering video tracks, that is, superimposing images. With this feature one can become immensely elaborate in creating complex imagery. Playback quality and **rendering**, the need to create attendant digital files for things you have created or manipulated in the computer, can be time-consuming and have implications in general image quality. Probably the most common complication is the desire to return to upstream media to create a better-looking product. Here, edit decision lists (see chapter 9) play a big role in rebuilding shows in online environments.

Procedures in the Editing Room

The individual roles of the people who do the work—the editorial staff—are central to the way in which the raw materials are organized and processed during postproduction. Although roles may have evolved in an NLE room, the general requirements and the basic structure remain the same.

Editorial Staff

The head of the editorial staff is, of course, the editor. Though there are many different working relationships, the **editor** is generally responsible to the producer for creating a workable version of the film. Depending on how powerful the director is, he or she may be an integral part of the process, usurping the producer for editorial supervision. In the heyday of the Hollywood studio, directors often handed over their raw footage to the editor, and that was the last they saw of it until the premiere. Such present-day directors as Spike Lee, Woody Allen, and Martin Scorsese have their hands in many editorial decisions.

The editorial staff can be quite large, with many members performing specialized or limited roles. The assistant and apprentice editors work most closely with the editor, and their roles comprise different tasks between a film edit and an NLE edit. In a film edit, the **assistant editor** is responsible for the overall organization of the editing room and all of the film or digital-related materials. The **apprentice editor** is responsible for many of the routine procedures that the editor does not do, such as syncing up, stringing out, configuring mixtracks, and so on.

In an NLE edit, the assistant and apprentice editors' jobs have become dominated by the need to manage and keep track of numbers. Time code is the major source of all their endeavors. Logging clips, managing sound for its own time code, checking timelines, and a host of other responsibilities have become central to the process. Particularly when matchback is involved, crunching numbers becomes an even greater part of the task.

Beyond these three positions, there may be a wide variety of specialists, who become involved at different stages of a project. These include sound-effect editors, music editors, Foley editors, and automated dialogue replacement editors, among others. Each of these jobs is very specialized, with some of the general activities detailed in later chapters. Indicating how specialized it can get, British films often have a quite-descriptive credit for a "footsteps editor," an individual whose sole responsibility is to edit in the sound of characters' footsteps. Most students and many indies cannot afford the participation of these late-in-the-game specialists, with

their tasks falling to that person called "the editor," often stretching the individual's contribution beyond his or her real-world abilities.

In terms of day-to-day operation, even if a director has power in the editing stages he or she rarely spends much time in the editing room. Editing is too painstaking and laborious to be effectively supervised, or even watched, by an at least physically uninvolved second party. The editor is generally given the footage and then trusted to do the best job possible, with a talented editor able to bring dimension to the scenes beyond what the director anticipates.

The producer and/or director will be shown rough cuts of the film as the editing process progresses and will usually make detailed suggestions. The editor will generally give a rationale for any questioned sequences, and some compromise will be reached. Directors with decision-making power thus negotiate the best possible cut of the film. Though film history is replete with examples of abuses of this process, this collaboration is generally the wisest path. Again, directors realize how much a talented editor can enhance a project.

Having people critique the work is a crucial part of the process. Even if you are editing a film that you have written and directed, nothing is created in a vacuum. The person who thinks that anyone else's opinion dilutes his or her work is usually the person who is intent on producing one more trivial piece of self-indulgence. Watch out for the myth of the lone genius. There may have been a few in the history of art, but to assume that you are at that level is more than a touch pretentious. Even van Gogh had Gauguin.

Organization

Organization in the editing room is essential. Film students generally start working on short projects. Because the films are brief, whether cut film or NLE, organization is not too complicated because the footage is limited. Many initial exercises are done without sound in film programs, and working without sound simplifies organizational concerns as well. This is a good discipline that gives valuable experience in telling a story visually. People who start on video, which is the vast majority, start immediately with sync sound and probably could not fathom working elsewise. The spoken word, however, can easily be a crutch, dominating the visuals. When many film beginners first get their hands on sync equipment, they wind up just photographing the dialogue. They film headshots of actors conversing, derogatorily referred to in the industry as "talking heads." This approach is not by definition bad, but it can deny the power of visual storytelling.

The material to be used in the film must be extracted from the rolls of uncut footage, called **raw footage**, and kept track of until it is incorporated into the edited workprint or identified and brought into the timeline in NLE. In a film edit, the outtakes and the **trims**—frames trimmed from the shots you are using—must be stored so that they can be found if needed later. In NLE the bins must be kept tidy, and detailed notes are necessary for finding desired sound and images.

There are many ways to organize when working with a small amount of material. You should develop good habits from the beginning. However you proceed, be aware that there are accepted industry practices that you will learn if you ever assist in an editing room. But for now it is important that you just save everything and know where to find it.

Film Equipment

Although almost obsolete, the flatbed tabletop editing machine (discussed earlier in this chapter) is at the top of the film-editing equipment pyramid. Used flatbeds can be found at very reasonable prices, although maintenance on such aging gear can be an issue. The **editing bench** is essentially a less expensive version of the flatbed editing table. **(SEE 16-20)** Although it appears, and to a certain degree is, cumbersome

The editing bench is a table that comprises rewinds, a viewer, a synchronizer, and other pertinent editing equipment.

© Photo courtesy of Bruce Mamer.

and archaic, its use has oddly enough remained a significant part of the interface between digital editing and conventional film editing.

A film bench consists of a number of standard components, including a pair of **rewinds** for hand-winding the film. The rewinds are spaced roughly 4 feet apart. A viewer is a standing viewing machine on which you can analyze the film at any rate you want, from frame by frame to normal movement. The greatest use of the viewer is in determining edit points—analyzing the shots and deciding on the start and end points of the segments of film that you intend to use.

A **gang synchronizer**, consisting of interlocked rolling drums with sprocket teeth, is not required for simple picture cutting but is necessary when working with sound. Sound and picture rolls can be locked to individual drums, called *gangs*, to be fed through the synchronizer in sync. With an amplifier/speaker, called a **squawk box**, and a sound head mounted on a gang, sound can be read and locked to the picture. With this equipment it is possible to outfit a workable and inexpensive editing room. Though flatbeds are preferable, you can do a substantial amount of effective work on an editing bench when resources are limited.

The **splicers**—used to cut and splice film—in general use are the Guillotine and the Rivas. **(SEE 16-21)** Inexpensive splicers that use precut splicing tabs are also available, but these are (or were, because of video) more for individuals and organizations that repair only a few home movies and institutional film prints. In terms of both the time they take to use and the durability of their splices, they are not adequate for extensive use.

Both Guillotine and Rivas splicers have a setup block with a series of sprocket pins. When the film is set up on the pins, they ensure that it will be cut on the frame line and that it will line up correctly when the splicing tape is applied. Both models have blades that cut the film. Guillotine splicers use rolled tape, which is pulled across the film. A recessed, two-bladed knife trims off the excess splicing tape when you press the handle down; pins also come down and clear out the sprocket holes. The Rivas splicer uses rolled tape, but the holes for the sprockets are precut. The tape is lined up and applied on the sprocket pins and then cut with a blade. The precut rolled tape is more expensive than the Guillotine's unperforated tape, but there is less waste.

Guillotine splicers have both a straight cutter for the film and an angled cutter for the sound. The angled cut cushions the splice as it crosses the sound head and makes it less apt to pop. Despite this many editors do not use the angled cutter, having determined that they can cut the sound with the straight cutter without experiencing any difficulties. With the Rivas splicer, doing angled sound cuts requires using a second splicer equipped with the angled blade.

The frame line runs between the sprocket holes on both 16mm and 35mm film, so the cut is right at a set of sprocket holes. Put splicing tape on only one side of the film so it is easy to take the splice apart if you do not like the cut. Editing is

16-21

On both types of splicer, the film is set up on pins, which ensure that it will be cut on the frame line and that it will line up correctly when the splicing tape is applied.

© Photo courtesy of Bruce Mamer.

Guillotine splicer

Rivas splicer

about trying different options until you find the desired cut. The tape splice method affords the best opportunity for experimentation.

There is a third type of splicer that requires mention. The **cement splicer**, also called a *hot splicer*, works on a principle of welding the film together; unlike a tape splicer, the cement splicer creates a permanent splice. Cement splicers are used largely in the preparation of rolls for printing, the repair of projection prints, and, most important, the process of cutting the negative. (The specifics of cement splicing are covered in chapter 18.)

All editing in 16mm and 35mm is done with the film on **cores**—circular pieces of plastic on which film is wound. Reels are too bulky for effective storage and are hard on the editing equipment. A **split reel** is used when film has to be projected or set up on a bench; it has the two flanges of a regular reel, with a threaded center so that they can be detached. One flange has a pin to hold the core from spinning in the reel. The core should be set on the threaded center of this flange, and the second flange is screwed down on top of it.

Setup for Nonlinear Editing

For many people, a simple setup is all that is required. A central processing unit (CPU), a monitor, and, if needed, a deck or camera to get the media into the computer will allow you to do a tremendous amount of work. Professional projects of large size or in any high-definition television (HD) format should be done on larger, usually tower, computers. You can use notebooks and smaller consumer computers, like iMacs and Mac minis, for small projects done in MiniDV and other less taxing formats, although more-robust units will still provide more stability.

The capabilities of video- and audio-friendly computers are stunning. I would set students' eyes to rolling when I would wax nostalgic about my first professional mix over 30 years ago, walking into a studio with banks of recording and playback equipment, selsyn motors to synchronize it all, cooling and cleaning systems to keep it from overheating, and bundles of audio cords snaking throughout the scene. Today *almost* all of that equipment is represented on my laptop. Those huge rooms of cast-iron racks and solid-state electronics have imploded into a unit smaller than a breadbox. For old-timers it boggles the mind what can be accomplished by the average user these days.

That said, anyone with experience also knows that just because one can do it doesn't mean that one *can* do it. Or, put more plainly, just because one can do it does not mean that one should do it. As stated, just because someone is proficient with a piece of software, say an audio-mixing system, does not mean he or she knows the first thing about sound. People devote careers to learning single aspects of the filmmaking process, and a lifetime of knowledge can make a world of difference to seemingly simple things like sound audibility, image quality, color correction, and . . . well, just go down any list of credits. The guy who simply learns a software program and then hangs out a shingle as, say, a sound mixer, may be an active danger to your audio track.

For postproduction of commercial projects, the systems that are in place are almost as extensive and at least as complicated as the studios of old—the difference being that there was no alternative. With waveform monitors, vectorscopes, color correction equipment, dust-spotting software, and so on, professional studios are at least as complex as and profoundly more expensive than earlier incarnations.

There are essentially four major goals you want to achieve in a personal studio. The first is to make the playback of the audio and the video as high quality as possible to be able to analyze the individual pieces as carefully as you can. The second goal is to facilitate any necessary signal processing. The third is to coordinate the connections of the playback, recording, storage, and processing units so that you aren't constantly plugging and replugging decks to send media where you want. This involves what is referred to in chapter 10 as the *signal path*, a concern of equal importance in the video world. The fourth goal is to put together a studio that is robust enough to handle the level of work you are doing.

The initial choice of monitor(s) is very important. Having a two-monitor setup is the standard, with one being a large screen with room for a good representation of the image and lots of room to move around. The second monitor can be smaller if budget and space are of great concern. It is generally used for the bin and other features to which you only need sporadic access. High-end setups have a true HD monitor in which to feed the edited program, with computer monitors not giving as full a display of color and luminance as a dedicated monitor.

While excellent-quality playback is always the critical goal, any list like this often includes something akin to an old beat-up TV so that you can experience the project on its most likely final destination—an average-quality TV in the color-adjustment-challenged and acoustically questionable environment of typical home viewing. Working in an environment that reproduces audio and video essentially perfectly, you may miss things that reproduce poorly on lesser equipment. If you can maintain audio intelligibility and decent image quality on an average TV set, most viewers will be able to do the same. Having excellent playback in consort with familiarity with the material can have potential drawbacks. Because you know what the characters are saying and what the viewers are suppose to be seeing, you may overlook the fact that those unfamiliar with the material may miss key dialogue or important visual information.

Students do this frequently; the best example is trying to make do with slightly out-of-focus shots. I had a student who did this with an early exercise he made about deer hunting. As occasionally happens, when he went out shooting (in both senses of the word) he did not even see a deer. His bad solution was to photograph a still picture of a deer in a book. He unfortunately missed on focus, however, and laboring under a deadline he used the shot anyway. So every once in a while when someone pointed a rifle at something, the filmmaker would cut to this image that looked pretty much like one of those old Rorschach blots. In reviewing the film, I still-framed on the shot and asked what the heck it was. On being informed, we both walked up to the screen and in tracing around the shape with a finger I was able to discern the rough outlines of a deer. Obviously, the standard audience experience does not provide that kind of soft landing.

The next thing to address is an adequate sound system. Built-in speakers on computers are woefully inadequate to the task of properly analyzing sound. Cutting any project on a computer's system and then playing it on an exhibition system will shock you with the number of warts and glitches that simply could not be heard. For some people, listening occasionally on a good set of headphones may help, but wearing headphones all the time is too constricting for most editors. A good set of speakers, possibly including a sideboard amplifier and a dedicated sound card, is necessary for serious work. A small sideboard mixer is also helpful for ramping up sounds past the software's volume limitations.

Trying to match ambience (see chapter 10) on an inadequate sound system is another instance where poor speakers will make the task impossible. Devoting the necessary care to trimming out the inevitable background interference and glottal extras from the dialogue cannot be done effectively, either. This is by no means a new problem, as the old flatbed editing tables generally had limited audio reproduction. Somewhere along the line, mixtracks needed to be evaluated on a high-quality playback unit.

Past the basic setup, a studio will break down into the basic software and hardware issues, many obviously interrelated. In terms of just the big things on the desktop, storage is a critical issue. A newer computer probably has enough gigabytes to work with small projects but will require assistance on larger ones. Video files are huge, and uncompressed HD really eats up the space. Stacks of multigigabyte drives are common, and terabyte drives are used on the features. Modern storage capacities are amazing and will continue to grow.

Any studio will need the playback and record decks for both audio and video that are required by your workflow. One possible need is a deck to capture image and potentially audio from the videotapes. Many people working on small projects who need to capture from tape use their cameras, although cameras are not designed for the wear and tear on the tape transport that the back-and-forth shuttling of capture requires. A dedicated deck is appropriate, although beyond the budget of many home setups. For those doing file acquisition, a deck may be necessary to create tapes for potential viewers, although DVD or some other digital form may do. If you also intend to capture the audio by itself, you will need the appropriate deck (digital recorders, DAT, analog cassette, or other). If you are going into your computer from an analog source, something to digitize it will be needed, although it could be dumped over to your capture device and brought in from there.

As suggested, when working with files on small projects, a basic desktop or notebook setup will do. Same for those who work with MiniDV tapes and a variety of audio sources. When you get into the world of uncompressed HD, longer projects, and similar complexities, there are a number of things both internal and external to the computer that are either required or highly recommended. NLE systems are always scrambling to catch up to the newest formats and standards that cutting-edge manufacturers are producing. FCP upgrades, for example, have made progressive accommodations to HD, then HDV (high-definition video), and eventually to AVHCD (Advanced Video Codec High Definition) plus DSLR generated material. Many of these advanced formats profit from requiring more-robust interfaces than off-the-shelf CPUs. Graphics cards, HD-SDI input/output (I/O) cards, and the like may need to be upgraded for high-end projects.

Both new and add-on software may require more RAM and other processing power. Final Cut Pro 6 was introduced with new color, sound, and animated graphics capabilities that would tax older machines. Second-party vendors offer many different products that expand the capabilities of NLE programs or initiate or take projects into new environments where additional manipulation can occur. After Affects from Adobe is a popular animation package, and products by Discreet, Matrox, and a host of other companies require faster processors and more-advanced graphic interfaces.

16-22

A screen with Vectorscope, Waveform Monitor, Histogram, and RGB Parade windows.

Beyond all this, many studio setups have a variety of image control and analysis devices. A *proc amp,* short for *processing amp,* can be used to boost brightness and manipulate color as it is captured or output from an NLE program. Tweaking the video in capture can make it more manageable in the NLE's or other color correction environment. Many NLEs come with a built-in waveform monitor and vectorscope, although many engineers like sideboard units as well. **(SEE 16-22)** A **waveform monitor** gives a representation of the video signal, analyzing the technical character of the picture from lightest to darkest elements. Measured in *IRE (Institute of Radio Engineers) units,* it is a critical tool for indicating if the blacks are within an acceptable range for both good picture quality and broadcast. All other tonalities can be monitored as well. The **vectorscope** monitors hue and saturation. NLE systems will usually have a variety of other analyzing tools, including histograms and RGB monitors.

The science of video engineering is just that—a science. A PhD in physics may not hurt. There are many ways that the video signal can be quantified and manipulated. A prosumer-level NLE, such as Avid Express, FCP, or Premiere Pro, has many excellent tools to control the audio and the video. For many independents and novices, that is all that is needed. Beyond that there are extensive sideboard hardware and software programs both to handle more-demanding formats and to take your media to a new dimension. The size of the project creates further needs as well. Editors and engineers will be able to identify many more toys than are listed here that add functionality to their systems. The size and the complexity of the studio that is right for you will be determined by those same defining parameters of the projects on which you will be working.

17

Cutting Picture and Sound

Covering the mechanics of editing presents a number of pitfalls. Clearly, the practical aspects of editing must be introduced before going through the detailed finishing processes of a project, whether it is cut on film or on a nonlinear editing (NLE) system. And yet in the complex world of multiple workflows, the details of how projects are finished must inform all decision-making as the cutting is done. There are countless stories of producers who proceeded under bad assumptions, winding up spending a lot of money to correct their mistakes down the road. It's a "you can pay me now or you can pay me later" kind of thing. This chapter presents the path that an NLE job would take; it also gives some insight into the parallel traditional sequence in which films are edited. In both cases, if you are interested in creating film prints, you should familiarize yourself with the specifics of workflows in chapter 9 and of cutting the negative in chapter 18. If you are finishing on video, your workflow may or may not be any simpler. Either way, there are many idiosyncrasies in the finishing process that must be understood.

The most important thing to remember aesthetically in cutting is that every frame counts. Whether at 24 or 30 frames per second (fps), in the rush of frames past a gate or a playhead racing through a timeline, the individual frames can start to feel like insubstantial entities. There is a certain truth to this in the global world of an individual viewer, but in the macro world of an editor nothing could be farther from the truth. A few frames here and there can make the difference between a cut that works and adds to the vitality of the piece and a cut that is awkward and derails the forward movement of the scene. When we talk about trying a cut a few frames in one direction or the other, we are talking about the guts of the editor's job. Although we cannot say that there is always a single correct place to cut between any two shots, there are myriad wrong places. The meat of editing, at least in terms of picture, is finding the right place.

NLE System Edit

The general features of a typical NLE edit layout are outlined in chapter 16. Again, most NLE programs have a *bin* for storing captured clips, a *viewer* for looking at and analyzing the shots, a *timeline* for putting together the edited program, and a *preview window* to monitor the edited project. (SEE 17-1) Although NLE software almost universally calls the individual pieces of media *clips*, they are referred to here as *shots* so as not to become too schizophrenic in the back-and-forth between NLE and film editing.

17-1

Most NLEs have similar four-window architectures.

17-2

The playhead indicates the exact position within the clip or the timeline.

NLE systems are designed to be used by editors with different working styles. They employ multiple paths to execute the same functions—for editors whose work is keyboard-based, for individuals who work primarily with the mouse, or for those who prefer to work from menus. The latter two groups, particularly the last one, are in for a long slog, not to mention a brush with carpal tunnel syndrome. Dexterity with the keyboard will save a lot of time and effort, not to mention avoiding the physical demands of repetitive movements. Many of the editing operations go by different names and come in various forms in the many competing software packages, but the general approach is almost always similar.

A number of typical functions found in NLE system windows need to be considered. The **playhead** is generally a scrolling vertical line that moves horizontally through the timeline, indicating where you are in the clip or the overall program. **(SEE 17-2)** There is a playhead in the viewer as well as one in the timeline, the latter of which is usually tied to another one in the preview window. To move a shot, you generally position the playhead where you want the shot to go in the timeline, and then drop in the shot. Clearly, the idea is to have the shot in the timeline trimmed to the desired length. This trimming can occur in either the viewer or the timeline or,

of course, some mixture of both. Many editors use the viewer to "rough" things in and then fine-tune them in the timeline.

All of the pertinent windows (viewer, timeline, and preview window) have shuttle controls to *scrub* through the picture at whatever rate desired. You can also click on the playhead and drag it back and forth. In many NLE systems, the keyboard arrow keys can be used for single-frame functions and to move among edits, the latter being a useful function that is often found in other places as well.

There will generally be a folder and/or menu choices for dissolves, fades, and a host of other effects **(SEE 17-50)**. There should also be options for marking frames for future reference and other applications. The toolbar in the lower right of the screen in Final Cut Pro (FCP)—and its counterparts in other NLE programs—also has many useful trimming and manipulation features. **(SEE 17-3)** The time code of each individual shot is displayed in the viewer. Time code will also be created for the program, usually starting at 01:00:00:00 (1 hour) as the beginning of the timeline. Program time code generally shows up in the preview window among other places.

Although analog **cuts-only video** systems, so named because you could do only straight cuts and no effects, are deservedly obsolete, many of their general features have been assimilated into NLE systems. *Assemble editing* was the bane of the old analog method, but NLE has a much more humane approach for the harried editor. With analog, the editor was forced to start at the beginning of a program and build the show shot by shot. There was no way to go back to trim or otherwise refine earlier edits unless playing time around the edit remained the same.

In NLE, the editor still generally assembles the project from the beginning but with complete freedom to fine-tune. If the NLE editor uses the assemble-edit function in the middle of a program, the added shot simply pushes back or brings forward the material already in the timeline, outcomes that were not possible in cuts-only analog editing. *Insert editing* is more for adjusting something that has already been edited in the timeline. The new shot overwrites the shot currently in the timeline, eliminating it rather than pushing everything back. All NLE programs have functions similar to assemble and insert, although they frequently use different names. FCP is the most confusing; the insert function is called *overwrite*, and the assemble function, just to muddle matters further and probably to stay away from copyright infringement, is called *insert*.

As stated, NLE software systems often have different options to execute the same editorial procedures. FCP is no different, with a number of ways to bring things into the timeline. One way is to click on the chosen picture in the viewer and drag it to a menu embedded in the *canvas* (FCP's preview window) that gives options for whatever editing function you want. **(SEE 17-4)** There are also buttons to click at the bottom of the canvas that will execute the desired function. Further redundancies include keyboard shortcuts, and you can simply drag the shot from the bin or the viewer straight into the timeline.

All viewers have methods for marking in- and out-points of the clips while they are being analyzed. **(SEE 17-5)** There are buttons on the window, keyboard commands, functions in the menus, or all three. You scrub through the shot and determine where you want to enter and exit it. You click Mark In for entrance and Mark Out for exit. In initial stages, marking general in- and out-points for both sound and picture is fine, but eventually you will want to be more discriminating in taking different amounts of audio and picture. This allows you to overlap dialogue on other characters' shots, to finesse ambience differences between shots, and to do a host of other things. (Rationales for these choices are covered in later sections.) To accomplish this in FCP, you use the Mark Split menu function. **(SEE 17-6)**

The Mark Split submenu allows you to mark separately both video and audio in- and out-points. Editors may handle this in different ways, but for complex projects this is the norm (although the truly complex sound work may occur later in the editorial process). Again, you can set the parameters of the clip in the viewer,

17-3

The toolbar contains a number of useful items.

17-4

There are a number of ways to perform assemble and insert edits in NLE systems.

17-5

The in- and out-point markers are beside each other in both the viewer and the canvas.

17-6

The Mark Split menu function allows you to set in- and out-points for audio and video independently.

17-7

The Razor Blade tool.

but you frequently find yourself fine-tuning in the timeline. The Razor Blade on the toolbar is critical for doing this in FCP, and you find similar counterparts in the other programs. **(SEE 17-7)** The toolbar also has tools for specific types of edits—Ripple, Roll, Slip, Slide, and so on. **(SEE 17-8)**

Linking is a common function. When audio and picture are recorded together with a video camera, they are generally imported or captured together and are thus "linked" when brought into the timeline. With film, picture and location

sound are recorded separately, so they must be matched up (*synced*) and the clips linked so that they do not drift apart during editing. Doing video and audio separately is also common. Linking is usually found on a menu and/or employed with a keyboard command. While you are editing, you frequently need to address separately the sound and the image of linked clips. You can either unlink the clips and cut them separately, usually with the Razor Blade tool, or in FCP you can use tools in conjunction with the Option key, that particular keyboard combination allowing independent cutting of linked audio and video. Linking and keeping tracks in sync take some management skills in complex projects.

17-8

The Ripple and Roll tools are above the Slip and Slide tools.

Film Edit

As stated earlier, on those rare occasions when a project is being edited on film, flatbed editing tables are the norm. Although the video revolution has forced many manufacturers of film equipment out of the market, there are still a number of flatbeds in use, specifically KEM, Steenbeck, and Moviola, the last of which is no longer manufactured. The *six-plate*—so named because it has two plates for each of the three transports, one plate for feed and one for take-up—is the table commonly available to students and independents (see figure 16-8). The more-versatile eight-plates are preferred because picture and sound are interchangeable on the fourth transport, giving the option of either picture searching or running a third mixtrack. Two-plates and four-plates can also still be found, both having been used extensively in television back when news was shot on film. They receive limited use now. Several tables have interchangeable transports so that the table can be switched between 17mm and 35mm. KEM has an adaptation to its tables that allows them to be used to transfer picture to video. This can be done in conjunction with mag track playback.

The crucial concept to understand when cutting film and corresponding sound tracks is that all relationships between sound and picture are controlled by the frames. Once the tracks are threaded and locked together on the flatbed editing table, the picture frame has a corresponding sound frame on every mixtrack. Conversely, each frame on a sound head is theoretically in sync with the one that is in the picture gate. The relationship of each frame can be easily changed, but the goal is to create, and eventually finalize, the relationships you desire.

Control Panel

The transport knobs and the lock buttons on the control panel control the movement of the film and which tracks are interlocked to which other tracks. **(SEE 17-9)** Manufacturers employ a number of approaches to how a control panel works, but the general theory is consistent from one table to the next.

Transport controls Each twist knob, called a **potentiometer** (*pot*), controls an individual transport, allowing you to run sound and picture independently. These hand controls can vary speed from creeping frame by frame to moving at more than 100 fps; the maximum fast-forward speeds vary with manufacturer. The transports can be run forward or in reverse.

Sound-1 and sound-2 locks The lock buttons do what their names suggest. By depressing the sound-1 lock, the first sound track is locked to the picture. The sound-2 lock does the same for the second sound transport. When the lock buttons are depressed, all rolls are fed at precisely the same rate across the sound heads and the picture gate, providing sync. The sound tracks are said to be *slaved* to the picture pot.

Picture lock and soundspeed Depressing the picture lock locks the picture pot to the soundspeed buttons at the left of the control panel. With this button, the picture and any sound tracks locked to it are run at *soundspeed* (24 fps). Almost all cutting is done to the left of the transports. The terms *head* and *tail* are both used frequently in these discussions. The **head** is the beginning of a shot or roll; the **tail** is the end of a shot or roll. As a film is set up on the bench or flatbed, the footage (the feed reel) is placed on a plate on the left side, with take-up occurring on the right. As the film travels, heads are on the right and tails are on the left.

Film: Preparing to Edit Sync Sound

Although many film departments justifiably have students start editing to sound effects and music tracks, the logical starting place for understanding the relationship between sound and image is working with *production sound*—the sync tracks. A number of things need to be done at the beginning of a film edit, but two processes are central: syncing up and creating the first assembly. *Syncing up* refers to matching the production sound, which has been recorded separately, with the image. Creating the *first assembly* involves choosing the desired takes and putting them in the order called for in the script.

Syncing Up

As suggested, although films are rarely cut on flatbeds anymore, **syncing up** is often still a part of the workflow on many feature films (see "Why Create a Workprint?" in chapter 9). Professionally, syncing sound and picture is done on the editing bench. It can be done on a flatbed, but that is not recommended. It may look easier, but the process is very exacting and mistakes can be made because the relationship of frames is more fluid on the table. The description of the process herein shows how syncing up is done on a table because it is easier to visualize. To do it on a bench, the same things must occur. Syncing on the bench requires that picture and sound logs be completed scrupulously and that the slate be clearly filmed on-location. Any discrepancies will cause confusion, particularly for novices. Whether on bench or

flatbed, the logs themselves are indispensable for all cutting, and most questions should be easily answered by consulting them.

The process starts with the production crew's work from the previous day. The film is picked up from the lab, and the mag stock transfers of the production sound, called **sync rolls**, are picked up from the transfer studio. Because the sound and the image are recorded separately, there are always different amounts of each. The apprentice editor must manually match them up. The hit of the slate is the reference point used to match the visual and audio rolls.

There are two basic procedures for synching a roll of sound to a roll of picture. The first sets up the rolls and puts the first shot in sync. Once the first shot is done, you employ the second procedure for every subsequent sync shot throughout the roll. Here we give a commonsense approach; procedures in a professional editing room will be slightly different.[1]

The first procedure is straightforward and logical: Thread the workprint into the picture transport and the sync-sound roll into one of the sound transports. With the transports *not* locked together, run the picture until the slate is hit. With some practice you will be able to control the transport to move the picture frame by frame and stop on the exact frame where the slate hits. This frame is easy to discern. The shot will start with the 2nd AC, or clapper/loader, holding the slate bar up. You will be able to see the frame where the bar starts to come down and then the exact frame where it hits. The diagonal white lines of the bar and of the board itself are designed so that you will be able to find the exact point where the two meet. **(SEE 17-10)**

With this frame resting in the picture gate, run the sound up to the hit of the slate. Play the sync track at roughly normal speed until you find the sound of the slate. It will be easy to find because it is accompanied by the starting instructions and the verbal identification of scene and take by the clapper/loader. Once you locate the slate, find the exact first frame of its sound.

Although the sound is not visible, it can be graphically represented. **(SEE 17-11)** You can determine this first frame, called the **attack**, by moving the stock slowly across the head. The attack will be loud and raspy, as distinct from the silent frames before it. For future reference, use a permanent marker to indicate the exact frame where the hit of the slate starts. Lock the sound transport to the picture, and you are set to go. At this point, the first shot, and only the first shot, is in sync. Once the picture and the sound are set up, the second procedure is used to sync each subsequent take.

1. The responsibilities of and the procedures used by the assistant and apprentice editors are detailed in Norman Hollyn's *The Film Editing Room Handbook* (Beverly Hills, CA: Lone Eagle Publishing, 1990).

17-10

The hit of the slate is the reference point used to match the visual and the audio.

© Photo courtesy of Bruce Mamer.

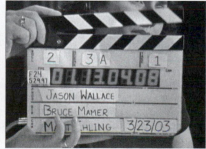
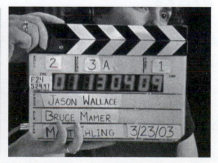

17-11

You can determine the first frame of sound—the attack—by moving the stock very slowly across the head.

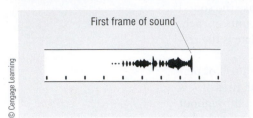

First frame of sound

It is imperative that you find the exact first frame where the slate hits on both the sound and the picture. If this is handled carelessly, the shots will not be in sync. Once the slates are removed in the actual editing, the mistake will not be discernible and the shot will be wrong until the very end. If you are lucky enough to catch the problem at the mix, it can possibly be corrected, but it takes time and can be inexact. If you do not catch it at the mix, it will be on-screen in your final print. A mistake of a single frame may be difficult to see on a table, but when the film is magnified 300,000 times in a theater, it will be noticed by many. Mistakes of more than one frame will be visible to all.

Now that the first shot is in sync, one more thing must be done before rolling on to the next shot. With the transports still locked, roll back several feet toward the head and mark a picture frame and its corresponding frame on the sound roll. Roll these marks out and put a hole punch on each mark. This will be used as a reference point to load the rolls. Their positioning is somewhat arbitrary because these punches will soon be replaced with the familiar countdown leader. **(SEE 17-12)**

Once you have completed this setup, roll on to the second shot. Nothing has to be done to the tail end of the first shot. The beginning of each new shot is always easy to identify because of the *flash frames*, the overexposed frames at the beginning of every shot. With the second shot, you will start the procedure that will remain consistent for all subsequent takes. It is broken down into the following simple steps. This will eventually be complicated by a number of issues that are important when working as an assistant or apprentice in a professional setting, but those complications are easily surmountable once you understand the basic theory.

These steps outline the second phase of syncing up and apply to all subsequent sync shots on the roll:

1. Find the hit of the visual slate and mark the corresponding frame on the audio straight across from it.

2. Find the actual audio slate and mark it.

3. Roll the film out to the left of the transports, cut from the first mark to the second mark, and splice the remaining pieces together.

Find the hit of the visual slate The hit of the visual slate is found in the manner previously described. Once you have the exact frame in the picture gate, mark the frame straight across from it on the audio track. The positioning of this marked audio frame on the mag stock will be random, but it should occur in the start-up sequence ("Speed," "Camera," "Rolling," "Mark it").

17-12

Step 1: Find the hit of the visual slate and mark the audio frame straight across from it.

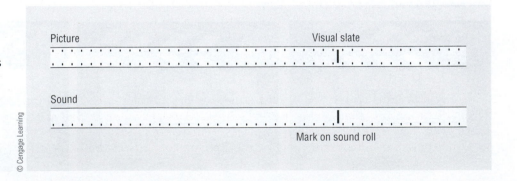

Picture Visual slate

Sound

Mark on sound roll

© Cengage Learning

17-13

Step 2: Find the actual audio slate and mark it.

A. Roll the film out of the transports, cut from the first mark to the second mark. . .

17-14

Step 3

© Cengage Learning

B. . . .and splice the remaining pieces together.

Find and mark the audio slate With picture and sound still locked, roll to the audio slate. There is almost always more sound than image for each individual take because the sound recorder is started before the camera in the sequence to initiate takes, so you will roll forward to find the audio slate. Find it in the manner described earlier and mark the exact frame. **(SEE 17-13)** You now have two marks on the audio: one on the frame that corresponds to the visual slate and the other on the actual audio slate.

Roll out, cut, and splice the pieces Roll the marks out to the left of the transports. Cut from the right of the first mark to the right of the second mark. **(SEE 17-14A)** Then splice the remaining pieces together. **(SEE 17-14B)** "Close" counts only in horseshoes and grenades. You have to find the *exact* first frame of the slate on both sound and image.

17-15

Code numbers on both sound and picture reels.

© Photo courtesy of Bruce Mamer.

With the exception of *MOS* shots, the picture should be kept intact, and all cuts should be on the sound. Even the botched takes should be synced and left on the roll. Sound effects that the sound mixer recorded on-location should be removed from the rolls and rolled onto separate cores. Film crews are rolling sound on almost everything now, but if there are any MOS shots, they should be dealt with in one of two ways. They should be removed, or **slug** or *sound fill*—leader or junk picture that is used to fill in the empty spots on sound rolls—should be cut onto the sound track against them. If the workprint is being transferred to video, the latter approach is generally taken.

All pieces should be clearly labeled once they are removed from their original rolls. On the film tape used to close the rolls, write the scene and take numbers. To cross-reference with the pieces of film themselves, the assistant will also make lists with brief descriptions of both effects and MOS shots. Keeping this material organized is important to efficient editing and is one of the primary responsibilities of the assistant editor.

Coding and Edge Numbering

An editorial staff will generally employ **coding** when a workprint is generated, a process wherein an entirely new series of code numbers is inked in on picture and mag stock. With **edge numbering**, the low-tech equivalent, one goes through the synced-up film and physically writes with a permanent marker all of the edge numbers from the picture on the corresponding frames of the sound—being sure to write them on the base side of the mag stock. The code approach is vastly preferable and relatively affordable and is the professional norm. Code numbers are usually composed of four letters followed by four numbers. **(SEE 17-15)**

Whichever approach you choose, the initial purpose is to provide a reference for sync. Once actual editing has begun, you will obviously be cutting out the slates. Without the slate as a reference, the numbers allow you to reestablish sync when you make the unavoidable errors in removing sound or picture. The more experienced you become, the less this will be an issue. Mistakes should diminish, although it is still crucial to have a reference if any questions arise. Little is more frustrating than looking at a shot and not knowing if it is in sync, and nothing is as time-consuming as going in and shifting frames to see if it is correct.

The more critical use of code numbers is in organizing the workprint. The assistant editor uses code numbers to log, identify, and store virtually all of the footage. They are the standard way of referencing everything in the editing room. In the process of trimming frames, storing them, and trying to find them later, things can get very confused—a situation that is unacceptable in a professional setting, though a potential and hopefully avoidable reality for inexperienced editors. Due to their flexibility and ubiquity, code numbers are also used as the reference points in one of the ways the feature world is currently approaching the matchback from digital edits to film (see chapter 18).

First Assembly

Creating the **first assembly**, or *string-out*, involves arranging the film in rough order: taking out the desired shots, organizing them, and then putting them back together in order. Given that few films are handled this way, our coverage will be brief.

The first step is to evaluate the synced film and pick your **selects**—the version or take—of each shot that you consider the best for your purpose. In NLE, this can be done more as you go, although there is some rationale for an old-fashioned string-out. There are several deciding factors in evaluation, most notably performance, continuity with other shots, overall compositional integrity, and sound quality. In conventional narrative films, performance tends to be the overriding factor, although shots with poor formal qualities, such as sloppy camera movement, are generally eliminated out of hand. You do not remove these selects during this evaluative process, but rather circle the chosen takes in the logs. Pulling them out is a separate step.

The first assembly should be done on a bench rather than on the flatbed. On a synchronizer, the relationship between frames is again exceptionally clear, and, as with every other stage, precision is a must. To cut out the identified select, roll to the flash frame at the head of the shot. Mark the flash frame and the corresponding frame on the mag stock. Roll the film out to the right of the synchronizer and cut at the marks (the first assembly is one of the few stages in which you cut on the right). Roll to the tail of the shot, hanging the head of it in a **trim bin**. Mark the first flash frame of the next shot and the corresponding frame on the sound. Roll the marks out to the right and cut. You now have two pieces—one sound and one picture—representing the entire take, and they are precisely the same length, frame for frame. With film tape, label the scene by its number. Keeping the material organized when it is hanging in the trim bin is essential.

In this manner, pull each desired shot out of the sync rolls. When you have finished pulling the selects, they should be numbered and hanging in the trim bin. It is now a matter of putting them back together, creating two new rolls—one picture and one sound—made up entirely of selects. Here you are back to working to the left of the synchronizer, feeding the takes through it onto the new rolls. If the scenes have been properly numbered and organized on the set, this should be a simple process of following the numbers, that is, taking the shots hung in the trim bin and cutting them onto rolls sequentially. As a precaution, have a copy of the script handy to make sure that the scenes are correct. When you are done, you will have the film in order—slates and all—from beginning to end.

Countdown Leaders

Before cutting the film back together, standardized leaders should be set up with reference points, called *head start marks*, for cueing up the separate rolls. This is done with **SMPTE Universal leader** (*SMPTE* stands for Society of Motion Picture and Television Engineers), which is also referred to as *Academy leader* or *countdown leader*. The leader is made up of the sequence of descending numbers familiar to most readers. **(SEE 17-16)**

The sequence starts with 8 and descends to 2. Each number lasts for 24 frames (1 second), with the exception of the 2, which is a single frame. This frame with the 2, the **Academy 2**, is used to sync up all of the other elements in the printing process. The frame right before the actual countdown sequence—the one before the first frame of the 8—should also be noted. Labeled "Picture Start," it is the point from which all shots are identified for the technicians engaged in creating a final print. The footage counter is zeroed on the synchronizer, and "Picture Start" is set up on the zero frame of the gang. If a shot needs special attention, it is identified in footage and frames from this point (see chapter 18 for further discussion). Countdown leader can usually be purchased from labs and film-supply retailers and online.

17-16

The standardized countdown leader is set up at the beginning of the edited workprint.

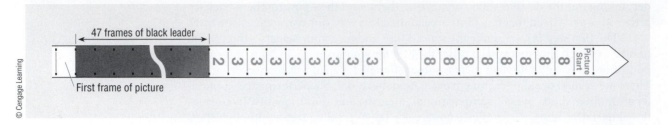

17-17

Cut in the first frame of picture where indicated.

Set up a countdown leader in one of the gangs of the synchronizer, with 10 or so feet of white leader in front of it. There will be an arrow symbol with "splice here" printed underneath it 47 frames after the Academy 2. **(SEE 17-17)** Cut your first shot in here, leaving its corresponding piece of sound in the trim bin.

For a sync-sound mixtrack, set up 10 to 15 feet of white leader in the gang across from the countdown leader. On the white leader, mark the frame corresponding to the first picture frame and cut in the piece of mag stock for the first shot. Now the first shot—picture and sound—is attached to these leaders in sync. To cue up the separate rolls, the frame corresponding to the Academy 2 frame must be indicated on the white leader of the sound roll. Mark the frame corresponding to the Academy 2 and replace it with a **sync beep**, or *sync pop*—a single frame of mag stock cut out of a longer piece with a constant tone recorded on it. **(SEE 17-18)** When it runs across the sound head at 24 fps, it provides the familiar beep at the head of every film reel.

NLE: Preparing to Edit Sync Sound

If your project was shot on film, there are a number of ways to approach syncing up with an NLE system. It can be done manually in virtually the same way as a film sync is done; or, if time code was used on the audio in shooting on-location, the sound can be electronically locked in the datacine process.

Syncing Up

If your project originated on video, you often do not have to sync up because the sound and the picture are recorded, and thus imported or captured, together in the clip. As suggested, the double-system approach—a separate recorder and camera

17-18

The sync beep is a single frame of mag stock that provides the tone at the head of the film reels.

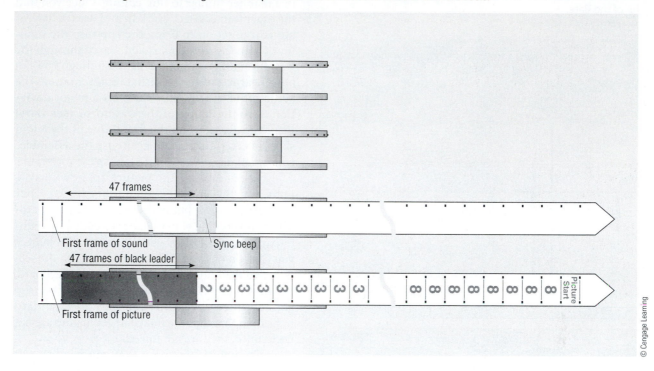

47 frames

First frame of sound
47 frames of black leader
Sync beep

First frame of picture

Picture Start

© Cengage Learning

on a film shoot—is frequently emulated in the high-end video world, so you may eventually find yourself syncing up video as well.

In double-system film, there are two options for syncing up when transferring to video at datacine, both requiring specific shooting methods on-location: jam sync and record run. With the first method, a small black box that provides a time code start point is plugged into the camera in the morning and similarly plugged into the recorder. Both the camera and the recorder are given a time code start point and are then recording the same time code numbers on each medium. After transferring picture on the datacine, the sound time code is chased internally and the slates are lined up. The operator need only stand back and watch. The buzz has been that you can throw away your slate, although most producers have been hesitant to take such a radical step.

With the second method, the sound recorder produces the time code, which is sent to the slate via a radio transmitter. The slate, referred to as a **smart slate**, hears it and sends it to a rolling LED clock on its face. When the slate is hit, the time code numbers stop for a second or so at the instant of the hit, then pick up again the appropriate amount of time later. The telecine operator finds the stopped number on the slate and types it into the computer; the computer finds the corresponding time code number on the sound and records the two together. In both cases, sound and picture are transferred onto the same video and eventually imported that way; thus, they are locked together throughout the editing process. Sound and picture are represented as one clip in the bin but are still displayed separately in their respective timelines, though they are internally linked.

For those of us who have to do manual syncing, the picture, whether originating on double-system film or video, and the sound are captured and/or imported separately. As with so many things in NLE, there are numerous ways to go about this, even within an individual software program.

In FCP one way is to scrub on the picture until you find the exact frame where the slate hits, in a manner similar to film editing. Once you find the exact frame, select Mark In and use the assemble-edit function to bring the clip into the timeline. Open the sound take, and search through the waveform for the hit of the slate. Although you can both hear it and see its visual representation, the audio hit of the slate should show a major deviation from the center of the waveform. **(SEE 17-19)** Place the playhead on the first frame of the audio slate, select Mark In, and again use the assemble-edit function.

The audio and the picture are now in sync in the timeline, but they still must be linked. They are sitting in sync, but nothing is keeping them together. If you slide either picture or audio, its counterpart would not move with it. To link clips in FCP, you click on one track, Command-click on the second, and then press Command-L on the keyboard. When you press Command-L, the label of the clip is underlined. The underlines are the standard indication that clips are linked. If clip names are not underlined, they are not linked.

Though the material that you need to edit is present, it can be irritating that the synced shot starts at the hit of the slate. FCP and other software have a function that allows you to extend the material ahead or behind a cut if it exists. When you place the pointer at the head of the shot, the drag symbol appears. Simply drag the head of the synced clip to its full length. It is recommended that the newly synced shot be dragged back into the bin and renamed—say, from 10A-1 to 10A-1S (using the S for sync)—so that it can be stored and retrieved for later use.

Datacine, or electronic, syncing appears to be a much more efficient method, but independents and professionals alike have found that they can sync up inexpensively and in a short period of time rather than pay for it at an expensive telecine session.

Assembling the Project

The notions of creating a first assembly are significantly different in video. In the old analog video-editing arrangement, putting all of the shots on one tape and then trimming them down is antithetical to the way analog information is handled on tape. Instead, cutting is designed to occur between a playback video deck with a tape of the source material and a record deck where you build the edited program from the beginning. When the next shot is desired, it is found on the source tape and, after the in- and out-points are determined, transferred to the edited master. On the old analog edit control units, you could preview the edit as many times and in as many ways as desired, but once you committed, the edit was done.

Due to the similarity in design between analog and digital editing, the same approach is generally used in NLE, except the status of the edit is far more fluid. The viewer is used to find the in-point of the next shot, which is then brought into the timeline at the point desired. You can generally set an out-point somewhere past where you know you are no longer going to use the shot. It will be trimmed to the appropriate length when you bring in the next clip. The major difference, of course, between analog and digital is that once you have a clip in the timeline, you can trim it and resize it to your heart's content. You can cut it one way on a Friday, and if you

decide you do not like the cut five Fridays down the road, you can always change it. This is the great glory of NLE; but if indecisiveness is part of your nature, it can also be your great downfall. You can keep cutting forever. You can do that with film, but just the bother of finding the rolls or trims and recutting mitigates against too much indecision.

One could, if desired, do a standard film-style first assembly in the timeline of an NLE. Indeed, there are many things to recommend that approach. In assembling and watching all of the shots in order, you can create a game plan for how a scene or sequence is going to be edited. If you are looking at all of the available material, more options may present themselves. You would then trim the ends and the beginnings of the clips as desired, usually with the Razor Blade tool, and the scene may take shape as you work. It is, however, one more step. Most editors presumably take the assemble-from-beginning approach, given that there are other ways to familiarize yourself with the footage. Some editing staffs may lay it all out in order, but the process of cutting is usually a matter of collecting all of the clips for a scene in the bin and then drawing them out as needed.

Dialogue Cutting

The statement that "every cut is an adventure" could not be truer than in dialogue cutting. Getting each individual transition to work is challenging enough, but the shape of the entire scene must be considered as well. It is possible to get the cuts to work well on an individual basis and still find that the scene is slow or awkward. As stated earlier, there are many wrong places to make cuts. The goal in conventional dialogue cutting is to find the cut point where the natural rhythms of human speech are maintained, the movement matches appropriately, the pacing in relationship to other cuts is right, and, of course, the dramatic emphasis is considered.

Straightforward shot/reverse shot sequences are used here as examples. Dialogue cutting obviously becomes much more complex than the simple examples used here, but the principles presented are the starting point for even the most advanced cutting. In a sense, these simple cuts act as a window into the more complex cutting that can be learned only by doing.

The first type of cut discussed is the *straight cut*, a cut that tends to be abrupt, and in this presentation is so arbitrary that it eventually will require a more nuanced understanding. Although the straight cut is a good starting point, the fundamental approach to dialogue cutting is the *overlapping dialogue cut*. This simply means that the picture cuts come in the middle of lines of dialogue. In many cases, we see a character responding before the speaker has finished speaking or something similar. The general viewer is rarely aware that someone has made a conscious choice between different shots and transition points and, particularly, that these choices affect our response and interpretation of what we are seeing.

Straight Cuts

A **straight cut** is one in which a character finishes a line of dialogue, and you cut to the next shot with the second character delivering his or her line. It is simple to execute, although there can be some complications with the sound. Again, you eventually will find that most cuts are more complicated than the simple, arbitrary straight cut demonstrated here.

An example is the exchange of two lines of dialogue suggested in the section on storyboarding in chapter 4. In shot #1 John asks: "Do you want to go to the movies?" In the second shot, Andrea responds: "I don't know. What times are the shows?" The clips consist of the entire shot, including all of the verbal and visual directions: the director's "Cut" on the outgoing shot as well as the start-up calls, the mark of the slate, and the "Action" on the incoming shot.

Let's start by assuming that we already have the shot of John in the timeline. Barring discussions of where we are going to start John's shot, we can open it in the viewer and simply click the system's assemble-edit function, Overwrite in FCP. It will appear in the timeline, and we can address the transition between it and Andrea's shot.

The first step in making a straight cut is to determine the length of the pause desired between the two lines of dialogue; that is, how much time you want to elapse between the end of the first line and the beginning of the second. Generally, the goal is to re-create the natural cadences and rhythms of human speech. Experienced editors cut to the inherent pace of the scene. For our purposes, however, it is helpful to think of a pause as a specific number of frames. When you cut frames in the timeline, you are dealing with increments of 1/30 of a second. If there are 30 frames between two lines of dialogue, the pause will be 1 second long. A 20-frame pause will be 2/3 second, and so on.

If you want the pause to be 1 second long, you need to plan 30 frames between the end of the word "movies" and the beginning of the word "I." Again representing a rather arbitrary approach, this example nevertheless illustrates the process. To start, find the **decay**—the trailing off of the sound—of the word "movies" in John's shot. Once you have found that frame, count 15 frames toward the tail and leave the playhead there. **(SEE 17-20)** In most NLEs, it is unnecessary to mark an in-point in the timeline because the next clip will come in where you leave the playhead.

Next, open Andrea's clip in the viewer. Find the attack of the word "I," count 15 frames toward the head—in front of Andrea's line—and now click the Mark In button in the viewer. **(SEE 17-21A)** Perform an assemble edit, and Andrea's clip will drop into the timeline behind John's. **(SEE 17-21B)** The two 15-frame extensions, one at the tail of John's line and the other at the head of Andrea's line, add up to the 1-second pause desired. Taking 15 frames from one side and 15 from the other is, of course, a completely random choice used as an example here. For a 1-second pause, you just need the total to add up to 30 frames. That we have paid little attention to the picture's content suggests how arbitrary an example this is.

Pauses are shorter than you might at first expect. Screen time is much more intense and concentrated than real time. If 1 second feels long, 5 seconds can feel like an eternity. Normal conversations generally have pauses of a little less than 1 second. If the pauses are too short, the lines will seem stacked on top of each

17-20

Park the playhead 15 frames after John's line.

B. The clip will drop into place behind
John's line.

other and unnatural; if the pauses are too long, the dialogue will sound stilted or
mannered. Very quickly you will internalize this and not think about specific times
of pauses. You will just cut it until it sounds right. The performers themselves of-
ten provide the pauses in situations where the camera covers lengthy exchanges of
dialogue. For now it is helpful to think out the pauses in specific numbers of frames.

To review, bring the first clip into the timeline and park the playhead where
you want to exit it. Open the second clip in the bin, consider the pause, determine
the in-point, and edit it in behind the first shot. Clearly, this leaves out notions
of where the first shot starts and the second shot ends, but the theory is straight-
forward. The notion of the nondestructive edit further helps you size the shots in
the timeline.

As stated, this type of cutting tends to feel abrupt and/or awkward. It can
be useful for interruptions and for dialogue that needs a punch; but, if all cuts are
straight cuts, a scene can resemble a Ping-Pong match, with the perspective abruptly
flipping back and forth. Oddly enough, straight cuts work better on television than
they do in films. Given the financial limitations and the brutal deadlines of the
medium, their greater ease in execution makes some sense. Editors who can make a

cut quickly are valued in television. This does not mean that the shows could not be cut better and that overlaps would not be appropriate, but the straight cuts do not look as abrupt on TV as they do on the big screen.

Overlapping Cuts

The overlapping cut is the bread and butter of narrative dialogue cutting, both conventional and otherwise. An **overlapping dialogue cut** is one in which the transition from one shot to the next occurs during a line of dialogue. In simple shot/reverse shot sequences, a common example is to cut from the speaker to the respondent before the speaker has finished talking.

One of the major reasons why film editors never really accepted analog cuts-only video editing is that the systems made overlapping cutting very difficult. NLE systems make any kind of cut possible, and overlapping cuts are relatively straight-forward. There are, as always, a number of ways to execute an overlapping cut. The simplest way may be to cut the shots as described in the previous section and then, with the aid of the nondestructive function, just pull the visual over the other char-acter's dialogue to the point desired. Many NLE systems will not allow you to just pull something over an existing clip, but there are tools that will do it or you can drag back or trim the previous clip. Again, using the Option key is a handy way of working on the audio and the video of linked clips separately. If you press the Option key, you can simply drag Andrea's clip forward. With the help of the wave-forms, you can drag it to right where John starts to say the word "movies" or wher-ever you want it. **(SEE 17-22)**

This approach is a little random in terms of analyzing the exact point where you might want to start Andrea's clip. You can drag it and let go, then play it and see if you like it. If you do not like it, you can continue making adjustments. Most NLEs, however, have some kind of marking system so that you can analyze the end of a clip, leave a marker on the desired frame, and then drag out the incoming clip to that marker. You still have to look at the cut, and then you can adjust it if you do not like your choice. The marking function can be accessed in a number of ways, but there is a button in the viewer and on the canvas that will leave the mark symbol where the playhead is parked. **(SEE 17-23)**

Final Cut Pro, like most NLEs, offers a variety of ways to execute the forego-ing cut. The Roll tool on the toolbar allows you to do the same thing. Again, you

17-22

Andrea's clip can be dragged into John's clip to create an overlap.

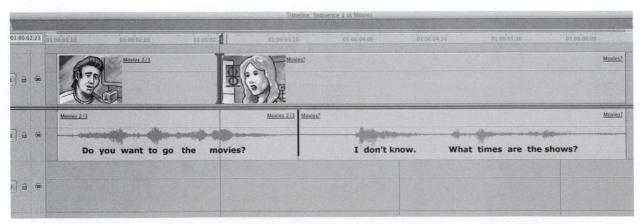

would want to use this tool in conjunction with the Option key. Here you do not have to eliminate the previous clip; you simply pull the clip back. There is also the Mark Split function on the Mark menu, where you can set the in- and out-points separately for the audio and the video. In addition, you could use the Razor Blade tool to trim the shots to the desired lengths. FCP also has a Trim Edit window that you can access by double-clicking on the cut you want to adjust. **(SEE 17-24)** This is a good way to try out one or two frame adjustments. With many NLE systems, another option is to move the clip you want to change to a higher video track. Then it can be resized without changing the other clips. Later in this chapter, we address alternating consecutive sync clips from track 1 to track 2, but for now any of these approaches works well.

As mentioned earlier, the overlapping dialogue cut is the mainstay of conventional film editing, particularly cutting that attempts the invisible style associated with realism and the Hollywood commercial film. Fluidity is the key. The cuts are masked by being put in the middle of the dialogue, where they are least likely to be noticed. The technique also fits into the great tradition of cutting for dramatic emphasis, with focusing on a character's response frequently being more important than showing the speaker.

Sync Film Cutting

In film, synchronization is based on the relationship of frames. The following is a fundamental principle of the mechanics of film editing.

■ **RULE** Whenever you make a cut in one roll—sound or picture—there must be an equal and reciprocal cut in all other rolls.

When cutting sync footage, if 20 frames are cut out of the picture, the sound roll is now that same 20 frames out of sync. To get back into sync, you have to cut out 20 frames of sound that correspond roughly, in some cases precisely, with the picture frames. This undoubtedly brings up a host of questions, but keep the idea of cutting equal amounts of picture and sound in mind.

The notion of a pause is pertinent here as well. Remember that the frame count of film is 24 fps rather than the 30 fps of NTSC video. You will get used to multiples of 24 rather than 30. If you are working with 24p video (the *p* stands for progressive), then you are already working with the 24-frame second.

17-23

Markers can be placed in the viewer, in the timeline, or on the canvas.

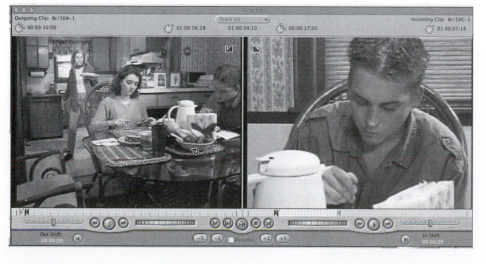

17-24

The Trim Edit window can be used to make a variety of adjustments.

17-25

Measuring sound and image pieces side by side is the standard approach to controlling and maintaining sync.
© Photo courtesy of Bruce Mamer.

Comparing sound and image pieces by matching
the number of sprocket holes

One other peculiarity of film editing merits mention. As stated, you must pull an equal number of frames of picture and sound to maintain sync. Do not hesitate to check the pieces by measuring them against each other as you pull them. Stretch them out side by side and match up the sprocket holes for the length of the shot. **(SEE 17-25)** Sometimes the mag stock might be slightly smaller, requiring constant adjustment to make sure you are going frame by frame. If the two pieces are not the same length, you have made a mistake that must be corrected or else subsequent shots will be out of sync. Although this method may at first seem odd and cumbersome, measuring sound and image against each other is the central approach to controlling and maintaining sync in film editing.

Straight cuts are approached in the same way. For a 1-second pause, you count 12 frames after the speaker finishes and 12 frames before the responder starts his or her line. For an overlap, there are two basic steps. As with NLE, your cutting will eventually become complex and sophisticated enough that these simple steps will appear overly schematic, but they should be helpful for starters. The right-to-left travel requires the backward dialogue in the following figures:

1. Make the audio cut.

2. Make the picture cut, displaced from the sound cut.

Make the audio cut Again, the rhythms and the cadences of human speech are the determining factors in making this first cut. Decide the length of pause you want between the lines and then cut, paying no attention to the picture. This will leave the next shot out of sync, the removed piece of sound representing the exact number of frames the following shot will be out of sync. **(SEE 17-26)** To restore sync, you will next remove an equal number of frames from the picture.

Make the picture cut, displaced from the sound cut Using the removed piece of sound as a guide, make the reciprocal picture cut but displace it from the sound cut you made in step 1. If you were to cut the picture at precisely the same place as the sound cut, the result would simply be a straight cut. A good approach for determining the displacement is to find where you want to exit from the first speaker.

17-26

Step 1: Make the audio cut.

© Cengage Learning

17-27

Step 2.

A. Make the picture cut, displaced from the sound cut...

B. ...resulting in an overlap.

If you decide that you want to exit during the word "movies," you would mark on the picture across from the word. **(SEE 17-27A)** Cut at the mark and stretch the sound against the picture toward the tail, cutting out an equal number of picture frames. The resulting cut will exit speaker A during the word "movies," overlapping speaker B over the word. **(SEE 17-27B)** The opposite approach would be to evaluate the cut in terms of where you want to enter the second person's dialogue.

For both straight and overlapping cuts, always cut the shot long before cutting it short; that is, cut the pause slightly longer than you think will be appropriate. It is much easier to trim the shots than to replace removed frames. Inexperienced editors tend to fiddle too much with cuts, adding frames in and taking them out, leaving both picture and sound frames prone to damage. Single frames are hard to line up on the splicing block, frequently resulting in frames at slightly skewed angles. This can make a picture cut hard to evaluate because it will jump at the gate. It

also increases the possibility of the film's tearing on editing tables and in projectors. The sound is even more of a problem because tight cutting on frames can increase glitches and dropout as the pieced-together area crosses the sound head. Keep in mind that, at least for students and independents, the mag stock you are cutting is the mag stock that you will be taking to the final audio mix. Any imperfections will be difficult to keep out of the sound track.

Cutting Nonsync Sound and Picture

Cutting in effects, music, and narration and smoothing out sync tracks constitutes most of the rest of the editorial staff's work. The sequence on a commercial feature (and on many projects for that matter) is as follows. The editor edits the picture with dialogue until an acceptable cut of the film is produced. Editing on the picture is then declared finished, and **picture lock** is called, denoting that the picture will not be touched again and that all subsequent cuts will be in additional sound. The edited piece is then turned over to specialized postproduction staff, including effects, Foley, music, automated dialogue replacement, and dialogue editors.

Effects, music, voice-overs, and the like are generally imported into NLE from a digital source. In FCP this function is found on the menus at *File> Import> Files*. Audio can be captured in the conventional way as well, if it is recorded to a Digital Videotape or if you have an audio capture card. Once in the bin, audio clips can be trimmed in the viewer, brought into the timeline, and positioned as desired.

Audio clips in FCP are represented by a small speaker symbol. **(SEE 17-28)** When opened in the viewer, an audio clip is represented by its waveform. This waveform can be scrubbed through just as the picture is, in- and out-points can be set, and the standard editing functions can be employed. An effect—say, the ringing of a telephone—will be represented as a standard deviation from the center. **(SEE 17-29)** Generally speaking, you want to include a second or two of ambience before the effect to finesse any ambience issues. You can either trim it early or use the nondestructive-editing function in the timeline.

If we want to position the ringing of the phone just after the end of Andrea's line, we would park the playhead against the line right where we wanted it to begin. **(SEE 17-30)** NLEs have a way to target the audio to a specific track. Here we chose the track just below Andrea's line, although it would probably go on a deeper track in a commercial edit. In FCP there are Destination buttons—A1, A2, A3, and A4—at the head of each track on the left of the timeline. **(SEE 17-31)** If the audio clip you have opened in the viewer consists of only one track, a Source button with a lowercase *a*—a1—will be in the column to the left. Click on the Destination button for the track on which you want to put the effect, and the Source indicator will jump to that track. If the clip has more than one audio track, there will be a Source button for each track. The Destination and Source buttons are to the left of the tracks. Choose the Overwrite function, and the effect will be dropped into place. **(SEE 17-32)** If you want to try slightly different positioning, you can drag the clip one way or the other or use the comma and period keys to shift it frame by frame to the left or right, respectively.

One minor irritation of NLE sound building is that it is somewhat easy to knock nonsync audio out of place as you are working around it or in other parts of the timeline. Effects can be linked to clips, but there are limitations. If you want to make sure that audio clips are not shifting, most NLEs allow you to lock the tracks so that no accidental changes can be made to them. On the left of the timeline, there is a little lock symbol. **(SEE 17-33)** When you click on it, a crosshatch pattern covers the chosen track, and no

further changes can be made. **(SEE 17-34)** Clicking again on the lock symbol unlocks the track. Also to the left of the tracks is a mute button that allows you to mute tracks so that you can listen to individual tracks or specific combinations of tracks. **(SEE 17-35)**

Music and voice-overs are handled in the same way, although they are frequently much longer and you are often fitting picture to them rather than fitting effects to the picture. Once in the timeline, music clips and, to a lesser extent, voice-overs can be thought of as representing a specific amount of time. Music can be scrubbed over and analyzed for specific events and measures and beats. The markers again can be used to indicate important points, and picture can be positioned as desired against the markers. FCP also has Key Frame and Match Frame functions that help positioning. Picture can also be fitted in against voice-overs, which can be trimmed and moved at will.

Any audio can be opened in the bin and scrubbed on for in- and out-points. Once identified, the clip is dragged or otherwise edited into the timeline and dropped into position. Although these types of cuts can be easily executed on any NLE system, it is very common to export the tracks to software specifically created for executing complex sound designs (see "Audio Finishing" later in this chapter).

A & B Rolling Sync Sound

A & B rolling the sync tracks is performed whether doing an NLE or a conventional film edit. It refers to *checkerboarding*, or alternating, the original sync track on separate tracks to facilitate the final mixing process. You create two tracks or rolls for the sync tracks instead of the single strand that has been discussed up to this point. All of the odd-numbered sound takes would be on the first sound track, and the even-numbered takes on the second track, though it does not always work out quite so cleanly and occasionally more tracks are required. **(SEE 17-36)**

The major question of A & B rolling sound tracks is at what stage in the process do you do it. In the professional world, it is done after the picture is locked and as the film is being prepared for the mix. In some instances, some A & B rolling might even be done at the mix. For the novice, there is a clear rationale for doing it at the beginning, particularly if cutting film. The reason the pros do not do it at the beginning is that the sync tracks are turned over to the **dialogue editor**. This member of the editorial crew does the A & B rolling, builds ambience, and does anything else necessary to smooth out the tracks. But you will presumably not have a dialogue editor—that is, *you* are the dialogue editor—and there are some compelling reasons for doing A & B rolling from the beginning particularly if editing film.

There are four important rationales for A & B rolling the sound. The first three must be considered in sound cutting at all levels of production, although digital recording has rendered the first more a theoretical concern. The fourth rationale pertains to film only and is more a consideration for inexperienced editors working on smaller projects. Commercial films generally have sophisticated resources to address these issues. The rationales are as follows:

- To facilitate volume control, equalization, and signal processing in the mix
- To allow interruptions and blending of dialogue
- To create ambience overlaps
- In a film edit, to avoid damaged splices and the problems associated with them

17-36

The A & B–rolled sound alternates from one audio track to the other.

Volume control, equalization, and signal processing Although the practical aspects of this first rationale were a consideration only for the old-fashioned film mix (see "'Conventional' Film Audio Mix" in chapter 18), the theory is still critical to understand. In a mix, each track is assigned to an individual channel on the mixing board. This channel has a fader to control volume as well as limited equalization capability. Each channel can also be assigned to sideboard signal-processing equipment, allowing for further equalization, reverb effects, echo effects, and other audio manipulations.

Thus each and every sound in your film will have the volume set for it in the mix and, if necessary, can be equalized or otherwise processed. In the old days, if the sound for a shot was cut to the sound for the next shot, the person running the mix obviously could not shift volume levels in the split second that the cut crossed the sound head much less create any complex equalization. The slug between the takes allowed the mixer time to anticipate and shift the necessary controls.

In the NLE approach, volume and signal processing is programmed in, eliminating the need for a rerecording mixer/contortionist. The notion that we need room and, particularly, overlap between audio pieces, however, remains. See "Ambience Overlaps" below for a complete explanation.

Interruptions and blending of dialogue It is impossible in the single-strand method to have an actor "step on" another actor's line of dialogue or to create any kind of *blending*, or layering, of dialogue. A & B rolling allows dialogue to be dropped on top of other dialogue. Robert Altman was famous for using this style of layered dialogue cutting. The frontier barroom scene that opens his *McCabe and Mrs. Miller* (Louis Lombardo, editor) has snippets of conversations underlying the foreground action. Although the cutting in this film includes other approaches to sound layering, sync tracks are frequently held and extended into surrounding shots.

Ambience overlaps When executing any dialogue cut, you want to maintain the ambience that follows or precedes the voice, overlapping it between shots if possible. Called *handles*, **ambience overlaps** allow the rerecording mixer or the person laying out the NLE tracks to soften any potential harshness of the cut. There can be substantial differences in the quality of ambience in any two shots, and the sound may jump between the two levels if the shots are cut directly together. If you can overlap the ambiences from the two takes, you can finesse the audio by doing a quick cross-fade of the volume between the two pieces. The room tone that the sound mixer recorded on-location is also quite handy here used either by itself or in conjunction with cross-fading the handles. The room tone is also employed for filling gaps when, despite all efforts to avoid it, enough material was not recorded to cover the pauses.

Damaged splices Obviously, this applies to film only. As stated, editing consists of trying different cuts until you find the one that works perfectly. You may like a cut one day and come back the next and wonder where on earth your mind was when you made that decision. If you decide that a cut is slow, you trim it down. If you then decide that the cut is too short, you add frames back in. Getting a cut right may take many attempts. This cutting and recutting can cause problems in the single-strand method. The cut becomes choppy, with several one- or two-frame cuts pieced together. With the picture, this is not a significant concern because you will be going back to the original.[2] But because this is the actual mag stock that will be used in the mix, too many quick cuts in a row can significantly affect audio quality. With the sound on alternating rolls, all trims and additions of frames made after the initial audio edit are cut in

2. This can actually pose a problem in compromising your ability to evaluate the cuts as well as affecting how projectable the film is. When going to the mix or when working with clients or backers, you want as clean and trouble-free a version as possible.

the slug, avoiding further splices in the mag stock. As suggested, the sync tracks are replaced by the dialogue editor in a commercial feature edit, meaning this is less of a concern. For the independent with limited time and resources in the editing room, it is better to keep the sound "mixable" all the way through the project.

The appropriate separation of sound is an issue for the mixtracks and is essential for an efficient mix, one in which the full potential of the sound can be completely explored (see "Track Configurations" in chapter 18). The sync sound is particularly critical; but if any or all of the mixtracks are a mess when you go to the mix, be prepared to have either an unpleasant mix or your project unceremoniously handed right back to you. A mix that is inappropriately configured is a clear sign to a mixer that the job is going to be one long headache.

So A & B rolling is not so much a matter of *if* as it is of *when*. The process of separating the sound has to be done before you finalize it—it is just a question of whether you do it in the beginning stages of editing or in the last few days before the mix. If at the beginning of a film edit, A & B rolling would be done after the first assembly is completed but before the creative part of editing—the actual cutting—starts.

If you decide to A & B roll an NLE edit, you would do it as you assembled the show. The reasons to separate the tracks as you go with the NLE approach are not nearly so compelling. Any separation of tracks very easily can wait until just before the mix. If you found you needed handles, any audio clip could be put on another track and, if the system had nondestructive editing, could be lengthened to provide some overlap. The *OMF* functions covered later in this chapter actually provide for creation of these all-important handles anyway. Still, A & B rolling gives you a clear idea of any potential problems, and forewarned is forearmed.

A Typical Scene

As suggested, a significant part of the process of editing is building multiple sound tracks that eventually will be mixed down to final version of the sound. Francis Ford Coppola's *Apocalypse Now* (1979) was reputed to have had more than 70 mixtracks. Jean-Luc Godard once made a feature film with only three mixtracks. When queried on why so few, he replied that it was because he had only three hands.

Although each individual film will have its own requirements, the tracks for a typical small project might look something like this:

Audio track 1:	Dialogue
Audio track 2:	Dialogue
Audio track 3:	Extra dialogue and narration
Audio track 4:	Music
Audio track 5:	Additional music (if necessary)
Audio tracks 6–10:	Sound effects
Audio track 11:	Ambience
Audio track 12:	Additional ambience (if necessary)

A scene from an independent feature that I worked on several years ago can serve as a good example of the way tracks are built. In indies, the person designated as the editor may be doing this work himself or herself. In a commercial project, much of this work would be turned over to the appropriate editorial personnel. Although this process is shown in an NLE timeline here, its representation in a film editing layout would be roughly the same.

The scene involved a taxicab driver and his passenger caught in a traffic jam. In a single take, the passenger gets out and runs past the cars stalled in front of them to insert her business card under the windshield wiper of an arguing couple who are causing the traffic jam. Still in the same shot, she runs back to the taxi and starts yelling at the driver and honking the taxi's horn. As the sound mixer, I was on the floor of the cab, miking and recording the dialogue between the cab driver and the woman.

It was senseless to jump out and record sound for the middle of the shot, given the phalanx of camera crew members, camera assistants, dolly and lighting grips, and sundry other personnel who were chasing after the action. As the actor and I waited in the cab, I continued to roll sound because turning off the recorder would have disrupted sync. When the woman returned, I had her hit the steering wheel next to the taxi's horn, faking the car honk. The horn may have covered key dialogue and would have been too loud for the volume levels I had set for the dialogue.

As I watched rehearsals, I started compiling a list of sound effects needed for the scene. After the shoot I took the actor aside and had her run in place to get the clacking of her heels on the sidewalk. I also had to record the sound of the taxi's horn being honked to fill in where I had her fake it. For stylistic reasons, the traffic jam was made up of classic cars. I went to each of the cars and recorded the distinctive sound of its horn. I asked the director if he wanted the sound of the engines idling, but he did not see that as part of the overall sound design. There were several other effects on the list that I knew could wait until postproduction.

The editor's first concern was the long, dead middle stretch of sync sound when the actress and the camera were elsewhere, the remaining actor and I having filled the time with idle chatter. With the Razor Blade tool, the editor would have simply cut on the audio portion of the sync clip after the usable sound ended at the beginning of the take and cut again before it started at the end. **(SEE 17-37)** The audio can simply be deleted—just a standard delete, not what is called a **ripple delete**, an operation that closes the gap between cut pieces.

17-37

Using the razor blade tool.

A. The sync shot is edited into the timeline with all of the unwanted audio.

B. With the Razor Blade tool, cut on either side of the material to be removed.

C. Press the Delete key on the keyboard.

Because there were narration and voice effects in other parts of the film, the editor used the third audio track for the arguing couple in the lead car. We never really see the actors' mouths, so we took them into the studio after shooting and just had them improvise an argument for a while. They are not heard until the woman is close to their car, so their voices occupy the center part of the scene. To achieve the appropriate sound perspective, the track was started with the fader down, bringing the volume up as the woman approached the car and bringing it back down as she ran back to the taxi. **(SEE 17-38)**

Next came the footsteps. The editor found a section that sounded appropriate and cut them in from the car door slamming at the beginning to the end of her run. There was also a brief pause in the middle as she put her card on the windshield. **(SEE 17-39)**

Because the main focus in location recording had been on the dialogue, the sound of the car door as the woman entered and exited the taxi needed some attention. The camera was outside the car, and the recording inside made the sound perspective wrong. Something like this is usually, though not always, easiest to address in postproduction. I recorded the opening and the slamming of the door on a number of older cars. As everything between the two sets of dialogue was being removed anyway, the sound of the car door being slammed was also completely replaced. In both cases, it was the combination of several sounds, the creak of the opening from one recorded door being mixed with the swing and the slam from other takes. This took two tracks. **(SEE 17-40)** Another two tracks were built out of the car horns recorded on-location. **(SEE 17-41)**

Last, the editor needed some light city ambience to fill out the overall sound design. This proved quite tricky to record, but the appropriate track was eventually created. It was cut uninterrupted into an ambience track. **(SEE 17-42)**

Just as we created an overview of an exposure in the lighting section, we can create an "exposure" of the way sound can be built. Although this leaves out several unused mixtracks—second sync, music, and so on—all of the mixtracks can be viewed together. **(SEE 17-43)**

17-38

Audio track 3: The couple's argument fades in as the woman approaches the car and fades out as she leaves.

17-39

Audio track 4: The woman's footsteps to and from the couple's car.

17-40

Audio tracks 5 and 6: The car door slamming, mixed from several takes.

17-41

Audio tracks 7 and 8: Car horns recorded on-location.

17-42

Audio track 9: An ambience track to fill out the overall sound design.

17-43

Audio tracks 1 through 9: The overall sound design.

This chapter may at times have appeared to be recommending dense sound, but it is simply illustrating how to create a multilayered track. There will be situations in which you find one sound that is absolutely perfect for a scene or sequence. The point is to do what is good for the given situation. Determine what kinds of effects will give the scene the flavor, ambience, and lushness you desire.

Audio Finishing

A typical commercial project will go through a number of phases in the editing room. As suggested, the person designated as the editor will in reality just work with the dialogue tracks and possibly a few important effects and "for position only" music. Once picture lock is achieved, the audio tracks are turned over to a battery of highly skilled specialty sound editors. The dialogue tracks are turned over to the dialogue editor, who, again, creates handles and finesses the audio with ambience and a host of other tricks to smooth out and create consistent dialogue tracks. There are effects editors, music editors, Foley editors, and a number of others.

17-44

ProTools is a sound design program in common use.

Courtesy of Digidesign

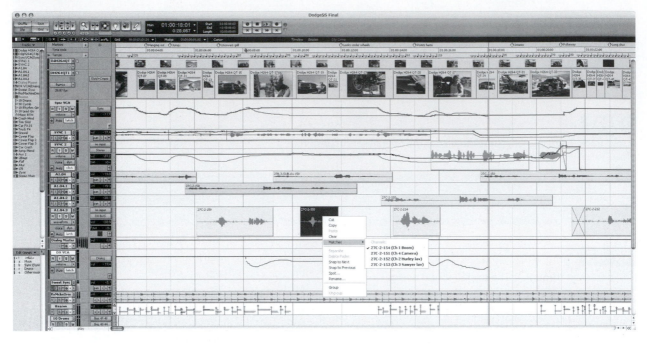

Although the audio components of many NLE programs are quite robust, it is very common to export audio tracks to sound software specifically designed for building complex audio layering. Digidesign (which makes ProTools) and Sonic Solutions are just two of the many manufacturers of proprietary software that can be interfaced with many NLE programs. **(SEE 17-44)** Being able to open the information exported from the NLE program in the audio software is thus a significant issue. The current industry standard is the **Open Media Framework (OMF)** file format. Developed by Avid Technology but incorporated by many NLE software producers, OMF provides the framework necessary to be able to share media information among software applications. Your audio tracks can be exported so that more tracks can be built against them or so that they can be mixed for the finished product. In most cases, it is a combination of both. Be sure that your NLE software supports OMF architecture before making initial plans.

Using OMF files has become a standard approach in how projects are completed in the commercial world. In FCP the OMF function is found on the File menu at Export> Audio to OMF. **(SEE 17-45)** In creating an OMF file, the NLE program analyzes the timeline and essentially writes to a new file all of the audio that you have used. It will go back into your capture scratch, grab the material you have used, and transfer it to a file that can be opened in proprietary audio software. It will grab the audio from sync takes or any other effects or music you have captured.

When you initiate an OMF file, the software requests some specific properties of the piece—such as sample rate (48 kilohertz) and bit depth (17 bit)—and, very important, what kind of handles are desired. As discussed earlier, the handles are extra audio at the beginning and the end of takes that can be used to finesse uneven tracks. FCP defaults to one second, but I recommend at least two seconds if you have the space. The OMF file will comprise your audio plus two extra seconds at the beginning and at the end of each audio clip. The NLE will ask you to name the new file and save it, and an OMF file will be created that can be burned to a CD or otherwise copied for transfer to another environment.

When you open the OMF files in the audio software, the on-screen representation should look essentially like the audio section in the original timeline. The audio clips will appear without the handles that were added in the creation of the OMF file. The handles are available to the audio editors, just as nondestructive elements are normally available in regular clips. Obviously, if you create uniform two-second handles, there can be unwanted audio in this extra material—other dialogue, extra effects, slating information, and so on. The editor can simply drag out the clip, take a look at the waveform and/or listen to it, and eliminate the unusable material if necessary. Ideally, the handle provides enough ambience to finesse the transition. If not, you may have to go into location presence takes or steal ambience from other takes.

Most, if not all, OMF exports eliminate the sound manipulations you introduced during editing, whether simple volume levels, equalization, or other signal processing. The reasoning is that your audio is going to be finalized in a new environment anyway. This gives the specialized editor and the final mixer the room to apply their extensive knowledge to making your sound the best quality possible.

So, in an OMF environment, all of the individual editors can work their magic. Obviously, picture is required to build audio tracks. Picture is generally brought to the editors on tape or in a QuickTime file and can be input to most any software designed for this purpose. The completed track can be written to a file—the Macintosh standard **Audio Interchange File Format** (AIFF) or other format—and can be re-imported back to your project as single or stereo (or other) tracks.

The OMF format has been a very stable and useful cross-platform design, but it has some limitations. The biggest is the maximum file size of 2 gigabytes, a great amount of data but a tad light for larger projects. There are other cross-platform formats—**Advanced Authoring Format** (AAF), among others—that may provide greater flexibility. With either format, moving audio into a proprietary software environment will remain a common method for achieving a high-end completion of audio tracks. The actual final mix may be done in another environment altogether, with the building of tracks done very efficiently in the audio program.

Practical Cutting Considerations

Exploring the full power of these remarkable systems would obviously be impossible here, but a few common features merit some discussion.

Br/10A-1a

Br/10C-1a

Volume Control

The approach to volume control is reasonably consistent among NLE programs. The typical way to handle it in FCP is with the Clip Overlays function, found on the bottom left of the timeline. **(SEE 17-46)** When you click on this, a straight red line through the audio clips appears that can be dragged up and down to control volume. **(SEE 17-47)** To shift volume within a clip, you select the Pen tool from the toolbar. **(SEE 17-48)** You then click on the red line to leave a pen mark where you want an effect to start—say, to fade down some music—and click again where you want it to end. Then you drag the second mark down to the desired level. **(SEE 17-49)** Audio levels can also be set in the viewer, and there is a useful Audio Mixer on the Tools menu.

Effects

All NLE programs offer a variety of transitional effects. They have the standards, such as fades and dissolves, plus a good variety of others, running from the reasonably common ones like wipes and irises to some esoteric options. In FCP these are found on the Effects menu under Video Transitions as well as in the Video Transitions folder on the Effects tab in the browser. **(SEE 17-50)** The most common item here is the Dissolve folder; what old-fashioned film people simply call a fade is called a Fade In Fade Out Dissolve, and the standard dissolve is listed as a Cross Dissolve. All of the other options incorporate some specialized effect into the dissolve.

All effects default to one second. To employ any effect, simply click on it in the browser and drag it to the desired cut. The effect may need rendering but otherwise applies simply. An effect can be lengthened or shortened by double-clicking either on the effect in the browser or on an already-overlaid effect in the timeline. A tab appears in the viewer, and the time can be changed in the window in the upper left. **(SEE 17-51)** The drag symbol on the right is used to apply the effect to the desired cut.

Color Correction

Color correction within NLE programs can range from nonexistent to quite power-ful. In addition, there are some exceptionally robust proprietary programs that are designed to give extensive control of many aspects of the image. Discreet, in particu-lar, makes a number of packages, all with fire motifs—such as Inferno, Smoke, and Flame—that are used extensively in professional applications. In FCP color correction tools are found on the Effects menu under Video Filters> Color Correction. They are also available on the Effects tab in the browser. **(SEE 17-52)** You would open the in-tended clip from the timeline into the viewer by double-clicking on it in the timeline. Then open the desired color correction tool. It will appear as a tab in the background of the viewer. It is usually best to drag the viewer over the canvas and to open the tool over the other two-thirds of the screen (or vice versa). Final Cut Pro 6, which came out as this chapter was being written, introduced an add-on program called Color

that has added substantial functionality to the correction process.

The Color Corrector option offers fairly broad-brush applications that can be useful for general changes. Color Corrector 3-way is a much more complex tool. **(SEE 17-53)** It opens to three color wheels, one each to affect blacks, midtones, and whites. A color wheel has the *additive colors* of light (red, green, and blue—*RGB*) ranged around its edges, with the *subtractive colors* (cyan, magenta, and yellow—*CMY*) arranged appropriately between them. The center of the circle is the combination of them all: white. Below each circle is a slider that controls the *luminance*—the brightness—at that tone. There is also a slider that controls the *saturation* of the entire image. This can reduce or eliminate the color—desaturate it or make it black-and-white—or heighten it.

Within each wheel is a small circle that can be dragged toward a color that will affect color at that tonal range. You can drag the image toward blue in the midtones, for example. With the Copy Filter function in the upper-left corner, you can apply the correction to other uses of the same clip or whatever you want. With these tools and functions, you can go through your entire show and correct it yourself. Be aware that effects you apply may require *rendering* (see "Editing on Video" in chapter 16), a time-consuming necessity that also takes up additional real estate on the hard drive.

Audio Sweetening

Most NLEs afford you the opportunity to manipulate the character of the sound. These functions can be found on the Effects menu under Audio Filters. Here you have the choice of Apple or Final Cut Pro filters. The Apple filters are imported from other software. There are some very good ones, but I generally use the FCP filters. **(SEE 17-54)**

Although you should experiment with all of the options, I have found the Parametric Equalizer to be quite helpful. Select it, and it will show up on a Filters tab in the background of the viewer. **(SEE 17-55)** The Frequency function controls what part of the frequency range you are affecting. Type the desired hertz, keeping in mind the general rules about frequencies presented in chapter 10. Finding the right frequency may take some experimentation. The Q function controls how adjacent frequencies are affected. Using lower numbers affects a narrow range of frequencies, and higher numbers apply the effect to a wider range. The Gain (dB) function controls whether sounds are amplified or reduced at the chosen frequencies.

There are quite a number of options under Audio Filters, including Echo, Reverberation, and a host of others. Experiment with these, but be aware that you can make an awful mess of things. You can make your clips sound good, but then play it back and find that your sound is all over the map. Consistency is the goal in most basic scene editing, and it takes experience and a trained ear to get it right.

NLE systems are capable of much more than the simple features discussed here. Although an understanding of film editing can be useful because it is the basis of most NLE design, an ability to use NLE systems is required for anyone in the field today.

18

Finishing Film/Finishing Video

Much of what you do at the end of a project is predicated on how you initiated it. Many beginning projects, whether shot on film or on video, will simply be completed within a nonlinear editing (NLE) environment. The output of Avid Xpress DV, Final Cut Pro (FCP), Adobe Premiere Pro, or many others can produce a finished show that is viable for many applications. While the offline/online distinctions are blurring, keep in mind that final masters for commercial productions are often not finished within the file-based NLE software in which they were edited. Generally they still return to high-end tape-to-tape (now file) online finishes. One film, however, quite famously made it to Sundance after being completed in Apple's iMovie. Nevertheless, it is not presently realistic to expect a transfer to film or a broadcast if you finish within the confines of a typical NLE system. As the capabilities of NLEs continue to expand, this is all changing but the involvement of other people and technologies remains both a benefit and common practice. Only if you have made something so original or so potentially popular because of the content or presentation will image or sound quality not be an issue. There will always be examples like Eduardo Sanchez and Daniel Myrick's *The Blair Witch Project*, but they are the exception rather than the rule. As a friend likes to point out, Hollywood is always happy to make money off your hard work, but the critical question is how are you going to be able to convert initial success into future work.

The particulars of finishing within an NLE system have pretty much been covered in the general flow of presenting how these systems operate. You can change volume levels or equalize the sound, and you can create all of the transitions and visual effects you desire. These audio and video file or manipulations are stored as digital files, and you can simply play the finished project out to tape. Most NLEs have basic finishing touches so that the audio tracks do not remain as separate entities, and the software has playback functions in which all resources are devoted to outputting the highest-quality product. In FCP the File> Export> Audio to AIFF command creates the audio as a single digital file that can be opened and pasted against the visual. **(SEE 18-1)** Thus, all of the audio is represented as one or, if stereo, two completed tracks. FCP also has a File> Print to Video option that focuses your show for optimal presentation.

So, finishing within a consumer NLE is relatively simple but is not always adequate for commercial release or broadcast. Of course, it is fine for YouTube and a host of other venues so there are many applications. In looking back at the six workflows, recall that some of the other approaches can be quite complicated, mostly in terms of returning to original elements or high-quality copies. Again, most of the finish is determined by your decisions when working with the camera originals,

whether film or tape. Did you do video dailies from film and create a Cinema Tools list for matchback? Did you do a high-end transfer from film and edit on low-res clones for a tape-to-tape finish? Did you do video dailies for a Digital Intermediate (DI) or a film-to-tape finish? All of these workflows are based on edit decision lists (EDLs) and/or negative cut lists. The following section discusses some issues of finishing in an NLE environment but mostly focuses on the requirements of high-end finishing.

Toward a Film Print

Except in a situation where a transfer from a video source to film is planned, finishing to a film print involves the three previously mentioned significant processes: audio mixing, negative cutting (conforming), and final printing. These three processes are generally performed in that sequence, although there is modest debate among postproduction personnel as to whether to mix first or to conform first. In the professional world, the audio mix is done at a commercial studio specifically designed for the purpose. On personal projects you can mix audio within most any NLE program, although we have suggested some reasons, and will offer more, why that may not be the best idea. Negative cutting is generally done by a dedicated professional, although students strapped for cash and willing to take risks—and taking risks with your negative has some obviously severe drawbacks—can do it themselves. For those who want to be involved in the film print world, conforming at least one short film is highly instructive.

The first two processes generate the **elements**—the sound rolls and the picture rolls needed to create the final film print. The final product of the mix is the *master mix*, the completed version of the film's sound. *Negative cutting* entails the return to the original film, generating a new version out of it using the edited workprint and/or a negative cut list as a guide. Final prints are created by a motion picture processing laboratory. The first print—the *answer print*—is essentially the lab's best shot at creating a print that you like. Although the goal is to get it right the first time, it occasionally takes the lab several attempts to produce a satisfactory answer print, color correction and exposure being the biggest issues. Once you have a print you like, all subsequent *release prints* are made, using the answer print as a guide.

It is essential that these three processes be executed to the highest standard possible. An indifferent mix, accompanying even the most visually interesting film, can give viewers the feeling that something is lacking. Sloppy negative cutting can leave the film damaged and dirty and, at worst, the sound out of sync. Unless you are attempting some specialized effect, you want the film to be as clean and polished as possible. Remember, there is no better advertisement for your talents and abilities than your work. Informality may be a desired aesthetic effect in certain circumstances, but generally viewers are unimpressed by work that appears crudely executed.

The separate film and NLE paths continue, but when the goal is a final print, these previously parallel tracks start to converge quite quickly. For film purists, if such a thing still exists, the traditional path of finishing a film "on film" (method 1 in chapter 17) has been dramatically affected by video and, particularly, by digital sound technologies. Be sure to learn everything you can about each approach.

18-1

The path to creating a finished audio track.

Titling

Films can have any kind of **titles**, from kids' drawings to scribbles on a chalkboard, although many filmmakers prefer the good, old-fashioned conventional white or colored text on a black background. In the traditional approach, this last type of title is generally shot on an *animation* or *copy stand*, an arrangement with the camera mounted on a column designed to shoot fixed artwork. Without such a stand, shooting high-quality titles can be more difficult than one might at first anticipate, and nothing announces an amateur project quite as loudly as sloppy, crooked, or out-of-focus titles. A good film may never recover from a slipshod start. Obviously, professional titles do not automatically mean a high-quality film, an observation that is endlessly proven, but at a beginning level they say something about the filmmaker's attention to detail. Though an audience may forgive an error, those considering hiring you or funding and exhibiting your work will take a dim view of what can only be chalked up to carelessness. Take the time to make sure that everything is perfect.

For conventional titles, the first step is to produce them on a card or paper stock. The title cards are then photographed on a large, high-contrast **sheet negative**, the paper source for a standard film negative often referred to as a *Kodalith*. Assuming the generation of titles on a computer, they must be output on a printer that produces completely opaque lettering, or there will be problems with the sheet negatives. These negatives are set up with strong backlighting and filmed, sandwiching gels if color effects are desired. It is possible to just shoot the artwork you have printed by itself with front lighting, but it is difficult to find an exposure that does not represent the blacks and whites as grays: you get the whites right and the blacks are dark gray; or you get the blacks right and the whites go to gray.

Anticipate the titles you will need before creating and shooting them. Negative cutters, mixing houses, and the lab that produces the final print are frequently credited in films. As do crewmembers, postproduction personnel use a carefully crafted film as a résumé item, and it takes preplanning to determine who will do this work.

When shooting be sure that the titles are composed within the *TV-safe frame*. Even when you have a final film print, video is the standard medium for submission of work for consideration, whether for grants, festivals, or job applications, so a transfer is a given. In addition, make sure spelling is correct, of both text as well as actors' and crewmembers' names. A friend once misspelled the word *believe* in a title, and it undoubtedly cost him screenings and, particularly, in grant applications. In a film print, a typo is extremely costly to correct.

One alternative approach deserves attention if you are making a conventional film print. With the ability to build titles in most NLE programs, many independents and students are creating their titles on video and having them converted to film. Given the expense of creating sheet negatives and shooting your own titles plus the difficulty of getting them right the first time, in the long run it may be cheaper to do a standard conversion. Creating the ever-popular scrolling titles on film is one example of a type of title that would potentially be too expensive and too difficult for the individual to shoot. Be aware, however, that scrolling titles do not always transfer well from video to film, given the often-awkward interplay between frame-rate conversions and movement. Some labs do it well and others do not, so talk to labs about doing the work and be sure to check out examples.

Final Sound Mixing

The whole concept of a mix has changed profoundly over the past two decades or so. It used to be that you got all of the audio tracks cut exactly the way you wanted them before you embarked on this major undertaking. Commercial features used to do premixes and the like, but any finalization of the audio happened in the very

last stages of postproduction. Now a final mix can mean many things, with many aspects finalized before you get to the mix and many elements potentially added and/or changed in what constitutes this final stage.

The mix is always done with the film's editor and other pertinent editorial and producing staff present. The mixing board itself is run by the studio's **rerecording mixer**—a credit that now requires some clarification, mostly in that the process can now involve much more building of tracks from library effects and the like. High-end mixes frequently have other personnel present for dialogue mixing and effects mixing as well as other functions.

Mixing is necessary when you are combining two or more sounds. The mix can be bypassed only when all of the sound is on one track of a timeline or on one roll of mag stock. This would be a situation in which you were working with a track that was finished before editing commenced, music videos being the best example.

You can create a finished single track in NLE software, but mixing in your own NLE system has drawbacks. Film and video producers—and certainly all commercial feature makers—routinely go to a commercial mix for the extra dimension in the audio that can be achieved.

"Conventional" Film Audio Mix

It is useful to understand how mixes work from the perspective of how they were done in the predigital age. Commercial mixing houses for motion pictures provided a specialized service that until recently could not be duplicated in other contexts. In the old days of conventional film mixing (25 or so years ago), the key requirement was the interlocking of mag stock playback machines, the projected film, and the sound's destination—the mag stock machine that recorded the master mix. You might find places that still do a true conventional film mix, but almost all commercial mixing studios now work with digital elements or digitize everything—picture and sound tracks—if the source is analog (e.g., mag stock).

The mixing studio itself was a screening room with a mixing console at the rear, with seating for the rerecording mixers, the editors, and the client. The playback equipment was in a separate sound-isolated booth behind the mixing console. **(SEE 18-2)** The film was projected into the screening space, and the sound playback was routed through the mixing console, each individual mixtrack being on its own dedicated mag stock playback machine and fed into its own channel on the mixing console. Except for reel changes, the finished sound was recorded to a single uninterrupted, uncut piece of mag stock. The projector and the mag stock machines—playback and record—were electronically interlocked to play all rolls in sync, frame-for-frame whether in forward or reverse.

Conventional mixing studios were set up so that you could run back and forth on short stretches, scenes, and sequences of the film, working on the sound until you were satisfied. The mixer would make one or more passes on a section just to listen to what sound was there and to see where it was located on the tracks. Then the picture and the interlocked tracks would be backed up in sync, and if the mixer felt ready, he or she would try recording the sequence. If the recording was not right, everything was backed up again, and the mixer would take another shot at it, recording over the first attempt. With "punch-in recording," you could go back and lay in whatever is necessary. The mixer determined volume levels at your direction, also doing everything possible—mostly equalization—to maximize the quality and the audibility of the sound. It invariably took a number of passes on each individual sequence to get it right. When you were done, you had one version of the sound recorded to mag stock that was the sound for the film. It had to be right because it was going to be with the project for the rest of its hopefully long and varied life. You could always very expensively remix, but eventually you had to commit.

18-2

The mixing studio was a screening room with a mixing console at the rear.

Except in certain circumstances, the position of all sound—effects, music, and so on—was determined by your cutting before you went into the mix. What was, and still is, being finalized at the mix is the volume and the character of the sound: the final product. The "certain circumstances" suggested above reflect the extent to which the role of the rerecording mixer has changed in the past 20 years. In the old days of the mag stock film mix, you could add some random effects—wind blowing, extras' chatter, and the like, but to significantly reposition a key effect would require unloading the machines and recutting the tracks—at studio prices. There was room for minor shifts, but any wholesale movements or additions were mix killers. With the advent of building tracks and mixing in a digital environment, the ease of moving and adding material has evolved to the extent that a certain, indeed fairly large, amount of audio building can occur in a finishing environment.

Digital Mix

Though some of the particulars vary, the same theory applies to mixes done digitally. Mixes are run on a computer, with tracks displayed in your NLE timeline or, more commonly, a timeline of proprietary audio software. Many NLEs and dedicated audio programs have menu selections for programmable mixing boards that emulate the old studio models. These can be beneficial to the process. Picture is displayed either by video projection or on a large, high-quality monitor. The major difference is that, in an old-fashioned mix, individual audio manipulations basically occurred in real time, and a good rerecording mixer looked like an octopus, with hands moving all over the mixing board, twisting knobs, patching equipment, and tweaking volume levels. In a digital environment, you can create effects in the timeline and those effects may, depending on how you finish, be the choices all the way to the end. Indeed, even the notion of the rerecording mixer has evolved, with that title suggesting a very specific process of "re-laying" the sound to new tape. It's

all files in a digital mix. A good new title has not quite been found. "Postproduction sound supervisor" has been bandied about but suggests greater involvement in the whole process. "Audio Session Supervisor" might be a better shot at it, although there may be numerous sessions. "Session Mixer" does not quite have the ring to it but may suffice.

The process of Open Media Framework (OMF) was discussed in chapter 17, and the audio you have built in the NLE system, should you choose a professional finish, is brought to the lab as a file. If your material is OMF, it would be translated into the studio's audio software and displayed on a computer monitor. If you had done a conventional film edit, the edited workprint would be transferred to video and the mixtracks digitized into a timeline environment. If you take this latter course, it is essential that the material be in good shape when you drop it off to be digitized. Any broken sprocket holes or ripped picture should be replaced with black leader, and damaged mag stock should be retransferred and replaced. If anything breaks or is lost in the transfer, time-consuming repair will be required before the mix can start, and studio personnel may not be familiar enough with the project to re-create synchronous relationships. The mix then proceeds essentially as described, with a few minor and soon-to-be-elaborated-upon differences. The master mix that is created will generally be a computer file, which can be output to a variety of media—including, if desired, good old-fashioned mag stock. For an independent, there are a number of reasons to go this latter route.

It is not uncommon for an editor to bring a project into a mix intending to find and place many effects out of the mixing facilities' effects libraries. And this is the biggest difference between old-fashioned mixes and those of today. Effects, music, and the like can be easily retrieved from hard drives or library CDs and imported into the timeline. I recently did a mix for a tutorial I was working on that took place in a restaurant. I went to the mix with just four tracks: two A & B–rolled dialogue tracks, one for additional dialogue, and one effects track consisting of a telephone ringing that was FPO (for position only), as I planned to replace it. At the mix we found some general restaurant ambience, some plates and glasses clinking, some silverware on plates, and the like. We found a piece of library music for it that was perfect. Although I had A & B–rolled the dialogue, the session mixer still moved a few things, finessed the handles, and crunched in a few pieces of ambience to smooth out the dialogue. The telephone sound effect that I brought turned out to be the best option, but the session mixer needed to equalize out some unwanted background ambience that I had not been able to hear on my home computer. We also decided to have him ramp up and down the phone sound to finesse both the in- and out-points so that they were not quite so harsh.

In the old days, I would have had to find or record the effects and music, transfer them to mag stock, and cut them into position. Now to find them and crunch them into place has just become too easy not to take advantage of. This approach is not necessarily valuable on features and other longer forms, where the unique quality of background effects may add an important fresh component to the film's overall feel. Effects, dialogue smoothing, and the like are part of an extensive campaign that requires much more extended thought and effort than could be brought to bear in a final session. But in shorter forms, particularly commercials, this approach is becoming reasonably standard practice. One of the most interesting things about the mix just described was that there was a big, expensive mixing console right next to the computer. It sat untouched. It was kind of in the way. It reminded me of the still-holstered six-guns at the end of Sam Peckinpah's *The Wild Bunch* (1969), the anachronistic reminder of a bygone era.

One of the beauties of the digital mix is that you can mix an entire project at a studio and still go back and tweak a few things yourself. While it may be frowned upon in professional circles, you can always add more tracks and putter with the sound. I did a mix recently on a short film that ended with a thunderstorm. I went

into the mix with some of the storm built, intending to flesh it out with effects from the mixing studio's library. As the mix progressed, I realized that I simply was not going to be able to achieve the intensity I wanted with the canned effects available. I finished everything that had to be done at the mix (such as sweetening the dialogue) and left with the finished file. On my system, I stripped off the original tracks built in the editing process and pasted in the mixed audio. When a storm of appropriate ferocity came through town, I recorded a bunch of thunder, wind, and rainfall sounds. With it input into Final Cut Pro, I continued to add these new sounds until I achieved the effect I wanted. One major pitfall is that if you do not have a good speaker system, you may introduce flaws, distorted sounds, or glitches that may not be audible or may not have their cumulative effect well represented until later played on a better system—hopefully not in front of a paying audience. Again, certain aspects of this last idea may occasion rolled eyeballs in certain circles, but mixes are nevertheless done more in stages now than before.

Track Configurations

When you take your tracks to a mixing house, whether in OMF or as conventional mixtracks, they must be laid out in a logical way, one that makes sense to the mixing-house personnel. As you are editing, you can be informal about which track each sound is on. You generally want the sounds where they are most convenient, particularly so that you can view the project with the sound clips as visible as possible. Before going to the mix, however, the different types of sound should be segregated onto separate tracks: all of the dialogue on specific tracks, music on its own track or tracks, effects spread out through however many tracks are necessary, and so on. This allows the mixer to find specific sounds quickly and to group together those that are to be treated similarly. This makes the mix simpler and faster. The mix is a substantial budgetary concern, so it should be as streamlined as possible.

Most mixing houses, especially those accustomed to commercial features, are very particular about how the tracks are set up. If your film is not set up appropriately, they may send you back to the editing room while still charging you for the time it took them to load and unload your project. Mixing houses in smaller markets might be a little more forgiving, but tracks not set up in a straightforward manner will require costly time to figure out.

In setting up the tracks for the mix, two requirements need to be emphasized. In the digital age, both of these are very easy to fix, but preparing properly keeps the mix efficient and the studio personnel happy and committed to doing their best work.

■ **RULE** There should be no sound-to-sound cuts anywhere in the tracks.

That is, the tracks should be cut in such a way that all pieces of sound are butted up against empty track, called *slug* in film, rather than to other pieces of sound. If one sound effect follows right on top of another, it should be put on a different track. The main reason for this is to allow the rerecording mixer scope to do sound manipulations; the rationales presented in the section on A & B rolling sync sound in chapter 16 apply here as well. In creating timeline tracks, this is not quite as important as it used be in that a rerecording mixer does not need the time to physically move his or her hands; plus, a session mixer can easily move any piece of sound. But having the tracks as visually uncomplicated as possible will facilitate efficiency in even a digital mix. If the session mixer is looking at a big jumble, it takes a while to decipher it.

In conventional mixing from mag tracks, the minimum slug length between any two pieces of sound used to be four or five seconds. If the sound was dirty and needed substantial manipulation, you had to introduce longer gaps. This required spreading the sound effects through more mixtracks. Again, the reality has changed

but the theory remains. One of the joys of the digital mix is that if you make a mistake here, the mixer can quickly cut the sound and paste it at another place on the timeline, thus allowing more-efficient treatment. Becoming too dependent on reconfiguring at the mix, however, can add time to an already costly procedure.

■ **RULE** There should be no place in the film where there is only slug or an empty track on the mixtracks.

There should be some recorded sound on at least one of the mixtracks in every part of the film, even if the sound is just silence. What the listener perceives as silence is not the same thing as an absence of sound. If there is nothing on any track, it will sound flat and empty. Mixing houses will be able to provide something, such as white noise or open-mic room ambience, to cover the gap if you make a mistake. Still, you should consider the character of the sound you want for any quiet moments and provide the appropriate track.

Mix Philosophy

The mixes of old had the appearance of being seat-of-the-pants affairs, with the rerecording mixer executing all volume control and equalization in real time. In those analog days of yore, the mix felt something like being in the cockpit of a 747: there are lots of dials, gauges, and indicators, and all you really know is that the plane takes off and lands. How the mixer was changing the sound was not logged anywhere, except by memory and an understanding of the complex nature of sound. The quality of the mix was dependent on the taste, experience, intelligence, and sensibilities of the rerecording mixer, with most studio professionals bringing a lifetime of knowledge to the project. The ear was the arbiter, and the mark of a great rerecording mixer was a great ear for the character of the sound, how intelligible the sound was, and being able to extrapolate how it would play in a theater or on the tube.

This last still holds true. A great ear and years of experience define a mixer's contribution. Beyond this, the mixer's job has become less physical in the age of digital mixes. The changes and the effects can be programmed to drive the mixing-board controls, making the faders move on their own as if by an unseen hand. Volume levels are set in the timeline and will execute in the same way every time. If we later change our mind and, say, want a sound to be quieter, we simply reprogram the effect. The same is true of signal processing—all changes are stored and are continually reproduced until we create a final track or make changes.

The mix is often the first time you get to hear your sound on an exceptional audio system along with your picture on a big screen—all in a controlled environment. The experience usually produces that giddy feeling a person gets when watching the many elements finally converge to create a finished product. This is where all of the work and preparation come to fruition. The process is not without its tensions, however. This is the sound that your film is going to live with for the rest of its natural life. The pressure to get it right can be intense, particularly if the preparation has been incomplete or sound problems that have gone unnoticed in the editing turn out to be significant.

I recommend mixing at a professional facility because a good rerecording mixer can bring out a dimension to your sound that you, as a layperson, simply cannot achieve. In addition, the better you understand the process, the more you can actively participate in it. And the better you understand the process, the more you will understand how to create tracks that give your film a rich and dynamic sound. Although the original location recordings are presumably, though not always, of good quality, the mixer can sweeten, or clean up, the sound, bringing it to its full potential. No matter how good you think your location recordings are, the exceptional sound reproduction of a mixing studio will unmask some heretofore-unheard imperfections. Editing tables and small speakers on computers, particularly

those in school situations, do not necessarily reproduce sound perfectly, so be prepared for a few surprises. Ideally, you will have no problems that the mixer cannot eliminate. Mixes at smaller houses range from $300 to $400 per hour, whereas the most advanced mixing facilities run in the range of $800 per hour and up. A mix on a reasonably uncomplicated five-minute film would probably take about an hour. Complex features can take many weeks.

The mixer's contribution can be the difference between a final track that is anywhere from functional to near unintelligible and a track that has character and vitality and effortless intelligibility. The mix is such a daunting expense that there is a great temptation to find ways to bypass it. In the "guerrilla days" of independent filmmaking, many producers outside of the mainstream would search out any conceivable way to avoid costly, conventional finishing processes like the mix. After years of puttering around the edges, most independents realized that this was a mistake. There are perfectly good reasons why things are done in certain ways, and established finishing technologies are designed to produce the highest-quality results possible. Although informality and roughness may be valuable aesthetic alternatives, the trade-off for trying to get by cheaply is often unintelligible sound.

I once assisted a young animator who had completed editing his first feature, a painstakingly executed puppet animation that had taken him more than a year to shoot. He was about to go to a mix, and I questioned him on how prepared he was. It turned out that he did not have the tracks appropriately separated and was going to mix at a rudimentary setup at a local college. I implored him to take some time to reconfigure the tracks and mix them professionally. He needed to meet a deadline and claimed complete poverty. I begged him to do anything to find the time and the money but to no avail. At the premiere of his film, the sound was virtually unintelligible. There are many false savings between the beginning and the end of a film.

Go into the mix with an open mind. The first mix of my work as a location sound mixer left me scratching my head. I went with a certain amount of cockiness, knowing that I had done a thorough and competent job on a difficult location. It is not possible, however, to get back into the editing room without flaws. I was amazed by the dimension that the mixer was able to bring to improve the audibility of my already high-quality tracks. He was also able to identify and correct many flaws, such as cable noise and unwanted background noise.

The master mix itself has the shortest life span among the elements required for a film print. It is quickly transferred to the optical master. The photographic printing element for a film's sound track, the *optical master* is a blank piece of film except for a narrow strip of diamond-shaped patterns opposite the side with the sprocket holes. Occasionally, you will find a mixing house that can produce the optical track, but such houses are becoming increasingly rare. Usually, a motion picture processing lab produces the optical master, although you may have to search around to find one that does.

Negative Cutting

The next step is *negative cutting*, or *conforming*, the original film to what you have done in the editing process. The *edge*, or *key*, *numbers*, whether read from a workprint or a negative cut list, are the reference points for replicating all cuts. Either the numbers will be read off the workprint, or the time code used in the NLE approach will be translated back to edge numbers by the editing software. Cutting the negative is not undertaken until the picture is 100 percent locked, that is, until you are absolutely sure that the picture is exactly the way you want it. The old adage *measure your cloth many times because you can only cut it once* is applicable: once you cut the original, there is no turning back.

As with so much else, procedures have evolved in the negative-cutting stage. If doing a film-to-tape finish, transfers can be created from conformed rolls of negative or come straight from the uncut camera rolls. In the latter approach, the datacine (or the telecine for that matter) can roll through uncut camera rolls and the selected sections can be transferred. The entire rolls are loaded and shuttled through to the desired sections. As a side note, most high-budget features never actually cut the original film when the decision is made to go the conforming route. They are always working from high-quality prints, either interpositives or internegatives. In many instances, there can be a number of these intermediary printing elements and, once you get into prints for international release and the like, they can go through quite complicated paths. In any instance, the original is too precious a commodity to go under the knife.

The following discussion excludes workflows that incorporate a DI. The path to a DI can include a workprint and/or a conformed negative, but instances of its being done that way are infrequent. These are workflows in which a conformed negative will be used to generate a film print.

Preparation for the Negative Cutter

Although students occasionally conform their first film themselves, the job is generally handed over to an experienced professional because careful handling of the film is so critical. The negative cutter (conformist) is generally independent of the editorial department. This vendor is brought on board after the editing staff has completed its work, although filmmakers who anticipate complicated printing jobs may require consultation with a neg cutter early in the editing process. The neg cutter's activities facilitate the lab's work in creating the final print, so a professional neg cutter is completely conversant with the material that the lab needs to finish a film. Complicated cutting, supers, mattes, fast cutting, mixing black-and-white and color, and so on generally require that the original be laid out in a specific way. A good negative cutter—bad ones do not last long—can give you guidance throughout the process.

One critical thing to keep in mind as you are preparing a project for the neg cutter is that everything you want in the final film must be present in the edited workprint (EWP) or timeline and must have a corresponding piece of original film. Things like freeze frames and other optical effects must be created on film by the time you get to this stage. There are also many fun video effects that can be created in NLE systems, but if they do not have a matching piece of original film, they cannot be re-created in your final print. Conversely, if you do not want something in the final print, it had better not be in the EWP. Flash frames or light-struck footage must be weeded out unless they are wanted for effect.

Although you could still fiddle with the audio mix, for the picture the song is essentially over. Of course there are famous stories of features that are "finished" but then go back for re-editing when someone determines that their commercial appeal can be improved. Producers can and frequently do go back and revisit the edit of a film. With the appropriate budget, you can return to the conformed negative, but it entails complications and pitfalls that will become evident. Major commercial features are working from high-quality intermediates and are not cutting the actual negative, so there are more options. For many projects, however, a conformed negative means that the end is indeed the end.

On an interesting side note, the movement toward restoring older films has brought to the fore many of the issues involved in recutting already-conformed negative. The 1989 restoration of David Lean's *Lawrence of Arabia* (1962) used many pieces of trimmed negative and intermediaries to reconstitute shots to their original form. The complications the restoration team encountered are quite informative in terms of the pitfalls of recutting cut negative.

Marking the Workprint

If you are submitting a workprint to the neg cutter, it must be appropriately prepared so that the negative will be cut correctly. The standard approach is to mark the workprint with a grease pencil, and the neg cutter reads the information right off of the film. In NLE you produce a negative cut list that provides the neg cutter with everything he or she needs. Many high-end projects have both a marked workprint and a cut list to add a level of redundancy to this stage, where even minor mistakes can have catastrophic results.

Every actual cut from one shot to the next must be clearly identified so that the negative cutter clearly understands your intentions. All **unintentional splices**—that is, splices where you tried a cut but decided to put it back together again—must be identified as such. All actual cuts in the film are marked with the letter *C*. **(SEE 18-3)** Unintentional splices should be marked with an equals sign (=). **(SEE 18-4)** When you are done, there should be a grease pencil mark on every splice in the edited workprint.

If there are standard effects such as fades, dissolves, or supers, they must be communicated to the neg cutter and lab personnel as well. Fades and dissolves are simple matters when finishing in an NLE environment, but they require some planning when either cutting film or matching back to it. Labs execute *fade-outs* and *fade-ins*—where the picture fades out to or up from black, respectively—at a number of standard lengths called **fade rates**. The standard options are fades of 16, 24, 32, 48, 64, and 96 frames. Fades of 24 frames are the most common; 16 is very fast and can have the look of trying to hide something, and anything longer feels very slow in the hyper-animated screen time. Fade-outs and fade-ins are again drawn on the workprint with a narrowing triangle and a widening one, respectively. Write a description of the effect next to the mark with a grease pencil ("16-frame fade-out" in the first example). **(SEE 18-5)** Keep in mind that if you are cutting NTSC

18-3

All marks are done on the base side of the workprint, with actual cuts being indicated by the letter *C*.

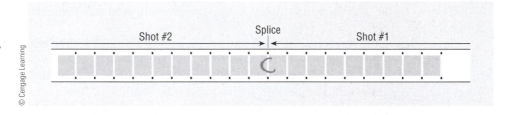

18-4

Unintentional splices must be marked with an equals sign.

18-5

Fade-outs and fade-ins are drawn on the workprint as well as indicated in writing.

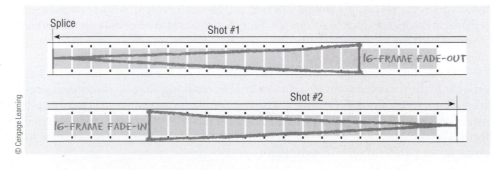

on a computer, one second is 30 frames. Most software will make the conversions for you, but always double-check.

Whenever you have a fade-out followed by a fade-in to the next scene, be sure to cut in some black leader between the two shots. The screen will not appear to achieve complete black if you do not. The length of the black depends on what you are attempting, but anything more than a second will feel lengthy, with the standard being less. Again, periods that seem brief in real life can seem like an eternity in screen time. Rather than going to or coming from black, you can go to colors or "fade to clear" for a more stylized effect. Check with the lab and the negative cutter about executing such specialized effects.

Labs have the same standard **dissolve rates** as are available for fades. Also like fades, 24-frame dissolves are the most popular. Slow dissolves (64 and 96 frames) have their applications, but they tend to call attention to themselves and are frequently used in a stylized or mannered fashion. The effect of a dissolve can only be suggested in a workprint because you cannot effectively sandwich film stock on a flatbed or in a projector. The workprint must be cut so that the splice represents the center point of the dissolve between the two shots—that is, the point when we are seeing an equal amount of each shot. The negative cutter will not understand other configurations.

If you are doing a 24-frame dissolve, you count 12 frames from the cut toward the head for the beginning of the dissolve. For the end of the dissolve, you then count 12 frames (for a total of 24) from the cut toward the tail. The following figure shows how these are marked on the workprint, with a widening triangle superimposed on a narrowing one, which is, after all, what is a dissolve is: a fade-in superimposed on a fade-out. **(SEE 18-6)** Again, write a description of the effect with a grease pencil just before the mark.

The technical requirements of dissolves are explained later in this chapter, but suffice it to say at this point that dissolves must be completely planned before they are called for in the workprint or negative cut list. You cannot go through your film and capriciously decide that you want specific cuts to be dissolves. Both shots of the dissolve will be extended in the negative cutting, so there has to be more usable footage than is represented in the edited workprint. Designers of matchback programs, like Cinema Tools, are well aware of these issues, and the software will look for any instances where there is not enough footage to execute an effect. Cinema Tools and its counterparts can be used to log effects, track opticals, check for double usages, and track whether the necessary frames are there to conform a film.

These are the basic marks. There are a few others, such as supers (a squiggle line), which should be discussed with the negative cutter. There are also detailed marks for replacing footage damaged or lost while editing the workprint—footage that is still intact in the original film and which can be incorporated in the final print. Again, there should be a mark on every splice when you send the edited workprint to the negative cutter. Unclear marks create the potential for mistakes in the conforming process. If the mistake is a result of sloppy marking, it is no one's fault but your own.

18-6

To indicate a dissolve, the workprint must be cut and marked so that the splice represents the midpoint between the two shots.

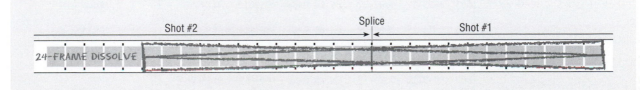

Creating a Negative Cut List

In one of the methods of matchback that Hollywood has adopted (discussed in chapter 17), there is still a workprint that is marked and sent to the negative cutter. The conforming process, in this case, proceeds just as it does in the conventional film edit. Whether or not a workprint is made and marked, a hard copy of the negative cut list is generated from the NLE system software. **(SEE 18-7)** The list will generally be composed of beginning and ending time code or code numbers in two vertical columns down one side of the page, with two columns of their edge number translations down the other side. **(SEE 18-8)** The negative cutter will perform the cuts from the numbers listed.

It should be noted that while matchback for many projects is being done within the NLE system software, a number of companies are providing their own dedicated systems for keeping track of the negative. The enormous job of managing the footage (all 4 million feet) for Peter Jackson's *The Lord of the Rings* trilogy (2001–2003) was done in a proprietary system created by US Computamatch.

18-7

The function for creating a cut list is found at File> Export> Cinema Tools Film Lists.

18-8

A negative cut list is made up of beginning and ending edge numbers.

Sequence 1.cut

The cut list in construction order:

Shot	Footage	Length	Keycode	In Frame	Out Frame	Roll	Scene	Take
001	0000+00	0008+35	FN 00 0483	5238&02	5281&09	1	MM,1	1
002	0008+35	0021+28	FN 00 0483	4761&05	4767&11	1	MM, 8	1
003	0030+23	0003+09	FN 00 0483	5022&12	5035&11	1	MM, 9	1x
004	0033+32	0002+27	FN 00 0483	4619&11	4624&15	1	MM10	1
005	0036+19	0004+29	FN 00 0483	4885&14	4893&06	1	MM, 11	1
006	0041+08	0004+07	FN 00 0483	4990&06	5003&07	1	MM,5	1
007	0045+15	0006+22	FN 00 0483	4609&19	4614&05	1	MM6	1

Having dedicated vendors whose sole responsibility is to make sure that matchback is accurate suggests both how fragile the system can be and how critical it is. Footage requires management and the knowledgeable professionals who can do it. In the absence of a workprint, usually conformists have a video of the work, with readable time code displayed in *window burns*—the small burn-ins of time code and edge numbers in the lower part of the frame. They can double-check against these numbers if any questions arise. Synchronizers can be interlocked with video playback decks to monitor the work. Window burns, again, are usually introduced in the original transfer from film to video as either a key or a supporting way of displaying matchback information.

Film and NLE

If the negative is going to be conformed and an answer print struck, it is here that two of the paths—film and NLE—that we have been following finally converge. The final product of this process is the same whether you cut on film or on an NLE system. Once the neg cutter cuts the original film, the final steps unfold in the same way.

Essentially, negative cutting is making an entirely new film out of your original, using the edited workprint and/or a negative cut list as a guide. Cement splicers are used exclusively to create splices that will be clean and durable in the contact printers. The original film, at least in 16 mm, is cut into two rolls—the A & B rolls—although there are instances where more than two rolls are needed. Generally, 35 mm is not A & B rolled, although there are instances where the 3-perf method requires it.

Negative cutting is the least creative and least romantic of these finishing processes. The negative cutter never looks at the film and is completely uninvolved with sound. On the surface it appears to be a dull and mechanical chore demanding little or no thoughtful involvement, and yet the process is extremely exacting, and any mistakes in handling or cutting the film can have serious repercussions. In a way, it is the most nerve-racking aspect of the process, although professional neg cutters cannot and do not make mistakes. They are dealing with a precious commodity: your original. The handling of the original in this stage must be scrupulous. If it is damaged or destroyed, you have nothing.

Clean Room

A professional negative cutter will have a **clean room**—a room designed to be kept as clean and dust-free as possible. Any dirt or dust that gets on the film will show up as spots on subsequent prints. If the dirt works its way into the film's emulsion, it can cause scratches and even worse damage. Fingerprints on the film must also be avoided. The negative cutter wears lint-free gloves to minimize contact with the film. The rooms often have double doors to limit the dust coming in from the outside world and have air-transfer systems to clean and purify the air. The room is cleaned before every job, more often if it is a lengthy project.

The room generally has two pairs of rewinds. One set is used for the A & B rolls, and the other is used to search for shots in the original. There is also a spool for the black leader needed to slug in the shots. A synchronizer and, of course, the cement splicer are also required items. Other equipment includes a trim bin, a pair of scissors, film tape, and a good supply of split reels, regular reels, spacers, and clamps.

How carefully and cleanly films are handled is the determining factor in a negative cutter's overall reputation. If the work consistently has dirt, fingerprints, or torn sprocket holes, no one is going to beat a path to that practitioner's door.

18-9

A cement splicer is used to create a strong, permanent splice that will hold up in the contact printer.

Maier-Hancock cement splicer / © Cengage Learning.

18-10

The blade that makes the cut at the head of the shot cuts about ⅛ inch into the bottom of the preceding frame rather than on the frame line.

© Photo courtesy of Bruce Mamer.

First frame of shot

Overlap area
(approximately ⅛")

Cement Splicing

The **cement splicer**, or *hot splicer*, works on the principle of overlapping and cementing the first frame of a shot on a small part extending from the last frame of the preceding shot. **(SEE 18-9)** Cement splices are permanent and strong and will hold up in the contact printers. The splicer has two film cutters, one for the head of the incoming shot and one for the tail of the outgoing shot. The head cutter does not cut on the frame line but about 1/8 inch into the bottom of the preceding unwanted frame. **(SEE 18-10)**

The neg cutter then scrapes the emulsion off of this overlap with a small tool on the splicer. This scraped area allows the two pieces of film to bond together, which would not be possible if the emulsion were left on. A small amount of film cement is applied to the scraped overlap to create the bond. **(SEE 18-11)** If two shots

18-11

The previous shot is laid on top of the overlap.

© Photo courtesy of Bruce Mamer.

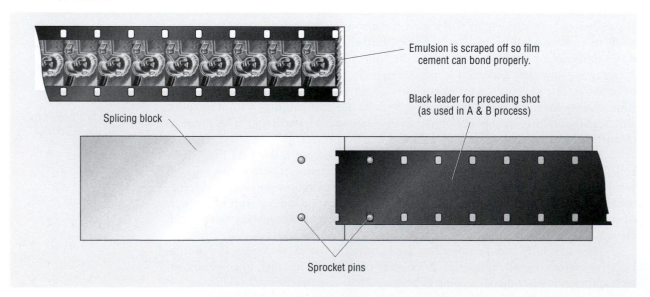

Emulsion is scraped off so film cement can bond properly.

Black leader for preceding shot
(as used in A & B process)

Splicing block

Sprocket pins

were cut together, this overlap would be visible as the film is projected, a small blip appearing on the bottom of the frame at every cut. The A & B process masks this by overlapping the cut on black leader. The cement splicing destroys the frames that are used for the overlap, an important consideration while cutting your film. (See "Notes and Cautions" later in this chapter.)

The cement splicer has a small heating element in its base that keeps the splicer warm. This heat reduces the time it takes a splice to bond from about one minute to roughly 15 seconds. The two pieces of film are not glued together; they are welded together. The splices should, if anything, be stronger than the film itself.

A & B Rolling Picture

When working from an edited workprint, the neg cutter goes through the film and records the beginning and ending edge numbers of each individual shot, counting from the edge numbers to the actual frame where the cut is. In the NLE approach, the neg cutter simply consults the EDL for beginning and ending numbers. If the first shot runs from, for example, edge number 3247 minus 9 frames to 3291 plus 17 frames, the neg cutter will go to the original and pull out that piece.

The process of *A & B rolling*, also referred to descriptively as *checkerboarding*, places black leader between alternating shots. This is done on the synchronizer with the edited workprint set up in a gang to act as a guide. The *SMPTE Universal leader (countdown leader)* is put on the B roll, and the first shot is put on the A roll. **(SEE 18-12)** Although it rarely works out this precisely, the A & B configuration puts the odd-numbered shots on the A roll and the even-numbered shots on the B roll (discussed in chapter 16). This leaves the original film with no image-to-image cuts. All shots are cut to black leader at both the head and the tail. The black leader between shots is the same length, frame for frame, as the shot on the opposing roll. As one might suspect, the reasons for doing this are similar to those for preparing for the mix.

Understanding the rationale for A & B rolling requires jumping forward to what the lab does with these rolls prior to and in printing. With a virgin piece of raw stock, a contact print from the A & B rolls is made in separate passes on a lab's printer. The A roll is generally printed first, printing the odd-numbered shots. In complete darkness, the raw stock is then rewound to the appropriate marks on the standardized leaders, and the B roll is printed. This second pass drops in all of the

18-12

In the A & B–rolling process, alternating shots are placed on separate rolls, with shots on the opposing roll replaced with black leader.

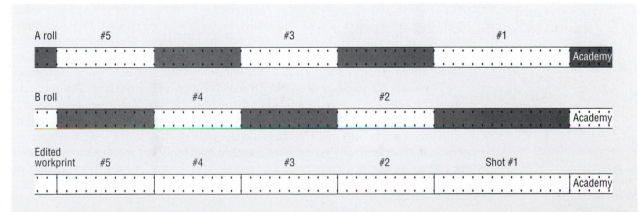

shots missing from the printing of the A roll. The optical master is printed at a separate gate that exposes just the edge of the film. It is run at the same time as one of the A & B rolls.

The following are what A & B rolling allows the lab to do. Be aware that the negative cutter has no control over these elements, although he or she can usually answer many questions about the printing process. These are aspects of finishing at a lab that are facilitated by the neg cutter's efforts:

- Color and exposure corrections[1]

- Optical effects: fades, dissolves, superimpositions, and the like

- The creation of "invisible splices"

Color and exposure corrections Prior to printing your film, the A & B rolls take another trip to the Hazeltine (see chapter 7). The rolls are loaded separately into the Hazeltine, and the *timer* goes through the entire film and analyzes each individual shot for color and exposure, a process called **timing** or, in some quarters, *grading.*

The *printer lights* for each individual shot—the actual volumes of red, green, and blue—are thus determined on the Hazeltine. The printer affords extensive opportunity to manipulate the character of the film's shots. The transmission of each primary color of light is broken down into a series of printer points, settings that correspond to the variable size of the valve that is in the path of each light and thus represent increments in the intensity of the individual colors. There are 50 points represented on a dial that controls the valve, with 25 theoretically representing perfect exposure. If a shot was overexposed on-location, the lights can be dialed to compensate. If a shot is too red, the appropriate light could be dialed to contribute less red, and so on. The timer looks at each shot and uses his or her best judgment for both the appropriate color and the appropriate exposure level. Although modern printers can "fire on a frame," the black leader between alternating shots gives the printer lights time to adjust for each individual shot.

These dials clearly allow substantial control over the image. Although there are limits, many difficulties can be corrected if there is enough information in the original. Material that cannot be corrected is that which is so overexposed or underexposed that there is no detail. Changes will generally affect the contrast range of the image as well as the amount of grain.

Another critical consideration is that the timer cannot manipulate specific elements in the frame, such as a blown-out window, without affecting the rest of the scene. Think back to the example of the man in front of the window: If the window area is overexposed, you cannot bring it down without bringing down the exposure of all of the interior elements. Nor can you change the color in just one area of the frame without affecting other areas. If you had not corrected for the exterior color temperature with filters or gels, you could not subtract the resulting blue cast without affecting the interior. To do so would, for instance, make the lamp much redder. Part of the deserved love affair with digital timing is that individual areas can be addressed, although our man in front of the window would still be a tough customer.

Exposure on-location is a tricky beast, as is printing from one film medium to another. Like sound, images frequently need to be tweaked for exposures that are slightly off or, simply, need a slight assist in being printed from the original to a print stock or an intermediate. Labs do the bulk of their work with commercial clients and thus generally go for photographic normal. They will try to make facial tones accurate and generally push for realistic representation. If you have color or

1. With black-and-white film, exposure is the only variable considered at this point.

exposure effects built into your shooting, you must alert the lab to that fact. Individual timers have their own preferences, and experienced DPs will find timers who have compatible tastes and will work closely with them throughout the printing-related aspects of a film.

Beginners tend to see this final printing phase as an opportunity to correct mistakes, as it most certainly is. Experienced DPs, however, are highly conversant with printer lights, and the role these lights play influences their plans before the first instrument is set up on a shoot. In fact, much of the discussion of lighting in part IV can be tied to the theory behind printer lights, but mastering basic exposure technique precedes these considerations.

Optical effects The A & B method allows the lab to execute the *optical effects*—dissolves, fades, superimpositions, and so on—that were planned in the editorial process. Dissolves, as well as supers and matte shots, clearly require two shots to be printed together. This would be impossible if a single roll of conformed original were used. The A & B method allows images to be on both rolls concurrently and thus printed together.

As the color and the exposure are analyzed and recorded on the Hazeltine, the effects indicated on the marked workprint are similarly logged. In the path of the light in a printer, there is a master shutter—the **fader unit** (see figure 7-10)—which is opened and closed to create the overall effects. All fades and dissolves are created by this fader. A 24-frame fade programmed into the printer instructs the fader to close in one second at the appropriate point. A dissolve has a fade-out start at the programmed point on one roll. When the second roll is printed, a fade-in is started at the same point. The result of the fade-out on top of the fade-in is the dissolve.

On the workprint a dissolve is marked in the manner explained earlier; the cut in the workprint always represents the midpoint of the dissolve, that is, the point where there is an equal amount of each image. The negative cutter extends the shot past the center point represented in the workprint. If it is a 24-frame dissolve, the negative cutter will extend each shot an extra 12 frames on the appropriate roll. **(SEE 18-13)**

To understand the requirements of dissolves, there are two issues that must be clear. The first is that the frames at the splice in the workprint are in the same position on the A & B rolls. Some people make the mistake of thinking that because

18-13

The dissolve occupies the same number of frames in the final film as its corresponding straight cut does in the workprint. The overlap portions simply are extended on the A & B rolls.

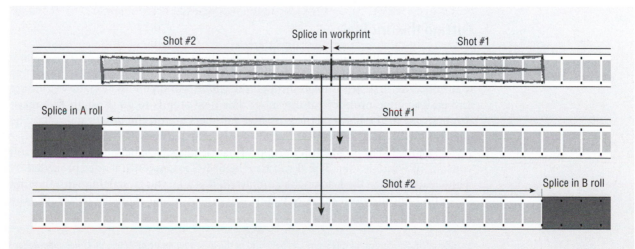

the shots are being extended that the film somehow becomes longer, thus requiring some adjustments in the mixtracks. As figure 18-13 illustrates, the dissolve occupies the same area, that is, number of frames, in the final film as its corresponding straight cut does in the workprint. The overlap portions of the shots are simply extended on the A & B rolls.

The second consideration is that there must be more usable frames than are represented in the edited workprint. In a 1-second dissolve, the negative cutter will employ the 12 frames after the cut on the outgoing shot. They must be frames that you want to be visible. The same is true on the head of the incoming shot. You cannot cut on the last frame of a shot and then call for a dissolve in the edited workprint. If you did, the extended part of the dissolve would overlap into the next shot.

Superimpositions and matte shots are also printed together in the A & B method. A super is created by putting images in the same place on the A roll and on the B roll. The lab adjusts exposure to compensate for two pieces of film being printed together. Similarly, mattes are generally made of two or more components printed together. One part of the frame might be blocked off on one shot while the opposite side is blocked off on another piece of film. The two are printed together in the A & B method to produce a composite shot. Mattes and supers may have other requirements that should be clarified with both the lab and the negative cutter.

Numerous situations arise in which more than two images need to be combined, thus requiring the addition of more rolls—C rolls, D rolls, et cetera. Special effects and matte shots are the clearest examples of this. Ivan Reitman's *Ghostbusters* (1984) has an excellent example of this in the scenes of the giant marshmallow man coming down the street to confront the ghostbusters.[2] The shot consists of three elements: an animated miniature of the marshmallow man walking down a city street, a painted backdrop of the cityscape at night, and the ghostbusters on a roof with their backs to the camera. Many special-effects shots and animations are even more complicated. A shot from George Lucas's *Star Wars* (1977) is reported to have had more than 70 separate elements. In both of these examples, the elements would be combined before final printing, but the theory is the same.

Invisible splices The term *invisible splicing* refers to a method of masking the glitches inherent in cement-splicing the film together. As stated, the cement splicer works by overlapping a small piece of the incoming shot on the outgoing shot. Left uncovered, this tab is visible when the film is projected. In the A & B method, this scraped tab is always covered by black leader laid on top of it and cemented. The picture is scraped and then covered by the outgoing frame of black leader.

Cutting the Original

Negative cutters have their jobs broken down into efficient systems. Although there may be some minor differences in approach, the following is the general sequence of events. The first step is to go through the edited workprint and log the beginning and ending edge numbers of the shots. The next step is to go through the uncut original and find what sequences of edge numbers are on the individual rolls. The neg cutter will then have some idea of where all the pieces will be found.

The next step is to set up the appropriate leaders. The beginning of the A roll consists of white leader. The B roll has the SMPTE Universal leader preceded by white leader. Once the leaders are completed, it is a matter of starting with the first shot and building both the A & B rolls from the original. The neg cutter gets the

2. A detailed description of this scene can be found in the June 1984 issue of *American Cinematographer*.

edge numbers from the first shot and determines on which roll of original it can be found. He or she then winds through the appropriate roll until the shot is found. While winding through the original, the neg cutter rolls the film gently but not to the point of its being loose on the reel; any snapping or undue stress that will cause the layers of film to grind against one another is avoided. The shot is carefully cut out of the original with a pair of scissors, pulling the piece indicated in the edited workprint. The neg cutter actually pulls out an extra one and a half frames on either end of the shot, which are needed for handling and the area to be scraped on the cement splicer.

This first shot is then cut onto the A roll at the place indicated in the workprint or EDL. The B roll has black leader across from this first shot. Black leader is cut to the end of the first shot, with the second shot being cut onto the B roll, and so on. By this method a new version of the film is built out of the original.

As mentioned earlier, commercial feature films rarely cut the original. It is always kept intact, and all cutting is done with duplicates of the original, often the beginning of a complicated family tree of interpositives and internegatives. The film that you see at the theater may be many generations removed from the original piece of raw stock that was exposed in the camera on-location.

Strapped for cash, many students decide to conform their own originals. This is an acceptable route, although there are considerable risks. The more you get into film, the more the idea of touching the original becomes an issue of substantial concern. Any handling involves risk. When you start conforming, be as prepared as conceivably possible. If any element of the process gets confused or messy, the whole effort can start on a downward spiral, which at this stage jeopardizes the time, effort, money, and, most significantly, emotion you have invested in the project. This is why most people turn the process over to a professional.

Notes and Cautions

Whether you intend to go to a negative cutter or do the conforming yourself, there are some basic considerations that should inform the process.

☑ All communication about specific shots, with both the negative cutter and the lab, is done in terms of footage and frames. The "Picture Start" frame in the Universal leader is stated as 0 feet, 0 frames, and everything is counted from there. If you have a shot that needs special attention, you would tell the lab or negative cutter that a shot at such and such a spot—say, from 125 feet, 12 frames to 128 feet, 32 frames—needs something done to it. Usually, this refers to alerting the lab to a shot that needs exposure or color correction, but there are also concerns that need to be relayed to the negative cutter.

☑ You should never be scraping black leader. Cement-splicing the tail of each shot presents a problem. The head of each shot feeds into the left of the splicer, so you are always cutting and scraping picture. When you cut the tail of a shot, however, the last frame would theoretically be dropped onto the scraped head of the black leader of the next shot. This scraped part would create a glitch that would be visible. To avoid scraping black leader, you have to orient the film so that you are still scraping picture when you cut the tail of all shots. This usually means bringing the tail of the shot from the right so that it feeds into the left of the cement splicer. **(SEE 18-14)**

This much handling of the fragile original justifiably makes some people nervous. Rather than twisting the film around, you may want to turn the splicer so that it faces away from you and

18-14

To avoid scraping black leader when splicing the tail of a shot, orient the film so that you are always scraping picture.

Splicing block

© Cengage Learning

move to the opposite side of the table to make all of your tail cuts. You will get a lot of exercise this way. Most neg cutters actually do all of the head splices on one pass and all the tail splices on a second pass.

☑ The lost frames, referred to as **splicing frames**, constitute one of the most difficult mechanical editing concepts to understand. It concerns how the requirements of the negative cutter affect the way you cut your film—specifically, how you need to account for the frames that are ruined in cement splicing.

All frames of the unedited workprint have precise corresponding frames in the original. Thus, if you have to cut and scrape frames when cement-splicing the original, the ruined frames correspond to real frames in the workprint. These corresponding frames must be identified, catalogued, and set aside. If they are used elsewhere in the edited workprint, the negative cutter is faced with a problem. Looking at a piece of workprint and its corresponding original should clarify this. **(SEE 18-15)** If you were to pull section A from your raw footage and use it in your edited workprint, the negative cutter would go to the original film and pull that piece, plus an extra one and a half frames on either side of A, piece B in the original. Frames 2 and 3 are needed for the scraped emulsion overlap required by the cement splicer. The negative cutter also pulls frames 1 and 4 because they provide safe handling of the film. Frames 1, 2, 3, and 4 in the original are thus destroyed in the negative-cutting process.

Therein lies the problem. These ruined frames have corresponding frames that are intact in the workprint and could potentially, but wrongly, be used elsewhere in the EWP. If these workprint frames are used later in the film, the neg cutter will not find them when attempting to pull the shot. The shot in the original must be the same length as the one in the edited workprint or there will be sync problems with the sound. The negative cutter has to do some fancy footwork to fix your mistake, usually pulling the necessary number of frames from the tail of the shot or lengthening the next shot. Although these solutions can work, they can alter sync for individual shots and cause cuts to be less fluid.

A mistake like this represents poor planning on the editor's part. You must take into account that these frames are going to be destroyed and simply discard two frames, rounded up from one and a half, at the beginning and the end of every shot that will be used in your film. Do not throw them away; mark them so that you will know they are off limits if you consider using them later.

As with dissolves, this invariably leads to confusion about whether this makes the film longer. "If I have to add a frame and a half, doesn't that affect my sound?" The answer is no. The piece that is represented in the workprint coincides with the

18-15

Always keep in mind that two frames on each side of a shot must be sacrificed when making the A & B rolls.

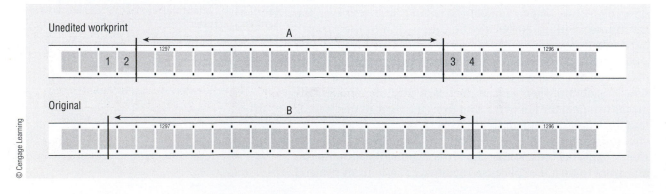

piece that will be in the conformed original frame for frame. The lost frames pertain solely to what is in your outtakes. The frames the negative cutter will need for cement splicing must remain intact in the unused portion of the workprint.

This rarely becomes a problem but it does require attention to avoid mistakes. Shots have flash frames at the head and the tail, and sync shots have the starting and finishing information that make mistakes almost impossible. It becomes a problem only when you want to use different sections of the same shot at different places in the edited workprint.

Again, matchback software is able to track whether these frames are available for the conformist. If it catches a mistake, there will be a warning message, and you should be able to go in and trim a few frames from the offending shot to make it conformable. You will want to run the matchback program occasionally during editing to check for problems so that they can be corrected as you go. All problems must be addressed before you have anyone build sound against locked picture.

☑ In the negative process, creating fades and stretches of black requires special handling. Using black leader on both the A & B rolls does not produce black on the resulting film print. Because everything is reversed, black leader produces clear or nearly clear film. Color negative, whether still or motion picture, has an orange cast to it, which is simply the shade that creates black in the resulting prints. So if you are working in color, you need to use **orange mask** on the A & B rolls, called a fade window, to create black in an answer print. Fades require unusual treatment, with the two shots to be faded uncharacteristically cut together on one roll and the orange mask on the opposing roll. **(SEE 18-16)** The fader is closed on the picture during the pass on the first roll. For the orange mask on the opposing roll, the fader is opened to produce black. In essence, you are really dissolving to black. A & B rolling negative requires knowing how the negative gets printed. Be sure to check everything with the lab if you are conforming your own film.

☑ Special care must be taken when doing fast cutting—cutting of shots less than one second long. Any piece shorter than 20 frames has the potential to lack an edge number, which would leave the negative cutter without a clue as to where the piece came from. As you are cutting, pieces that do not have an edge number must be identified and logged for the conformist. The best way to do this is to lay the film that you intend to take the piece out of on a sheet of white paper. Put a pencil mark in each sprocket hole of the intended piece from one edge number to the next. Transfer the edge numbers to the page as well. **(SEE 18-17)** When you are done, you will have a line of more than 20 dots with the edge numbers indicated. Draw a line on the frames that are being used in the shot. This page is given to the negative

18-16

Fades require the two shots to be cut together, with orange mask on the opposing roll.

Fade-out and fade-in in workprint

Cut on one original role

Orange mask on opposing roll

Film pieces that do not have edge numbers must be identified and logged on paper for the negative cutter.

Section used

6105 6104

cutter, with a note saying that this is the shot at this location in the film. Again, the location of the shot is indicated in footage and frames from "Picture Start."

☑ Nothing in the editorial process requires more practice than cement splicing. Considering that you are working with the original, it behooves you to become completely comfortable with the procedure before tackling the job. Scraping the emulsion on the overlap without damaging the frame is tricky. Try scraping many test frames, practicing not ripping sprocket holes or weakening the film. Practice applying the film cement so that it does not spread onto adjacent frames. These splices should be tested by gently twisting them to see if the edges separate. Holding the film in both hands and snapping it is the final test. The splice should be stronger than the rest of the film. Be absolutely comfortable with splicing before attacking your original.

As stated earlier, there is modest debate among film professionals about whether to mix first or conform first. Most filmmakers mix first. If there are any structural problems with the film, they will presumably show up as you watch it in all its glory in the mixing studio. Though it may be costly, you can always terminate the mix and return to the editing room. This would not be possible if the film were already conformed.

The counterargument is that if there are any errors or miscalculations in the negative cutting, the audio tracks may need adjustments to compensate. If you have already mixed, all sound remaining in sync depends on the film's being conformed frame for frame to the edited workprint. Given the complications of the process, lost frames, and so on, mistakes are occasionally made. If the guidelines have been followed and the negative cutter is an experienced professional, however, this should not be an issue.

Again, negative cutting may seem mechanical and tedious, but it is a critical process that must be done meticulously. Mistakes in conforming can be disastrous. Any errors or carelessness will result in ruined shots, difficulties with synced sound, or prints with dirt and scratches.

I worked on a film in which the negative cutter misread the numbers on one shot, a rare but costly occurrence. **(SEE 18-18)** Rather than pull piece A, he pulled piece B and spliced it into the roll. When the wrong piece is pulled, what resulting problem is immediately noticeable? Sync. When the otherwise perfect answer print was projected, we were stunned to see one shot in which the dialogue and the picture were completely mismatched. Because the piece used was in front of the piece we wanted, correcting the head of the shot was no problem.

Misreading the edge numbers on a shot while conforming—pulling piece B rather than piece A, for example—results in irrevocably lost frames and a disruption of sync.

A

Destroyed frames

B

The incorrect tail cut, however, occurred in the middle of the desired shot, thus causing substantial problems. The one and a half frames already pulled and destroyed were frames intended for the film. There was no getting them back. We were left with the unenviable choice of finding another shot with sound timed similarly to the already mixed sound or accepting a slight (two-frame) jump in the footage and a disruption of sync for the length of the shot. No suitable replacement shot worked, and the latter solution was reluctantly agreed upon. Though many viewers do not even notice it, I still flinch when I see the jump.

As suggested earlier, the film and NLE paths we have been following merge at this point. Proceeding under the assumption that a film print is the final goal, these chapters have sketched out two different routes by which to arrive at the same place. Regardless of your editing approach, the products of the mixing and the negative-cutting processes are the elements required to make a final print.

The Final Print

With all of the elements created, it is time to produce an *answer print*—the first attempt at a final print of your film. The lab you choose needs a minimum of four elements to make a print: the A roll, the B roll, the optical master, and the marked edited workprint. If it is a complicated job, printing may require C rolls, D rolls, or more.

In many ways, this last process is the most exhilarating. It is when you finally get to see a project that you have put so much into come to fruition. Be prepared for some disappointments as well. Too often beginning filmmakers expect the lab to magically create perfect exposures and correct all the deficiencies in shooting. Making an answer print involves many variables, and there may be trade-offs between what the filmmaker desires and what the lab can actually do. The lab staff make their best attempt to produce the print you want, but they cannot work miracles.

There is a certain irony in that the more ambitious you have been in lighting, filtering, and exposure, the harder the job is for the lab and the timer. A flat image is easy to time. When there are exposure gradations and color effects in an image, the timer may legitimately become confused about what you are attempting to achieve. Communication is the key. Let the timer know what you have done and what you want. Frankly, the biggest variable in printing is how well you have executed the shots. If the negative is exposed properly and the lighting volume and quality are consistent in continuity scenes, the timer's job should be easy. If the shots are a mess, the potential for problems grows.

There is an old joke among filmmakers about fixing films. When presented with problems in preproduction, the saying goes that "We'll fix it in shooting." Problems in shooting will be "fixed in the editing room." Problems in the editing room? "We'll fix it in the mix." And problems at the mix are "fixed in the answer print." This takes on a certain aspect of gallows humor, but the buck stops with the final print. There is no place to fix the film after this. There is a certain painful finality to going to a print.

You need to be aware of some of the pressures involved in finishing. Like the birth of a child, it is a joyous occasion. And, similar to a birth, there can be both a sense of separation and nervous fretting over what this wrinkly, squalling thing will look like to other people.

Reversal Versus Negative

Before discussing printing theory, the different approaches necessary for negative and reversal must be addressed. *Reversal film*, which has all colors and shades rendered normally on the original, is very straightforward. If a film is underexposed, you pump up the light to get a better exposure. If there is too much red in the

original, the lab simply reduces the amount of red in the final print. If there is a light area in the original, it will be light in the print.

In *negative film*, however, everything is the opposite: the lights and the darks are reversed from how they are normally perceived. An underexposed negative is very thin, that is, almost clear, so it would need less light from the printer. An overexposed negative is very dense, or thick, needing more light from the printer. In addition, when the lab increases a color, the result is less of that color in the final print. If there was too much blue in a shot, for example, the lab would, paradoxically, need to increase the amount of blue. This last part is the most difficult to understand, and the novice may not have much immediate need to apply this knowledge. As with everything, though, the long-term goal is to understand every element of the process. And the process of printing—creating the final version of your film—is clearly one that demands significant attention.

Printing Program

As stated earlier, the timer analyzes each shot for color and exposure. The resulting decisions are fed into a computer-generated decision list, called a **printing program**, which runs the printer lights as the A & B rolls are printed. The timer also checks the marked edited workprint for cuts and effects and encodes all such **printing cues**—instructions to the printer lights and the fader unit—into the printing program. This decision list comes in a number of forms but is usually an old-fashioned punched computer strip. Whatever the form, the decision list controls the values at which the red, green, and blue printer lights will be set for each individual shot. It also instructs the fader unit to open and close for dissolves, fades, and any other optical effects.

The following figure shows the beginning of a typical printing program. It represents a simple short film employing just A & B rolls. It had no dissolves or fades and was shot on negative. **(SEE 18-19)** The numbers under the *RD*, *GN*, and *BL* headings represent the red, green, and blue printer light settings for each individual shot. This film had 73 shots, with the cue total being slightly higher (75) because of head and tail leaders. A feature with, for example, 1,200 shots would have 1,200-plus settings. That some numbers are duplicated suggests that material from certain setups was used more than once, a shot/reverse shot in this case.

One of the first shots was evaluated at 22-18-13. Although the precise meaning of these numbers would not be consistent from lab to lab, this suggests that the shot was slightly underexposed and a little too red. Because it is negative, less light is needed to get through the less dense negative. The higher number on the red is what suggests that the red component in the image had to be decreased. When the red is reduced, it affects overall exposure. This explains why the green and blue numbers are lower. The fact that the green light is set higher than the blue suggests that the red being eliminated had a little bit of yellow in it, the mix of red and green producing yellow. Remember, more is less in negative. The shot that was evaluated at 24-16-11 is similar to the one just described. The shot at 28-27-34 would suggest slight overexposure but with too much blue. Indeed, it was tungsten-balanced film shot in daylight without an 85 filter.

When the A roll is printed, the computer decision list created by the timer controls these settings on the light valves in the printer. The transition from shot #6 to #8 is a good representation of what occurs. The printer lights are set for 24-16-11 for shot #6. In the time that the black leader corresponding to shot #7—140 frames, or almost six seconds—is masking the gate, the printer lights are instructed to change to 28-27-34. Again, modern printers can fire on a frame, so this is more theory than practice. Also, 35 mm is not A & B rolled for this very reason.

This particular program had no fades or dissolves, so there are no effects cues. If there had been, the computerized printing program would have had instructions to the fader unit to create effects. Both the fader unit and the light valves require

```
                        PRINTING PROGRAM

            JOB NUMBER:      DATE:        SCENES:  73
            EFFECTS  CUES    MIN CUE     LAST CUE    MAX FPM
   A ROLL            36       4   00      357  00     2000
   B ROLL            37       5   00      357  00     2500
```

SCENE	FEET	FRAMES	A ROLL	RD	GN	BL	B ROLL	RD	GN	BL
	0000	25	ZC	00	00	00				
0001	0008	03					LC	10	13	06
0002	0013	08	LC	22	18	13				
0003	0014	20					LC	16	16	09
0004	0060	25	LC	22	18	13				
0005	0073	05					LC	16	16	09
0006	0074	15	LC	24	16	11				
0007	0077	05					LC	24	16	11
0008	0080	25	LC	28	27	34				

18-19

The beginning of a typical printing program for a short film employing A & B rolls.

© Cengage Learning

some response time to reopen or adjust to the programmed values. Short shots may not allow the fader unit or light valves sufficient time to adjust to new settings. Individual labs may require different response times, but it is generally around one second. If your shots are very short, you may have to put some of them on a C roll.

First Answer Print

The first answer print should be evaluated in terms of your standards. Although labs generally do a highly professional job, the print is rarely perfect—perfection being virtually impossible to achieve with so many variables. Sometimes you have to look at a print and decide whether it is worth the cost and the effort to correct a few minor mistakes. If it is good enough, the lab makes all subsequent *release prints*—those designed specifically for distribution—from the printing program that has been created. If there are problems, you may have to negotiate with the lab about the cost of another answer print. If you can demonstrate that the mistakes were the lab's fault, the lab should absorb the cost of or cut a deal for the next print. If the mistakes are a matter of poor preparation or communication on your part, you will have to foot the bill for the next answer print.

A key factor is that the lab tries to make the best print according to its established standards. This is as it should be; but, if you are going for any unconventional effects, some kind of discussion of your goals is required. Effective communication with the timer takes experience and a clear understanding of the variables. Many times what the timer sees and what you are hoping to see may be two completely different things; it may be that what you are hoping to see is not possible. More often than not, disparities result because you have not communicated your desires effectively. In the final analysis, it may be that printing as well as shooting is an

inexact art. There are situations in which even the most capable cinematographers are stymied by elements that are beyond their control.

In chapter 14, there is a story about a scene involving two people sneaking up on a house as the sun rises. The character of the shots was different enough that the filmmakers pinned their hopes on the answer print. Their first step was to alert the lab to a potential problem. Not being familiar with a scene's context, the timer would have a limited way of knowing that it had problems. Once alerted, the timer can use only personal judgment to get the scene close. Although there are undoubtedly timers who can look at a negative and perfectly predict the look of the film, most mere mortals do not know precisely what a sequence is going to look like until it is printed. Once you see how close you have gotten, you can take another shot at it. In the sunrise story, it took three tries to get the printer lights set appropriately for the scene.

Again, be aware that most labs do the bulk of their work with commercial clients and thus are generally geared toward a reasonably straightforward photographic normal image: flesh tones are normal, colors are true, exposure is within a certain range, and so on. If you want to create unorthodox images, this is simply a reality that you must accept. If you have specific aims in either correcting or not correcting a shot, they must be clearly communicated to the lab both verbally and in writing. As was stated earlier, all communication is done in footage and frames, which are counted from the "Picture Start" frame in the SMPTE Universal leader as 0 feet, 0 frames in the synchronizer.

The finality of these processes should be re-emphasized. Corrections to create a change in a print require going back into the A & B rolls, a proposition that is very expensive and in some cases completely impossible. In a film about chemical contaminants, for example, a director absentmindedly, and foolishly, used a 20-frame shot that included an identifiable product name. He had secured a well-known narrator and made multiple prints, anticipating wide interest in the film. When company representatives saw the film, they threatened legal action if the shot was not immediately removed. There was some unsubstantiated evidence that the company had produced the contaminant, but the director could never have afforded the protracted lawsuit that the company threatened to bring.

His options were all bad. On a final print, the picture and the optical sound track are printed side by side. There is no way to replace one without affecting the other. He could go to every print and cut out the 20 frames, but the problem is that he would eliminate 20 frames of sound. Because of the displacement (see chapter 10), it would not even be the corresponding sound. Another approach would be for him to go back to his A & B rolls and cut out the offending shot, but then he would have to remix the sound and replace the existing prints, both expensive propositions. To avoid remixing, he could replace the shot in the A & B rolls with another shot but would, again, have to reprint everything. Someone suggested that he take a permanent marker and blot out the offending shot, a wisecrack proposal until we noticed his expression, suggesting he was actually considering it.

He finally decided to cut the 20 frames out of one print, a radical action given the cost of an individual print. Mercifully, the sound that was cut turned out to be unimportant, and he cut the 20 frames out of the rest of the prints. While bemoaning his fate over a few beers, another documentary filmmaker pointed out the obvious: the shot should never have been there in the first place. If you are going to take on a corporation, go ahead and do so straightforwardly. Do not let 20 frames endanger an otherwise secure $80,000 project.

For most students and independents, a final print is just that: final. Commercial feature films can experiment with different versions because, again, most producers never cut the original. For those of you who have to cut the original, everything must be exactly the way you want it before you embark on any of these processes.

Despite the countless potential headaches that have been described, the creation of the answer print is the most exciting part of filmmaking. You finally have something you can hold in your hands. This is what all the effort, agony, and tears have gone toward. With the hurdles that had to be jumped and the peaks that had to be scaled to reach that moment, there is nothing as satisfying as seeing a project, no matter how complex or simple, come to fruition. And the more you understand the requirements of each individual step, the more those hurdles and peaks will become surmountable. Once you have an acceptable answer print and begin making release prints, your film takes on an entirely different life: that of distribution and exhibition.

Alternatives

The alternatives are finishing in your own NLE, doing a DI, or doing an online finish in the computer. The NLE approach has been covered and if no film prints are envisioned, a DI is not necessary. With a DI the object is to create a perfect video version of the project. Either the show can be built from high-res transfers (most common), the neg can be conformed, or the shots can be transferred from uncut rolls. All color correction and a host of other manipulations can occur within the software of your choice, generally in a dedicated image program like Discreet's Flame or Inferno. The digital files for each frame are then written to film, and one or more master versions are created. Prints have to be struck from the master, and although the master may not go through the conventional timing, some fiddling may be required to get the prints right. Sometimes a lot of fiddling is required.

A file-based finish can proceed in a number of ways. If the project was edited on low-resolution versions, EDLs can be used to return to high-end originals. The EDLs drive the reconstruction of the project from the low-res copies in the online suite, and the show is rebuilt from beginning to end. Otherwise, the show can be done entirely with high-res media and the finish can be done entirely with these elements. Color correction and any other manipulations can occur at this stage. Given current storage capabilities, shows can be edited on high-res media as well and still return to the online suite for visual sweetening.

Whether the project was shot on file or film, postproduction processes have become highly streamlined. An editor working in Century City can e-mail an EDL to a postproduction facility in Burbank, and a show can be finished from that information. Or the cities could be Jakarta and Paris for that matter. Episodic TV shows used to conform the neg in case prints should ever need to be struck, but now EDLs and cut lists give access to the required elements if the need should ever arise for a rebuilt version.

End Result

Once you have a finished product, whether on film or video, more hard work of a different sort ensues: getting your project seen. In certain ways this struggle can be even more demanding and draining than the production itself, particularly for independent filmmakers. Although venues for nonmainstream films are becoming more plentiful, it is still a challenge to get a project out there and seen even if it is incredibly good. Festivals offer opportunities to get attention. There are also the "markets," convention-like events where indies can screen work for potential distributors. The direct-to-video market may hold possibilities as well, although the film you are making may not conform to the product commonly found on the shelf at your local video store.

After the deluge of high expectations in the late 1990s, the Web has just recently started to produce useful results—but when it started the floodgates opened. With sites like YouTube and Vimeo and technologies like the iPad and smartphones, the movement toward downloadable media has started to emulate what is happening in the music industry. Festivals like South by Southwest in Austin, Texas, are playing a big role in getting work out and seen. The social networks and blogger worlds are showing and directing the ambitiously curious to a series of new works, like the so-called mumblecore group of films that are achieving some Web-based popularity. If you can make a feature for a few thousand dollars and get some buzz going, you can make some money. Stepping up to the next level will be a challenge. With all the great strides, the Web remains a question mark when it comes to film/video presentation and financial return.

While independents scramble to be recognized, we hear about only the successes. The story behind Robert Rodriguez's *El Mariachi* (1992) is generally well known: studio executives saw it, snapped it up immediately, and offered the maker opportunities for future work. We rarely hear about the films that languish in some netherworld because they are not good enough or are perceived as unable to command a wide enough audience to attract a distributor. Despite the many pitfalls, the growing number of successful films—both independent and commercial—is greatly encouraging. Somebody has to make them, and it might as well be you. But this is a different story that goes far beyond the one being told here. For students and novice independents, the key is to work, get experience, and, maybe most important, learn, learn, learn from reading, watching movies, and working with the experienced folk who can help guide the way. You have to pay your dues and you have to make the films before anyone is going to come to see them.

Glossary

0 VU *See* **zero VU**

⅓–⅔ rule A rule stating that one-third of the depth of field is in front of the focus point and two-thirds is behind it.

1st AC *See* **first assistant cameraperson**

2nd AC *See* **second assistant cameraperson**

16mm The midsized film format used in many independent film projects and most intermediate and advanced film production classes.

23.98 An alternative to 24-frame video that allows media to be played and recorded on NTSC video equipment.

24-frame progressive *See* **24p**

24p A digital video format that records 24 frames of progressive video per second, although much of what we refer to as 24p is actually shot at 23.98.

30-degree rule The principle that says an editor should not cut toward a subject in a straight line; that is, if a subject is shot from one angle, the next shot should vary by at least 30 degrees from an axis drawn from the original camera position to the subject.

35mm The format in which the bulk of professional work is shot.

180-degree rule The principle used to create an understandable sense of the space in which the action is occurring. Also called *axis of action* and the *line*.

A & B rolling For picture, it entails alternating the original on separate rolls to facilitate the final print. Also called *checkerboarding*. In sound tracks, it entails alternating the sync sound on two tracks to facilitate mixdown and general track building.

A & B rolls The two different rolls into which the camera original is separated to facilitate printing effects.

A, B, C, and D frames A way of identifying the field arrangement of film frames that have been transferred to video.

Academy 2 The single frame with the number 2 at the end of the countdown leader.

Academy leader *See* **SMPTE Universal leader**

acoustics The total effect of sound and how it travels in a given space and particularly how it reflects off of surfaces before arriving at the microphone or the ear.

action The interrelationship of the pull-down claw, the shutter, and the other elements of the basic mechanism of the film camera.

AD *See* **assistant director**

adapter A connector that converts one type of audio or video plug to another.

ADR *See* **automated dialogue replacement**

Advanced Authoring Format (AAF) A framework that allows a large amount of digital information to be imported or exported to different software programs.

aerial shot A shot executed from a helicopter or an airplane.

AF Auto focus—An electronic sensor that automatically sets focus distance on a lens. It is usually center-weighted, although can be changed on most complex cameras.

AGC *See* **automatic gain control**

AIFF *See* **Audio Interchange File Format**

ambience The character of the underlying sound in any given space.

ambience overlaps The overlapping of ambience between sync takes that allows the rerecording mixer to soften any potential harshness of the cut. Also called *handles*.

ambient light The general level of light in a space; the amount of light reflected off of walls and other surfaces from the source(s) back into the space.

American Society of Cinematographers (ASC) An organization dedicated to excellence in and the aesthetic appreciation of film and digital cinematography; publishes the *American Cinematographer Manual*.

amperes A rating of the load-bearing potential of individual circuits. Also called *amps*.

amplitude A measure of the strength (loudness) of a sound signal, determined by the distance from the baseline of the sound wave to the peak.

amps *See* **amperes**

analog video The encoding of an electrical signal on a conventional magnetic videotape.

animation A single-framing technique that puts inanimate objects in motion.

answer print The first attempt at creating a final print of a film. *See also* **married print**.

anticipatory camera Rehearsed, highly choreographed camera movement that leads rather than responds to subject movement.

antihalation backing The antireflection coating on a film stock.

aperture The opening inside the camera where each individual frame is exposed. Also called *gate*. The term is also used to refer to the *f*-stop opening.

aperture plate The polished metal plate inside the camera that guides the film to the gate, where it is exposed. Also called *film guide*.

apprentice editor The person responsible for many of the routine procedures that the editor does not do, such as syncing up, stringing out, configuring mixtracks, and so on.

area selection mode The function on DSLRs and many other digital still cameras that allows the user to select the area of the frame to target for automatic focus.

arm A crane-style device that has a suspended camera controlled electronically by a remote.

art department The crewmembers involved in the design elements of the image.

art director An expert in materials and building; responsible for executing the production designer's plans.

ASA Stands for *American Standards Association*. *See* **exposure index (EI)**.

ASC Stands for *American Society of Cinematographers*

aspect ratio The film frame's width-to-height relationship.

assistant director (AD) The crewmember primarily responsible for organization and efficiency on the set.

assistant editor The person responsible for the overall organization of the editing room.

attack The first frame of an individual recorded sound.

Audio Interchange File Format (AIFF) An audio file format standard used for storing sound data for personal computers and other electronic audio devices.

audio mixing The mixdown of the mixtracks created in editing. Also called *final audio mixdown*.

audio tracks The generic term for individual tracks of sound in an NLE timeline.

automated dialogue replacement (ADR) A method of creating and replacing dialogue in postproduction. Previously known as *looping*.

automatic gain control (AGC) The function on a sound recorder that reads the audio signal and automatically adjusts the recording to an appropriate level. Also called *automatic level control (ALC)*.

automatic level control (ALC) *See* **automatic gain control (AGC)**

automatic-threading mechanism A feature on some cameras designed to feed the film unassisted.

axis of action *See* **180-degree rule**

baby legs Short tripod legs used for low-angle shots.

background noise Interfering sounds such as those from distant traffic, refrigerators, fans, and so on.

backlight A lighting instrument generally positioned above and behind the subject to provide texture and definition to the hair and separation from the background.

backwinding A function that allows the basic mechanism of the camera to be driven backward with a hand crank.

ball joint leveling A design feature used for leveling a tripod head.

banana plugs Audio connectors in which the individual leads are divided into separate plugs.

barn doors Adjustable black metal doors mounted on the front of a lighting instrument that are used to focus the beam.

barney A padded hood used to dampen unwanted camera noise.

base The acetate vehicle for the emulsion in the construction of the film stock.

batch capture An NLE software function that is used to capture a number of clips in one continuous procedure after logging them.

best boy The gaffer's first assistant.

Betacam SP An analog broadcast standard format that is heavily employed in television news and industrial applications. *SP* stands for *superior performance*.

bin The window in an NLE program where unedited shots and audio clips are stored.

bird's-eye view A shot from above that tends to have a godlike, omniscient perspective. Also called *overhead shot*.

Black Magic Cinema Camera Introduced during the writing of this text, a digital video camera that has the potential to further revolutionize the accessibility of digital media. Released at an unheard of price point, it should obtain widespread acceptance if it proves technically durable.

black wrap A foil material that is, among other things, wrapped around the barn doors of instruments to cut light.

BLM *See* **boundary layer microphone**

blocking for the camera Staging action for the camera.

board *See* **storyboard**

boom operator The crewmember who holds the mic on a boom.

boundary layer microphone (BLM) A small, flat mic designed to sit on a surface or be taped to a wall.

breaker box Generally, the main fuse box in a building.

breathing An effect created by the moving front element of the lens; a slight zooming effect that is a by-product of a rack focus.

broadcast quality A nominally objective set of standards that represents the industry requirements for a video image that is of sufficient quality to be broadcast.

cable puller A sound crewmember who helps with setup, keeps the mic cords out of the way during the shot, and often takes care of the sound logs.

callbacks Used to take a closer look at talent after general auditions.

call sheet A sheet that informs the talent and the crew of the time they must be on the set, how much time is devoted to makeup and hair, and the like.

camcorder A video camera and recorder combined in one unit.

camera mounts An umbrella term that includes tripods, dollies, cranes, the Steadicam, and many other specialized camera mounts. Also called *camera support systems*.

camera noise Problematic sound created by the camera during sync takes.

camera obscura A phenomenon in which light passing through a pinhole creates an upside-down representation.

camera operator On most commercial films, the person who does the actual shooting.

camera package An umbrella term for the camera, lenses, magazines, batteries, battery chargers, tripod, and any other camera needs specific to a shoot.

camera report The daily record of shooting kept by the 1st or 2nd AC. Also called *log*.

camera support systems *See* **camera mounts**

camera tape A 1-inch-wide opaque tape with an adhesive that does not leave a gummy residue. One of its many purposes is to protect the film against light leaks.

Canon plug *See* **XLR plug**

capacitor mics *See* **condenser mics**

capture The acquisition of image and/or audio into a digital environment.

cardioid mics Microphones that pick up sound in a heart-shaped pattern; the pickup is to the front of the mic, to the general exclusion of sound sources behind. Also called *unidirectional mics*.

cement splicer A device that welds shots together; used mainly in preparing rolls for printing. Also called *hot splicer*.

CGI *See* **computer-generated images**

changing bag *See* **photographic darkroom bag**

characteristic curve A representation of a film stock's latitude that plots the density of grains on the negative against rising exposure.

charge-coupled device (CCD) *See* **chip**

cheating Shifting elements in the composition to balance the frame, thus improving an otherwise problematic shot.

checkerboarding *See* **A & B rolling**

chip A flat board behind the lens in a video camera that is covered with thousands of light-sensitive pixels. The chip collects the light and converts it into an electrical signal. Also called *charge-coupled device (CCD)*.

chip chart A chart used by the lab to set printer lights; a series of distinct colors on a chart that are shot at the head of every roll.

cinematographer *See* **director of photography (DP)**

circuit A series of outlets that are tied to a breaker or fuse in the main power box of a building.

clapper/loader *See* **second assistant cameraperson (2nd AC)**

clean room A space that is designed to be clean and dust-free for cutting original film.

clips The generic term in an NLE program for shots and audio takes.

clone A high-end video copy that includes the time code information from the upstream media.

close-up (CU) Essentially a head shot, usually from the top shirt button up. Variations are the *extreme close-up (ECU)* and the *medium close-up (MCU)*.

coaxial A magazine design that has the feed roll in a chamber on one side and the take-up in a second chamber on the other side.

codecs Translation tools that allow you to convert a variety of video standards for general viewing and/or editing in an NLE.

coding A set of numbers printed on both the picture and the sync-sound rolls; used for organization and as a reference for sync.

color balance The way film stocks are designed to respond to different colors of light.

colorist The studio employee who operates the telecine in a film-to-video transfer. The colorist has a wide range of color and exposure controls at his or her disposal.

color space The ratio at which luminance and chrominance (color) are sampled in playback or transfer. Also called *sampling rates*.

color temperature The distinct color of a given light source, measured on the Kelvin (K) scale.

color temperature meter A device for measuring the color temperature of a light source.

component video An industry standard that breaks down the video signal into combined RGB elements plus a luminance component.

composite video The conventional standard that breaks down the video signal into RGB elements.

composition The arrangement of shapes, volumes, and forms within an artistic frame.

compression The discarding of redundant digital information to facilitate the efficient storage and the easy retrieval of video footage. Some digital formats (such as DSLRs) compress very heavily, and a number of high-end formats employ no compression.

computer-generated images (CGI) Film frames and shots that are either manipulated or wholly created in a computer environment.

condenser mics Microphones whose signal is produced by battery power. Also called *capacitor mics*.

conformist *See* **negative cutter**

contact print A print made in a lab by sandwiching the processed original film with a piece of raw stock.

continuity shooting The creation of shots that when cut together appear to be continuous, producing a real-time relationship between the shots.

contrast The play between light and dark in the photographic image.

contrast ratio *See* **lighting ratio**

control track A type of track employed on some videotapes, devoted to a series of pulses that control the playback speed of the tape and that can be used to identify frames.

core A circular piece of plastic on which film is wound.

core adapters Adapters used in the magazine to compensate for the larger centers of cores as opposed to daylight spools.

core loads Raw film stock loaded on cores.

countdown leader *See* **SMPTE Universal leader**

coverage Shooting action from more than one angle to provide options in the editing room.

crane A camera support on a rolling vehicle with a single elevating arm.

crosshairs Two intersecting lines in the center of a camera's viewing screen.

crystal camera A speed-controlled camera required for simultaneous recording of sync sound.

crystal motor *See* **synchronous (sync) motor**

C-stand A commonly used stand for setting nets, flags, silks, and the like. C stands for *Century*.

CU *See* **close-up**

cutaway A shot to which the editor can cut to show an action or solve an editing problem.

cut list *See* **negative cut list**

cuts-only video A basic analog video-editing system that performs only straight cuts from one shot to another.

cutting *See* **editing**

D *See* **daylight**

D-1 The first in a series of high-end video formats made by Sony that are heavily used, particularly in the television industry.

D-5 The most recent in a series of high-end video formats made by Sony; the most widely used format in mastering for broadcast.

dailies The footage from the previous day's work. Also called *rushes*.

DAT *See* **digital audiotape**

datacine A device similar to a telecine but which transfers the film image to data files rather than to videotape.

daylight (D) Photographic white; that is, light at 5,500 K.

daylight spool A camera load that allows film to be loaded in subdued light.

dB *See* **decibel**

DC servo-controlled motor *See* **synchronous (sync) motor**

decay The trailing off of a sound.

decibel (dB) A unit of measurement of the amplitude of sound.

deck control The function of NLE software that controls playback operations of a video camera or deck.

deep focus A theoretical term for an approach that keeps all elements in the frame in sharp focus. *See also* **shallow focus**.

depth of field The distances down the field of the camera's view that remain in sharp focus.

depth-of-field tables Charts of the near and far parameters of focus for the common focal lengths.

detent A click stop at a position on a movable ring on a lens.

DI *See* **Digital Intermediate**

dialogue editor A member of the postproduction crew whose job is to blend and even out the dialogue tracks.

diffused light Indirect light that has passed through a medium or that has reflected off of a textured surface.

Digibeta *See* **Digital Betacam**

digital audiotape (DAT) A digital sound-recording technology.

Digital Betacam A Sony format that is one of the high-end standards for NTSC digital video. Also known as *Digibeta*.

Digital Intermediate (DI) A process for finishing to a film print in which the image is stored as a data file, corrected as desired, and then written to film.

Digital Negative (DNG) A file format that has gained widespread use since its introduction in 2004. It is particularly useful for archival purposes and conversion on analog images.

Digital Video (DV) A family of digital video formats that are designed to a specific set of industry standards to interface with NLE software like Apple's Final Cut Pro.

diopter An adjustable glass element in an eyepiece that allows operators to adjust the camera's viewing system to the peculiarities of their eyes.

director The person who is usually the key decision-making force in most stages of a film.

director of photography (DP) The person responsible for all things photographic in the film, primarily composition and lighting. Also called *cinematographer*.

dissolve A technique in which one shot is faded out while the next shot is faded in on top of it. Also called *lap dissolve*.

dissolve rates Rates of dissolves available at labs; 16, 24, 32, 48, 64, and 96 frames are the standard options.

DNG *See* **digital negative**

dolly A wheeled vehicle with a camera-mounting device on it.

double perf Film stock with sprocket holes on both sides. Also called *two row*.

double-system sound Audio-recording method whereby sound and picture are recorded separately. Used in all film shooting and occasionally in video shooting.

downloading Unloading the film from the camera.

DP *See* **director of photography**

dramatic emphasis Use of the camera to show the action in the desired order and with the desired amplification.

dummy load A ruined roll of raw stock used for practice loading.

Dutch angle *See* **oblique shot**

DV *See* **Digital Video**

DVCAM Considered an industry standard, Sony's Digital Video upgrade from MiniDV that has proven both popular and durable.

DVCPRO Considered an industry standard, Panasonic's initial Digital Video upgrade from MiniDV.

dynamic mics Microphones whose signal is produced by air movement within a magnetic field.

ECU *See* **editing control unit** and/or **extreme close-up**

edge numbering The process of transferring edge numbers onto synced mag stock by hand.

edge numbers Latent numbers encoded in all film stocks by the manufacturer. Also called *key numbers*.

edit controller *See* **editing control unit**

edit decision list (EDL) From an edited video program, a list that represents the start and end points of all shots as well as all visual effects.

edited workprint (EWP) The workprint version of the film that is created during editing.

editing The process of selecting the shots and the sounds that are good and serve the needs of the film, putting them in the desired order, and cutting them to the appropriate lengths in relation to one another. Also called *cutting*.

editing bench A table with rewinds, a viewer, a synchronizer, and other pertinent editing equipment.

editing control unit (ECU) Analog control hardware on which video editing decisions are previewed, made, and programmed. Also called *edit controller*.

editor The head of the editorial staff, responsible for creating a workable version of the film.

EDL *See* **edit decision list**

EI *See* **exposure index**

electricians Lighting-crew members responsible to the gaffer.

elements The sound rolls and the picture rolls used to create the final film print.

ELS *See* **extreme long shot**

emulsion A gelatin bath that contains the silver halide crystals used in exposure.

equalizer A signal processor commonly used to manipulate the quality of sound, cutting or boosting it at specific frequencies.

establishing shot *See* **master shot**

EWP *See* **edited workprint**

expendables Supplies used while shooting, such as spun, gel, cheaters, gaffer's tape, and so on.

exposure index (EI) A numerical rating of a film stock's sensitivity to light. Also referred to as *ASA* (American Standards Association), *ISO* (International Standards Organization), and *film speed*.

extreme close-up (ECU) A very tight close-up, essentially the nose and eyes.

extreme long shot (ELS) A shot in which the subject is far away from the camera.

eye-level shot A shot taken with the camera near the eye level of the subject.

eye light The light used to highlight a subject's eyes.

eyeroom Compositional space given in the direction a character is looking. Also called *looking room*.

fade-in Where the picture comes up from black.

fade-out Where the picture fades to black.

fade rates Lengths of fades that labs will perform; 16, 24, 32, 48, 64, and 96 frames are the standard fade rates.

faders The sliding amplitude controls on a studio mixing console.

fader unit A valve in the printer that is opened and closed to create the overall effects (fades, dissolves, and so on).

falloff The speed (degree) with which light intensity decreases as it gets farther from an instrument.

fc *See* **foot-candle**

feature A film roughly 70 minutes long or longer that is intended for commercial release.

feed spool The spool inside the camera that holds the unexposed film in the film chamber.

field mixer A device used for mixing microphones on-location. Also called *mic mixer*.

fill light The light used to fill in the harsh shadows created by the key light.

film chamber The space in the camera where the unexposed and exposed film is stored.

film guide *See* **aperture plate**

film noir Most identified with the 1940s, a style of film that used stark and atmospheric imagery to suggest a claustrophobic world filled with the darker and more ambiguous aspects of character motivation.

film plane The place where the film is exposed.

film speed *See* **exposure index (EI)**

film tape A type of tape used on the barrel of the camera lens for marking focus points and for hanging shots in the editing room. Also called *white paper tape*.

film-to-tape A process whereby an edited program is rebuilt from high-resolution retransfers from the film negative.

filters (1) *Audio:* Options on recorders or sidebar gear that affect a range of frequencies. (2) *Visual:* Glass or gel materials that alter the color, quantity, or character of light.

filter slots Small slots either in the film chamber or on the exterior of the camera, where a filter in a holder can be inserted.

final audio mixdown *See* **audio mixing**

fine cut In editing, the fine-tuning of the rough cut.

FireWire A connection that can transfer a high volume of information.

first assembly The assembly of the desired takes in the order laid out in the script. Also called *string-out*.

first assistant cameraperson (1st AC) The crewmember responsible for everything to do with the cleanliness and the operation of the camera and the camera support equipment.

fish-eye lens A lens that sees almost a full 180 degrees in front of the camera.

flag A framed square or rectangular piece of black material used to block specific paths of light.

flange The lip on the back of the lens that is inserted into the camera.

flash card recorder A tapeless technology that writes the audio signal directly to a hard drive or similar storage medium.

flash frames The overexposed frames at the beginning and the end of every shot.

flashing Running unprocessed film past a small light to create an effect.

flatbed A tabletop film editing machine in common use in film's heyday.

flex file A data file created during the telecine process that interrelates film edge numbers with video time code for matchback.

floodlight A lighting instrument that produces a diffused, indirect light beam; the three types are scoops, broads, and softlights.

fluid camera technique An approach to efficient shooting that smoothes out or eliminates bumpy camerawork.

fluid-effect head A tripod head similar to a friction head, but the moving parts are further cushioned with an enclosed viscous fluid that assists smooth pan and tilt movements.

fluid head A common professional tripod head used to produce smooth movements.

flying spot scanner A device used in film-to-video transfer that employs a strong piece of light that is shot through the film; it rapidly scans each frame, separating out the RGB and luminance components to create the video image.

focal length The length of a lens, calibrated in millimeters or, less common, in inches.

focusable spot A lighting instrument that produces a direct, specular light beam; can be lensed or open-faced.

focus ring A ring on the lens with which focus is set for every shot.

Foley A method of creating sound effects in a specially equipped studio.

footage counter An indicator that keeps track of how much film has been shot. Also called *gas gauge*.

foot-candle (fc) A unit of measurement of light based on the volume of light 1 foot from a burning candle.

force processing Overdeveloping film; generally used to compensate for underexposure. Also called *pushing*.

format The size of the film stock and the image standard. Three film formats are in common use: 35mm, 16mm, and Super 8. In video, formats include MiniDV, DVCPRO, DVCAM, Digibeta, and D5.

FPS *See* **frames per second**

frame Each individual photographic image on a piece of motion picture film.

frame counter A gauge on the camera that counts individual frames; helpful in such applications as animation.

frame line The hairline dividing one film frame from another.

frame rate *See* **frames per second (fps)**

frames per second (fps) The number of individual frames photographed per second; the professional frame rate is 24 fps. Slower speeds create fast motion, and higher speeds yield slow motion. Also called *frame rate*.

freeze-frame A printing technique that repeats individual frames to freeze the action.

French flag A small flag on an articulated arm that mounts on the camera; used to cut lens flares.

frequency range The spectrum of audible and inaudible sound; represented in hertz.

frequency response How evenly and completely a specific recorder or playback format reproduces the audible range.

Fresnel The most popular type of lensed lighting instrument, whose lens employs steplike concentric rings of glass. Named for its inventor.

friction head A type of tripod head that employs swelling rings to create resistance in pan and tilt movements.

front-filter A glass filter mounted in front of the lens.

front-surfaced mirror A mirror that is coated on a surface (of a shutter, for example) for optimal optical performance.

f-stop A setting for the diaphragm in the lens that is used to regulate the amount of light reaching the film plane.

full-blue gel A modifying material that cuts a lighting instrument's output by one f-stop and adds a blue component to amber tungsten instruments, bringing them up to the daylight color temperature.

full-body shot A shot that includes a person from head to toe. Also called *full shot*.

fullcoat *See* **mag stock**

full shot *See* **full-body shot**

gaffer The head of the lighting crew; responsible for the technical implementation of the DP's lighting plan.

gaffer's tape A 2-inch-wide tape used for a multitude of purposes on a set.

gain controls *See* **potentiometers**

gang synchronizer Interlocked rolling drums (gangs) with sprocket teeth; sound and picture are locked into gangs and then fed through the synchronizer in sync.

gas gauge *See* **footage counter**

gate *See* **aperture**

gear head Tripod head with separate gears that control movement of the head and are in turn controlled by hand cranks.

gel A colored, cellophane-like material used to change the color or quality of the light.

generation The number of dubs away from an analog original. In the family tree of an image or a sound, a first-generation copy is struck directly from the original. A second generation is a copy and so on. The greater the number of nondigital generations, the greater the quality loss.

grader *See* **timer**

grading *See* **timing**

grain The silver halide crystals that are the building blocks of the photographic image; similar to pixels on a computer screen.

gray scale A scale representing a series of distinct shades of gray, from black to white.

grip The jack-of-all-trades on a set.

grip equipment Specialized clamps and tools used for mounting instruments.

ground glass The glass target in a film camera viewing system that gives the parameters of framing for different formats and often has crosshairs indicating the center of the frame.

half-moon shutter A half-disk–shaped shutter in the camera that rotates in front of the gate.

handheld camera A filming approach that can give a sense of urgency or chaos to action, often making the viewer feel like a participant.

handles *See* **ambience overlaps**

Hazeltine Machine used to analyze the original film prior to printing.

HD *See* **high-definition television (HDTV)**

HDMI *See* **high-definition multimedia interface**

HDTV *See* **high-definition television**

HDV *See* **high-definition video**

head (1) Mechanism with pan and tilt controls on which the camera is mounted for attachment to a tripod. (2) The beginning of a shot or roll.

headroom (1) *Audio:* Room above 0 VU where the recorder still reproduces an undistorted signal. (2) *Visual:* Compositional space above a subject's head.

helical scan recording A rotating record head that multiplies the speed of tape travel; used in video and digital audio-recording technologies.

hertz (Hz) A unit of measurement of the pitch of a sound.

HFAs *See* **high-frequency attenuators**

hi-def *See* **high-definition television (HDTV)**

high-angle shot A shot from above that tends to diminish a subject.

high-definition multimedia interface (HDMI) A transfer interface used to move high-volume digital media to a variety of audio and video devices.

high-definition television (HDTV) A newer, high-resolution broadcast standard that employs a widescreen (16:9) aspect ratio closer to standard 35mm theatrical presentation. Also known as *hi-def* and *HD*.

high-definition video (HDV) A mix of high-definition television and the MiniDV format, HDV is a standard that is getting wide use in the independent world.

high-frequency attenuators (HFAs) Audio filters that cut frequencies above a preset level.

high hat A tripod head mount that stands about 6 inches tall, used for mounting a camera on a tabletop or other surface.

high-key Even, fairly flat lighting; it could be called nonjudgmental lighting.

high-pass filters Audio filters that allow high frequencies to pass through while cutting low frequencies.

high-res A copy from either a film or video master that indicates the highest-quality transfer possible.

hiss Inherent system noise in analog recorders.

HMI lighting A relatively new line of daylight–color temperature instruments.

hot splicer *See* **cement splicer**

hyperfocal distance The closest focus point that includes infinity in the depth of field.

Hz *See* **hertz**

inches per second (ips) The standard unit of measurement for the rate of travel of analog audiotape—the running speed.

inching knob A knob used to manually move the camera's action backward and forward.

incident light The light that falls on a subject. *See also* **incident-light meter**.

incident-light meter Measures how much light is falling on an object; you point the meter toward the light source or toward the camera.

instrument An industry term for a piece of equipment used to produce light—a lighting instrument.

interlaced video Video with interlaced scanning that alternates fields of information to create each individual frame. The NTSC and PAL systems are interlaced.

intermittent movement The alternately moving and stationary state of the film inside the camera as it is being exposed.

invisible editing A conventional approach to cutting in which the editing is designed to go largely unnoticed by the viewer.

ips *See* **inches per second**

ISO Stands for *International Standards Organization*. *See* **exposure index (EI)**.

jump cut A cut in which there is a jump in time between the shots.

k *See* **kilowatt**

K *See* **Kelvin**

keepers Devices that keep the film tight against the sprocketed rollers in the camera.

Kelvin (K) A unit of measurement used for the color temperature of light.

key grip The head of the grip crew.

key light Usually the major source of illumination; generally a beam of light that casts harsh shadows.

key numbers *See* **edge numbers**

kicker light A light on the fill side and behind the subject that brushes or rims the cheek.

kilowatt (k) 1,000 watts.

kinescope A motion picture camera designed to photograph video off a television monitor.

Kodalith *See* **sheet negative**

lab The motion picture processing laboratory.

lamp An industry term for the bulb used in a lighting instrument.

lap dissolve *See* **dissolve**

Latham's loops Bends in the film where the continuous motion of the sprocketed rollers and the intermittent movement of the pull-down claw are reconciled.

latitude The amount of under- or overexposure that the film stock can accept and still render objects with detail.

lav *See* **lavalier mics**

lavalier mics Small clip-on mics that are frequently used for interviews, although they have a wide variety of applications in film. Also called *lavs*.

lens flare An effect caused by light shining into the lens, producing either washed-out areas or multifaceted patterns on the image.

lens mount The method with which the lens is attached to the camera.

lens perspective The way a lens represents space.

lens speed The maximum aperture—the widest the lens diaphragm will go.

lens support system Rods that extend from the body of the camera to support the weight of the lens, avoiding undue stress on the camera's lens mount.

lens turret A movable plate in a camera in front of the film gate with which different lenses can be rotated in front of the film, allowing for switching lenses between shots.

LFAs *See* **low-frequency attenuators**

lighting The application and the manipulation of artificial light for illuminating a scene—a key building block of the photographic image.

lighting continuity Photographic consistency between shots.

lighting ratio A representation of the relationship between the key and the fill. Also called *contrast ratio*.

light leaks Any unwanted light striking the film, caused by irregularities in the camera's tight-fitting junctions.

light-struck Pertaining to footage that has been exposed to light in the loading process. All efforts are made to minimize the amount of film subject to this effect.

light trap The chamber where the film passes out of the magazine; designed to ensure that light will not seep in.

limiter An audio recorder feature that adjusts peak signals that are liable to be distorted.

line The principle used to create an understandable sense of the space in which the action is occurring. Also called *180-degree rule* or *axis of action*.

lined script A version of the script created by the script supervisor while filming; uses vertical lines to detail the action being covered from each setup.

line-in An input jack for transferring an audio signal from another machine.

line jump A shot that breaks the 180-degree rule.

line-out An output jack for transferring an audio signal to another machine.

line signal A specific type of audio signal that is used to transfer sound from machine to machine.

linking A function in NLE that indicates that clips are joined together and will be treated the same. The term most frequently refers to picture and its sync sound.

location manager A crewmember who is responsible for all of the permissions, paperwork, and general logistics involved in shooting on a location.

location scouting The process of finding locations suitable for individual scenes.

lockdown A situation in which the framing must be absolutely consistent from shot to shot. The camera is securely fixed with weights or hardware so that there will be absolutely no movement between one take and the next.

log *See* **camera report**

long lens *See* **telephoto lens**

long shot (LS) A shot that includes the full human body or more.

look The visual character of an individual film stock; mostly has to do with issues of grain, color separation, and how stocks respond to under- and overexposure.

looking room *See* **eyeroom**

looping *See* **automated dialogue replacement (ADR)**

loop setters Small guards above and below the gate on automatic-threading cameras that create loops of the appropriate size and shape.

low-angle shot A shot in which the camera is below the subject, tending to make characters or environments look threatening, powerful, or intimidating.

low-frequency attenuators (LFAs) Audio filters that cut low-frequency signals.

low-key Contrast lighting that is atmospheric and might be considered judgmental.

low-pass filters Audio filters that allow low frequencies to pass through while cutting high frequencies.

low-res A lower-quality transfer from a film or video master that indicates that the copy will be used for off-line work.

LS *See* **long shot**

luminance The way objects and materials reflect light and how film responds to that light. Also called *reflective quality.*

mag *See* **magazine**

magazine A separate film chamber that is mounted on the camera. Also called *mag.*

mag stock Audio stock that is the same size and dimension as the film itself; the medium for audio cutting in conventional film editing. Also called *fullcoat.*

married print A film print in which picture and sound are finally joined together.

master mix The product of the mixdown of the mixtracks; the final sound for a film.

master scene technique A common approach to shooting scenes, in which the sequence of LS-MS-CU is used to move from general to very specific information.

master shot A shot that establishes the setting: where the characters are, any important objects that may be present, and so on. Also called *establishing shot.*

matchback The process of converting the frame information from a digital edit to the edge numbers needed to conform a version of original film.

match cut A cut in which the action matches from one camera angle to the next.

matte box An accordion-like bellows attachment that is placed on the front of the lens and is used for mounting filters or shading the lens from direct light.

maximum aperture The widest *f*-stop opening on an individual lens.

MCU *See* **medium close-up**

mechanical head A type of tripod head designed for still photography; there is no means to cushion pan and tilt moves or create any resistance because the head is designed simply to get the camera from one position to another for still photographs.

medium close-up (MCU) A shot of a person that is a little wider than a standard close-up.

medium shot (MS) A shot of a person from roughly the waist up.

memory The phenomenon wherein a battery that has not been totally discharged often enough "memorizes" the small amount of charge it needs to be topped off.

meter Short for lightmeter.

mic mixer *See* **field mixer**

mic signal A specific audio signal that is created by a microphone.

MiniDV The most common consumer digital video format.

mini plug A smaller version of the quarter-inch plug, generally used as a microphone input on consumer cassette recorders and video cameras.

mirrored butterfly shutter A shutter shaped like a butterfly that, as it rotates, alternately sends light to the viewing system or allows light to reach the film plane.

mixtracks The sound rolls created in the editing process.

modulometer *See* **peak program meter (PPM)**

mono A presentation of sound in a single-signal channel rather than in channels with separated signals, as in a stereo or multichannel configuration. Short for *monaural.*

MOS Shots executed without sound being recorded.

MS *See* **medium shot**

Nagra A popular audio recorder used for sync-sound filming. The analog version was a standard for many years, now replaced by digital technologies.

National Television System Committee (NTSC) The organization that sets the standards for video signals in the United States. The 29.97-frames-per-second American standard is referred to as *NTSC.*

negative cut list A list of edge numbers created by NLE matchback software, used to guide transfer or negative cutting. Also called *cut list.*

negative cutter The person who matches the camera original to the edited workprint. Also called *conformist* or *neg cutter.*

negative cutting The process of conforming the camera original to the edited workprint.

negative film A type of film stock that has all of the lights and darks reversed from how they are normally perceived.

neg cutter *See* **negative cutter**

nicad A rechargeable nickel-cadmium battery used for many cameras with electric motors.

NLE *See* **nonlinear editing**

nondestructive editing An approach of some NLE systems with which the shots and the sounds can be lengthened and shortened after being brought into the timeline.

nonlinear editing (NLE) Hardware and software systems that permit editing digitized video on a computer.

nonsync sound Sound that is recorded at times other than when the camera is recording; includes location sounds, studio recordings, and prerecorded music tracks.

normal exposure The exposure that produces a clear and true-to-life picture.

normal lens A lens that essentially gives a normal representation of space and perspective.

NTSC *See* **National Television System Committee**

oblique shot A shot in which the camera is tilted laterally; often used to suggest imbalance. Also called *Dutch angle.*

off-line editing An editing system in which time-consuming editorial decisions are made within a less sophisticated, less expensive, low-resolution environment.

ohm A unit of measurement of the resistance to a signal passing through a line.

OMF *See* **Open Media Framework**

omnidirectional mics Microphones that pick up sound in a spherical pattern, that is, equally in all directions.

one row *See* **single perf**

on-line editing A high-end, high-resolution editing environment wherein projects can be finished at the highest quality possible.

Open Media Framework (OMF) An open framework that allows the export and the import of any media information among different NLE audio and graphics software programs.

optical effects Effects incorporated during final printing, such as dissolves, fades, wipes, and supers.

optical master The photographic printing element for a film's sound track. It is a blank piece of film except for a narrow strip of diamond-shaped patterns opposite the side with the sprocket holes.

optical printer A printer used to rephotograph existing footage; essentially a camera shooting into an apparatus that projects the film.

optical track The photographic sound track that is printed on the edge of the final film.

orange mask A leader that creates black in the resulting color prints from a color negative.

original The film that actually ran through the camera when shooting.

OTS *See* **over-the-shoulder**

outtakes Unused shots, usually stored together on rolls for easy review.

overexposure Film that received too much light, resulting in overly bright images.

overhead A drawn view of a scene from above; helpful for planning blocking and camera positions.

overhead shot *See* **bird's-eye view**

overlapping dialogue cut A cut in which the transition from one shot to the next occurs during a line of dialogue.

over-the-shoulder (OTS) A shot done over a character's shoulder.

PA *See* **production assistant**

pan A shot in which the camera is pivoted horizontally on the tripod. In lighting, it is turning the instrument on a stand in a similar fashion.

parallax A problem on rangefinder cameras, in which the viewfinder is not seeing precisely the same frame that the film is seeing.

parallax adjustment A control to correct parallax.

PD *See* **production designer**

peak program meter (PPM) An improvement over the VU meter that reads the peak of every signal from the microphone or line. Also called *modulometer*.

perforations *See* **sprocket holes**

phantom mics Mics powered by the recorder's battery rather than an internal battery.

phasing A complex phenomenon in which specific frequencies are canceled out and thus not recorded.

phone plug *See* **quarter-inch plug**

photographic consistency The continuity of shots in terms of the color and the quality of the light.

photographic darkroom bag A double-zippered bag used to load and download raw stock in total darkness. Also called *changing bag*.

pickup pattern The graph of a microphone's directional characteristics as seen from above—how a mic picks up sound that is coming from different directions. Also called *polar pattern*.

picture gate The opening that light passes through to project the film on an editing machine or a projector.

picture lock The point at which the editor determines that picture editing is complete, usually followed by extensive sound-effects and music editing.

pitch The distance between sprocket holes on the film stock.

pixel (1) A single imaging element that can be identified by a computer; the more pixels per picture area, the higher the picture quality. (2) The imaging sensing devices on the video camera's chip that translate the light it receives into an electrical signal. Short for *picture element*.

plant mics Mics placed on a set to pick up sound in areas that are difficult to record with a boom.

plastic memory The tendency of film stock to stiffen in the shape in which it was left.

playhead A vertical scrolling line in an NLE system that moves horizontally, indicating the position in the clip or the timeline.

PM *See* **production manager**

point-of-view shot A shot that represents the vision or the viewpoint of a specific character.

polar pattern *See* **pickup pattern**

postdubbing Recording replacement sync-sound dialogue in postproduction with the intent of editing it into the sound track.

postproduction The editing stages of a film, including scoring, titling, and all finishing processes.

potentiometers The twist knob controls on a studio mixing console. Also called *pots* and *gain controls*.

pots *See* **potentiometers**

PPM *See* **peak program meter**

preamp A small amplifier in a mic or line chain that boosts a weak signal to recordable or amplifiable levels.

preproduction The planning and preparation process required to be in position to shoot a film.

presence The innate audio ambience of a given space. Also called *room tone*.

pressure plate The plate in the camera that holds the film flat against the aperture plate.

preview window The window in an NLE program where the edited program is played.

prime lens Any fixed-focal-length (nonzoom) lens.

principal shooting The concentrated shooting schedule of a film's scenes.

printer A contact printer where film is duplicated.

printer lights The individual controls of the three primary colors of light—red, green, and blue—in a contact printer.

printer points Increments in the intensity of a printer light.

printing The general term for the process of duplicating the processed original onto frame-for-frame copies.

printing cues The instructions to the printer lights and the fader unit needed for every shot.

printing program A computer-generated decision list that will run the printer lights and the fader unit.

producer The person who is the central organizational and capitalization force in a motion picture's production.

production All of the actual shooting of a film.

production assistant (PA) Generally responsible to the assistant director, the PA is a gofer who is available to handle any last-minute details on a set or in the production office.

production board A large chart that cross-references the scenes with the resources needed to execute them. This is now largely computerized.

production designer (PD) The person responsible for the design of all of a film's settings.

production manager (PM) The person responsible for the day-to-day running of a film's production.

production office Central command center for a film shoot.

production sound *See* **sync sound**

production values An umbrella term that refers to the amount of resources devoted to the image and its overall quality.

progressive video The sequential presentation of video information. Computer monitors and a number of high-end digital formats employ the progressive-scanning standard.

projection print A duplicate copy of the final product of a film project, produced for distribution and exhibition.

projector The equipment used to show a film on a screen.

props master The crew member responsible for finding, obtaining, and organizing all the props required by a script.

proxemics The distance between subject and camera. From the word *proximity.*

pull-down The process of slowing down sound so that it can stay synchronized with film transferred to video that runs at 29.97 frames per second.

pull-down claw The mechanism in the camera that advances each individual film frame for exposure or projection.

pull-up The process of speeding up sound edited in NTSC to match the faster speed of film.

pushing *See* **force processing**

quarter-inch plug An audio plug used extensively as a mic or line connection. Also called *phone plug.*

quick-release plate A detachable plate that is used to easily secure a camera to a tripod head.

rack focus The physical shifting of the focus ring as a shot is being executed.

radio mic *See* **wireless mic**

rangefinder viewing A viewing system in which the operator looks through a facsimile lens that is mounted on the side or top of the camera.

raw footage The rolls of uncut footage.

raw stock The unexposed film purchased from the manufacturer.

RCA plug Probably the most common audio line connection; found on a wide range of equipment from consumer stereos to VCRs.

recanning Putting a short end back in its packaging when film rolls are downloaded at the end of a day or for any other reason.

record run A style of slating scenes in which the sound recorder produces the time code, which is sent to the slate via a radio transmitter.

RED ONE Revolutionary digital camera that is used extensively for shooting projects. It changed the industry as much for its price point as for its capabilities.

reflective light Light that is bounced off of the illuminated subject. *See also* **reflective-light meter.**

reflective-light meter Measures how much light is reflecting off of an object; you hold the meter close to the camera, pointed toward the illuminated object.

reflective quality *See* **luminance**

reflex viewing The industry-standard viewing system in which the operator is actually looking through the camera's lens while filming. Also called *through-the-lens (TTL)* viewing.

registration The stability, or lack thereof, of the film image in the camera as it is being exposed in the gate.

registration pin A pin in the camera that holds the image steady as it is being exposed in the gate.

release prints Designed for exhibition, all subsequent prints of a film that use an acceptable answer print as the guide.

rendering A time-consuming process specific to certain NLE systems, in which material created or modified in the timeline must be saved to a hard drive before it can be played.

rerecording mixer An employee of the mixing facility who orchestrates the mix at the filmmaker's instruction.

resistance The force in a tripod head against the operator's movement.

reversal film A type of film stock in which all colors and shades are rendered normally on the original.

reverse datacine The process of going through captured NTSC video and undoing the three: two pull-down, creating clips usable in a 24-frame environment.

rewinds The mechanism on an editing bench for hand-winding the film.

RGB The abbreviation for the three primary colors of light: red, green, and blue.

riding gain The process of watching the display on an audio recorder, manipulating amplitude control to ensure that the sound is being optimally recorded at all times.

ripple delete A feature in most NLE software that allows the editor to delete material from the timeline while bringing the subsequent parts of the show forward to fill the gap.

room tone *See* **presence**

rough cut The first complete cut of a film.

run-through A rehearsal of a scene at normal speed, generally used to watch for technical problems.

rushes *See* **dailies**

sampling rates *See* **color space**

sandbags Weights used to secure tripods, light stands, and other equipment against tipping over.

scale The size of objects in relation to one another in the frame.

scene The basic unit of a script, with action occurring in a single setting and in real time.

scene correction A supervised transfer in which the colorist determines optimal exposure and color for each individual shot during the transfer process.

scratch track A conventional sync track that serves as a guide in editing.

script supervisor The crewmember responsible for keeping track of continuity as well as other general script considerations.

scrub To move slowly or frame by frame through picture or sound in NLE software.

SD *See* **standard-definition**

SDI *See* **Serial Digital Interface**

second assistant cameraperson (2nd AC) The crewmember responsible for slating shots and loading magazines. Also called *clapper/loader.*

selects The shots that have been chosen for use in the first assembly.

Serial Digital Interface (SDI) A digital video interface used for storage and broadcast-grade video.

series 9 The most common size of filters and ring adapters for 16mm zoom lenses.

set decorator The crewmember responsible for planning the small items on the set.

set dresser The crew member who is responsible for the positioning of all props, furniture, and any other objects on the set.

set lights Lighting instruments used to create effects in the background and other parts of the set.

setup The basic component of a film's production; refers to each individual camera position, placement, or angle.

SFX *See* **sound effects**

shallow focus An approach in which several different planes of sharp and soft focus are incorporated within a single image. *See also* **deep focus.**

sheet negative Used to photograph title cards. Also called *Kodalith.*

shock mount A suspension system that absorbs any moderate shocks to the microphone or boom.

shooting for the edit Considering how a scene is going to be edited as it is being shot.

shooting script A detailed, annotated version of the script, usually put together by the director.

short ends The unexposed portion of a roll remaining either when a day's shooting has ended or when a different type of stock needs to be loaded.

short lens *See* **wide-angle lens**

shot The footage created from the moment the camera is turned on until it is turned off; a sequence of frames.

shot list A less formal alternative to the storyboard; a list of brief written descriptions of the intended shots.

shot/reverse shot The process of shooting all of one person's dialogue and then moving the camera to the reverse shot to shoot all of another person's dialogue.

shoulder The precipitous drop-off to overexposure at the edge of a film stock's latitude.

shutter The mechanism that is constantly rotating in front of the camera's gate, blocking the light while the film is being pulled down and allowing the light to reach the film when the frame is stationary for exposure.

shutter release button The button that is used to trigger the taking of a still frame on a DSLR or any still camera. It is also frequently the button used to activate the electronics of the camera for predetermining exposure, focus and a variety of other functions. It can double for starting a video shot on a DSLR, although this function is frequently found elsewhere.

shutter speed The amount of time each individual frame of film is exposed. In motion pictures it is usually a constant that is dependent on frames per second.

sightline The direction that a character or characters are looking in a shot.

signal path The route that an audio or video signal takes.

silver halide crystals Crystals suspended in the film's emulsion that change their properties when struck by light and subjected to chemical developers.

single perf Film stock with sprocket holes on only one side. Also called *one row*.

single-system sound Audio-recording method whereby sound is recorded along the edge of the film.

slate The clapboard used for organization in shooting, easy identification of shots in editing, and, most critical when shooting film, matching location sound and picture.

slowdown In the transfer of film to video, it is the .01% conversion of 30 pulldown frames to the 29.97 fps of NTSC and other video formats. The .01% slowdown is also used for other frame rates both in transfer and video shooting.

slug Leader or junk picture that is used to fill in the empty spots on sound rolls. Also called *sound fill*.

smart slate A slate with a radio receiver that displays rolling time code on its face.

SMPTE Universal leader The standard countdown leader with descending numbers used at the beginning of films. *SMPTE* stands for *Society of Motion Picture and Television Engineers*. Also called *Academy leader* and *countdown leader*.

sound Vibrations produced by the compression and the separation of air molecules, generally represented as a wave.

sound effects (SFX) Incidental sound cut to action, not music or the spoken word.

sound fill *See* **slug**

sound log Similar to a camera report, the log of the daily activity of the sound crew.

sound mixer The person who operates the tape recorder and is head of the sound crew.

sound perspective The way listeners expect to experience sound at specific proxemic positions.

sound track Any edited track of audio; generally refers to a finished version of a program's sound.

specular light Light that is direct, generally produced by focusable spotlights.

spider *See* **spreaders**

spill Excess light from an instrument.

splicer The block on which one piece of film or sound is cut to another.

splicing frames The two frames that are sacrificed at each end of a shot when cement-splicing the original film.

split reel A reel with a threaded center so that the two flanges can be detached.

spot printing A common practice on feature films, in which desired takes are circled on the camera report for later identification and printing.

spreaders An apparatus with three extendable arms that is put on the floor to hold the tripod legs in position. Also called *spider* and *tridowns*.

spring-wound motor A camera motor driven by a spring similar to that found in a mechanical clock.

sprocketed rollers Rollers inside the camera that feed the film into and out of the area where each image is exposed.

sprocket holes Holes along the edges of a strip of film that facilitate movement past the gate. Also called *perforations*.

spud The mounting piece on most small light stands.

squawk box An amplifier/speaker used on an editing bench.

standard-def *See* **standard-definition**

standard-definition A term for NTSC video that has come into use recently to distinguish it from hi-def. Also refers to PAL and SECAM. Also called *standard-def* and *SD*.

standard legs A tripod that extends from roughly 4 to 7 feet, used for shots that are done at a standard height.

Steadicam A device that mounts on the camera operator's chest, giving fluid movement to what are essentially handheld shots.

Steadicam Junior A less complicated and less expensive version of the original. It is no longer produced.

stereo Channel configuration wherein recorded sound is separated into two components and presented on different speakers in amplification.

storyboard A form that has each shot drawn on one side of the page, with the script material it covers—dialogue, action, and so on—on the other side. Also called *board*.

straight cut A visual cut at the end of one line of dialogue to the beginning of the next.

stress The aesthetic result of an unbalanced image. Also called *tension*.

string-out *See* **first assembly**

striped film *See* **single perf**

studio mixing console A large audio mixing board generally used for mixing multiple sound components down to one master version of a program's sound.

sunshade An attachment mounted on the front of a lens to shade the lens from direct light.

super *See* **superimposition**

Super 8 The smallest format in common use and the amateur standard for years.

Super 16 An adaptation of the 16mm format that uses the area of the film that would be taken up by the second row of sprocket holes for additional image area.

superimposition One shot overlaid on another; can be achieved either in the camera while shooting or in the editorial and final printing processes. Also called *super*.

supervised transfer A telecine transfer in which the video colorist determines settings for each individual scene.

sync The synchronization of sound and image.

sync beep A single frame of mag stock that creates a tone that is cut across from the Academy 2. Also called *sync pop.*

synchronous (sync) motor A speed-controlled motor that produces a virtually perfect 24 fps. Also called *crystal motor* and *DC servo-controlled motor.*

syncing up Using the slate to match the production sound with the image.

sync pop *See* **sync beep**

sync rolls The mag stock transfers of the production sound.

sync sound Sound that is recorded as the camera is rolling on-location or on the soundstage. It is generally, though not exclusively, dialogue. Also known as *production sound.*

T *See* **tungsten**

tail The end of a shot or roll.

tail slate A slate recorded at the end of a shot rather than at the head.

takes The number of attempts at a shot needed to produce at least several usable versions.

take-up spool The spool inside the camera that takes up the film after it has been exposed.

talent An umbrella term for all of the performers in a film.

tape/direct switch The option of monitoring either the playback head or the record head on an analog audio recorder.

tape-to-tape A finishing approach wherein a show is finished from high-resolution initial transfers.

target The series of markings on the camera's viewing screen.

technical camera Everything concerning the camera except calling different shots.

telecine A high-end film-to-video transfer machine. An industry workhorse for many years, it has largely been replaced by the datacine.

telephoto lens A long lens that magnifies the subject in a manner similar to magnification by binoculars. Also called *long lens.*

tension *See* **stress**

three-point setup The textbook approach to figure lighting, comprising a key light, a fill light, and a backlight.

three: two pull-down The common strategy for converting between film and video frame rates in which the telecine prints three video fields of every other film frame.

through-the-lens (TTL) viewing *See* **reflex viewing**

tilt A shot with the camera moved vertically on a tripod head. In lighting, it is turning the instrument on a stand in a similar fashion.

time code A numbering system that is encoded on the videotape that provides an address for each individual frame.

timeline The master editing control window in an NLE system.

timer A lab employee who goes through the entire film and analyzes each individual shot for color and exposure. Also called *grader.*

timing The process of evaluating each shot before printing. Also called *grading.*

titles The credit lines for a film or video.

toe The precipitous drop-off to underexposure at the edge of a film stock's latitude.

track Specially built track used for fluid dolly movement.

tracking shot A shot that follows alongside, in front of, or behind a moving subject.

transitions Shots that bridge one setting to another or that mark the passage of time.

transport The mechanisms in a flatbed editing machine that move the film or mag stock past the picture gate and the audio playback head.

tri-downs *See* **spreaders**

trim bin A bin for hanging film during editing.

trimming Changing the shape, quality, or intensity of the light an instrument produces.

trims In editing, frames trimmed from the shots that will be used.

tripod Three-legged camera support, consisting of two separate pieces: the legs and the head.

tripod threading holes One or more holes in the bottom of the camera body that are used to attach the camera to the tripod head.

***t*-stop** A measure of exposure that takes into account the light that is lost by passing through a lens.

tungsten (T) A type of lamp rated for motion picture photography that is 3,200K. Tungsten lamps produce the same color that a black-bodied surface does when it is heated to 3,200 degrees.

TV-safe frame A frame on the camera's viewing screen that defines the boundaries of the image once transferred to video.

tweaking Fine-tuning what each instrument is accomplishing in a lighting setup.

two row *See* **double perf**

two-shot A shot of two people from roughly the waist up.

underexposure Film that received too little light, resulting in dark areas in the frame.

unidirectional mics *See* **cardioid mics**

unintentional splice A splice where an attempted cut was put back together again.

unsupervised transfer A datacine transfer in which general RGB settings are determined and then maintained through the entire process.

upstream media Usually, masters or original film that is of higher quality than low-resolution work tapes.

variable shutter A control on the camera that allows the operator to change the size of the shutter.

vectorscope Monitors hue and saturation.

video assist A tiny video pickup device mounted in the viewing system of the film camera, giving a video representation of the shot.

video dailies Inexpensive low-resolution transfers that are used for screenings and as worktapes.

video field The two pieces of information that, when presented sequentially, create the interlaced video frame.

viewer In an NLE program, the window where clips are played back and analyzed for insertion into the timeline. Also refers to a traditional, standing viewing machine on which film can be analyzed frame by frame or at any other desired speed.

visual shorthand Accomplishing an action visually in as economical a way as possible.

visual subtext Information that is not present in the content and the structure of the narrative but implicit in the visual presentation.

VU (volume-unit) meter A meter that gives a visual representation of the level of the audio signal being fed to the record head.

walk-through An initial rehearsal in which the technical personnel and the actors walk slowly through a shot to identify potential problems.

waveform monitor Gives a representation of the video signal, analyzing the technical character of the picture from lightest to darkest elements; a critical tool for indicating if the blacks are within an acceptable range for both good picture quality and broadcast.

white balance The adjustments of the color circuits in a video camera to render light of various color temperatures as white.

white paper tape *See* **film tape**

wide-angle lens A lens that gives a wide view of a scene. Also called *short lens.*

widescreen Created in the 1950s, any presentation that has the aspect ratio of 1.66:1 or greater. In the United States, most widescreen is 1.85:1.

wild camera A camera that cannot do sync-sound filming.

wild motor A camera motor that produces a general speed rather than a precise one.

wind noise Unwanted sound created by wind hitting the microphone.

window burn A small window that can be created in the video frame where time code and any other pertinent information is visually represented.

wind shield *See* **wind zeppelin**

wind zeppelin An attachment with a baffle design that cuts much of the sound interference from wind. Also called *wind shield*.

wireless mic A mic, generally a lavalier, that is plugged into a radio transmitter; the signal is then sent to a receiver on a recorder. Also called *radio mic*.

workflow An umbrella term for the path a producer chooses to take to a finished product. There are a variety of choices, and the impact on the final product and its market must be carefully considered.

workprint A contact-printed copy for editing that is a frame-for-frame replicate of the original film; made by a motion picture processing laboratory.

XLR plug The standard mic connection on most professional audio and video equipment. Also called *Canon plug*.

zero frame In the edge-numbering system, the frame on which the counting of each sequence of 20 or 16 frames starts.

zero VU (0 VU) Often presented as the point that the audio signal should not exceed on an analog recorder because the signal will distort, although there is some room above it for viable recording.

zoom lens A lens with a variable focal length.

Index